For David Kratz —

a Statesman of
his profession...

Bin un

Praise for
William O'Shaughnessy's
Airwaves

"I read every word. Keep writing, speaking, and urging. The game is lost only when we stop."
Mario Cuomo

"Bill O'Shaughnessy's editorials make his New York TV counterparts look like so much mish-mash."
The New York Times

"O'Shaughnessy is widely heard and heralded in Westchester—and beyond."
Walter Cronkite

"I applaud Bill O'Shaughnessy's intelligent editorials on Free Speech. His is a brave stance."
Howard Stern

"William O'Shaughnessy has for years been keeping alive the disappearing art of radio station editorials."
David Hinckley, critic-at-large, *New York Daily News*

"Reading Bill O'Shaughnessy is a great reminder that politics and people in New York don't have to be sleazy. O'Shaughnessy, the radio baron and squire of Westchester, is perhaps the last of our great advocates."
Neal Travis, feature columnist, *New York Post*

"His is an authentic voice."
Louis Boccardi, president/CEO, Associated Press

"O'Shaughnessy's pronouncements add up to . . . true centrism, a search and call for common ground, for a consensus built on fair play, decency, common sense, getting along."
New York Daily News

Bill O'Shaughnessy's writing is marvelous."
Brooke Astor, philanthropist

"I have been 'neighborly involved' with Bill O'Shaughnessy for a long time. I never enjoy myself more than when I turn on his special radio station and he's carrying on about something . . . it's like coming home."
Ossie Davis, actor, playwright, activist

"As a Westchester neighbor and old friend . . . I am a great admirer of Bill O'Shaughnessy's pithy editorials."
Vice President Nelson A. Rockefeller

"Bill O'Shaughnessy is a prophet with honor in his own time. I savored every line . . . especially that which declared 'we can amplify the sweet strength of the people.'"
Don West, editor, *Broadcasting & Cable,* Cahner's Business

"Bill O'Shaughnessy maneuvers words like Nelson Riddle arranged notes!"
Thomas F. Leahy, CBS-TV executive

"A lot has been written and spoken about Rockefeller. . . . But O'Shaughnessy's tribute was the most accurate and thoughtful."
Senator Daniel Patrick Moynihan

" 'The Rockefeller Years' were so eloquent and personal. Only someone who really knew Nelson, as O'Shaughnessy did from his perch at Nelson's favorite radio station, could have said it so well."
Henry Kissinger

"Anything Bill O'Shaughnessy touches or writes turns to gold. His new book is something I'm going to want to buy. And I'm sure every New Yorker will want to read it too."
Governor George E. Pataki

"His commentaries represent the skillful narration of the human drama of our time."
President Richard M. Nixon

"The kind things Bill O'Shaughnessy says about me are very meaningful."
John Cardinal O'Connor

"O'Shaugnessy should be required reading in every English lit and writing class at all journalism schools in the country. Superb craftmanship."
Arnaud de Borchgrave, president/CEO, United Press International

"I have Bill O'Shaughnessy's first book at my fishing camp . . . and everyone who picks it up tells me how much they enjoy it and so did I."
Dan Rather, CBS Television

"This is great stuff! And wonderful writing. O'Shaughnessy puts all us ink-stained wretches to shame."
Phil Reisman, Gannett feature columnist

"We've always grown king-sized politicians in this state—the Roosevelts, Dewey, Harriman, Rockefeller—politicians who strode across the national stage. What makes O'Shaughnessy noteworthy, in an era of unparalleled public revulsion for politicians and the political process, is his obvious affection for those who've played key roles in the public life of this state, virtually all of whom he has known personally."
Dan Lynch, feature columnist, Albany *Times Union*

"No one comes within miles of O'Shaughnessy in wordsmithing."
Governor Malcolm Wilson

"His observations, like wine, become better with time."
Joseph Reilly, president, New York State Broadcasters Association

"His taste remains impeccable . . . with wit and depth. . . ."
A. M. Rosenthal, *The New York Times* and *New York Daily News*

"Whether you're offended or inspired, you won't be bored by this collection."
Hudson Valley Magazine

"Another colorful tile in the mosaic of observations, recollections, and personal impressions that make up the written record of the Empire State in the late twentieth century."
Albany *Times Union*

"Bill O'Shaugnessy makes sure the honorable people do not go unnoticed or unappreciated. And what a contagious fury he directs at their opposites!"
Ed Brown, former WNEW and network newscaster

"The seventeenth-century diarist Samuel Pepys would have loved this excellent book. No other book I know of gives one such a sense of living in the period."
Justice George B. Burchell, New York State Supreme Court

"Once again, Bill O'Shaughnessy has made the case for local radio with substance and style."
Don Thurston, former chairman, National Association of Broadcasters and BMI/Music Licensing

"I *loved* O'Shaughnessy's first book! And I'm looking forward to the next volume!"
Frank Gifford, pro football player and commentator

It All Comes Back
to Me Now

Communications and Media Studies Series

Robin K. Andersen, *series editor*

WILLIAM O'SHAUGHNESSY

IT ALL COMES BACK TO ME NOW

Character portraits from the "Golden Apple"

FORDHAM UNIVERSITY PRESS
New York | 2001

Communications and Media Studies, No. 7
ISSN 1522–385X

Library of Congress Cataloging-in-Publication Data

O'Shaughnessy, William.
 It all comes back to me now : character portraits form the "Golden
Apple" / William O'Shaughnessy.— 1st ed.
 p. cm. — (Communications and media studies series ; no. 7)
 Includes index.
 ISBN 0-8232-2142-3 — ISBN 0-8232-2143-1 (pbk.)
 1. United States—Biography. 2. Biography—20th century. 3.
Interviews—United States. 4. United States—Social life and customs—
1971– I. Title. II. Communications and media studies ; no. 7.
CT220 .O82 2001
973.9'092'2—dc21 2001040625

Printed in the United States of America
01 02 03 04 05 5 4 3 2 1
First Edition

For Nancy

Damn, but Mario Cuomo was right when he told me one day, "Sometimes God puts angels in our path."

The one I encountered twelve years ago has incredible style and a laughing face, as in the sweet Sinatra song that bears her name. She is the most loving, generous human being I have ever met. There is no one like the woman on this earth, and I dedicate *It All Comes Back To Me Now* to Nancy Curry O'Shaughnessy.

Contents

3: Radio Editorials

4: Of an Evening

Special Acknowledgments

These are the ones "without whom."

I should tell you, up front, of my tremendous gratitude to Fordham University Press for bestowing its imprimatur on this, my second book. This prestigious academic publisher has been advancing scholarly studies since 1907, and next year the Press will celebrate it's ninety-fifth anniversary. During those ten decades Fordham University Press has focused primarily on philosophy, theology, history, literature, and communications. It has also produced volumes on the Hudson River Valley and several timely and important books on regional issues concerning the Tri-State Area. It was one of these, a brilliant collection of speeches by the legendary Federal Judge William Hughes Mulligan, that led me to its door.

My thanks to Saverio Procario, director of Fordham University Press, whose gentle encouragement was invaluable to me.

Anthony Chiffolo, managing editor of the Press, believed in this book from the very beginning. Many is the afternoon and evening we spent in the Whitney Radio conference room in good-natured debate, while his seven-year-old daughter, Lisa, settled our predictable, but always friendly, writer-editor disputes. Anthony won most of them. Lisa won a few. And I lived to write about it.

Thanks are also due to Robin Andersen, teacher, scholar, and series editor of Fordham's Communications and Media Studies Series. Robin's blessing of this project and her dynamism have kept us all focused.

Over the years Fordham's books have had a quality "feel" to them. The tasteful covers and jackets that clothe the worthy contents are the handiwork of Loomis Mayer, a gifted production manager. It has been wonderful to work with Loomis and designer Willem Hart.

We were also fortunate to be the beneficiary of the marketing talents of Jacky Philpotts. Ditto Margaret Noonan, who as business and office manager has her finger on almost everything in that quaint house just off the Fordham campus where the university press is located.

I left this acknowledgments section of the book until the very last moment. But that doesn't lessen my profound gratitude for the tremendous assistance I've had from several of my Whitney Radio associates. You may recall I observed in my previous volume that every writer, every broadcaster, every soul deserves a Cindy Hall Gallagher. As my friend and confidante for almost thirty years, Mrs. Gallagher has been invaluable in every season of my life, and I could not have mustered the patience or found the focus required for a project like this without her unwavering commitment and support. This amazing woman of few but well-chosen words often rules with merely a nod or a gesture. And she is possessed of awesome intuitive powers.

As I attempt to thank her, I should also express my gratitude to her husband, Kevin Gallagher, and their children, Kevin, Jr., Joseph, and Alicia (truth to tell, practically the very first words they knew how to utter at a very tender age were "Mom, it's Mr. O' on the phone!"), and also to Cindy's beloved parents, Stella and Robert Hall, for sharing this marvelous woman with me and my associates at Whitney Radio.

As with my previous book, *Airwaves,* we have drawn from a great many sources while compiling *It All Comes Back to Me Now.* This enterprise could not have succeeded without the brilliance and relentless devotion of Matthew Deutsch. This gifted young broadcaster of considerable talent started in the Whitney Radio Internship Program five years ago, and now at the age of twenty-five he's practically a veteran broadcaster. Young Mr. Deutsch brought his abundant good nature and dynamism to this project early on. Night after night and on weekends he combed through Whitney Radio's voluminous archives to help us gather material. If I were giving out titles or job descriptions instead of bestowing accolades, this terrific young man would have to be properly called the "executive producer" of this volume.

As I acknowledge Matt's tremendous contribution, I should also properly mention my long-time broadcasting associates Judy Fremont, Larry Goldstein, Joe Biscoglio, Richard Littlejohn, Nick Saramis, Gregg Pavelle, Monique Emilyne Thomas, John Harper, Mark Weiss, Clif Mills, Jr., and, above all, Don Stevens, our chief of staff, who kept WVOX and WRTN operating twenty-four hours a day and, I hope, in the public interest. Don is a tremendously dedicated fellow, and I can't thank him enough for all he does.

For the necessities of my business life I've relied on the wisdom of Jeffrey Bernbach, Paul Lenok, Frank Connelly, Jr., Deacon Frank Orlando, Bill McKenna, John Vasile, Rosemary McLaughlin, Bep McSweeney, Joe DePaolo, and Francis X. Young. And for counsel on broadcasting and First Amendment matters I've resorted to Harry Jessell, John Eggerton, Don West, Erwin Krasnow, David Hinckley, Patrick Maines, Gordon Hastings, and Joseph Reilly.

And while I'm counting my blessings in this regard I should acknowledge my father-in-law, B. F. Curry, Jr. I've included observations about this remarkable eighty-one-year-old in this book. He is respected and admired by so many. And Nancy and I are among them.

All of the above not only helped with this book, they've also made significant contributions toward helping us keep WVOX and WRTN away from the speculators and absentee owners who have descended on the radio profession in the last several years.

I'm immensely proud that WVOX and WRTN are today just about the last remaining locally owned and locally operated independent stations in the entire New York metropolitan area. And as I read through this manuscript, the thought occurs that maybe it *was* all worth it because I am once again struck with the belief that I've been uniquely blessed to serve as the permittee of two altogether unique stations that have amplified the voices of those many worthy individuals you'll read about in these pages.

Allow me a brief but heartfelt thanks to my colleagues at Cablevision. This great entertainment company, which is headed by the incomparable Charles Dolan, has been very good to me and mine. Many of the interviews herein also appeared on Cablevision in the New York area, and I'm most grateful to Bob Rosencrans (the "Winston Churchill" of the cable profession, who founded C-Span), Ira

Birnbaum, and Craig Watson for pushing me in front of a camera. Also the directors of *Interview with William O'Shaughnessy* Chris Ciulo, Miles Rich, Ralph Kebrdle, and Matt Mansfield.

A very personal note: I've tried to indicate my great gratitude and love for Nancy Curry O'Shaughnessy in the dedication. It is Nancy's approval I seek above that of all others. But I have also been blessed with four children. So permit me only a father's pride or author's privilege to tell you just a bit about each of them. Matthew is a senior vice president of Whitney Radio. He has made very significant contributions to the recent tremendous growth of our stations. David is manager of business affairs at Miramax and is considering invitations from several very prominent business schools to return to the classroom. Kate is head of the Domestic Violence Unit for the City of Los Angeles and is achieving a national reputation in her field. Michael is in the executive training program at the headquarters of CurryCorp, which is headed by his grandfather. I'm proud of all four of them.

Finally, everyone who has ever heard me on the radio or been made to suffer one of my speeches knows of my profound admiration for a former governor of New York. Mario Matthew Cuomo is the finest speaker, writer, and thinker I've encountered during my sixty-three years. He is easily the most impressive public figure of our day and age. As I observed in *Airwaves,* most Americans know the power of his words and the sweep of his oratory. Nancy and I know the sweetness of his generous heart. I've never played basketball with the governor, though many still do, even to this day, at their own peril. But I *have* been privileged to listen to the musings and stunning brilliance of this towering American during hundreds of early-morning and late-evening phone calls over the past twenty years. And during one of those delightful conversations came the none-too-gentle instruction to do this book. I hope Mario Cuomo is not disappointed. I'm reminded that Phil Donahue once told an interviewer what he wanted to do with his life after television. Said the TV star, "I want to be a *herald* for Mario Cuomo." Maybe we can both do that in the *next* life, Phil.

I reserve my greatest affection, admiration, and gratitude for the people of Westchester County, New York, and their neighbors in the tri-state metropolitan area who have indulged my enthusiasms for almost forty years. I consider their forbearance as some validation

of my notion that a radio station achieves its highest calling when it tries to be more than a jukebox and instead resembles a platform, or forum, for the expression of many different viewpoints. As I finish this book and lay down these words on a brilliant spring day, I think of how much I owe *them* for allowing a "townie" broadcaster the privilege of their hearth and home. It all comes back to me now . . .

<div style="text-align: right">

W.O.
July, 2001
Westchester, New York

</div>

Friends of Bill

I'm also grateful to these generous souls who have indulged my enthusiasms. My writing, my broadcasts, my editorials, my pronouncements, my speeches—indeed, my whole *life*—have been helped by their encouragement and support, and, in many cases, by their love:

Bob Abplanalp, Cindy Adams, Roger Ailes, J. Lester Albertson, Paige Albiniak, Harry Albright, Jr., "Snoopy Allgood," J. R. Allen, Mel Allen, David Allyn, David and Leslie Alpert, Warren Alpert, Lynne Ames, Capt. Joseph Anastasi, Kelly and Ernie Anastos, Patricia Anderson, Senator Warren Anderson, Walter Anderson, Dean Andrews, Father Charles Angell, Dan Angiolillo, Joe Angiolillo, David Annakie, Joe Apicella, Antonio Aponte, Bob Armao, Louis Armstrong, Brooke Astor, Rick Atkins, Deacon James Attridge, Monsignor Terry Attridge, Ken Auletta, Marian Auspitz, Al Ayers, Paul Aziz, Whitney Balliett, Frank Bandy, Barducci, the waiter at Mario's, Roy Barnard, Tim Barrett, James Barron, Mary and Bruce Barron, Hank Bartels, Charles Barton, Ralph Baruch, Henry "Jeff" Baumann, Frank Becerra, Charles "Bill" Bell, George Bellantoni, Rocco Bellantoni, Jr., Markham Bench, Gerald Benjamin, Richard Rodney Bennett, Tony Bennett, Tom Benz, Max Berking, Susan Berkley, Hilda and Bill Berkowitz, Randy Berlage, Ben Berman, Fran Berman, Henry Berman, Richard Berman, Robin and George Bernacchia, Karen and Jeffrey Bernbach, Jerry Berns, Steve Bernstein, John Bertsch, Phil Beuth, Mario Biaggi, Ron Bianchi, Stanley Bing, Richard Biondi, Ira Birnbaum, Paolo Biscioni, Joseph Biscoglio, Junior Blake, Michael Blumenfield, Lou Boccardi, John Bodnar, Tyrus Bonner, Alfred Boone, Rich Borla, Tradeep Bose, Philip Boss, Frank Bowling, Michael Boyle, Frank Boyle, Jack Boyle, James Brady, Noam Bramson, John Branca, John Brancati, Oscar Brand, Lydia and Sergio

Braszesco, Paul Braun, Dr. David Breindel, Jimmy Breslin, Jimmy Breslin, Jr., Judge Charles Brieant, Stefano Briganti, Ashley Brody, Ira Brody, Lois Bronz, Jill Brooke, Alexander Brooks, Ed Brown, Gary Brown, James Brown, Les Brown, Marilyn and Warren Brown, Michael Brown, Roberta and Rick Brudner, Bob Bruno, Col. Paul Bryer, Rick Buckley, Adam Buckman, Peg and George Burchell, Johnny Burke, Barrett Burns, Colin Burns, Sr., Jackie Burrell, Jodi and Jonathan Bush, President George W. Bush, President George W. Bush, William "Billy" Bush, William Butcher, John Cahill, Frank Calamari, Robert Callahan, Bob Cammann, Jimmy Cannon, Joseph Wood and Trish Canzeri, Tony Capasso, Louis Cappelli, Paul Cappelli, Danny Capello, Bob Capone, Nat Carbo, Governor Hugh Leo Carey, Keri Carey, Arthur Carlson, Leslie and Peter Carlton-Jones, Jim Carnegie, Oreste Carnevale, Michael Carney, Joanne "Carmella" and Felix "Sonny" Carpenito, Dr. Margaret Carreiro, Kathleen and Patrick Carroll, Maurice "Mickey" Carroll, Arthur Carter, Dr. Frank Cartica, Bill Cary, Dan Castleman, Jim Cavanaugh, Father Joseph Cavoto, Bill Cella, Ken Chandler, Richard Chapin, John J. J. Chapman, Dr. Alan Chartok, Jessica and Mark Cheetham, Patty Chiavernini, Anthony Chiffolo, Paul Chou, Sir Harold Christie, John Cilibergo, Jim Cimino, Casper Citron, Joe Claffey, Richard McC. Clark, Bill Clark, Bobby Clark, James Mott Clark, Jr., Monsignor Eugene Clark, Lynn Claudy, Gayle and Linden Clay, Tony Cobb, Mike Cockrell, Jules Cohen, Nick Colabella, Anthony J. Colavita, Kenneth Cole, Maria Cuomo Cole, Nat "King" Cole, Dr. Robert Coles, Brian Collins, Michael Collins, Pat Collins, Alan Colmes, Rick Condon, Peggy Conlon, Cheryl Connelly, Frank Connelly, Jr., Monsignor Edward Connors, Katherine Wilson Conroy, Tom Constantine, Elaine and E. Virgil Conway, Dorothy and Burton Cooper, Judith and Richard Cotter, Jack Coughlin, Rev. Lester Cousins, General Richard Crabtree, Ouida Crawford, Fran and Bruce Crew III, Guido Cribari, Walter Cronkite, Barbara and Tony Crowe, Robert Page Crozier, Matthew J. "Joe" Culligan, Jerry Cummins, Bill Cunningham, Pat Cunningham, Andrew Mark Cuomo, Christopher Cuomo, Governor Mario M. Cuomo, Matilda Raffa Cuomo, Walter J. P. Curley, Bernard F. Curry, Jr., Bo, Jack, Cynthia, and Bernie Curry, Connie Cutts, Alfonse D'Amato, Armando D'Onofrio, Florence D'Urso, Rocco Dalvito, Marvin Dames, Fred Danzig, Joan and Richard D'Aronco, Carl Dash, Emory Davis, Ernie Davis, Evan

Davis, Ossie Davis, Arnaud de Borchgrave, Morton Dean, John Dearie, Ruby Dee, John Deen, Ray Deenihan, Margaret DeFrancisco, C. Glover Delaney, George Delaney, Dee DelBello, Sal DelBene, Jerry DelColliano, Franco Delle Piane, Cartha "Deke" DeLoach, Ed Dennehy, Ed Dennis, Matt Dennis, Matt Denti, Joe DePaolo, Richard Derwin, Abramo DeSpirito, Matthew Deutsch, Fred Dicker, Mary Dickson, Tara and Arthur Diedrick, Bernie Dilson, Firorita and Michael DiLullo, Joseph Paul DiMaggio, Lynn DiMenna, David Dinkins, Dr. Joseph DiPietro, Dave DiRubba, Charles Dolan, Charles F. X. Dolan S.J., Jim Dolan S.J., James Dolan, Robert Royal Douglass, John E. Dowling, Hugh A. Doyle, Brother John Driscoll, Sean Driscoll, Steve Dunleavy, Larry Dwyer, David Dziedzic, Cashie and Tom Egan, Edward Cardinal Egan, John Eggerton, Arthur Emil, Jean T. Ensign, Alex Eodice, Jaime Escobar, Rick Evangelesti, Lee Evans, Ed Evers, John Fahey, Jinx Falkenburg, Kevin Falvey, Bill Fanning, Erica Farber, Joe Farda, Mario Faustini, Norm Fein, Frederic Fekkai, Giancarlo Ferro, Bram Fierstein, Mike Finnegan, Brad Firkins, Jim Fitzgerald, William FitzGibbon, John Fix III, Mary and John Fix, Jr., Adrian Flannelly, Doug Fleming, Barbara Fluker, Ed Flynn, Thomas Fogarty, Marty Fogelman, Trevor Forde, Richard Forman, Bob Forstbauer, George Forstbauer, Arnold Forster, Joe Fosina, John Fosina, Al Fox, Ray Fox, Roy Fox, Kathleen Frangeskos, George Frank, Joe Franklin, Frank Franz, Dr. Richard Fraser, Joe Fredericks, Justice Samuel Fredman, Roy Fredriks, Maurice Freedman, Louis Freeh, Rick Friedberg, Judy Fremont, Bob French, Richard French, Ralph Freydberg, Michael Friedman, Richard Friedman, Martha Dale and Eddie Fritts, William Denis Fugazy, Bob Funking, Mario Gabelli, Judge Joseph Gagliardi, Bob Galante, Bernard Gallagher, Cindy, Kevin, Kevin, Jr., Joseph, and Alicia Gallagher, Jay Gallagher, Jim Gallagher, "Scoop" Gallelo, Bernie Galli, Dave Gardner, Jack Gardner, Rev. Richard Garner, Marina Garnier, Jim Gdula, Ira Gelb, Leon Geller, Dr. Irwin Gelman, Harold Geneen, Linda and James Generoso, Arthur Geoghegan, Edward "Ned" Gerrity, David Ghatan, William Gibbons, Dick Gidron, Kathy Lee and Frank Gifford, Lou Gigante, Phil Gilbert, Jr., Jim Gill, Joan and Judge Charles Gill, Bill Gillen, Ben Gilman, Fred Gioffre, Louise and Anthony B. Gioffre, Dr. Bernard Gitler, Robert Giuffra, Jr., Chris Godfrey, Anne Goldberg, Marla Golden, Judge Howard Goldfluss, Marvin Goldfluss, Kevin Goldman, Larry Goldstein, Niles Golovin, Terry Golway, Peter Goodman, Senator Roy

Goodman, Bryon Gordon, Melissa Gorsline, Laurel and John Gouveia, Jim Graham, Murray Grand, Alicia Grande, Bob Grant, Emily and Eugene Grant, Ralph Graves, Peter Greeman, Bill Greenawalt, Bernadette Greene, Robert Greene, Teddy Greene, Jeff Greenfield, Jon Greenhut, Fred Greenstein, Peter Griffin, Steve Grossman, Phil Guerin, Tony Guest, Thomas Guida, Mireille Guilano, Ralph Guild, Denny Haight, Doug Halonen, Pete Hamill, Lynn and Jerry Handler, Anne Harmon, John Harper, Ron Harris, Michael Harrison, Willem Hart, Gordon Hastings, Cindy and Carl Hayden, Chris Hazelhurst, David Hebert, Mark Hedberg, George Helm, Darel Henline, John Hennessy, Jr., Jim Henry, Nat Hentoff, Joyce Hergenhan, Scott Herman, Ralph Hersom, (The Rev.) Rayner W. Hesse, Jr., Jamie Hewitt, Ernest Hickman, Bob Himmelberg, David Hinckley, Milton Hoffman, Tom Hogan, Philip Hollis, Napoleon Holmes, Al Hood, Gary Horan, Cheryl and Bill Howard, Debby and Jim Howard, Ed Hughes, Bobby Hutton, George Hyde, Bob Hyland, Tim Idoni, Don Imus, Brent Inman, Dennis Jackson, Mary Ann Jacon, Barbara Curry James, O. Aldon James, Jr., Bernard Jarrier, Marian Javits, Senator Jacob K. Javits, Harry Jessell, Coula and Steve Johnides, Father Art Johnson, Tom Johnson, Margo Jones, Jim Joyce, Judy Juhring, Jack Kadden, Milton Kael, Charles Kafferman, Peter Kalikow, Peter Kanze, Peter Kaplan, Mel Karmazin, Paul Karpowicz, Dr. Neil Katz, Gerald Keane, Ralph Kebrdle, Nancy Q. Keefe, William W. Keifer, Bob Keller, Sue Kelly, Ed Kelly, John Kelly, Keith Kelly, Linda Kelly, Irving Kendall, Walter Kennedy, William Kennedy, Andy Kenney, Doug Kennison, William W. Kiefer, Comdr. Robin King, Guy King, Larry King, Les Kinsolving, Claude Kirchner, Henry Kissinger, Seiji Kitavato, Ruth Kitchen, Marv Kitman, Karen Klein, Sam Klein, Fred Klestine, Jack Knebel, Ed Koch, Peter Kohler, Oliver Koppell, Burt Korall, Peter Korn, Robin Kotz, David Kowalsky, Carmela Kozinski, Larry Krantz, Erwin Krasnow, Emily Kratzer, Rainer Kraus, Pete Kreindler, Dr. Bernard Kruger, Cathy Kumbios, Bill Kunstler, Jim Lanza, Joseph Lanza, Bob Lape, Marge Lascola, Tony Lash, George Latimer, Jim Latva, Rena and Leonard Lauren, Connie Laverty, Patricia and Rick Lazio, Thomas F. Leahy, Peter Leavey, Barbara Leavy, Rita LeDuc, Jerry Lee, Louis Lefkowitz, Sam LeFrak, Irene Lemus, Paul Lenok, Jacques LeSourd, Mike Letis, Father Peter Levierge, Jan Levin, Mel Levin, Arthur Levitt, Jerry Levy, Marcel Levy, Lava Libretti, Mike Licalzi, Mary Ann Liebert,

Brother James Liguori, John V. Lindsay, Mare Lindsay, Joshua Lipsman, Richard Littlejohn, Father James Lloyd, Jack Loftus, Jimmy LoPilato, Jim Lowe, Nita and Steven Lowey, Charles Luce, William Luddy, Richard Lung, Lucille Luongo, Dan Lynch, Peter Maas, General Douglas MacArthur, Gavin K. MacBain, Bob Maccarone, Egidiana and Sirio Maccioni, Lauren and Mario Maccioni, Marco Maccioni, Mauro Maccioni, Olivia Maccioni, Paul MacLane, Margaret and Howard Maier, John Mainelli, Patrick Maines, Jim Maisano, Tony Malara, Nick Manero, Squeegie Mangialardo, Jim Mann, Ann and Wellington Mara, Carl Marcucci, Tom Margittai, Don Mariani, Kevin Marquis, Martin and Rose at Kennedy's, Douglas Martin, Julie Martin, Angelo Martinelli, Ralph A. Martinelli, Ralph R. Martinelli, Archbishop Renato Martino, Charlie Massimi, Val and Nick Mastronardi, Col. Jim May, Walter May, Loomis Mayer, Judy Mayhew, Lowry Mays, Bill McAndrew, Charlie McCabe, Kevin McCabe, John McCain, Joyce and Carl McCall, Brother James McCarthy, Mary and Bob McCooey, Tim McCormick, Bernard McCoy, Chief Justice Francis McDonald, Claudia McDonnell, Susan and John McDonnell, Tim McDonnell, Edwin McDowell, Bill McElveen, Kieran McElvenie, Steve McFadden, Jim McGinty, Bill McGorry, J. Raymond McGovern, Father Felix McGrath, Kevin McGrath, Bill McGrory, Mary McGrory, Bryan McGuire, Bill McKenna, Don McKenna, Gerald McKinstry, Renate and Thomas McKnight, Sandy McKown, Paul McLane, Pat and Ed McLaughlin, Rosemary and Charles McLaughlin, Stu McMillan, Patrick McMullan, Leslie McPherson, Bep McSweeney, Dennis Mehiel, George Melkemus, Mabel Mercer, Ian Merlino, L. Robert Merrill, Jack Messmer, Frank Micelli, Edwin Gilbert Michaelian, Dr. Marciano Miclat, Mike Miele, Barbara, Joseph, Rose, and Mario Migliucci, Ray Miles, Cay Miller, Elmer Miller, Henry Miller, Luther Miller, Marcia Egan Miller, Mark Miller, Sandy Miller, Clif Mills, Jr., Philip Milner, Dr. Richard Milone, Jackie and Roger Miner, Peter Mintun, Bob Minzesheimer, Vincent Mirabile, Adam Miressi, Lee Miringoff, Adriana and Robert Mnuchin, Joe Mondello, Senator Joe Montalto, Louise Montclare, Nino Monte, Garry Moore, Walter Moore, Mark Moran, Archbishop Eugene Moreno, Tom Moretti, Robert M. Morgenthau, Mike Moritz, Billy Morley, Michael Mortara, Beverly and John Woodrow Mosch, Arthur H. "Red" Motley, Carl Moxie, Liz Moynihan, Senator Daniel Patrick Moynihan, Ruth Mulcahy, Thomas Mullen, William Hughes Mulligan, Bill

Mulrow, Rupert Murdoch, Paul Murnane, JoAnn and Joe Murphy, Kent Murphy, Mark Murphy, Andrew Murray, Ray Murray, Helaine Naiman, "Catfish" Nardone, John Nashid, Richard Nathan, Vincent Natrella, Jimmy Neary, Gustav Neibuhr, Jack Newfield, Dean Newman, Edward Noonan Ney, Julian Niccolini, David Nolan, Margaret Noonan, Alex Norton, Deborah Norville, Richard Novik, Jerry Nulty, Jack O'Brian, Archbishop Edwin O'Brien, Father John O'Brien, Monsignor Bill O'Brien, Bob O'Connell, Brother Justin O'Connor, John Cardinal O'Connor, Rick O'Dell, Madeline and Brian O'Donohue, Joseph O'Hare S.J., Buzzy O'Keefe, Monsignor Jack O'Keefe, Valerie Moore O'Keefe, Rita O'Mara, Paddy O'Neil, William O'Neill, Bill O'Reilly, Adm. Andrew O'Rourke, Cara Ferrin O'Shaughnessy, Catherine Tucker O'Shaughnessy, David Tucker O'Shaughnessy, John Thomas O'Shaughnessy, Julie O'Shaughnessy, Kelly and John O'Shaughnessy, Laura O'Shaughnessy, Nancy Curry O'Shaughnessy, Rory O'Shaughnessy, William Mac O'Shaughnessy, Kate Wharton O'Shaughnessy, James O'Shea, Jim O'Toole, Tom O'Toole, Christiana Oakes, Kathy and Walter Odesmith, Sho Ohkagawa, William Olson, Frank Orlando, Nick Orzio, Dick Osborne, Richard Ottinger, Bob Packwood, Len Paduano, Carl Pagano, Antonello Paganuzzi, Bruno Paganuzzi, William S. Paley, Father Bernie Palka, Steven Palm, Cheryl Palmer, Richard Parisi, Rev. Everett Parker, A. J. Parkinson, Richard Parsons, Michael Lawrence Pasquale, Ron Patafio, Governor George E. Pataki, Libby Pataki, Kay Patterson, Ken Paul, Amy Paulin, Gregg Pavelle, Carole Peck, Walter Peek, Sandy Perlmutter, Rich Petriccione, Augie Petrillo, Jennifer Peyton, Alex Philipidus, Jacky Philpotts, Joe Pilla, Albert Pirro, Jeanine F. Pirro, Senator Joseph Pisani, Kathy and Richard Pisano, Caryl and William Plunkett, Peter Pollack, Don Pollard, J. William Poole, Mary Porcelli, Cole Porter, Tom Poster, Irene and Fred Powers, Chris, Jeff, Fred III, and Stephen Powers, Ginny and Frederic Powers, Jr., Frances Preston, Norman Pride, John Pritchard, Saverio Procario, Dominic Procopio, Barbara Putnam, Ward Quall, Jim Quello, Joe Rao, Ken Raske, Dan Rather, Ian Raz, Maria Razumich, M. Paul Redd, Mary Jane and Jack Reddington, Dr. George Reed, Rex Reed, Frank Reffel, Cary Reich, Ambassador Ogden Rogers Reid, Carol Fernicola Reilly, Joseph Reilly, Phil Reisman, Steven Reitano, Vinnie Restiano, Antonio Reyes, Eric Rhoads, Miles B. Rich, Mike Richards, W. Franklyn Richardson, Monica and Vinny Rippa, Eddie Robbins,

Dick Robinson, Col. Marty Rochelle, Governor Nelson Aldrich Rockefeller, Happy Rockefeller, Larry Rockefeller, Mark Rockefeller, Nelson Rockefeller, Jr., Dotty Roer, Tom Rogers, William Pierce Rogers, John, Joe, and Joseph Roma, Tim Rooney, Janine Rose, Harold Rosenberg, Pam Rosenberg, Robert Rosencrans, A. M. Rosenthal, Philip Rosenthal, Kyle Rote, Liz Rothaus, Marcie Royle, Kevin Ruddy, Michel Rudigoz, Susan and Jack Rudin, Spencer Rumsey, Natale Rusconi, Sylvia and Justice Alvin Richard Ruskin, Tim Russert, Ed Ryan, Tony Ryan, Ray Sacher, Steve Sachler, Marcy Sackett, Al and George Salerno, Oscar Sales, Howard Samuels, Irv Samuels, Louis Sandroni, Nick Saramis, Steve Sayles, Jack Scarangella, Bob Schaeffer, Pat Schillingford, Edwin K. Schober, Rob Schumann, Cheryl and Barry Schwartz, Gil Schwartz, Larry Schwartz, Louis O. Schwartz, William "Kirby" Scollon, William Scott, Paul Screvane, John Scroope, Harold Segall, Phyllis and Ivan Seidenberg, Ginger and "Honda Bob" Seiperman, Nino Selimaj, Chris Selin, Tony Serao, Benito Sevarin, Charlie Sgobbo, Hugh Shannon, Michael Scott Shannon, Noel Shaw, Wilfrid Sheed, Thomas Sheehy, Val and Judge Preston Sher, Dan Sherber, Gary Sherlock, Allie Sherman, Jami Sherwood, Robert Sherwood, Bernard "Toots" Shor, Bobby Short, Linda and William Shuhi, Mike Shuhi, Mary Shustack, John Shuster, Norman Silver, Fred Simon, Mark Simone, Francis Albert Sinatra, Herman Singh, I. Philip Sipser, Frank Sisco, Curtis Sliwa, Jeff Smart, Francis and John Smith, Jan Johnson Smith, Richard Norton Smith, Sally Bedell Smith, Shepard Smith, Walter "Red" Smith, Tommy Smyth, Bruce Snyder, Jane Wharton Sockwell, Ellen Sokol, Scott Soloman, Tony Spadacini, Andy Spano, Brenda Resnick Spano, Domenico Spano, Len Spano, John Spencer, Jerry Speyer, Rob Speyer, John Spicer, Sue Spina, Gen. Joseph Spinelli, Jeffrey Sprung, Tara Stacom, Gary Stanley, Dr. Frank Stanton, Sheila Stapleton, Jeannie Stapleton-Smith, Michael Starr, Ariana Steig, George Steinbrenner, Andrew Stengel, Stuart Stengel, John Sterling, Howard Stern, Irena Choi Stern, Claire Stevens, Don Stevens, Gary Stevens, Martin Stone, Ellen Sulzberger Straus, R. Peter Straus, Chuck Strome, John Sturm S.J., Edward O. "Ned" Sullivan, John Van Buren Sullivan, Arthur O. Sulzberger, Frederic Sunderman, Seymour Surnow, Marianne Sussman, Ernie Sutkowski, Brad Sweeney, Steven Sweeny, Tony Taddeo, Laurence Taishoff, Sol Taishoff, Chris Taylor, Eddie Taylor, Sherill Taylor, Tom Taylor, Oren Teicher, Steve Tenore,

Ann Wharton Thayer, Harry M. Thayer, Jeanne Thayer, Thomas Courtney Thayer, Walter Nelson Thayer, Lowell Thomas, Monique Emelyne Thomas, Paul Thompson, Kevin Thomson, Donald Thurston, Marnie and Adam Tihany, John Tolomer, Father Emil Tomaskovic, Neal and Tolly Travis, John Trenavan, Diane, John, Alex, and Kate Trimper, Diane Tripp, Frank Trotta, Jr., Diane Straus and Carll Tucker, Jr., Billie Tucker, Father Robert Tucker, Hy B. Turner, Randy Tuttle, Mayor Joe Vacarella, Joe Valeant, Jerome A. Valenti, Lionel VanDeerlin, John Vasile, Linda and Roger Vaughn, Patrick R. Vecchio, Lloyd Veitch, Bonnie and Nick Verbitsky, Carl Vergari, John Verni, Davey Vichram, Nancy and Carlo Vittorini, Floyd Vivino, Alex Von Bidder, Vic Vuksinaj, Mario Wainer, Claire and Howard Walsh, Judge William Walsh, Paula Walsh, Frank Ward, John Ward, Claudia and George Wardman, Father Robert Warren, Craig Watson, Rosemary and William Weaver, Charles Wendelken, Joan Weinberg, Richard Weinstein, Mary Ann and Mark Weiss, Walter Weiss, Don West, Dr. Tom West, Merold Westphal, Jerry Whelan, Jack Whitaker, Bruce J. White, Ambassador John Hay Whitney, Margarita and Tom Whitney, L. H. "Hank" Whittemore, Ronny Whyte, Duffy Widmer, Chuck Wielgus, Alec Wilder, Frank Williams, William B. Williams, Governor Malcolm Wilson, Rabbi Amiel Wohl, Andy Wolf, Fran Wood, Jonathan L. Wood, C. V. "Jim" Woolridge, Greg, Mark, and Dave Wright, Leonard Yakir, Raymond Yassin, Leigh and Frank Young, Ryan Christopher Young, Tony Yurgaitus, Nina and Tim Zagat, Paula Zahn, Trish Zimmerman, and John Zogby.

Foreword

Introducing William O'Shaughnessy

Governor Mario Cuomo

Fordham University Press and my incomparable Nancy threw a little party at Le Cirque 2000 to celebrate the publication of my first book, Airwaves. *One hundred fifty-five were invited. Three hundred twenty-seven showed up! One of the guests at the launch was Mario Cuomo himself, who was on his way out when Ken Auletta and Peter Maas intercepted the governor and persuaded him to "introduce" the author. "He's kind of new at this, Mario. Show him how it's done. Say something nice."*

This is what he said:

My name is Al D'Amato (laughter!). Actually, my name is Mario Cuomo, and I'm mentioned by Mr. O'Shaughnessy in the book. And I'm so favorably mentioned that I dare not say anything to rebut the presumptions he created there. I've been given just thirty seconds to introduce the feature of the evening and the only speaker of the evening and the reason we all came. If you look around at the room and measure the people who came, you get some idea as to who O'Shaughnessy is. This is an extraordinary gathering. I've been here before. I've even been here for a book party by my wife that starred Hillary Clinton a couple of weeks ago, and this is a more impressive crowd to me. (Matilda, fortunately, is in Paris at the moment and can't hear me!) There are all kinds of people here—a lot of bright people, a lot of people from different parts of our society—and they are all here to honor Bill O'Shaughnessy and his extraordinary writing and talent. I've asked three or four of them, "Actually, what is it about O'Shaughnessy?" And they all say the same thing. They say he's good with people. He's good at understanding people. He's good at being with people, and he's especially good at speaking about them and speaking words that he's written himself. That's what I saw in Bill O'Shaughnessy very early. And that's what I have witnessed in all the years I've known

him since our first meeting. He is a great lover of human beings, and he has a gift of being able to share his own instincts, his own impulses, which are very, very strong with those people and engaging them and telling the world about them. And when he does, his principal criterion, apparently, is how deep the feeling is. Not how eminent the person is or how Republican or how Democrat. He loves people of all kinds. And that's a simple virtue, I guess, but it's so rare now. Especially for those of us who were in the political world for a while. You have to treasure it when you find it. We found O'Shaughnessy and treasure him, and we always will.

<div align="right">
Le Cirque 2000

New York City
</div>

Introduction

L. H. "Hank" Whittemore

When I first met Bill O'Shaughnessy in 1965, he was operating liter-
ally out of the basement of a building in New Rochelle, New York,
the heart of his listening area. Tall, handsome, full of energy, and
with fiery passion in his Irishman's eyes, he had taken over radio
station WVOX and was determined to transform it, he said, into
"the Voice of the People" in Westchester County and environs. Pre-
viously, the station had merely played bland music and was not in
any sense the "dynamic factor" in community life that Bill was con-
vinced it could become. For the better part of 1966, I joined the
team as news director, sharing the vision and experiencing one of
the most demanding yet rewarding phases of my life.

Bill was keenly aware that his audience contained enough con-
trasts of American life to require an extremely delicate, complicated
juggling act. On the one hand, his listeners lived in some of the
wealthiest suburban areas of the nation—places like Scarsdale, Pel-
ham, Larchmont, Bronxville, and Rye. And on the other, they
included people in large pockets of urban poverty and ethnic con-
centration—in cities such as Yonkers, Mount Vernon, White Plains,
and, of course, New Rochelle. Each morning, hundreds of execu-
tives of national corporations arose from bedrooms in the WVOX
broadcast area for another day of key decision-making in their
influential fields. At the same time, thousands of listeners rose to
begin the daily struggle to survive amid poor housing, deteriorating
schools, racial prejudice, rising crime, and inadequate political rep-
resentation.

In between, there was the broad spectrum of the "middle class"—
from New York City to Connecticut, from the Long Island Sound
to the Hudson River—whose members included cops, fire fighters,
townie politicians, educators, retailers, community workers, and
so on.

These contrasts within his audience posed an exciting challenge for Bill, who meant to "wake up" all of them to the potential for building a better life. Could he become the "Voice" that would be able to speak to, and for, them all? Could he bring together in collaboration so many diverse elements, steering them toward a common goal? In many more ways than are possible for me to list, Bill achieved his aim by "opening up" his station and allowing it to become a platform, a free medium of expression for all. Overnight, it seemed, WVOX was reborn as a station dedicated to community involvement, debate, and service. Suddenly, the many divergent voices, previously unheard except in the pages of isolated, local newspapers, were rippling over the airwaves. From every corner, people were talking and listening to one another; and in the most real, specific ways possible, local radio had been resurrected as a powerful force in their lives.

What I remember most, even about the early days, was the sheer magic of Bill O'Shaughnessy's personal style as a broadcaster. It seemed he was everywhere at once, from saloons to shopping centers to City Hall to the neighborhood streets, but each morning he was there at the microphone, a sheaf of papers in one hand, ready to deliver what he called an "editorial of the air." This was a speech he had written out, usually late the night before, bringing events and issues and "local color" to his listeners' attention.

They were not "editorials" in the usual sense of the word; in fact, I used to think of them as short stories. In the form and style of great columnists such as Jimmy Cannon or Pete Hamill or Jimmy Breslin, the broadcasts were dramas with heroes and villains, crammed with details of dialogue and action. Most of all they were filled with emotion; and as you listened to Bill's voice on any given morning, you tended to drop everything else and simply give in to the mesmerizing effect of his forceful, humorous, often irreverent words.

Only a select portion of those words—from the sixties, seventies, eighties, and nineties—are preserved in the pages that follow, as well as some brilliant highlights of more recent vintage. They are the words without the voice behind them, but they still sparkle and crackle off the page. Bill has never, to this day, thought of himself as a "real" writer, but his use of the written word reveals the talent of a genuine author and storyteller. The skill, craft, and labor behind each of the entries in this book are clearly evident; and, I

believe, the ultimate effect is that of a unique "portrait" of ourselves, no matter where in the United States we may live. This collection of "character portraits" can also stand as a model for local-radio broadcasters across the country: how to wake 'em up, hit 'em where they live, and galvanize an entire listening area.

There are too many faces, places, and events to mention in this brief introduction. The material speaks for itself; it unfolds as a kind of narrative saga.

One may ask: Is Bill O'Shaughnessy a sophisticated preppie or a down-to-earth champion of the little guy? Is he a hard-nosed, capitalist Republican or an emotional, sentimental Democrat? No category will stick; the answer is: it depends. Bill cares enough to be deeply loyal, passionately convinced, and recklessly enthusiastic. For listeners (and readers), there can be no better spokesperson than that; and in the end, we come to regard him as one of the "townies" who keep appearing in these pages, between Bill's pilgrimages to the White House or to the Governor's Mansion or to the back rooms of City Hall.

A townie, that's what he is—along with politicians, cops, bankers, social workers, barmaids, priests, schoolteachers, cabdrivers. A townie—anyone who is part of the fabric and history of the community, whose name may be famous or unknown but whose life makes a difference. Bill O'Shaughnessy has made a helluva difference, and his influence extends far beyond Westchester.

"None of his damn business," say those who continue to regard him as not a townie but an outsider. But he made it his business, and now, along with those who heard his words for the first time and couldn't turn off their radios, we can enjoy these "editorials of the air," pronouncements, essays, and interviews and be grateful that he did.

1

Tributes and Essays

Malcolm

Malcolm Wilson, the fiftieth governor of New York, passed away peacefully at the age of eighty-six in New Rochelle at the home of his daughter, Katherine Wilson Conroy. Malcolm Wilson served in New York State government longer than anyone. His career in public service began as a young assemblyman from Yonkers. He later teamed up with another aspiring, would-be politician from Pocantico Hills named Nelson Aldrich Rockefeller. Malcolm Wilson, as legend has it, drove Rockefeller to every far-flung corner of the Empire State in an old Buick automobile. And in 1958 Malcolm Wilson became lieutenant governor of New York State and a close associate and partner of Governor Rockefeller. In the early seventies, when Rockefeller left Albany to pursue the presidency, Malcolm Wilson became governor, in which office he served for more than a year. Governor Wilson ran for reelection against Democrat Hugh Carey and lost a close race. After his defeat he became chairman of the old Manhattan Savings Bank, which was famous for the ice skaters and piano music in the bank lobby.

By his own words we know him and remember the fiftieth governor of New York:

"I'm wondering what it is I could say to you in the few moments of your lives which are given for my keeping . . ."

"A very brief perusal of this room would instantly reveal any number of individuals more deserving of your generosity. But you could search the world and not find anyone more grateful . . ."

And Mario Cuomo, who named the Tappan Zee Bridge for Governor Wilson, said of him: "He was a master of the language. Malcolm would put you away in *English* . . . and then, just to finish you off, he'd switch to *Latin!*"

He was the greatest interpreter and definer of Nelson Rockefeller as well as his herald. Nelson would not have been governor, nor, for that matter, vice president, but for Malcolm Wilson.

Malcolm Wilson's career in public service is instructive for every one of today's contemporary politicians. As Bob McManus said, in a lovely and touching *Post* editorial, "We have lost a gentleman."

He was, even more than Nelson Rockefeller, Hugh Carey, or Mario Cuomo, a true son of New York State because he understood and knew all of it.

"New York State has been richly endowed by a bounteous and generous Creator," he used to say.

He loved to weave the Latin phrase *sui generis* into his speeches. Malcolm himself was "unique and able to be defined only on his own terms."

He was the only politician I ever met who, when he inquired, "How are you?" waited for an answer.

When Senator Randy Kuhl and a group of upstate politicians (playing to their constituents' dislike of New York City) floated the ridiculous notion that upstate New York should "secede" and create a new state, Governor Wilson, in retirement, called the idea "nonsense" and stopped the "secession movement" in its parochial tracks.

Unlike today's eager politicians, Governor Wilson never "worked" a dinner. If invited to a function, he arrived at the appointed hour and stayed the entire evening. He never traveled with a retinue or outriders. And his phone number was listed in the phone book—even as governor!—all the days of his life.

A true child of New York, he returned each year to his small family farm in Oneida County and summered at the Onteora Club in Tannersville in the foothills of the Catskills near the Delaware River.

He never forgot his roots. Even when he moved to the big, beautiful brick mansion at 24 Windsor Road, he always insisted he lived in "Yonkers," not fancy, tonier "Scarsdale," where the house was actually located.

He was a frugal man. When he finally gave up smoking, Malcolm kept a carton on his dresser for many months, so as not to "waste" anything and to strengthen his willpower.

On one very special occasion I was invited to come down and have lunch alone with Governor Wilson in his New York office. At a few minutes past noon, his secretary placed before us two magnificent china plates emblazoned with the Great Seal of the State of New York. Then the governor reached over and retrieved a *canta-*

loupe from his lawyer's black leather accordion briefcase! It was actually a Saratoga hand melon, he explained. After very carefully cutting the melon in half, Governor Wilson inquired if I wanted "a little cottage cheese to top it off." I passed.

Although he might set a lean table, Malcolm Wilson was extravagantly generous with the warmth, wisdom, and love that proceeded from his brilliant mind and lovely, graceful soul.

He was a man of culture and great dignity, yet the governor knew no ostentation. One evening as we were walking through the Executive Mansion in Albany, I asked him about a Picasso tapestry that had recently been placed near the staircase by Nelson Rockefeller. Governor Wilson replied, "It *is* quite interesting, but you'd better ask Nelson about its lineage. I'm afraid I can advise you only on how to apply paint to the side of a *barn*. You'll have to rely on Nelson for the 'heavy' stuff like this."

There is a magnificent oil painting of Governor Wilson at Fordham Law School. He was the greatest orator the Fordham Jesuits ever graduated.

Malcolm Wilson was of the Westchester of Bill Condon, Frank O'Rourke, Jim Hopkins, Frank McCullough, Ed Michaelian, Otto Jaeger, Herb Gerlach, Bill Butcher, Bill Fanning, Ed Hughes, Bill Olson, B. F. Curry, Jr., Joe Pisani, the Barretts of Katonah, Arthur Geoghegan, Nils Hansen, the Russos of Greenburgh, Ed Vetrano, Sam Fredman, John Marbach, Jim Hand, the Martinellis of Yonkers, George Burchell, Tony Veteran, William Hughes Mulligan, Dick Daronco, Bill Luddy, Max Berking, General Dick Crabtree, Tony Gioffre, Bill Griffin, Bob Abplanalp, B. J. Harrington, Andy O'Rourke, Tom Langan, Boss Ward, Fred Powers, Bill Mooney, Burt Cooper, Tony Colavita, Al Sulla, Edwin B. Dooley, J. Ray McGovern, Jim McCarthy, Dick Ottinger, Harold Marshall, Fred Sundemann, Milton Hoffman, Joe Shannon, Joe Gagliardi, Marty Berger, Frank Connelly, Sr., Lowell Schulman, Joel Halpern, John "Chippie" Flynn, George Delaney, Brother Jack Driscoll, Sal Prezioso, Frank McCullough, Tim Rooney, Eddie Egan, Stanley W. Church, Alvin Ruskin, Al DelBello, and Ossie Davis.

And in the public arena he was of the time of Oswald Hecht, Irving Ives, Kenneth Keating, Walter Mahoney, Tom Dewey, Averell Harriman, Hamilton Fish, Douglas Barclay, Perry Duryea, Harry Albright, Ogden Reid, John Lindsay, Robert Wagner, Jacob K. Javits,

Hugh Carey, Stanley Steingut, Joe Carlino, Paul O'Dwyer, Daniel Patrick Moynihan, Jim Emery, Paul Curran, John Cardinal O'Connor, William "Cadillac" Smith, John Burns, Joe Crotty, Ralph Marino, Mario Biaggi, Jock Whitney, Walter Thayer, R. Burdell Bixby, Herbert Brownell, Howard Samuels, Charlie Goodell, Bill O'Dwyer, Adam Clayton Powell, Amo Houghton, Erastus Corning, Clarence "Rapp" Rappelyea, Neal Moylan, Dan Walsh, and the incomparable Rockefeller himself.

He outlived most of them. Not alone in terms of longevity.

He was *sui generis*. And as Dan Lynch said in an upstate newspaper, the Albany *Times Union*, I think we have lost a very great man.

March, 2000

John Cardinal O'Connor

I still miss his warmth and presence in our lives.

I was recently interviewed by a writer for a metropolitan daily about the life of John Cardinal O'Connor. This is what I told the reporter:

There are a lot of people who knew him far better than I—like Bill Plunkett, Florence D'Urso, Jim Gill, the Maras, Helen and Chuck Dolan; and here in Westchester, B. J. Harrington, certainly Bob McCooey, and the Egans, the Rooneys, the Mastronardis, and many others. And anyway, I'm a poor, stumbling, staggering, Catholic who does not feel qualified to comment on the cardinal's life or stewardship. But I did love and admire him.

To tell you the truth, I didn't much like the guy at first—and I don't think he particularly liked me. Rich Lamb of CBS, his favorite reporter, said it was because I was always trying to get the cardinal to read Mario Cuomo's books! Incidentally, *no one* in recent days has spoken of the cardinal with more eloquence or greater respect and affection than Governor Cuomo himself.

His Eminence was also a great wordsmith. Eloquence came easily to him in his writings and homilies. His sermons and pastoral letters were masterpieces. He loved a graceful turn-of-phrase.

He had "John Connally eyes." Like that former Texas governor, the cardinal could be addressing a crowd of three thousand, and *everyone* would go home convinced he was looking *directly* at them, and that the message was meant exclusively for them alone.

He was also an indefatigable shepherd. Many is the night I would walk him to his car and watch the pain in his eyes as he dragged his right leg up inside the door as the car was starting up.

Cardinal O'Connor also had a marvelous sense of humor. When he saw an article about my television show, which quoted me as

saying I could get just about anybody to come on "except, perhaps, the cardinal, with whom I've encountered some 'scheduling conflicts,' " he immediately dispatched a note: "Since when did I ever deny *you?*"

He was the most recognizable and beloved figure in New York. What a sight he was in those red robes! One night a few years ago the cardinal came over to Le Cirque 2000 for a dinner party Nancy had for the Franciscans. (He told Sirio Maccioni he'd come to collect the rent!) When I walked him back across Madison Avenue to his residence, the whole block stopped! All traffic came to a halt. And as he climbed the steps to his residence behind Saint Patrick's Cathedral, the cardinal whispered, "Do you and Nancy come into our town often? Do you suppose you might be persuaded to have supper one night at my humble abode?" I told him: "That would be very nice, Your Eminence, but we're going to *eat* across the street with Sirio!" He thought that was a splendid idea!

He loved to tell about the time Louis Freeh, the director of the FBI, kept him waiting "five minutes . . . ten minutes . . . almost a half hour. Then I thought I might step outside the residence for some fresh air. And as I looked down Madison for some official-looking vehicle, all of a sudden, a block away, I see the director of the FBI pushing a baby carriage! Mr. Freeh was bringing his entire family to meet the cardinal!"

To understand his stewardship and what the cardinal meant during his years as archbishop of New York, you have to understand Pope John Paul II, to whom he was absolutely devoted. These guys didn't bend, especially on things like human life issues.

And if he did nothing else, he was at least able to slow down the "slaughter of the innocents." The cardinal never wavered on that. He never gave up. I guess you could say that, ultimately, he *stood* for something very fundamental. And that he was a teacher of rare gifts.

I was always telling him he should be a writer. And I think that's what he really wanted. One night, after we had both "worked" a dinner at the Waldorf, I said, "Forgive the impertinence, Your Eminence, I've been reading some of your stuff in *Catholic New York,* and I think you should give up the damn staff and miter and just write!" The next morning there appeared on my desk a collection of his columns.

He's often described as being the most powerful among the American prelates. But Cardinal O'Connor was also the quintessential New York cardinal, perfect for the Church in New York.

For all his reputation as a tough, unyielding, doctrinaire prelate among my colleagues in the press, the cardinal was also, as Cuomo reminds us, one of the Vatican's most stellar and compassionate social activists who worked on behalf of labor unions, among the poor, and with those with AIDS.

As he himself lay dying, I recall one night when I came out of Le Cirque after a wonderful supper. I just stood there in the rain on Madison Avenue, looking up at the cardinal's room with the light on. Duane, the doorman, said, "I know, Mr. O'. I think of him a lot too." It wasn't the rain running down my cheeks.

I mentioned in my book *Airwaves* our hope that the cardinal would live to be one hundred. He sent me a note: "I'm glad there is at least *one* New Yorker who wouldn't mind if I stuck around a little longer."

I really loved the man, complicated and human though he was.

January, 2000

The Priest: An Appreciation of Monsignor Terence Attridge

The Roman Catholic Church in New York lost an archbishop last year. And one remarkable priest named Terry Attridge.

Father Terence Attridge, a priest of the ancient Roman Church, lay dying in a hospital room at Calvary Hospital in the Bronx on Palm Sunday. And in Westchester at St. Pius X Church, Father John O'Brien, who had just recited the Passion and Crucifixion of Jesus Christ, went up on the altar and asked for prayers for Monsignor Attridge, "who is undergoing his own final agony."

Father O'Brien's spontaneous petition only confirmed what everyone in the New York area has known for months. Monsignor Terry Attridge, with his easy manner and central-casting looks, had a major problem, a form of cancer that even the best doctors at Memorial Sloan-Kettering couldn't help him defeat.

And so he remains at Calvary Hospital, beyond the reach of all those thousands who love him. The priest who made so many sick calls himself is now comforted only by his "immediate" family and parish associates like Claire Farrington and Sister Connie Koch, a Dominican nun.

Archbishop Edwin O'Brien, the chief of all the U.S. military chaplains in the world, flew up from Washington to be with his old classmate from the seminary. New York's newest bishop, James McCarthy, paid a visit, and so too did Monsignor Bill O'Brien, who runs the Daytop program.

Officially, the newspapers will tell you Terry Attridge is pastor of Sacred Heart Church in Dobbs Ferry, a parish that is already in mourning. As pastor he performed weddings and baptisms, heard confessions, ran church socials, and raised money. He said Mass every day and several times on Sunday, the day of obligation.

He also ministered to state troopers, DEA undercover operatives,

FBI agents, street cops, fire fighters, nuns, and other priests. And— I'm probably not supposed to broadcast this—a few months ago he even placed a call directly to John Cardinal O'Connor, requesting that His Eminence "give me a call, if you just need to talk to someone." With Terry Attridge, it seems, even princes of the church are worth saving.

As a young man, he was a favorite of kindly, saintly Terence Cardinal Cooke. And over the years Cardinal Cooke's popular protégé served as associate superintendent of schools and head of the D.A.R.E. drug program. Father Attridge gained a national reputation as a wise, practical voice in the field of substance abuse prevention and addiction. And for a while, he was the Pied Piper of the archdiocese in charge of vocations and recruiting young men for the priesthood. It was in this post that Father Terry developed the memorable campaign "The New York Priest: God Knows What He Does for a Living!" He also had a popular radio program on WVOX and was the "commentator" on some of the first televised Masses.

As chaplain for many law-enforcement groups, he drove around in a souped-up Curry Honda equipped with pursuit lights and a siren that he never activated. On his belt was a beeper that was always chirping. And in his pocket the priest carried one of many badges, which he never displayed. His handsome Irish looks and Roman collar got him everywhere he wanted to go.

He loved to play golf with Monsignor Charles Kavanagh, the vicar of development, or any other pigeon he could find! And Jim Bender, the pro at Ardsley Country Club, even named a tournament after him. This year the Tenth Annual Monsignor Terry Attridge Charity Golf Tournament will be held on June 12 at Ardsley.

He was a natural, unassuming guy with a tremendous network of friends. And so the news of his terminal illness resonates with thousands of people in all walks of life.

Rich, generous Catholic women—philanthropists like Florence D'Urso, Hope Carter, Mary D'Ablemont, Mary Jane Arrigoni, Josie Abplanalp, June Rooney, and Ann Mara—were great admirers of the candid style and no-nonsense commitment of this particular diocesan priest. He moved easily in all the rarefied philanthropic circles and attended many dinners as an honored guest.

But Father Attridge was not unlike Robin Hood in that he did his best work among those who were without influence, money, or

high estate. He got hundreds of youngsters into high schools and colleges after persuading the administrators to forego or "finesse" the tuition. And he got countless people without insurance into hospitals and nursing homes. Just last month he called for the number of a grammar-school official who had thrown out a kid because his mother's restaurant business had failed and she couldn't afford the tuition.

He was always getting youngsters off the streets and into drug-rehab programs. And I have lost count just how many times he called my wife or her father, Mr. B. F. Curry, Jr., the auto magnate, to waive a down payment or arrange a "little creative financing" for a nun "with bad credit," a priest "who just needs to get back on his feet," or a school teacher "whose husband just left her." There was always a "story" and some people who needed help.

It must also be fairly said that his enlightened, often courageous approach to many of the great moral issues of the day did not exactly endear him to some members of the hierarchy or the zealots of his own Church. He was a pro-life priest who once told me, "You've got to be for life in *every* instance." Meaning you've got to be against abortion *and* capital punishment. Father Terry fought against the current "slaughter of the innocents" right in his own backyard, not with civil disobedience, but with something more powerful. While others picketed the infamous abortion clinic in Dobbs Ferry, Terry urged his parishioners to "pray" for the doctor who ran the clinic.

He was enormously respected by other enlightened priests like Ed Connors, the wise and beloved former vicar of Westchester, who said of Terry Attridge: "How sad to lose him at such a young age. But what a wonderful, full life he's had. And what a wonderful priest he was."

I can still see him here at WVOX. Whenever I would inquire after him when Father Terry had finished his radio broadcast, the reply would come back: "Oh, he's out in the parking lot, talking with one of your announcers about a problem of some sort or another."

Like Father John O'Brien said when we left Mass on Sunday: "He was a great priest."

And I expect God also knows what he did for a living for thirty-five years.

May, 2000

JVL

Thousands of his beloved New Yorkers came to the Cathedral of St. John the Divine last year to bid adieu to this attractive man who once was mayor of New York.

In my neighborhood, we always gave a wide berth to prep kids from Bedford and Bronxville who had names like Chip and Jock and Lance and would grow up to be like John Lindsay. Actually, we hated them. And not alone because they usually got the best-looking Manhattanville girls.

John Vliet Lindsay was mayor of New York during an angry time in America. There were abroad in the land racial turmoil, assassinations, Vietnam, big, fat Beatnik poets, sexual revolution, the dawning of gay rights, feminism, and an accommodation of the abortion culture. Secularism, entitlement, and selfishness swept across our nation as cities went up in flames and our flag was desecrated and burned. The entire country was up to its ankles in the mud and slime of the Woodstock nation.

But here on the teeming, crowded, roiling streets of New York was this tall, magnificent, amiable, beautiful WASP who brought glamour, grace, idealism, and style to urban governance. Episcopalian John Lindsay was to Republicans what Roman Catholic John Kennedy meant to most Democrats and all the Irish everywhere.

He never had JFK's famously driven father or the Kennedy contacts and retainers bought with family money. Nor did Lindsay possess Nelson Rockefeller's vast resources and dynamism. And standing at a podium, he never could summon up Mario Cuomo's dazzling passion and oratory. But before John Lindsay every Republican wore a hat and a three-piece suit and looked like Wendell Willkie or Herbert Hoover. And when Rupert Murdoch's pal, the writer Neal Travis, arrived in this country from Down Under, Travis won-

dered, "My God, do all American politicians look and carry themselves like this fellow!"

The Eastern Establishment Republicans of the day—Walter Nelson Thayer, Jock Whitney, Herbert Brownell, former president Dwight Eisenhower, William S. Paley, Walter J. P. Curley, William Pierce Rogers, and the great Rockefeller—forged an uneasy alliance with wily, ancient Alex Rose, boss of the Liberal Party, to take this gloriously handsome Brahmin congressman from the Silk Stocking District of Manhattan and install him as mayor of the entire, sprawling city.

The Limousine Liberals and Rockefeller Republicans never could control him, and in 1971 John Lindsay became a Democrat. Richard Nixon was in the White House. And Ogden Rogers Reid, the brilliant Westchester congressman, who had been ambassador to Israel and publisher of the *Herald Tribune,* also jumped ship at about the same time. And so did J. Edward Meyer, another rising GOP star. And one afternoon at "21" the publisher Walter Thayer, when informed of their perfidy, predicted, "Nothing will ever come of these SOBs. The Democrats will never accept them, and Republicans will never forget what they did." (Ogden Reid is now president of the Council of American Ambassadors, and Ed Meyer served for many years as quite the most intelligent and creative regent of the State of New York.)

Lindsay ran for the Senate and declared for president of the United States, but the elders of the Democratic Party rejected him and instead ran such stellar candidates as Walter Mondale and Michael Dukakis. When the political years were behind him, the former mayor repaired to Bridgehampton with his devoted and beloved Mare, where he would ride his bicycle down to Bobby Van's to drink with Howard Samuels, Jimmy Jones, Willie Morris, and Jack Whittaker. Mare Lindsay, to this day, thinks he was at the Candy Kitchen for coffee.

They also kept a flat in the fancy apartment building over the Café des Artistes on the West Side where media guru David Garth lives. And occasionally, an exhausted John and Mary would roll out to Kennedy Airport to be met at the Pan Am VIP entrance by Peter Giordano, who would put them on a plane for some R&R in a warm place. Lindsay also did a turn as chair of Lincoln Center and would dispatch notes to his old colleagues in the House of Representatives.

And every few years, he would be the honored guest at reunion dinners attended by his City Hall staffers Dick Aurelio, Bob Laird, Charles Moerdler, Tom Morgan, Jerome Kretchmer, Henry Stern, Jeff Greenfield, Jay Kriegel, Steve Brill, Leslie Stahl, Leon Panetta, Sandy Berger, Jeff Katzenberg, Tom Hoving, Harvey Rothenberg, Bobby Ruskin, Pat Vecchio, Bob Sweet, and Lindsay's machiavellian deputy Bob Price.

He also journeyed to Elmira, New York, for the funeral of Harry O'Donnell, his old press secretary. Over a thousand upstaters turned out for the service, many in hopes of seeing John Lindsay once again. And one winter day a long time ago, he spoke at the Dutch Treat Club on Park Avenue. After the luncheon he waived off a couple of limo rides and asked a radio reporter to "stretch your legs" and take a walk with him down into Midtown. Bundled up against the wind with one of those Irish tweed bucket hats favored by Daniel Patrick Moynihan, John Lindsay walked through the city streets that once were in his care and keeping.

Although the glory days were far behind him and he had become a bit stooped, people called out his name as, block after block, he walked toward Rockefeller Center. When the former mayor encountered a homeless man huddled against the cold outside Saks Fifth Avenue, JVL reached in his pocket for a few bucks and told his companion, "I wish I could do something more for the fellow." And then Lindsay went on his way, thinking of the days when he had it all in this town.

Lindsay spent his last years on crutches and in a wheelchair. But he was a bright star and a classy man in every season of his life. And his footsteps and graceful presence were welcome in every neighborhood of the great city.

January, 2001

Edward J. Hughes: The Journalist

Ed Hughes was the quintessential newspaperman in the Heart of the East-
ern Establishment. As editorial director of the old Macy-Westchester papers,
Hughes wielded enormous power for a good long time in the Golden Apple.

They stopped the presses yesterday in White Plains. Halfway
through the run, somebody had to go and put a story on the
front page of *The Reporter Dispatch*, the flagship of the Westchester-
Rockland newspaper chain, that Edward J. Hughes had died.

Ed Hughes, the editorial director of the papers that are read all
over this county, was one of the most powerful men in Westchester.
But you would never know it from looking at him or talking with
him. He was a sweet, jolly, and gentle soul.

He was seventy years old, this lovely man, when they stopped the
newspaper run to put his obituary on the front page. For fifty-four
years, Ed Hughes wrote his love of Westchester across the editorial
pages of our hometown newspapers. He never knew you, perhaps,
or the people sitting across your breakfast table this morning, but
he fought for you and he was your advocate, and you live the way
you do because of this man.

Ed Hughes would sit there in White Plains on the fifth floor at 8
Church Street, and he would champion unpopular causes and
munch on his Metrecal biscuits like they were potato chips. And
you can be damn sure that the governor, Nelson Rockefeller, and
Malcolm Wilson, Edwin Michaelian, and all the others took what
he said and wrote very much to heart.

His wife died of cancer in 1969, and his son, Edward J. Hughes,
Jr., whom he called John, died a heroic death in that awful place,
Vietnam. And although there never was a better family man, Ed
Hughes did not become bitter as sorrow and tragedy came after
him. His "purity of soul," which is what one of his fellow journalists

called it yesterday, neutralized all of that, and he worked even harder in recent years.

And late last night, on the fifth floor of the Westchester papers, Milton Hoffman, the chain's ace political reporter, sat over his typewriter and tried to tell you about Mr. Hughes. "He was a man of vision," said Hoffman. "He would back projects that nobody could understand, like the Rye Bridge. He would go beyond the small and narrow politicians and look into the future."

And Hoffman, who worked five hours on his own time last night, was telling callers about how Ed Hughes was chairman of the board of trustees of the State University at Purchase and about how he also caused the Medical College to be built in Westchester.

Editor Hughes would climb down from his ivory tower at the newspaper and take his vision and serenity and display his kindness before groups all over the county. He would talk to Jewish organizations one night and go before the Masons the next. This amazing man was also president of Saint Agnes Hospital, and last year, when he spoke before the Advertising Club of Westchester, he talked about seeing slaves in the Village of Port Chester, the County of Westchester, in the State of New York. "Just fifty-five years ago. . . ." You won't see it mentioned in any of the town records, but it was there. And they were there. And a sixteen-year-old boy named Hughes couldn't figure it out. And he fought all the evils like this one, for the rest of his life, as a truly great newspaperman, at his typewriter every night at 6:30 and 7:00 even to the end.

Milt Hoffman, the star reporter, was saying last night that maybe somebody will name a college after Ed Hughes. Then Hoffman said, "You know, I don't think he'd give a damn if they did. That kind of stuff—honors and all—didn't mean anything to him."

We'll never forget last year when the Christian Brothers of Iona College had Mr. Hughes over to discuss censorship and freedom of the press after the student editor of the college paper printed *the* four-letter word in the college newspaper. And old, balding Ed Hughes stood nose-to-nose with this long-haired kid. Mr. Hughes listened and tried to get through to this know-it-all. And finally, this glorious old man reared back and said, "Look, young man, you're the editor, all right. But it doesn't give you the right to defecate in print, you pipsqueak! It's not your paper. It belongs to your read-

ers." It was a marvelous exchange, after which the editorial director walked out of there arm-in-arm with the radical student journalist.

He was quite a man. And Thursday morning at Our Lady of Sorrows in White Plains, Monsignor Murtha won't need to pull out all the stops in order to bombard heaven for this Edward J. Hughes. The place we live in, this Westchester, is his memorial.

<div align="right">Broadcast August 17, 1971</div>

Hugh Doyle: The Councilman Emeritus

Hugh Aloysius Doyle was a politician the way the men of our father's time imagined them to be. This twinkle-eyed Irishman was a pal of Terence Cardinal Cooke and was the "Tip O'Neill of Westchester."

I t is the morning after Election Day. But we are thinking about a man named Hugh Aloysius Doyle. He was the Councilman Emeritus of our city.

There was so much he loved: the little Saint Gabriel's Catholic parish, the Kennedy family, the Democratic Party, the city council on which he served.

And for three days at Lloyd Maxcy's funeral home, they came to pay respects to old Hugh Doyle. They came out of the wet streets of the South Side of town. And they came from way outside our city— from the Bronx, Brooklyn, and as far away as California. They came to New Rochelle all this week with their stories, holding onto their love for this good, decent man.

The organizations he loved were represented: the Rowing Club, the Coast Guard, the Elks, the Knights of Columbus, the Holy Name Society. The people also came to wake old Hughie—the Italians, the Irish, the Jews came, townspeople and neighbors, rich and poor, from all walks of life, their only credentials, the appellation they all carried with considerable pride: friends of Hugh Doyle.

As the old gentleman lay there surrounded by grand floral tributes and guarded by the regal-looking Knights of Columbus in full dress with their flowing red satin–lined capes and golden swords, Hugh Doyle's cousin, Betty Gordon, was saying: "His friends were his jewels, but he didn't think of them like a collection." The Irish are the only ones left on the planet who would say something as lyrical and graceful about someone who had just died. And then a

black man came up to Betty Gordon to tell her how Hughie Doyle got him an apartment in 1929.

He was out of the time of Al Smith, Jim Farley, Jimmy Walker, and Francis Cardinal Spellman. And he knew about such quaint things as camaraderie and patriotism, of joining and belonging.

It was a fine wake. And Hughie Doyle would approve, said Alvin Ruskin, the former mayor, because Hughie had made more condolence calls than anyone in history during his seventy-eight years. And Father George Homell, the popular priest from Blessed Sacrament, once said he saw Hugh Doyle at so many funerals he thought Doyle was the funeral director Maxcy.

Because this old man with his brogue and white hair touched so many lives, just about everyone in this sad city has his own story about Hugh Doyle.

Mine started the very first week I ever set foot in New Rochelle. It was twelve years ago when there was a very big "do" indeed at Temple Israel, an anniversary or something. And as everyone who was really important at the time was to attend, I made it my business to crash the affair to drum up support for this community radio station.

The only name or face I recognized was that of the legendary Stanley Church, who was surrounded by hale fellows, well met, in one corner. And then I spotted a man who used to be a car dealer in this town. He was wearing a blue blazer, this car dealer, and his name was Peter Griffin. And when I tried, awkwardly, to introduce myself as "the new guy at the radio station," he quickly disengaged my hand, to put it mildly, and drifted off. (There had been a lot of "new guys" at the radio station.)

And then I remember a kindly, white-haired man came over to my side and said his name was Hugh Doyle. And he asked, "Who would you like to meet, young man?" And so for the next several hours Hugh Doyle introduced me to every person in the place. The names and the faces have blurred along with their rank and station. But I remember Hugh Doyle rescued me in the midst of an alien sea of strangers.

And so after his wake at Lloyd Maxcy's I went with Judge Alvin Ruskin and his wife, Sylvia Bessen Ruskin, to have an ice cream soda. We came out of the cold rain and sat in this ice cream parlor

and told each other Hugh Doyle stories. And most of them made us laugh.

And as we sat feeling good with our memories about Hugh Doyle, Alvin Ruskin said: "Bill, do a good piece on the radio for Hughie."

But I can't think of any greater tribute to the man, ladies and gentlemen, than to report to you that we were sitting there and smiling and feeling warm and friendly and very good on this night after he had just died.

There are a lot of wealthy and powerful individuals in this county. But when they go, how many people will sit in an ice cream parlor feeling about them the way Alvin Ruskin and I felt about Hugh A. Doyle?

Broadcast November 8, 1977

William Butcher: The Escape Club Loses A Member

Bill Butcher was chairman of the old County Trust Bank. He collaborated with the legendary Westchester County Executive Edwin Gilbert Michaelian to bring international business to the I-287 corridor.

This county is changing. Bill Butcher and men and women like him saw to that. Change, as they say, is all for the better. Or most of it is, I guess. You can read all about it in today's paper, all those wonderful, extraordinary things Butcher did for Westchester. He persuaded great companies to invest in our region. He talked the language of the banker, the investor, and the builder. And his credentials among the Establishment were impeccable. But he was also a pushover for young Irishmen trying to start up radio stations. And as long as you pledged the enterprise to the service of Westchester, it was good enough for him.

I probably shouldn't be so personal about this because Bill Butcher helped lots of young men with lots of crazy, way-out ideas. But he was among the very first to help us when we were getting started. I like everything about him. He was a man's man and a tilter at windmills, a storyteller and a dealmaker. He handled lots of what the gangsters and politicians call "contracts." Only a contract to Butcher was to get on his telephone as he did so often and try to help somebody. It came naturally to this natural man.

He was suffering from cancer in recent months and could hardly talk. And last week he slipped out of the hospital to attend a meeting at the Dictaphone Company. The nurses and doctors still don't know where he was during that unexplained absence.

It is one more story that will be told about this marvelous man. Our newscasters and the papers told you about all the organizations to which he belonged. But they all forgot to mention The Escape Club. It is a group of about fifteen so-called Establishment types

who meet at the Scarsdale Golf Club for lunch, drinks, and some stories and good fun. You have to be the president of General Foods, National Bank of Westchester, or Nestlés to get an invitation to the Escape Club. Bill Butcher loved these meetings, and he loved to kid these high-rollers and knock them around. They will miss him. And so will thousands of ordinary people who live a better life here in Westchester because of his efforts on their behalf. Forget the Escape Club, we've all lost a member-in-good-standing.

In this day of fast-food places, phoniness, conglomerates, and tinsel, we can ill afford to lose Bill Butcher, who conducted himself and his business in very personal ways.

First Eddie Hughes. Then Fred Powers. And now Bill Butcher . . .
Where once giants walked the land.

<div align="right">Broadcast November 29, 1976</div>

Joe Candrea

This townie from the west end of New Rochelle had an opinion on damn near everything, which he felt compelled to share with his neighbors every morning at precisely ten o'clock over the airwaves of our local radio station. When his voice was stilled by a slammer heart attack, even the objects of his wrath shed a tear.

J oe Candrea was a Runyunesque figure. He might also have been imagined in the mind of Ring Lardner. But instead of Broadway, the Big Apple, or the Great White Way, his canvas was our home heath. It was here in New Rochelle that Joe Candrea lived most of his sixty-seven years with great conviction.

He confronted every proposition and every civic issue with a relentless passion. Although his resumé said "newspaper delivery man" and "truck driver," Joe Candrea could put power and energy into words, which usually became majestic proclamations. His podium was behind this microphone, down at city hall, or on any street corner he could find.

He possessed what most of us search for all our lives. There was a *sureness* to Joe Candrea's proposals and observations. He was the great articulator, the undiminished champion of the forgotten neighborhoods in the West End of our city. The politicians used to call it the old Fourth Ward. It is where Rocco Bellantoni once lived, and Tony and Sal Tocci and the Fosinas came from there. But in recent years there was only Joe Candrea to rage against injustices of every kind as they might be committed against his neighbors in the West End.

I expect the greatest appellation I can apply to Joe Candrea this morning is to remind our listeners that he was, ultimately and essentially, a *townie.* The way Evie Haas, she also of sainted memory, was, a townie.

New Rochelle was his mistress. And also his fortress. He felt about our city the way some men of his generation felt about the U.S. Marine Corps or the Notre Dame football teams. Other callers and radio talk-show hosts often discuss, with great erudition, the cosmic issues of the day. Theirs is an international curiosity or a national inclination, but Joe Candrea's enthusiasms and passions extended only as far as the city limits. Zip Code 10801 was his territory, baby, and don't you forget it.

He could murder you one day on the radio and a few hours later encounter you at a civic meeting with a warm embrace and even a kiss on the cheek. He ran flat out and went straight for everything. There was no halfway station, there was no middle ground with the man, and never, ever a doubt about where he stood on civic issues or politicians, bureaucrats, and other disreputable types.

His loss, then, is a very significant one, I think, for our city. For, you see, we have thousands of residents who use the place as a bedroom, who take and put nothing back, who never have an opinion about anything, who live out their days without ever trying to make things better.

Speaking of which: Mario Cuomo talks often these days about the admonitions of a Hebrew God, using these two marvelous phrases: *Tikun Olam* and *Tzedakah,* which mean, "You are all children of one God. You are all entitled to dignity and respect for one another. And your mission is to repair the universe and *build up the neighborhood."*

And then, according to the great Cuomo, the Christians stole it whole from the Jews with the outrageous suggestion, given to them by a carpenter's son in the Temple one day, that we should love our neighbor as we love ourselves.

So I think that's what Joe Candrea was all about. He was all about building up the damn neighborhood. But as Mayor Tim Idoni and Legislator Jim Maisano said on the radio yesterday, that work is not quite finished.

Have I got it right, Joe?

<div align="right">December 21, 1999</div>

Frank: A Radio Tribute

These were the words we broadcast when the great Sinatra died in May of 1998, but Sinatra was about music, the music of the heart.

N at Cole, Louis Armstrong, Fred Astaire. And now we have lost the great Sinatra.

This is a damn sad day for everyone who ever heard him sing "I've Got You Under My Skin" or "I Get a Kick Out of You." It is an especially bleak day for those who work in radio. When we heard the news of Sinatra's passing, we immediately lowered the flag at our Westchester studios. We have done this to mark the departure from this life of politicians, diplomats, and even cardinals and popes. Most of these stellar figures left us only with words fashioned into admonition, instruction, and majestic pronouncements. Frank Sinatra left us with music that encouraged us to feel and to love.

Radio amplified Sinatra's genius. If it had not been for the airwaves that carried his voice to millions, the crooner's genius might have been confined to theater stages like the Roxy and Paramount or to one-night bandstands. Today, in the New York area, only a very few radio stations still play Sinatra's music. But "New York, New York," which has become the anthem of George Steinbrenner's Yankees, is played after every game.

Francis Albert Sinatra was a dynamic and beguiling character for most of his life. There was always an aura of mystery and danger about him. But a joyful quality also attended the singer. And, always, a great sense of vulnerability. Sinatra's exquisite musicianship has never been equaled. His remarkable phrasing was absolutely flawless, and the way he landed on a note was, well, perfect.

Sinatra was unquestionably the most romantic of all crooners. Ask any woman, and she'll tell you what this skinny guy from Hoboken had. He had it for all the years he was able to climb up on

a stage. And almost until the very end, he never faded. He "stayed." In every season of his life Sinatra was the coolest guy who ever put on a tuxedo to walk out and stand in a spotlight and entertain an audience. He was able—better than anyone—to intuit and interpret exactly what was in the mind of the composers of his sweet songs.

I once inquired of our Westchester neighbor, Robert Merrill, "Who is the greatest tenor—Luciano Pavarotti or Placido Domingo?" Without missing a beat, the legendary Metropolitan Opera star replied, "Sinatra!"

Bing Crosby once said, "A talent like Sinatra comes along once in a lifetime. Why the hell did it have to be in *my* lifetime?"

Everyone got a kick out of the man. But radio, which brought his achingly beautiful music into our bedrooms and courting rituals, has a special claim on the singer William B. Williams called the "chairman of the board."

I wish William B. was still around to play a Sinatra record right now, damn it. And I'd like to see Frank walk into "21" just one more time.

<div align="right">May 15, 1998</div>

A Farewell Tribute to Andrew P. O'Rourke

Andy O'Rourke has led an amazing life as a Quiz Kid on the radio, politician, candidate for governor, author, lawyer, and naval officer. And to this day this New York State Supreme Court Justice even rides a motorcycle! All the disparate elements in his remarkable life came together on one memorable night when he was promoted to rear admiral of the Naval Reserve and stepped down from the office of county executive on his way to a judgeship.

There will be other tributes and honors in the coming months for you, Admiral O'Rourke, with proclamations filled with encomiums. And they might even name a building, a road, a park, or a bridge. You'd probably rather have a battleship, Andy!

We know not what beckons Andy O'Rourke: judicial robes or academia or a prestigious law firm or *The New York Times's* bestseller list. But, Andy, if you forget everything else said tonight, know only this: *we* go with you wherever you go.

But all of that will be dealt with another time, at another venue. Tonight this is a "family" party, a bittersweet occasion, to be sure. You have reluctantly endorsed it, Mr. County Executive, so as not to disappoint the devoted staff that planned it and summoned us. And we want to recall, briefly, the uniqueness of your administration, the uniqueness of *you*. So this is a tribute and an appreciation for your thirty-two years of public service, which, combined with your eight years of active military duty, totals forty years!

We're here tonight in Westchester, the "Golden Apple," and for the privilege of presenting Admiral O'Rourke, they chose a *private!* I didn't even make PFC! I served "overseas" during my tenure in the Army—in Staten Island! At Fort Wadsworth. I got home every weekend! But I had the three best jobs: the post commander's driver, editor of the post newspaper, and bartender in the officers' club! So,

clearly, you didn't check my background before you allowed me up here tonight!

The story of Andrew O'Rourke is well known to all here assembled. Now, I spent a good part of the weekend studying the archives at the radio station, and I noticed that your official biography curiously didn't mention half the important details of your life. You were raised by an Irish mother after your father passed away when you were only one.

Nowhere does your curriculum vitae mention that because you, Admiral O'Rourke, did such a good job as county executive, the elders of the New York State Republican Party bestowed on you the unique "privilege" of running for governor of New York State. You did it without money, without support from even your own tribe. It was underfinanced and against long odds. It was an implausible pursuit. But they said, as so many others have, "Send me an Andy O'Rourke." And so you did it, armed only with your wits and your intelligence, your decency and your charm. You joined the battle; you carried the banner—and also that damn cardboard cutout of Mario Cuomo—all across the state!

Andy's bio doesn't tell us, ladies and gentlemen, that he was a Quiz Kid on the coast-to-coast radio program. Nowhere does it say that Andy served in the Persian Gulf, as the general told us tonight, when our country needed his wisdom and judgment on the Judge Advocate General's staff. He'll never admit it, but he's also a very successful author of swashbuckling novels. Many politicians don't even know how to *read* books. He writes them!

There's no mention in your bio, Admiral O'Rourke, of the housing you built with Andrew Cuomo, which became a national model for transitional housing. Or Workfare! Some Midwestern governors took credit for it, and a mayor of Newburgh flirted with it, but Andy O'Rourke *started* it here and perfected it and made it work.

So tonight, ladies and gentlemen, you've come to honor a Quiz Kid, a city official, a county legislator, a chairman of that board, a law professor, a teacher, a writer, a published author, a military officer of flag rank and high standing, a judge advocate general, and a civic leader. But you'd never hear it from *him*. So tonight, hear it from us. I'm very happy to be your surrogate, to help us remember it.

There have been disappointments in the story of Andy O'Rourke, which is a work in progress—the run for governor, perhaps. But a

banker said at cocktails this evening that if you did nothing else, you won the respect and support of investors and kept Westchester's bond rating high as a result of your splendid stewardship. And for that alone we owe you, Andy.

You brought to all of it a wonderful good nature and a kindly spirit. You are simply the nicest man many of us have encountered in public life. You are a model that both Democrats and Republicans can learn from. And as Mario Cuomo has said of you, "He has been a superb public servant: effective, committed, high-minded, principled, but not ideologically obsessed. O'Rourke served with a graciousness and warmth that the political world will miss."

Your commitment to taxpayers, improvement of government services, increasing of the parklands, and reforms of our bureaucratic systems will be remembered forever.

We thank you, Admiral, Mr. County Executive. We're proud of you. We're proud to be your friends. We are glad you are of us and ours. Please welcome Mr. Westchester, Admiral Andy O'Rourke.

Spring, 1997

Edward Cardinal Egan

New York has a new archbishop, a diplomat of great gifts and enormous talent. He is also a marvelous priest.

E dward Cardinal Egan begins his stewardship as Archbishop of New York with a wide array of obvious talents. He is a courtly man of great dignity, and his stentorian voice and basso profundo delivery were made for the great cathedral that is now in his care and keeping.

He is a man of wit and humor and a great diplomat with powerful friends in the Vatican. He is a prodigious fund-raiser; and our new cardinal archbishop has embarked on the monumental task of rebuilding and shoring up the aging, far-flung infrastructure of the Archdiocese of New York. But for all his considerable gifts, Edward Egan is ultimately and essentially a priest. The man, I promise you, will be about more than brick and mortar. Our new prelate knows that he is called to be a minister as well as one who *ad*ministers.

He comes to New York and to all of us with quite a different set of virtues than those possessed in great abundance by the two archbishops who preceded him, saintly Terence Cardinal Cooke and the complex but altogether endearing and beloved John Cardinal O'Connor.

I hope it is not a presumption to suggest—and this is just a hunch from a poor son of his church—that if a pope is ever to be elected from the United States, he will look and sound and carry himself exactly like Edward Egan. Pope John Paul II has given New York a gift of great value.

2001

"The Peacemaker": A Salute to Michael J. Armiento, Police Commissioner

Michael Armiento was New Rochelle's first modern-day, born-and-bred police commissioner. Before elevating this nice man, the city had always brought in paid guns from out of town. I made these remarks at his retirement.

Assembled here tonight at this gathering of neighbors is the largest crowd in the history of this establishment, which is supposed to accommodate no more than 470 patrons. We have, at last count, 550. And so we pray for the indulgence of Fire Commissioner Doc Kiernan. Call it an historic evening in our city. Historic, because so many of you have left your hearth and home to be here on this spring night to honor not only a beloved and respected figure, but an historic one as well.

He is a child of the neighborhood, the first commissioner of police and public safety to actually grow up in our city. The very first born and bred and raised here on these streets in our own hometown. We honor him for that fact alone. And the presence of so many of Mike's neighbors and colleagues in law enforcement is a reflection of the great pride we all take in his accomplishments.

His public career began on July 1, 1952 and it will end, as it began, on July 1, 1993. He came off the streets of the old Fourth Ward, in the West End of town, around Sickles Avenue and Sixth Street, the same neighborhood that gave us Sal Tocci, John Fosina, Donny Zack, Frank Garito, Lenny Paduano, Nicky DeJulio, Jimmy Generoso and his father before him, Sal Generoso, and the incomparable Junior Bellantoni, a/k/a Rocky Bal.

It was forty-one years ago, on July 1, that Officer Michael Armiento took his first post at Huguenot and Division in the downtown

area. He was twenty-one, a rookie cop. Other young officers of the day went off to other pursuits. But Officer Armiento stayed here among us and in the service of our city and its people. And now all of us are the beneficiaries of the confidence and love he had for his hometown and his neighbors.

To honor you and Roz this evening, Commissioner, have come chiefs of police from Yonkers, Mount Vernon, Bedford, Suffolk County, Rye, Larchmont, Rye Brook, the FBI, the DEA, and the International Association of Chiefs. Also admirers of yours from New York, even the police chaplain (and your confessor, Father Brian Brennan). We recognize your friends from the John Jay College of Criminal Justice where you received your degrees, some of your friends from the Davenport Club, the Rotary, which you served as president, the YMCA, of which you are a director, and even some of your associates from the Police "Golf" Association!

We also greet your associates from the prestigious Police Executive Research Forum in Washington, members of the Council of our city, the mayor, members of the great Assembly of New York State, chairman Steve Tenore of the County Board, Mrs. Pearle Quarles and Legislator Andy Albanese. Also the elders of the Chamber of Commerce, the library, the Boys and Girls Club, the P.B.A., and the captains, sergeants, deputy commissioners from your own department, Commissioner John Carboni, Judges Ken Rudolph, DeLucca, Sandy Sher, and Tom O'Toole, Judge Jeanine Pirro, chairmen Jim Generoso and Phil Wanderman who sounded the call for this wonderful evening, and even your predecessor, all the way from Grand Rapids, Michigan, Chief William Hegarty. And these proceedings are greatly enhanced by the presence of Nancy Q. Keefe of the Gannett Suburban Newspapers, she of brilliant pen and generous heart.

Your genius as a solid, skillful administrator is legend, Commissioner, and so I will presume to remind us of just a *few* of the good things you caused to happen in your department of 179 men and women. First, you gave our officers steady shifts, which means you also gave them a stable family life. And for that you have the gratitude of every wife and husband of every cop in our city and their sons and daughters as well, who can now see their father or mother on a regular, predictable basis.

You raised the educational level of your troopers. Everyone above

the rank of sergeant has a college degree. You greatly increased minority representation in our diverse, multicultural city. You did it quietly, but surely and consistently. During your watch New Rochelle appointed the first black deputy police commissioner in our region, in 1983. You sent your best and brightest down to the FBI Academy, and fifteen graduates received that valuable experience.

You expanded the Youth Unit. And for that you have the gratitude of every parent in the city. I've raised kids in this city, and I'm telling you, in the intimacy of this grand ballroom, that the sensitive men and women of that special unit are the best: Detectives Bruce Danielle, John Rosabella, Vinnie Mirabile, Gisan, Castro, Ewell, and their chief Lt. Dominic Locatelli. You also persuaded the city to let you hire a police social worker, Bob Fleming, the first of his kind in this part of the country. So, you've given us a progressive police department during your eleven innovative years as commissioner. We thank you for all of this.

And as we think of your accomplishments, Mike, I wonder if we might reflect, briefly, on what we have a right to expect from our police in this day and age. I think we expect too much from those to whom we entrust a badge and a gun and designate a peace officer. We expect them to be brave, nay, fearless; to confront and contain violence in our community while handling domestic and family disputes with compassion and understanding. If called on, we want them to rescue us, to save us, to protect us, to provide security. But I think the highest appellation we can bestow on Mike Armiento and those like you is that of "peacemaker." For forty-one years our honoree has been a peacemaker.

Jimmy Cannon, the great sportswriter, used to lament that once in this country, a cop was always *the* single, most respected individual on every block, in every neighborhood. *On* or *off* duty, that is, though it could be asked: when is a cop ever "off" duty? Roz Armiento would understand.

On only this can we all agree: that even today, the first order in a society is for public safety. All else proceeds from it. All else is informed by it. And we depend on it. And so tonight we honor a cop.

There is a marvelous story about one of our modern-day saints,

Angelo Giuseppe Roncalli. He did not come from the Fourth Ward. But he did pretty well, as Pope John XXIII, the most *human* pontiff of our time. As the story goes, His Holiness revealed in a letter to a youngster who had pleaded with him for some career advice, that Mike Armiento's profession was greater than his own. The Holy Father wrote to the young man: "Learn how to be a policeman, because that cannot be improvised. As regards being a pope," said John XXIII, "*anybody* can be pope; the proof is that *I* have become a pope."

Your greatest accomplishment, Mike, occurred on that September day thirty-two years ago when you won the favor of Roz DiMartino. She is here tonight, and as we honor you, Commissioner, we thank you, Roz, for all the sacrifices and interrupted dinners, weekends, and vacations. And the sleepless nights. We thank Krista and Michelle, too, for giving us their father at all hours of the day and night.

I questioned Mike about all this and inquired why the hell he's doing this and causing the bittersweet feeling we share tonight. "There comes a time," he said, "when you know it's time to move on." And so, fourteen days hence, he will retire from public service. But the good news is that the Armiento family is staying right here, on Forest Avenue. The phone number remains the same. And it's still listed, as it has been for all these years.

So you depart with a splendid record. We have tried to thank you for all of it tonight. But all the accolades, honors, and titles fall to the fact that you have been a peacemaker. And so we can only observe, near the end of a brilliant public career: Blessed are the Peacemakers. And blessed are we to have been in your care and keeping for these years.

Finally, we have heard from many speakers on this warm night, representing many organizations. There is one other segment that wishes you well, Commissioner. We also thank you on behalf of the underprivileged of our city, the poor and the hurting and those we cannot see across the table in this grand ballroom, those who don't speak like us, those who can't afford the price of a ticket to come here to honor you. But they thank you too for setting a tone, an attitude, in which those who are without high estate, title, or stand-

ing in our community can receive fairness and understanding and respect in their encounters with the law.

There is something about this city to have produced and kept a man like you.

<div align="right">

The Fountainhead
June 17, 1993

</div>

Presentation of the Coalition for Mutual Respect Yitzhak Rabin Peacemakers Award to Christopher Edley, Jr.

Christopher Edley operated at the highest levels of the Clinton White House. But he was a child of our city and came home to receive a prestigious award from his old neighbors.

Rabbi Amiel Wohl, whose wise, clear voice is heard and respected in all the disparate neighborhoods of our good city; and your co-partner in the Coalition for Mutual Respect, Reverend Michael Rouse, worthy successor to Vernon Shannon, now at the Mother Ship of the A.M.E. Zion Church in Washington; and Superintendent Linda Kelly, in whom we are all so well pleased and whose pride in our honoree was chronicled in the Gannett newspapers. These proceedings are also greatly enhanced by the presence of two of New Rochelle's most valuable (and today, our proudest) citizens: Mr. Christopher Edley, Sr., the distinguished former president of the United Negro College Fund, and your spectacularly beautiful mother, Chris.

Ladies and gentleman, neighbors: we're glad you've come on this brilliant May afternoon to witness another lovely moment in our city's history. This is a very sweet moment, and your presence speaks volumes of your regard for the work of the Coalition for Mutual Respect.

It is a tribute as well to Yitzhak Rabin, peacemaker, and enlightened leader not only of Israel but of the world. We remember the chill, the horror of that November day in 1995, when he was taken, and our tears were joined with those of people all over the world, of every religion, of every nation. It seems these things happen in November. This morning in Manhattan I encountered the great Mario Cuomo, for whom I have tremendous admiration, and I was reminded of a remark by the governor that Yitzhak Rabin was only the first Jewish leader cut down by his own tribe in almost four

thousand years. So the Jewish people have a somewhat better record on this kind of horror thing than we Americans.

Mario Cuomo also said: "I know Christopher Edley." And so do we. You are of us. You are ours. This is not the first honor or award your mother and father have witnessed. And the signs are everywhere apparent in Washington that it won't be the last. But as it comes from us, from your hometown, I hope it is special.

We've read and we have heard here today of your work in the highest councils of our nation, and most recently a national news magazine has identified you as a future cabinet officer in our federal government. But for now, this afternoon, your hometown neighbors have assembled to show their pride in your work, your example, and your contributions to justice and equality. But please know that for all your brilliance and accomplishments, for all the wise things you have written and uttered in the White House and in your classrooms at Harvard Law School, the highest compliment *we* can pay, the greatest appellation of which we are capable, is to observe, proudly and simply, that you are one of the neighbors' children.

We've also read about you, Chris, in the best-selling book by George Stephanopoulos (those towering figures Trent Lott and Newt Gingrich used to call Stephanopoulos and Edley "the Sandanistas!"). George also has his own ties to New Rochelle, as he is also a famous son of a famous father who served in our Greek Church.

I want to quote just a few lines from that book (which, as I'm married to a wonderful Republican woman, I had to read under the covers by flashlight! The other night I was even caught watching Hillary Clinton on television. And Nancy came in the room: "What are you *doing?*" I assured her I was looking for the *Yankees!* Now when Lou Boccardi, another of our prominent neighbors who is president and CEO of the mighty Associated Press heard about this, Mr. Boccardi inquired, "Does the First Amendment stop at your *bedroom door,* O'Shaughnessy?").

These lines from the book illustrate, I think, your qualities that were forged in our schools, on our streets, and at the knee of your mother.

It seems the president had to make a long-awaited pronouncement about Affirmative Action. So he turned to our Harvard professor. And as the president's senior policy advisor Stephanopoulos wrote:

In my single best decision about Affirmative Action, I recruited Chris Edley. A tenured Harvard Law Professor and associate director of the Office of Management and Budget, Chris was a brilliant policy analyst who liked to say he "grooved" on complexities and knew how to extract facts from the bureaucracy. He prided himself on facing hard choices head-on. He was a black man with a sterling civil rights pedigree.

Chris was wary of being used but unable to resist the challenge. Legal pad in hand, he prodded our group to ignore the politics, examine first principles, and ground our deliberations in "values and vision." Edley's academic rigor blew the dust off neglected parts of my brain. I soon understood that, paradoxically, Chris's idealism was the most pragmatic approach.

In the end you prevailed, Chris. And Professor Edley persuaded President Clinton to "mend but not end" Affirmative Action. And it had to have been another proud day for you when the president of the United States stood up, with you in the second row between the glass-enclosed Declaration of Independence and the Constitution, and spoke of a "rocky but fundamentally righteous journey to close the gap between the ideals enshrined in those treasures and the reality of our daily lives."

Professor Chris Edley, you are one of our city's great treasures. And thus it is a privilege to be asked to present you, Sir, with the *Yitzhak Rabin Peacemakers Award* of the Coalition for Mutual Respect. It is a tremendous compliment for which I'm grateful. But with the permission of the elders of the Coalition, I hope they won't mind if I ask someone greater than I to do the honors.

This Peacemakers Award is named for Yitzhak Rabin. And I can't elevate it any more than to ask Mr. Christopher Edley, Sr., to make the actual presentation to his son and heir.

Our son . . .

Mr. Edley, would you do the honors, Sir?

City Hall, New Rochelle, New York
May 12, 1999

Bob Peebles: A Reminiscence

O ver the years the NYSBA (New York State Broadcasters' Association) has been enriched by the presence of so many vivid and absolutely unique broadcasters who come each year from every corner of the Empire State to our high councils at Cooperstown, Saratoga, and Lake George.

Through the mists of time we remember Phil Spencer, Oscar Wein, Bob Klose, Mike Hanna, Mike Cuneen, Glover Delaney, Curley Vadeboncoeur, Bill McKibben, Harry Thayer, Jim Champlin, Walter Maxwell, Marty Beck, Dick Novik, John Kelly, Carol Reilly, Ellen Cody, Hal VandeCar, Paul Dunn, Frank Lorenz, Leavitt Pope, Matt Cooney, Ed Levine, Bob Ausfeld, Randy Bongarten, Dick Beesemyer, George Williams, Gordon Hastings, Ed McLaughlin, Si Goldman, John Hensel, Pat Tocatlian, Les Arries, Jerry Gillman, Rob Wein, Chris Lynch, Ray O'Connell, Wally Schwartz, Jim Delmonico, Mike Collins, Maire Mason, Mike Eigner, Bob King, Jack Thayer, Artie Angstreich, Larry Levite, Arnie Klinsky, Warren Bodow, John Van Buren Sullivan, Matt Mataraso, Bob Bruno, Rick Buckley, Jack Tabner, Neal Moylan, Ken Harris, Cam Thompson, Al and Bob Lessner, Ellen Sulzberger Straus, Larry Sweeney, R. Peter Straus, Lou Severine, Jim O'Grady, Keith Horton, and Eric Straus.

No other state association has had quite so many colorful players. And we're grateful that many of them are still active and contribute. There was also, as I recall, one Anthony Malara, a beguiling young man who came down from Watertown with big-time ambitions, a quick wit, and too many vowels in his name. And Philip Beuth who prayed each night to a "Saint Murph." One of them—Malara or Beuth—recently gave $10 million to Union College. I think it was probably Beuth.

A big, tall, handsome guy named Bob Peebles was one of those marvelous, indispensable, and altogether unique souls who enliv-

ened the ranks of our association during the last four decades. Bob was an endearing and enduring character who loved our profession. And like Beuth, he was a CapCities guy who often prayed to that "Saint Murph."

A strong, dynamic man of great conviction who brought a rock-solid sureness to all his pronouncements on the great industry issues, Peebles was always, it seemed, on his feet to interrogate and engage the speakers and presenters at our conference sessions, including every governor of New York all the way back to Nelson Rockefeller. Bob's move toward the microphone usually occurred at the precise moment it was relinquished by Oscar Wein or Les Arries. Never at a loss, Bob could also be observed dispensing words of wisdom to Don West, Les Brown, and Larry Taishoff from the broadcasting trade press.

And as I read the sad announcement of his passing at the age of eighty-three, my mind drifted back to one long-forgotten afternoon at the prestigious Fort Orange Club in downtown Albany where the NYSBA board of directors was locked in an all-day debate over whether to hire a full-time executive to manage our affairs and establish a real presence in the state capital.

Hour after hour the elders of the board deliberated without any clarity or resolution. I was not a member of the board at that particular time, but as I happened to be in Albany that very day I decided to drop by the Fort Orange just to see if I could stir up a little trouble and also test an earlier resolution that former presidents were entitled to the "privilege of the floor," if not a vote. I *really* went to find out what the hell they had been talking about since nine o'clock that morning. The heated, seemingly endless discussion wore on as the shadows of early evening lengthened over the city.

Having made my majestic presence known during a break in the proceedings, I headed for the parking lot to drive back down the Hudson River Valley to Westchester. Just then an exhausted Bob Peebles came rushing out and said, "Look, O'Shaughnessy, you and I have disagreed about damn near everything. But I'm trying to get them to open an office and set up a real presence in Albany. We may not need it now, but we will down the road. The board is not quite sure they want to make the damn investment! Frankly, I haven't got the votes."

Now, as I recall, it was well past five o'clock—drinking time, even

by Albany standards—and Bob and I hatched a plan out in the parking lot to have the chief steward rush into the boardroom with silver trays full of good, stiff cocktails. "Top shelf stuff!" Bob insisted. Needless to say, after a few libations, and possessed of the newfound wisdom that had eluded them all through the long day, the board had a significant "attitude adjustment" and quite effortlessly came up with the bucks to hire a charming Irishman from New Jersey named Reilly.

Incidentally, all this may be confirmed with former Senator Warren Anderson, the legendary Senate majority leader, who was staying at the Fort Orange Club in those days and decided to join us for a few cocktails himself after the meeting adjourned. (I *do* recall getting home that night—somewhat late, I think.)

That's just one story I know about Peebles. There are many others from our sessions at the Otesaga, the Gideon Putnam, and the Sagamore. Bob spent the last years on crutches and in a wheelchair, attended always by his devoted Trudy. But for about thirty years he never missed one of our meetings.

He was a big man all the days of his life. A "top shelf" kind of guy. We will miss him.

<div align="right">May, 2001</div>

The Sum Total of a Tragedy

Sometimes a terrible event brings out the best in a community.

On Wednesday, December 29, 1971, at eleven minutes past two o'clock in the afternoon, an explosion blew apart two automobile dealerships in the City of New Rochelle, Westchester County, New York, population 76,483.

That tremendous explosion and the awful fire that followed took the lives of three of our neighbors and injured thirty-one.

U.P.I. carried the news of this tragedy all across America. It did not mean much to people who did not live in this area, and what happened on that day was probably quickly forgotten. But it is not forgotten in New Rochelle, New York.

And even now, the facts and the statistics are still being compiled. These bear testimony to the heroism and sacrifice of the people who fought the holocaust during twelve long, anxious hours. Here are some of them:

One hundred thirty-seven New Rochelle firefighters reported to contain the blaze, many on their day off. They were joined by 103 firefighters from neighboring communities. They came from Mount Vernon, Pelham, Larchmont, Mamaroneck, Eastchester, Rye, Harrison, and Port Chester. Fifteen fire engines, hook and ladder trucks, and pumpers were in use all at once. Three rescue units and twelve utility fire vehicles showed up from the Salvation Army, the Red Cross, the Third Alarm Association, and others; two volunteer ambulances were there. And so were two ambulances from the New Rochelle Hospital and Medical Center.

Fifty-three police officers directed traffic in the cold winter air near Boston Post Road, a mile away from Long Island Sound. Five tired men and women worked all night in the Fire Control Center of Westchester, and six others dispatched equipment from the

Emergency Communications Room at New Rochelle City Hall. Hundreds of individual citizens took people into their homes in the area near the fire for food and coffee. Four members of the Chamber of Commerce called to volunteer trucks. A Civil Defense crew from New Rochelle was joined by one from Yonkers and one from Eastchester. The Town of Greenburgh sent one badly needed lighting truck.

At our magnificent hospital forty-one doctors treated the victims. They were assisted by seventy-five nurses and twenty-nine hospital volunteers. Fifteen members of the dietary department fed the victims, their worried families, and several hundred others far into the night.

Telephone operators, deputy sheriffs, assistant district attorneys, maintenance workers, detectives, porters, and auxiliary police officers worked throughout the city. A man who owns a delicatessen on Second Street loaded most of his foodstuffs on a truck and gave it away to the firefighters.

One tired mayor took to the airwaves to reassure citizens who were concerned that the Armory might go up. And the radio station broadcast bulletins throughout Westchester to call in off-duty firefighters and volunteers. News broadcasts on the local station also warned motorists to avoid the area and even carried an urgent message about a missing set of keys to the city's high beam, high-intensity portable light system. The keys were found, and the system lighted the scene all night.

Ten valiant crews from the Department of Public Works and eight crews from the Edison Company were there. As were engineers from the Water Company, which provided 1.45 million gallons of water for the $5 million, three-alarm fire.

There are the facts, cold and stark. They are just figures and statistics. They don't begin to tell of the heroism or the sacrifice of the people of the City of New Rochelle, New York, during the disaster.

We beam our broadcasts to thousands of people in other parts of Westchester, in many fine cities and towns and villages.

But on the terrible day, December 29, 1971, we were proud to be the radio station of the people of New Rochelle, New York.

December 29, 1971

This Christmas: We Ask Three Wise Men

The incomparable Bernard "Toots" Shor once observed that "the great ones rarely have great sons." This marvelous bit of wisdom emerged from the famous saloon-keeper after five brandies, a jar of pickles, and a chaser of Diet Coke as he held court in his glorious joint on 52ⁿᵈ Street one Manhattan afternoon long ago. Toots was referring to the errant scion of one of the great men of the Republic. But then the legendary barkeep thought better of his pronouncement and looked up to the heavens to acknowledge, "Well, I guess there was just one exception, if ya know what I mean" as he made the sign of the cross.

This is an odd way to lead into the Christmas story, and I hope it's not the least bit irreverent. But that incredible event that occurred in Bethlehem some two thousand years ago continues to change the world. I asked three New York priests for their "professional" interpretation of this astonishing story.

W. O'SHAUGHNESSY: In this Christmas season it is a privilege to have on the air three of Westchester's most respected priests. Monsignor Edward Connors, pastor of Immaculate Heart of Mary Church, former superintendent of schools, and a fabulous preacher known for his brilliant homilies; Father Stuart Sandberg, of the Siloam Cooperative in White Plains, one of the most thoughtful and cerebral of all the priests of the Roman Church; and Father Terry Attridge, the famous "junkie priest" from Sacred Heart in Dobbs Ferry, who started the D.A.R.E. program.

Monsignor Connors, what are you going to talk about when you preach this Christmas?

MONSIGNOR CONNORS: The fundamental meaning of the whole event, Bill. That God sent a signal of his love for people in the person of his only Son, Jesus Christ, and that was to assure us all of God's love. He came in humble circumstances and was revealed to very

poor people as a sign that he is for everybody, the poor as well as the rich, the powerful as well as the powerless, and that not only does God love us, God wants us to love one another. God is our Father and we are brothers and sisters—not competitors, but helpers.

The meaning of Christmas is that by going out of ourselves and becoming interested in others, by becoming centers of love and joy and service rather, we actually are *entering* that peace that God is giving us. The whole purpose of living, according to the Christian philosophy, is giving; and when we give of ourselves, we gain a great deal more in the long run.

w.o.: Father Sandberg, have you figured out the meaning of Christmas?

FATHER SANDBERG: We are encountering the mystery of God in our lives, in our relationships, in the ways we are open to life and the ways we're closed to life. So I haven't figured out the mystery of God or the mystery of Christmas. But I'm open to the many ways in which God reveals himself in everyday life, and I think that's what Christmas is about. We say the Word of God becomes flesh and dwells among us, that Jesus is God's love risking becoming vulnerable in our human condition. And we are so often hardedged, trying to make ourselves invulnerable and to control things that it's hard for us to hear that Word even at Christmas, *especially* at Christmas, when it's the winter solstice and the time in which some non-Christians try to fill up the coldness of winter and the darkness of winter with light and celebration. We're all nonbelievers, at some level. We all have that human need to deal with this time of year with that kind of exuberance. And yet it easily gets in the way of letting Jesus be born because Jesus is love, and love depends upon vulnerability. It depends on being open to our own poverty and to the poverty of one another. It's a time when there's a lot of this tension between God's loving action and the world's attempt to manipulate this into something materialistic that will fill us up and take away the necessary vulnerability.

w.o.: What do you do when you feel overwhelmed by the commercialism and crassness of Christmas?

FATHER SANDBERG: I just turn it off and keep making room for Scripture, for prayer, and for people. In the midst of all the commer-

cialism, we can still take time to be with people and with God and trust that the mercy of God is always breaking through when we make room for it.

MONSIGNOR CONNORS: The question could well be how do we get away from it at other times too. Do we find *any* islands of peace for ourselves where we try to get in touch with a higher Being and our own feelings and ask ourselves some fundamental questions. Where have I come from? Where am I going? How do I get there? What's the meaning and purpose of life? A great many of the younger generation are turning to spirituality, not necessarily formal religion but various forms of spirituality, to try to get in touch with those things. We see it with young families. In some places it's been dramatic. In other places it's been relatively modest, but it's on the increase.

W.O.: But how do we get away from the crowds, the exhaustion, and tension? How do we get to Christmas, Father Attridge?

FATHER ATTRIDGE: Christmas is a celebration of Jesus as the Light of the World, and we need to refocus and look at the priorities in our lives rather than what's in it for me, to deal with the spiritual aspect. We can begin within our own families and maybe create an inner peace within, to see Jesus existing within ourselves. Then we can have a better sense of the dignity of the person next to us, to see Jesus in them.

If we had a better respect for the dignity of the person we wouldn't have the problems we have today. We wouldn't have abortions, partial abortions, infanticide. We wouldn't pull away from our brothers and sisters with AIDS at a time when they need love, affection, attention, and support. We wouldn't take flight from reality by using drugs or abusing alcohol. If we have a better respect for one another we'll be able to turn around the injustices that take place. But it begins with ourselves.

W.O.: Are you suggesting that infant birth in Bethlehem so many years ago can cure all those ills today?

FATHER ATTRIDGE: I think so, because when we're refocused on Jesus, who came into the world as God's gift to us, we understand that his presence represents unconditional love and forgiveness. Once we allow ourselves to experience that love, we get beyond the "poor me" stuff.

W.O.: But don't you think God has gotten lost in all this?

FATHER SANDBERG: God is always getting lost in our world. Central to the Christian mystery is that God *allows* himself to get lost in our world. I think of a priest who got very angry when people would come up to Communion with their hands in their pockets and with an attitude that says, "Who cares what this is all about?" To me, the mystery is that God still keeps feeding us and giving life to us even though we are preoccupied and filled up with ourselves.

W.O.: The great know-it-all scholars now say that there is no proof in the Bible that December 25 was the birthday of Jesus.

FATHER SANDBERG: Most scholars have known that for a long time. Actually, the early Church first celebrated Epiphany, the appearing of Jesus. Later on, the materialistic West became more preoccupied with the actual birth of Jesus.

Scholars are always finding reasons to be skeptical. That's their business, to question. But ordinary people have doubts too. How do we believe in a God when there are so many evils, when human beings hurt one another in so many ways? That is what Jesus is all about: believing anyway and loving in spite of what we're doing to one another. Jesus' birth teaches us to keep trusting that God keeps loving us. That's what *faith* is. If it were simply logical or something that scholars could give us, then all we would have to do is go and read the Book and get the answer.

W.O.: Okay, what about these guys who say people just need something to brighten the winter's long, drodsome days?

MONSIGNOR CONNORS: There's a lot of truth to that psychologically. The light is beginning to get a little stronger each day now. The Christian Church only began to celebrate Christmas in the fourth century, and they established this celebration to try to moderate the excessive debauchery and drunkenness with which other people were celebrating the feast of the winter solstice. Now, unfortunately, there seems to be a bit of excess in our partying and consumerism.

W.O.: It's an implausible story, you have to admit. This couple comes down from the hills, the authorities are after them, the mother is pregnant with child, the father a journeyman carpenter, no funds even for a room in the local hotel. Could that story happen again today?

FATHER ATTRIDGE: It's happening, Bill. There are a lot of homeless peo-

ple out there. As we try to reform welfare, we have to be sensitive to those people around us who are in need and not just throw everything away to correct certain abuses in the process. We have been empowered to find and help those who can't make it on their own.

W.O.: How would the media have handled the Christmas story if it happened today?

FATHER SANDBERG: Most likely, it would be ignored. The major events in human experience are not easily convertible into journalistic clichés. The only way Jesus is even discussed or mentioned is in expletives for the most part. The media do not pay attention to the deeper dimensions of our lives. And audiences just don't have the patience to attend to anything that asks them to listen with any deeper part of themselves.

W.O.: Why would God send Jesus to be born in such bleak circumstances? Not even room for them at the inn . . .

MONSIGNOR CONNORS: To show that salvation and peace is not purely the work of human beings. It's also the work of an all-loving and all-powerful God, who can use the weakest things of the world to affect his purposes and bring his peace on earth.

W.O.: Monsignor Connors, you once did a sermon some years ago that I have never forgotten. You talked about the infant Jesus warmed only by the breath of smelly shepherds.

MONSIGNOR CONNORS: I think I said, "This Christ, I tell you, is not what we expected. He came in poverty and weakness and in suffering, attended only by smelly shepherds. We find him not in a palace, but in a cave. He comes not as a warrior king, but as a tiny, powerless infant. He is a strange kind of king who has a manger and, one day, a cross for his throne. When the song of angels is stilled, when the star in the sky is gone, when the kings and princes are home, when the shepherds are back with their flock, the *real* work of Christmas begins: to find the lost, to heal the broken, to feed the hungry, to release the prisoners, to rebuild the nations, to bring peace among brothers and sisters, to make music with the heart." He was not just for the rich and powerful but for everybody.

W.O.: Which is the most important feast of our Catholic Church, Christmas or Easter? Saint Paul said, "If Christ be not risen, then is not our preaching in vain."

FATHER SANDBERG: Easter is the deepest revelation of God's love for us. God enters into our dying and rises to new life: this is the core revelation of what God is about. And yet Christmas is the incarnation that makes the resurrection possible. They're both communicating the same mystery. Christmas is the more popular because a child born in a manger is more accessible to most people than a crucifixion. The revulsion and fear people have of dying interferes with their celebration of Easter.

MONSIGNOR CONNORS: We celebrate Christmas only because of Good Friday and Easter. It's very attractive to commune with the infant Savior, but an infant is nonthreatening and hasn't lived a great deal and doesn't have any big example of sacrifice and love to give all of us. But when a person suffers and dies, especially for a cause or for other people, then we have a much more important event. Jesus, by dying on the cross and rising from the dead, has affected our salvation. And his birth is significant only in those terms.

W.O.: Could a God give any greater gift?

MONSIGNOR CONNORS: I don't think so, Bill. There's nothing more God could give. God didn't send a committee. God didn't send a great prophet. God sent the One who shares in God's divinity.

W.O.: Still, not everybody is so happy around Christmas time, Father Attridge.

FATHER ATTRIDGE: That depends where they are coming from, Bill. When Jesus came to this world, it was almost the same type of society as we have, a world filled with oppression and injustice and inhumanity. If we understand that we've been empowered to rectify these problems, then Christmas can be a joyful time.

W.O.: You priests would say that if you see a homeless person in the streets, we should feed them, clothe them, take them in. But they don't always look so clean and they're not always so attractive.

FATHER ATTRIDGE: But also there are a lot of attractive people today in Westchester who might be hurting emotionally or spiritually, and we just walk right by them too. We can help one another in many ways and take care of both the *physical* poverty and the *spiritual* poverty. We can invite people to reach out to the arms of the Lord who is reaching out to them.

W.O.: I once heard a simple, stark, wonderful description of Christmas, in just a few lines, that went like this:

"You have sinned," said those who know the Law, "and you must pay."

"It is time," said He who knows no time. "I am here. And you have been redeemed."

Has anybody ever put it better?

<div align="right">December, 1997</div>

2

Interviews

Interview with
Mario M. Cuomo

Mario M. Cuomo is the most impressive public figure I've encountered during my time on this planet. I long ago lost my objectivity about this extraordinary man, who is not only America's greatest living orator but the only one among our contemporary leaders who confronts the moral issues of the day. The governor does this with clarity, passion, and great intelligence. In recent years he is doing the best work of his life. Everybody knows about his speeches at Notre Dame and to the Democratic National Convention. Yet even as he approaches seventy, he continues to leave his Manhattan base at the Willkie, Farr, and Gallagher law firm and each week goes out on the road to jog our consciences with soaring speeches about our basic need to love our neighbor. Not everyone appreciates the lovely music of this graceful soul.

W. O'SHAUGHNESSY: Do you think the last year has been a good one for you?

M. M. CUOMO: Every year is a good one for me. I don't total up the pluses and minuses, because if I do I come up so far ahead I wonder if anyone up there is keeping score—because if they are, I may be accountable. I've had a tremendous life. I've done just about everything I could've hoped to do, and a lot of the things I've been able to do I never could have hoped for—like being governor. I have a wonderful wife and wonderful children with wonderful parents on both sides. I have no regrets about anything that's happened in my life. If anything, I've gotten a good deal more than I've deserved, and I'm working very hard to come as close as I can to deserving it.

W.O.: You told a young journalist once that you pray for *sureness.* What does that mean?

M.M.C.: I think we all do. Everybody wants to know *Who* is God? *Is* there a God? If there is a God, how come when I pray for some-

thing it doesn't happen? Why was I *born?* Why do little Vietnamese children get their eyes blown out of their sockets by bombs they have no relationship to? Why does evil happen? What's it all about? Everybody wonders about life, I think. Some of us get so busy maybe we don't take the time to stop and wonder about it all. Given time, everybody has the same questions and the same lack of clear answers. I pray for *sureness:* "Enlighten me." I think most people do that.

w.o.: You gave a speech the other night. You had a lovely line that went something like "I am not enough for me."

m.m.c.: There's really nothing too profound about that, Bill. After a lot of fumbling around and involvement in a lot of things like playing baseball, trying to raise a family, suffering disappointments, I looked up at one point to conclude that there are some general propositions. This is a very confusing life unless you believe in something *bigger* than yourself. If you are committed only to yourself—if the whole game is making yourself as beautiful as possible, as successful, as respected—you're doomed. You are a vessel so large you can't fill yourself in a single lifetime. You can't do it with self-gratification. You have to find something you can give to, because nobody can stop you from giving. They *can* stop you from receiving. So if you learn to give to something bigger than yourself, like a mother to her child, that's fulfillment. What I concluded is if the only reason for me to be in this world is to make myself happy, that's not enough. I can't believe that any intelligent force—call it God if you like—would waste his or her time putting together a universe like that because you can't make yourself happy enough. There isn't perfect justice in the world. The game must be trying to relate to all the other pieces, trying to get into some kind of synergy with all of them, some kind of synchronization. We're all in this together.

w.o.: There are those among your admirers who think you're wasting your time trying to get more Bob's Big Boys on the Thruway, or building roads; that you ought to be just sitting and churning and *thinking* things out . . .

m.m.c.: No, no, no. Life is motion. The best thing you can do is move, sweat, cry, fight, love, be rejected—but *be in the game.* As long as you can't figure everything out, use everything that you have. Use it as fully as you can use it. I don't want to sit around and think

and write. I want to *do*. I'm the governor, and every day I wake up, I have an infinite number of opportunities to do things that can be useful. I foul up a lot. I'm human. I fail probably more than I should. But every day I can do something good. I can save little children's lives. I can build great institutions of learning. That's real. That's tangible. That's what I want to do.

w.o.: Ossie Davis said, "God has not yet revealed what he or she wants Mario Cuomo to do . . ."

m.m.c.: I don't think God has revealed what he or she wants Ossie Davis to do! Or Bill O'Shaughnessy to do. That's another of the great frustrations. How unfair that God should hit Saul in the tush with lightning and convert him into Saint Paul! He knocked him off his horse and told him to straighten up and fly right! Change your name to Paul and become a saint! He gave him a *mission*. That's what we need.

w.o.: But God sometimes speaks in whispers.

m.m.c.: Sometimes you have to guess at what God is saying. Sometimes you have to *think* it's his voice and act on it. God is mostly suggestion, not mandates.

w.o.: You have a new book, *More Than Words: The Speeches of Mario Cuomo*. Some people are saying you should spend all your time thinking and writing.

m.m.c.: What some people say is that if you *speak* well then you must not *do*. People who *talk* don't *act*.

Nancy Q. Keefe of Gannett got at this in a column she did, and so did a guy from the *Wall Street Journal*. What they say in reaction to the speeches is, "Governor, you're constantly calling for us to uplift ourselves as a state and a country, to get all the kids off drugs and all the homeless into shelters. And now we look up and all the kids are not off drugs and some of the homeless are still on the streets." Does that mean we ought not to have given that speech? We ought not to call upon ourselves to reach a level that's beyond us? Ralph Waldo Emerson says, "Hitch your wagon to a star." Let me reach for something I cannot attain. That's what you're *supposed* to do. Would you rip the Sermon on the Mount out of the Holy Books because it never came out the way Jesus said it should. We're supposed to aspire to more than we can reach. Kierkegaard said he thought the Christian religion, especially, pushed you to reach a level of conduct you could never

possibly attain. If you are a Catholic, you go to confession on Saturdays. That means you failed every week. But every Sunday you hear that you have to be like Francis of Assisi if you can. You don't tear up the objective because you failed to reach it; you just try harder to reach it. If you get close, lift the bar and try harder still.

Fall, 1993

What's Happened Since . . .
Over the next several years, I would from time to time ask Mario Cuomo for his thinking on current issues.

W.O.: You took a lot of kidding from your friends when you wrote a book for children. I'm afraid I was among those having a little fun at your expense. What was *The Blue Spruce* all about?

M.M.C.: Never give up trying to follow your dream, whatever it is. Papa taught me you're never too young or too old for dreams. Every time I thought I was going to fail—in politics particularly, or when I failed a test and I was crushed—all those moments when you want to hide and you don't want anyone to see you— all those times when I wanted to quit—I thought about Papa and how he would never quit on a dream.

W.O.: Mario Cuomo once said, "When the People say, 'Send me a president,' they are really saying, 'Send me a *moral* leader.'" But you told some friends, "I don't *want* to be the *moral* leader of this country." What would you tell the children of America about Bill Clinton? Your friend Jack Newfield called him a liar, a weasel, a cad, a scoundrel, among other things.

M.M.C.: I would tell the children of America what I would tell a child about his or her father. What we hope for in our father, our mother, our heroes, our presidents is somebody perfect. Someone who is so good, so correct, so right that whenever we're confused about life, we can go and put our arms around him or her and say, "Thank God for the Truth, and there is the Truth." Unfortunately, that has only happened once in my experience and knowledge. Only once have we been given such a person, and even then we didn't recognize it. That was the beginning of the Christian era. Since then, and before and maybe forever, we're

going to have imperfect creatures. And they will *all* sin, according to the good Jewish book and the good Christian book, seven times seven times a day! That's true even of presidents, of popes, of great rabbis. Some day in another universe we will achieve perfection. That is called nirvana, heaven. You have to hope for institutions that can survive the weakness, the venality, the shortsightedness of leaders such as we have had for many years. This is not to confuse what is *real* with what is *desirable*. Nor to suggest that we shouldn't continue to aspire for more excellence—and insist on it.

But understand that when you bring this person down, you are toying with a very important principle in this country. You brought down Richard Nixon, and we thought that was appropriate. Now you are going to bring down Bill Clinton, and maybe we'll think that's appropriate. But you do that too often, you *destabilize* our system, which is built on having a president for four years. If you encourage opposition parties to bring people down for whatever transgression they find in the middle of a term, it gets to be a convenient way to eliminate the opposition without beating them in an election.

The presidency should be a place where you send signals to people about how they should behave, about how to be civil: you shouldn't hate someone because the other guy is Jewish or black or female or gay; honor your relationships, live up to your contracts; don't mess around with interns in the back room. We all have an obligation to put out these signals of civility. Everybody is a parent or role model to somebody.

We have two things going against us, O'Shaughnessy. The first is our humanity and vulnerability, our concupiscence: just because Adam and Eve bit that darn apple all those years ago. And the other thing is *freedom*. Because we are a relatively *free* society, because we insist on giving ourselves a lot more room than most other successful nations ever have, we are free to make mistakes and bad choices. We are free to be disgusting and even mean in our language. We are free to lie about public officials as long as we don't do it maliciously. We're free to have all the sex we want.

We're free to do a lot of things a lot of people regard as not good for the making of a healthy society.

w.o.: Governor, you're not blaming all of Clinton's problems on Adam and Eve, are you?

m.m.c.: I blame *everything* on Adam and Eve, Brother Bill!

w.o.: A few weeks ago, out on the West Coast, you addressed two thousand people, and at the end of the program some nut in the back row screamed out, "Why don't *you* run for president?" He brought the whole, damn gathering to their feet. Why *don't* you run?

m.m.c.: I think my moment has passed, Bill. I think there was a time when I might have been able to make the case. I think the party has enough quality to make the race, and I don't think there is a need for me. If I believed there were a need, I would consider it. There are other people who run not because they think they are the very best but because they think they would like to be president. That has never been enough for me. Would I like to be president? Yeah, but I don't think I'm anywhere near the best available, and so I'm not even considering it.

I do miss the opportunity the governorship gave me to do good things. I described it once this way: Every morning you are lucky enough to wake up as the governor of New York, you have an infinite number of opportunities ahead of you to do good things. It is a great gift to be in a position to help a lot of people to make their life a little bit better. The private sector has many rewards, and I have been luckier than I deserve to be, but I do miss the opportunity to be useful to a lot of people. The test is not so much what you achieve, although we all strive to achieve; the test really is *how hard you try.* So I'll keep trying as long as I have the energy to do it.

w.o.: You gave a stunning, very spiritual talk down at Union Square. You called it "The Whole Law."

m.m.c.: It's very simple, O'Shaughnessy. Even for a Republican without socks! All the religions—Judaism, Christianity, Islam—have only two ideas at their foundation. Just *two.*

It started with the Jews, four thousand years ago. They looked up to their Hebrew God and said, "Hey, what am I? What *is* this?"

And the Hebrew God said, "You see the person who looks a little bit like you? And the one a little bit *different* from you? You are all *alike!* You are all children of *one* God. You are *all my* children. You are all entitled to dignity and respect from one another." That's number one! *Tzedakah,* we call it, for the Jews.

And so the Hebrew says to his or her Hebrew God, "Alright, now I know the relationship. We're all in this thing together. What do we do with that? What are we here for?" And God says, "It's very easy. *Tikkun Olam. Repair the universe!*" The Hebrew said, "Repair the universe? I have enough trouble staying alive! They're chasing me through the desert! I can't feed my family!" God said, "I know you have problems. What you do is the best you can do under all the circumstances. You start with yourself. And then your family and the people you have an obligation to provide for. They're part of the universe. Just make that as good a family as you can. And as you get stronger, if you get to be the mayor of the village, then help the whole village. If you get to be king of the kingdom, then help the whole kingdom."

And the Christians borrowed it (actually, *stole* it!) whole from the Jews! Remember the rabbi who started the Christian religion? Imagine him walking down the dusty street when the scoffer (probably a lawyer!) stops him and says, "I understand you dazzled them in the temple." And the rabbi says, "Well, yeah, I had a pretty good day." So the wise guy lawyer says, "If you are *so* smart, let me hear you sum up the *Whole Law* for me in a twenty-second commercial!" The rabbi says, "I'll do it in a *ten*-second commercial. Are you ready? *Love one another* as you love yourself, for the love of me, who is Truth."

And the Truth is that God made the world but didn't *finish* it and left that work for *you* to do. God asks you to be collaborators in Creation. That is the *Whole Law.* There is nothing else more complicated. There is nothing more profound, O'Shaughnessy. That's your *mission.* Try to make this place as good as you can make it.

And don't ask how. God says, "I've sent down the tablets: don't take someone's spouse, don't take someone's goods, don't kill anybody. That is all you need. The rest you have to work out for

yourselves. You know what sweetness is, as distinguished from bitterness. You know what fairness is, as distinguished from unfairness. You know what it is to be good. And to be bad. Just do the right thing. That's all I'm asking."

And if you think that's not a good enough answer, show me another one!

And that's what Islam believes too.

And God also admonishes us, "And don't be telling me you don't have the capacity to change the world. I know you don't have that capacity. But you have the capacity to *try!* I *know* how grand and complicated a place this is. And I know how *little* you are. And so if the best thing you can do in your lifetime is find one other human being along the way and comfort her in her moment of distress, then terrific! I'll settle for that. Don't worry about fairness when judging your effort. *I'll* know when you tried and I'll know when you didn't."

That's what I tell my grandchildren. And if you understand this, then you can live *justified*.

They ask me, as they ask every politician, I guess, "What do you want on your tombstone when you die?" That's easy for me. I always give the same answer, "Just put: 'Mario Cuomo: 1932–fill in the blank. He *tried*.' " Tried what? Just forget about that. He *tried*. That's all you have to do to make yourself successful. In this life and the next, Brother Bill.

w.o.: Whew! Governor, what does it mean to be an Italian American?

m.m.c.: You say it accurately when you say, "Italian American." I'm not really Italian. I'm an American born here. Mama and Papa were born in Italy and came here. They were from a place called Salerno, in the Mezzogiorno, one day's journey south from Rome. This is important to remember when you're thinking of Italian Americans. Milan and Florence are where the industry, money, and high culture have always been. The south has always been the poorer part of Italy, with fewer educated people, fewer successful people, more poor people and strugglers. That was true for all the current century, and it's why so many people came from Sicily and the lower part of Italy to America. My people were among them.

w.o.: It's part of the popular culture, Governor, that your parents were very poor.

m.m.c.: They were poor in Italy, and that's why they came here. And they were poor here because they chose, unfortunately, to come here just before the Depression. My father and mother never went to school a day in Italy. And whatever they learned about Italian writing and words, they learned from their families and from the streets in Salerno. When they came here, my father had no skills other than labor. He was a small man, not big and powerful. What he did was use a shovel. He was a ditchdigger, literally, in Jersey City. He was able to make a living until the Depression stopped the construction work, and then he was desperately poor. My mother came over a year after my father did, which was the established pattern. You'd get married, the woman would become pregnant, you'd go to America, and a year later she'd come over with her first child.

They were saved in the Depression by a gentleman from Queens County by the name of Kessler who owned a grocery store but couldn't run it himself because he was ill. He put my parents in a back room of the grocery store in South Jamaica and taught them what they needed to know. It is hard to say we were poor because although my father wasn't paid in the beginning, we had food and shelter and probably did better than most people in the neighborhood.

w.o.: Governor, you mentioned Mr. Kessler, the owner of the grocery store. I've heard you speak of this story to Jewish groups. Are there similarities, I wonder, among Jewish people and Italian Americans?

m.m.c.: I think, Bill, as I've grown older—and this is true of a lot of people I know—you arrive at two conclusions about *values* in this society. One is that it is harder and harder to look to the collectivity, to the American culture, and say, "This is going to supply me with all the values I need." Especially at a time like this, given the current argument: What is it that we believe in that truly uplifts us? And because we're troubled by a lack of heroes and a lack of *clear* values, we tend to turn more and more toward our ethnicity, toward our *roots*.

I'm probably more distinctly Italian American now than I was when I was fifteen. When I was fifteen, it didn't mean as much to me. For some immigrants—and this is a shameful thing to admit—if you were poor and your parents couldn't speak the language and you weren't particularly good at it yourself, there can even be embarrassment at being Polish or Jewish or Romanian or Greek or Irish. But as you grow older you come to appreciate your roots. If you happen to be an Italian American, then part of your heritage is Italy itself. Not withstanding my mother and father weren't educated and never visited a museum in Rome and never knew who Cicero or Caesar was, it's in their blood to some extent. They share that culture, and, therefore, I inherited it to some small extent. And that's meaningful, knowing you come from a people thousands of years old.

You see this in the African American community very vividly. They're going back to their roots. Remember Alex Haley's book *Roots*. And when they go back they are reminded that however badly they're been treated here, they have an immense contribution to give. They have been left a tremendous legacy of intelligence and accomplishment from Africa, and these things take on much greater value.

I feel that I have the culture of the Italian American, the *values* my mother and father brought over. These they have in common with all the other immigrants of their generation, whether they were Irish, Polish, or German. And these values were a willingness to work very hard, a total commitment to *family*, and an instinct for *religion* that no philosopher had taken the time to teach them. They had a general sense of a God to whom we owe loyalty and obedience and who in one way or another will save us when it's all over. They also had incredible patriotism and developed this very powerful commitment to the United States of America. People that came here as immigrants appreciate better than those who were born here the difference between this place and all others, and, therefore, they have a fiercer love even than some of the native-born people.

w.o.: Mario Cuomo, who are some *other* Italian Americans who have made great contributions to this country?

M.M.C.: My mother and father were truly great people! If you consider what they accomplished with what little they had—raised a family of four, one died, and the others grew up reasonably straight and well situated in this country—theirs was a fantastic accomplishment. If you want to talk about "historic" Italian Americans who achieved great fame in this country, there are the scientists and inventors like Enrico Fermi and Guglielmo Marconi, great athletes like Joe DiMaggio, artists like Frank Sinatra, Arturo Toscanini. Incidentally, there are great Polish Americans, Irish Americans, Greek Americans, Jewish Americans, African Americans: we all have our Pantheon of Heroes. But I must tell you, Bill, as great as they were, when I look at the range of great people all across the board, none of them is greater than my mother and father.

W.O.: When you sit in your ivory tower at the Willkie, Farr and Gallagher law firm in Manhattan, or go around the country making those magnificent speeches, does your mind drift back to that one room behind the grocery store?

M.M.C.: When I am all finished with my speeches, O'Shaughnessy, and when I'm all finished with the day's work, what I think of is a plate of good pasta, and a good glass of red wine, a nice piece of bread! That's enough for me.

W.O.: Mario Matthew Cuomo, give us some predictions for the new millennium.

M.M.C.: Predicting what one thinks will happen in the new millennium gets easier when you remember it's going to take a thousand years for anybody to prove you were wrong, O'Shaughnessy! And I'm comforted by that reality. The change that has been so dramatic over the course of my own lifetime is going to continue, and it's going to change the way we play, the way we look, the way we think, the way we relate to one another. And it will present us with immense challenges: to our intelligence, to our political wisdom, and to our *soul*. Physicians are going to be able to operate on people on the other side of the world through robotic hands by using computers, without ever moving from the great hospitals here in New York. Computers will

grow more intelligent and more effective. Artificial intelligence will allow a computer to beat us at chess. The newspapers will probably become less needed because of the Internet. You won't be able to work unless you're computer literate. Space travel will become so frequent it will drop out of the headlines. They'll be going back and forth to the moon. There may be colonies there.

The cascading of new possibilities constantly says to the intelligent person: you can't rule *anything* out. The interconnectedness and interdependence of *all* people will become clearer, and that will have its consequences. It will spur more and more linkages and mergers of political groups. The European Economic Community will be well established within the first quarter of the new century, and so will the Euro. And we'll have a bipolar economy with the Dollar and the Euro. NAFTA will become AFTA, the *American* Free Trade Agreement. The ability to destroy one another with even newer and more powerful devices, unfortunately, will continue. Our insecurity, our imperfection, will be sufficient so that we'll keep guarding against the enemy. What this will do is remind us we had better *talk* with one another, or we may just *destroy* ourselves. And so the United Nations will continue. The World Trade Organization will be more meaningful than ever.

Thanks to television, the computer, and other technological marvels, we're already the most knowledgeable people in history. Kids will sit in front of that Internet, as they do now, and get information from all over the world that you didn't dream of when you were twenty-two. It's frightening in a way. We're going to be much more knowledgeable. Will we be wiser? Does it follow that because kids or adults *know* a lot that they *understand* a lot? Or will we confuse *facts* with *philosophy*.

How will we deal with our ability to clone life? We're so afraid of the issue now we're saying "Don't mess with it. Don't even *look* at it." You can't tell the world, "Don't see what it *means*."

I did an article a hundred years ago at St. John's Law School for *Catholic Lawyer* Magazine on artificial insemination, and I thought the dean would go crazy. So I said to the dean, "It's com-

ing and it's *real* and we have to think of the *morality and* the *legality* of it." He said, "That will *never* happen!"

Will our computers become our soulmates, withering our relationships with humans? Will we fall in love with our computers? Will we become too introverted? Or will chat rooms that make us disembodied conversational companions to people all over the world draw us closer together? We'll certainly be stronger and smarter. But will we be better?

Ever since Adam and Eve wondered why the fruit was forbidden, and Albert Einstein struggled with the meaning of energy, thinkers have been forced to admit there are more questions than answers. But because it's true that where there is no *vision* the people perish, we have to continue asking ourselves these questions. We should be practical and constructive about preparing for this future or we risk a world run by computers, which would be a grotesque immensification of the Frankenstein fable.

What is the condition of people? You have more millionaires and more billionaires than ever before in our history. About 5 percent of the American people now are in that shining city on the hill above $100,000 a year. That's very good. But there's a *second* city where the glitter doesn't show, inhabited by 40 million poor people. We have 16 million children at risk of malnutrition, under-education, teenage suicide, teenage pregnancy. Things could be better. Unless you're willing to concede that there is no more room in the circle of opportunity.

One last thing, more important than anything. No matter how much cloning we do and how fast we do it, we're never all going to look alike in America. Thank God there'll always be tremendous diversity of race, of color, of sex, of sexual orientation, of national origin, of economic class. We're made up of *differences.* And we continue to be nurtured by them. No matter how hard we try to widen the distribution of opportunity and success, there'll always be winners and losers, the well-to-do and the strugglers, the people who can afford to *give* and the people who desperately *need.* And how will we deal with that as a society? That's the *question* for the new millennium. Above all things, we should be sure that Americans and New Yorkers remain fully *human.* We should

make ourselves masters of the technical universe without ever forgetting a truth thousands of years older than our computers and infinitely more powerful: That we will find our greatest good as individuals in the good of the whole *community*.

2000

Interview with
Matilda Cuomo

Matilda Raffa Cuomo chairs Mentoring U.S.A. She was a terrific first lady of the Empire State. I've always seen her as a sheer, pure, natural force, who along with her husband and son can captivate and beguile a crowd. Matilda continues to devote her life to helping families throughout the world and is respected on every continent for her work with children.

W. O'SHAUGHNESSY: I was thinking on the way over here about the greatest tributes I've ever heard for women of achievement and women of goodness, and I couldn't find anything that quite fit Matilda Raffa Cuomo. As first lady of New York, you're dealing with all kinds of "women's issues." Let me ask you straight out: where is the place of the woman today? At home, as some people would have it?

M. CUOMO: It was for me. I gave up teaching and decided to stay home and take care of my children. I never regretted it. I adored my children, and taking care of them full-time kept me very busy. We didn't have any help at the time, and I was doing the carpooling and everything. Mothers watching their children have wonderful administration skills. If you have more than one child, you have to schedule yourself to coordinate the children and schoolwork and everything else.

W.O.: But are there different views of this? Maybe one day we're going to regret shipping our kids out to daycare and Head Start. Your daughters are professionals, and they're able to balance work and family, but is not an entire generation being raised by nannies and the government?

M.C.: Not really. So many women out there are doing it well. It's knowing what your priorities are. I don't say it's easy because a lot of times a working mother has to give up a lot of personal things they would rather do, but their child comes first if they're

smart. These are wonderful times for women. We have one life to live, and there is nothing wrong with developing your talents to your highest potential.

w.o.: There are a lot of angry women out there.

m.c.: They shouldn't be angry because I think they've got everything going for them. They have men who understand their place in the family now. I've never seen men relate to their children and families as much as today—more than in my time. They are willing to enjoy their children, and maybe it's just knowing that life is short and you'd better smell the roses and take care of your children before they grow up too fast and you've lost all those precious years. I think family men realize that.

w.o.: Are we losing a whole generation?

m.c.: According to my husband, who knows the statistics better than I do, we have lost a whole generation, especially young African American men who are in our prisons. Those young men are products of families that truly broke down. The parents might have been on drugs. Many of those children were the latchkey kids, and many of them were thrown out by their families. It still is happening.

w.o.: Is the country going down the tubes?

m.c.: No way, Bill! We are the most wonderful country in the world. I've been fortunate to travel to Africa, Spain, China, and Japan, and I wish more people could travel just to see what we have going for us here. We always want it better because we have high standards for our country. We're not happy when so many are doing well but many are not. We have to take care of those less fortunate.

w.o.: Isn't that the Democratic line?

m.c.: That should be everybody's line, not just the Democrats'. Children become victims of broken-down families. Is that not nonpartisan? Children don't vote. Imagine if they did how we would listen to them. The fact is, they are at our mercy. We should know better. We have the responsibility to take care of all children. I wish more people could feel guilty when they hear these terrible statistics about homeless children and about children not being immunized in our country, Bill. They're dying of measles: thirty children died in New York City. Why does this happen?

W.O.: But aren't day care and foster care and all these programs just part of the welfare state?

M.C.: We have 178 languages and ethnicities and 131 countries represented in this state. We're not like any other state. When I talk to the other states' first ladies, they don't realize that most of our state is really rural and that our main industry is agriculture. They can't believe that. The fact is, we have a lot of challenges here. The whole idea of family is really different within all the cultural backgrounds that exist in our state and among all the different ethnic and cultural groups.

W.O.: Now there you go again. Mario Cuomo can't say two sentences without using the word *family*. Not everybody has a family like the Cuomos.

M.C.: No, but there is usually some family. There is usually a nucleus, a unit where the child belongs, where the child came from. We hope for that.

W.O.: You live with the governor. You ask someone on the street about him and they'll say, "Mario Cuomo: big spender, big liberal." You once told a reporter that this guy is so frugal he spends it like it were his own.

M.C.: You better believe it. He didn't give me a penny of the state's budget when we came into the executive mansion, which was in terrible disrepair when I came there. I started an Executive Mansion Preservation Society in the private sector and raised almost $1 million with the help of Brooke Astor, Ed Reed, Oscar De La Renta, and lots of wonderful people.

W.O.: True or false? They wanted to do the sitting room first, the Roosevelt Room, and you said, "No way. Let's do the *kitchen*."

M.C.: The kitchen *was* first on my wish list. I believe in cooking inhouse and not catering. My children always ate very well. You eat better and more frugally when you eat at home.

W.O.: Does it bother you when some of my colleagues like Bob Grant say bad things about Mario Cuomo?

M.C.: You call him your *colleague!* I want to tell you something. And we love you, Bill. But I think Bob needs a lesson. He has to go back to school and learn about manners. We need a lot more civility in our society, a lot more understanding of one another's feelings and rights. In *his* case, much more.

W.O.: George Bush said the other day that yours is a tough business.

Mario Cuomo says the same thing. How does it affect you when they go at Mario Cuomo?

M.C.: I get very disappointed in everyone involved who is negative. It's draining. You ask yourself why do they do that? There is so much more positive in this world than negative. I'm an optimist at heart. I really have always been, and I like to see the better side of things rather than the grimy side.

W.O.: How about the kids? Do you ever get mad when they go at your children?

M.C.: I think I relate to what Hillary Clinton and Barbara Bush have said. You necessarily have to feel terrible when they do that. My children are not the candidates, so why do that? Just the fact that their fathers are in the political world makes them vulnerable anyway.

W.O.: Recently you lunched with Barbara Bush and Raisa Gorbachev and Nancy Reagan. Give us a read on those other first ladies. Nancy and I are nuts about Barbara Bush.

M.C.: In the New York State Mentoring Program we have a hospital course for parenting skills that all the states are replicating. Barbara Bush came to me during one of the National Governors' Association Seminars and asked me to give a presentation of the New York State program. We have corresponded with each other, and she keeps me abreast of what's happening with literacy because she sees the tie-in. She is a very nice lady.

W.O.: I hear that when Raisa Gorbachev came to this country, there was a big, fancy luncheon, and she completely ignored Nancy Reagan and Barbara Bush to dish in the corner with you.

M.C.: We were sitting at the same table for lunch, but it just happened that Barbara kept prompting me to talk to Raisa about my recent trip to Russia with Mario. I was given the freedom to speak with the National Soviet Women's Organization and also to speak with the cosmonaut Valentina Tereshkova to talk about their day care, teen pregnancy rate, . . . and I found out about all the terrible similarities we share in these problem areas. It was staggering. That's why my husband came back and told President Ronald Reagan to cut the money for defense: we didn't have to worry too much about the Soviet Union because they had lots of serious domestic issues.

w.o.: Your son and heir, Andrew Mark Cuomo, told me that you're the toughest one in the family.

M.C.: I don't think I'm the toughest one. I just know I've had five children who grew up pretty well and I'm very proud of them. And my only regret is that I didn't have more children. They are beautiful kids. It also is a joy to have grandchildren. All that you leave behind is the children. They're all that matters.

w.o.: Do you ever say, "Mario, let's just chuck it and walk a beach?"

M.C.: I think if I had said that, in all honesty, he wouldn't have run. It's a team effort, and anyone who tells you differently has no marriage or it's some kind of partnership deal. The fact is, to have a marriage and to be in politics, you must have the full cooperation of your wife and your children. That's the way it is. It was that way since the beginning for Mario Cuomo. He would never have lasted. It's such a difficult job. He works so hard, and if he doesn't know that I'm at his side, in a sense *completely* involved with him and wanting him to do this, and if he doesn't have the support of his children, it wouldn't make sense. How could he fight all the negativism? How could a man do that? Or a woman who is running? You have to have your spouse and your family behind you.

w.o.: He once called you the single most effective instrument of his success. Somebody else called you a sheer, pure, natural force. You are that, Matilda Cuomo.

1992

Interview with Andrew Cuomo

I first encountered Andrew Cuomo when he came to Westchester to build housing for the homeless. I began to really admire him as he confronted all kinds of NIMBY opposition from the elders in our community with patience and dynamism. Andrew founded HELP (Housing Enterprise for the Less Privileged) in the Golden Apple, which has become the national model for transitional housing for the homeless. As we go to press, Andrew is being mentioned as a successor to his father as governor of New York. He is married to Kerry Kennedy Cuomo, one of RFK's daughters. Andrew, like his father, is a very gifted public speaker. He always had Mario's pace and rhythm, but in recent years he's developed that passionate "catch in the throat." The genes are clicking in, and I find a very compelling combination of his father's intellect, compassion, and great richness of soul, together with some of the pragmatism he learned in Bill Clinton's cabinet. But make no mistake: Andrew is his father's son and hears the same music. Unquestionably, Andrew will be one of America's future leaders.

w.o.: He is an advisor to governors. He has run presidential campaigns, although not his father's. He has built more housing for the homeless than anyone in this country, and he is chairman of the housing commission of the city of New York. And Andrew Mark Cuomo is doing wonderful things in our home heath. You've built housing for the homeless. Now you're building affordable housing. When are you going to stop?

a.c.: When the need is filled, which will be quite a while, Bill.

w.o.: We read about you in the Gannett Westchester papers almost every day. You and Andy O'Rourke, the county executive, felt pretty strongly about this housing for the homeless. HELP, you call it.

a.c.: Housing Enterprise for the Less Privileged, we called our state-wide effort. In Westchester we called it Westhelp, a partnership

between Westchester County and HELP. The thrust of Westhelp was to provide emergency housing for the homeless, to get them out of the welfare hotels and motels. If you live in this county, you know about the use of welfare hotels and motels for homeless families. We've been using them for close to a decade now, at exorbitant cost to the taxpayers. Sometimes it's been as high as $36,000 per year to put a family in the squalor of a welfare hotel, and sometimes it's for years. What Westhelp said was let's get the family out of the welfare hotel. Let's use that money more intelligently. Let's even save taxpayers money at the same time. And let's work with that family to get them back into mainstream society. We did that. And the good works of Westhelp go on every day.

w.o.: You did it in Mount Vernon, and you did it in Greenburgh. I want to retire to that place you did it in Greenburgh—it's that nice.

a.c.: It's a special place.

w.o.: But you got zonked out of White Plains. You got outflanked by a wily guy named Al DelVecchio. He took you to the cleaners.

a.c.: Mayor Al DelVecchio of the city of White Plains voted against the Westhelp effort.

w.o.: Why?

a.c.: You would have to ask the mayor that. I have my own notion of why he changed his mind. As you recall, Mayor DelVecchio originally supported the concept. That's why we went in to White Plains. Westhelp doesn't go into a locality unless it is supported by the local officials. Politicians are wont to change their minds.

w.o.: You worked cheek by jowl with Andrew O'Rourke on Westhelp, then he ran against your father for governor. He even took a cardboard dummy across the state and said, "Here he is, my friend Mario Cuomo." Was it tough? You ran your old man's campaign.

a.c.: I don't think there was any personal animosity about the campaign. Andy O'Rourke was a Republican, a good one, who ran for governor and carried his party's banner, as he should. Obviously, we had a different ideology that we articulated through that campaign. Mario Cuomo was successful. I was happy about that. But once the politics are all over, you get to the job of governance, you get to the programs. Westhelp is a good idea, so we put aside the politics and did what had to be done.

w.o.: But it's an unlikely trio: Cuomo, Cuomo, and O'Rourke. Now you're doing it for affordable housing. What's the difference?

a.c.: You raise an interesting point. I think the novelty of the O'Rourke-Cuomo-Cuomo relationship was one of the things that made it successful. I think people said, "Hold on a second. Something special must be going on." And it was something special. The idea was so good that it transcended the politics and brought an Andy O'Rourke and a Mario Cuomo together. We did good things for five years on the homeless front. We recently announced that we're building affordable housing for a larger segment of people.

w.o.: What's affordable, Andrew?

a.c.: This is one of the highest priced counties in the state if not the nation. If you make $30,000, $40,000, $50,000 a year—what at one time would be considered a good salary by anyone's definition—you can't afford a home here. The solid middle class, which is the backbone of this county . . .

w.o.: You mean teachers, firefighters, police officers?

a.c.: Municipal employees, union workers, or just private-sector workers who make $30,000, $40,000, or even $50,000 a year. That is the middle class. That is the majority of our workforce, and they can't afford a home in Westchester County.

w.o.: So where do they go?

a.c.: They move north where the area is less proximate but the housing is not as expensive. Westchester can't survive like that. You can't prosper as a county if you lose your middle class. We have to find a way to provide affordable housing here in the county.

w.o.: You started out as a lawyer. You were a dollar-a-year councilor to your father, the governor. There are those abroad in the land who would say that you're still your father's numero uno councilor. They say he listens to you as to no one else. Why are you knocking around Westchester?

a.c.: There are people in the land who say all sorts of things. I worked for Mario Cuomo for a number of years. I treasure the times that I did.

w.o.: Do you still talk to him every morning?

a.c.: Sure I do.

w.o.: How early?

A.C.: He is an earlier riser than I am. Do I offer him advice? On occasion. Does he listen to it? Rarely.

W.O.: Mario Cuomo says you are tougher, brighter, and smarter than he is. How do you plead?

A.C.: I think there is a pride that only a father can have toward his son, and I'm obviously very appreciative of what he said.

There is no doubt my father and I have a special relationship. Not only is it personally a very close relationship—as is my entire family, as you know—but professionally we've had the good fortune to work together for years in very tough circumstances. Campaigns are very tough. The highs are very high, and the lows are very low. People forget, but Mario Cuomo had a political career that didn't bat .500. He lost many elections. So there were many dark days. We went through them, and I was whatever help I could be at whatever age I was at the time. The relationship I think is stronger for that. If you have a personal relationship and you have a professional that can complement that personal, I think they both grow—which was the case with us.

W.O.: Is it tough being his son?

A.C.: In what way?

W.O.: When they pound him and beat up on him and say there's got to be some reason he didn't run for president. They say that you are the protector of the family.

A.C.: If you allow the media to be the barometer, then it's tough. If you allow them to define the lows or the highs, I think it's a poor way to lead your life.

W.O.: At what point do you step out from his considerable shadow? People are trying to persuade you to run for Congress down in Queens. They're trying to talk you into doing a lot of stuff. When do you step out and say, "Here I am. I'm flying on my own." Do you aspire to run for Congress?

A.C.: I don't have any aspiration to run for any elected office at this time. I enjoy what I'm doing. I think we are performing a public service, really. I have my cake and eat it too, now. I can do all those good things that public service allows you to do. You can help people. You can feel you accomplished something for someone other than yourself. But you don't have to put up with all the bologna that going into elected office often brings.

w.o.: When you build this housing, you've got to jive with local politicians.

a.c.: I have to jive with local politicians when I choose. When you are in elected office, it is different. You are open to the public. You are open to reporters, and you have to respond to their questions no matter how inane, no matter how personal, no matter how off-base the question—and you have to do it with a smile. That is the price you pay when you're in elected office. I have not chosen that path, but I enjoy the public service component of it.

w.o.: What about Mayor David Dinkins? You are the chairman of his city housing commission. Is he going to succeed in the housing initiative that you've recommended? He's dragging his feet a little bit.

a.c.: Yes. What happened was we put out a commission report that outlined a very different path for the city to follow on homeless policy and housing issues. The mayor has come back with a timetable to implement those recommendations. The timetable goes out about two years. A lot of people—I'm one of them—feel that timetable is too long, that the problems are too critical.

w.o.: Why can't you get Dinkins to get his teeth into it right now?

a.c.: His administration believes that's how long it takes.

w.o.: You have a lot of sway with those guys.

a.c.: My sway is I say what I think, and then public opinion has sway. I don't think the people of the city of New York will sit still for a plan that says it will take us two years to come up with a plan to deal with homelessness. The people of New York are saying, "We have a problem and we have it now." And New York is no different from Westchester, which has the worst homeless problem in the state.

w.o.: Is it because of the NIMBY thing? Your father once said that's not hate, that's fear. Now you've been dealing with it for a couple of years.

a.c.: It's not hate. It is a fear that has some basis in historical fact. When people hear that government wants to low-income housing in your backyard, the first response is no. Why? Because people have seen government housing. They've seen these low-income projects built to the sky, and they've seen those projects sink so low that they sucked in the existing neighborhood. What

they're saying is, "You're not going to do that in my backyard. I've heard these plans before . . ."

W.O.: But you say . . . ?

A.C.: I say we've learned from our mistakes. Those low-income housing projects that were built were flawed. They were too big. They were in the wrong area. They didn't have the right services. We recognize all the mistakes, and we have corrected them.

W.O.: But why are you all of a sudden the model for the whole country? What's different about what you're doing?

A.C.: I think we have a model that has met with some success. As you mentioned, in seven years we've built more housing for the homeless than any organization in the nation.

W.O.: You're going to do twenty-five moderate-income houses in Harrison. Is that going to make a difference? Aren't you just doing something against the wind?

A.C.: There is no doubt that building affordable housing right now is against the wind for the reasons I think we discussed before. People are predisposed to be against government-supported programs. Even the word *project* is a bad word. Mayor Charles Balancia of Harrison, County Executive O'Rourke, and Chairman Steve Tenore have gotten together on a program, and we're going to build twenty-five two-family homes: fifty units.

W.O.: Do you want to do it any place else?

A.C.: Obviously fifty units isn't a drop in the bucket.

W.O.: So are you looking for sights?

A.C.: Yes. The relevance of this program is that it is a prototype for the rest of the county.

W.O.: When you were building housing for the homeless, your father called me late one night and said, "Is there no one of bravery in that county? Is there no one of courage?" If I asked you that question, you'd name Tony Veteran, Ronny Blackwood, Andy O'Rourke, Charles Balancia. Who else?

A.C.: That's a pretty good start. The county executive has been an outstanding leader. He is a Republican by enrollment, and by ideology he's a progressive Republican. And they should name an award for Tony Veteran in Greenburgh.

W.O.: You named the place after him.

A.C.: Yes, we did. And now you have Mayor Charles Balancia in Harrison, who knows that affordable housing is not popular, that the

current wisdom, if you were to poll the people right now in Harrison, would say don't do it. But he knows there is a need, and he believes he can deliver the product intelligently for his town; and he's going ahead. That's a leader.

w.o.: These are the good guys. What about the guys who fought you and said, "Not in my backyard." Ed Brady, former chairman of the Westchester County Board. You did him in. He's out.

a.c.: Well, I don't think that I did him in. And I don't think that you can say he's a bad guy. I don't think it works that way. I don't think there are black hats and white hats. Elected officials disagree. They do it all the time. It's not that one is good and one is bad.

w.o.: I have to ask you. What would you tell your father if he called you up and said, "Clinton just asked me to run with him"?

a.c.: I would say he has to do what he believes he should do. I don't believe you can make those decisions for someone. I believe they are personal. They are about motivation. They are about commitment. They are about mission. When you are someone like Mario Cuomo, you are driven by a passion and an ideology and a commitment. You can't do it on a piece of paper. It's not what someone else tells you. It has to be what you feel in your heart and in your soul, and you have to believe it. It doesn't matter if it's right or if it's popular, if I agree or if I disagree. You go and you do it.

w.o.: What is he to become? The philosopher? The moral leader of the country? The coach of Bill Clinton? The nemesis of Dan Quayle? Or the governor of New York? Is he going to run again?

a.c.: I think he has said that he wants to be the governor of New York and he wants to be the best governor of New York that he can be. And that's what he does and he does it everyday. He does it more hours a day than most people work, and he does it seven days a week.

w.o.: What's your read on Bill Clinton?

a.c.: I think he has some interesting ideas. I do not think he has captured the imagination of the country yet. I think there is a vacuum. That's why you see Ross Perot. I don't think the country is really driven toward Perot. I think what they are saying is they are not happy with what we have on the table thus far. But there's still plenty of time. You still have conventions. Anything can happen.

w.o.: What do you think about George Bush and Dan Quayle?

A.C.: I think if I were advising the president, I would be very, very skeptical about our political chances for victory. I think this country does not have a good feel about the direction it is headed.

w.o.: How long have you been married to Kerry Kennedy Cuomo? She's wonderful. Even people who don't like you are nuts about her.

A.C.: We've been married two years.

w.o.: Does she she put up with all this politicking and building houses?

A.C.: She more than puts up with me. We are very much a partnership. It's a trite word, but we are very much inclusive of each other in what we do professionally. Kerry works in international human rights.

w.o.: Isn't she the head of the Robert Kennedy Foundation?

A.C.: Yes, she is. And it is a fascinating field. I'm very interested in that, and on the flip side she is interested in what I do.

w.o.: How do you find time for each other?

A.C.: We happen to have our offices on the same floor in the same building in Manhattan. So we share the ride in and the ride out.

w.o.: Isn't that a little close?

A.C.: It hasn't been so far.

w.o.: Are you still in love?

A.C.: Very much.

w.o.: On a recent Saturday morning at ten o'clock you were in the office. Do you ever take a day off? Your father is a workaholic. You're not getting to be like him, are you?

A.C.: No, I'm not a workaholic, and I don't know that the governor is a workaholic. He works very, very hard. I think a workaholic takes it a little far.

w.o.: What about Matilda Raffa Cuomo?

A.C.: The best Cuomo.

w.o.: She is, indeed. She has been accused of being the greatest first lady this state ever had. Your father, every time someone says that you are a chip off the old block, attributes it to Matilda Raffa Cuomo. How about the dynamics between your mother and father. She has a lot of things she does and he has a lot of things he does, but they're crazy about each other. So how does that

work? You see people in public life today who make appearances, but your mother and father work on a lot of things together.

A.C.: They've been working at it. The governor just recently celebrated his sixtieth birthday. They've been together most of their lives, through five kids, through good times and through bad times, and they've gotten all the stronger for it.

W.O.: How old are you, Andrew?

A.C.: I'm thirty-four.

W.O.: I've seen you at midnight and two in the morning when the dew is coming up, outside high schools like Woodlands High School, after people had screamed at you and yelled at you. You call it fear, but I saw hatred those nights. You are fast achieving a national reputation, and you've done much of your good work right here in our home heath. I just want to tell you that I admire all the good stuff that you are doing. I just wanted to thank you for all you've done for Westchester.

A.C.: Thank you, sir.

June, 1992

Interview with Malcolm Wilson

Malcolm Wilson, our Westchester neighbor, served in State government, with great distinction, longer than anyone in New York history.

W. O'SHAUGHNESSY: Our guest today is a most extraordinary man. He is a great orator and, some say, the greatest advocate Fordham ever graduated. He is probably the finest student of statecraft and state government who ever lived in New York State. This is the first interview he has granted since he left office in Albany, and we're flattered he would choose his local community radio station. He is, in addition to all that I've mentioned, a husband, a father, a grandfather, a lawyer. He was lieutenant governor of the State of New York. And the fiftieth governor of New York. Governor Malcolm Wilson.

M. WILSON: I'm just delighted to have a chance to meet all of you, ladies and gentlemen, through my friend Bill O'Shaughnessy and the great radio station WVOX. Before I yield to any questions Bill wants to ask me, I want to add that among the many very fine qualities Bill O'Shaughnessy possesses, which commends him to the favorable judgment of all who know him, is his *charity*. And, therefore, with respect to all those nice things he said about me, I hope you will credit them to his charity, and not charge them against his veracity!

W.O.: Just a year and a half ago you were governor of this state. Do you miss the job?

M.W.: I do. I was in state government and in elective office longer than anyone in the history of this state, and I served fifteen years as lieutenant governor working on a day-to-day basis with Governor Nelson Rockefeller, then having that privilege myself for a little more than a year. No one could have had that experience and not miss it when he was out of office. I guess I'm like the old fire

horse who when he hears the gong sound wants to respond to the alarm.

w.o.: I was at a dinner party the other night with some people who know and admire you, and one of the guests said, "Damn, if only we had worked harder for Malcolm." Why do you think the 1974 election went the way it did?

M.W.: Well, it's awfully hard for me to say, Bill. I would hasten to say that no matter how much this person regretted not working harder in Westchester, I was immensely gratified by the work that was done here in my interest, regardless of their political affiliation. I was very pleased that I carried my home county and my home city of Yonkers.

What we experienced in 1974 was massive numbers of voters staying home on Election Day, in this county and throughout the state. This resulted from their disaffection with what had been going on in Washington—what we collectively call Watergate, the pardon of President Richard Nixon by President Gerald Ford, the inquiries that were going on at the time by the Senate with respect to Governor Nelson Rockefeller's confirmation as vice president and all the talk of his gifts. And the interesting fact is that Governor Hugh Carey, in winning the election, had a vote total a million fewer than the total number of enrolled Democrats in the state. And in losing the election, I received about 800,000 fewer votes than the number of enrolled Republicans in the state. But the Republican Party is outnumbered in enrollment by the Democrats by about a million, so you see it was the people who stayed at home who really decided that election.

w.o.: There's a national election coming up. You've spoken very recently with President Ford. You're a delegate to the Republican National Convention. You were uncommitted until last week, when we carried the story on WVOX and it went out across the nation to the wire services that you were voting for President Ford. What kind of a man is he, and what did you talk to him about?

M.W.: I'd like to explain my posture as an uncommitted delegate. I was chosen by the Republican State Committee as a delegate-at-large the same day the state committee adopted a resolution requesting the delegates to go uncommitted. Thereafter, there was a contest in my congressional district between an uncommit-

ted slate and delegates committed to Governor Ronald Reagan. I was asked by the uncommitted slate if I would address a letter to my neighbors urging them to vote for the uncommitted slate, which I did. I pointed out in that letter that I thought it was better to have an uncommitted delegation than a committed delegation—whether that delegation was committed to Governor Reagan or President Ford—because a committed delegation is morally if not legally bound to cast their votes for the particular candidate until released and therefore becomes a delegation of the candidate rather than a delegation of the Republicans in the district. And that's why I waited until after all the conventions and all the primaries had been completed and after the Democratic convention to announce my support for President Ford.

I do not claim to be an intimate of President Ford. I met him first when he came to speak at the Republican dinner in Scarsdale at the invitation of Malcolm McIntyre about four years ago. I met him when I was governor and had occasion to go down to the White House to ask for some financial aid for the State of New York, because all the money is now in Washington. I saw him on three or four other occasions, but as I view him, he is a middle person.

Our country, in my view, is a middle country. It is made up of men and women who work hard and do their very best to provide shelter and food and clothing for their children and a decent education. And our country provides the opportunity for all citizens to enjoy the full meaning of liberty and freedom. We are not an extreme country of people who feel that everything has got to be either black or white. Our whole system of government is based on an idea that we have to hammer out our differences on the anvil of discussion and reach accommodation and compromise in order to advance. That's the genius of our system.

I regard President Ford as a believer in that which I think is typical of most of my fellow Americans. He's a middle person, philosophically. When I spoke with him last week, the occasion was his invitation to all of the New York delegates to come to the White House.

w.o.: So what about the Ford-Reagan battle?

m.w.: I know Governor Reagan. I knew him before I worked with him when we were both governors and met with other governors

at the Republican Governors' Conference in 1964. I was his seat-mate at a dinner at which he spoke at the Kings County Republican dinner earlier this year. I regard him as a fine man.

Now the problem with politics today is that, unfortunately, it is not so much what one *is* as what one is *perceived* to be that counts. By perception I mean the average citizen's perception of any candidate for office, because the average citizen really doesn't, except in rare cases, know the individual involved and so relies upon the perception he or she gets from the media.

Basically, I would regard Ronald Reagan as what I would call—if you have to have labels—a moderate. The problem with words like that is that they are somewhat subjective rather than objective. But he is perceived as being very far to the right, because that's the way he is painted in most of the media accounts.

You take Barry Goldwater, who was painted also way off to the right; but if you look at history you will see that most of President Lyndon Johnson's programs were the programs that Mr. Goldwater enunciated. As a matter of fact, I think one of the best stories that came out of the 1964 campaign was about a man who said to his friend, "They told me if I voted for Goldwater we'd be at war in Vietnam in six months—and I did and we were."

I think that the perception of the people with respect to Gerald Ford is more accurate than the perception of the people with regard to Ronald Reagan.

w.o.: You called President Ford a middle person and Reagan a moderate. What's the difference?

m.w.: It's hard to say who is more middle. I would regard President Ford as being more of a middle person than Ronald Reagan. I would say that Ronald Reagan would be a bit more to the right than a middle person, than Gerald Ford is.

w.o.: They've called President Ford the most conservative president since Coolidge or Hoover, and Reagan is to his *right!*

m.w.: I really can't explain, Bill, why people are described as they are. Take a case in point. I think that virtually all Americans, except those who know him well and analyze his record, consider Nelson Rockefeller to be way out in left field some place. The fact of the matter is, he is basically what I am, which is conservative on economic matters and progressive in matters of human rights. There's no label for that. That was what the late Ken Keating was,

and he had label problems. And when people asked him if he were a conservative or a liberal, he got a little tired of that and so he said he was a "conserveral."

I think—and I'm answering a question you didn't ask, I hope you don't mind; it bears on this subject—the actions of President Ford are responsible actions that are consonant with what I call the thinking of most Americans, the Middle Americans. He has shown not only great judgment but also great courage in vetoing bills that had a popular ring but that did not serve the public interest. I think they were to his special credit, the vetoes of the modified Public Works Bill and the Mineral Rights Bill, even though had he signed that bill he would have gotten delegate votes from the mountain states. I really think that if he is the nominee of our party, he can most usefully campaign by running against the majorities of Congress.

w.o.: How does he position himself? Isn't President Ford's situation similar to yours? You just didn't cotton well to Madison Avenue. What do you do in this time of charisma and "media-genic" and photogenic candidates? What do you do about somebody who is good, solid, courageous but doesn't go around shouting about it?

m.w.: I wish I could answer that. There is no question that the media, notably television—I say that with all due respect to you as a fine radio man is very dramatic—as far as the viewer is concerned. Therefore, one who has this quality of *charisma*—one who has a nice smile and perhaps some glibness but, nonetheless, who has the capacity and the will to say things that sound good in small, short sentences because most people who watch political programs have a limited span of interest—has the advantage today.

The great peril I discern today—and unfortunately, it's much too prevalent among people who are in government or among candidates for government—is the tendency to *oversimplify*. I've referred before to an essay written by Jacob Berkhardt, who was an eminent Swiss historian, just about one hundred years ago—a devastatingly prophetic essay about what sort of a world we'd be living in between 1960 and 1980. Berkhardt opined that we would be living in what he called the Age of the Great Simplifiers, those who offered *simple* solutions to *complex* problems. The one sentence that is graven in my memory because it is so accurate is Berkhardt's observation that "the essence of tyranny is the denial

of complexity." It is always the dictator who has the easy crowd-pleasing answers. The road of history is strewn with the nations that have perished because they have listened to oversimplifiers, like Adolf Hitler.

The average citizen—and I don't say this critically, I say it factually, as I pointed out before—has to solve the problems of family support and job advancement and doesn't have either the opportunity or facilities available to analyze all the country's problems. Therefore, they like to feel that somebody knows the answer. They feel reassured when somebody offers a solution that sounds credible. I don't blame the people for that. I blame those who practice oversimplification.

There is no simple answer for a complex problem. Berkhardt went on to say that what we need are more "complexifiers"—that is, people who understand the complex nature of the problem. And that's difficult. But the most difficult part is the balance, namely, daring to share that understanding with those whom they purport to represent, translating that insight into common, everyday terms. We need men and women who will level with the people, who will not indulge in giving quick answers. "I'll reduce taxes" and "I'll get more jobs" and "I'll solve the housing crisis" and "I'll guarantee that we'll have peace in the world" are crowd-pleasing oversimplifications in articulation of purported solutions to what are very complex problems. They'll get votes, and that's the tragedy of it. Nonetheless, they do not serve the people well.

W.O.: What about your predecessor, Nelson Aldrich Rockefeller? Is he at the end of the road?

M.W.: In terms of elective office, I would say so. Tragically, because I think one of the tragedies of the age is that every time we had the election of a president, Nelson Rockefeller did not secure the nomination of our Party. He is an immensely talented man whose whole life has been devoted to the service of people—and, in my judgment, in an excellent fashion. And he is knowledgeable about the most intimate facets of our international relations. But I think that the ballgame has passed by. He is a very vigorous man, mentally and physically, but the fact is that he celebrated his sixty-eighth birthday on July 8 of this year.

w.o.: Do you think there's any chance that President Ford will ask Nelson Rockefeller to continue as vice president?

m.w.: I think there is a chance. The president has said—and since he has said it publicly, I can say that he said it to the delegates—that Nelson Rockefeller was one of those in his field of consideration.

w.o.: He told me at the White House a year ago that he and Nelson would be nominated and elected. He looked me right in the eye when he said it. A lot has happened since then . . .

m.w.: It was suggested to him by Mr. Howard "Bo" Calloway, who was Ford's campaign manager, that he could not get delegates from the Southern states as long as Mr. Rockefeller was in prospect as a vice-presidential nominee. This intelligence was communicated in some fashion to Nelson Rockefeller, who thereupon announced that he was not a candidate. And he has, indeed, been working most earnestly for President Ford's nomination. I think Calloway's judgment was very bad. If you take a look at the roster of delegates, there aren't too many from the Southern states who are casting their votes for President Ford.

It is difficult for me to be objective, of course, with respect to Nelson Rockefeller because we are very close on a personal basis. We had many differences of opinion. But what I always admired about Governor Rockefeller was that he was not only tolerant of views that were different from his own but that he also sought them and that he listened to advice. At the end of the line he made the decision—which was as it should have been since he was the chief executive. But there were times, virtually without number, when after discussion he either abandoned or modified his concept in some way when there were differences of opinion. Sometimes he persisted in a particular course of action over my objection and the objection of others, and history proved that he was right and that we were wrong.

w.o.: Did you ever have any shouting matches, Malcolm Wilson versus Nelson Rockefeller?

m.w.: No. We had our differences, but they were always discussed calmly and very frequently just between the two of us. Not infrequently we differed in the small setting of a staff meeting, but there were no shouting matches or anything of that character.

w.o.: I've asked you about some of the great men of our day and age. What about former President Nixon?

M.W.: I have no defense for what President Nixon *did*—and *omitted* to do. But I blame the people around him. I think that he was insulated from a lot of these events. Maybe he should have been more aggressive, but the tragedy is that this has marred what I regard as a most effective performance as chief executive by President Nixon. In the perspective of history, when it's written twenty, thirty, forty years from now, what he did in terms of improving the posture of the United States in the world and in advancing the cause of peace is going to go down as one of the greatest achievements of any president.

W.O.: You don't find too many people who will speak a kind word on his behalf, and I think it's very interesting that you, a governor of New York, would speak for him.

M.W.: I believe, as I say, that this is tragedy in the classic sense. No matter the reason for the events collectively called Watergate, they have blanked out the vision of his great performance, notably in the international field. But this I'm satisfied is going to be corrected by history.

W.O.: I'd like to ask you to tell us what's going on in the Republican Party of the State of New York. If Mr. Rockefeller leaves Washington, there's Judge Richard Rosenbaum, who is the Republican chairman. Perry Duryea is still in Albany as speaker. What's going to happen in the future?

M.W.: And Warren Anderson is still in Albany, and we have a Republican majority in the Senate. Now, the virtue of the Republican Party, frankly, is that it is not a party of personality. It bears the stamp, from time to time, of those who are in leadership positions. Tom Dewey was the governor in 1938. And I remind you, Bill, that in 1938 Tom Dewey beat Herbert Lehman on the Republican-Democrat line, but Herbert Lehman pulled enough votes on the then–American Labor Party line to triumph. Beginning with 1938 and running through the expiration of his final term in 1954, our Party bore the stamp of Tom Dewey.

In those years from President Franklin Roosevelt's first election in 1932 until 1938 when you couldn't find a Republican with a search warrant in any public office, our party was kept alive by women. This is overlooked. There was a wonderful woman named May Preston Davey, who died about seven or eight months ago. She organized what she called the Republican Build-

ers. And her faith in the Republican Party was such that she just rallied women around her.

Then from 1954 on, when Averell Harriman lost, our party mainly bore the stamp of Walter Mahoney, who was the majority leader of the Senate, and Ozzy Hecht, who was speaker of the Assembly, because we kept a Republican majority in both houses during that four-year period. However, during this same time, men and women here in Westchester and throughout the state were working in the Republican Party and held offices in local government.

From 1959 until currently, our party pretty much bears the stamp of Nelson Rockefeller. But we're blessed with men and women all over the state—and I'm pleased to say we've always had young people: the Young Republican organizations and Teenage Republicans—working in the interest of our party. They're still there, and they were disappointed and set back by my loss in 1974; but they were not discouraged, and they're working very earnestly now.

You see, our party, happily, is not a monolithic party. It is a party that gathers men and women because we're a minority party and we have to reach out and attract people from all shades of opinion within the broad philosophical precepts of the Republican Party. And in that way, as I said before, the Republican Party in New York State is a *middle* party.

w.o.: I'd like to ask you about your successor, Governor Carey. What kind of job is he doing?

m.w.: One of the criticisms of me was I used to lapse into Latin. All I can say is *Res ipsa loquitor:* "The thing speaks for itself." In my opinion, all that has saved us—meaning the people—from the excesses of the Carey administration is the Republican majority in the Senate. I don't rejoice at that. I regret it. The State of New York is paying a dreadful price for what's going on in Albany and will for generations. Our credit is destroyed in the credit markets. That's the basic criticism I make about this administration. It was not done deliberately by Mr. Carey. I would have to say, however, that he should have consulted people who knew something. I'm not talking about me. He should've consulted people with knowledge of state government. He came from Washington with no experience in Albany, and one might suspect he went down to

the Greyhound bus terminal to recruit those who would work in close relations with him in government. I'm shocked by the prices that New York taxpayers are having to pay on their borrowings.

w.o.: I think he's a good fellow, incidentally—and I don't want to embarrass you. But someone said it's almost that Hugh Carey doesn't really enjoy being governor, and he doesn't want to be governor. You *loved* it.

m.w.: Bill, I don't know who said that—and I don't want to know— but I have no basis for judgment in that regard. Hugh Carey is a decent, fine citizen, but his whole experience was as a legislator in Washington. Experience has shown that you do have to have some executive experience to be governor of New York. For example, I was in the Assembly for twenty years. When I got to be lieutenant governor, I thought that I knew everything there was to be known about state government. But I learned when I was working at the executive level with Governor Rockefeller that there is a lot of difference between being a legislator who advocates nice crowd-pleasing programs and serving as the executive who has to administer those programs and finance them. New York City had that same experience with John Lindsay, who was a member of Congress for many years but when he came to the mayoralty was unable to function as an executive. This does not disparage Mr. Lindsay as a person, nor do I disparage Mr. Carey as a person.

w.o.: Who would run for the Republicans against Mr. Carey the next time?

m.w.: I would never want to speculate in the summer of 1976 as to who might be the Republican candidate in 1978. I remind you that as late as April, 1958, all of the pundits and experts and fine radio commentators were speculating as to whether Speaker Oswald Hecht or Senator Walter Mahoney or Leonard Hall or Paul Williams would be the Republican candidate that year! Four months later, in August, 1958, Mr. Rockefeller, about whom no one was speculating in April, was the nominee of our party, and he went on and beat Averell Harriman in November.

w.o.: He had some help from a man named Wilson who knew state government pretty well.

M.W.: You might say that. And I was pleased that I had the opportunity to help people know Nelson Rockefeller.

W.O.: What about your own "home heath"? That's a phrase I picked up from a kindly gentleman named Wilson.

M.W.: Well, my relationship to the county government is as a citizen of the county. I have noted that my county tax bill has been leaping forward, and that does not necessarily leave me in what I would call a euphoric state.

W.O.: Is that the judge of a government's performance, the tax bill?

M.W.: I think that is a major factor any citizen should use in his or her assessment of the quality and caliber of the government. After all, taxes are a fact of life, and we are a very heavily taxed people. It does seem to me that the county tax has gone up more than it should have when you realize that a county government provides very little in the way of services to people. The State of New York, as well, provides very little in the way of direct services for its people. It has the mental hygiene institutions and the correctional system. Our county government has only the county penitentiary, the county jail, the Grasslands medical complex, and the parkway police. That just about sums it up. On the other hand, the city, town, and village governments are the ones that have the very expensive services to perform: police, fire, sanitation, potable water supply, education. And these governments, unfortunately, have no way of avoiding constant increases in the cost of their government and consequent tax rates, because in times of inflation, everything goes up, including the necessity to pay better salaries. That situation, however, should not obtain for the county government to the extent it has in our county.

W.O.: Malcolm Wilson, Nelson Rockefeller, and Edwin Gilbert Michaelian, the legendary county executive who built the modern Westchester: they're all out of office right now. Are there any bright young men or women coming along?

M.W.: There is an old Latin expression very familiar to lawyers: *Inclusio unis et exclusio alterius.* That is to say, "The mention of one has a tendency to exclude others." And I wouldn't want to even start to try to recite a litany of names, but we have some very able men and women in the state legislature. We have some able representatives of the people in the Congress of the United States,

and we have some fine men and women who are serving in local government.

w.o.: How do your days go now? Do you miss the limousines and troopers, Governor?

m.w.: No. I have to say that as persons, as individuals and friends, I really miss the members of the state police detail. They are the greatest, and they are totally nonpolitical. These members of the State Police were a blessing to me. I miss them on a personal basis. I have kept in my personal employ the same man who drove me all the years I was lieutenant governor and governor: David Harding.

I returned to the private practice of law with my firm in White Plains on January 1, 1975. My new place is Kent, Hazzard, Wilson, Jaeger, Freeman & Grier: it's a big name, but the men there are like my brothers. Otto Jaeger was a young partner in that firm when I went to work as a law clerk in 1934. (I was going to law school at night.) There were only three partners: Ralph Kent, who was a great citizen of New Rochelle, Larry Hazzard, a fine man from Yonkers, and Jaeger, from White Plains. Anyway, I'm back to where I began. Jaeger came back to the firm after he retired as surrogate.

All the years I was in elected office I would never accept election or appointment to a board of any bank or any business organization, only charitable and educational things. I was always concerned about the possibilities of conflict. When I left office that situation no longer obtained, and I was invited to join a number of boards. I really think I made good choices.

w.o.: You *ran* the State of New York. Does being on these boards satisfy and stimulate you?

m.w.: I find it absolutely the most exciting thing. Having spent all of my life in law and government, and now to be on the other side, in the business field and the field of commerce and banking, I find intensely interesting. And also, Bill, it offers me a challenge that, frankly, I feel I need. Before I left the law and became lieutenant governor I used to spend a great deal of time in court, mainly in the appellate court as an advocate. I liked the work very much. When I returned to the practice of law I made my own resolution that I would not go into a courtroom because I know most of the judges all over this state and I wanted to avoid any

possibility of embarrassment, and also because I felt, in all candor, that it would demean the office I had held. Not because I don't have great respect for the court, but there was something unseemly to me about a former governor of this state going into a courtroom. The consequence is that an office practice, delightful though it is, does not really offer me the challenge I feel I need, and that's why I have been spending more time in these different enterprises. And as a matter of fact, relatively recently I was elected vice chairman of the board of the Manhattan Savings Bank. Come January I will become the chairman of the board and chief executive officer.

W.O.: A lot of people are familiar with your love and respect for the law. You used to quote the inscription on the façade of the courthouse at Foley Square . . .

M.W.: "True administration of justice is the firmest pillar of government."

W.O.: How many times we've heard you point that out when you speak to young people at colleges and to lawyers' groups. Would you like to be a judge?

M.W.: No. I am sort of unique, I guess, as a lawyer who never had any aspirations for the bench. Frankly, when I returned after World War II, I was asked by the leaders of my party whether I would be willing to take a nomination for the city court of Yonkers, a traditional steppingstone. That bench leads, in due course, to the county court and the New York Supreme Court.

W.O.: I was thinking of something like a federal . . .

M.W.: I have great respect for the judiciary, but I would have to say that I am more an activist and a partisan. If I know myself at all, I know it would be difficult for me to have that degree of objectivity I regard as an essential characteristic of a judge.

W.O.: Are these directorships and your law practice big enough platforms to allow you to speak out and influence your party on a national level?

M.W.: In terms of the party, I probably devote 15 or 20 percent of my time to what I call the most effective *vehicle* of good government, which to me means men and women who are elected to serve as Republicans. I have helped raise funds to keep our party functioning as a party. I do not accept all the invitations I receive, but I still accept some and speak in the interest of our candidates all

over the state. I have been up in Dutchess County. I've spoken at the Nassau County dinner, the New York dinner, the Kings County dinner, the Bronx County dinner. I'm going to speak in Franklin County and Oneida County later this year. But with my professional responsibilities as a lawyer and my obligations as a director and a trustee at a bank, I just do not have the time to do as much as I would like.

w.o.: One final question. Jimmy Carter got some credit for talking about religion. Before it became fashionable to talk about religion and politics, you, very quietly, were always a deeply religious man. You always attended Mass every day. Are we as a nation coming back to religion?

m.w.: Yes. And I'm not talking about a specific religion but moral values, which are, at root, what religion tries to inculcate into all of us. I was immensely gratified to note, in a major New York newspaper about three months ago, a report that only served to confirm what I myself had felt: more than 80 percent of the respondents in that nationwide poll said they wanted to have moral values taught to their children in public school. I really think that's a very encouraging thing. I think this last decade was an extremely difficult one with its movement toward materialism, with its values that were ephemeral and attractive at the time but were counterproductive. That era is coming to an end. We find young people today on the college campuses studying hard. Tragically, many of our young people are still victimized by drugs. I think there's more respect now on the part of young people for their parents and for older people. I discern a great deal more respect for government than any of us saw during those years when people were rebelling openly against government. But the most important thing I discern is an increasing return on the part of people to an awareness of our essential dependence on a Power greater than any of us mortals.

w.o.: Are you a happy man?

m.w.: I am indeed, for a variety of reasons. Chief among them being that I have been blessed with the most understanding, self-sacrificing wife anyone could ever have. I've often said I could never stay married to myself, but Katherine has. She has just been wonderful, she and my daughters. I'm blessed with wonderful daughters and many grandsons.

1976

Interview with Nelson Rockefeller

Nelson Aldrich Rockefeller, Westchester's dazzling son, was governor of New York for fifteen years, then vice president of the United States. I think he would have made a great president. He would often shake off the national press to give exclusives to his Westchester community station. He was always the best story of the day.

But who better to introduce this exclusive interview with the great Rockefeller than Governor Mario Cuomo, who himself sat at the great, ornate desk of Theodore Roosevelt?

I am pleased to have this opportunity to acknowledge the immense debt that is owed by this state to the great governor who served us so brilliantly for so long. Dr. Kissinger observed in his White House years that history knows no resting place and no plateaus, and neither did Nelson Rockefeller's tenure as governor. His legacy is as enduring as the generations of enlightened minds that have graduated and will continue to flow from the world's largest university system, which he established. It is as beautiful as the art that is protected and preserved and promoted by this state's Council on the Arts. And his legacy is as gentle and caring as the social programs that he implemented to save thousands of our neediest from want and despair. No one who did as much as Nelson Rockefeller could escape the carping and the quibbling of lesser minds and the honest disagreement of some of his peers. But no one ever could successfully challenge the depth of his commitment, the extent of his ability, his strength, his judgment, and his generosity.

There was a spiritual quality to Nelson Rockefeller's dedication. A great French priest once said of the truly inspired person, "It is not himself that he is seeking, but that which is greater than he." And certainly that was true of Nelson Rockefeller.

W. O'SHAUGHNESSY: We're flying in Whiskey Kilo 100 at forty thousand feet somewhere between Cleveland and the Westchester airport,

and it's late at night. Governor, what was a nice former governor of New York doing in *Cleveland* on a Friday night?

N. ROCKEFELLER: I just finished a Republican fundraising dinner in Cleveland, and prior to that I stopped over at some radio and television stations for a couple of interviews. I went to the *Cleveland Plain Dealer* to talk about what's going on, and then met with the executive committee of the Republican Party, and then attended a party before the dinner. This is an interesting, fascinating, and important time in the history of our country. I believe deeply in the two-party system, and I feel it's important that those of us who are affiliated with one party or another do the best we can to support the parties. Because I think our country needs them to meet the problems at home and abroad.

W.O.: You've been going around talking like this to people in Seattle, Phoenix, and, tonight, Cleveland.

N.R.: These are trips to speak at fundraising dinners for the Party. When I do that, I do not talk about the National Commission for Critical Choices, on which I am privileged to serve, thanks to the president. In other words, I keep a very sharp line between supporting the Party as fundraising and talking about the Commission. If I'm asked at a newspaper or television station about the Commission, then I'll talk about it. But I won't talk about it at a Republican rally.

W.O.: Let me ask you about that Commission. What are you getting done?

N.R.: I think it would be very safe to say that the basic concept, the objective of this study, is to be able to take subjects like food, health, population, and quality of life and make the projections, come up with the basic, critical problems we face as a nation, and also come up with a range of desirable and realistic objectives that can be achieved by 1985. Then what critical choices are we faced with in order to *achieve* those objectives? This we'll do in each of six areas—probably be eight areas before we get through. The present six deal with the quality of life of individuals and communities in the United States, which embraces all of the problems we face and the opportunities for each of us as individuals and in our communities.

W.O.: You've got a lot of brains and heavy thinkers on this Commission. Which is the toughest area?

N.R.: The more I've gone into this—and I've been in and out of government for more than thirty years, so I've had reasonable exposure to these different problems as they've evolved—I have to conclude that our society is like a woven web. You can't pull one string out and maintain the structure as a whole. You could make a very good point that national security is fundamental to our society. True. You could also say freedom at home is what it's all about, and it's also true. You could say human dignity and equality are the basic concepts and elements of this society and equality of opportunity, and that's true. But they're each dependent on the other. Our society doesn't function without energy or without food or raw materials: we wouldn't have jobs. It's very difficult to say that one is more important than the other, unless maybe one could say that the most important is the concept and structure of the government, because that is the framework within which all these things are achieved.

We've got three or four scientists on the Commission: Johnnie Foster, a nuclear physicist, just left the Defense Department after eight years as the chief scientific advisor on Defense Department Research and Development, in weapons. Edward Teller is a nuclear physicist. Bill Baker, who is head of Bell Labs, is probably one of the great space scientists. Then we go over to education: the chancellor of the State University of New York, Ernie Boyer, is a member. So is Wilson Giles, who is the commissioner of education for the state of California—a black educator who just received the endorsement of *both* parties for reelection although he is a Democrat. The commissioners are divided into panels. I might also say that the four leaders of Congress, the two Democratic leaders and the two Republican minority leaders, are ex officio members. And Dr. Kissinger, secretary of state, an ex officio member, was director of the previous study. George Shultz, who just retired as secretary of the treasury and chairman of the Domestic Economic Council, was a member.

W.O.: I'd like to ask you about Nelson Rockefeller. Are you having fun these days?

N.R.: I enjoy this. Nothing has ever appealed to me more than problems that affect people's lives: the opportunity to understand the nature of these problems, the trends, the impact, and how we can shape these forces so we can improve the lives of Americans and

people living in other parts of the world. To me it's the most exciting, rewarding experience I've ever had.

w.o.: *The New York Times* had a headline the other day, quoting you as saying that you are not a politician. Were they putting you on, or were you putting them on?

N.R.: I said it, and I mean it. I said tonight in my talk that politics is not an end in itself. Politics is a means to an end, and the end is good government. If you're going to have good government, those who are in government and those who support government have to understand the issues. What I'm doing now is studying the problems faced by people and government.

w.o.: Do you miss your old seat on the Westchester County Board of Health, Governor?

N.R.: That goes way back. I was a member of that board and vice chairman for twenty-one years. But the last fifteen years I've been governor, so I hadn't really thought too much about that job.

w.o.: It's where it all started for you, though.

N.R.: Well, it did, I guess. Old Boss Ward, as he used to be called in my day, called me up when I was out of college about a year and said, "Look, Westchester has done an awful lot for your family. It's time you did something for Westchester. I want you to go on the Board of Public Health." I said, "Okay." And I did.

w.o.: Are the Democrats creeping up in your own backyard?

N.R.: Westchester has to be one of the great communities of our state and our nation. There are tremendous opportunities here, and just like every other part of the country, there is evolution taking place: change of lifestyle, change of patterns, change of population—groups emerge, groups migrate in. The Republican Party had been in the leadership position for a long time. When any party is in office for a long time, the other party starts to grow and get muscle. What's happened in Westchester is what's happened elsewhere: you get a change of government.

w.o.: Your old nemesis, a gentleman who has been critical of your family over the years, Richard Ottinger, the heir to the U.S. plywood fortune, is threatening to run again for Congress over on the other side of the county. Are you concerned about his returning to Congress?

N.R.: No. I think Richard Ottinger is an opportunist, to a certain degree, and although his family was well known, he was not. And

so if he attacked my family—for some reason that was good PR for him.

w.o.: What about Henry Kissinger? He's been making headlines lately, when he went nose-to-nose with the press. Bayard Rustin suggested he perhaps didn't do the right thing. Do you think he did the right thing in drawing the line?

N.R.: This man has done more for our country in the international field than any secretary of state in history. He was attacked in a press conference when he came back on the basis of leaks of information from either Congress or the executive branch or staff members. None of it was new; all of it had been before the Senate Foreign Relations Committee. So they had examined all this, questioned him, and then approved him, virtually unanimously, I think, for secretary of state. Then these allegations were made, and crack out of the box, he's asked if he employed counsel to defend against criminal charges. I know this man very well. There is no man more patriotic, no man of greater integrity than Henry Kissinger. And he was sore. I don't blame him. If somebody is attacked for something that is a total distortion, I respect him for having the courage to say what he felt.

w.o.: What's Kissinger's greatest talent?

N.R.: His greatest talent is his capacity to understand complex issues and to create a conceptual framework within which they can be handled. He saw, and the president saw, that we couldn't cope with Communist China by isolating China while still preserving stability and mobility for our country in Asia. So they changed U.S. policy and reestablished communications.

w.o.: Let me ask you a couple of things about the state. Do you think you might have gotten out of Albany just in time?

N.R.: No, I don't. I think it's a great state with a great governor. I think Malcolm Wilson is going to be reelected.

w.o.: Do you miss being governor?

N.R.: No, sir, I don't, because I had fifteen years, and I came to the conclusion that the problems that would most fundamentally affect the future best interests of the people of New York are not primarily going to be decided in Albany. They are going to be decided as national and international issues. I wanted the time to devote myself to those questions so I could help the American people understand these issues so they could then support the

kind of action that Congress, the president, and local governments throughout the country are going to have to take.

w.o.: You mentioned the other day in the press that "breakfast with the boys" is different now. How is it different?

N.R.: I've got more time. I'm not under the pressures I had before, when this political figure or that department has a crisis and this county chairman has a problem and your life is not your own. You don't have time to think or be with your family quietly.

w.o.: But the "boys" are different. You're referring to Mark and Nelson?

N.R.: I missed your pun, to tell you the truth. I'm no longer in public life, so I'm out of politics. So "the boys" to me now mean my two sons, not the political leaders.

w.o.: What about your young sons? Somebody told me earlier that you say prayers before breakfast.

N.R.: That's right. It's a family tradition, and a wonderful one, I think. This is the way young people start to get an understanding of spiritual, moral, and ethical values.

w.o.: Do you say prayers with them at night?

N.R.: Sure.

w.o.: Do you play ball with the boys?

N.R.: I'm not as good as I once was. I've got to get my arm back in practice.

w.o.: What do your sons want to be when they grow up?

N.R.: They might be professional ballplayers. That's where they're going now. They're very into it. We watch the ballgames together on television.

w.o.: What about President Nixon? Is he going to ride it out?

N.R.: I think this is something only the Congress of the United States can tell us after the Judiciary Committee has acted and then presented its recommendation to the House. And depending on what that is and how the House votes and if it goes to the Senate, and then how the senators act . . .

w.o.: But what is your guess? In the intimacy of your private jet . . . Do you think Nixon will ride it out? Will the *nation* ride it out?

N.R.: The nation has never been stronger. I think that one of the things we lose sight of sometimes is that this country has been faced with Vietnam and now Watergate, and the American people have shown a quality and stability and character that is fasci-

nating. The rest of the world is filled with admiration for the United States that we can go through the soul-searching we have with total freedom and preserve our balance and our government in the process. They just can't understand it.

w.o.: Do you think this country could stand a good spiritual and moral revival?

n.r.: I think we're very anxious for it. This is the thing that people today are feeling the need of and perhaps the *lack* of more than anything else.

w.o.: Where are people going to get it?

n.r.: They're each going to go about it their own way, and it's going to come through established religious groups. I feel that our own established church structures are evolving to meet change, and they will gain strength out of the present situation.

w.o.: You said tonight in Ohio these are exciting times. When you sit with your young sons before breakfast or at night, what do you tell them? What direction are you sending them in?

n.r.: They know me very well, and I know them very well, and we're very close. Just the same as Happy is with them. I'm basically an optimist. I think this is the most exciting time in the history of our country. And perhaps the most exciting time in the history of the world. There is more rapid change and greater opportunity—if we have the intelligence. I tell my sons they are coming into a fantastic world. They better prepare themselves, train themselves, so they can be constructive citizens. They need to have understanding and compassion and love and belief in fundamental values to be able to deal with the coming questions.

w.o.: A quick political question. Do you think your successor, Malcolm Wilson, can win?

n.r.: Yes, I do. Malcolm Wilson is a man of extraordinary ability and tremendous integrity, and deep knowledge and awareness of this state, and an understanding of people where they live and work, and a capacity to lead government in playing its appropriate role and doing it on a sound economic basis. I think he's right in the current of public thought today.

w.o.: We hear a lot about the feuding in the Republican Party that you sustained for so many years . . .

n.r.: I didn't sustain it.

w.o.: You inspired it.

N.R.: I *contained* it!

W.O.: What about the Republican feuding? Duryea and Lefkowitz [Perry Duryea was speaker of the Assembly and Louis Lefkowitz was New York's attorney general] and so on. Have you had to use your powers of persuasion to calm the waters?

N.R.: You can't expect individuals who are strong characters and individualistic not to have differences. Let's face it, when that difficult situation arose involving the speaker and the attorney general, obviously everybody felt badly about it, but each one of them tried to do what they thought was right under the circumstances.

W.O.: Have you tried to get them together?

N.R.: They were there at the dinner last night! The speaker introduced the attorney general. They shook hands. The attorney general then spoke and was very friendly. They are mature citizens. They are able men, and I think this thing will work itself out.

W.O.: What's next for Nelson Rockefeller?

N.R.: The Westchester airport! I'd like to thank you, Bill, because I'm one of your great admirers and boosters. And I've got to say that the job you do with your station is a crucial one, because unless the public understands what's going on in a democracy, what the issues are, who the personalities are, people cannot act effectively. Radio and the media today are vital factors in making that democracy work. So I'm grateful to you, and I'm delighted you came on the trip. I look forward to seeing you again soon, neighbor. Happy and the boys send their best. We're glad you're our friend. And a really good one when it counts.

W.O.: Thank you, sir.

Spring, 1974

Interview with Cary Reich

Cary Reich devoted eight years of his life to a magnificent biography of Nelson Rockefeller, Worlds to Conquer. *That volume traces Nelson's remarkable career in building Rockefeller Center, bringing the United Nations to New York City, and administering South American policy for FDR. However, while working on the next volume of Rockefeller's biography, Reich passed away. Fortunately, the distinguished scholar Richard Norton Smith, who heads the Gerald Ford Library, will be completing the biographical study in the near future.*

W. O'SHAUGHNESSY: Tonight, we have an author of great renown and sensitivity. Cary Reich is the biographer of Nelson Aldrich Rockefeller, who is, in every telling, Westchester's dazzling favorite son, who left us almost eighteen years ago.

Cary, volume 1 is a very handsome book, and all my friends at Barnes and Noble, including Leonard Riggio, are very pleased for you. Eight years of scholarship, and it's one of *The New York Times's* eight Best of the Year, so it must be good. Was it worth it?

C. REICH: Every minute was worth it. Rockefeller never bored or disappointed me. He was always fascinating and always turning new sides to me. Every time I thought I had him down, he would throw me a curve ball.

W.O.: Nelson Rockefeller traveled far and wide but always came home to Westchester, his home heath, and Pocantico, in Tarrytown. What kind of man was the great Rockefeller?

C.R.: He was very complicated. He was very much what he seemed to be to most of the public. He was an open, expansive guy. A man who loved to eat blintzes and knishes. A guy who loved pounding backs and pressing flesh. At the same time, he could be withdrawn, extremely cold, extremely ruthless. The other side of him,

the side the public didn't see, was as deep and as profound as what we did see.

w.o.: You've done over eight hundred pages, and your first volume ends with Nelson Rockefeller's being sworn in as governor in 1958.

c.r.: Actually it ends with his election as governor. I don't think I went as far as his being sworn in.

w.o.: You have fascinating stories of how he got the United Nations built. Didn't he also go around selling real estate to put up Rockefeller Center in the heart of Manhattan?

c.r.: He was one of the original real estate operators of Rockefeller Center. What he did was offer to take prospective tenants' leases off their hands if they would move to Rockefeller Center. The result was a major lawsuit by a man named August Heckscher who was the grandfather of the August Heckscher we knew as parks commissioner in New York City. He sued him and others at Rockefeller Center for these predatory tactics back in the thirties.

w.o.: Rockefeller was a man of great zest and energy. Did he ever get tired?

c.r.: He almost never did. There are people who claimed that they saw him tired. People who noticed that in the course of a meeting his head would slump or he would lean back, but almost instantaneously he would perk up again to say something like, "I hear you" or "I'm listening to you." He never became tired throughout most of his governorship. He was inexhaustible.

w.o.: The book is called *Worlds to Conquer*. Do you think he conquered those worlds?

c.r.: He certainly conquered the worlds he set out to conquer in his first fifty years. He became the great American presence in Latin America, both as a government official and later in private life. He was instrumental in starting the Health, Education, and Welfare Department, in promoting the Open Skies Initiative by Eisenhower at the 1955 summit, in taking over Rockefeller Center and the Museum of Modern Art. Obviously, the big world he *wanted* to conquer, the White House, was never his, but almost everything else that was within his reach he got hold of.

w.o.: Who better to ask than you, Cary Reich: would Nelson have made a good president?

c.r.: I think he would have made a good president. In some ways he

would have been very similar to the president we got in the sixties, Lyndon Johnson. He was as much of a cold warrior, maybe even *more* of a cold warrior, than Lyndon Johnson. So it's highly likely he would have been as committed to Vietnam as Johnson was. He was also as committed to big government as Johnson was. And, in fact, he and Johnson were quite friendly throughout the sixties. But he probably would have been a much more politically attuned president than Johnson was and more likely to change course if things weren't moving in the right direction.

w.o.: Why didn't he make it to the White House?

c.r.: He had what I call a *strategic blind spot*. He could often plot out great tactical moves, great initiatives, and great programs without seeing the impact they would have on his larger aspirations. He was often burning bridges behind him and creating enemies needlessly within the Republican Party—basically not really calculating how these things would play out in his career. He always seemed to be fighting the wrong war.

w.o.: But you think of Nelson Rockefeller as the happy warrior.

c.r.: He was everything he seemed. He was vigorous. He loved campaigning. There was nothing artificial about him on the campaign circuit. In a quote I have in this first volume, someone says that God must have meant for Nelson to be a politician. And that's true. He had these innate, almost instinctive, political skills.

w.o.: Did the other Rockefeller brothers always defer to Nelson?

c.r.: They did. In fact, he was the ringmaster of the family. Some of them resented that, but nonetheless, he was such an overpowering presence with them, as well as with everybody else, that they couldn't resist him. He was also the one who always intervened with his father.

w.o.: Did the Rockefeller brothers—the ones still around—and the rest of the family cooperate with you?

c.r.: Some did, and some didn't. The two brothers did cooperate, Laurance and David. It was largely a judgment call on each one's part. There was no "party line."

w.o.: Did anyone try to stop you?

c.r.: In the beginning, the family tried to enlist another biographer. They did this because they wanted someone they had a hand in with, and the fellow they approached didn't want to do it, and

they were determined to find someone "proper" to do it. They wound up finding me all over again!

w.o.: But eight years of your life is a long time . . .

c.r.: It is a *very* long time. I certainly didn't think it would take eight years. I enlisted for this on a four-year basis. After four years went by I hadn't even started writing the thing yet. It just got bigger and bigger and bigger . . .

w.o.: One of the final chapters is about Malcolm Wilson.

c.r.: He was an obscure assemblyman and one of the more ardent conservatives in the Republican Party at the time. He was against almost every progressive piece of legislation, including rent control. But he also had a mastery of New York State and its politics and knew the officials at every level. No one could compare to Malcolm Wilson. So Nelson Rockefeller, when he went into state politics, needed someone to pilot him around, and Malcolm Wilson signed on. Really, without Malcolm Wilson, and Nelson said this many times, Nelson Rockefeller never would have been governor of New York State.

w.o.: You have a lovely story about their early days. Didn't Malcolm say, "No Rockefeller outriders. Just thee and me and my old Buick?"

c.r.: They drove around the state together in what Malcolm called not his old Buick but his *new* Buick. It was just Nelson and Malcolm. And later on Steve Rockefeller, Nelson's son, joined them in the car, and they went from hamlet to hamlet and city to city and town to town, pressing the flesh. There was never any flunky paying the people off. Nelson, after a while, really got tired of this and told Malcolm they could do a lot better if they flew to places. And Malcolm was scared to death of flying but finally agreed to fly from place to place with Nelson.

w.o.: Do you recall that delightful story you have in the book about the first day they struck out into the Hudson Valley in Malcolm's Buick?

c.r.: They're driving, and suddenly this Rolls Royce, driven by an "old lady," overtakes them, and Nelson points and says, "There's *Father!*" It turns out to be John D. Rockefeller, Jr., and Nelson's mother. They pull off to the side. John D., Jr., is astonished to see Nelson driving with this fellow he's never met before, Malcolm

Wilson. When he asks Nelson where he's going, Nelson says he's going to his first political event, in Columbia County.

w.o.: Is it true that he couldn't read?

c.r.: He could read. But he had dyslexia. He transposed letters and what not. For that reason he never really read books. He always said that the best way to read a book was to *talk* to the *author*. He didn't write memos more than a page long, and he was terrible as a speechmaker for that reason.

w.o.: But he had a lot of gifts. He could've been quite a glorious bum. A rich man's son . . .

c.r.: There was no reason for him to do what he did. There was no reason to go into politics or public service. I called him a patrician Sammy Glick. He was always hustling, struggling, and looking for the main chance, and you'd never have guessed that this was a man worth hundreds of millions of dollars.

w.o.: Patrician Sammy Glick? Are you sure you mean that?

c.r.: I mean it in the sense that this was a man who was always scraping and scrounging. He was a hustler. That's what I mean.

w.o.: After eight years, did you like this guy?

c.r.: I liked him. There were parts of him I did not like, parts of him that surprised me, and parts of him that I was aghast at, but I basically found him fascinating, because he was so complicated and because he had so many facets. At the same time, his energy, which was inexhaustible, helped propel me. It's great if you're writing a biography to have someone you are writing about who is inexhaustible because that fires *you* up as well.

w.o.: Was Rockefeller a liberal?

c.r.: Not really. Actually, people thought of him as a liberal, but what he was was a problem-solver. Problems with the welfare system, the judicial system, and the transportation system—he liked taking on those problems. When he began moving to the right later in his career and people said that he was doing it as a political gesture, it *was,* but at the same time it was not out of keeping with Nelson Rockefeller as a problem-solver.

w.o.: For all his money, could he have gotten anywhere in today's Republican Party?

c.r.: It's doubtful. Right now the term "Rockefeller Republican" is still being used by the conservatives to knock various political candidates. They slammed Colin Powell because they called him

a Rockefeller Republican. Pat Buchanan, in the early days of the campaign, was saying that if Dole nominates a Rockefeller Republican as his running mate, there'll be a floor fight at the convention. It's always used as a codeword for this liberal-internationalist wing that is still in disrepute among the mainstream Republican Party.

w.o.: Rockefeller Republican used to be a proud appellation. Was it more the strength of Nelson's personality, or was it a political philosophy?

c.r.: It was a political philosophy, not only of Nelson Rockefeller but also of John Lindsay, Thomas E. Dewey, Walter Thayer, Jock Whitney—these were the Rockefeller Republicans. These were the people who believed in a government that was *compassionate* and got involved in people's problems. And a government that was internationalist that got involved with the world's problems. They believed in a synergy between business and government. At the same time, they did not think that government was the enemy or that government should be stripped down.

w.o.: There's nobody around like that anymore . . .

c.r.: No. In a sense, Nelson took Rockefeller Republicanism with him. There hasn't been a quintessential Rockefeller Republican again, largely for political reasons.

w.o.: You have some stories about Nelson's personal life. He came here to Westchester once, and someone presented him with the "Great Sword of Excalibur," and Nelson cracked up on the podium and said, "Are you trying to tell me I'm a great *swordsman?*" Was he?

c.r.: Yes, he was. It was part and parcel of this inexhaustible energy. He did not have a very good first marriage, probably because he did have a wandering eye. Invariably, he would be involved with women who were working for him. And invariably, he would treat them very well after the fact. He was not John F. Kennedy, who was basically a "love them and leave them" guy. Nelson had a very soft side and a very compassionate side. So you did not see that kind of "assembly line" that you saw with John F. Kennedy.

w.o.: Rockefeller had a great deal of charm for everyone. He was able to get his way even with presidents. Was that charm real stuff?

c.r.: Oh, yeah! The thing he did also was *flatter* people. He learned that the best way to get results is to flatter the official *over* you,

the one you are trying to get something out of. And so he would flatter Franklin Roosevelt endlessly. He would flatter Roosevelt's secretary of state, Cordell Hull. Later, he would flatter Truman, and the most egregious flattery was of Dwight Eisenhower.

w.o.: But sometimes people flatter and it doesn't ring true. Nelson got away with it. Why?

c.r.: Well, I think it's because there was that enthusiasm, that kind of boyish quality to it. He didn't seem to be calculating. But I also think that people are suckers for flattery. And I think if you really lay it on thick enough, almost anybody will fall for it.

w.o.: Did Nelson Rockefeller really put together that United Nations deal?

c.r.: There were *two* United Nations deals. One was the organization, and the other was the building. The United Nations would not have been in New York had it not been for Nelson Rockefeller. Up until the eleventh hour it was going to be in Philadelphia. Nelson stepped in, convinced his father to give $8.5 million to the UN to enable the organizers to buy a parcel of land on the East River from Bill Zeckendorf, the real estate developer. Zeckendorf was going to build this monumental thing called X City on the site, and he dropped it when John D. Rockefeller bought the land. With regard to the UN *organization*, Nelson Rockefeller was very instrumental in the UN Organizing Conference.

w.o.: He always surrounded himself with some pretty good people.

c.r.: He had first-class people. He was not one of those important people who want a lot of toadies and flunkies. He wanted people who had independent minds, who could come up with ideas. He loved the interplay and clash of ideas, so he always had great minds around him.

w.o.: The first time I ever laid eyes on him was outside a Jewish delicatessen, Rattner's on Delancey Street, which is now in a Puerto Rican neighborhood. He plowed right into this sea of Hispanic faces, and they were calling him "Señor Rocky."

c.r.: They loved him. He could go to almost any ethnic group and immediately hit it off. He spoke French, so he would go to French Canada and speak with them there. He was great with Spanish— very articulate. He liked the Spanish rallies more than the American rallies because he could really use that Spanish exuberance,

whereas he had to tone it down a little bit for non-Spanish audiences.

w.o.: What about his own element, his own WASP fraternity? What did they think of Nelson Rockefeller?

c.r.: There was a slight mistrust of him. He seemed too ambitious and unreliable and untrustworthy because he was in some ways an FDR "New Deal" personality. And so he was counter to what some of the anti-Roosevelt WASPS felt was acceptable. He was an unguided missile.

w.o.: How about Dwight D. Eisenhower? Did he ever warm to Nelson?

c.r.: He did. Once when Nelson was having breakfast with Eisenhower, Eisenhower idly said, "You know, Nelson, my farm in Gettysburg needs some landscaping." The next thing you know, Nelson was shipping cars and trucks loaded with trees to the grounds and hired his own landscape architect to work on the farm! So he and Nelson hit it off very well indeed. Eisenhower later became very disillusioned with him and one day said, "The problem with Nelson is that he borrows too many other brains instead of using his own." He held a caustic view of Nelson later on, very caustic.

w.o.: What about the other brothers at Pocantico? They all lived there for a long time. Any back-fence arguments or disputes?

c.r.: There were some. The thing about Nelson was that *he* was the dominant brother. He made it known in various ways, like owning more of Rockefeller Center than any other brother. He was a titanic force, so while there were some disputes, invariably Nelson would get his way. It wasn't until later on in the seventies, when he came back into the family fold after leaving the government, once and for all, that the family really began to rise up and there was some resistance to him.

w.o.: But doesn't Laurance Rockefeller, who ran Chase Bank, idolize Nelson to this day?

c.r.: He worships him. In fact, my interview with Laurance was in Nelson's old office in room 5600, the Family Office in Rockefeller Center, which is still maintained as Nelson Rockefeller's office eighteen years later. The furniture is still there. The artwork is still there. Even the family photographs are still on the desk, as if he might walk through the door at any moment. And I think, in some way, Laurance wanted to do the interview there partly to

infuse himself with Nelson's spirit. I'm not sure that Laurance has accepted that Nelson is gone . . .

December, 1996

Cary Reich died of cancer a few years after the publication of the first Rockefeller volume. Several attempts have been made to find a writer of equal stature and talent to finish volume 2 using Reich's research on Rockefeller's fifteen years as governor of New York and his brief tenure as vice president of the United States. Fortunately, Professor Richard Norton Smith, a distinguished American scholar and historian associated with the Gerald Ford Library, has stepped up to the plate and is completing the work.

Interview with
Larry Rockefeller

This soft-spoken, earnest Rockefeller, Nelson's nephew and Laurance's son, has concentrated on environmental and preservation issues.

W. O'SHAUGHNESSY: The newspapers accuse me of being a Rockefeller Republican. It's an appellation I proudly encourage. Tonight's guest is a Rockefeller, Larry Rockefeller, who grew up in our home heath. You had quite a year at the election booth. You backed some candidates, and they all won.

L. ROCKEFELLER: Governor George Pataki won, as he should have. As someone who cares about the environment, I was particularly pleased about that.

W.O.: You're an environmentalist?

L.R.: That's right, along with about everyone else. I guess some 80 percent of the voters.

W.O.: You put your money and energy where your heart is. You support a lot of causes. You are chairman of a major national organization. Are you still up at the Beaverkill in the Catskills?

L.R.: The western Catskills, that's right. This election season I teamed up with the League of Conservation Voters. We put out a bipartisan message across the state on behalf of the environment for both Governor Pataki and Senator Chuck Schumer, each of whom have excellent records on the environment.

W.O.: I've caught glimpses of you over the years at dinners and civic functions. You are the son of Laurance Rockefeller.

L.R.: That's correct. He, in turn, is the brother of Nelson Aldrich Rockefeller, your friend, Bill. He knew you well. And admired you.

W.O.: Your father, Laurance, was the "environmental brother." Didn't he save the Palisades and the Hudson?

L.R.: He's been involved, as have so many members of our family,

with the environment. He's been a leader on the Palisades Interstate Park Commission, on which he served for thirty-five years. I've just been there a mere twenty. He was active in saving the Hudson Highlands and was head of the New York State Council of Parks. He worked closely with his brother, Uncle Nelson, on issues like the Adirondacks, the protection of that great resource.

w.o.: Who are some of the others of that generation?

L.R.: There's Uncle David, who's a banker and a lot more than that. He's really been a civic leader in so many different ways, starting new groups like the Council on the Americas. And he's still involved worldwide—in his eighties like my father, but very active. Then, of course, there was Winthrop Rockefeller. He was governor of Arkansas for a while—actually during the same time Nelson was governor here in New York. In fact, I think the Bush brothers—Jeb and George W.—are the second duo to be governors at the same time. John D. Rockefeller, Jay Rockefeller's father, was active in a lot of causes. He was the creator of Lincoln Center, and he devoted himself to world population issues. He died in an auto accident when he was seventy.

w.o.: So of the brothers, there's just your father, Laurance, and David left?

L.R.: David is still alive, and they had a sister, Abby, who has also passed on.

w.o.: That generation was known as "The Brothers." And then the next generation, of which you're a part, is called "The Cousins."

L.R.: Right. By us. There are twenty-one of us, and we've gone on to have children of our own, so we're sort of multiplying. We're spread out across many states, but we still get together twice a year to talk about things.

w.o.: We have admired from afar—because I'm not much of an outdoorsman—your environmental work. Tell me about that place where you fish up in the Catskills.

L.R.: That's the Beaverkill, our river, which is really where fly-fishing began in America. I fish and enjoy it, and if you want to give it a try, come on up.

w.o.: What do you do? Wade out there with those tall boots and throw out a line?

L.R.: Yeah. It's particularly fun in the spring, when the birds are singing and the water is flowing, to get out and act like a trout. I *think*

like a trout, and it turns out that trout are like people. They want food and shelter and security, and they swim upstream. They teach you to *think* like a trout on weekends.

w.o.: Do you throw them back?

l.r.: One can keep one or two. There is among those who go fly-fishing a growing tradition of catch and release on the theory that a fish is too good to be caught only once.

w.o.: This is up past Liberty in the foothills of the Catskills. Aren't you developing a lot of land up there?

l.r.: As a conservationist, my goal has been to conserve this wild mountain valley, which runs from the high peaks of four thousand feet and then downriver about twenty miles. It's been part of a team effort with other fishing clubs and hunting clubs. There are other people there, and then New York State holds two-thirds of it forever wild, as a forest preserve.

w.o.: Aren't you selling land up there for $20,000 an acre?

l.r.: The idea has been to conserve the valley by very careful development—you might have a house that's tucked out of view from the road and the river and the forest but still with views. Careful development helps pay for the conservation.

w.o.: If somebody buys there, they have to put the house where you tell them to put it?

l.r.: We have a "discussion" to figure out beforehand where the appropriate sites are so people have a choice. This is actually a technique that is being used all around the country by other so-called land trusts that are trying to protect a scenic resource, but to do that they can't buy it all. Even if the funds were there, they'd buy it and resell it but with restrictions on further use. It's called a conservation easement, so there are now 105 in the Beaverkill Valley.

w.o.: Your father did a lot of development. He built all those Rockresorts. Do you think he's proud of you?

l.r.: I think so, and I'm proud of him. That was a similar approach to what's called worldwide "sustainable development," the need to save the environment but also provide for the economy and jobs. He created land for a national park in the Virgin Islands, on St. John's, but also started a hotel there called Caneel Bay.

w.o.: I've seen you at political gatherings. Your Uncle Nelson was a

progressive Republican—a Rockefeller Republican, hence the term.

L.R.: I'm a progressive Republican, too, in that same tradition that goes back even before him. He stood for those principles of inclusion, and on the environment he was great, as Governor Pataki is too. So that's the wing of the Republican Party I'm in.

W.O.: Are the Bush boys where you are?

L.R.: They are in the mainstream. They sent a message to the Republican Party of inclusion, of reaching out to people and focusing on education—things that people really care about—rather than just dwelling on impeachment or teaming up with the gun lobby or blocking clean elections—all of which the Republican Congress, sadly, has done. That's probably why Senator D'Amato lost. He was seen as being out of the mainstream.

W.O.: You also spent some of your own fortune to beat him.

L.R.: Such as it is, yeah. With the League of Conservation Voters, I toured the state.

W.O.: You were on WVOX, and some of our listeners worked you over pretty well. Did the Rockefellers, except for Nelson, have a reluctance to be in the spotlight? Is it hard for you to talk about your accomplishments?

L.R.: My mother was a Vermonter, and I suppose there's sort of a natural reserve there. I guess I'd rather talk about the challenges ahead or where we're all headed.

W.O.: What about the Republican Party? In New York State it was once run by your family.

L.R.: Uncle Nelson was the governor and the leader. I knew him well. I really admired him and felt close to him, and he gave me a chance to tag along over the years in some campaigns and even let me sit in on some of the leadership discussions in Albany back in the days when it would be the speaker and the Senate majority leader and Uncle Nelson.

W.O.: He knew disappointment and rejection and defeat. He wanted to be president.

L.R.: He really did. As you know, he ran three times, and had he made it, I think he would have been a great president in that Teddy Roosevelt tradition.

W.O.: You're not going to like me for saying this, but you are known

as being one of the most thoughtful and cerebral and intelligent of "The Cousins," the current crop of Rockefellers.

L.R.: I don't know, they're all pretty good thinkers.

W.O.: How old are you?

l.r.: I'm fifty-four.

W.O.: What do you want to do when you grow up?

L.R.: I care about the environment, Bill, and I've been working on it over the years, on Alaska lands, coastal barrier islands, and in New York State on the Adirondacks and the Hudson-Catskills region. That's been a real focus in my life, and that will continue.

W.O.: Weren't some people trying to run Larry Rockefeller for mayor of New York or the Senate?

L.R.: I don't know about that. I did have that opportunity, six years ago, as a citizen's gesture, to run in the primary against Senator D'Amato. But that was a last-minute thought based on the feeling that somebody should speak up for the environment.

W.O.: We hear talk about global warming. Are we in trouble?

L.R.: I think so. It's one of those crises that develop gradually. It's like the frog in the pot with the water that is gradually heated a degree at a time, and the frog just gets used to it until it boils. Global warming is something that will take place over the next decades, but it's also happening now. This is probably the warmest year of hundreds of years. The upside has been that fall has been a little bit more pleasant, but there are effects already, including coastal erosion rates, as the oceans rise, that are going to accelerate. It's already had an effect on trout streams and cross-country skiing, and it affects people with relatives in Central America. There's a sense that hurricanes will become more frequent and more powerful because the ocean temperatures, as they rise, will add energy to the storms. It's interesting that insurance companies are taking steps to pull back from coastal regions because they believe this is serious. And even some oil companies are concerned about fossil fuels as the source of most of the carbon dioxide warming gases.

W.O.: You have access to a lot of brainpower on this subject. What's going to happen to the earth?

L.R.: It's going to burn up. If you project the trends, you see consequences such as coastal flooding and climate shifts to disease from mosquitoes and other bugs. It sounds very gloomy, but there's hope in the sense that the world has come together on the

ozone hole—which is still there, but we pinpointed the problem and took action on it. And there's the Kyoto Pact, which was reached recently. Now we just have to persuade Congress to take this seriously and create incentives for people to save energy.

w.o.: Another famous son, Bobby Kennedy, Jr., has done a lot of work on the Hudson. What kind of shape are the Hudson and Long Island Sound in?

L.R.: Bobby has done great work there and on the New York City watershed. This historic agreement between upstate and the city was reached with real leadership provided by Governor Pataki. That was one of his environmental achievements. As Bobby wrote in an op-ed recently, the city needs to take more seriously their requirements for further development within the watershed because there's that additional contamination problem. The Hudson River is being discovered by people worldwide—it's our Rhine Valley. It's increasingly becoming a tourist attraction. The waterfront area is being reclaimed, with new parklands and trails.

w.o.: Your family gave a lot of land for Rockefeller Park. Have you ever walked around there?

L.R.: Yeah. And I was recently at the dedication of the Rockwood Hall, a new piece being added right along the Hudson. It's about eighty acres with wonderful views.

w.o.: Did you grow up at Pocantico Hills, the family estate?

L.R.: We were there on weekends during the school year and in June.

w.o.: Your grandfather was John D. Rockefeller, Jr., and your great-grandfather was the original John D. Rockefeller. Do you remember them?

L.R.: Well, my great-grandfather died before I was born. I remember well my grandfather as a person with a great sense of humor, in a quiet way, as his father before him had that same sense.

w.o.: Is it in the genes? You have youngsters. Do you tell them about nature and the land and public service?

L.R.: They absorb it when we discuss it. We talk about it not so much out of a sense of duty but as an opportunity to take action and be effective in whatever it is that one cares about. One doesn't have to be a Rockefeller to do that. Everyone in his or her own way has that opportunity.

w.o.: Is there hope for Rockefeller *progressive* Republicans? D'Amato

has fallen. Newt Gingrich has fallen. Do you think the GOP will ever come back to where your uncle wanted to take it?

L.R.: Throughout history there are these times when more conservative sensibilities are in sway, like the Roaring Twenties or the fifties or a hundred years ago, the 1890s. And then there are other periods when progress is made, as in Teddy Roosevelt's days in New York State and Malcolm Wilson's days, so my own sense is that the pendulum has swung out as far as it's going to swing to the right and that this election was the start of it's coming back to the point at which Republicans are going to continue to be elected and certainly to be the majority in Congress. They're going to have to find the mainstream again and focus on the issues that really matter, like education and the environment, and take seriously the need to reform HMOs and deal with those questions rather than exotic issues that people don't care about.

W.O.: Is George Pataki closer to the Rockefellers?

L.R.: He *is* in the mainstream. If he were to run for president, he would find a good response out there.

W.O.: What about George W. Bush, governor of Texas?

L.R.: His focus on education is what made him so attractive to people from all parts of Texas during the last election, because that's an issue that cuts across all boundaries, and he's made a difference there.

W.O.: What can I do to get you into the arena?

L.R.: In a sense I am, because if you care about the environment, as I do, there are ways to participate even without running for office. There's the Natural Resources Defense Council that I've been associated with for years. We're in New York City, and we're active with the global environment as well. There's the New York League of Conservation Voters, and there are groups right here in Westchester, like Scenic Hudson and Federated Conservationists of Westchester County.

W.O.: There are some other cousins, the sons of Nelson: Nelson Rockefeller, Jr., and Mark Rockefeller. What are they doing?

L.R.: They are outstanding young men, in their thirties. Nelson is at business school right now, having served in Congress with Senator Dole. He was in the majority leader's office, and he was at the Office of Management and Budget. He has a lot to offer.

w.o.: You believe deeply, Larry, and, frankly, you make me proud to be a Rockefeller Republican.

l.r.: Thanks. You're a real Westchester leader and an institution, Bill. It's a privilege to be here with you.

w.o.: You won't make me go fishing with you?

l.r.: You're welcome any time.

November, 1998

Interview with
Robert Abplanalp

*Bob Abplanalp, plain talking multimillionaire industrialist and inventor of
the aerosol spray can, was Richard Nixon's best pal. He's been ducking
interviews with Mike Wallace and* Sixty Minutes *for years, but I got him to
come into our Westchester studio and talk about his extraordinary relation-
ship with President Nixon.*

W. O'SHAUGHNESSY: Do you think God has a plan for you? You're a
multimillionaire. You've got your own plane. You've got five
thousand employees. You own your own island . . .

R. ABPLANALP: I'm aware of all the success I've had in business. I
started in 1941. And I'm convinced there is just no substitute for
dumb luck. If you discount that in the framework of business,
you're just plain stupid, because more things have happened to
me because of luck . . .

W.O.: You have been accused by my colleagues in the press of being
the best friend of a president, Richard Nixon. You miss him?

R.A.: I'll put it to you this way. I really have not been able to look at
the tapes of the funeral. I miss him. I recently returned from San
Clemente with my family and the Nixon family. It was a little
commemoration. It's been a year. And I don't know if it's com-
mon knowledge, but one of the last appearances President Nixon
made was at my daughter's wedding at Westchester Country
Club. The wedding was on Saturday. He called me Sunday morn-
ing to tell me what a great time he had at the wedding. On Mon-
day afternoon he had the stroke. I was in the hospital every night.
Bebe Rebozzo flew up from Florida. He's a great guy. One of Presi-
dent Nixon's legacies to me was that he introduced me to
Rebozzo. And along with my friendship with the president began
a relationship with Bebe Rebozzo that I prize very highly.

w.o.: You're a tough guy. Was it difficult for you that you were unable to save Nixon?

R.A.: I thought the doctors were crazy. His respiration was normal. The stroke had been five days before that. My own judgment was he looked a lot better than he did on Tuesday night. We left the hospital two hours before he died, thinking, "Gee, he looks great. We'll go back tomorrow to see how he is." There *was* frustration—I'm a good *mechanic*—but there was nothing I could do about this. I'm not a miracle worker . . .

w.o.: How will history treat your friend?

R.A.: I never really paid much attention to his books while he was alive. He sent me autographed editions every time. I've started reading them, particularly his memoirs. I think they'll become classics, textbooks. He will have a unique place in the history books. The brilliance, I mean, did not ordinarily come through in a day-to-day conversation. But as I read more and more of his books, I've come to believe the man was absolutely incomparable.

w.o.: What about the Nixon-haters? Was there a dark side to your friend?

R.A.: Not that I ever saw. There were a lot of Nixon-haters. I never saw any signs in him of any reciprocation of that hatred. He felt people were entitled to their opinions. I never really saw anything in Nixon that should have aroused hatred. His mother was a big influence in his life—and his father too. He came from nothing very extraordinary. They were far from wealthy. His father ran a grocery store. Nixon worked to get himself through college. I think his parents' patience and tolerance had a great influence on his life. You know the Quaker attitude was not to hate. You turn the other cheek . . .

w.o.: Is that hard for a tough guy like Bob Abplanalp?

R.A.: Well, yeah, from time to time I've found it difficult. I would read things in the newspaper that I knew were absolute lies, but Nixon's reactions were calm. On the day he resigned, he went back to California on *Air Force One*. When he was over the Mississippi River—it was about noontime—he called me to get Rebozzo on the phone and meet him in San Clemente that night for dinner. I was in my office in Yonkers, but we managed to do it. I met Rebozzo in Dallas, and we got to Los Angeles in time for dinner.

w.o.: Was he a beaten man at that supper?

R.A.: No. The surprising part was, he said, "It's over, Bob, the presidency is over." And then he just went on and increased his writing and traveled a great deal. It's amazing that he was respected all over the world. I traveled with him in Russia and France and other places. He consulted with heads of state. I had the pleasure of meeting Yeltsin—which was a thrill. I remember Nixon running up the steps and me puffing along behind him. It was just a couple of years ago. He was a valued advisor to Yeltsin.

W.O.: What did you three guys—Rebozzo, Nixon, and Abplanalp—talk about of an evening?

R.A.: Well, President Nixon was a great sports enthusiast. We talked about baseball, football . . .

W.O.: Girls . . . ?

R.A.: Today, if the president were here and you asked about girls, Rebozzo would say: "Well, we had a very strong interest in the female gender. But my problem is, I can't remember *why!*"

W.O.: What would you like us to know about Nixon?

R.A.: Of all the Americans I've ever known or read about, he is *the* most outstanding man. I include George Washington, Abraham Lincoln, Franklin Roosevelt. All of these men, the thread they had in common was a bloody war. Nixon inherited not a bloody war but a conflict, and did his level best to stop it. He prevented the disaster of nuclear war from happening in the future. His tactical position in containing the Russians had absolute genius written all over it. I've discussed this thing with Henry Kissinger many times. Henry was *not* the architect. And I think Henry *was* something more—a good bit more—than the messenger boy. I think Henry had some genius in his own right. Once he got to know Nixon, he was dedicated to doing what *Nixon* wanted done. I don't think that during Henry's Rockefeller days he may have had the same attitude. But I like him.

W.O.: Was the story true about Nixon praying on his knees? You know the story: he called the secretary of state into the Lincoln Bedroom and said, "Henry let's . . . "

R.A.: I don't believe a *word* of it. I've never asked Henry. I can picture Nixon praying in *private*. If he got down on his knees, he did it in the confines of his home, not for observation. I never saw him pray, but I'm sure he did.

W.O.: Have you ever been in the Lincoln Bedroom?

R.A.: Yes. I slept overnight. It was one of his favorite rooms in the house.

W.O.: Is it true you and Nixon and Rebozzo were closer to one another than you were to your wives?

R.A.: Well, I guarantee you there were things the president discussed with Pat Nixon that Rebozzo and I never knew anything about. And there were things discussed between Josephine Abplanalp and myself that *they* never knew anything about. Of course, Rebozzo got married only ten or twelve years ago!

W.O.: But you were close . . . ?

R.A.: As close as any three friends. I regard President Nixon as a friend. I grew up in the Bronx, New York, but to picture myself as the friend of the president of the United States . . .

W.O.: Tell me a Nixon story you never told anyone.

R.A.: OK, O'Shaughnessy, here's one just for you. One day when he was vice president, we were down at Walker's Cay, my place in the Bahamas. Nixon, Rebozzo, and I were sitting around after dinner when the vice president requests a cigar. But the steward informs us that we were out of the kind Nixon favored. So we went down to the dock and took out a little Boston whaler to run across the channel to the next island where there was a general store that doubled as a restaurant. It also had cigars. And brandy. As we were about to cast off, Leonard Garment, Nixon's counsel, came running down from his cottage to protest that the vice president was setting sail with only me and Rebozzo. Nixon dismissed him: "Go back to your briefing papers, Leonard. We'll be fine. We've got a flashlight, and Bob knows the waters." Garment was so upset he threatened to wake up the vice president's Secret Service agent, who had turned in early. In those days, the veep had only one or two agents. Anyway, by flashlight and a little moonlight we struck out into the channel. And as we crossed, the lights went on in the little village. So we sat until the wee, small hours, enjoying our brandy and cigars. Now, what no one knows: it was the exact day the Bahamas declared independence! You can look it up! And to this day, there are people on that remote, far-flung little island who still think the U.S. government sent the vice president of the United States to help them celebrate their independence! In a Boston whaler, with two questionable shipmates! It's an absolutely true story!

w.o.: What do you think he saw in you?

r.a.: Well, I think he saw a friend who had experience that was totally different from his. I never got involved in politics. He saw a successful blacksmith, somebody who knew how to pound iron, knew how to work with metal-working tools and equipment. He saw somebody who was in a field totally removed from his sphere of activity. Shortly after the election in 1968—I don't know whether this is public knowledge or not—the first foreign soil he went to as president-elect was Walker's Cay to see me. And while he was there, he got into a discussion of who he wanted in his cabinet. He began describing the secretary of defense as a "young man, about forty-four to forty-eight, somebody with broad-based industrial experience." Well, I was forty-six at the time and had twenty-five years of "broad-based industrial experience." I began to get the creepy feeling that he was talking about me . . .

w.o.: Secretary of Defense Abplanalp has a nice ring . . .

r.a.: Well, it would have affected a lot of other things. Number one, I would have had to divest myself of the company that I had built . . .

w.o.: So as Nixon went on with this . . . ?

r.a.: I broke into the discussion and said, "I think that would be a horrible mistake." Because if you're going to hire some young hot-shot from the industrial world with no military background (I got out of the Army as a corporal! That gives me something in common with two other very famous characters. One was Napoleon. And the other was Hitler!), you're going to place this guy in the position of dealing with all the admirals and generals in the Pentagon who will be ten or fifteen years older than he is . . .

w.o.: Did you think you could pull it off?

r.a.: Yeah, I could have pulled it off, but that wasn't the question. My point was the guy was going to have a terrible row to hoe. On the other hand, when it comes to negotiating with the Appropriations Committee in Congress, you're going to have aging senators and congressmen who all resent the youth of a guy like me. You know what he did? He appointed Melvin Laird as secretary of defense. And he got David Packard as assistant secretary—which covered all the bases.

w.o.: Why don't you write books?

R.A.: Well, it's been suggested many times. I'm a busy man. I still go to work every day.

W.O.: What do you want them to refer to you as? Friend of the President? Sportsman? Philanthropist? Industrialist? What do you want on the stone?

R.A.: I hope they could just say he was a nice guy. You know, the rest of it is going to be history. As far as the history books go, I don't have to worry about it. I have 150 patents with my name in the Patent Office. *That's history!*

W.O.: But as chairman of Precision Valve, you've been accused of being the man who destroyed the ozone layer . . .

R.A.: I have to tell you, the element for that aerosol manufacture has not been used for twenty years. It's referred to as CFC. At this stage, it's old news. Today it's safe to use aerosol cans. You're not going to destroy the life-supporting ozone layer.

W.O.: Was there ever anything to all that?

R.A.: Well, as in the story of Chicken Little, bad news travels fast. Good news is seldom ever noticed. I think the media and the Madison Avenue marketers overblew those aspects of the ozone theory. It was sensation, and so if you want to attract readers and viewers, you don't tell them the dull things that go on every day.

W.O.: Do you still go to your island in the Bahamas?

R.A.: Oh yes, Walker's Cay is thriving, with deep-sea fishing, scuba diving, fly fishing . . .

I have a theory about fishing. My theory is kids who go fishing *don't* get into trouble. Studies have shown that most of the federal prisoners wouldn't be where they are today if they fished. The biggest fish I caught was a blue marlin that weighed six hundred pounds. But I was like a piece of bacon when I brought it in. The percentage of prisoners who fished is so far below the normal exposure. We also have Eldred Preserve, three thousand acres, here in upstate New York. Eldred is mostly to encourage young people to fish. You see a lot of fathers and sons. If you bring your kid up, you get a fish!

W.O.: Whom do you favor among today's Republican wannabees?

R.A.: I have a strong liking for Dole. I know him. I think he's a strong character. But I'm not really backing anybody.

W.O.: Have you lost your taste for it?

R.A.: I wouldn't say that. I got involved with Nixon because I'm a

Catholic and I kind of resented the way Jack Kennedy postured himself as a third-generation Al Smith who was not going to make it because he was Catholic. I belong to one of the smallest minorities on Earth. I'm a *Swiss Catholic!*

w.o.: What about the current president, Bill Clinton?

r.a.: I marvel at the foibles of the American system when I try to figure out how a man who got fewer popular votes than Michael Dukakis could be elected president of the United States. Clinton doesn't appeal to me. It's nothing personal. I have some problems with a Vietnam War protester who suddenly appears at all the battlefield sites in Europe. I wonder how does Clinton suddenly adjust himself. Here is a guy who protested the draft bitterly. How does he make the switch to commander-in-chief?

w.o.: What about Governor George Pataki?

r.a.: Again, I don't know about the breadth of his experience. But I think his intentions are in the framework of what his mandate is: less government. I think he's trying to do something. And I'm for it.

w.o.: What about your faith?

r.a.: I don't think anybody could classify me as a religious fanatic. But I go to church. I went to Catholic schools. I support the Church, which is having some tough times, but I don't know of any entity around the world that supports the Ten Commandments that *isn't* having a tough time. Because there seems to be so much "semantic" interpretation of what Moses brought down from the mountain. A given word can have six different meanings these days. I think biblical interpretation is not as rigid or traditional as I would like it. But *every* religion—Moslem, Jewish, Protestant—is having its problems today. There just seems to be a lot of liberalization of what we were all taught. Listen, let's get off this. I don't want to preach. I don't have a damn collar.

May, 1995

Interview with Joe Canzeri

A former advance man for the New York governor, Joseph Wood Canzeri later ran all the Rockefeller properties at Pocantico as president of the Greenrock Corporation. He also held a very high position in the Reagan White House. Canzeri was the Oval Office staffer who decided the pecking order on Air Force One *and who sat where on* Marine One, *the president's chopper. On loan from Nelson Rockefeller, he also helped coordinate the funeral services for Dr. Martin Luther King, Jr., and Robert F. Kennedy. He also found time to tour the country with Frank Sinatra, raising money for Ronald Reagan.*

W. O'SHAUGHNESSY: Tonight, we're going to talk about Nelson Rocke-feller, Gerald Ford, Frank Sinatra, Ronald Reagan, and George Bush. And who better to ask about all of these great figures than Joseph Wood Canzeri? Welcome back home, sir. Do you remember the days when you ran "the Park" for the Rockefellers.

J. CANZERI: It was just a little farm in upstate New York, 3,500 acres and about 300 employees. We cut a lot of grass! All of the Rocke-feller family lived there: Nelson, Laurance, and David. John lived up the road in a little place called Fieldwood Farm.

W.O.: David is still around, and Laurence. They're in their eighties. We lost the incomparable Nelson, how long ago?

J.C.: 1979. I remember it well. It was the first evening I had ever gone out and hadn't left a number where I was. I arrived home late that evening, and the housekeeper was outside on the driveway wait-ing for me. She said, "Something is wrong. Get on the phone. I have a number for you." I called the Rockefeller security office at 812 Fifth Avenue, the apartment. One of the security men answered and said, "The governor has been taken to Lenox Hill. I have the number." I called the number and got the emergency

room. Laurence answered the phone. I asked what was wrong, and he said, "Nelson is gone, Joe."

w.o.: They say that the other brothers, Laurance, David, John D., deferred to Nelson. How was he different from his siblings?

j.c.: Nelson was the force. When he walked into a room, you knew he was there. He looked you straight in the eye. He was more of a public person. He wasn't a private person. He could eat a hot dog at Coney Island or blintzes at Ratner's.

w.o.: Laurance Rockefeller was the environmental brother, David Rockefeller was the banker—he also collected beetles—but Nelson had this dynamic thing.

j.c.: Nelson was more of a people person. He could get down in the weeds with you and weed the garden. He was the kind of guy who could look you in the eye and you would feel like you were the only person in the room with a thousand people. He had a little bit more of the common touch than the other brothers. Rockefeller also had a marvelous sense of humor. One Saturday we were out touring the family property at Pocantico. On weekends especially he liked to buzz around in a golf cart or sometimes in a Mustang convertible with the top down. Nelson would bark out orders and make observations: "Joe, let's move that tree" or "Joe, let's widen that path." And I would dutifully record his instructions. One day as we approached the perimeter, he mentioned that he had read a report in the local paper that a body had been found outside the Rockefeller property, on the side toward Pleasantville. With that mind of his that never stopped, Nelson said, "Joe, do we have contingency plans in case it was on *our* side of the fence?" I looked up from the clipboard and, without missing a beat, said, "Governor, I guess I would just wait until you were looking the other way . . . and throw it back over the fence!" He smacked me on the back and with a great laugh said, "Joe, you're faibulous, just faibulous!"

w.o.: You traveled with Nelson Rockefeller in golf carts and jet planes all over the world. He really wanted to be president, didn't he?

j.c.: Yes. I remember at one point, Bill, we were standing on the front steps of Kykuit. I had been given an offer to run a hotel in Alaska for Governor Walter Hickel, and I said, "Governor, I think it's time for me to move on." He turned and looked at me and said,

"Joe, you've got to stay with me one more time. I stood here with my father when I was nine years old and told him I want to be president of the United States. We've got one more shot at it, Joe, and I need you to help me get there."

W.O.: He never made it. Do you think he died a broken, disappointed man?

J.C.: Maybe not broken but probably somewhat disappointed. Nelson was a realist though. I'll never forget riding in his airplane one day taking off from LaGuardia, and the F-27's pilots stomped on the brakes, and I ran into the cockpit and asked, "What's wrong?" And the pilots told me there were birds on the runway. Nelson never looked up from his papers. We rolled back in line, took off again, and I heard this bang, bang, bang. We hit the damn pheasants when we were taking off. The governor never looked up. Everybody else on the plane was whiter than your hair, Bill. He was fearless. I never saw him flinch in rough weather, and we had some pretty rough trips. In upstate New York, in the fall, in the thunderstorms, you bounce around a little. You've been there. He was a fatalist. He was a no-knuckle flier.

W.O.: They would kid about him in the press about his "Hiya, fella, how ya doin' " and the way he'd wade into a crowd. Was that for real?

J.C.: It was for real. But Nelson had different phases. Of all of us who worked for him, none of us had the whole pie. We all had a piece of the pie, and that's the person he was at that particular time.

W.O.: You've worked for Ronald Reagan, George Bush, Gerald Ford. Would Nelson Rockefeller have made a good president?

J.C.: He would have been an exciting president. He would have made things happen. What a lot of people didn't realize was that Nelson Rockefeller was a fiscal conservative, but he was also a hawk on defense. They sent Nelson to Taiwan to attend Chiang Kai-shek's funeral, and Barry Goldwater was part of the delegation. I knew he was a senior guy, so I put them both up front in that cabin of *Air Force 970,* which was the 707 we flew in. When we got off that airplane in Washington, after about forty hours with Rockefeller and Goldwater in that little cabin all alone, Goldwater said, "Why the hell didn't I meet him years ago?"

W.O.: Do you remember when he became vice president of the United States?

J.C.: I sure do. We were at Pocantico, and we had to send the plane to Westchester because there was a lot of speculation. So the press all went to Westchester, and we dispatched a plane to Stewart Air Base and then flew him into Washington, and he came in the back door of the White House.

W.O.: Was Gerald Ford nice to Rockefeller? Did they get along?

J.C.: Gerald Ford and Rockefeller got along very well. Our current secretary of defense and our current vice president, Rumsfeld and Cheney, blocked him at every turn. Ford was a terrific guy who was influenced by these guys. I think the biggest mistake Ford ever made was taking Rockefeller off the ticket. He would have been president that term. I'll never forgive Ford for it, and I've told him so and he said he understands.

W.O.: How about Happy Rockefeller, his second wife?

J.C.: Happy Rockefeller was terrific. She was a great mother from her former marriage. She had four children. And she and Nelson had Nelson and Mark, all good children, all nice people. Happy was very dedicated to her family—both families.

W.O.: We see those two boys, Mark Rockefeller and Nelson Rockefeller, Jr., who looks just like his father. They're grown now. You watched those boys grow up.

J.C.: I think they have yet to be heard from. I don't think they'll charge out there any time soon. That's not the Rockefeller style, in a sense. You *will* hear from young Nelson politically in the future, and you'll hear from Mark more in the philanthropic area.

W.O.: You were a lot more than Nelson's valet or body man. You were a top executive in the Rockefeller court. It's been suggested he had an eye for the ladies.

J.C.: Well, don't we all? If we don't, we have a basic problem. High executive? I think I was the highest paid bellhop in North America.

W.O.: But was he quite a moral guy?

J.C.: Let me say this about being a moral guy. I many times put him to bed at night and woke him up in the morning. Many times I was in suites all over the world and in palaces and so forth. Never, ever was I in a situation in which he asked me to compromise myself or cover something up. I never saw anything I could question, so from that standpoint I think he was morally very strong. With regard to morals from a government standpoint, probably

no one was any *more* moral. I'll never forget the time he was coming in from Washington and the F-27 landed in Utica. Ann Whitman, who was his secretary, and Eisenhower's secretary previous to that, got off the plane and said, "Don't say anything." I asked what was wrong, and she said, "The Nixon tapes come out today." He was very depressed that Nixon would tape and do something like this in the Oval Office.

w.o.: Did Rockefeller like Nixon?

j.c.: No, I don't believe he liked him. Nixon was very hard to like. He might have been talented in some ways, but to like? No. He was devious.

w.o.: Nelson Rockefeller loaned you out to run two funerals, Bobby Kennedy's and Dr. Martin Luther King, Jr.'s.

j.c.: I worked St. Patrick's Cathedral with the cardinal and the Kennedy advance staff and the Kennedy family in New York, and I was sent to Atlanta with Wyatt Tee Walker, a former associate of Dr. King, to go down and handle the New York delegation. I arrived in Atlanta and thirty minutes later I'm sitting at the bedside of Coretta King, making plans for the funeral services. I didn't quite know what we were into, but we were into a hell of a lot more than I thought we were. The first thing we had to do was get a plane to fly the Southern Leadership Conference back to Memphis to finish the march. That was eleven o'clock at night. We needed the plane there at seven in the morning, so I called Louise Boyer, the old Rockefeller assistant, and I told her I had some problems that are going to cost some money, and she said, "Do what you have to do to make it right. The governor wants to provide any service he can for the King family at this particular time."

w.o.: As you look back and we reminisce about these mythic figures, do you think today's crop of politicians measures up?

j.c.: I don't know. We haven't seen George Bush, Jr., take his beanie off yet. I think he's still a freshman. Looking back to Bush, Sr., I think he was a wonderful man. He didn't stand for as much as I thought he should stand for. He was kind of here and there and everywhere. There is not a lot out there. McCain has a little potential in him. McCain has gone through an awful lot. I don't think some of the others have gone through it. They are sort of to-the-manor-born types.

w.o.: You've known them all. You spent half your life in the White House. There are no heroes out there? Nobody we should look for?

j.c.: I originally thought of all these politicians as my heroes. Nelson will always be my hero. Reagan will always be a hero. But my real heroes are my father and my grandfather, who came out of the mountains of Sicily on a donkey in 1900. He came to this country; didn't speak a word of English; made a living, served in the military, fought for America; was never on welfare, never in jail. Fifty years later I was working in the White House. Those are my real heroes, men like my father.

w.o.: You ran the White House for Ronald and Nancy Reagan. Was Ronald Reagan a nice man?

j.c.: The best. First class. I'll never forget the day we were out on the South Lawn during one of the arrival ceremonies in which the troops go by and the cannons go off. It was one of those hot August days, and at the end of the meeting Mike Deaver and I accompanied the president into the Oval Office. Mike took off his coat. We were all perspiring, and Mike turned to the president and said, "Mr. President, take your coat off." The president looked over at me and he looked back at Mike and he said, "Not in this office." He had tremendous respect for the presidency, and what he believed in, he really believed in.

w.o.: Did you ever see the onset of his disease? Did you ever see him starting to fail?

j.c.: No. The only thing I ever saw was sometimes he would repeat stories, but I was there every day and it was always a different audience.

w.o.: What about Nancy Reagan? Devoted wife or dragon lady?

j.c.: The best wife in America. The best wife in the world. She was the most devoted wife I've ever seen and not a dragon lady. She didn't try to influence policy. What Nancy Reagan did was try to support the people who supported her husband. If you didn't support her husband, look out.

w.o.: Did you ever see her get mad and tangle with somebody?

j.c.: No, she would either call Mike or me or Jim Baker or someone like that.

w.o.: Jim Baker recently gave us a new president. What kind of guy is he with the cowboy boots and the nice suits?

J.C.: Baker is a terrific guy. But Baker has a great ability of taking care of Baker. I'll never forget the night we were in Los Angeles— remember when we shot down those two Libyan jets? I was the guy on watch there in L.A. There was always someone on watch, and I got a call at about five o'clock in the morning from Ed Meese, who said, "Joe, we've got a problem. We just shot down two jets in the Gulf of Sidra. Do you think I ought to wake up the president?" I told him yes. About fifteen minutes later and got a call from Deaver, who said, "What the hell is going on? We leave you on watch all alone . . . " Then I got a call from Baker down in Texas. He asked what happened, and I told him Ed, for whatever reason, didn't make the call. He said, "Well, it didn't happen on my watch." A great guy, though, Baker, with terrific talent. In that business you've got to cover your butt, and Baker was good at that.

W.O.: Isn't Ronald Reagan a man of few words?

J.C.: He is a man of few words, but he is a very sensitive guy, much more than you could see on television. You know he is sincere. Everybody liked him. At one point we were in Cleveland, and we found someone who had done a Carter ad on television when Carter was using the rank and file to do his ads for him out there. I found her in the audience, brought her on to the plane to meet then-Governor Reagan because she was very unhappy that Carter's people didn't keep in touch with her. She said, "Now that I've met you, who are you going to have keep in touch with me?" And he said, "Tony Canzoni" and pointed to me. Every time the president saw me, which was three or four times a day, he'd put his arm around me and apologize for missing my name, and he really was sincere. He said I could call him "Reegan."

W.O.: But you never dared.

J.C.: No. Once in a while I'd slip and ask, "Where's the Gipper going tonight?" I wouldn't say it directly to him. I called him "Chief" and "Boss" occasionally.

W.O.: Of all of them—Nelson Rockefeller, Ronald Reagan, Gerald Ford, George Bush—who is the greatest you've known?

J.C.: I think Nelson would be number one. I had an affection for Nelson that I had never had for anyone outside of my family. Although I wasn't family to him. There is an interesting story from November, the year before he died. We were walking around

the estate and I said, "Governor, I've been asked the question frequently over the last two or three weeks why I've lasted so long with you." He said, "Hell, that's easy." I said, "If it's so easy, tell me." He said, "Because you never forgot whose name was on the door." He was very sensitive. He knew that I was a single father. He set up a trust fund for my son to go to college. He treated me very well. I also got along with him by saying, "Yes, sir," "No, sir," "Done," and "Got it." And I had to resort to "No, sir" only a very few times.

w.o.: You're a Rockefeller Republican. They're a dwindling breed.

j.c.: I guess you can call us Independents now.

w.o.: What is a Rockefeller Republican?

j.c.: Fiscally conservative, militarily strong, with a social conscience. There are some great concerns out there, particularly with great numbers of Hispanics coming into the country as immigrants and non-immigrants.

w.o.: You were with Nelson Rockefeller when the boos rained down on him from the yahoos and the right-wingers and the haters in the Republican Party. Did the governor take that personally?

j.c.: I don't think he took it personally. He always felt that everybody should have the right to their voice. He didn't necessarily agree with it, but I never saw him try to be vindictive about it.

w.o.: In recent years, you've done a lot of show-business management and run a lot of tours for big stars including Francis Albert Sinatra. What was Sinatra like?

j.c.: The best. The thing I remember most about Sinatra is loyalty. If you were loyal, Sinatra was loyal. I'll never forget climbing out of Palm Springs one day in his Lear, and it was just the two of us sitting there with a bottle of Jack Daniel's—corked, because he had stopped drinking—and a package of Camels—unopened, because he stopped smoking—and we were flying across the country to do some fundraising events for the Reagans. He looked over to me and asked what I was thinking about. I said, "I am thinking about Joe Canzeri, whose parents came out of Sicily on a mule in 1900, and here am I riding across the country on a jet airplane with Frank Sinatra." He looked at me and said, "My parents came out of Sicily on a donkey in 1900. Here am I riding across the country with Joe Canzeri, assistant to the president of the United States."

w.o.: Sinatra had a pretty good eye for the ladies. Did you see any of that?

j.c.: Apparently from what I have read, he did. But I never saw him actually do anything or act in an ungentlemanly way. Ever.

w.o.: What was it about Sinatra? It was more than the singing, which was superb. You sat alone with him of an evening.

j.c.: The same thing about Sinatra as Reagan: they were consistent. He was consistent about how he handled the media. He didn't give. He didn't bend.

w.o.: But were they natural or were they always working to burnish their image? Did you ever see Frank Sinatra in a pair of jeans and sneakers?

j.c.: Oh sure, I saw him in his shorts shaving in front of the mirror. I saw him in his little caboose bar in back of his house in Palm Springs. I saw him go after his wife one night verbally at a restaurant because she said something to one of the waiters that he didn't like.

w.o.: Did Sinatra have a pretty bad temper?

j.c.: It was a flash temper. Being of Italian heritage I can understand it better than some. It's a quick fuse. Sinatra held some grudges against people, particularly one of the reporters who took a shot at his daughter, Nancy, calling her a pizza waitress after she did a great song.

w.o.: You talked about how loyal and what a great wife Nancy Reagan was to the president. How about Barbara Sinatra, when he got ill late in his years.

j.c.: I didn't get to see him much during that period. From what I understand, she was there every minute, taking care of him.

w.o.: Did you ever see Sinatra move about of an evening? He used to sit at "21" for supper.

j.c.: He used to go to Patsy's, too, for pizza. I was at the Pump Room in Chicago with him and he would go in and sit down. One night in Washington he said he wanted to get some pasta faggioli. I told him about this restaurant in Alexandria. He asked how far it was, and when I told him it was about twenty minutes away, he said he didn't want to ride twenty minutes. I told him it was worth it. So we got in the car and went over to the restaurant and had dinner. When we got back in the car, he said, "That's the first time

anybody has ever recommended a restaurant that far away that was that good."

w.o.: What was it like when Sinatra walked into the restaurant with you?

J.C.: He was a force. He lit up the room. Everybody looked, whispered, turned their heads. We would sit down and order a $1,500 bottle of Petrus.

w.o.: Was he a good tipper?

J.C.: The best. The hundred dollar bills just kept reeling off.

w.o.: Did he ever sing when you two guys were alone?

J.C.: I've heard him hum a little bit but never croon. The only guy I've ever seen sing was Perry Como. I spent a weekend with him once down in Florida with his son, Ronny, and Perry would come for dinner and he'd be singing a song as he came through the door. It was marvelous fun.

w.o.: You've had a pretty good life.

J.C.: I've had a hell of a ride.

w.o.: You live in Manhattan now with your wife, Tricia Novak Canzeri, the immigration expert. On Park Avenue.

J.C.: How about that? From the hills of Sicily to Park Avenue in one generation.

March, 2001

Interview with Ogden Reid

Ogden Rogers Reid, a/k/a "Brownie" Reid, to distinguish him from his brother Whitelaw, was a child of privilege who grew up at Ophir Farm in the rolling hills of Purchase, New York, across from Manhattanville College. He was publisher of the legendary Herald Tribune *newspaper. A former U.S. ambassador to Israel, he went on to quite an illustrious career in the House of Representatives, where he was a respected liberal voice. Brown Reid now serves as president of the Council of American Ambassadors.*

W. O'SHAUGHNESSY: Tonight, an old friend who served this country for decades. He is a great sailor. He was a newspaper publisher, president of the late, great *Herald Tribune*. He was a paratrooper in his day, a country squire, an ambassador from this nation to the infant state of Israel. He was also a highly respected U.S. congressman, a candidate for governor, and the environmental commissioner of New York State. His name is Ogden Rogers Reid. It's great to see you, sir. Do you still have the paratrooper ring?

O. REID: Yes. It's just the wings folded around the parachute.

W.O.: Would you tell me how old you are?

O.R.: Over forty-five, Mr. O'Shaughnessy. Not as young as you, but I'm getting there.

W.O.: You look wonderful. Are you still sailing the high seas?

O.R.: I'm still sailing on a boat called *Flyway II*. I'm just an amateur trying to have some fun in the Newport-to-Bermuda races and things like that.

W.O.: "Amateur" sailor, Mr. Ambassador? You sail with Dennis Connor, who won the damn America's Cup! Where did you get the name *Flyway II?*

O.R.: We have a little spot down in North Carolina for hunting and fishing, on the Atlantic Flyway, on Currituck Sound, which

means "Call of the Wild Goose" in the Native American language of the area. *Flyway II* became a name we cherish.

w.o.: They call you "Brown" or "Brownie Reid."

o.r.: We dropped the "i-e." Some people think it's the opposite of my brother, Whitelaw, because he's "White" and I'm "Brown."

w.o.: How did that come about?

o.r.: It's just the suntan, Bill. I got brown as a berry, I guess.

w.o.: You grew up in Purchase.

o.r.: I got in all kinds of trouble. At one point the King of Siam came, and I had a little red bug, which was a battery cart, and I had the king on the rear. I thought I would go around the corner very fast, and he tumbled off. So I was in the doghouse for a while. We were right opposite Manhattanville.

w.o.: Did you ever go over and court the ladies?

o.r.: We had a dog who "courted" the nuns and got all sorts of cake for his trouble. I was always trying to get him back.

w.o.: Didn't your family give that land to Manhattanville?

o.r.: "Give" is not quite correct. It was purchased. That was White-law Reid's land, and he, after a fire, rebuilt what became known as Ophir Hall. In '92 of the previous century he accepted the vice presidential nomination from the front steps of what is now Reid Hall at Manhattanville. One of the interesting questions was what the hall should be named for. The suggestion was to name it for grandmother because she had helped start the Red Cross. She was Elizabeth Mills Reid, and she sent nurses to the Philippines in the previous century. So it's technically Elizabeth Reid Hall.

w.o.: After you were finished running around in the red bug cart, you then became, at a very young age, publisher of the *Herald Tribune*.

o.r.: I went as editor and publisher of the Paris edition, and that was a fascinating experience for two years because it was one of the best international editions, going into about fifty or sixty countries. We had a chance to get to know the leadership in England and France and to see the impact on the French journalistic fraternity of a newspaper that tried to play the news absolutely straight. And on the editorial page, we took editorials from different papers from around the country, so it wasn't just *The Washington Post* or *The New York Times*, but it had San Francisco and Texas

and Idaho and various papers that would give a balance to what was on the editorial page in Europe.

w.o.: In those days there were the Reids and the Sulzbergers. Does it bother you that the Reids are not in publishing anymore?

o.r.: No. I have high regard for Punch Sulzberger and the Sulzberger family. What bothers me is the trend in this country to single-newspaper towns. One of the things that was in the public interest is when the *Tribune* and *The Times* came out with their bulldog editions, and they both sat there tearing apart the paper and seeing what they had missed. Now, of course, *The Times* is in a position to leave a story on the spike for a while because they've got no competition. The *Tribune* played a role in the formation of a progressive, moderate Republican Party. I remember telling LBJ how important it was to have two strong *national* parties representing a cross-section of opinion. The *Tribune* played a role, starting with Horace Greeley.

Freedom of the press is so important, as you well know, Bill. You've been a great champion of this fundamental concept, especially among your colleagues in broadcasting, for many years. It really means everything to America. When I was president of the *Herald Tribune*, Tito Gainza Paze, the great Argentinean publisher of *La Prensa*, came to see me. He was the most distinguished newspaperman in Latin America during the time of Juan and Evita Perón. When I suggested to Dr. Paze that there was at least "partial" freedom of the press in Argentina, he looked at me squarely and said, "Mr. Reid, you either *have* freedom of the press, or you *don't.*"

w.o.: When you were in Congress, you were a hell of a fighter on the floor. Do you remember a man named Harley Orin Staggers?

o.r.: I do indeed. He was chairman of a certain committee.

w.o.: The House Commerce Committee. And he had all the votes and was going to throw Walter Cronkite and Frank Stanton in jail because they wouldn't turn over . . .

o.r.: The TV outtakes from *The Selling of the Pentagon,* and I thought that was an infringement of First Amendment rights. Basically, what I tried to say on the floor was the fact that the founders did not mention radio or TV media in the First Amendment didn't mean that what we now call the broadcast media did not enjoy the same protections as the printed press. And I feel very strongly

that it would be an infringement to do what they were talking about. Fortunately, the measure was defeated.

w.o.: You're being modest, sir, because you were a lone voice prowling those halls. Les Brown of *Variety*, who is a resident of Westchester, called me once and told me he never saw anything like Ogden Reid. You were beating up those guys. And you won.

o.r.: We won, Bill. And free speech won.

w.o.: Do you miss your days in Congress?

o.r.: I enjoyed it immensely. I particularly enjoyed, in some ways, campaigning, getting out with people. You learn your county and your country in a way that you don't if you're not in public office and in the arena. I enjoyed going down to see Martin Luther King, Jr., with five others in a jail and then being cursed at by the local jailer because I was someone from the North. And I remember seeing Martin Luther King come out of the jail and kids going all around the block saying one word: *Freedom*. And it had a ring to it I haven't heard since. That led to five of us putting in the first Voting Rights Bill, and Jack Kennedy put in a bill about three weeks later. I like to think taking some initiative on voting rights has been important to the future of the country. We had a chance to work on education, foreign affairs, and another area that I care very much about, the arts and humanities. When we started we got $5 million through Congress. It wasn't even appropriated the first year, but now we have the Endowment on the Arts and Humanities.

w.o.: You started as a child of privilege in Purchase, on lands in your family for years. Then you ran a big Republican national newspaper. You were a Republican congressman. And then you switched, Brown Reid. You became a Democrat.

o.r.: That's right. We had to do something, not alone in civil rights, but in education and health as well. I remember one day a great friend of mine, Silvio Conte from Massachusetts, who was senior on the Appropriations Committee, had a modest health bill—I think it was for open-heart treatment and research—and I went on the floor and thought it was a simple amendment and would pass. One leader of the Republican Party was encouraging: Gerald Ford. And another one, Mel Laird, was back a few rows and going thumbs down. The Party did not in those days, in my opinion, fully support education, the right of any American to go to col-

lege. John Brademas and I got legislation through enunciating that principle. The Republican Party was good on the economy and defense, but they were a little behind the curve on education and health. And then there was a certain vice president I didn't think all that much of. He was with Mr. Richard Nixon. You may recall his name.

w.o.: Spiro Agnew.

o.r.: That is correct.

w.o.: But was that a tough decision for you? All of a sudden Ogden Reid, big moderate Republican, becomes a Democrat.

o.r.: It became a matter of principle, Bill. I believed the Congress, to be effective, had to have the moderates on both sides of the aisle working together. When I was first sworn in as a Republican, the first to walk across the aisle to shake hands with me was Adam Clayton Powell. Neither Democrats nor Republicans said terribly disparaging words when I became a Democrat.

w.o.: They didn't call you a traitor or a Judas? John Lindsay and Ed Meyer, now a regent, became Democrats at the same time.

o.r.: And Pete McClosky decided to stay a Republican, and a fellow named Don Reigel decided to become a Democrat, and he's now chair of the Banking Committee of the Senate.

w.o.: But there ain't no more liberal Republicans around.

o.r.: There used to be the Wednesday Club that had the likes of Mac Mathias from Maryland, Robert Stafford from Vermont, and Bob Taft from Ohio. They were moderate Republicans. The Wednesday Club played a role in the House. There has been more polarization recently. In my own view, the Republican Party needs to latch onto the center and the future. It can't be exclusionary. It has to stand for certain things that are basic to our kids and the environment.

w.o.: Do you remember when you ran one year for Congress, Nelson Rockefeller went ballistic and put up a couple of hundred grand and Carl Vergari against you? That was a hell of a battle.

o.r.: I have high regard for Carl, who has been a distinguished and wonderful Westchester district attorney. That was an interesting race. And I remember that a certain radio station whose owner was a personal friend of Nelson's stood bravely by my side.

w.o.: What about you and Nelson?

o.r.: I can tell you a little story. We had a "difference of opinion."

Part of it was over a bridge. I said he could build his Rye–Oyster Bay bridge through Rye, but there would be one small problem. He wouldn't be able to *connect* it to the land on either side because that became a federal matter!

w.o.: Were you being serious?

o.r.: No. But we prevailed with an amendment to stop his bridge. Still, I think Nelson would have made a great president of the United States. He was innovative. He was excited. He had all kinds of ideas. He believed in the arts. He cared deeply about this country. He did more on Latin American relations than any other president. But on one or two matters we did have some differences. When the vote in the House on his becoming vice president occurred, as chance would have it, I was leader and took the tally sheets back to him because he was in an anteroom having a private reception. And he threw his arms around me and said, "Let's bury the hatchet." And there were some press guys around who were saying, "What hatchet? What's going on?" I just smiled.

w.o.: That was a good moment.

o.r.: The *Tribune* was the first paper to back him for governor. And it was a good decision. He was absolutely first rate. If we could only have had more of his ability, but there is only one Nelson Rockefeller.

w.o.: At the risk of patronizing you, Brown Reid, why don't we see more Ogden Reids or Nelson Rockefellers submit to the rigors of public service?

o.r.: One of the problems is that we tend to scrutinize people in public life awfully hard. There should be a distinction between private and public life. One or two of my sons, I hope, will go into politics. But part of the problem is that their wives are not so sure they want to go through all of it. I think it's a noble endeavor. Of course, there are all kinds of ethics questions raised. When I ran for governor I put ten years of income taxes out, which were on the front page of *The Times*. But I think we can go too far in examining everything; and very simply, if someone has *never* made a mistake, I wouldn't want them in public office! You learn from your mistakes. In some respects President Bill Clinton has gone through a tough campaign . . .

w.o.: Why were we both thinking about Clinton?

o.r.: The American people have matured, but will people go into Congress now or become a member of the cabinet or an ambassador? Not as readily as they used to because they are concerned that every single thing they ever did is going to be examined, and that casts a little bit of a chill. I think that particular statute ought to be revised.

w.o.: You're now president of the Council of American Ambassadors. Is Mrs. Pamela Harriman in that?

o.r.: Pamela Harriman has just become a member, and she's on her way to Paris shortly and is about to be confirmed. She is terrific. She's gracious, beautiful in many respects, knowledgeable, and has absorbed all kinds of history from the Churchill family and from Averell. One of the things she wants to do is make a particular effort to help American business overseas. When we talk about global economics, we're talking about American companies getting to the starting line much faster and in some cases being helped by government. The French, the Germans, and the Japanese do it, and we're in a competitive battle overseas on the economy. She has to worry about the Uruguay Round and the French position on that, but she'll be great. Jean Kennedy Smith, another new member, will do great.

w.o.: It sounds as if you miss this international stuff.

o.r.: I've been particularly fortunate to be in the newspaper world and then government, both elective and appointive. I'm now trying to work with the prime minister of the Ukraine on nuclear safety. There are ways to go from one thing to the next and remain useful.

w.o.: I want to ask you about the present leaders of the state of Israel.

o.r.: Let me talk about two of them. Ezer Weizman is now about to be the new president of Israel. He was defense minister. When I was there, he was chief of staff of the Air Force and nephew of the first president. He is a good guy, a moderate. Prime Minister Yitzhak Rabin I was with recently. He's going to do his level best on the peace process, including meeting Syria halfway on the Golan Heights, provided there is a genuine, full-fledged peace with Syria, not just the illusion of it. He is concerned about another subject: Islamic fundamentalism. There was a meeting held recently of Egypt, Tunisia, and Algeria on the subject, and part of the reason is that in Egypt last year they lost $2 or $3 *billion* of

tourist revenue because of the Islamic fundamentalists and the explosions they set off and the like. And if the World Trade Center bombing doesn't give us a wakeup call . . .

w.o.: But will there ever be peace?

o.r.: The peace process can make some headway, but if the fundamentalists want to destroy or eliminate all secular Arab governments, then there will be no democracies, no free press, no great station like WVOX. What that means is that the only country in the Middle East that remains democratic is Israel. Ultimately, Prime Minister Rabin would say, if you're going to negotiate peace, you've got to negotiate with *something* and with *someone* who stands for human rights and democratic values and is not a total dictator. In terms of the Palestinians, part of the problem is that we don't know precisely *who* speaks for them, and any real leadership of the Palestinians is apt to get knocked off.

w.o.: Ambassador, publisher, congressman, sailor, country squire: you're not finished yet, are you?

o.r.: No, sir.

October, 1998

Interview with Jonathan Bush

The Bush family is a modern-day political dynasty that has produced two U.S. presidents, governors of Texas and Florida, and a prominent U.S. senator. Jonathan Bush is a member of the formidable Bush clan and an engaging fellow. Although he grew up in Connecticut, Jonathan Bush knows a lot about politics in the Empire State. We interviewed this nice man just before the 1992 presidential election. Jonathan is a brother of one president and uncle of the current chief executive. He and his wife, Jody, are also parents of William A. "Billy" Bush, a delightful young man who, like his father, started in show business as a disc jockey at one of our Westchester stations. (Billy is also loaded with charm and is among the most attractive of the next generation, and I predict a bright future in radio and television for him.)

W. O'SHAUGHNESSY: The individual we're about to meet is chairman of the United Negro College Fund. He is also First Brother of the United States: Jonathan Bush. Who is going to win this bizarre election? Your brother, Bill Clinton, or Ross Perot?

J. BUSH: Bill, President Bush is going to win a great victory. Let me give you a little history. There have been two elections in this century in which the incumbent president was dramatically far behind in the final week of the campaign.

W.O.: One is easy: Dewey vs. Truman.

J.B.: The other was in 1936 when Alf Landon was leading Franklin Roosevelt 59 to 41 on October 31 in the Literary Digest Poll, which had been correct in each of the four preceding elections. It was the largest, most sophisticated poll ever conducted to that time. Ten million people had been polled. They had over a thousand fulltime staffers running the poll! But polls don't indicate how people are going to vote in presidential elections. You see tremendous turnarounds. The Gallup Poll almost went broke after

1948, and the Literary Digest Poll did go out of business after 1936.

W.O.: Just before we came into this studio you were on the phone with Jim Baker, campaign manager for your brother. What did he have to say?

J.B.: He said we were coming on very, very strong. I told him he was doing a great job, and he said the person who is doing the best job is my brother. Jim said he's the greatest campaigner he'd ever seen in his life.

W.O.: He was fabulous in Iowa early this morning. But he didn't do that well in the debates.

J.B.: Bill, in the first debate, he was president of the United States. The second debate was a minefield. This was supposed to be a bunch of people who hadn't made up their minds. George sensed the danger right away. He literally did not know what was coming next. So he realized he had to go very, very carefully.. The president won the third debate hands down and going away.

W.O.: Mario Cuomo once told me you are the brother George Bush always wanted to be.

J.B.: It's the other way around. But that's a great compliment coming from the governor. The president is an extraordinary person and an extraordinary brother to all of us. He never lets anything interfere with his love for his family. That's the way it always has been.

W.O.: Does he know you're out stumping?

J.B.: Sure. Every Bush is out campaigning.

W.O.: Someone said there is nobody within the Beltway who dislikes George Bush.

J.B.: It's very hard to dislike George Bush. Everyone likes to feel important, and George is interested in what everyone has to say. He's a little bit like Jack Kennedy. You knew Jack Kennedy, Bill, I know.

W.O.: And I admired him.

J.B.: Personally, he was one of the most charming people I have ever met. He could relate to you personally in a matter of seconds, and you had the feeling you were the most important person in the world when you were with JFK.

W.O.: Does it hurt you when they push your brother around in the press?

J.B.: It does, Bill.

w.o.: In years past, you were a Broadway star. You traveled and toured and even sang with the legendary Sylvia Syms.

J.B.: I spent about five years in show business—and let's please get off this as quickly as we can—back when I was in my twenties. People do things when they get out of college and out of the Army. You don't really want to go to work. You're just not ready. You want to see if you have something inside. I wouldn't trade one minute of it—including being Santa Claus at Macy's for three years! I had a huge following who came back to see me each year.

w.o.: At what point did you give up the lure of the greasepaint and the roar of the crowd to become an investment manager?

J.B.: When you are approaching thirty and employment is not that regular . . . a lot of things conspired to tell me I should do something else.

w.o.: When you were growing up with George Bush, did you share a room with him?

J.B.: When he would come home from school. My older brother Prescott was another great guy.

w.o.: You were the baby brother?

J.B.: No, Bucky was seven years younger.

w.o.: Around the dinner table, was it "even then we knew" about George Bush?

J.B.: Even then. On the night before the Inauguration I got a phone call from a girl I was wild about fifty years ago, and she said, "You may not remember me but I just wanted to call to remind you that you told me, when we were eleven years old, that your brother, George, was going to be president of the United States."

w.o.: Did you have a hard time explaining that to your wife, Jody Bush?

J.B.: I think she was impressed that I made an *impression* on that girl! Everybody knew George would be in the White House.

w.o.: You were all over the state yesterday with Senator Doug Barclay, who heads your campaign in New York.

J.B.: We were in Albany, Schenectady, Rochester, Buffalo, Watertown, and Westchester.

w.o.: What did you find? I ask you this because Gannett said the president is going down two-to-one in this state.

J.B.: I saw a poll today that shows the president behind 13 points with 20 percent undecided and 15 percent for Perot. I don't think

this means a darn thing. The president is going to take this state, and I think people are really pulling up their sleeves to get that message out. I was at a county dinner in Lake Placid and told people if they wanted George Bush to get reelected, they had to get to the supermarkets. And the county chairman called me up this morning and said, "Guess what? Mildred whatever-her-name, who was at the county dinner, signed up twenty friends, and they're ringing every doorbell in the neighborhood."

w.o.: Why are all the mighty press barons against George Bush?

j.b.: I wish *you* could answer that for me. You are a great press lord in the state. You know the media. Can *you* tell me why?

w.o.: I have a simple answer to that: the economy. Their advertising revenues are down.

j.b.: I hadn't even thought of that. Economics can be at the heart of a lot of problems.

w.o.: But the rising tide that lifts all boats, as Jack Kennedy used to say, also recedes to lower all boats, and your brother, the president, would argue it's a worldwide thing. Is he right?

j.b.: The president would also argue that our economy is stronger than anyone else's in the world. If you look at our Gross Domestic Product, which is the measure of how our economy is doing, you'll see we're not doing that badly. It's not a recessionary GDP. It's not booming *growth*. But get the president back in there and give him the confidence of the American people, and he will get the legislation required to give this economy extra stimulation. And it *isn't* government spending. What he's calling for, Bill, are across-the-board reductions in personal taxes and the capital gains tax. Our country operates by businesses employing people. It's that simple. That's what democracy is. Democracy and capitalism are two sides of the same coin.

w.o.: Do you really believe in "trickle down"? You make the rich richer and they'll create jobs?

j.b.: When you think of trickle, you think the pipe isn't working. You have to get it fixed, right? Clinton has dreamed up a very good metaphor. But what he's talking about is democracy. He's saying that what we have done since our country was founded, with people running businesses and employing people, is no good. He suggests that what needs to be done is to have the government

employ people and run businesses. He wants *"government* trickle down."

w.o.: Forget that George Bush is your brother. How would you, as a citizen, like a Democrat president *and* a Democrat Congress?

J.B.: Gee, what a terrible thought. Look at England when it went socialist. Or Argentina in 1946. Argentina was the fourth most productive economy in the world, and when the Peróns came in, it became one of the *least* productive and went totally bankrupt. The new Argentine president has finally started to turn that around, after the country went through great agony.

w.o.: Let me ask you about Barbara Pierce Bush.

J.B.: You know her, Bill. She is as much fun as any woman in this world. You talk about laughs. Nobody has a *bigger* laugh than Bar! It comes right up from her toes. She grew up in Rye. She and the president were sixteen and seventeen when they met.

w.o.: What do you think about Ross Perot?

J.B.: Here's a guy who knows so much but is using totally false figures. The media, who I believe has a bias, is constantly trying to turn your attention to Ross Perot—anything to head off this wonderful surge the president is making.

w.o.: It's been suggested that Perot is a creation of Jim Baker, that you guys are keeping Perot propped up.

J.B.: You've got to be kidding! There's absolutely nothing in that at all.

w.o.: What do you think Perot will get?

J.B.: Would you mind, Bill? I just don't want to talk about Perot. I like to think he's not a factor in this race. People should be thinking about these two candidates—Bush and Clinton—and the differences between them. My own feelings about Clinton are that he just is not remotely ready to be president, and I don't think the American people are going to want to go in and vote for this man to be president.

w.o.: What's happened to the Republican Party? Have the Neanderthals and arch-conservatives captured it?

J.B.: I've been around politics off and on throughout my life, and I think the Republican Party has a state chairman now who is going to be similar to John Bailey in Connecticut when I was a young man. Bailey was dead honest. You could trust him, and he was a great leader. He knew how to bring candidates along. He

knew how to marshal financial resources and put them where they were needed. And I think this fellow Bill Powers is one of the finest state chairmen I've seen in a long time. You can already see a dramatic turn in the attitude of the Republican State Committee. He understands the discipline of politics. We have sixty-two county chairmen, and he has them all in lockstep. It's the first time we've really had that.

w.o.: You are the president's brother, an ambassador without portfolio. That gives you a lot of clout.

J.B.: Yeah, and because I was finance chairman for six years, the guy who raises the money and pays the chairman's salary, everybody probably treats me with a little bit of respect.

w.o.: Who have you got in the wings to take on Cuomo for governor?

J.B.: You have been such a great, staunch supporter of Governor Cuomo, Bill. He hasn't had a stronger supporter in his entire political life, and you've been enormously valuable to him. Every governor—or president—needs someone to boost his spirits in times of need. My own view is that there is a good chance Governor Cuomo will not run again. The president is going to be reelected, and Governor Cuomo will have an opportunity to run for president in 1996. And I'm only thankful that Mario Cuomo is not running right now because he is a very honorable person, whether you agree with him or not politically—and I disagree with him on a *lot* of fundamental things. But in '96 he could be pretty tough. And I also think he cannot really run for governor of New York again and then run for president.

w.o.: You serve your brother so well, and I can only observe, if you'll allow me, that you really *are* the nice man we had heard you are.

J.B.: Bill, what a nice thing to have me onboard right at the end of this very tough campaign.

<div align="right">November, 1992</div>

Interview with Mario Biaggi

Mario Biaggi, one of the most decorated officers in the history of the N.Y.P.D., almost became mayor of New York. But he went to Washington, D.C., where the popular congressman served several terms in the House of Representatives as a great ally and pal of Speaker Tip O'Neill. The hero-cop turned congressman also endured a humiliating chapter in his colorful and varied life when he was brought down by Rudy Giuliani who, as a U.S. attorney, snared Biaggi in the Wedtech scandal. To this day, Biaggi maintains his innocence. Now in his eighties and on crutches as a result of injuries suffered in the line of duty, Mario Biaggi is still a popular and beloved figure. He currently resides in Riverdale overlooking the Hudson River.

W. O'SHAUGHNESSY: This really is his first public appearance in a long time. He's a former member of Congress, a former candidate for mayor of New York, and the most decorated police officer in the history of the New York City Police Department: the Honorable Mario Biaggi. You're like a Lazarus. How old was Lazarus when he rose from the beyond?

M. BIAGGI: I really don't know, but he was young enough and strong enough to rise with a little help from the Lord.

W.O.: How old are you, Mario?

M.B.: Seventy-four.

W.O.: I had lunch with you the other day in a public restaurant, and I thought I was with a movie star. My ego was on the ground when I got home and told Nancy nobody paid attention to *me*.

M.B.: That's not quite true. But people have been kind as I move about. Not only do they greet me, they encourage me to get back into public life. That's been going on for a number of months.

W.O.: You were in the *New York Post* the other day, prominently displayed going around your old congressional district. Are you going to run again for Congress, Mario?

M.B.: I haven't made a final determination. It's something I'd like to do. But because of the seriousness of it and the commitment that must be made, I am assessing it very carefully. A great deal depends on the final new district lines the Legislature is in the process of preparing.

W.O.: You wouldn't go against Nita Lowey.

M.B.: No. Nita is doing a fine job where she is, and that's the northern part of Westchester. I'm not just running to satisfy Mario Biaggi's ego. My purpose in running would be to answer a need and fill a void that has been there since my departure.

W.O.: Are you talking about Eliot Engel?

M.B.: Clearly, that's the man who has prompted the people to urge me to consider this.

W.O.: But do you need it, Mario? You have known great triumphs in your life, but you have also known great unhappiness and great sorrow.

M.B.: That's exactly the point. I always felt that I was a victim, clear and simple.

W.O.: A victim of Rudy Giuliani?

M.B.: No question about it. If my name were John Doe, I would not have been in this plight. I was a high-profile character, and Rudy was in the process of building up his own profile in preparation to run for mayor—which, in fact, he did.

W.O.: Are you going to endorse Rudy Giuliani for mayor this election?

M.B.: I'm sure he'd be the very last person in the world I would ever endorse, nor would I ever encourage anyone else to do so. I may one day be able to forgive him for what he did to me. But I can never forgive him for what he tried to do to my sons.

W.O.: Are you bitter about the Wedtech stuff and having to go down to that awful prison in Texas?

M.B.: I'm not bitter. You must understand my philosophy. I have had many ups and downs in my life. I have four children, ten grandchildren, a wife, and a host of friends. I'd like, however, to submit myself to the people's will again.

W.O.: Did you do nothing wrong?

M.B.: Absolutely not. As a matter of fact, I took a lie detector test and offered to take his. And by the way, the polygraph expert is a man who was and continues to be hired by the Department of Justice

to administer the test for the government. Giuliani refused. He didn't want honest resolution to the case. There was a $250 million scandal committed by four principals who cooperated with the government. They kept their money, served minimal sentences, and I was the "case."

w.o.: When you were convicted, another Mario in public life, Mario Cuomo, called someone in this county and said, "What an awful tragedy to have him there in that federal prison." Pete Hamill, your friend, wrote a column about being in the slammer the other day. Do you know what he and Leona Helmsley, for example, are going through?

m.b.: Sure. But they'll survive it. If you have inner strength and resolve, you'll survive it. If you know within your mind and heart that you didn't do anything wrong, you can endure anything.

w.o.: So you're walking the streets again. Is there anyone you can't look in the eye?

m.b.: Not a soul. And that's more than some of the people who participated in that trial can say.

w.o.: What would you say to Giuliani if I produced him right now? He's not outside, by the way.

m.b.: I'm always a gentleman. I'd say hello. As a matter of fact, at a Christmas party people were surrounding me and waiting to say some nice things and shake my hand, and who do you think was waiting in line to shake my hand? Giuliani. I wouldn't have shaken his hand if I had known he was there, but it was almost instinctive.

w.o.: It's over. It's behind you.

m.b.: Absolutely.

w.o.: You want to go back to Congress? You've still got the ring on?

m.b.: Oh, yes.

w.o.: Let's see the ring.

m.b.: That's a ring I had made out of an identification pin that each member of Congress is given every two years to put on the lapel so the staff and security people know you're a member.

w.o.: There was a wonderful story going around that you gave Tip O'Neill a ring.

m.b.: That's gospel. I was talking to Tip one day, and we're chatting about some other matters and he saw the ring and said, "Marty, that's a very nice ring."

w.o.: He calls you *Marty?*

m.b.: He *always* called me Marty.

w.o.: Why?

m.b.: I don't know. I guess I was held in such high regard he wanted me to be Irish. Anyway, this was the end of his last term, and he admired my ring several times, so I told him if he likes it that much I'll get one for him. I gave it to a jeweler who recessed it into a ring. Of course, to make a long story very short, I gave him the ring. I wrapped it up in a Kelly Green box. It was the holidays. When he opened it up he blushed; there were tears in his eyes, and he hugged me. What a feeling. It was worth everything. I had called his secretary and told her what I planned to do and asked for his ring size. It was a 13, and gold was $800 an ounce at the time!

w.o.: Do you miss Tip O'Neill?

m.b.: Yes, I do.

w.o.: Did you hear from him when you were in trouble?

m.b.: Yes. He's a fine man. He's avuncular in nature and holds no grudges. He and I were head-to-head on many issues. But when it was over, the arm went around my shoulder and we'd sit and chat.

w.o.: What about his successor, Tom Foley, who's in some trouble himself now?

m.b.: Tom is not Tip O'Neill. Let's put it that way.

w.o.: But wasn't he respected?

m.b.: Oh, he's respected. He's a great floor man.

w.o.: What do you mean, "a great floor man"?

m.b.: He could function on the floor of the House, especially on parliamentary procedures or in conflicts with the Republicans.

w.o.: What marks do you give him as speaker?

m.b.: He certainly was not as good as Tip O'Neill, and the members of the House have been very critical of him. There's a question of whether or not he'll be reelected in the next Congress.

w.o.: This check-cashing thing? Is this a nothing story? Does this make them venal or bad or just plain stupid?

m.b.: For those who had a few bad checks, that could be casual mistakes. But when you talk about 10, 15, 100, 500, 600—well, that's susceptible to some other interpretation. Right now you have a

prosecutor inquiring about fraud, tax evasion, or improper usage of money in relation to campaigning.

w.o.: Is the story going to die, Mario?

m.b.: No, because the investigation is under way.

w.o.: Would you vote against a guy because he bounced a check?

m.b.: No, not because he bounced a check. But if he bounced several hundred checks, it establishes a pattern.

w.o.: Do you miss the perks? The free haircuts . . .

m.b.: I never had a free haircut. I wouldn't let a barber down there touch my hair, and I'm sure you wouldn't either. *You* know that!

w.o.: But you get free parking at Washington Airport.

m.b.: I never had a car. Either I took a taxi or someone would pick me up.

w.o.: What about the presidential election: George Bush, Ross Perot, Bill Clinton?

m.b.: We're going to watch the whole play unfold. Perot makes a big difference.

w.o.: What do you think your old district will say when they hear that you are moving around again?

m.b.: They know it. They've seen me, and I keep getting more invitations every day. A lot of folks are saying, "Come back. We need you."

w.o.: In Eastchester the other day a guy almost fell off a Con Edison pole trying to shake hands with you.

m.b.: There's a void. The people haven't been dealt with properly. They're not providing the service I provided, and it offends me. They call me at home, and I still provide that service. Would you believe, when I was away in prison they wrote to me and called my home with problems and I'd resolve them?

w.o.: Aren't some people unforgiving?

m.b.: I'm sure some are like that, but there will always be people like that in life. We never expect it to be unanimous.

w.o.: How about your old pals in the New York City Police Department? First of all, I understand you weren't that popular among them anyway when you used to book prisoners.

m.b.: That was so many years ago. I worked in the 24th Precinct, and we went bowling with a number of the fellows, and there was a fight and I arrested a few folks and brought them in. I dressed well in those days, when I was young, and the desk officer was address-

ing his remarks to my prisoner. I said, "Wait just a minute. I'm the officer here, Lieutenant." He asked to see my shield, and I showed him my shield, and he called up the 24th Precinct to confirm!

The Police Department is the greatest. They've always been my friends. As a matter of fact every line organization of the department has been supportive. You know about the National Law Enforcement Memorial that was dedicated in Washington last year.

w.o.: It wouldn't have been built but for you.

m.b.: I sponsored it. I monitored it continuously, from Texas and from here, and I was there the day it was opened and President Bush was on the platform with me and a few others. It was a memorable event.

w.o.: Do you like Bush?

m.b.: Yes. I've always liked him. As a matter of fact, we had a masseur downstairs in the gym. The vice president would precede me, and while waiting he and I would chat. The masseur was a wild Hungarian, and his profanity was beyond belief.

w.o.: We're going to get letters now from the twelve Hungarians watching tonight.

m.b.: No, just this one particular Hungarian. He was a good guy and a great masseur.

w.o.: Are you sure you don't miss those perks?

m.b.: What perks? The gym? I think it's critical that people get exercise and a massage if you can get it. I had trouble with my legs. You know that. That was very helpful.

w.o.: Are you still on those crutches? Are you going to be on them always?

m.b.: I'll be able to walk my way out of them onto a walking stick, which I had before I went away. I fell down several times and broke some bones and exacerbated an injury I had in my right leg, an injury I was inflicted with while I was in the police department when I stopped a runaway horse.

w.o.: You once ran for mayor of New York. Here we sit just over the line in Westchester. If New York City falls, is it possible we'll be next?

m.b.: Not Westchester. Westchester has its own vitality.

w.o.: And we don't depend on New York?

M.B.: Not that much. Of course, there's employment. And New York will survive. I'm sure of it. I remember way back when we had another crisis and there was a loan guarantee bill required and we had to go to Washington. New York was unpopular and had a bad image as the place of muggers and prostitutes. That's how the members of Congress, especially those not from urban areas, perceived New York, and their constituents had the same views. So anybody who bashed New York was popular in those areas.

W.O.: You are a child of New York City. Can you look me right in the eye and tell me New York ain't going down the tubes?

M.B.: When you say "down the tubes," you almost say "to oblivion." I don't think it's going to oblivion. If you say it's not the way it was and it's decaying, I'd give you that. I'll tell you about David Dinkins. He's been bashed, and everything he seems to do has gone bad, but he had the courage to curtail expenditures. He's reducing the size of personnel, which has inflated substantially in the last number of years. There'll be another seventeen thousand to be reduced in the next couple of years. Now we have half a billion dollar surplus.

W.O.: You like David Dinkins?

M.B.: He's a gentleman and a decent person.

W.O.: What about Ed Koch? You went to Congress with him.

M.B.: Eddie is just who he is.

W.O.: Is that what you call him?

M.B.: Oh, yes. He's a great character. I've always enjoyed him. He and I are good friends. He has gumption, and he was a good mayor.

W.O.: What about Mario Cuomo? Have you ever heard him tell the story about this woman who came up to him and said, "I want you to meet my greatest friend, the most wonderful politician that ever existed. He's terrific. I want you to meet Mario *Biaggi*"?

M.B.: Mario told me that story himself! She said, "I love you so much. I've always loved you. You're wonderful." And all of a sudden she called him "Mario Biaggi" and started to embrace him. Of course, he felt good and then his chin dropped.

W.O.: Will Cuomo ever be president?

M.B.: Well, he had a great opportunity this time. He could've won that nomination in a walk. The general election would be another story because you never know about the entire nation. He's formidable, he's articulate, but he does have some baggage.

W.O.: What do you mean?

M.B.: The State of New York; the record here . . .

W.O.: Does an Italian American still face prejudice?

M.B.: It's there. There's a mystique in relation to organized crime and Italian Americans that will not dissipate with the passage of time, and that's the shameful part of it. It will be revisited upon us, our families and our grandchildren and great-grandchildren because it's saleable. The writers and the movies perpetuate it. It makes great copy.

W.O.: Will there ever be an Italian president?

M.B.: Sure. And it may be Cuomo. The man is head and shoulders above most politicians.

April 1992

Nine Years Later

W.O.: You still live near us in Riverdale, overlooking the Hudson River . . .

M.B.: . . . and the rest of the great city. It is a wonderful town, and I still love it. It has its faults, but there's only one New York City.

W.O.: You're now eighty-three. Does that make you wiser?

M.B.: Ha! Somehow wisdom develops in it's own inevitable way, and the grandchildren pay more attention to me now! My proudest achievement is that I have eleven grandchildren and one great-grandchild.

W.O.: You're a hero-cop. How many times were you wounded, Mario?

M.B.: Ten times. I was shot, I was stabbed, I was clubbed.

W.O.: Ten times? Mario, were you a little stupid or a little slow?

M.B.: I was "adventuresome," Bill.

W.O.: You don't need ten scars.

M.B.: I know. I certainly would have preferred being someplace else all those times. It wasn't destined that way. The last time, when I lived on Mosholu Parkway, I was driving a friend's car and a man stuck a gun into the window and got into the car. We exchanged eleven shots *inside* the car. I killed him, but he shot me twice.

W.O.: You used to ride a horse.

M.B.: I was also on foot patrol one day when an equestrian lost control of his mount, and having some knowledge of horses, I

thought I'd be able to stop it by grabbing the halter. I had my arms crooked, and I didn't account for the jolt. The horse dragged me, and I was hospitalized for quite a while.

W.O.: Which were your best years? The hero-cop or the U.S. congressman, friend of Tip O'Neill?

M.B.: I guess I was more productive as a member of Congress because we reached out to so many people in so many ways. But I can never forget the friendship, affection, and collegiality I had with the great men and women of the New York Police Department.

W.O.: You still go to their dinners, and you get the biggest rounds of applause. I've seen and heard it.

M.B.: They are very kind to me, and I appreciate it. Aside from that, I see old friends. But what seems so sad is when we have roll calls. It's a tradition: when people don't respond to a roll call when their name is read, it means they've passed away. It's a question of days for me, Bill. I'll be there soon. God has been good to me and I'm ready.

W.O.: Don't talk like that, Mario. You better stick around because you are one of the most recognizable icons of New York. You look terrific. I don't want you to say you're ready for anything but coming back to our radio studio.

M.B.: The truth is, Bill, I'm looking forward to many years to come, and I want you to be here.

W.O.: We love you, Mario Biaggi. New York loves you, sir.

March, 2001

Interview with Bill Plunkett

Bill Plunkett is the most powerful lawyer in New York State. He is Governor George Pataki's mentor and an advisor to New York's cardinals. He is one of America's most respected Catholic laypeople.

W. O'SHAUGHNESSY: He's a Westchester civic leader, senior partner and founder of Plunkett and Jaffe. He's an advisor and counselor to governors . . . the previous one *and* the current one. He is also president of his beloved alma mater, Stepinac High School. He does so much for them and for so many other organizations. He is William Plunkett, Esquire.

I still can't believe George Pataki beat Mario Cuomo.

B. PLUNKETT: I know you can't. A lot of people can't. You've known George Pataki for a long time, as I have, Bill. You know what a terrific person he is, what an able man he is. And as he proceeds into his first gubernatorial year we're going to see he's a strong, forceful, committed leader and a fellow of real substance. You'll be watching the evolution of somebody who I believe will be one of the greatest governors in the history of this state.

W.O.: I believe everything you tell me, Bill Plunkett.

B.P.: Governor Pataki is what many of us used to call a natural for this business. He's a lawyer and a farmer. He has the common touch—worked his way through both Yale and Columbia Law School. And he has a great rapport with the people. For instance, the other day at Reader's Digest, he insisted upon getting out in the audience to meet the people, not just the business leaders but the ordinary people. That's George Pataki. He's a regular guy and a great guy.

W.O.: He was your junior partner.

B.P.: Many people said *I* worked for George Pataki! George was with our firm for about fourteen years. He was outstanding. He's a very

able guy in anything he does—except he's not a good shooter with the basketball. He's a rebounder.

w.o.: Do you play ball with him?

B.P.: We've played together in the past. I'm getting too old for it.

w.o.: There are those abroad in the land who say they should've run Plunkett for governor.

B.P.: They're confused. Why should I run for governor? George Pataki had the courage to run for governor. He made the sacrifices necessary to run, and he won. You can't get any better than him, and you certainly can't argue with the results.

w.o.: You've been around Westchester for years. Nelson Rockefeller, Jr., now thirty, working for Senator Bob Dole in Washington, called yesterday and said, "You've got Bill Plunkett on the show. He's a great man. He could have been county executive." You could've had a judgeship ten years ago. Why didn't you do any of it?

B.P.: I have different priorities. First of all, I have tremendous respect and admiration for anyone who runs for public office and serves. It's a demanding, challenging, twenty-four-hours-a-day, seven-days-a-week job. For those who serve, I say thank you, no matter what party they're in. Particularly today, it is a tremendous sacrifice and we all owe them a debt of gratitude. I don't care what you think about them. My priorities are different: family, church, my law practice.

w.o.: But you and Caryl Plunkett are on every dinner committee for every cause. You're always giving speeches. Why don't you just leap in?

B.P.: It's not a twenty-four-hour, seven-day-a-week thing that I do—or that you do for that matter, O'Shaughnessy. I'm able to pick and choose my spots. A political person cannot. You're not in control of your life when you're in politics.

w.o.: I hear that you're working pretty hard on the governor's budget and on advising and counseling him. I feel good that you're whispering in his ear, but who else is?

B.P.: I'm just one of many. I have no special connection at all, other than that the governor and I are very good friends. George Pataki is one of the best listeners you'll ever want to meet. He genuinely cares about what you have to say. That will be one of his great strengths. So when you talk about an issue, as complicated as it

might be, he gets the point very quickly. He also has assembled—and I give him enormous credit for this—one of the great executive chambers that will serve in this state. His secretary is our longtime friend Brad Race, who is a very successful lawyer who has made a great sacrifice to take this job—in the best tradition of public service, really.

w.o.: Who else is in the court?

b.p.: Mike Finnegan, who was with our firm for many years, is a favorite of mine. He is counsel to the governor. Those are the two top positions. And he has two or three other people. I regard them all highly. One of Pataki's really distinguishing characteristics is that he delegates. He has as his deputy secretary in charge of public authorities and agencies a fellow named Lou Thomson, who is a special friend of mine, a partner for years, but he's really one of the most able guys in the state. You're already seeing his abilities.

w.o.: My colleagues in the press are worried about the D'Amato influence on these guys.

b.p.: Your colleagues in the press are often confused, as you know, particularly about Governor Pataki! Senator Al D'Amato is a U.S. senator from New York. He is the ranking Republican. When it came time to select a gubernatorial candidate, obviously, the ranking Republican in the state is going to have something to say about it. D'Amato did not ordain Pataki. It was the "Governor of the Week" club there for a while. Throughout it all, George Pataki persisted. Pataki said, "I'm going to run for governor. I want to put my candidacy first before the leaders and then the public." He never deviated from that. When Senator D'Amato finally realized what a great candidate he had here, then he embraced Pataki's candidacy. Of course, he supported him, and of course, the governor owes Senator D'Amato a great debt of gratitude, as do we all.

w.o.: One more question on Pataki. There's a story going around that on election night, while you and George Pataki had supper, he asked you, "Are we going to win this thing?"

b.p.: He did ask that question, and my answer was, "I hope so." Nobody could have said with complete authority an hour before the polls closed that Governor Pataki was going to win. We *thought* Governor Pataki would win. We *hoped* he would win. There was no empirical data to suggest that was an absolute certainty.

w.o.: You enjoy the friendship of both governors, the current and the former. You hired one of Mario Cuomo's youngsters, Madeline, and gave her a job right out of law school. Mario Cuomo regards you highly even though you beat him. You're now competing, aren't you?

B.P.: Because he just became a lawyer? I don't think anyone is competition for Mario Cuomo. I mean that. He's one of the most extraordinary persons and public figures who's ever been seen in this state—a man of enormous talent and intellect. I don't know of a finer speaker, with the possible exception of Sister Bridgette Driscoll, my friend at Marymount. Cuomo is in a class by himself as a public figure. And the Cuomos have a great sense of family—something that is particularly important to me and, I know, to you, Bill. I wish Cuomo hadn't run. Twelve years was enough. He had an uphill fight because of that, and I happen to be in favor of term limits.

w.o.: Even for Pataki?

B.P.: No question about it. I think Pataki should get out after eight years.

w.o.: You have another endeavor, I've learned. Your law school roommate wants to be president of the United States. It must have been something in the water.

B.P.: My law school roommate, Lamar Alexander.

w.o.: Do you think he can possibly be president?

B.P.: He has the same chance to be president that Governor Pataki had to be governor.

w.o.: That's a great line. Do you really believe it?

B.P.: I really believe it.

w.o.: He looks like kind of a dull guy.

B.P.: He's a great guy. How many honky-tonk piano players do you know in the United States? How many guys have appeared at the Grand Ole Opry on a regular basis! He was a two-time governor of Tennessee, a White House fellow, a Circuit Court law clerk to a very prominent judge in New Orleans, Judge Minor Wisdom. He comes from east Tennessee, which was one of the few places in the South that remained loyal to the Union during the Civil War. He's a great family guy, a religious man without wearing it on his sleeve. He's very strongly rooted in values and a man of enormous intellect.

w.o.: What about Colin Powell?

B.P.: Who knows? Is he a Republican? Is he a Democrat? Does he want to run? Will he run? There can always be speculation about new candidates. Again, I go back to what I said a few minutes ago about Governor Pataki, when there was a new candidate floating around every week. Politics rewards those who are persistent, those who have a goal, those who stick with it, such as Governor Pataki did. You can't be in and out. Lamar Alexander and Phil Gramm and Bob Dole apparently are the three top contenders right now, and Lamar is perfectly situated. He's got money. He has excellent advisors. Obviously, I'm hopelessly biased.

w.o.: And obviously, you're persuaded Clinton has to go.

B.P.: I believe he does. But I must say that I respect a man who is persistent, who takes a challenge and is focused on his objective. And I think the American people admire those characteristics too. I'm not a person who says this is a sure-shot Republican win in '96 at all. I believe it will be a real contest.

w.o.: Tell us about our home heath. There's a terrible battle going on between Tony Colavita, who is your friend and my friend, and the Spanos of Yonkers. I only know what I hear in the press, so it must be true.

B.P.: That's your first mistake—but you know that, Bill.

w.o.: Don't you believe what you read?

B.P.: It depends who is writing it!

w.o.: Tell us what's going on. We both know we like Tony Colavita.

B.P.: It's time for a change in Westchester. It's no secret that our good friend Tony did not enthusiastically back George Pataki, and it's no secret many of Governor Pataki's people think the chairman should move on.

w.o.: To the victor belong the spoils.

B.P.: That's partly true. Tony has been chair here for a long time, and he's done an excellent job. He deserves to be treated with dignity and respect. I'd like to see him voluntarily step down.

w.o.: But it's unseemly, what they're doing.

B.P.: It's always unfortunate when such good friends like Tony and Nick Spano are at loggerheads. Nobody likes to see that, and I hope it will end soon.

w.o.: Can we disagree on this as we do so often? I'm for Colavita.

B.P.: I'm not against Colavita. We are very good friends. We serve on

the Stepinac board together. I had the privilege of conferring the Hall of Fame honor on him last year. I think the world of Tony.

w.o.: I know you're very active in the County Association with Larry Dwyer and George Delaney. We used to have Bill Butcher, Fred Sunderman, Harold Marshall, Fred Power, and Ed Michaelian.

b.p.: You're older than I am. You remember all these guys?

w.o.: Maybe they weren't so great, but we thought they were. They were active in everything, and they built the county. Where are the builders of tomorrow?

b.p.: The county has changed a little bit. We used to get those bright, attractive young men and women out of the banks and the business establishments in the county. The days of the strong personal banker, the Jim Hands or your friend Tom Langan, for instance, who knew everybody and went to the wakes and funerals, are gone. I'm also reminded of Malcolm Wilson, who, to me, is in a class by himself. But you're not seeing the same leadership you would normally see coming out of the corporate businesses. Probably the thing that strikes me most is that you're going to see significant leadership coming from women in this county. You're also going to see leadership from people in law firms.

w.o.: A lot of them take but don't want to give back.

b.p.: There are some people who give of themselves. I think of B. J. Harrington, who gives so much to the 52 Association, Joe Carlucci, Frank McCulloch. My own brother Kevin Plunkett is a rising star.

w.o.: You mentioned the fiftieth governor of New York. He's now eighty years old and practices law to this day in White Plains. You were Malcolm Wilson's advance man, weren't you?

b.p.: George Pataki, Brad Race, and I were his upstate coordinators in 1974. We both know Malcolm Wilson's compassion for people. We know all the people he has helped, all the things he has done. We know his outreach, his decency, his family values, and his dedication to the church. You don't find that package very often in one human being. God bless Malcolm Wilson is all I can say.

w.o.: Give me ten seconds on the cardinal archbishop. You're a Knight of Malta, which is very high in the church, higher than I will ever get.

b.p.: John Cardinal O'Connor is an absolutely great leader. A man of principle. A man of courage. He understands that you don't have

to bend with the wind. He knows what he believes in, and he represents that belief better than anybody I know.

w.o.: Andy O'Rourke?

b.p.: A great county executive who will go down in history as the leader who has done as much as anybody, if not more, to make this a truly great county.

w.o.: Caryl Plunkett?

b.p.: She's a great lady, the mother of six spectacular kids. I love her.

w.o.: Thank you for coming on the show.

b.p.: You're one of my idols. Even though we were on opposite sides of the last race for governor!

1994

Interview with John F. Kennedy, Jr., and Andrew Cuomo

A lot of attention was paid by my colleagues in the press to J.F.K., Jr.'s swashbuckling youth and all the beautiful women he squired about New York as a young bachelor before his marriage and tragic, untimely death in a plane crash. Often ignored, however, were the serious, purposeful side to this young man and his contributions toward making this a better place. One night he showed up at our studios with his friend Andrew Cuomo to advocate for the homeless in Westchester.

W. O'SHAUGHNESSY: John Kennedy, what would compel *you*, a bright, beamish young man, to come out on this drodsome night to Westchester to talk about *housing*, a very dull subject?

J.F. KENNEDY, JR.: Well, I've recently joined the Board of HELP, Housing Enterprise for the Less Privileged. So I have become an advocate for the homeless, just like Andrew Cuomo. But more importantly, as a resident of New York City and someone who has lived in this state their whole life who, like many in this community and in New York, is confronted with the prospect of homelessness every-day, it's clear that it's not just a human-resource issue. So I'm glad to be able to come here and talk about what is a very good idea. HELP has managed to take some very good intentions and do something that is very concrete with them. It is a unique partner-ship between the public and private sector and a good idea mor-ally that also makes a great deal of economic sense.

W.O.: John, Andrew went across the country in a camper to talk this up. We've seen pictures of *you* riding your bicycle about town. Has he asked you to go across the country for him on a bicycle?

J.F.K., JR.: No, I didn't get invited to go on that trip, unfortunately! I'm looking to go on the next one. But actually, at the time I was studying for my final law school exam. I did pass, and I'm going to graduate on Friday.

w.o.: That's wonderful. Did you pass the Bar exam?

j.f.k., jr.: I take the Bar on July 26. Andrew and I were discussing that on the way up because he has successfully done it.

w.o.: Then you're going to join Mr. Bob Morgenthau's office?

j.f.k., jr.: Yes, I'm going to be an assistant district attorney.

w.o.: John Kennedy, you could have joined a lot of boards because a lot of people would love to have you and your name. Did Andrew come to you, or did you go to Andrew?

j.f.k., jr.: We met through a mutual friend, but it really happened when Andrew invited me out to see the HELP facility in East New York. I came away with a much more developed understanding about just what homelessness entailed and the kind of people that were homeless. I was glad to join after seeing that, and I have also joined the board that I serve on with you, Mr. O'Shaughnessy. It is an issue that seems to be getting worse and worse each day. HELP has done an incredible job and has some very tangible signs of their accomplishments: the facilities they have built already, the partnerships they have created with the private sector. It seemed like an organization that had really done something. I felt lucky to be part of it.

There is a very well developed recreational facility within the center of the development. Andrew runs a Little League team that is doing "quite well" . . .

a. cuomo: Thanks, John. The reason John says that, Bill, is that last year our season was sixteen games and zero wins! John always makes it clear that it's *my* Little League team. But we never lost a *fight*, I can tell you that!

w.o.: John Kennedy, besides a losing baseball team, what else do they have?

j.f.k., jr.: We've all heard what homeless shelters can be, and I think the first thing you are struck with is what a really hospitable environment it is in which young children can be afforded some stability and some space of their own and really live a normal life under very difficult circumstances. Whether it's in the form of recreation, or just going back to the same four walls every night, it's a place that they can call theirs, which I think is really the first step.

w.o.: John Kennedy, what if somebody wanted to build housing for the homeless in Hyannisport?

J.F.K., JR.: Well, I would imagine that they would be met with a certain amount of resistance. My family has been involved with working with people with mental disabilities through the Joseph P. Kennedy, Jr., Foundation. They were very involved in pioneering group homes, bringing citizens with disabilities to communities, and you had a similar resistance when people were not familiar with the mentally disabled. They had the worst expectations and many of the same fears that people in White Plains and the Westchester community have. Once people are able to see their fears are not realized—that people with disabilities are like everyone else, with aspirations like everyone else and a need for the same kind of stability as everyone else—then many of those fears dissipate. That initial resistance is inevitable, but education is probably the best medicine for it.

W.O.: So when Andrew Cuomo comes calling and says, "John, there are homeless on Cape Cod. We've got a wonderful spot in Hyannisport . . . "

J.F.K., JR.: I'll do all I can. He can start at my house.

W.O.: I don't want to stir up any trouble, but, John, I am reminded, as I look across the table at Andrew, we asked him when he started this thing if it were a prelude to a political campaign. And he said, "If I did want to run for office, building housing in people's backyards is not the best way to build a political career!" Why are *you* doing it?

J.F.K., JR.: I'm involved with HELP because I believe homelessness is an important issue that effects New Yorkers in a very fundamental way regardless of where they live. It's probably the number one human-resource issue in the sense that 50 percent of the homeless population are children. They can still be productive members of society, and I think the first prerequisite to effective participation in society is an intact family in their own house.

W.O.: John, you spoke beautifully at the Democratic Convention. Andrew, just blew them out of the room at the ACLU dinner this past week. Why don't you two guys aspire to public life?

J.F.K., JR.: I'm working for the New York County district attorney. Politics and being a district attorney don't really mix too well, so my next few years are accounted for. There are many other things to do. I'm sure Andrew knows that politics are not the only means of public service. In fact, you may be able to do more in a less

public way by doing things more subtly and more behind the scenes.

W.O.: How do you plan to expand the work HELP has done?

J.F.K., JR.: There are the Greenburgh and White Plains facilities. Also a facility in Albany. There are a number being planned, and each has a social-services component to it. One of the issues I am interested in is education and employment training for young people to enable them to be productive members of society once they are in a housing unit. The sky is the limit. I think the only limitation is how good an idea you have and the energy to run with it.

The first step is stability within the family. Other things fall into place after that. My experience with the juvenile justice system in Brooklyn is that virtually every case of delinquency involves a broken home, and many of the kids are living on the street and have no place to go. I think your point about the welfare hotels is very well taken. A welfare hotel is a decaying place. It sends a message of decay and hopelessness to its occupants. In subtle as well as very tangible ways, to live in a place like that, surrounded by crime and feelings of hopelessness, doesn't give the growing child any hope, any self-esteem or the sense people really care what happens to him or her.

W.O.: There is a marvelous man with an Irish face, John Kennedy. He is a Republican, the chairman of the county board: Ed Brady. He's been around here a long time, but he is not so crazy about this idea. What would you say to him tonight?

J.F.K., JR.: The way the HELP plan is structured, we can also make a very sound economic argument for this project. Westchester spends $36,000 a year per family to keep people in welfare hotels. That doesn't make sense from the taxpayers' point of view. I'm sure Mr. Brady knows the value of helping people, but I really feel the more compelling argument from his point of view is that it makes economic sense and has a good bottom line.

W.O.: If I were a panhandler and I saw these two bright, beamish, attractive young men coming up the street with their English clothes, I'd see a "score." If *I* asked you for a buck, what would you say?

J.F.K., JR.: If *you* asked me for a buck, Bill, I wouldn't give it to you! But anyone can call HELP and ask for Andrew or me at 212–779-HELP.

w.o.: John Kennedy, do you realize what you just did, the offer you just made, by giving out that phone number?

J.F.K., JR.: I'm helping Andrew's social life! And it needs it.

w.o.: John, I should tell you, that the last time Andrew was here, we asked him how he was doing since he gave up that Park Avenue law firm, and he said his love life was not too good.

J.F.K., JR.: I don't believe it!

w.o.: You've become *less* eligible! Is that true, Andrew?

A.C.: It *has* been a problem. I was talking to John about it on the way up.

w.o.: Well, you're both very dull guys. John, Andrew's father, Governor Mario Cuomo, when asked about Andrew's activities with the homeless, said, "It's magic. I'm very proud of him." Does your mother, Jacqueline Kennedy Onassis, know what you're doing tonight?

J.F.K., JR.: She will, within twenty-four hours! She knows generally that I am involved with HELP. She is very happy about that. As far as the day-to-day details, she *learns,* one way or another! She *learns!*

w.o.: Does your family push you to get involved with various causes? Do you have to screen them out?

J.F.K., JR.: Oh, no, not at all. My family affords the opportunity to get involved, but there is no pressure if you don't. I'm very proud of that.

w.o.: John, does someone of your celebrity think it's enough to merely lend your name to great causes? Or do you feel compelled to leap in and actually do the nitty-gritty stuff?

J.F.K., JR.: I recall Mother Teresa's telling me one day that you save people one by one by one . . . ! I think that's good advice.

May, 1989

Interview with
Robert Kennedy, Jr.

Bobby Kennedy, Jr., is continuing in his father's tradition of activism in unpopular causes. He has done splendid work in cleaning up the Hudson River and protecting New York City's watershed. In this interview he speaks touchingly of his late father.

W. O'SHAUGHNESSY: Robert F. Kennedy, Jr.: that's a great name in these parts. We still get a ripple, more than a mere tug, when we hear the name carried by you and your father before you.

R.F. KENNEDY: I'm very proud to have it.

W.O.: You've been very active in a lot of ways around here, Bobby. Why do you call yourself merely an environmental lawyer?

R.F.K.: I work full-time on environmental law. Environmental law was really in its infancy when I was in law school in 1980. It's now the fastest growing area of the law—even faster than bankruptcy law, which is in second place. We have here in Westchester Pace University Law School, one of the nation's specialists in environmental law.

W.O.: You made the morning tabloids with this big walk you're going to do around one of our Westchester lakes.

R.F.K.: We're doing an eight-mile walk around the Croton Reservoir, and there are going to be a lot of celebrities: Glenn Close, Billy Baldwin, Edward James Olmos who was in *Stand and Deliver* and *Miami Vice,* and dozens of soap stars from New York, stars from *All My Children* and *One Life to Live.* The purpose is to bring the attention of the people of Westchester and New York City to the deterioration of the water supply.

W.O.: That's a hell of a long walk, eight miles! Do you think some of those stars will make it?

R.F.K.: I hope so. They say they're all in good shape, so I hope they'll all make it. Also a lot of our Westchester public officials are going

to be there. We're hoping that County Executive Andy O'Rourke comes.

w.o.: He'll never make it!

R.F.K.: He looks like he can make it. David Dinkins is going to come up and give a little talk. We're going to have several bands provided by VH1 and a big picnic afterward. It's a family day.

The water supply today is probably the most important issue in New York State. New York City's water supply is called the *city* water supply, but actually it provides 80 percent of the water in Westchester. It provides water for 10 million people, more than half the population of the state. It used to be the finest water on earth. It wins taste tests year after year. It's what makes New York bagels and New York pizza taste great. The Twinings Tea Company uses New York water to test their teas. Some of it is still very good. Some of it is deteriorating—the part of the water supply that is in Westchester, in Croton.

w.o.: Do you mean the lead in the water?

R.F.K.: Lead is a different problem. Lead comes from the pipes or solder that is used to bind the pipes together. I'm talking about pollution from sewage and road salt. Also fertilizers, pesticides, and all the other chemicals now being used in the watershed that weren't being used here before World War II. The watershed is the area around the reservoir. This is an unfiltered system. There are now 135 sewage-treatment plants that discharge into our drinking-water supply. You would go to jail in Connecticut or Rhode Island if you had a sewer that discharges into drinking water. We don't have a law like that to protect us in New York State. We have relied for the last one hundred years on New York City to protect the drinking water. But New York City has never come up here and protected it.

One sewage-treatment plant now discharging into our system is really grotesque: the Bedford Correctional Facility, just a few miles from here, where Amy Fisher now resides. I've brought two lawsuits against that plant.

w.o.: You *sued* the state?

R.F.K.: We sued them for violating their own permit. By their own records, they violated it ten thousand times in a five-year period. That's raw and partially treated sewage from a prison population that's going directly into our drinking-water supply. That's a

health risk, but also it's causing the ecological deterioration of the system. If you drive by the Muscoot Reservoir, which is right alongside I-684, you can see in the summertime that it is covered with a thick layer of algae. That's emblematic of the fact that the whole system is deteriorating and dying.

w.o.: Are you saying it's not safe to drink our water?

r.f.k.: The Croton system is not good water. It violates some of the proposed federal health guidelines. It violates at least one existing federal guideline for color. It's probably still safe to drink. It is not high-quality water like the water that comes from the Catskills and the Delaware supply.

w.o.: What about that body of water north of White Plains on Route 22?

r.f.k.: The Kensico Reservoir. It's the most critical reservoir in the entire water system. The water in that reservoir is actually from the Catskills and Delaware water supplies. If we lose that Kensico Reservoir, we will have to build a filtration plant for the whole Catskill and Delaware supply, and that would be enormously expensive. It will be expensive for Westchester residents who drink from the Catskill and Delaware supply, and it will bankrupt New York City.

w.o.: How much will it cost to build that plant?

r.f.k.: It will cost about $8 billion to construct the plant. And about $300 million a year forever to operate the plant. It is a total waste of money. The EPA is going to decide by December whether or not to order New York City to build a filtration plant. At this time, it appears that the EPA is going to order New York City to filter. The only thing that could change that is if Mayor Dinkins comes up with a plan to permanently protect this water supply. The mayor wants to do the right thing. We got him this year to commit to spend $50 million on land acquisitions in Westchester and Putnam Counties and the Catskills. According to the EPA and according to almost all observers, he needs to spend at least another $250 million.

w.o.: When you sued the prison, you're really suing your uncle-in-law, aren't you?

r.f.k.: I'm suing the Department of Corrections, which is a state institution.

w.o.: What does Governor Mario Cuomo say to you now?

R.F.K.: He's my sister's husband's father. And he's been wonderfully supportive.

W.O.: Your sister Mary Kerry Kennedy is now Mary Kerry Kennedy Cuomo. How do you get along with Andrew, the governor's son?

R.F.K.: I love Andrew. I have the same relationship with him as I do with all my brothers. I admire him. He's one of the most brilliant people I've ever met, and he's somebody who could be making a ton of money practicing law because he is a very good lawyer. But instead, he has given his life to something that is beyond his own self-interests. He's solving one of the worst problems that we have in this country today, which is homelessness. He has come up with solutions for it. He is probably in front of everybody in the way he has thought through this problem and the kind of solutions he has envisioned.

W.O.: I'm fascinated by this notion of famous sons of famous fathers coming on the scene. Nelson Rockefeller, Jr., was at the Rockefeller Awards Dinner the other night. Is it tough for you all sometimes? Why don't you start a club?

R.F.K.: I wouldn't say it's tough. It's hard for me to put it in perspective because I don't know anything else. I think the most basic explanation I can come up with is that twenty-five years after my father's death there are still a lot of people out there who hold him in high regard, and the affection for him is so deep that they are willing to give his children the benefit of the doubt and give them access. And because of that, we are able to be more effective in pursuing the interests that grip us. For me, that's our water supply, the Hudson River, and the environment in New York State. Because of my relationship to my father and because I bear his name, I've been able to be more effective than I otherwise would have been in doing the kind of things that I like to do.

W.O.: Do you remember the California campaign, your father's last, in 1968?

R.F.K.: I remember the whole presidential campaign. I was fourteen years old. My father took all of us on the campaign trail with him. I was not in California the day he died. But June 6 was the twenty-fifth anniversary.

W.O.: Where were you?

R.F.K.: I was at a Catholic prep school in Maryland run by the Jesuits. I flew to California and was with him the night he died, but I was

not with him during the California Primary or the night he was shot. We brought his body back here, waked him in St. Patrick's Cathedral, and then I rode with him with all my brothers and sisters on the train down to Washington. I remember looking out the window and seeing these huge hoards of people outside— blacks and whites and priests and rabbis and nuns—just all different kinds of people holding American flags. A lot of them were crying. A lot of them had signs that said, "Goodbye." We brought him to Union Station in Washington and then drove him to Arlington to bury him. On our way up the hill we passed through the mall, and at that time Ralph Abernathy was out there with the Poor People's Campaign. There were thousands of homeless men camped out in shacks and shanties on the Washington Mall, and they all came to the sidewalk and stood silently and took their hats off and held them against their chests as we brought my father by. Those are things that I'll always remember . . .

w.o.: William Randolph Hearst, Jr., who just went to another and, we're sure, a better world, was another famous son of a famous father. He said that he always lived in his father's shadow. And he was in his eighties.

r.f.k.: I don't know what Mr. Hearst's life was like. I am very comfortable with my father's legacy. He left all of us a notion of his love for this country, his sense that we should grow up, not to be necessarily people of success, but, more importantly, people of values and principles. The notion that this country had been very good to the Kennedys and we owed it something in return. And also his idea that this country is unique in the world in that we're not bound together by any common history or race or religion or language. We're bound together only by an ideal. We are supposed to be a bold *experiment,* the city on the hill, an example to other nations about what human beings from all over the world can do if they all get together and do their best. My father really loved democracy. His life revolved around this very strong belief that this is the only system of government ever invented—and we invented it essentially in its present form—that can harness the energies of all different kinds of people and make them work together and produce something in this nation that represents the highest aspirations of humanity. His whole life was devoted to that vision. That's something that I believe very deeply in, as

do all my brothers and sisters. It has directed them in what they're doing in their lives as well.

w.o.: Do you all still compete among your tribe? We read stories about the Kennedy football games . . .

R.F.K.: We're all very competitive, and it's a healthy competition. We also all are very supportive of one another. I was raised with twenty-nine cousins on the Kennedy side. We were all raised almost communally as brothers and sisters, and we were raised to support one another and also compete with one another.

w.o.: How about your cousin John Kennedy, Jr.?

R.F.K.: He is a very good athlete. We get together constantly for football and basketball.

w.o.: How about Andrew Cuomo? Do you compete with your brother-in-law?

R.F.K.: Yes. He's now part of the tribe, so he gets it as everybody does.

w.o.: But can he hold his own with the Kennedys?

R.F.K.: Andrew is very tough, as you must know. He is also a great athlete.

w.o.: You don't expect Mayor Dinkins to walk the entire eight miles around the reservoir, do you?

R.F.K.: We are "encouraging" him to walk. I understand he has an appointment in Washington.

w.o.: How about Mario Cuomo, your uncle-in-law?

R.F.K.: I don't know if he's going to come or not. And I hope that you use your influence with the governor, Bill, which is considerable.

w.o.: I may make a little cameo myself, but I'm not walking eight miles. Bobby, a lot of people think environmentalists are way out there. They use the example of the West Side Highway, still in drodsome shape—the piers are rotting—just because you guys wanted the fish to do, you know, what they want to do in the water.

R.F.K.: You're asking a couple of questions. One is: did the West Side Highway get killed because of the fish? There were a number of reasons why that wasn't a good project. It was a $2 billion boondoggle to developers. It wasn't just the environmentalists who believed it was wrong. A lot of people believed that money should go to public transportation to improve our subway system in New York. It really was going to create a large area—hundreds of acres—on the West Side of Manhattan where developers could then put buildings, for *free!*

w.o.: There's nothing there now, after twenty years.

r.f.k.: That's right, and the city still has to come up with a plan that satisfies all the different interests. The project would have been bad for the Hudson River, but that's not why it got killed. The reason it was killed is that the Army Corps of Engineers lied on the Environmental Impact Report.

w.o.: What do you mean, "lied"?

r.f.k.: Even though they knew that 64 percent of the fish—striped bass—in the Hudson River were using that area as an over-wintering ground, they said there were no fish there. Judge Thomas Griesa, after two months of litigation, stood up in the courtroom and pointed to the colonel who was running the project for the Army Corps of Engineers and said, "I know what *perjury* sounds like. I've heard it from the Corps of Engineers in my courtroom. Don't ever darken the door of my courtroom with this permit application again."

What environmental law says is that you have to look before you leap. It's not saying that fish are more important than people, because environmentalists don't believe that—at least the ones I know don't believe that. We believe people are important, and that's why we preserve the environment, because it is our economic basis in this country—because it is the foundation of our culture—there's a spiritual importance to it. But we don't protect nature for its own merit. We protect nature because of what it does for human beings. We're protecting this water supply not because we think fish are more important than people but because if we don't protect the water supply, the economy of our area is going to be flattened, and people in New York City and Westchester are going to get sick. So that's why we do these things. What's happened is that some people who have a strong economic interest in activities that are environmentally damaging, and that economically don't make any sense, want to keep their tax subsidies: the loggers out West and the farmers who use pesticides that we're all paying for in health costs, contaminated water, and contaminated food supply. People who want to continue those kinds of environmentally damaging activities are saying that you're putting owls before people. That's not true! The reason we want to preserve the old-growth lumber out West is because those stands of lumber are more valuable standing where

they are than cut down and sent to Japan. They're more valuable to all of *us*, not for the spotted owl!

W.O.: As I watch you gesture, Bobby, and look at your eyes, I'm reminded of your father. You speak with the same conviction and with the same pace and rhythm and cadence. Do you think he would have been proud that you're going around doing this?

R.F.K.: I think that he'd be happy with what all his children are doing. He lives in all of our hearts, and he was a critical formative element in the way that all of us view the world. And I think that his vision is one that everybody in my family—eleven children—at some time in their life, really bought into.

W.O.: There's a pretty strong resemblance. Do you remember that picture we've got up on the screen?

R.F.K.: That picture is the basis of his picture in the Justice Department. All the attorneys general have a portrait, and they used this one for my father. Incidentally, my brother Michael actually looks a lot more like my father than I do.

W.O.: Yeah, but you're *Junior*.

R.F.K.: Yeah . . .

W.O.: Is that a heavy thing to put on somebody?

R.F.K.: For me it's an honor, and an opportunity. People say there is an up side and a down side. For me it's been mostly good. Seventy percent of the people give you the benefit of the doubt. That's basically how it falls out.

W.O.: Those are good odds. What about your mother, Ethel Kennedy? Was it hard for her raising you?

R.F.K.: Yes. Eleven kids, all of us hard-headed, and we gave her a run for her money. She comes from very strong stock herself. She was up to the challenge.

W.O.: Anything else to add?

R.F.K.: Please wear comfortable shoes for our walk around the reservoir. We need a big showing from the people to send a message to our politicians.

W.O.: Thank you, Robert F. Kennedy, Jr. You are your father's son. . . .

Spring, 1993

R.F.K., Jr., is still at it. During the summer of 2001 Bobby was ordered to jail for thirty days by a federal judge for protesting the U.S. Navy's bombing of the island of Vieques.

Interview with Jeanine Pirro

District Attorney Jeanine Pirro is Westchester's chief law-enforcement officer and is a great favorite on the national talk-show circuit. Many political observers believe this impressive woman might have bested Hillary Rodham Clinton to succeed Daniel Patrick Moynihan had it not been for her flamboyant husband's legal and tax problems.

W. O'SHAUGHNESSY: Tonight, a woman of great energy, dynamism, and tremendous talent. I could almost feel the earth move when she walked into the studio. She was damn near lieutenant governor a few years ago. She was a judge, and a highly regarded one. She completely nuked her opponent in the last election and became district attorney of Westchester. There are those abroad in the land who think she is destined for even greater things! The Honorable Jeanine Ferris Pirro. How do you like being the chief law-enforcement officer of the Golden Apple?

J. PIRRO: I love it. It's great to get up in the morning when you can't wait to get to work.

W.O.: You gave up being a judge. That was so nice and peaceful . . .

J.P.: Being a judge was a very quiet life. It was a very nice life, and I certainly enjoyed it. But as the DA you have an opportunity to set policy, to make a difference, to have an impact on more than just the one person in front of you in a courtroom. I often felt that as a judge I was an instrument of the appellate courts. My duty was to impose the decisions of higher courts on the particular set of facts before me. So I felt that going back to the work I love, prosecution work, would give me the opportunity to make an impact, to set priorities, to bring certain kinds of cases into the criminal justice system that haven't been there before.

W.O.: You were a lawyer. Don't they always dream of being a judge?

J.P.: All lawyers do dream about being judges. It's the citadel, and I

worked very hard to get there and I worked very hard when I was there. But for me I have to feel that what I'm doing is making a difference, that I can use all my energies—and I have a lot of energy—to impact the lives of victims and the lives of the helpless. For a person with my particular background and energy, this is the best place to be, and it's a good opportunity for me to help the people of this county.

W.O.: You are the boss of a lot of guys. You've got a lot of lawyers working for you.

J.P.: We have 112 assistant DAs and a staff of 250 people. Our budget is almost $14 million, but certainly not enough to do the job that needs to get done. I was the first woman county judge. When I joined the DA's office in 1975 as maybe the second woman assistant DA or the third, the thinking was that women belonged in the appeals bureau because we didn't have what it took to *try* cases, that women couldn't "go for the jugular." And so I had a mission back then and that was to prove that I could try a case as well as a man, and I was, in fact, the first woman to try a murder case. I have, in answer to your question directly, given up worrying about what my sex is. People don't care what you look like. People don't care what your sex is as long as you're competent and as long as you get the job done. The important thing for a woman is that we have a sense of humor about ourselves, that we don't take ourselves too seriously, but that we are always competent.

W.O.: I saw you walk into the studio here at TCI, and a few guys gave you a little air kiss. We wouldn't do that to Sam Fredman. Actually, I do kiss Judge Fredman, but do you know what I mean?

J.P.: People react differently. My personality is such that I tend to be warm with people and they react the same way. Do I take it as a negative because I'm a woman? Absolutely not. When the situation requires there is tremendous decorum, and people treat you with respect if you deserve respect. The image is really irrelevant. All of us make decisions based on our own preconceived notions. We imagine that someone is a particular way, and if that person does one thing that adds credence to our preconceived notion, then we jump on it and we draw conclusions that are not always based upon facts. But I think that people have very strong feelings about women in the political spectrum when they might not

have those feelings about men because people think that women are or are not a certain way.

w.o.: You've got a lot of dynamism, lady. Even your detractors, and they are few, will tell you that. Do you ever have to appear *not* to be a "threat" to other women or, indeed, to men who work around you?

j.p.: I used to worry about that, Bill. When I tried cases, I would always wear a pinstripe suit, like a Brooks Brothers suit, and a light cotton shirt and a little bowtie. I would try to fade into the woodwork. The most important thing in the courtroom is the witness and the testimony that comes from the witness stand, so I didn't want other women, maybe on the jury, focusing on me because I was unusual in a courtroom. We've gotten beyond that as a society. People are now more accustomed to seeing women in positions of power or positions of prominence, so the concern about how you act or how you look is not as important as the presentation of a competent, prepared individual.

w.o.: I once introduced Gloria Steinem at a meeting, and I said, "She is not unattractive, as you can see." She took great offense at that.

j.p.: There was a time when women did take offense at that, and maybe years ago I might have as well. I think we've gotten beyond that. We're all human beings, Bill. There are women who would say that a particular gentleman is good looking. So what? We can't get crazy about that stuff. Once we get beyond the little stuff, we can get to the real issues at hand.

w.o.: You gave up the life of a judge to become DA. What makes for a good prosecutor?

j.p.: To be a great prosecutor you have to have a lot of energy. You have to have compassion. You have to believe in your case, believe that victims need a voice in the criminal justice system, and represent with a passion the young, the elderly, the victims of violent crime, deal with the families of homicide victims so that they feel they are getting their fair day in court. My job as a prosecutor is to make sure that the public has confidence in me. I have to be accountable, accessible. I am a public servant, and the message that I give my staff is that it's not a nine-to-five job. I'm certainly not there nine to five. It's a seven-days-a-week job. It's a twenty-four-hour-a-day job, if necessary.

w.o.: Do you walk around with a beeper?

J.P.: Yeah, it's right here, and with a flip phone. I'm on call constantly. But it's more than a job, Bill. It's a passion about making sure that people who are victimized are not lost in the system and making sure that criminals pay, making sure the punishment is as swift and severe as it can be depending on the case. That compassion for victims, Bill, in some cases belongs to the defendant who is not accused of a violent crime, who may be a young individual. Maybe an alternative to incarceration might be appropriate, but once we cross the line to *violent* crimes, all my energy and all of my staff's energy is used to make sure that the guilty end up in jail.

W.O.: Cuomo says they're going to put it on his tombstone: "He built 10,000 prison cells!" It's a cottage industry. In upstate New York every town has a prison, and they love them. You see, going up Route 17, prisoners, on buses. But it seems to be getting worse.

J.P.: The reality is that we live in a violent society. The United States is more violent than most Western countries, and this recent caning in Singapore brought to life the fact that people feel that maybe even something like caning should be instituted in the United States. My job is to enforce the laws that are on the books, and I put together my own legislative package trying to increase penalties, trying to mandate jail time. But to answer your question directly, I, even as a judge, was never told that there's no room in the jails. We have to send criminals to jail. At the other end of the spectrum, we have to understand that we have one of the most violent societies in the world. Young people are totally desensitized to maimings and shootings and stabbings. Even my young children will make a comment, which, to me, is incredible, about, "This one shot that one" or "This one cut that one's neck with a knife." Or even the Bobbit case. My five-year-old came home and said, "Did you know, Mommy, somebody cut somebody's weenie off with a knife?" My children only watch Disney and Nickelodeon, so they're hearing this stuff at school. The truth is we have to put people in jail because we're more violent than we've ever been. We have to make young people accountable. In my office we're making sure that youthful offender adjudication—in which the record is sealed and there is no real conviction—is opposed in any case in which a violent crime is involved. That makes some people very unhappy, but as far as I'm con-

cerned, my job is to make sure that young people who start on a track of violent crime get caught early and are put in jail.

w.o.: But do you attribute all this to the breakdown of the family? So many people say that's the whole thing.

J.P.: Absolutely. I started in criminal justice twenty years ago. When I was on the bench a few years ago I couldn't get over the number of younger and younger people who were coming to my courtroom: fourteen- and fifteen-year-olds who were kicking schoolmates to death in Westchester, sixteen-year-olds who were walking up to their friends and blowing their brains out. I don't think the public, even though they're in an uproar, has any sense of how bad it is out there. I'm not here to scare people, but I am here to get the message out that we have to take stronger measures against criminals.

There is something called love and limits. Janet Reno talks about it. We need to love our children, but we also need to show them where the limits are. What's happened is that in my generation so many of us are busy at work, we just give off the child-care responsibilities to someone else without really monitoring what's happening, without making sure that there are limits and there is punishment when it is appropriate. Not physical punishment, but punishment so that the children understand that they just can't do certain things.

w.o.: The kid with the spray paint in Singapore: would you have whacked his behind?

J.P.: Caning is not something that we've even anticipated in the United States. I'd be happy if we'd have the death penalty. We need the death penalty in New York State. We need stronger measures to deal with criminals.

w.o.: Mario Cuomo will forever disagree with you. He would maintain that every industrialized, sophisticated society has given up on it. It's not a deterrent. It doesn't work. It costs too much money to fry 'em or poison 'em or whatever you take them out with. Why do you want to do it?

J.P.: I respect Mario Cuomo's position. He has his own reasons, but I don't think he's on the front lines. I don't think he knows what's going on in New York or Westchester or some parts of this state where people are not safe to walk the very streets. I'm going to tell you about one case. There's an individual by the name of

Lemuel Smith who killed someone in Albany in the seventies. That someone was a drug dealer, and no one took it too seriously. Smith went to jail for a few years and was paroled, then killed again. This time he was convicted of intentional murder, and everybody in law enforcement patted themselves on the back and said, "Great, this man is convicted and he's going to get the recommendation of no parole and he'll never hurt anyone again." Well, unfortunately, there was a female corrections officer by the name of Donna Payant. She was married and had two children like myself. They found Donna's body in a laundry bin after she was essentially bitten to death. They were able to determine who killed her through the dental marks on her neck and her breast. The person who killed her was Lemuel Smith. At some point, Bill, people have to understand that there are sociopaths who will continue to kill.

w.o.: So you say, kill them back.

J.P.: Yes.

w.o.: Is that vengeance?

J.P.: You know what that is? It's making our society safe for the rest of us. I'm not proposing that we kill for one murder, although I think people who kill a police officer should be met with the death penalty, hired assassins who kill should be met with the death penalty, people who torture intentionally before killing should be met with the death penalty. We have to do something.

w.o.: You are suggesting that vengeance works.

J.P.: I'm not going to get into the argument about whether it has a deterrent effect on Joe and Harry and Joan out there.

w.o.: Does it?

J.P.: I don't know, and I don't care. What I care about is the individual who continues to kill. I'll tell you another category. We've got to make sure that people who come to this country and kill à la the World Trade Center bombing—terrorist acts that result in death—will be met by the death penalty.

w.o.: You're going to have a lot of people on death row, lady.

J.P.: I don't know if we're going to have a lot of people, but we are going to have people who should be there. Some people may say, "We got the wrong guy." Look at John Wayne Gacey. How many years did that appellate process take? This is not done willy-nilly.

There are appeals and appeals and federal appeals and habeas corpuses. At some point we have to take charge of our own destiny.

w.o.: I called up Nancy Q. Keefe, the star columnist of the Gannett papers, after John Wayne Gacey was killed. I asked her if she felt any better. She said, "No."

j.p.: That's not the test. You have to get serial murderers off the streets and out of the prisons.

w.o.: I'd hate to be against you in a courtroom, lady.

Besides being DA and a leader in your party, you're a wife and a mother. Your husband, Al Pirro, matches your dynamism. Who's better looking, me or Pirro?

j.p.: I think you're both good looking, but I have to say my husband is my sweetheart. How's that, O'Shaughnessy!

w.o.: He has his own career. How do you find time for each other?

j.p.: It's very hard, especially with this job. Every day we're matching schedules to see if we can find time for each other. The primary thing in our marriage is to make sure that we're home with the kids for either dinner or at night, making sure that one of us is reading to them, that one of us puts them to bed. I'm fortunate I have a husband like Al, who understands that I have a job and an obligation and that the calls come in at all hours of the day and night. He is supportive of me.

w.o.: He has to go to a lot of dinners for you.

j.p.: The interesting thing is that for so many years I went to dinners for Al and with Al, and now he's coming to dinners with Jeanine. It's kind of interesting and fun.

w.o.: Is it a good marriage?

j.p.: It's a great marriage. No marriage is perfect and, I'm not going to get up here and say that my marriage is perfect, but it's one in which we respect each other and we work hard to be together.

w.o.: You're both pretty strong. Does that work?

j.p.: We lock horns occasionally.

w.o.: Who blinks?

j.p.: Neither.

w.o.: Is that a good way?

j.p.: We've been married for almost twenty years, and you learn when to blink if that needs to happen.

w.o.: You almost ran for lieutenant governor. Are you sorry you didn't do that?

J.P.: Not at all. That happened almost ten years ago when I knew almost nothing about politics. The time just wasn't right. I'm happy that I am where I am. I couldn't be happier, actually.

W.O.: I don't want to start rumors, but some people think you're not long for the DA's job.

J.P.: I have loved prosecution work and I love what I'm doing. I am so proud that the people of this county elected me to do this job. Anyone who knows me knows there isn't much that's going to take me from this.

W.O.: You rocketed to fame when you started the Battered Wives Bureau. Is that still a hot issue? Are wives still getting belted?

J.P.: I hadn't even take my coat off on January 3, when I took over in the DA's office, when the Ann Scripts-Douglas case was put on my desk—the Bronxville case in which Ann was killed by her husband.

W.O.: Did you really think that he jumped off the bridge?

J.P.: Yes, but there was no concrete evidence to indicate that he did. The FBI Psychological Profile Unit is a unit that I worked with as a prosecutor, so I called them in. I asked them to help tell me if he jumped, and they said, "Yes." But since there was no concrete evidence pointing, we had to proceed as though he were out there on the run. The more publicity this case got, the more calls we got that he's in Brooklyn, he's in Brazil, he's in Florida, he's in the Caribbean, and we had to track these leads. Domestic violence is still a pervasive problem. It rises to the level of a homicide. We have to take it seriously.

W.O.: Who are some women in this country to watch?

J.P.: Kay Bailey Hutchinson, now that she's gotten beyond that indictment she was faced with, is a very strong woman. I'm proud of women like Judge Judith Kaye of the Court of Appeals in New York State. But it's not just the women who are on top and are very visible. Women who go to work every day, who raise families, who make society the place that it is. We have to make sure that we credit all women who are out there doing a good job.

W.O.: My Nancy likes Christine Todd Whitman.

J.P.: I met Christy Whitman. She is very articulate, and she has gone through a lot. I imagine that she'll be on the national scene before too long.

W.O.: What about our own Westchester County? Andy O'Rourke is

the county executive. Steve Tenore is chairman of the board. Do you get along with those guys?

J.P.: Sure. My job is to make sure I do the best I can for the DA's office, and that means I have to be nonpolitical. It's not about playing favorites or parties. In fact, I was at the White House a couple of weeks ago, and when CNN interviewed me, I was asked about how being a Republican relates to the crime package, and I said politics has nothing to do with this. We've got to get the job done, and we can't bicker about parties or anything else.

May, 1994

Jeanine Pirro will run again for districty attorney this fall. She is expected to have broad support from both parties and only token opposition.

Interview with Hugh Price

The thoughtful, cerebral president of the National Urban League is a resident of New Rochelle.

w. o'shaughnessy: Tonight, a national figure who is one of our neighbors. He was a member of the editorial board of *The New York Times,* a senior executive at Channel 13, and a vice president of the Rockefeller Foundation. But he is now taking on his greatest and most important national assignment. Please welcome the new president of the National Urban League, Hugh Price. We're so proud of you, Mr. Price. You've been all over the country making speeches . . .

h. price: I've made one speech that has been covered all over the country. That's very efficient.

w.o.: You sit where once a man named Whitney Moore Young, Jr., sat. Remember Whitney Young, our New Rochelle neighbor?

h.p.: I live right next to him. As a matter of fact, when my wife and I go walking, we pass right by Whitney and Margaret's house. Several of the past presidents of the National Urban League have been Westchester residents. Vernon Jordan lived in Hartsdale. John Jacob, my immediate predecessor, lived in Hartsdale.

w.o.: What's John Jacob doing now?

h.p.: John has just become executive vice president of Anheuser-Busch. He has a major position overseeing all their communications and public-service operations.

w.o.: And Vernon Jordan?

h.p.: Vernon is a force in Washington, D.C. He's a partner in a law firm, and I think he's categorized as President Bill Clinton's best buddy.

w.o.: I won't hold that against him. Are you political? Democrat or Republican?

H.P.: I'm a Democrat by nature. I was once very active in Democratic politics in New Haven when we were there. I've been a little less active in partisan politics since we moved to the New York area.

W.O.: I remember when your predecessor's heart stopped beating on a beach in Africa.

H.P.: There are many interpretations of what happened . . . It's not clear if it was an undertow or a heart attack. Whitney Young was a very strong swimmer, and he was in very good shape. People wonder. But the fact is, he died in Africa.

W.O.: I still have a card Margaret Young, his widow, sent out. It had a black angel and a white angel talking to each other in heaven, and it said, "Lord, Whitney Young is here."

H.P.: Margaret is a special person. She is a dear friend.

W.O.: Spot the players for us in civil rights. First of all, are you a civil-rights leader?

H.P.: I'm uncomfortable with that characterization. I have become that, I suppose. I oversee an organization concerned not just about civil rights, but also social and economic justice. So our mission is economic, social, and racial equity in this country. The Urban League, historically, has been concerned with trying to help people move from poverty into the economic mainstream. It was Whitney Young who actually brought the Urban League foursquare into the civil rights movement in the early sixties in conjunction with the march on Washington in 1963. The League essentially added that to its portfolio and is now concerned with all these issues.

W.O.: But while many civil rights leaders—I have to use the term— were out on the streets picketing, Whitney Young was in the boardroom saying, "I want fifty jobs."

H.P.: There are people who work *inside* the mainstream, building bridges and helping folks across. There are people who *straddle* the mainstream and the outside and say, "Goddamn it, somebody has to build some bridges." And there are some people who say, "Even if they build bridges, I'm not going to cross, because I don't believe the grass is greener on the other side." The Urban League operates inside the mainstream, building the bridges. There are advocacy organizations and sister organizations like the NAACP, which stands and says, "Somebody has to build bridges.

Goddamn it, build bridges." And that's a crude way of dividing up the roles we all play.

w.o.: You mentioned the NAACP. They've had tough times. They deposed their president, Ben Chavez.

h.p.: I don't know him. I'm just in my seventh week in office. It is a difficult time, but I have no doubt the NAACP will bounce back. It's a resilient organization, and it has a very important role to play. Its chapters have got to be there when strident advocacy is absolutely necessary—strident, yet constructive, advocacy.

w.o.: Tell me about the Rainbow Coalition and Jesse Jackson.

h.p.: Jesse Jackson is a great and remarkable man. He established our bona fides as candidates for prominent national office. He has played an historic role in our movement. The Rainbow Coalition is an attempt, as the name implies, to build bridges across communities and to try to effect a multiracial coalition for economic, racial, and social justice in this country.

w.o.: But is Jesse Jackson legit?

h.p.: Jesse is a brilliant man. He has dedicated his life to our work. With the kind of smarts and charisma he has, he could've done anything he wanted to do. He has devoted himself to our cause.

w.o.: He's not in it for himself?

h.p.: You have to be internally driven in order to do this work. Anybody who runs for elective office has to be. You have to have some ego to keep overcoming the obstacles. But I don't have any doubt that Jesse is in it for the people.

w.o.: You mentioned those who don't want to go over the bridge. Are you talking about Louis Farrakhan?

h.p.: In the African American community there have over the years been people who have been skeptical that the mainstream was really open to us: people like Marcus Garvey and Malcolm X. That skepticism is bred of a reality that during our history, whether we're talking about slavery or the kinds of economic changes that are occurring now, there has been a real basis for that skepticism about whether there will be room for all African Americans in the economic mainstream. This is a reality based on the perpetuation of racial discrimination in this country and the attitudes that whites have toward blacks. My view is that you can't let those obstacles stymie you from trying to cross into the mainstream because I don't think there is any future in separation. Skepticism

about whether or not the economic mainstream will ever admit us—whether white America will ever be comfortable with us—provides the fodder for those who aren't willing to cross the bridge.

w.o.: You were on the editorial board of the mighty *New York Times*. You ran a television station and served at the Rockefeller Foundation. Have you seen any reluctance toward Hugh Price?

H.P.: I have encountered it. I made a run for the presidency of the station, and my candidacy wasn't taken seriously, in my judgment. That was quite instructive to me that the station and selection committee weren't "ready." I can deal with not having been chosen president. What was difficult was not being taken seriously as a candidate.

w.o.: Why didn't they take you seriously?

H.P.: I don't know. Those are the experiences that you encounter when you smack your head against the glass ceiling, and it smarts and you don't forget it. But the fact is that many blacks are breaking through. We have a neighbor in New Rochelle, Ken Chenault, who runs American Express. Ken is a very good fellow. Dick Parsons, who is a resident of Tarrytown, is head of the seventh or eight largest financial institution in this country, Dime and Anchor Savings. [Parsons is now president of Time Warner.] African Americans are breaking through because, as I said, there is no future in isolation. The glass ceiling does break, but you have to have people who are willing to pound against it and take the mallets and even crack it with their heads.

w.o.: They're talking about Parsons for *governor!*

H.P.: Dick Parsons can do anything he wants to do. He's also a lawyer. He once represented the Rockefeller family. His grandfather, if I'm not mistaken, had worked as a groundskeeper on the Rockefeller estate.

w.o.: How about Carl McCall?

H.P.: A terrific human being. I've known Carl for many years. He's very dedicated to public service. He preceded me at Channel 13. He worked in government affairs for Citibank. He was chairman of the board of education in New York City. He too is the kind of fellow who could go off into the private sector and do a terrific job, but Carl has decided to dedicate his life to public service.

That's what makes him tick. [McCall is now comptroller of New York State and may run for governor in 2002.]

w.o.: What about Hugh Price? Do you have the political bug?

h.p.: Not really. I thought about that a number of years ago when I was in New Haven. There was an opportunity to run for a state senate seat. There would have been a three-way primary, and the name of the fellow that went on to win the primary was Joe Lieberman, now a U.S. Senator. But I stared then at the possibility of running and decided I didn't want to because I didn't want to be in the public eye that much . . .

w.o.: Well you're in it now.

h.p.: I feel that I'm ready. But also at the time I would have had to work for a company, and I felt I would have been a "kept" politician. There was no way to practice law and develop an independent source of income. And I didn't want to work for a major corporation and be an elected representative because I don't think I could've been free in the judgments that I would have had to make. But I am in the public eye now. It's an interesting experience to have people dissect every word that you say and interpret it. I've been in public life before. I was a city administrator in Connecticut.

w.o.: Who supports the Urban League?

h.p.: We receive support from a variety of sources. We get government grants from agencies like the U.S. Department of Aging and the U.S. Department of Labor. We have support from corporations and foundations. To a much lesser extent we get support from individuals. We get support from mainstream institutions to do the kind of work we do inside the social and economic mainstream.

w.o.: Is it fair then to ask you—as you acknowledge where the support comes from—what you think of some of the players on the national scene? What do you think of Bill Clinton?

h.p.: I think Bill Clinton is a remarkable man. I like his politics. By and large I think he understands the issues we care about and he cares about the issues we care about. He's obviously having a tough time, and I hope that Bill Clinton will get back out into the countryside and talk to people about what is on their minds. I think his instincts and his policies are by and large compatible with my own personally and are comparable with what we care

about. The expansion of the earned-income tax credit to provide more income for low-income working people, the expansion of Head Start, the new education legislation that establishes higher goals for young people, the effort to extend healthcare to working families that don't now have it—those are initiatives that are very difficult to push through, and he's been brave in pursuing them. And I wish him well.

W.O.: What do you think of Clinton as an individual? Do you really like him?

H.P.: Yeah, I like him. He's had his problems. He is a human being. We hope that he can navigate his troubles, and we hope the American people can place them in perspective, because for me what he stands for and what he's trying to do are vastly more important.

W.O.: What about in this state? There's a big battle for the governorship, Mario Cuomo running again against George Pataki.

H.P.: I believe very strongly in Mario Cuomo and what he stands for.

W.O.: They're just killing each other.

H.P.: That's to be expected. I don't know George Pataki at all. I haven't really followed his policies, but I think Mario Cuomo and his views are more consistent with my own.

W.O.: As you move around this country, what's the politically correct way to speak: is it black American or African American . . . ?

H.P.: I'm going to be cavalier about this because that's an issue that doesn't interest me. I'm fifty-two years old, and I've been called *five* different things in my lifetime. And I'm waiting for my sixth now that I'm in my sixth decade. I've been Negro, colored, Afro-American, African American, and black. I don't expend a lot of energy thinking about it. I guess the two terms we tend to use now are black and African American.

W.O.: Why did I ask you that question?

H.P.: It's something we can get tangled up in. In fact, the curiosity didn't occur to me until several years ago when I was listening to a Latino colleague of mine stumble over whether she was Mexican American, Chicano, or Latino—and she was about thirty. She has wrestled with *three* labels in her thirty years.

W.O.: Will we get to the point where we don't do labels?

H.P.: I'm not sure we will. We seem to be in a period when labels are

very important, and I think a sense of self and people is critically important. Again, that's not something I expend a great deal of intellectual energy wondering about. The big transition for me and for people of African American descent was essentially in the sixties when we crossed over from thinking of ourselves as Negroes or coloreds to blacks, which obviously had color connotations. That was a big deal, and I had thought we put the labeling to bed at that juncture, but obviously we haven't.

W.O.: In your speeches you worry about the children of America, and you worry about cities. Moynihan has some ideas about this. Now I'm going to give you a lot of power. You can do anything you want with cities, our own included. What would you do?

H.P.: I would try to make our schools work for youngsters so that they all—not just a select few, but all—have the kinds of schools they need to be successful in the twenty-first century. What has happened to the economy of cities? Many of the jobs that required only blue-collar skills, but nonetheless enabled people to participate in the economic mainstream and to earn enough to buy a home and a car, have essentially vanished. Factory work, the kind of work my uncle did in New Haven. The factory he worked for is gone. He was not a college man. If you have low education and low skills, then you can only earn lousy wages. So I think that we have to make sure that all of our children have much higher skills that enable them to participate in the information-age economy, the service economy that is growing and providing decent wages. That's concern number one.

The second concern is that many parents are not there for their children, for economic reasons. I'm part of a group in Westchester called the Westchester Clubmen, and we support a program at the White Plains YMCA for young African American males at the middle school. Many of their mothers are out stringing together several jobs that don't pay terrific wages, and they can't be home at three o'clock when their youngsters come home. So we have to make sure that there are constructive activities and caring adults in the lives of our youngsters when they're done with school and over the summer while their mothers and fathers are out working. I think we have to rebuild what I call the "developmental infrastructure" for youngsters. That is an infrastructure that is now

being created by gangs. And that is why we have this upsurge in gang activity and violence.

I think we also have to look at the economic conditions and economic self-sufficiency of families. Somehow, even as we work in preparing our youngsters to participate in the economy, we've got to do a much better job of helping their parents who are living in inner-city areas gain access to the mainstream economy. I think that means focusing even harder on job training. But preparing people for jobs that are in the sectors that are paying *decent* wages. I think we have to work with public-sector and private-sector employers and say, "You have to include people who live in the inner cities in your work force." We can't have a society that walls off significant sections of the population from economic opportunity, because if we have that then we end up with struggles and tensions and we end up with the erosion of the economic bases of communities, the erosion of families, and the exacerbation of crime.

w.o.: Is that an intelligent way of saying that the rich are getting richer?

H.P.: That's *exactly* what has happened. It used to be that the rich grew and folks that weren't rich nonetheless progressed. They weren't moving at the same pace, but everybody was moving forward. But now, if you are well educated and highly skilled, you have enjoyed a tremendous growth surge in the last couple of decades. If you have few skills and are not well educated, your purchasing power has declined by 20 percent or so in the last couple of decades. That is feeding a lot of social tensions, and it's feeding the impulse on the part of those who want to separate, who say there is nothing in this mainstream for me.

w.o.: There are those who think some people don't want to get off welfare. And there are people on SSI now. Everybody is on the dole, it seems.

H.P.: Everybody is not on the dole. Most people that are on welfare are only on it temporarily. They're passing through because of some family situation, because they've lost their job due to a shutdown of a plant or whatever. But it's also a fact that some number of people are on welfare for a longer haul. Some people may like it that way, but I don't think most people want to be on public assistance. But I think, if they look at the alternative of public assistance with insured healthcare and the ability to be

home with their children compared to working and earning poverty-level wages, with no healthcare and no child care, the calculus doesn't make any sense. That's the problem now. Economically, people in some parts of the country are better off financially being on public assistance than they are working. We've got to do something about that, and that's why the press by the president to greatly expand healthcare coverage for low-income workers and the press to expand child care and Head Start and the press to expand the income supplement of people earning low wages are all very important because if we expect people to work, work must be worthwhile financially.

w.o.: But there are people watching an attractive, intelligent, articulate, and bright Hugh Price, and they're thinking that he wants more government doles.

h.p.: I don't want more government doles. I want the African American community—and *everybody*, frankly—to do a much better job of making sure that their children are prepared for the twenty-first century economy. That's our responsibility as parents, in the first instance, and that's the responsibility of each of our communities and each of our ethnic groups in the second instance, not just to make our public school systems work better but to ensure that your children are equipped for the twenty-first century. And that responsibility rests with us who are parents. I think that the responsibility of ensuring that the developmental infrastructure is there for children is essentially a public responsibility.

w.o.: What do you put in there in place of gangs?

h.p.: The schools that once had a vast array of extracurricular programs and no longer do. The park and rec departments had all those clubs and youth workers and teens. That used to be paid for by taxpayers. They don't anymore, and we need that now. The YMCAs and the boys' clubs and all those programs that provided all those father figures who are no longer there. That was all a part of the community's responsibility to its children. We've all walked away from that responsibility as parents and taxpayers. That's not dole. That's community responsibility for kids. This is not a problem that individuals can solve.

w.o.: I don't think you walk away from anything . . .

h.p.: I try not to.

August, 1994

Interview with Martin Stone

Martin Stone was a television and radio pioneer. He made Howdy Doody a household name and really showed us that radio can be more than a jukebox when he founded WVIP, one of America's first suburban community radio stations.

W. O'SHAUGHNESSY: Tonight, a certifiable legend. The one thing he's ever done that's really questionable was to give me my first job. A visionary, a dreamer of dreams, he was the creator and producer of *Howdy Doody*. He made millions in the early days of television with programs like *Author Meets Critic* and *Twentieth Century*. Our guest is Martin Stone.

It's been almost thirty-five years since I darkened your door. I was eighteen years old. I thought you were the most dynamic, colorful, brightest human being I'd ever met—and I still do.

M. STONE: I thought you were pretty dynamic in *your* time, Billy.

W.O.: You didn't hear my knees rattling?

M.S.: I remember you as a young man. The story I always tell about Bill O'Shaughnessy happened in the year we started; and you're right, it was thirty-five years ago: October 27, 1957. That winter we had bad snowstorms, and my instructions were that everyone on the staff, including O'Shaughnessy, our star salesman, would get out on the road and cover the snows. Actually, Billy O'Shaughnessy was more than a salesman. He had that yen to be on the air and be a star, as he is now. He would jump out of his car and stop at the nearest telephone booth and say, "This is Bill O'Shaughnessy reporting live from mobile unit number four on the road."

W.O.: We didn't have four cars.

M.S.: We didn't have *cars!* We didn't have any cell phones, either!

w.o.: And sometimes I didn't have a quarter! You used to accept those collect calls, thank God, from mobile unit number *seven*.

m.s.: Forgive me. I underestimated you!

w.o.: You're still running your beloved WVIP in Mt. Kisco and Chappaqua and Bedford.

m.s.: Northern Westchester, what we call "VIP country."

w.o.: Aren't you bored? You've been doing it for a long time.

m.s.: The great kick that one gets out of life is seeing all the young people grow and go to big jobs in the business. You've been part of that. When you were there, who was the newsman?

w.o.: Morton Dean, now at ABC Television.

m.s.: And who was the program director? Didn't he fire you a couple of times?

w.o.: I forgot that guy . . .

m.s.: Dick Doan, who later became the television critic for *The Herald Tribune*. And later did a column in *TV Guide* called "The Doan Report."

w.o.: You even had a guy in those days who used to come in and advise on sports—some lawyer from Pound Ridge who used to drive us crazy. What's his name?

m.s.: Howard Cosell.

w.o.: You kind of broke him in . . .

m.s.: In 1957 Howard made his debut on national television on a show I produced called *Grocery Special*. And Howard—I will never forget—wanted desperately to be on television, so I had him on a conference of writers. And I suggested we ought to have Ted Williams on film. I asked if anyone knew Ted Williams, and Howard said, "I do." So I asked him to go up to Boston to get ninety seconds of film with Ted Williams. I said, "I don't want you on camera, but I want you to do this interview." He went up there. The film came back: ninety seconds. Beautiful. I called Ted Williams and introduced myself and told him I thought the Howard Cosell interview went very well. He said, "Howard *who?*"

w.o.: You started *Howdy Doody and* made a lot of money . . .

m.s.: I don't think the money was as important, and certainly it wasn't anything like the money that is made today. It was a great thrill to be involved in a show that had the influence that *Howdy Doody* had. So many people remember it. I think it was successful for a number of reasons. Number one, it was the first show of its

kind. I remember so well people at NBC asking if there were any room for television in the *daytime*. *Howdy* succeeded mainly because of the talent of Bob Smith and because of the talent of a young man named Eddie Kean, who had a brilliant creative mind. Buffalo Bob Smith used to live around here, in Pound Ridge.

w.o.: Could *Howdy Doody* make it today?

m.s.: No, because it was done in the days of live television, when what was most important was not necessarily the production values but Bob's communication with his audience and the puppets. The puppets of those days can't compare, of course, with the action you can achieve today with *film*. Not only cartoons, but the things that are done today, like *Sesame Street*.

w.o.: Didn't you hold your breath with all of those kids and what they might say?

m.s.: Oh, sure. As a matter of fact, the reason Clarabelle was on *The Howdy Doody Show* was that we one day discovered that while Bob was off doing his old-time movies, there was a lot of noise in the peanut gallery. So I said to Eddie Kean, who was the writer, "We gotta keep those kids quiet. Is there anyone outside we can use?" He said, "There's a page boy who sits outside to keep people from coming into the show. Why don't we have him sit in the peanut gallery?" And we did, and the camera would once in a while pick him up in his page boy uniform. We had to do something about that, so we put him in a costume. That was Clarabelle. And the reason Clarabelle never talked is that we didn't have the money, so we had to have a horn. And, secondly, the name of that boy who sat outside was Bobby Keeshan, who became Captain Kangaroo!

w.o.: I heard a story at dinner the other night: weren't you offered the presidency of ABC at one time and you turned it down?

m.s.: The main reason was that I didn't want to live most of my life in California and be away from my family. My wife had no interest whatsoever in moving to California. And, secondly, I didn't think I would have the independence to promote the sort of things that I wanted to do. Rather than submit to the rules of stockholders and heads of the corporation, I just thought there was value to being an independent producer.

w.o.: What about some of those other Martin Stone programs?

Author Meets Critic, talking about books, and *Twentieth Century*— would they have bombed today?

M.S.: No. *Author* is a viable format and idea because it is based on talk shows, but its format provided conflict. With all due respect to the kind of talk shows that you're doing, to me the excitement that we provided is the kind of excitement *The McLaughlin Group* provides: conflict. My favorite program is *This Week with David Brinkley.* I think that is masterfully done, and it provides the conflict you need.

W.O.: Who is your favorite anchorman? I like Tom Brokaw and Dan Rather.

M.S.: Bill Moyers. Peter Jennings, I think, is probably the most competent in terms of the appeal he has, and I think I would vote for him as my favorite newscaster.

W.O.: Why do you like Moyers?

M.S.: Because I think Bill is so interested in what he's doing and because Bill is more than simply an interviewer. Bill is a producer, the kind of person who prepares himself before he does a program and even after he does the program. He's in on all the editing.

W.O.: You did some deals with Walter Cronkite. As a matter of fact, you have eyebrows a little like Cronkite's. What was it about Cronkite? We all loved him.

M.S.: Well, Walter was always, to me, a combination of Walt Disney and General Eisenhower. He was fatherly as Eisenhower was fatherly, and he appealed to every age range and every element in the country. He was American.

W.O.: Was the Cronkite you saw on the tube the same man you saw in the boardroom?

M.S.: No, he was *quite* different. Walter was a great talent. There's no question about that. It's a shame that he hasn't done more since he retired that would last through the years. The shows that Walter has done on television have been news shows, and they have disappeared. Some of the things on radio like *Hear It Now* remain as audio records, but television's *See It Now*—they talk about restoring it, but they haven't restored it—though a damn good program, is gone. So future generations are going to say, "Walter *who?*"

W.O.: I heard you talking to the production people before we began

about General Sarnoff of NBC and Bill Paley of CBS. Give us a little sketch.

M.S.: They were entirely different. Bill Paley had great zest. He was fun, he *loved* people, ladies *and* men. He could talk on any subject and wanted to try everything intellectually. Not only that, but he did some very exciting things in the early days of television, as he did in the days of radio. When you think of a Norman Corwin and the *CBS Playhouse* and the *CBS Symphony* and the things he did in radio, you think also of the things he did in television, particularly the Ed Murrow era. Sarnoff was not that kind of a *programmer*. Sarnoff did not think as much in terms of programming as he did in terms of *engineering*.

W.O.: But Paley was the great showman.

M.S.: Sarnoff was not a showman. Remember, in the early days of television RCA had the patents on the tubes. Sarnoff wanted to sell RCA inventory. And programming was the way to get people to buy television sets so that you made money on the *sets* and not necessarily on the programming. Paley didn't have that. Paley, at one point, thought he had the answer to color, as he was experimenting at CBS's laboratories in Stamford. But he never had the inventory, the mechanical and electrical engineering that would make CBS buyable. He had to do it with programming.

W.O.: Who would you rather spend an evening with?

M.S.: I think you'd want to spend it with *both,* for different reasons.

W.O.: What about the current crop of network chieftains. There's Bob Wright at NBC; Tom Murphy, our Westchester neighbor, and Dan Burke are still keeping an eye on ABC. And at CBS there's Larry Tisch, our neighbor in Scarsdale, and Tony Malara. Are they in the same league?

M.S.: I think the times are entirely different. In the early days of television it was all *live*. And, therefore, you were trying different things on the spot, under very difficult conditions. The size of the one studio at NBC in the forties, studio 3H, is the size of the studio we're sitting in now. So you experiment.

W.O.: I hear you trying to be a diplomat. The current crop—they're really not in the league with Paley or Sarnoff . . .

M.S.: Remember, first, that these are large companies with large holdings and stockholders unlimited, and what they're trying to do is make the bottom line attractive. They also have the tough com-

petition from cable and the other media that are making inroads in an era when advertising revenue is down.

w.o.: But has it changed?

m.s.: I don't think it has necessarily changed for the good. I think the answer is that television is relying on the tried and the true. The producers of the new shows that are being planned are the producers from shows that have been successful.

w.o.: Do you watch any of the sitcoms?

m.s.: No.

w.o.: What about cable television. We're coming into living rooms tonight because of cable. You were a pioneer of cable. I heard you talk thirty years ago about "the wired nation" that would result from all of this.

m.s.: You and I have been in broadcasting for a long while. Cable is *narrowcasting*, determining a niche and going for that niche. If you're CNN, you're news. If you're Nickelodeon, you go for children. If you're CNBC, you're talking business, and so on down the line. There are some networks that are broad networks as you and I have known them. Lifetime is one. USA is another one. Arts and Entertainment to some extent, although it resembles Channel 13 in its approach. But it's still finding a niche. The future of cable lies in the development of narrowcasting.

w.o.: You used to say—and they thought you were deranged at the Tarrytown Hilton that day so many years ago—that people would sit in their living rooms and pay their bills via television, that people would order from electronic catalogs. Is that going to happen?

m.s.: That's going to happen with the development of fiber optics and the multiplicity of channels, and there will be all kinds of services and all kinds of specialized appeals. I'm absolutely sure of it. One area I am most interested in is the development of local cable television.

w.o.: That's the genius of this local cable channel and your WVIP and our WVOX. Are they antiquated now? Can you kill radio off?

m.s.: Kill radio? We haven't even seen the many forms of communication that lie ahead of us. But *radio* represents a unique kind of narrowcasting. It is mobile. You have a car, you have a radio. You may have an audiocassette, but most likely you're tuned to radio, for information if not for music. Radio is also mobile in that you

don't have to *look* at something. If you're *doing* something else at the moment, you're *listening* to radio.

w.o.: George Plimpton calls it a nifty little *slave* that follows you down the street and to the beach. You can make love listening to radio.

M.S.: I think there's a difference between AM radio and FM radio that has to be recognized and separated so that each can appeal to whatever elements it seeks to capture. But I think, so far as cable in concerned, it has its own vistas ahead of it. You're going to have 77 channels in most areas. You're going to have as many as 150 in New York City.

w.o.: Which will people rely on? Ye local radio or ye local cable?

M.S.: Different folks, different strokes. If you're home and you can watch cable, you'll watch cable rather than listening to radio, provided it has the kind of programming you are looking for. So if you have an interest in a local television program such as this, you'll tune to it, radio or no radio.

w.o.: A few weeks ago, one of the great visionaries and another great legend died, John Van Buren Sullivan. He was a resident of this county who ran WNEW during its glory days. WNEW is in a tailspin, almost relentlessly declining and nearing extinction. What's happened to radio?

M.S.: In the first place, just like cable, radio stations have to be a *place* on the dial. You have to go to that radio station and expect a certain kind of response from it. People expect news in the morning—and a lot of news—and thereafter we play the kind of music that fits that population in the same way that you're doing at WVOX and WRTN. You're appealing to a certain element. Nostalgia, if you will, a certain period that you thought represented the best in music.

w.o.: So what are we running, *jukeboxes?*

M.S.: No, because I think what a jukebox represents will be dangerous, because there will be substitutes for such.

w.o.: Your base is in northern Westchester. Andy O'Rourke may soon be a judge. Do you have a candidate to replace him as county executive?

M.S.: Bill O'Shaughnessy would make a good candidate, but he won't run.

w.o.: Do you still do editorials?

The Christian Brother. In recent years Christian Brother John Driscoll has devoted his ministry to Judeo-Christian relations as head of the Bat Kol Institute at Hebrew University of Jerusalem. President of Iona College for two decades, he led the rejuvenation of the school in the seventies and eighties. (Below): **JVL.** Episcopalian John Lindsay was to Republicans what JFK was to the Democrats and all the Irish everywhere. Mayor of New York during the sixties, he was a graceful, vivid figure on the teaming, roiling streets of the great city.

The Chairman of the Board.
As the author has pointed out, Sinatra's passing was an especially bleak day for radio. But for the electronic media, Francis Albert Sinatra's genius would have been confined to big-band remotes, supper clubs, and saloons.

Charity Events. Crooner Tony Bennett and the author at a charity dinner in Manhattan.

(Above): **Westchester Power Brokers.** (L–R) Albert J. Pirro, William F. Plunkett, Jr., District Attorney Jeanine Pirro, and megadeveloper Louis Cappelli. Pirro took criticism for his flamboyant lifestyle and has run into tax troubles. William Plunkett is George Pataki's mentor and carries a lot of clout in the Empire State. Jeanine Pirro, district attorney of Westchester, is an articulate crime fighter in the Golden Apple. Louis Cappelli is the Donald Trump of the New York suburbs. (At right): **Rising Stars.** Maria Cuomo Cole (daughter of the former New York governor) and her husband, designer and philanthropist Kenneth Cole. Maria chairs HELP, the nation's largest provider of transitional housing, founded by her brother, Andrew Cuomo.

The Author's Father-in-law. B. F. Curry, Jr., at his eightieth birthday party. Mr. Curry owns CurryCorp., one of the largest independent automobile dealer groups in the country.

(Above): **Friend of Bill.** Tom Rogers, founder of MSNBC and CNBC, is an active resident of Westchester. He now chairs PrimeMedia, the magazine conglomerate. (Below): **New Neighbors.** The author greets then-President Clinton during the president and Hillary's house-hunting trip in New Rochelle. (Clinton inquired about "a room upstairs over the garage.")

At the Podium. One hundred fifty VIPs were invited to Le Cirque 2000 for a party given by Nancy Curry O'Shaughnessy in honor of the author's first book, *Airwaves*. Three hundred showed up. But Maestro Sirio Maccioni was able to accommodate all of them.

Nancy . . . Out and About of an Evening. Nancy Curry O'Shaughnessy and the author at a charity dinner at the Plaza. They received a papal award from Pope John Paul II for their philanthropic activities. *(Photo by Joe Vericker)*

Father-Daughter Combo. Bernard F. Curry, Jr., the author's father-in-law, and Curry's daughter, Nancy O'Shaughnessy.

(Above): **The Author's Rabbi.** Rabbi Amiel Wohl is a nationally known leader in interfaith dialogue. (Below): **The Whole Law.** Former Governor Mario Cuomo is America's greatest living orator; his insights have inspired the author and countless others.

M.S.: Not the way *you* do them. I don't think I could compare with the energy and the ability you put into your editorials. I don't have the time to do them, and I don't think I'm familiar enough with all the issues that I could do them on a consistent basis.

W.O.: I have spent an evening at your rambling, lovely home in northern Westchester. There have been railroad company presidents, bank presidents, politicians, and you editorialize . . .

M.S.: To answer your question about the county: I have a love affair with Westchester, as you know. I don't really think there is enough attention by the media to what Westchester County represents, what its future could be with the proper kind of direction, what its problems are. I think the radio stations and Gannett, all the media should combine in a total effort.

W.O.: What about the southern tier? New Rochelle is losing Macy's. Mount Vernon and Yonkers are in decline. Can those cities be saved?

M.S.: Sure they can be saved, but it's going to take a lot of work, and it's going to take a joint effort. In other words, New Rochelle can't solve its problems alone.

W.O.: Do your neighbors up there in Bedford and Mount Kisco care what the hell happens down here?

M.S.: They probably think they should secede from the county!

W.O.: What do you think?

M.S.: It's one county, and everybody works together. I do think, however, it's necessary for all the municipalities and townships to work with one another on a much more equal basis. I think there is somewhat of a disproportionate representation.

May, 1992

Martin Stone passed away in 1998, just after his beloved WVIP burned to the ground. My eulogy for this amazing man is included in my previous book, Airwaves.

Interview with Lou Boccardi

Despite his lofty position in the media as president and CEO of the mighty Associated Press, this unassuming man of keen intelligence still has a deep and abiding interest in our local community.

W. O'SHAUGHNESSY: I've been looking forward to testing his bright, fine mind. You've seen him on television all over the world at the side of Terry Anderson, the hostage journalist. Our guest tonight is himself one of the most thoughtful and respected journalists in America and a top executive in that profession. He's president and CEO of the largest news-gathering organization on the face of the earth, the Associated Press. Lou Boccardi, you have reporters, bureaus, listeners, stringers, and watchers all over the world, and they all direct their findings into your headquarters at the AP in New York. Who better to ask what is going on in this world today?

L. BOCCARDI: The overwhelming characteristic of the news in recent years has been its velocity. Just in the last ten or fifteen years—even the last couple of years—news has been moving at a velocity beyond anything we've had to deal with in the past.

W.O.: Forget the speed of it. Forget how quickly you can spread the word. What's the word itself? We have hurricanes out of season, volcanoes erupting, a plague called AIDS, governments falling. . . .

L.B.: Change is the characteristic that all those news events share— and the fundamental element of news, which is surprise. If anybody had predicted a few years ago some of the things that have happened, like the dissolution of the Soviet Union or the fall of the Berlin Wall, they'd have been cast aside as someone whose predictions weren't worth very much.

W.O.: What do your bureau chiefs tell you about Europe and the Middle East?

L.B.: They tell us different things. Clearly, the most dangerous place

in the world now for reporters is Yugoslavia, where thirty report-
ers and photographers have been killed while trying to bring the
rest of the world word of what's going on there. In the Middle
East there is just a pinpoint of hope in the peace talks. I can't
characterize in a few words what they say about all of Europe or
the Middle East.

w.o.: What about Russia? Once the giant, is it now sleeping?

l.b.: The public is so much better informed now about the former
Soviet Union because, finally, we can move around a little bit in
that vast country. The economic and political difficulties are
pretty well reported, so those who are paying attention have a
pretty good picture of how the countries are trying to find a new
way. With some political turbulence, which, so far, Boris Yeltsin
has managed to ride. I don't know Yeltsin, but I've met Mikhail
Gorbachev. He was very impressive, one on one. He is obviously
the man who changed things over there. He was ultimately over-
whelmed by those changes. He had one little communication
technique. It's trivial, maybe, but it's something I remember
about him. When people have to use interpreters, there's a great
tendency for both participants in the conversation to begin to
talk to the interpreter so that you say, "Now tell him so and so."
You lose a lot that way. Gorbachev never did that. He would run
on and go right down your throat in his own language, and the
interpreter would be interpreting simultaneously. Gorbachev was
right on you all the time. You found yourself nodding in agree-
ment as you listened, and then you'd hear something about the
heinous capitalist press. And you'd have to stop yourself because,
of course, you wouldn't agree with what he's saying. One to one
he was a very strong and impressive man.

w.o.: You dine at the White House, and at both political conventions
you are about ten feet from the speakers' platform in your own
special box, watching everything. Are there any great leaders
around?

l.b.: One of the results of the way our own political figures are
reported these days and the intensity with which they're reported
is that some of the mystique falls away. It doesn't take much for
a president to have an illness and his X-rays are there on the
screen for the world to see. The political leadership is close to the

people, which is generally a good thing, but it takes something away from what you're reaching for.

W.O.: You help strip away that mystique with your satellites and wire service and pictures, which show the president throwing up all over his Japanese host!

L.B.: Well, I'm sorry. He did it in public! We didn't invade his privacy.

W.O.: Now the question: has it gotten to be too much? Are there places where the press ought not venture?

L.B.: I don't think I agree that it's gotten to be too much. There are in this area some lines, but I think when we start to draw them in the abstract, we get into trouble awfully quickly. We don't have an absolute right to say absolutely anything about a person's private life, but there are lots of issues that are pretty gray and the line is difficult to draw. And when there is a question, a balance to be struck, I think the balance ought to come down in favor of disclosure. The people benefit when they know more rather than less.

W.O.: You control most of the words, pictures, and images that go to every radio, television station, and newspaper in this country and in much of the world. Do you like being the messenger of news like the marital infidelity of a presidential candidate or of a president?

L.B.: I'm going to quarrel a little bit with the word "control," which has all sorts of connotations, but I'll answer your question, Bill. It's up to the people to decide—the voters—whether those things are issues on which they want to base their vote. We discharge a fair obligation when we report what we can learn about the character and behavior of a person who wants to be president. Is it an important issue? That's for the voter to decide. Has there been too much coverage of Governor Bill Clinton on this subject? If you think so, turn away from it. Don't read or listen to it.

W.O.: You're the big six hundred–pound gorilla at the AP mothership. Do you ever go in there and kill stories like this?

L.B.: It's not my job to kill stories. We discuss the content of our wire, what we think is fair to do. I'm no six hundred–pound gorilla walking through the newsroom, killing things. That's just not the way we operate.

W.O.: Do you have your own biases? In other words, when you and

Joan Boccardi sit around your Westchester home, do you ever rage at politicians?

L.B.: Sure.

W.O.: Is it hard to leave that behind when you get to AP headquarters?

L.B.: I do leave it behind, and that's fundamental to what we do. Let me tell you a little story that goes back a few years. I was in China shortly after our chief political writer had won a Pulitzer Prize for his coverage of one of Jimmy Carter's campaigns, and I was with a person who, in our terms, would be sort of chief-of-staff to a governor. He had obviously been briefed and knew who I was. So he congratulated me on the prize we had just won. He asked, "This man who won, what party is he? What are his beliefs?" I sort of recoiled a bit, and I said, "You know, I don't know." He didn't believe me. But I didn't know then and I don't know now, and people I work with now don't know my political views. They have absolutely no relevance to the judgments we make. They're not supposed to. We serve more than 1,500 newspapers. We serve several thousand radio and television stations. If we were veering off that road of objectivity and neutrality, there are thousands of bosses out there who would come and say, "You're off the mark."

W.O.: Do the big newspaper barons call you up to tell you they don't like a story?

L.B.: I don't know whom you mean by the big newspaper barons. We talk to editors of newspapers all the time, sure.

W.O.: We remember you at that Air Force base in Germany, when they released your man, Terry Anderson. How long had he been in?

L.B.: Six and a half years.

W.O.: At first you had a worried look on your face, and then you were the happiest man . . .

L.B.: It was a great weight lifted from all of us . . .

W.O.: What did you do to get him out?

L.B.: Terry was not released because of anything any of us did. We tried to do many things in the years he was held. My honest view is that he came out at the end because it was time. His release fit everybody's motive and everybody's need to, as the phrase went in the Middle East, "close the case of the hostages." Whatever value there had been for taking hostages had evaporated by this

point. And so I really don't think anyone can say that having done x, y, and z, therefore, Terry and the others were released. You recall there were several Americans released over several months.

w.o.: Somebody told me you talked to some "funny guys" with diamond pinky rings to try to get him out.

l.b.: That's a little melodramatic. People "representing" us talked to *lots* of people. Some of them might fit your definition of "funny guys."

w.o.: Some "extraordinary" channels?

l.b.: Some extraordinary folks. But, again, I felt from the beginning that this was a tragedy that was going to take its time to play out and would finally end when forces larger than anything we could effect, or other people working for Terry and the hostages could effect, finally came into play. You had the war. You had the collapse of the Soviet Union, which had been a patron of the Syrians. You had the imminence of a peace conference in which the participants each had reasons for wanting the United States to be favorably disposed to them. You had the plain fact that holding the hostages had clearly become counterproductive.

w.o.: But people who know you tell me you were like a man driven for six years to get him the hell out of there. What did you say to him?

l.b.: The best quote was not mine to *him,* but *his* to *me,* when we threw our arms around each other on that tarmac in Germany just before dawn. The first thing he said to me was, "I'm sorry, Boss." By which he meant that he was sorry for the pain that he knew his predicament brought to everyone. By his own admission he was not as careful as he should've been. We didn't know until much later that there had been another kidnap attempt before the one that was successful.

w.o.: Did he not say, "I forgive my captors"?

l.b.: He said, at that memorable press conference in Germany, that he was a Catholic and obliged to forgive his captors. This, to ordinary folks, is an extraordinary emotion, but he means it.

w.o.: And there's no bitterness you can detect in the man? Is he for real?

l.b.: You bet. You look incredulous, and I can understand that, but he is very much for real.

w.o.: He's not even the least bit angry with those guys who held him?

L.B.: He said something I thought was profound. He said, "They got six and a half years of my life. If I go around hating them I'll be giving them the rest of it, and I don't want to do that. I've got too much else to do." There's wisdom in that.

w.o.: What's happening to the media? The great newspapers are declining. Some magazines are in trouble. It looks like television will get stronger. Will radio survive? What about the newspapers?

L.B.: The one constant is that all these industries are undergoing a tremendous amount of change. The afternoon newspapers, which once dominated the field and were the bulwark of daily journalism, are diminishing.

w.o.: You mean no more evening papers?

L.B.: That goes too far. There are still several hundred evening papers, but several have disappeared or merged into the morning field.

w.o.: Are people reading less?

L.B.: I don't think there's any doubt about that. The circulation of newspapers is flat, while the population has grown—which means, in the jargon of our business, that the penetration is diminishing. Society has an obligation to keep reading. Television, whether broadcast over the air or via cable, is a tremendously powerful medium. But there is still so much that only the newspapers can do, and that is said by proponents and some of the leadership of television. For instance, in our election campaigns, I don't think you can consider yourself fully informed if all you've done is absorb what you can from television. There are things you just need to sit and read and—I almost hesitate to use the word—study. You can do that with a newspaper, but it's a little hard to do it with television.

w.o.: Like the conventions, in Houston and New York. Is what we saw really what happened there?

L.B.: The conventions have become mostly a television event.

w.o.: Showbiz?

L.B.: I think that's a fair characterization.

w.o.: Why do you dignify them?

L.B.: Because it's happening. They're where the presidential candidate will be nominated, and they are significant political events.

The event, this thing called a convention, is now structured as a show for television. That doesn't mean we should ignore it.

W.O.: You know them all. I'm not going to ask you for whom you'll vote.

L.B.: Good, because I won't tell you.

W.O.: We're approaching the election. Just give us a journalist's view of George Bush, the president of the United States.

L.B.: As we speak now, we're in for a close vote. It's obvious that the economy is the dominant issue, and that comes through in every survey. For Governor Clinton, some issues of trust remain. And when I talk to people—not fellow journalists, but people outside my business—I hear very often, in a variety of ways, "I'm not happy about where the economy is and I see a lot of pain, but I don't know about Clinton." That's where a lot of people are as we move into the homestretch of the campaign.

W.O.: Give me ten seconds on J. Danforth Quayle.

L.B.: Dan Quayle has worked very hard publicly to change the image that was created for him virtually in the beginning. He's certainly been a boon for *Murphy Brown*.

W.O.: Mario Cuomo, governor of your state and mine . . .

L.B.: A lot of people were surprised that he didn't step up to the nomination this time. A lot of professional politicians think he could have had it if he had chosen to take it. But in his wisdom I guess he thought it wasn't a good idea.

W.O.: How about Ross Perot?

L.B.: Ross Perot is, to my eye, a case of "what you see is what you get." He is a feisty, determined, quite self-confident man. As we speak, I'm not sure whether he's in or out. He is a formidable force, as you see from the millions of volunteers and the almost unheard of fifty-state ballot status that came out of nowhere in a matter of a couple of months.

W.O.: We're going to have a *new* senator or another senator: Al D'Amato or Bob Abrams? Were you concerned about the race Abrams ran against Geraldine Ferraro?

L.B.: That's not something I spend my time being concerned about. I'm a journalist, and we cover campaigns. It's up to the politicians to run it their way.

Fall, 1992

Interview with Walter Isaacson

Walter Isaacson is one of America's premier journalists. He wielded power as editor in chief of Time *magazine. And he's written several well-received books, including his best-selling tome on Henry Kissinger. In July, 2001, he was named president and CEO of CNN.*

W. O'SHAUGHNESSY: Tonight, one of the preeminent journalists in this country. He is managing editor of *Time* magazine and the author of *Kissinger,* which was just named one of the best books of the year: Walter Isaacson.

W. ISAACSON: It's great to see you again, Bill.

W.O.: Which would you rather be, a big editor of *Time* or the author of *Kissinger?*

W.I.: You get a lot more satisfaction with the book because you can collect your thoughts and ideas. You can live with it for years and wrestle with it. A great satisfaction comes with a book, but then something comes along like Somalia, and it's wonderful to be a journalist covering something so important.

W.O.: People who know you tell me you work eighteen-hour days at *Time.* How did you find time to write a book like *Kissinger?*

W.I.: The dirty little secret is that nobody really works eighteen-hour days. I was interested in Kissinger, and getting people to talk about him was so easy. All you have to do is push a little button and say, "Kissinger," and they come forth with tales. So in the six years I was researching the book I would go down to the basement office in my home in Westchester and work on the book in the evenings. I didn't find it that hard to make the time. And I took a nine-month leave of absence from *Time* magazine when it came time to really write the thing. I felt I needed to work solid twelve-hour days writing or I would never get it done.

W.O.: I hear Henry Kissinger didn't like the book.

w.i.: He likes the *title*. I saw him on TV last night talking about the book. He gave me two dozen interviews and access to his archives. I think if he reread his own memoirs or his own Nobel Peace Prize citation, he'd be outraged because he is notoriously sensitive and thin-skinned and would think they weren't favorable! One of the television talk shows quoted *The Washington Post* review of the book, which said something like it was a "superb" book about a "fascinating, but overrated" man, and asked him if he agreed with that assessment. Henry thought it was an *overrated* book about a fascinating and superb *man!* We have some disagreements. I agree with him that it's about a fascinating subject: Henry Kissinger.

w.o.: Do you like the man?

w.i.: I find a lot of his policies and methods to be appalling at times. He knew there was no moral justification for the bombing of Cambodia, which is why he kept it secret. I found it appalling that he would secretly wiretap the home phones of his close friends, honorable people like Winston Lord and Tony Lake, people he should have trusted.

w.o.: What did Kissinger say about that?

w.i.: He apologizes now for the wiretaps. He feels the bombing of Cambodia was necessary because we had to destroy the Communist sanctuaries there, and the secrecy was necessary because otherwise the uproar would have made the bombings impossible. He has excuses for a lot of what he did. But I found aspects of his life totally appalling, especially the deceitfulness, that reputation for secrecy and conspiratorial actions. Yet there is a lot about this man I respect: his enormous brilliance, his real "feel" for power. If only his feel for *morality* had been as good and acute as his feel for power, he would have been a truly great statesman.

w.o.: Henry Kissinger is a great icon of the Republic. You are suggesting he is almost dangerous.

w.i.: I'm suggesting that a lot of the policies he and Richard Nixon pursued were not in the best interests of our country in the long run. Take the bombing of Cambodia. The Cambodians knew full well *they* were being bombed, so we weren't keeping it a secret from *them!* He was keeping it secret from Congress, the American people, and the State Department. Even the secretary of the Air Force was deceived because they had false reports sent up the

channels. And then when the news started to leak out, Kissinger and Nixon put the wiretaps on the home phones of Kissinger's aides. And after you do that, it's not a big step for the same plumber's unit to start putting wiretaps in the Watergate headquarters of the Democratic Party. I'm suggesting that things like the secret bombings were more destructive to our government than they were to the Cambodians. The Cambodian Communists won *their* war. A lot of Kissinger's policies failed because of the lack of feel for the basic values of morality we have in this country.

w.o.: Kissinger has a lot of friends in Westchester. Some are watching this program now. Did you get any pressure to ease up on the guy?

w.i.: No. I tried very hard to keep the book balanced. I didn't have an ax to grind against the man. I think I show a lot of his brilliance, charm, and intelligence and the deep caring he had for America's national interest. I've talked to hundreds of people close to Kissinger who said nice things. Even though I criticize him on a lot of the policies that seem to me to have backfired and failed, it doesn't mean I didn't at least try to give a well-rounded portrait of the guy. I tried to show why his friends find him so charming, why his policies were so intelligent.

w.o.: Before Henry Kissinger went to Washington, we saw him around Westchester at the side of our legendary neighbor Nelson Aldrich Rockefeller.

w.i.: Nelson Rockefeller was one of the great patrons of Henry Kissinger. Kissinger was at Harvard. He took a brief leave to come down to the Council on Foreign Relations in Manhattan to write a book called *Nuclear Weapons and Foreign Policy*. There he was "discovered" by Nelson Rockefeller. Kissinger once said Rockefeller had a "second-rate mind, but a first-rate intuition" about people—which was a little conceited of Kissinger. Kissinger was the opposite: he had a first-rate *mind* but a second-rate *intuition* about people. Nelson Rockefeller put Kissinger on retainer, $25,000 a year or so from the middle 1950s to 1968, when Nixon finally won the presidency. And Rockefeller helped make Kissinger the success that he is. Kissinger used to spend a lot of time at Pocantico.

I'll tell you a little story. Kissinger secretly wiretapped his *own*

phone and made transcripts of the calls he received. During Watergate he was so worried about what would happen to those transcripts that he shipped them up here to Westchester and put them in the bomb shelter, the vault, under Nelson Rockefeller's estate. That's how close he was to Rockefeller. Kissinger trusted Rockefeller more than he trusted Nixon or the people in the White House even when he was working for Nixon. Rockefeller was unafraid to have smart people around him. That was the genius of Nelson Rockefeller.

w.o.: What about Kissinger and the ladies?

w.i.: When he was national security advisor and then secretary of state he became our first celebrity statesman. He loved celebrity, being the most admired person in America, according to a Gallup Poll. But what he really loved was that year the Playboy bunnies voted him the man they'd most like to go out on a date with! He was a guy with thick eyeglasses, a thick waistline, and a thick German accent, and all of a sudden he's a sex symbol. When you ask him why, he says, "Power is the ultimate aphrodisiac." He had power, so that made people think he was sexy. He liked to go out with women, to be seen with Jill St. John or Angie Dickenson. I think most of them would tell me that once eleven o'clock rolled around, he liked to drop them off at home and he'd get back to his work. A lot of them say they would have loved to have had a real romantic affair with Henry. He wasn't married and he had no reason not to have an affair, but his work was his true love. And the dirty little secret about Henry Kissinger was that there weren't that many dirty little secrets! Of course, he went out with some pretty stunning women, and I'm sure he had a good time. But, unfortunately, I can't try to sell my book by saying you're going to get a whole lot of sex in it. I have too much respect for Kissinger's privacy to go too far into his private life.

w.o.: Did you really ask Jill St. John, "Did he really just drop you off?"

w.i.: She was embarrassed, as many women were. She did say, "I almost thought he was going to develop a romantic interest in me, but he never really did. We liked to talk. He'd call me on the phone late into the night, and we'd even talk about sexy things, but he never seemed to have much of an interest in taking me home." I don't think these gals were lying to me because they

would have all been quite flattered to have had an affair with Henry Kissinger.

I'll tell you a little story. It gets in the papers one day that Henry is dating Jill, and his father, Louis Kissinger, a very orthodox Jewish man, calls Henry up and says, " 'St. John' doesn't *sound* like a Jewish name." And Henry says to his father, "Actually her real name is Jill Oppenheimer, and she is Jewish." She confirmed it.

Henry eventually married Nancy MacGuinness, who was a Rockefeller aide. She taught at the Masters School in Dobbs Ferry. She was from one of the nice social-register families of White Plains. Her father was a Park Avenue lawyer and she is quite brilliant.

w.o.: Do you think it's a good marriage?

w.i.: They respect and like each other very much. When he became secretary of state and they got married, she put aside most of her intellectual interests and became more interested in social matters. But she has the intelligence and spunk to stand up to him.

w.o.: What about the story of Kissinger and Nixon on their knees, praying?

w.i.: It really did happen. Nixon and Kissinger had had a falling out. Nixon was consumed with jealousy at Kissinger's popularity, but his last night at the White House, the only person Nixon called was Kissinger. Nixon was upset, crying, talking about his place in history and asking how history would treat him. Kissinger said, "History is going to treat you better than your contemporaries. They are going to remember you for the great things you did. They are going to remember you for the opening of China." Kissinger was being very nice at this point because Henry liked to take some of the credit for the opening of China, but he gave Nixon the credit that night; and they talked for almost two hours. And at the end, when Kissinger was ready to go home, his shirt drenched in sweat, Nixon stopped him and said, "I know you are of a different religion, but I think we both believe in the same God. Would you kneel down and pray with me?" And Kissinger got down on one knee and finally the other knee. Kissinger later admitted that no prayer came to his mind. He was just struck with the oddness of this experience. In some ways it's a very moving story.

w.o.: Do you think it's a sweet story or a scary story?

w.i.: Like a lot of things about the Nixon–Kissinger relationship, it has a lot of mixed angles to it. Nixon had been quite anti-Semitic, at times calling Kissinger "my little Jewboy"—and then making him kneel down and pray with him! What makes it even stranger was that when Kissinger went back to his office in the West Wing of the White House, Nixon called and told him to please not tell people he cried: "I want people to remember me as strong." And Kissinger said, "If I talk about it, I'll talk about it respectfully." So they get off the phone, which had been tapped, and the next morning a transcript was made and it leaked out.

It's such an odd story. It shows you the best and the worst about Nixon and Kissinger and their need for each other but also their distrust of each other.

w.o.: When you're not writing books and are only a top editor of *Time,* the politicians and government leaders present themselves to you. What about Nixon?

w.i.: It was interesting interviewing Richard Nixon for this book. He was very generous, but there was always a little bit of an edge to it. He would praise Kissinger, but he would tell me you had to know how to *handle* him. I also saw notes that Nixon insisted Kissinger see a psychiatrist. Kissinger never did, but it's that odd relationship again. Nixon had that wry sense of humor. I was taking shorthand notes, and he asked me why I didn't use a *tape recorder* and that he *always* used a tape recorder. I thought he was joking, but he pulled out a tape recorder and put it on the desk in his office in New Jersey. After about a half hour the tape ran out, and he was all thumbs trying to turn the tape over, and he said, "I was never really good with these taping devices!" and he pushed it aside.

w.o.: What do you think about Mario Cuomo?

w.i.: I think Mario Cuomo is one of the brightest, sharpest intellects I have ever engaged. His mind has such fast-paced logic. He can find the soft spot in any argument. In some ways it hurts him as a politician because a politician almost has to put aside too much intellect and reflection, otherwise they get a little bit paralyzed. Mario Cuomo loves to wrestle with a problem. And Ronald Reagan, who *never* loved to wrestle with a problem and saw things very simply and didn't have the intellect that Mario Cuomo has,

was a much better leader. I think Mario Cuomo would be an absolutely great Supreme Court justice.

w.o.: How about president?

w.i.: I don't know. I think he has a bit of a thin skin. He sometimes is not decisive enough. I feel more comfortable with Bill Clinton as president than I would with Cuomo.

w.o.: What's the skinny on Clinton?

w.i.: He loves government. He loves the details about how government is going to work and make lives better for people. He believes that you can use government as a tool. You have to remember that from the George Bush years, the Reagan years, even the Carter years, there was a feeling government was not a good tool to make people's lives better. Clinton believes in government. He's not as much of a liberal as you might think. I'm from Louisiana, so I've known him since I was growing up. He is an absolutely charming guy. He is a moderate. He is thoughtful and truly understands government, and I'll admit to being, at least for the moment, on the honeymoon with Bill Clinton.

w.o.: What about George Bush?

w.i.: I think George Bush is a real decent and honorable man who ran a bad campaign but really ran an extremely good foreign policy that was based both on our national interest and some concept of our national values and morality.

w.o.: Who is Betsy?

w.i.: Betsy is my daughter. She is two and a half, and I dedicated my book to her. She's quite a handful, but she made writing the book a magical, worthwhile experience.

December, 1992

Interview with Terry Anderson

This was one of Terry Anderson's very first interviews after being freed from captivity in Lebanon. His ability to forgive has been both controversial and inspirational.

W. O'SHAUGHNESSY: Tonight, one of the best known journalists in the world: an authentic American hero. Terry Anderson, does it bother you when an O'Shaughnessy calls you a hero?

T. ANDERSON: The word *hero* bothers me because I have my heroes, and certainly I don't consider what *I* did particularly heroic. You know, you do what you have to do, and it just gets you through the best you can.

W.O.: It was what was *done* to you.

T.A.: It was not a matter of choice. You want to call Terry Waite a hero, there's something. He volunteered.

W.O.: He was the big English fellow . . .

T.A.: The Church of England envoy who was trying to negotiate our release when he was kidnapped. He spent three and a half years in solitary confinement before he finally joined us for the last year. Never heard him utter a word of regret.

W.O.: I remember Lou Boccardi, our Westchester neighbor, the president of the Associated Press, your boss, flying to Germany, and there you were, *free!* How long ago was that?

T.A.: Almost eighteen months ago now. December, 1991.

W.O.: Do you remember the day?

T.A.: I remember it very well, every single second of it. From the morning in the cell through that long day, listening to the radio, which was reporting I had already been released and I was on my way to Damascus, as I sat there in my cell playing solitaire, waiting for them to come and get me. They finally took me out in the evening, put me in a car, took me to the Syrian Foreign Ministry

to turn me over to the American ambassador. We had a very brief press conference there. And then to the American Embassy where I finally saw Madeline again and my daughter.

w.o.: How many days and nights were you confined?

T.A.: Two thousand four hundred fifty-four I think is the figure the AP finally agreed on, so it must be right.

w.o.: Did you keep count?

T.A.: Not really. We didn't know how long it would be. Tom Sutherland, my great and good friend and cellmate for five and a half of those years, was a fanatic about the numbers. He would count and say it's been 1,000 days or 1,200 days or 1,400 days. I'd say, "Tom, shut up. I don't want to know. I'm not counting." I tried not to think about it too much.

w.o.: I don't want to bring those years back, but you've written a book about your experience.

T.A.: *Den of Lions,* from Crown.

w.o.: Why did you write the book?

T.A.: We wrote the book. Madeline wrote a good portion of it. She wrote her story, and I wrote mine. Every journalist wants to write a book. It was a natural idea, but I hadn't intended to write it right away. I wasn't really ready for that when I got out. But I was offered a marvelous fellowship at The Freedom Forum at Columbia University for a year, which seemed to me an ideal way to ease back into my life, spending a year on a great college campus.

w.o.: Was it therapeutic? Did you just have to get it down on paper?

T.A.: It was difficult for both of us, because we wanted it to be right, and it's not good enough to write what you think about what happened or what you ought to have thought. You have to actually go back there in your mind and feel what you felt then, and it was sometimes not very good.

w.o.: Madeline is the woman who waited for you . . .

T.A.: Seven years. I can't possibly describe what that means to spend six years and nine months and some odd days in prison and walk out and find my lady standing there waiting for me.

w.o.: What was the first thing you said to her?

T.A.: We cried. We hugged each other and held each other for a good long time. My daughter was asleep—it was after midnight. She took me and woke her up and introduced me to my *daughter.* It was a wonderful day.

w.o.: I have to ask you something. What the hell were you doing over there?

t.a.: I was the chief correspondent for the Associated Press. And I loved it. That's kind of a strange thing to say. I went over there to cover a war in 1982. War is terrible.

w.o.: You had enough seniority. You could've been posted in Syracuse.

t.a.: I could've done anything. That's what I wanted to do. I am a journalist, a newsman, a foreign correspondent. That was the biggest story going, and I wanted it. I loved Lebanon. It fascinated me. The Middle East fascinated me. The people—most of them—are wonderful people.

w.o.: You loved Lebanon?

t.a.: I stayed too long. Two and a half years I wandered around there and did my job, took a lot of chances, got away with them, and I got a little arrogant. I didn't pay attention to the danger when they started kidnapping people. They tried to kidnap me the day before, and they missed. I didn't tell Madeline, of course. Other journalists had been leaving. I was being my somewhat arrogant, adamant self, saying that I wouldn't leave until they come through the windows. Madeline just looked at me and told me that they don't come through the windows. The next morning, stupidly, I got up and kept a tennis date, and they got me.

w.o.: Where did they grab you? Off the tennis court?

t.a.: No. I was taking my tennis partner, a friend of mine, Don Mell, an AP photographer, back to his apartment. I stopped the car. That was the problem. The day before they tried to run me off the road, and I outdrove them. I had a nice, snappy little car. But this time I stopped the car and turned it off so Don could get his gear out of the back, and there was no way I could get out.

w.o.: I hear you admitting there was a little arrogance . . .

t.a.: More than a little. I was stupid. I should've paid more attention to the danger. As I said, we took an awful lot of chances during those two and a half years and got away with them. You get that feeling: I can handle this, I know what I'm doing. I obviously didn't.

w.o.: I've heard you speak in public about your Catholic faith. Did you ever get mad at God?

t.a.: I did all the things that are almost cliché in terrible circum-

stances. I prayed and I pleaded and I promised—I'll do *this* and I'll do *that;* I'll be good—can I go home now? I got mad, but I had a lot of time to work through that.

w.o.: Did you ever get mad at God?

t.a.: Oh sure. "OK, God. I've been a bad boy. Isn't this enough?" I remember Father Martin—who I was blessed with in there for a time—used to walk around in a circle. There were five of us in the room at that time, and every once and a while Father Martin would look up and say, "OK, God, my name is not Job!"

w.o.: A priest used to say that?

t.a.: Yeah. As I said earlier, you have to work through it and come out the other side.

w.o.: Forgive me, but I must tell you, it didn't quite ring true when I heard you say, "I forgive my captors."

t.a.: Why not?

w.o.: They put you through a lot of stuff.

t.a.: Yeah . . .

w.o.: Aren't you a little angry?

t.a.: I don't like them. I don't hate them. Look, forgiveness is a difficult thing to understand, let alone do. What does it mean? Does it mean they shouldn't be punished for what they did? Does it mean I have to love them? I'm not that far yet. But I am a Roman Catholic. It is required of me that I forgive my enemies. It's part of the bargain. It is also, I think, necessary for me personally. I have a second life. I'm enjoying myself. I have a beautiful, loving wife and a child. I'm forty-five. Why should I waste my time hating somebody or being bitter or angry? It's not going to hurt them. It's not going to help me. It's going to spoil things for other people around me. I can't do that. I can't waste my time.

w.o.: Before we leave those desperate days and that awful place: will the Middle East ever be straightened out?

t.a.: I have high hopes. The talks are moving forward.

w.o.: Will Jews get along with Muslims and Christians?

t.a.: They *have* to. That's the important part. And they know it. There isn't any other way. Israel is a Middle Eastern country. It has to be accepted as such, and it has to accept that fact itself. I was in Atlanta recently, attending CNN's world conference. The two speakers were the Palestinian delegate to the talks and the Israeli consul general of New York, a powerful and eloquent

woman. They stood up and talked to each other as equals. I heard an Israeli official say to a Palestinian, "You are much like us. Some of the things that were done to us, we're doing to you." I sat at dinner with them and Jimmy Carter. Now there's one of my heroes. I listened to the three of them talk about elections on the West Bank and whether they were possible, and how Mr. Carter could supervise them. They were talking seriously about serious issues. It's going to take a long time. But they're going to do it.

w.o.: How did you come up with the title for the book?

T.A.: *Den of Lions.* It's not a reference to Daniel, as everyone assumes. It comes out of the Song of Solomon, which is one of my favorite books, because it's about a beautiful Lebanese lady, and I happen to know one like that. There's a verse in there, 4:8, I think: "Come away with me from Lebanon, my bride; come with me from Lebanon. Descend from the crest of Amana, from the top of Shenir, the summit of Hermon, from the lions' dens and the mountain haunts of the leopards." That's where I got the title for the book.

w.o.: Who'd you dedicate the book to?

T.A.: I dedicated the book to my two daughters.

w.o.: There's a suspicion abroad in this state that you aspire to a career in, God forbid, politics. Probably the two worst things, journalism and politics.

T.A.: Let's put it this way. I am determined to be involved in politics. I speak around the state to various county Democratic dinners. I supported President Bill Clinton. I campaigned for him. I campaigned for Bob Abrams for attorney general of New York. Should things work out, I will be campaigning for Mario Cuomo in '94.

w.o.: Someone who admires you might say, "What the hell is this guy doing touting President Clinton?"

T.A.: I like President Clinton. I admire his ideas. He is the first president we've had in a long time who is offering at least the possibility of change. He is not above criticism. He has had a rough time in the past four months trying to get organized and trying to take control of that madhouse in Washington.

w.o.: I'm asking you as a journalist now: hasn't he become almost a laughingstock?

T.A.: I don't think so. No president is ever a laughingstock. I think it's unfair to attack him so bitterly, but expected—we *do* that to our presidents. He's had a rough time. I think a lot of it is reality

shock. This guy came out of Arkansas, where his style of consensus and talking and sensitivity worked. He comes into Washington, and he's got a million people running around with their own agendas in his own White House, and he hasn't been able to take control of them and insist, "It's *my* agenda that counts here, and if you're not playing on *my* team, then you're going to have to leave."

W.O.: Is he in over his head?

T.A.: I don't think so. I think he's a brilliant man. I think he's going to have to get tougher than he is, but he has a long time to go. And one thing: he *has* had some accomplishments. The things that we're fighting over in Washington are important ideas and deserve a full debate. If he can push them through, think about the changes we're going to have in this country.

W.O.: Let me ask you something. Did George Bush do everything he could to get you out of there?

T.A.: I think he did. A great deal he *couldn't* do. I have no great criticism of the American government, except that I think the arms-for-hostages deal was a very bad idea and badly executed. I have to start by saying it got three hostages out, all of whom were my cellmates, and I was very glad to see them go home. However, more Americans were kidnapped even before the third one went out. That's to be expected. All they did was set a price. Five hundred TOW anti-tank missiles equals an American. What do you think is going to happen? They become marketable. Even Ollie North admits that.

W.O.: Word on the street is that your boss, Lou Boccardi, head of the Associated Press, used somewhat "unorthodox" methods to get you sprung.

T.A.: Lou Boccardi did everything in his power to get me sprung. He assigned a senior executive full time for years to my case to go out and do whatever he thought was necessary. He was very concerned, and rightly so, that the fact that the AP had a correspondent in prison and in danger in the Middle East should not ever affect the AP's news coverage.

W.O.: Did he use, shall we say, unorthodox . . .

T.A.: I don't know what he did. Lou won't tell me. You know Lou can be very closed-mouthed. I have to say that he's been a fine, fine friend, and one I hope I keep for a long time.

w.o.: Why did you leave the AP?

t.a.: I enjoyed being a journalist and a foreign correspondent. It's an exciting, fun, important job. But I had a lot of time to think about what I wanted to do. I didn't want to go back overseas—twenty out of the last twenty-five years were overseas. I wanted to live in the States for a while, be an American again. I'm not a headquarters person. Lou is eager for me to go to 50 Rockefeller Center, AP headquarters, and try to take up an executive job there; he told me I could have virtually any position that seemed good for me—but I'm just not a headquarters-type person. I have a daughter who is eight now. She just had a birthday. She needs stability. She needs to know that this is where we live and where we are going to live for a long time to come. As a journalist, I fully believe in what journalism does. It is a vital part of any Democratic system, certainly ours. But it's really hard, as a journalist, to point to anybody and say, "I helped *that man*. I fixed *that* problem. I did something for *those* people." The satisfaction is a great deal more diffuse. I decided I wanted to do something more direct about the things I believe in. People in this country were marvelous to us . . .

w.o.: When you got out?

t.a.: . . . both when we were in there and when we got out. They took us to their hearts in such a deep and personal way. I just feel like I want to give something back.

w.o.: There's a suspicion that you would fancy being lieutenant governor, the number two job. It's now held by a man named Stan Lundine.

t.a.: I've met Mr. Lundine. I like him. He's a very nice man.

w.o.: Are you running for lieutenant governor?

t.a.: I'm not running for anything at the moment.

w.o.: Would you like to be lieutenant governor?

t.a.: It would be an honor to hold any position that high in government, but I'm not sure I want to do that just now. I've been out a year and a half. A lot of people have been talking to me about running for various things—I don't want to get specific right at the moment because there are other people interested in those jobs too. . . . I would love to be lieutenant governor. I'd love to be in Congress. I'd love to be in the Senate. I'd love to serve in government. Maybe not just now.

w.o.: What about Mario Cuomo? You mentioned him earlier.

T.A.: I admire him very much. He is a brilliant man, an honest man. He has been trying to bring this state into the modern age and trying to institute reform for twelve years. I hope he'll be in office for another four.

W.O.: Do you think he should've gone on to the Supreme Court?

T.A.: I think he would have made an excellent justice, and I told him so when I met with him a couple of weeks ago. He's a very dedicated man. He had his reasons for not doing that. One thing you can say: nobody is ever going to convince Mario Cuomo to do anything that he doesn't believe is right. And he didn't think that it was time for him to go to the Court. I think he'd be an excellent president. Why he didn't run, I don't know.

W.O.: Now, if he should dump Lundine, what about Cuomo-Anderson?

T.A.: I don't think there's any chance of his dumping Stan Lundine. They are very close. Mr. Lundine is very loyal. If he wants to run again, I'm sure the governor will be happy to have him as his deputy. I don't know what Mr. Lundine is going to do. I don't know what Mr. Cuomo is going to do. Nobody seems to know. And I certainly don't know what I'm going to do just yet.

When I say I am involved in politics, that means I believe in the political process. I'm a Democrat. I am vitally interested in New York. It's my state. I was raised here and live here. It's a marvelous place. I'm interested in bringing our state government up to date. We badly need some reform. People are very unhappy with the system here. They tend to blame bureaucrats, legislators, and so on. I think it's the *system*. People are good, bad, and indifferent, whether they work in the Education Department or the Motor Vehicle Department. We need to improve the system. It's a different age. It's a new time.

Spring 1993

Interview with Ken Chandler

Ken Chandler's newspaper is an essential and colorful piece of the great mosaic of New York journalism, and the publisher himself is a delightful fellow.

W. O'SHAUGHNESSY: Tonight, another Westchester neighbor of extraordinary accomplishment. He is one of the most powerful men in New York City and is the boss-man of my favorite newspaper: the publisher of *The New York Post,* Ken Chandler. I'm glad I got you out of your ivory tower, sir.

K. CHANDLER: I don't think I'm in an ivory tower, but you may differ on that.

W.O.: Maybe I need a good editor! You've also been a television producer. You produced *A Current Affair.*

K.C.: I did, albeit only for three weeks. That was my one television interlude. But the rest of my life I've been involved with newspapers. I ran *The Boston Herald* for six years. Before that I was at *The New York Post.* And I helped start a magazine called *Star* back in the seventies, and earlier I was in London working on a variety of newspapers.

W.O.: You've been a longtime associate of the legendary media baron Rupert Murdoch.

K.C.: I worked for Rupert Murdoch in London in the early seventies on *The London Sun,* which he still owns. I was lucky enough to work with an editor there who had the unlikely name of *Sir* Larry Lamb. He was a very talented editor, but he had a habit of taking very long lunches, and when he came back from lunch he had an absolutely fearsome temper, so he was to be avoided at all costs.

W.O.: You had to get him before lunch.

K.C.: You actually had a very narrow window of opportunity to get him in the morning. I remember being summoned to his office

on a Thursday afternoon, and I was so terrified of going to see him after lunch that I concocted an excuse that I couldn't be reached until Friday morning. Usually if you were summoned to see Sir Larry it was bad news. You had done something dreadfully wrong or landed the paper in a huge libel action or something. When I went to see him Friday morning, true to form, he kept me waiting outside his office for an hour and a half. It got to be half past twelve and I thought, "Good God. He's going to go to lunch." But on his way out he said, "Oh, you're waiting to see me?" So I said, "Actually, *you* wanted to see *me*." So he said, "That's right. I want you to go to America." So I said, "That sounds nice." He said, "We've just started a new magazine over there and we need some help, and you're to be there on Monday morning. But don't worry, it will only be for one year." That was in the beginning of 1974.

w.o.: Now you and Rupert Murdoch have saved *The New York Post.* I read six newspapers every morning. I have to tell you Gannett has been very good to Bill O'Shaughnessy, but I read your paper first.

k.c.: A lot of people have been involved in saving the paper. Murdoch owned the paper in the seventies and early eighties, and then he bought the Fox Television Network. And the law says you can't own a TV station, which in this case is Channel 5, and a newspaper in the same city. So he had to get rid of *The Post,* and he sold it to a real estate developer by the name of Peter Kalikow who operated the paper quite successfully for four or five years. And then in the early nineties there was an economic downturn, real estate was the pits, and Kalikow got into some problems. *The Post* was put into bankruptcy, to make a long story short. The bankruptcy judge in 1993 determined that nobody else had the know-how or financial ability to operate *The Post* except for Rupert Murdoch.

w.o.: But didn't you have a "nut job" in there for a while?

k.c.: It was like a circus that went on for six or eight weeks. I'm not going to categorize them as "nut jobs" because I don't want to see you get sued, but let me just say that one of the people who owned *The Post* for about two weeks during this period is now in a federal prison serving a twenty-year sentence for bilking investors. That was Steve Hoffenberg. And then Abe Hirshfeld, who has made a fortune with parking lots in New York, owned the paper

briefly. But you have to know a little bit about a newspaper to operate it. It's not like running real estate or parking lots. So Murdoch came back, and when you said that he saved the paper, that was true. He did it with a lot of help from Governor Mario Cuomo at the time. And Senator Al D'Amato was extraordinarily helpful. So too was Mayor David Dinkins. Politicians from all sides—even the ones *The Post* had been most critical of—came to the table and said they wanted to see the paper saved. For one thing, there were eight hundred jobs in jeopardy, and second, we think it's important that another voice, a conservative voice, be retained.

W.O.: You not only have survived, you're prospering. You're in a hell of a battle with *The Daily News*.

K.C.: We've been fortunate. When I came back to *The Post* in 1993 as Murdoch reacquired it, the paper really was in a dreadful mess. I remember going back into the newsroom on the first day we were there and because of the bankruptcy there was no paper to put in the Xerox machine, so the editors couldn't pull page proofs to see what was going to go in the paper. There was no soap in the bathrooms. The elevators hadn't been inspected. Some things you could fix pretty quickly, but the circulation had also been run down. It's true that we really had nowhere to go but up. In the six years we've been back we managed to increase the circulation every year. All newspapers have their circulations audited in six-month periods. We have increased every six-month period by about fifty thousand copies a day, and we're the only newspaper in North America to have shown an increase.

W.O.: You preside over the most disparate, colorful stable of swash-buckling reporters. What do you call your gossip columnists?

K.C.: The divas! The men and the women.

W.O.: That makes you the boss of shy, modest, retiring Cindy Adams, also Liz Smith, and wonderful, bright Neal Travis, who's the only gossip columnist who won't hurt anybody. Also the infamous Page Six.

K.C.: The very *influential* Page Six. That's edited by Richard Johnson, who does a terrific job. The column comes out seven days a week, and a lot of people tell me it's the first thing they turn to in the paper.

W.O.: I plead guilty as well. Do people ever call you up and say, "What are you doing to me?"

K.C.: There are two groups of people, those who don't want to be *on* Page Six at any cost—and they do call—and those who don't want to be left *off* Page Six. So when you get a call about Page Six, you're never quite sure whether it's somebody saying, "Why did you put me *in?*" or "Why did you leave me *out?*"

W.O.: Like Donald Trump: he wouldn't mind.

K.C.: No, normally he wouldn't mind. He's a pretty good sport.

W.O.: But you've taken a couple of whacks at him.

K.C.: Someone like Trump realizes that you can't be good copy all the time. You've got to have a little bit of criticism.

W.O.: Besides featuring all those gossip columnists, every Sunday you also dig into your archives and bring out gold called Jimmy Cannon.

K.C.: The Sunday paper has been our other big success story. When I came back in '93 there was no Sunday paper, and we felt there was an opening in this market to do something. When someone mentions a Sunday paper, you conjure up images of a huge paper with multiple sections. You stagger home with half a Canadian forest under each arm. We figured we might be more successful if we just did a seventh-day version of the daily paper and charged the daily paper price, which is fifty cents. People's habits are changing. Sunday is not the day it used to be, when people would lay around the house all day and do nothing. Sunday is now one of the busiest shopping days of the week. People are commuting to work on Sundays, at least in the service jobs. We were surprised by how successful the paper has become.

W.O.: As the boss of Cindy Adams, do you ever have to edit her stuff? Do you call her up and tell her you don't like "that word"?

K.C.: Yes. Cindy is the consummate professional. It doesn't happen very often, but I occasionally call her up and say, "Cindy, I don't want to run this" for whatever reason. And she'll accuse me of being a coward, but at the end of the day, I win . . . most of the time. She's a terrific reporter, and she came to *The Post* back in 1979 when the Shah of Iran had come to the States—I'm not sure whether it was after he had been forced to leave—but he was in the hospital having cancer treatment. She didn't even work for *The Post,* but she managed to get in and get an interview, and then she came in and knocked on the editor's door, and the interview was published and she was hired.

w.o.: What about Liz Smith?

K.C.: She's terrific to work with, a wonderful columnist.

w.o.: She must be one hundred years old.

K.C.: I wouldn't dare discuss her age! She was formerly at *The Daily News* in the 1970s. She was really the first modern gossip columnist of any of the New York papers.

w.o.: I see Neal Travis around New York. He is terrific. And he has a pal who works for you named Steve Dunleavy: a crusading, rather "swashbuckling" journalist.

K.C.: To understand Dunleavy properly, you have to turn the clock back maybe forty years. He'll probably kill me for saying this. Steve started his career as a reporter for a newspaper in Sydney, Australia. At the same time his father was a news photographer for a rival newspaper in Sydney. The competition between the two papers was intense, but it was nothing compared to the competition between father and son. We know that Steve Dunleavy slashed the tires of his father's car to stop the father from getting to a story before Steve's own newspaper got a photographer there!

w.o.: That's awful.

K.C.: That was the old way of doing things, and Dunleavy is such a competitor. You put him on a story and he just goes at it until he gets it. He's not a young guy anymore, but he has more energy and drive than a lot of younger reporters, and I wish I had a newsroom full of Dunleavys.

w.o.: You have a big say in who will be the next senator from New York. You're a resident of Westchester, and your wife is the principal of the School of the Holy Child. So during supper at the Chandlers, what do you say about Hillary?

K.C.: Let me just say that my wife and I have very different views on this senate race. She's much more of a Hillary supporter than I am. This race is going to be so interesting it's going to eclipse the presidential race in this state. Both Rudolph Giuliani and Hillary Clinton are both very formidable candidates, and we really haven't seen the race yet. I wouldn't begin to predict how it's going to end up. The only thing I know about politics is that whatever seems certain now is going to be turned upside down in six months. Don't believe anybody who tells you who is going to win this race.

w.o.: Did you ever meet anyone who says, "I just love Rudy?"

K.C.: He's proven to be an extremely effective mayor for New York. This is particularly evident to people who live in Westchester and go into the city. You know that it's a safe environment. Ten years ago I wouldn't have wanted my teenage daughter to go to a Broadway play with her friends. I would've been worried about her in Times Square. Today Times Square is perfectly safe. He's not without faults, but he's been one of the great mayors.

W.O.: At the risk of provoking Mrs. Chandler: what about this Evita-cult-like Saint-Hillary-from-the-balcony stuff? George Bush used to call his wife Barbara. There is no such thing in the constitution as a First Lady. Hasn't she played that a little too hard? Or did we create her?

K.C.: Coming from being a First Lady to a senatorial candidate: I'm not sure that it's going to be that big an issue. Her personality *is* an issue. Where I differ with her is on her policies. I feel that she is someone who feels she always knows what's best for me and for everybody else, and I'm not sure she really does know what's best for us.

W.O.: Is the *Post* really conservative?

K.C.: We're really the only dependable conservative voice of all the papers. *The New York Times* is certainly not conservative. *The Daily News* is occasionally conservative, but *The Post* is dependably conservative.

W.O.: What about our Gannett newspapers?

K.C.: I'm not sure I can quite decipher what their editorial policy is. It's a different sort of newspaper, to be fair to them. It is serving a community. The pie that we have divided among *The Times, The Post,* and *The News is* big enough to have papers of differing views appealing to different constituencies. It's a great benefit to have us there.

W.O.: Who writes the famous *Post* headlines? Neal Travis said, "I don't do the headlines, dear boy."

K.C.: There are about three or four senior editors who get together in an office at about seven each night, and out of that little cluster usually comes the headline. We take it from wherever we can get it. Sometimes a reporter will think of a headline and walk past the office and give us a marvelous line.

W.O.: Is sports important to a newspaper? I just read about the Yankees.

K.C.: Sports is not only important, it's absolutely fundamental to *The New York Post*. We have Peter Vescey, who covers basketball. The one who seems to cause the most uproar is Phil Mushnik, who writes about sports on television. He gets a huge response from readers. And we have Steve Serby.

W.O.: I see Mr. and Mrs. Wellington Mara at a little restaurant every Sunday, and I can tell if Steve Serby has gone after the Giants.

K.C.: I often take the Metro North train home because it's faster and I get work done. I look at people reading the paper, and I would say that more than half look at the front page and then go to the back and read the sports section before they read anything else.

W.O.: You hear a lot. What about this coming year? Is it going to be a good one? Is the stock market going to hold?

K.C.: All I can tell from talking to companies and getting a sense of their advertising budgets and plans for the year is that people seem to be reasonably confident things are okay. I don't think anybody is expecting it to be quite as hot as it's been in the last year. The economy, particularly in New York, is so dependent on Wall Street because there have been relatively few new jobs created in other sectors, especially upstate.

W.O.: Who are you going to elect the next president of the United States?

K.C.: We haven't finally endorsed a candidate, although we probably will, before the New York primary. It's not clear at this point who is going to be left. We have to get through New Hampshire. If I had to look in a crystal ball, I would say we probably would endorse George W. Bush.

W.O.: But would you agree that John McCain is rather interesting?

K.C.: Yes. But looking at it today, I'm not sure whether he's going to be there in November.

W.O.: They all come to see you.

K.C.: They do.

W.O.: What about Steve Forbes? He looks like he's from another planet, but he did pretty well in Iowa.

K.C.: Forbes hasn't been to see us yet this year, but we've seen him in previous years, and he is, one-on-one, a very impressive man. He doesn't come over that way on television, unfortunately.

W.O.: You think years ago Steve Forbes would have had a better shot?

K.C.: I think so. You have to be a different person for television.

w.o.: Let's say I'm running for president of the United States, and I come in to see you, Mr. Editor-In-Chief. What do you ask me?

k.c.: You kind of know where the candidates are on their positions because you've seen all their position papers, so our reporters try to get a story out of it. They push and prod to see if the candidate will go a bit further on this issue or retreat on another issue. The truth is that you don't actually get a lot out of these meetings, but it's a good opportunity to meet them face-to-face.

w.o.: Would you ever endorse a Democrat?

k.c.: We *have* endorsed Democrats.

w.o.: You mentioned your admiration for Mario Cuomo. How is George Pataki doing as governor?

k.c.: Governor Pataki started very strong. I have to confess I'm a little disappointed by the way he seems to be tacking a bit to the left, and I don't really see the point. I'm sort of pessimistic about the future of the Republican Party in this state. I don't see who the next generation of leaders will be.

w.o.: I'm going to throw a name at you: Fred Dicker. What do you know about him?

k.c.: Fred Dicker is our Albany bureau chief.

w.o.: The enfant terrible of the capital press corps. He is the best. But he drives them absolutely crazy in Albany!

k.c.: He has been there many years, and he drove Mario Cuomo nuts. He's also having the same impact with Governor Pataki, so I said to Fred, "You must be doing something right if you've upset them both!" He's a great reporter and has this historical knowledge of Albany because he's been there a long time and knows all the players. He's by far the best state reporter in New York.

2000

Interview with Terry Golway

Terry Golway, city editor and feature columnist of The New York Observer, *is a brilliant historian and a contributor to* America, American Heritage, The Boston Globe, *and* The New York Times. *His most recent book,* For The Cause of Liberty, *which recounts a thousand years of Ireland's heroes, was described by Frank McCourt as the "perfect book." Golway also co-authored* The Irish in America. *He is presently writing a book on the life of John Cardinal O'Connor.*

W. O'SHAUGHNESSY: Tonight's brilliant young journalist is also an author and historian of considerable note. He's an expert on "The Troubles" in Ireland these days and is a keen observer of politics in New York: Terry Golway. You have a day job as deputy editor and feature columnist for *The New York Observer.* I would say that is one of my top three newspapers. I read about twelve.

T. GOLWAY: What are the other two?

W.O.: *The New York Post* and Gannett's *Journal News.* I love *The Times,* and I love *The News* for David Hinckley but I read you every week in that salmon-colored, funny kind of paper. What is that?

T.G.: People have described it as pink, orange, and salmon. All I know is that it's the same color *The Financial Times* is printed on. I think we deal with the same distributor.

W.O.: All the big shots on the East Side read the damn thing, and you can subscribe for only about $15 a year.

T.G.: We should raise that so *I* can get a raise!

W.O.: *The New York Observer* is owned by the legendary Arthur Carter.

T.G.: Arthur is a great man. He is the most generous person I have ever worked for. He made his money on Wall Street in the sixties, and then having made $200 million or so, decided to lose a little of it. So he got into publishing. He started doing so by putting out a newspaper in Litchfield County, Connecticut, called *The Litch-*

field County Times, which, rumor has it, actually turns a profit. But *The New York Observer* has been his special project. We've been around since 1987. I've been around since 1990. It's not a very good business, but one heck of a newspaper.

W.O.: Every politician in this state and a lot in Washington wait for it every Thursday. Is it a liberal paper or a conservative paper?

T.G.: Our philosophy has been, for years, to take no prisoners. Everybody is guilty until proven innocent. We have endorsed Mario Cuomo, George Pataki, David Dinkins. We have endorsed Bob Dole. So you figure it out. My guess would be that if we were going to endorse in the upcoming presidential primary, I would suspect Bill Bradley and John McCain are good candidates.

W.O.: You're a columnist *and* editor.

T.G.: It's a very difficult thing. I am loath to give my opinions on New York political topics because, after all, as the city editor of a newspaper, I'm assigning articles, and the last thing I need is for someone to come up to me and say, "You said on O'Shaughnessy's program that Hillary Clinton is terrible and now you're assigning stories about Hillary Clinton."

W.O.: You've got a lot of famous writers: Christopher Byron, Rex Reed . . .

T.G.: Joe Conason, who is almost the public face of *The New York Observer* because he's on television so much. Tish Durkin is covering the Senate race. We've got some wonderful young writers by the names of Greg Sargent, Josh Benson, Kate Kelly, Andrea Bernstein, Moira Hodgson—terrific people I feel privileged to work with.

W.O.: Peter Kaplan is the editor, a resident of our home heath. He's another brilliant "bespectacled" one. Do all great editors wear glasses?

T.G.: Yes, but some of them don't have to. They just do it for the effect, like some of the movie stars.

W.O.: Tell me what you think of Hillary Clinton. I've read some of your stuff.

T.G.: Well, I think that she means well. She is actually brilliant. She should be in public service.

W.O.: In Pat Moynihan's seat?

T.G.: Why not? After all, as people pointed out from time to time, Pat Moynihan's seat was Jim Buckley's seat, which was Bobby Kenne-

dy's seat, which was Kenneth Keating's seat. That's how far I go back.

w.o.: Jim Buckley is Bill Buckley's brother.

t.g.: Who lived in Connecticut. And Bobby Kennedy, of course, lived in Massachussetts. So New Yorkers seems to be tolerant of people coming in to represent them in the Senate. Now, of course, Moynihan is the gold standard, one of the great senators of the twentieth century. I hope we start naming things after him. We should name the new Penn Station, which I'll be going into from New Jersey every day, Moynihan Station. Is Rudy Giuliani an appropriate choice for the Moynihan seat? I guess, ideally, you would want a more scholarly type, like a Jacob Javits. I wouldn't say either one of the candidates is of a scholarly bent.

w.o.: I know the respect in which you are held by the pooh-bahs and panjandrums of New York, Golway. Can you find any realness in Hillary?

t.g.: There certainly is a sense that she takes a poll before she makes any decision. I think there are certain things Hillary Clinton believes in. For example, she certainly believes in a woman's right to choose. She believes that government should be more active. The healthcare debacle was an insight as to where she believes government should be. She is a liberal-progressive Democrat. She has a core. Once you get into more marginal issues, she might be too "poll-tested." I would ask her about school vouchers. I get very upset about what I see as the pop culture taking over politics. Politics is a serious business. Al Smith once said, "The most dangerous thing for a public man is to be funny. And the second most dangerous is to cheat on his wife." And Al Smith actually was a funny man. He had a choice at one time between vaudeville and politics, and he chose politics. That having been said, the idea of Hillary Clinton going on David Letterman and submitting herself to this quiz about what the state tree is may have been funny, but I'm more interested in hearing what Hillary Clinton has to say about school vouchers.

w.o.: Who are you going to endorse, Giuliani or Clinton?

t.g.: I have no idea. I'm going to evade this question as long as you keep asking it, O'Shaughnessy.

w.o.: Will your publisher, Mr. Carter, have an opinion?

t.g.: It really is the publisher's call. And that's true of every newspa-

per in the country. Maybe once in a while a publisher will say, "I'm not really too sure. Why don't you guys on the editorial board decide?" *The Observer* is a very eccentric institution. A very high ranking member of the Clinton cabinet called to make an appointment with *The* Observer's editorial board. I don't know if we've broken the news yet that we really don't have an editorial board per se. It's sort of ad hoc. Who wants to get in on this discussion about this or that or the other thing? Am I part of those discussions? Absolutely.

W.O.: All you brilliant young men and women get together, I'm told, in a townhouse on the East Side of Manhattan.

T.G.: That's correct.

W.O.: Do you just throw the paper out the window when it's done?

T.G.: That might be more efficient than the way we do it now!

W.O.: A lot of people in Westchester read the damn thing.

T.G.: In New Jersey too. I'm always encouraged to see people on my train going out to Maplewood, New Jersey, with *The New York Observer* in their hands. Yes, we focus on the Upper East Side and the Upper West Side of Manhattan in terms of our core circulation, but my contention is that New York really is a state of mind after all. There are a lot of people who consider themselves New Yorkers who actually live in Maplewood and Westchester.

W.O.: You mentioned Moynihan. Is there anyone around today . . . ?

T.G.: In my night job, I'm an amateur historian currently working on mostly Irish projects, but down the line there are a few political biographies I'd like to write. The more work I do on my night job, the more I've decided I like my politicians dead. They're far more interesting, and they don't talk back. I think Bill Bradley is a great man. And John McCain. I'm not sure he's been a great politician, and I'm not sure he can be a great leader, but if you look at his biography, you see that there has to be an element of greatness there. I've read Bradley's books, and I'm a great fan of his. Al Gore is a very decent person. Actually, I think *The Washington Post* said in an editorial today, that the top four people running for president—Gore, Bradley, Bush, and McCain—are pretty good. We don't look at them and wonder what our Republic has come to. These are very earnest, sincere, qualified people. I just don't agree with all of them.

W.O.: You leave your desk and office and go home and write these

books. One is called *The Irish in America*. Another is *The Irish Rebel*. They both did very well, were very well reviewed and received. And you have a new one out called *The Cause of Liberty.*

T.G.: It's about the thousand-year battle by the Irish to win their independence. It starts in 1155. Don't let that scare you. It gets to modern times very quickly. It's only four hundred pages. The book will be out in time for St. Patrick's Day. With people paying attention to Northern Ireland and the peace process under way there, we are going to wonder how this started. What I did was take this sweeping story and found about forty people, eight or ten in each period, and told their biographies. So it's essentially mini-biographies of great Irish patriots right up to today.

W.O.: How did you talk a major publishing house like Simon and Schuster into this project?

T.G.: Luckily, I have "advance men" out there like Frank McCourt, in the sense that their books did so well. McCourt and Tom Cahill wrote *How the Irish Saved Civilization*. My own *The Irish in America* sold very well. The TV program, which was in conjunction with our book, did very well. So there was clearly some interest out there. Actually, we didn't have to talk them into it. We had four publishing houses at one point bidding for this book.

W.O.: Who are the good guys and the bad guys in this conflict? We know the Brits are the bad guys.

T.G.: He said that, ladies and gentlemen, not me! The British withdrew in 1922 and have held on to the six counties of Northern Ireland as part of the United Kingdom since then. From 1922 until very recently, Roman Catholics, who make up a majority of population of the island of Ireland but are a *minority* in Northern Ireland, were discriminated against in a way that you would have to say reminds you of our South and the attitude toward blacks in the fifties and sixties.

W.O.: The Orangemen, the Protestants in the north. Are they all bad?

T.G.: The Orange Order, which they belong to, was founded in the 1700s specifically to lynch Catholics.

W.O.: Their charter says, "We will go out and kill Catholics?"

T.G.: It's essentially very close to that. They are defending their faith against the invader, the papists, et cetera. That having been said, we're all friends now. And I'm sure there are a lot of Orangemen in Northern Ireland who are willing to accept Catholics as equal

citizens. However, the Orangemen still march on July 12 to celebrate a battle that was fought three hundred years ago, and they march to taunt Catholics. That's not necessarily the spirit of brotherhood.

w.o.: What about the IRA? They're our bad guys?

t.g.: The IRA are murderers. Some of the outrages the IRA has committed over the last thirty years are inexcusable, and you have to understand the context from which the IRA sprang. In 1968 the IRA consisted of about twelve guys with four guns. And as the British came in and brutally suppressed the Catholics, the IRA all of a sudden got all these recruits because of bad behavior by the government.

w.o.: How about the guys who come to Washington, such as the one who looks like you, Gerry Adams. Is he a good guy?

t.g.: He's a good guy because what he is doing is very difficult. He's trying to lead the IRA, this paramilitary guerrilla organization, down the path to peace. He's telling the IRA, "We've got to put away the guns."

w.o.: Are they going to give up their guns?

t.g.: Absolutely. There's not a doubt in my mind.

w.o.: George Mitchell, that senator from Maine, went over there and did that peace treaty. Is it going to hold?

t.g.: Yes. I really do believe that. I was in Belfast in 1985, and I felt as though I were a war correspondent. I wasn't Edward R. Murrow standing on the rooftops of London in 1940 during the Blitz. However, I had guns pointed at me. And I was there this past April and saw what it was like in peacetime. You know what? Peace is good. Peace is nice. People can get used to peace, and that's why a guerrilla organization has to have a modicum anyway of popular support, if only to hide people. The men with the guns have no support anymore.

w.o.: Do the "Castle" Irishmen in this country understand all of this? And what is a "Castle" Irishman?

t.g.: A "Castle" Irishman is someone who has gotten so wealthy and affluent that he or she has forgotten from where he or she has come.

w.o.: You move to Pound Ridge and become a Congregationalist.

t.g.: And a Republican!

w.o.: What of Eamon De Valera? He was a Jewish guy.

T.G.: Well, there has been that rumor.

W.O.: Let me ask you another ridiculous question. Who better to ask than a historian? Was Saint Patrick really Irish?

T.G.: He was British! I've even heard some people say he was Italian, but that was probably Mario Cuomo, who's jealous, and you can tell him I said that!

W.O.: Cuomo is afraid of you.

T.G.: This is because St. Joseph's Day isn't as popular as St. Patrick's Day.

W.O.: What of Cuomo? He thinks *you're* brilliant.

T.G.: I think *he's* brilliant. He was a giant intellectually. He was a giant as a politician. Twenty years from now, when my children are studying New York State history, they'll look back and see a picture I have with Mario Cuomo and say, "Wow, you *knew* him?" We'll look back at him in the same way that we look back at the giants of the thirties and forties.

W.O.: Why didn't he run for president?

T.G.: I'm not even sure he knows. *I* certainly don't know. I do think that there is about Governor Cuomo a sense that he is not worthy. Not to say he doesn't have an ego. He couldn't be in that business without an ego, but he felt that he was not sufficiently driven for the job. Remember Walter Mondale, in 1972, dropped out of the presidential primaries right after New Hampshire, and he used the phrase, "I don't have the fire in the gut." To run for president, you have to have that fire in the gut. I don't know how these people do it. I don't know how someone runs for Congress, let alone for president. You have to sacrifice everything, and for Mario Cuomo, that means sacrificing his family, that means sacrificing leading, that means sacrificing time to reflect, and I think that means a lot to him.

W.O.: But he's still out there making speeches all around the country. He debates Jack Kemp and Bill Bennett and Dan Quayle, and he gets paid for it.

T.G.: He gets paid for it, and he can do it on his own time. And he can say, "You know what? I just don't feel like doing this today." I have great sympathy for politicians. I've observed enough people on the local level very closely to be able to say, "What kind of a life is this?" If your Little League or your Girl Scout troop is having some function, you invite your local councilperson, your

local assemblyperson, and if they don't show up, you'll remember. It's a terrible life, and you have to be driven to do it. I could never do it in a million years, even though when I was in fourth grade my nickname was "Governor Golway" because *I* was the guy who was going to be the politician.

w.o.: Now you've made a career out of commenting on them.

T.G.: Because I can go home at six o'clock to my wife and two children in Maplewood, New Jersey, and forget about it. I can go down to the basement and write about Irish history or political history. No one is asking me to go to their bar mitzvahs and communions and all of those other things politicians do. Rudy Giuliani talks about it being a seven-day-a-week, twenty-four-hour-a-day job. That's true of most politicians. Rudy Giuliani probably works harder at it than most. But it's a tough job.

w.o.: Does Eileen Golway understand when you're at that typewriter . . .

T.G.: Thank God it's not a typewriter. I've upgraded to the computer world, although it took some convincing. But yes, she understands that it's something I really love and that if I had my way and somebody came up to me and said, "You can be the Frank McCourt Chair of Irish Studies at Fordham University and write about Irish history the rest of your life," I would probably tell Mr. Carter and Mr. Kaplan that it's been nice. I'm only kidding! Without Eileen's understanding, none of it would be possible.

w.o.: When you're writing, either your books or your columns, do you ever sit down and say, "I've got nothing?"

T.G.: Oh, yes. Russell Baker, who is one of my journalistic heroes—and I wish he were still writing for *The New York Times*—wrote twice a week and was confronted with that same thing. And he once wrote a column that started out by saying, "Nothing happened this week." And it went on for eight hundred words, and you were laughing hysterically about the fact that nothing had happened! Many times I feel like that.

w.o.: Who are some of the great writers today?

T.G.: It depends on if you are talking about journalists or novelists or nonfiction writers. I can tell you who I read. I read Pete Hamill. I read Alice McDermott, who won the National Book Award last year for a wonderful novel. I *love* Russell Baker. I tend to read op-ed pages a great deal. My favorite novelist—unfortunately, this

reflects some ethnic bias—is Thomas Flanagan. I love Phillip Roth.

w.o.: What's your favorite book? If you were stranded on an island and could have one book?

t.g.: My favorite book would be a book by Thomas Flanagan called *The Tenants of Time*. It is about Ireland in the 1880s, and I was transformed by that book. I said, "If I could ever write half as well as this man writes, I will be very happy."

w.o.: Do you read the Bible?

t.g.: Yes, I've read the Bible. I still do. I'm a practicing Catholic, the best I can be. I choose my Midnight Mass very carefully because I want to go to the Mass where the Gospel of Luke is read. The gospel according to Luke is wonderful writing.

w.o.: You did a nice piece about John Cardinal O'Connor. Are we going to miss him?

t.g.: He became a quintessential New Yorker—which is high praise, considering he was from Philadelphia and I live in New Jersey. He is a voice for the poor, the dispossessed, and the disenfranchised.

January, 2000

Interview with
Walter Anderson

Walter Anderson is now editor in chief and chairman of Parade, *the Sunday magazine supplement that is carried in newspapers all over the country. He began his journalistic career in Westchester. In this revealing interview, Anderson talks about his exciting career as a big-time editor and then reveals the spirituality that shapes his life.*

W. O'SHAUGHNESSY: Tonight, we're going to talk about newspapers and reading with one of the most powerful editors in the country: Walter Anderson. You were a blithe, beamish boy who raised a lot of hell in this county when you ran *The Standard Star* and Gannett's flagship paper, *The Reporter Dispatch.*

W. ANDERSON: My first editorship was *The Standard Star.*

W.O.: You drove us crazy, Walter.

W.A.: And *you* and WVOX caused us many sleepless nights on breaking stories, Bill. The one thing we shared, which I know is true today, is a love for the community and the neighborhoods and what they represent, the culture of Westchester.

W.O.: I remember those front-page editorials you used to do, with short, dynamic, bold, on-your-sleeve sentences.

W.A.: I have this idea that's formed my philosophy of journalism: that newspapers started because someone got mad about something. Newspapers had to have a point of view. They had to stand for something. They had to have *vision.* When I became editor and general manager of *The Standard Star,* I was only twenty-nine, but I had an *idea.* I *liked* the community. And I liked the people who were there. I found them exciting. New Rochelle seemed to be a microcosm of the entire nation, with every kind of ethnic group, every level of socio-economic culture you could find. What an exciting place to be a part of and to influence. I also understood that the editor himself really doesn't have power. The

editor is a gatekeeper. The power is with the readers. Even with *Parade* it's not *me* who causes things to change. It's the readers who get excited when we give them information and a point of view, and not one they necessarily agree with.

w.o.: How did you become an editor? I always thought that you were going to be the Jimmy Breslin of the nineties.

w.a.: I met and married this beautiful woman Loretta, and together we began with a son and then a daughter. You got paid more as an editor than as a reporter, and we needed the money. But after I became an editor, I found it was something I really wanted to do. I liked the idea of having an idea and being able to ask someone else to check it out. It was like being fifty reporters at one time.

When I was a young reporter, I had the opportunity to interview the legendary Ed Sullivan when he lived at the Hotel Delmonico in Manhattan with his wife, Sylvia. I was about twenty-four years old. Ed Sullivan at the top of his career. And I asked him, "Mr. Sullivan, how did you get to be so smart about the arts and entertainment?" And he took me by the hand over to the window and said, "Do you see those people down there?" I looked down thirty-two floors and said, "Yes, sir, I see them." He said, "Walter, it's not that I'm so *different,* it's that I'm so much the *same.* I'm not an expert. I'm the man in the third row. I'm more like my audience than unlike my audience. And if you understand that, if you can be the man in the third row, you can do things for millions." Later, when I became an editor, I began to understand that if something troubled *me,* it probably troubled others. If I weren't sure, probably others weren't sure.

w.o.: You run *Parade* magazine, distributed in newspapers all over the planet.

w.a.: The circulation is about 37.5 million. It's in 353 newspapers. One out of three households receives *Parade* magazine. This represents a tremendous opportunity to share with the nation and to get a sense of what our nation is really experiencing.

w.o.: You are assuming people still read, Walter. You've done a lot of work on literacy. You wrote a book on it, *Read with Me.* It was a bestseller for a couple of months. Do people still read newspapers?

w.a.: Yes, they certainly do. There was a time when somebody began

scribbling on a wall. And someone said, "My God! If we teach people to do that, to read, they'll lose their ability to remember." In this century radio was dominant, and when television burst on the scene, the end of radio was forecast. Today, radio is more powerful than it has ever been.

There is a fundamental problem with literacy in the United States. As we speak more than 40 million people are functionally illiterate: not able to fill out a job application or get a driver's license or pass a test to get a promotion or even add up a lunch check. This is not good for our society. We are creating an underclass. Literacy is a core issue. It affects every form of communication, including television and radio.

When I was a boy in Mount Vernon, I was raised in an abusive home. I often felt safer on a street corner than in my own home, and I lived in a violent neighborhood. But I could go to a library where the librarians didn't judge me or correct me as my teachers did. All they did was encourage me to read. And they would give me books, and I could read and be anywhere, be anybody, do anything. I could imagine myself out of the slum. I read myself out of poverty long before I worked myself out of poverty. The power of reading is extraordinary. It affects every essence of our being. It enlarges us. And it begins with a parent or an adult reading to a child.

w.o.: How do you get the children unhooked from the computers and the television screen?

w.a.: It starts at home. There are many reasons adults come to not read. One out of seven children has language learning disabilities. Some need hearing aids or glasses. And there are homes that *discourage* reading. I have asked all the successful people I have known—from Nobel laureates to Pulitzer Prize winners to people who run countries and companies—"Who encouraged you when you were a child?" There was always someone. We make a terrible mistake in our society. We say adults have an unqualified right to raise children. By doing that, we take away *children's* rights. What children need are love, attention, discipline. There is no government agency that can provide what they need. All children are mine. All children are yours. Our responsibility is to all children.

w.o.: Our kids are growing up. Is it tough for a strong guy like you to let go?

W.A.: Oh, it's very hard, and I don't do a very good job of it, as my son and daughter would say. I love those kids so much. It's very hard to let go.

W.O.: A lot of famous writers darken your door, saying, "Publish me!" Who are some of the people whose words you have circulated to 37 million people?

W.A.: Norman Mailer, Carl Sagan, Gail Sheehy, two presidents of the United States, Cleveland Amory, Alistair Cooke, James Michener, Herman Wouk. Hugh Downs has now become a regular contributor. He is an extraordinarily talented man.

W.O.: As bold as you are, do you dare edit a president of the United States or Norman Mailer?

W.A.: Absolutely. People ask me if David Halberstam and Carl Sagan and Mailer or Presidents Clinton or Bush are difficult to edit. The truth is, they are professionals who really look forward to a helpful hand. Norman is one of the dearest people to work with, as are David Halberstam and Carl, because they look for suggestions. And if I think a point isn't explained well, I'll tell them.

I was walking on the street with Dick Stolley, who created *People* magazine. He said, "People are always asking me what is quality, and I don't really know how to define that." And I said, "Quality has three characteristics: clarity, authority, and substance." *Clarity.* Is it clear? Is it what it says it is? *Authority.* Is the voice of authority there? The authority is obvious if Carl Sagan talks about science or Chief Justice Burger talks about the Second Amendment, but it's even clearer when you have an anonymous reporter who has done his or her homework for a year writing on a subject. Finally, *Substance.* Did I learn something I didn't know before? Clarity, authority, and substance. If something has those characteristics, you have quality. Writers want that.

I went through this about a dozen years ago the first time I realized I was going to have to edit Norman Mailer. I thought I was going to have a baby. I was so terrified. He made it easy, and it was an authentic growth experience for me because Norman was gracious and he listened and he cared.

W.O.: You say you have the common touch, but I see you often at the Four Seasons restaurant.

W.A.: I like the Four Seasons because a writer likes to be seen by others, but we're really talking about business. If I'm with a writer,

it's to persuade her or him to do a particular story. I'll give you an example. Norman has just finished a book for Random House on Lee Harvey Oswald, and it's going to take about two months for him to finish the editing and all his rewrites—because an artist like Norman is never *finished* with a piece, he just "abandons" it, as the old saying goes. But before he works on his next book, which is on Picasso, I wanted him to take a month to interview someone of extraordinary importance in the world, so I talked to him to get him excited about the idea.

Some writers want to know what *I'm* interested in. I want to know what makes *their* blood rush. Yesterday I had lunch with Marlo Thomas, and she began talking about child's rights, but then she started telling me about a movie she is doing. I told her I'm more interested in the movie about this woman who lost a child because of something she did and how this woman dealt with anger. I said, "That's fascinating. That touches all of us." So I'm going to have her write her own feelings about it.

I sat with Clint Eastwood one day. Clint is a nice man, anything but the "Dirty Harry" character. He is intelligent, well read, and sensitive. And, as every woman would attest, Eastwood is a very handsome guy. He does not draw attention to himself, though. He began telling me about a project he was working on and how excited he was, and I said, "Clint, let me record what you're saying." So I transcribed everything he said, and I sent it out to him. Then I went to see the roughs of his movie, and I called him and said, "Clint, editors will say sometimes, about a writer's work, that this book *justifies* a writer's life. You're one of the greatest actors ever, and your work is monumental. But had you never done anything else, *this* movie would justify your life. This single movie, *Unforgiven,* is the greatest Western I have ever seen. It will be called a classic." And we published the story six months before it was even considered for an Academy Award. It won Picture of the Year.

Am I so different from an audience? No. When I know I like something, most other folks like it. I'm never comfortable with critics who spend their life criticizing someone. The easiest thing to do is be against something. It takes guts to be *for* something. To take a stand *for* something is the right thing to do.

w.o.: You have so much enthusiasm and optimism. Do you ever get down on things?

w.a.: I do, and I'll tell you how I deal with that. I work with people who are in a lot of trouble and children who are without parents or who are abused and battered. And sometimes I get very depressed and wonder if anything I do really matters. Then I look at what's happening and get angry, and that anger drives me back up, and I say, "I refuse to accept that I cannot change the world. I can!"

A friend of mine, Wally Amos, "Famous Amos," the cookie guy, likes to tell a Spanish story about a little boy walking the beach after a storm, and he's throwing starfish into the ocean because they've all been swept up on the beach. An old man says to him, "Son, you're wasting your time. What difference can you make? There are hundreds of miles of beach and millions of starfish." And the little boy listens to him, picks up a starfish, dusts it off, and tosses it into the ocean. He says, "I made a difference to *that* one." We do make a difference, Bill.

w.o.: You've interviewed thousands of people. You've been to the White House and at table with monarchs, princes, and poets. Who are some great souls? Sometimes we look around and we don't see giants walking the land anymore.

w.a.: Elie Weisel, for one. He's one of the greatest men it's ever been my honor to meet. Also Andrew Vachs. He is a child's rights activist, not famous, except he is the reason why President Clinton just signed a child right's bill. One of the greatest ever just passed away at Christmas: Norman Vincent Peale. He taught me a great deal.

w.o.: Was Dr. Peale all that he appeared to be?

w.a.: Yes, he was a kind and loving man. I asked him once, "Why does God let all this awful stuff happen? People are starving." And I began to get worked up. He let me finish. And he said, "Walter, God has given us all we need to feed one another, to clothe one another. All the resources are there. It's not God who has done this. It's we who have done this. He has also given us the *choice*. We can *choose* to be who we are. It's up to us to care for one another."

w.o.: But when it starts spinning out of control, do you pray?

w.a.: Yes, I do. I believe if you remove a drop from a raging stream,

you affect that stream. I believe each of us is a drop, and the raging stream itself is what we call God. I believe God is in all of us. I don't concern myself with questions of heaven and hell. What I understand is that I can choose every day to do good or to do bad. I know that if I do good, I feel good. I know that if I do bad, I feel bad. I guess we call that *conscience*. But do I believe? Yes, I believe that what we need to be happy is something to be excited about, something larger than ourselves. Our lives are worth a noble motive, something larger than ourselves.

<div align="right">March, 1997</div>

Interview with Phil Reisman

Reisman is a marvelous writer. In my previous volume I accused him of writing like an angel—or on a good day like Mark Twain! He is the star feature columnist for The Journal News, *Gannett's powerful Westchester newspaper.*

W. O'SHAUGHNESSY: It's easy to get on the radio, and our viewers indulge me on television each week, but I would hate to have the pressure of writing a column three times a week. Tonight's guest is the great chronicler of life in Westchester: Phil Reisman.

P. REISMAN: Thank you, Bill. I'm not going to let you sit back. I think I should be interviewing *you*. What kind of tree would you be if you could be any kind of tree? That's what I want to know!

W.O.: A blue spruce. Seriously, Phil, you were a newspaper editor, a bigshot in the hierarchy of Gannett, and then they said, "Wait a minute. This guy is too good." And they gave you a three-times-a-week column.

P.R.: It's the kind of job that doesn't come every day in journalism, and it's probably the best job you can get in newspapers. I was metro editor before I became a columnist.

W.O.: In my book, *Airwaves,* there was the line "Phil Reisman looks like Sam Shepherd, the playwright, with his tight jeans and cowboy boots." Have you got the cowboy boots on?

P.R.: I have the cowboy boots just for you, but I'm also wearing khakis.

W.O.: I also said, "He writes like an angel, or on a really good day, like Mark Twain." Who were your heroes? What writers formed you?

P.R.: In newspapers I would say Pete Hamill, Mike Royko, Russell Baker—sort of an eclectic group of columnists that I like a lot. I grew up the son of a writer, and I probably admired my father, first and foremost, as a writer who earned his living at writing. He

Whitney Radio's "Broadcaster of the Year." Matt Deutsch, a gifted young radio executive, has served as "executive producer" of this volume.

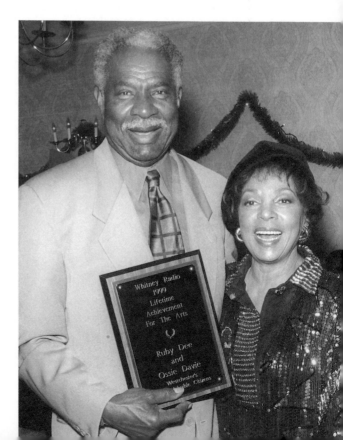

Most Beloved. Ossie Davis and Ruby Dee are two of New York State's most beloved citizens. Here they accept a Whitney Radio Award for their outstanding work as actors, playwrights, civic leaders, and philanthropists.

(Above): **Campaigning.** Congressman Rick Lazio was defeated by the Hillary juggernaut. The attractive and amiable legislator from Long Island ran *against* Hillary but was never able to get across what *he* stood *for.* (Below): **Cabaret Crowd.** (L–R) Legendary Broadway press agent Gary Stevens, the author, cabaret star and producer Lynn DiMenna, and beloved disc jockey Jim Lowe of WNEW fame.

(Above): **The Coach.** Giants football coach Ally Sherman, who in recent years has become a top executive with New York's OTB. (Below): **Legends of Little Italy.** Mama Rose Migliucci (center), the first lady of Arthur Avenue in the Bronx, with Barbara, Mario, Jr., and Joseph Migliucci.

(Above): **Three Kindly White-haired Gentlemen.** The author is flanked by Ed McLaughlin (left), Rush Limbaugh's discoverer, and Gordon Hastings, president of the Broadcasters' Foundation of America. Mr. McLaughlin, a former president of ABC Radio, is chairman of the board. (At left): **"Mr. Jerry."** The author signs a book for Jerry Berns, a founder of the "21" Club and the first inductee into the Hall of Fame at the Culinary Institute of America in Hyde Park.

(At right): **Westchester Leaders.** Democrat Andy Spano (left), who succeeded Andy O'Rourke as Westchester County Executive. O'Rourke is now a State Supreme Court Justice. (Below): **The Writers.** Famed writer-journalist Ken Auletta (center), Peter Maas, and the author at the *Airwaves* publication party.

(Above): **Of an Evening.** (L–R) The author, Governor Mario M. Cuomo, and Neal Travis, the *New York Post* feature columnist, known as "the one gossip columnist who never hurts anybody." (Below): **Tête-à-Tête.** The author and legendary New York gossip columnist Cindy Adams.

The Fred Astaire of Madison Avenue. Ambassador Edward
Noonan Ney, chairman emeritus of Young and Rubicam, and the
author. Ambassador Ney represented American interests in Canada
for many years.

Dutch Treat.
Ralph Graves, the
last editor of *Life*
Magazine, wel-
comes the author
to the Dutch Treat
Club in Manhat-
tan to talk about
current events.

(Above): **On Cable TV.** Famed Metropolitan Opera baritone Robert Merrill at a taping of *Interview with William O'Shaughnessy*. On the left is cable TV power Ira Birnbaum. (Below): "**God Knows What He Does For a Living . . .**" Pope John Paul II in Rome with Father Terry Attridge, the "central casting" handsome New York priest who was known for his many ministries. Monsignor Attridge died last year. *(Photo by Felici of Roma)*

was a big influence on me growing up. He wrote for television for a number of years, going back to the early days of television. As far as nonfiction writing, I'm a big fan of David McCullough, who wrote about Harry Truman and the Brooklyn Bridge and Teddy Roosevelt.

w.o.: Your father inspired you. You lost him last year.

p.r.: In June. He was eighty-two.

w.o.: Did your father read your columns?

p.r.: For years he collected them. He actually cut them out and put them in a folder and saved all of them—which surprised me. He was a big fan at the end. It was really nice.

w.o.: Did he ever criticize your writing?

p.r.: Early on he did. He was quite a stickler for accuracy and things like that. He was always supportive of my own efforts.

w.o.: One of the current elders at Gannett, Bill Cary, used to be a regional editor like you were. He said to me the other day, "Reisman is so good he's scary."

p.r.: That's a scary thought! It's flattering and very nice to hear that kind of praise. But I don't know how to react to that. I just write. That's what I do for a living, and if people like it and they enjoy it, that's great. Some people don't like it, which goes with the territory of writing a column. I get a lot of e-mail and voice mail. When you write a column, you're leading with your chin in public a lot of the time, and it's quite interesting to see what kind of reaction you get. I probably shouldn't even mention this on the air: I wrote a column in which I admitted that I kicked a Canada goose, out of self-defense. That's a first-degree felony in the minds of some people. I understand that a letter came to the publisher suggesting that I was a potential serial killer as a result of my crime. But one actually came at me when I was running on a high school cinder track, with its jaws wide open. And in a defensive maneuver I gave it a nudge with the toe of my right foot. I almost broke my foot, by the way.

w.o.: Was the damn bird all right?

p.r.: The bird was fine. How's that for an issue?

w.o.: You see a lot of humor in life, don't you?

p.r.: I like to laugh. There's a lot to laugh at. I sometimes mix up the columns. I don't always write joking, one-liner columns. I tend to do that when I'm in the worst frame of mind. I'll write something

funny on a day when I'm at my darkest. And if I'm writing a few of those that are allegedly funny—one after the other—then I must be in one of those dark periods that sometimes overcome us.

w.o.: Do you churn and struggle over these columns? I stopped in to see you once in your office at Gannett. Your office was not a pretty sight.

p.r.: There's junk everywhere.

w.o.: But when you're alone there . . .

p.r.: It's awful. In fact, today I have to write a column, and I don't know what I'm going to write about. When I leave here, I probably have four or five hours to think of something, and I better write it by six o'clock because that's the deadline.

w.o.: Have you ever missed a deadline?

p.r.: Not yet. Deadlines actually are a good thing in that they galvanize you to respond under pressure and get the job done. As an editor you had to do it too. As a writer it almost is something you *need* after a while. I don't understand anybody who can write with a deadline that is seven months away without going absolutely crazy. My father used to do that. He didn't have daily deadlines. His were a few months off.

w.o.: Your father wrote for the movies.

p.r.: He wrote for movies and television. He was actually a study in writer's block. He would sometimes have several weeks to do something, and he would let it go until the last minute and then literally stay up all night and type away. This was before home computers. He had a beat-up Royal typewriter, and he'd write practically the whole script in two days, nonstop, and then get it into the mail. It was amazing. I need the daily rush to do it, and I need it to be hanging over my head.

w.o.: You're now the hometown feature columnist of Hillary Rodham Clinton. You've been pretty tough on her.

p.r.: She can take it, number one. And number two, there is a legitimate issue here about coming in from outer space and deciding that you are a New Yorker and you're going to run for the Senate. There is a carpetbagger issue that comes with this, and there's a certain amount of hubris that comes with assuming you're automatically the candidate. She has assumed it. And she is.

W.O.: I expect you'll have a chance to interview her, probably several times. What questions would you ask Hillary Clinton?

P.R.: There is a question that hasn't been asked yet. I really wonder where she stands on the World Trade Organization that her husband is pushing so much. We're in a strong union state here, and I would be curious to hear what she has to say on that.

W.O.: What about the Clintons, in general?

P.R.: They're America's number one dysfunctional couple, and I'm damn glad we have them.

W.O.: What about Rudolph Giuliani, the mayor?

P.R.: The thing with Giuliani is that a lot of people give him a lot of praise for cleaning up New York, but I miss the danger of midtown and Times Square. I used to love going in there and feeling that there was going to be somebody accosting me at every turn.

W.O.: Jimmy Breslin said the other day that 42nd Street used to be very Runyonesque, with pimps and prostitutes, and now it's Walt Disney.

P.R.: You used to see people walking around with no pants on in Times Square. Now you don't have that fun. Now you see Mickey Mouse. How would Hillary Clinton do as mayor of New York City? People keep asking how Rudy can be senator because he's this pugnacious, litigious guy, and he's got a bad temper; but a fair question would be to ask how would *she* do as mayor? I think, on balance, the guy has done a wonderful job.

W.O.: You *like* the mayor?

P.R.: Not particularly, Bill. I have a problem with these politicians who have a stockade of press handlers who keep people away from them. That is a very closed administration. On principle, as a person who works in newspapers, I don't particularly enjoy that.

W.O.: In your days as an editor and reporter in the Empire State, whom have you come to admire?

P.R.: A name that comes right to mind is George Latimer, the county board chairman. He is the straightest guy I have met in politics. Very sincere. And bright. On the state scene I don't see anybody. Maybe you can jar my muddled brain.

W.O.: What about John McCain?

P.R.: On the national level, I like John McCain. He's a brave and forthright man, and he's got the right issue: campaign finance

reform. I know the press has a love affair with him right now, and, of course, we're all criticizing ourselves for liking him. I don't think there is anything bad about that, but there's always a self-loathing that kicks in with the press. It's always like, "Why are we doing this?" And then we start attacking ourselves for going against the conventional wisdom. It happened with Clinton, too, back in '91–'92. There was this feeling he was catapulted into office by the media, and there was a backlash of criticism about that. Why was he pushed ahead of the other candidates? I was going to say one thing about McCain. This temper issue blew my mind. Clearly, if anything, this crucible that he went through in Vietnam is a testament to the man's bravery and leadership.

W.O.: In a local journalism class they were talking about you and your columns, and one young man stood up and said, "I've been reading this guy and he always finds a different angle."

P.R.: I try to do that. A lot of reporters covering county or local government tend to look at things in a linear fashion. You get the facts and write down the facts. I think columnists, and even people who are writing straight news, ought to look at things from the side a little bit, from a different perspective or a different angle. I have this great opportunity to do that, plus I don't have to follow all the rules. I think I'm writing a very personal kind of thing. I'm probably reaching out to readers in a more personal way than a reporter can who is confined by the rules of objectivity.

W.O.: What about the elders at Gannett? Do they ever tell you what to write?

P.R.: Never. They have been incredibly supportive of what I've done. I'm sure I've ruffled some feathers.

W.O.: You've been on a streak about greed in Westchester. What do you mean by that?

P.R.: We're all susceptible to a syndrome in this country—maybe it manifests itself more here than in other places—a feeling that we don't have enough, that we need to acquire more and more things as a path to happiness. It's a real spiritual crisis. I'm not a religious man, and I'm not particularly an anti-materialist, but I do think that there is a sentiment right now that suggests that money is everything and that acquiring things is everything. It's all around us.

W.O.: Do you talk to your sons about this?

P.R.: I guess I rant a lot at home, and they pick up on that. I don't really sit down and "counsel" them on things, but we do talk.

W.O.: Are you the type who jumps up in the middle of the night and says, "I have to write right now?"

P.R.: No. I usually jump up in the middle of the night and have to go to the bathroom! Often people think they're getting great inspiration when they sleep, but if you get up and write what you're thinking at three o'clock in the morning, you won't be able to understand it the next day.

I'm probably the least prepared person in the world. When I need a notepad, I don't have one. When I need a pen, I don't have one. People say, "You call yourself a newspaperman and you have to borrow my pen?" So I try to put notepads everywhere. I have two in my car. I carry one around. I try to have one in a drawer nearby, and I usually lose them anyway.

W.O.: You say you're not religious. I don't believe you.

P.R.: Why don't you believe me? I'm bringing up my children in a church environment, but I don't regularly attend church. I don't read the Bible every night. I do have a certain point of view on the world that I hope is consistent with the teachings of religion. But I don't have a strong attachment to organized religion. I haven't lost faith, but I don't have a desire to go to church all that much. Although you're trying to get me to go to your church.

W.O.: With Father John O'Brien at Pius X. He tells great stories, as you do.

What about the years ahead? What do you see for Westchester, our "Golden Apple?"

P.R.: I see bigger cars and more traffic.

W.O.: What of the planet? Tell us. You're supposed to know these things.

P.R.: This is what's so funny. You get a column and suddenly you're the sage of everything. You're talking about religion and the planet.

W.O.: You're paid to know these things. How about the market? Is it going to stay up?

P.R.: If I were you, I would sell everything you own. Next year, we'll be worrying about the same stuff as this year. The primary thing is the continuing need to make sure our children are getting the

best education they can. I hope that we come to understand that we don't necessarily have to tie everything to test scores.

W.O.: I hear the New York papers are trying to lure you away.

P.R.: Not after this interview with you, Bill!

<div align="right">1999</div>

Interview with Craig Watson

Craig Watson is a real gentleman. This classy, thoughtful guy will be one of the stars of the wired nation for many years to come.

W. O'SHAUGHNESSY: I don't want you to think I'm playing "customer golf" tonight, but I'm pleased to present one of the elders of Cablevision, and he's going to tell us all the secrets of cable television. The wired nation has arrived in Westchester, and it's now in the capable hands of Craig Watson. You came to Westchester in 1997. Since then, Cablevision has grown in wisdom and stature, and now you're in charge of everything from Hartford to Atlantic City. The wired nation is really here . . .

C. WATSON: It is, Bill. You can't pick up a paper and not see the changes that are sweeping telecommunications, and we're at the center of that, serving the most important media market in the world. That's always been the strategy of Cablevision.

W.O.: I'm a little nervous interviewing the boss. You could pull the plug on me instantly.

C.W.: Why would we do that? What the beauty of your show demonstrates is that we can develop some really new voices. Whether it's C-Span, which helps Americans discover their government in a very deep and meaningful way, or the local shows, like what you do, cable is fantastic.

W.O.: Most broadcasters are at sword's point with the local cable operator, but you and your predecessors have been very good to me. You have not once censored me or tried to temper any of my enthusiasms, so please allow me to thank you publicly as I do so often in other venues. What's going on in the world of cable? In Westchester we sure get a lot of channels.

C.W.: Depending on where you live, it's seventy or eighty. We took over systems previously served by TCI, and those systems are

going to be rebuilt using fiber optics that allow us to squeeze in more channels. In our Connecticut systems we're up to 110, and the state of the art would be not only 100 channels but with the potential for *hundreds* of channels using digital compression. Our goal is to keep ahead of the technology and provide Westchester, Connecticut, and New York City with a state-of-the-art system. The future is to take this network we've built and continue to invest millions and put more on it, and I think that's one of the things Westchester can look forward to.

w.o.: But you can only watch one channel at a time, Craig.

c.w.: While you can only watch one channel at once, that same wire that is delivering a TV channel to some part of the house can simultaneously, over the same cable, deliver high-speed internet access to your child or spouse on their PC. You wouldn't have to have a local phone company provide that service.

w.o.: Is that what your cable colleagues are really after?

c.w.: Increasingly, I think everyone understands that the strategy of the survivors in this tremendous consolidation in telecommunications is to see the internet as the connective tissue of all our transactions, our entertainment, our business activity. So yes, while television will always be a core part of a family's time and entertainment, we know the internet can almost take the place of the phone network and the television network because it's such a powerful medium.

w.o.: I should know all these things, but I'm computer illiterate. First of all, how does this program—these pictures—get into our viewers' television sets at home?

c.w.: We like to imagine a network like this: if you tie a string to every doorknob and interconnect them all, you'll have the network that we serve on coaxial cable, which is copper. Right now we're sending signals in analog form, more like a radio signal. In the future, more parts of our network will be fiber-optically delivered—by means of a light signal. We're all moving toward digital. In fact, we have customers who get their television signals digitally delivered. The beauty of digital signals is that you can squeeze them into a small space, so if you can carry a hundred channels analog, you can carry hundreds or thousands of channels digitally. Digital is the future.

w.o.: Are we sure of that? The mobile phone guys all push digital, but I think the analog works better.

c.w.: We're still working out some of the kinks, but clearly, digital is definitely going to take over the analog delivery of service. We've talked about high-speed data today, but another advantage of digital is telephony, the ability to provide a telephone alternative. We're already selling an alternative telephone service so that at home you can have TV, high-speed internet access, and telephone.

w.o.: You sit in the high councils with the Dolans—Charles Dolan and his son and heir, James—are you going to buy the Yankees?

c.w.: That may be out of our hands now. When the Yankees decided to link up with the New Jersey Nets, it put in place an important stumbling block. Legally, the way the League rules work, you can own only one basketball team in a market, so if George Steinbrenner now has inextricably linked himself to the Nets . . .

w.o.: And you own the Knicks . . .

c.w.: . . . that may be the trump card that says, "Boy, it's not going to happen." But certainly, the Dolans have had a long history and relationship with Mr. Steinbrenner and the Yankees for the TV rights, and it's our hope to continue that relationship for many years to come.

w.o.: Tell me about Charles Dolan, cable pioneer.

c.w.: He started a service that provided updates of weather and, eventually, television to hotels. Then he founded Sterling Cable in Manhattan and, in the process, created the precursor to HBO. That initial startup company sold to Time, Inc. created his stake, which he took to Long Island to start a cable system. It had fewer than two thousand customers initially, and it was from that somewhat modest beginning that all you see today was created. In the New York market we're upward of 3 million customers. I have a third of that in Westchester, Connecticut, and Brooklyn and the Bronx.

w.o.: Is it true that people pay their cable bill before Con Ed and the telephone?

c.w.: You hear those stories. People care passionately about their TV. Certainly many homes feel that cable is affordable entertainment for the family when compared with all the other things people can spend their entertainment dollars on.

w.o.: In California you were head of the Southern California Cable Association, and you were an elder in Rhode Island, from whence you came. As a leader in your profession, tell us what's going to happen with the whole cable thing. Is it going to survive as we know it today?

c.w.: It's evolving rapidly. We've already seen major acquisitions and consolidation. The move afoot, even two years ago, was to cluster, on the notion that we were going to compete with telephone companies. To control a cluster is important, because if your phone competitor can compete, border-to-border, then you want to have that same area as well. What you're seeing is a shakeout. AT&T's purchase of TCI was certainly a watershed moment that said AT&T wants to own that final connection to the customer. And of course, we're already in that position, so we see that as a major endorsement.

w.o.: I'll give you the telephones. I'll give you a hundred channels or more. Have you got the *programming* that goes on it?

c.w.: That's the beauty of our model. With hundreds of channels, in a digital world it really becomes a niche-oriented service. We have lots of jokes about having hundreds of channels and by the time I find the channel I'm interested in the program is halfway over! In the future, the navigation through all those choices will become much more intelligent. You could have a customized lineup, so the moment you turn on your TV, the channels you are interested in are the only ones that are listed. Or if you are into a thematic feeling—say you want to know all the sports on at that moment—you could have a guide that would interact with you, getting you to what you want to see. We own some of the finest things on cable: American Movie Classics, Bravo, the Independent Film Channel. Not only can we acquire programming, we want to be on the cutting edge of producing it.

w.o.: Do you put a lot of money into local stuff?

c.w.: Yes. Chuck Dolan's concept was the whole News 12 effort that has rolled out throughout our service area. It's one of the most outstanding versions of local focus. Dolan is pushing us to become hyper-local, because we're sitting in the shadow of New York City. Certainly your business in radio is an attempt to fill that local gap, and ours is as well. We think News 12 has been

very successful. When customers move to a new area, they call up and ask if they're going to get "that local news thing."

w.o.: I know people in New Rochelle don't care what goes on in Yonkers, and Mount Vernon isn't particularly interested in Port Chester.

c.w.: It's human nature that if it doesn't have any relationship to your personal life, then it's of less interest to you.

w.o.: You're a father of young children. Are you happy with what they see on television?

c.w.: The key is how do we guide our children with what they see. We, as parents, have a responsibility to make sure they see the best of what's on. The quality that exists on cable television is outstanding, and you can almost always find something that is both appropriate and productive.

w.o.: What is your and your wife, Carolyn's, favorite thing to watch on television?

c.w.: We love old movies and foreign films. We tune in Bravo on occasion. We don't get out to the movies that often although our company has invested in the Clearview Cinemas chain. I don't want my friend Bud Mayo, who's chairman of Clearview, to think that I don't attend his theaters, but when I can't attend the theater, I watch movies at home.

w.o.: Do you ever say, "Tonight, we'll have a quiet night?"

c.w.: Absolutely. We both are avid readers and keep ourselves stimulated in lots of different ways. We also love the internet, so we've become fans of surfing the net, and I've discovered E-bay. My wife is almost getting to the point where she has to cut me off. It's one of the most fascinating parts of the internet, this vast network of millions and millions of global customers. My particular interest is in antiques and folk art, and you might be interested to know that I collect miniature chairs. It's something I picked up from my grandmother.

w.o.: Are you concerned about what your children might encounter when they learn to surf the internet?

c.w.: All parents have to acknowledge that with this vast new openness and connection to people and places it's increasingly incumbent on us to monitor and control. And it's very tough when you have two working parents? We in the media and technology fields have to help parents. We do it on the cable side, with pro-

grammable remotes that allow parents to absolutely lock out any channel.

w.o.: I'm sure you spent a lot of time and a lot of sleepless nights trying to keep the government from controlling cable. What about the internet? The same problem?

c.w.: I think so. I'm certainly a free speech advocate. You and I very much share that view, Bill. We have to, as people involved in the media, help our communities make intelligent use of these products. And yet I would hate to think that we would turn over that control to some third party like the government, even if it's with the best of intentions. The marketplace, with intelligent leadership, can make good decisions and help people avoid the problems.

w.o.: Are we always going to have NBC and CBS and ABC?

c.w.: I think so. The most successful networks have decided that they're actually going to branch out into this medium of cable. Of the major networks, NBC is probably the most successful with MSNBC, CNBC, and some of their other activities. Your friend Tom Rogers started that. They have some ownership interests in Cablevision and some of our programming networks. We've had a long and fruitful relationship with NBC in this area. CBS has been slower, but I think the notion that networks offer a historical place, where certain types of programming are offered and families gather to watch, is probably going to be around for a long time. I don't predict the deaths of the networks at all. In fact, I think they're getting more and more savvy as a way to be a partner with us.

w.o.: Why don't you buy a network?

c.w.: You never know. We've had great success in sports and entertainment, like our acquisition of Radio City Music Hall Productions and the Rockettes and every show produced in Radio City Music Hall. We're investing upwards of $70 million in the historic renovation of Radio City Music Hall, and after that's done, there will be a place where we can originate outstanding concert entertainment programming.

w.o.: Do you like Westchester?

c.w.: I love Westchester. I just think it's the greatest place in the world. When we moved from California, I remember my wife said, "At some point, Craig, I know we're going to Rhode Island,

I'd love to live somewhere within an hour of New York City. That would be my dream." So to live fifty minutes north of the city in a beautiful area with great public education and a community that we enjoy is wonderful. We're involved in the arts and our local church, so it's been a great place for us and our children.

Spring, 1999

Interview with George Plimpton

George Plimpton is George Plimpton. There ain't nobody like him in New York. Or in literature. He is a marvelous man of great style and erudition.

W. O'SHAUGHNESSY: Tonight, one of the most delightful individuals in the Republic. I've admired him from afar for many years. He is one of the literary giants of our age. He's also an actor, an editor, and a writer: George Plimpton.

G. PLIMPTON: I should carry you around, O'Shaughnessy, and have you make announcements of that sort.

W.O.: You've written a new book. Len Riggio himself tells me it's flying off the shelf: *Truman Capote.*

G.P.: It's an oral biography, which is strange. I think Norman Mailer said it sounded like a nonspecific disease. It is a way of presenting a man's life not through the third person, which is the way biographers work, but through the first person. That is to say you take the transcripts of people who knew the subject and you edit these and then you put them in chronological order. The image I have for it is like a cocktail party you go to with about two hundred people who knew Truman Capote, and they are all arranged chronologically so that the first group you would eavesdrop on would be the townspeople of Monroeville, Alabama, where Truman Capote grew up. He was in the care of these three fairly crazy aunts. One of them, Soup, was a bit of a lunatic, a tobacco chewer, and she turns up in a lot of Truman's stories. Next door, interestingly enough, lived Harper Lee, the author of *To Kill a Mockingbird*, and Dill, a character in *To Kill a Mockingbird*, is almost surely Truman. They knew each other very well. In fact, there are some people who thought Truman helped with *To Kill a Mockingbird* because Harper Lee never wrote a word after it. I don't think that's so. The styles of Truman and Harper Lee are not at all identical.

He probably helped her get it published and introduced her to people around New York. He was always rather upset because *To Kill a Mockingbird* won the Pulitzer Prize, and Truman never won the Pulitzer Prize for *In Cold Blood*, his really monumental study of the Clutter murder case.

w.o.: We read about your exploits. You're sort of the Evel Kneivel of writers, as when you suited up and played for the Detroit Lions!

G.P.: I've often been compared to Evel—what a wonderful name. Of course, he did the things simply on dares, leaping across the Grand Canyon and all that sort of rocketship stuff.

w.o.: Why do you do these crazy things?

G.P.: I do these things to write about them. People call up and say, "Gee, I want to do what you did. I want to play baseball in the major leagues. I want to play for the Boston Bruins or the Boston Celtics." And I always tell them the first thing they have to do is get a job writing for *Sports Illustrated,* because it was the *Sports Illustrated* editors to whom I went and suggested these things and they said, "Well, sure. We'll back you, and we'll publish what you write about these adventures."

w.o.: Have you done anything exciting lately, like set off skyrockets?

G.P.: I'm a huge fireworks buff, and every year we have a big fireworks show on Long Island.

w.o.: Didn't you damn near blow up the Hamptons, George?

G.P.: Yeah. This year we had a rather interesting idea. I got four famous East Hampton artists to choreograph a minute and a half of fireworks, and I took them down to the Gruccis, the great fireworks family. John Alexander was one, David Sally another, Donald Sultan III, and the fourth was Dennis Oppenheim, who does famous constructions. And Oppenheim did his things, which were very simple—saturns and moons in the sky, a very simple, little show for a minute and a half. And when the great night came, we had these four segments scheduled for the beginning of the show, and when Dennis Oppenheim's came along, the technician out on the barge pushed the wrong button, and up into the sky went the Grucci finale, which lasts for about three minutes. Oppenheim couldn't have been more surprised! And, of course, the finale of this particular evening was one of the more minor finales! I think there were two parachutes, and everybody

was quite disappointed. They hadn't realized the *finale* had gone off at the *beginning* of the show!

w.o.: You have a lot of fun being George Plimpton, don't you?

G.P.: I think I'm very lucky in that respect. I have a lot of interests. Fireworks is certainly one. I wrote a book about fireworks, and I've been around the world looking at them. In fact, John Lindsay once appointed me "Fireworks Commissioner of New York." I love being called "Commissioner"! Birdwatching is another great passion. In life it helps to have a quest, something that drives you beyond the simple everyday job that you do. If you have those it makes life endlessly fascinating.

w.o.: What about your labor of love, the *Paris Review?*

G.P.: It's a literary magazine that was started in 1953 in Paris. Paris was full of writers because of the G.I. Bill just after the war. It was terribly inexpensive. You could literally live in a bad hotel for $20 a week. It was exactly the right place to start a magazine. It only cost $500 to put out the first issue, some seven thousand copies. I eventually had to come back to New York. It's a quarterly magazine, and its emphasis is entirely on creative writing, poetry, and short stories—which was a departure from the literary magazines of that time, such as the university journals and the *Partisan Review,* which tended to be mostly critical essays. Our idea was a simple one: to put criticism almost out of the book and concentrate entirely on fiction and poetry. And as a result, over the years, the magazine was the first to publish a lot of writers whose names are very familiar now. Richard Ford published his first short story there. Phillip Roth, James Salter, Peter Mathieson—a long, long list. We're very proud of these writers. It's supposed to be a place for starting off—and most writers do start off in these small publications—Hemingway started off in the *Transatlantic Review,* and so did almost every writer you can think of.

w.o.: Do people send you their manuscripts?

G.P.: We get twenty thousand a year, and there are interns that work for the magazine as readers. All the manuscripts are read. A lot of other magazines simply will not accept unsolicited manuscripts.

w.o.: You kept it going. Why?

G.P.: Most of these magazines only last for a year or so. They are sort of like butterflies. They flutter and then collapse because their backing disappears or the writers get bored and move on to some-

thing else or get better job offers. Way back then I was offered the job of running *Playboy*. I used to go to Chicago and talk to the managing editor there, and I've often thought of what would have happened to my life if I had gone there, but I kept thinking of how I was to explain this to Mother. And besides, I used to tell them, I have my own magazine. Although there was quite a difference in circulation, I felt easier doing the *Paris Review* than going to Chicago and doing that vast thing.

W.O.: Who are some of the great writers today? Who should we be reading?

G.P.: Well, I think all the ones that you probably know the names of are always worth reading, because when they produce something it has to be read. I would put on the list Saul Bellow and William Styron and Norman Mailer, Don DiLillo, James Salter—who I think is very underrated—Peter Mathieson, Jeffrey Eugenides, Rick Moody—whose novel *Ice Storm* was just made into a film—the list is long. Barnes and Noble has a discovery shelf, which is always interesting to look at because it has novels that would escape notice if it weren't for the idea that the writers are new and interesting. A good idea, I think.

W.O.: But you know them all. Who is the greatest writer? If you want to learn how to write, who do you . . .

G.P.: I think if you want to learn how to write, perhaps you'd look at your contemporaries, but I think it's more sensible to go back to writers that you've studied in college or in school. I go back to Mark Twain, for example. My only small gift, I think, is humor, and so I read him to see how deliciously he can put funny and interesting characters or interesting lives or anecdotes into his prose. He's full of that, and I've tried very hard to emulate that in the stuff I do.

W.O.: You've written over twenty books. Your newest one is called *Truman Capote*. We've got a picture of it. Was that a young Capote on the cover?

G.P.: It's a picture taken by Dick Avedon, the famous photographer. I would guess Truman Capote was in his mid-twenties. Capote was famous very early. His first novel was *Other Voices, Other Rooms*. It's sort of a gothic, Spanish-moss-drenched book about the Deep South and some rather weird characters, including a bedridden patriarch figure who communicates with the family by throwing

tennis balls down the staircase. Not only that, but they were *red* tennis balls!

W.O.: Was Truman Capote a nice man?

G.P.: I think they called him the "Tiny Terror" because he was capable of saying rather wicked things about people. He referred to everything Jack Kerouac produced, for example, simply as *typing!* He once described Jerry Zipkin, who is one of the great "walkers" of New York—meaning someone who walks the rich ladies around and entertains them and takes them to the theater when their husbands couldn't go—as having a face like a bidet. He once referred to Lillian Hellman, the playwright, as George Washington in drag! My favorite one is a description of William Paley, who was the head of CBS, as you know, Bill. I think he described him as a man who looks as though he just swallowed an entire human being!

W.O.: Didn't he lose all his friends? Didn't the ladies turn on him?

G.P.: Yes, he made a mistake, and nobody really knows quite why. He was their favorite. He was their toy. And he called them his swans, these elegant women with the long necks they all seemed to have. He went to lunch and the theater with them. He walked them and went on their yachts. And all the time he was collecting material for what he thought was going to be his great Proustian novel, which was called *Answered Prayers*. He published one of the chapters in *Esquire* magazine, and it was a story about that restaurant opposite the St. Regis Hotel with all these people sitting around, and they are being observed by a Lady Ina Coolberth, who is surely Slim Keith, one of his swans. Lady Ina Coolberth looks out at all these people, and she begins telling stories about them, and they were stories that Truman had heard in confidence as he had traveled with these people on their yachts and in their drawing rooms. These were tales told out of school, and people were outraged when these stories appeared about their crowd. Bill Paley was one of the victims. And Ann Woodward, who had mistaken her husband for a burglar and shot him, the heir to a great fortune. He was actually getting out of a bath at the time. The reason Truman used that one, apparently, was that he had overheard Ann Woodward calling him a "fag" over in Europe somewhere—he was a small man, about five feet one, with a rather effeminate manner and a high lisping voice—and he pointed his

finger at her and said, "Bang. Bang." So in this story he took his revenge, and indeed, when she read this is *Esquire*, so the story goes, she leaped out a window in Gracie Square and was killed. So he became a pariah. They threw him out. They wouldn't speak to him.

When we look at Truman very late on, actually, you can see the despair. When he was kicked out of that world of high society, his career began to go downhill. He spent a lot of time at Studio 54 and various hangouts in New York, staying up very, very late at night. He became involved with drugs, cocaine mostly, and also drinking. He would start drinking vodka and orange juice very early in the morning. And you can see that he's quite dissipated in this photo. This is probably the very top of his arc, if you can describe it as that. This photo is from the "black and white" ball he gave for Kay Graham. That's Kay Graham on his left, who was the publisher of *The Washington Post*. Her husband, Phillip, committed suicide and left this huge empire to her, and she was a rather shy woman and very ill at ease in crowds and so forth. Truman had the brilliant stroke to give this ball in her honor. She was very much surprised at that. In fact, her daughter Lally Weymouth told me that this ball gave her a tremendous sense of responsibility, and it was a big turning point in her life. About four hundred people were there. Everybody had to wear a mask, and I had one sort of made for me. There was a guy who did such things. Mine had been glued together and the glue hadn't dried, and I remember sort of "wheeling" around this party. But anyway, it was quite a night. All of New York knew about this ball. People who hadn't been invited took off for Europe so they could say that they couldn't get to the ball because they were away. As one of the people in this book pointed out, Truman invited four hundred people and made four thousand enemies!

w.o.: You move easily with those ladies. Tell us about this picture.

g.p.: This is probably the most famous illustration on a book. This is *Other Voices, Other Rooms*, and on the back cover there's this picture of Truman. He was then about twenty-one or twenty-two, but as you can see he looks to be about sixteen with this sort of "come hither" look. Truman arranged it. Although he always denied it. People used to talk more about that picture than the novel.

W.O.: What did you think of him as a writer? He was a character and a showman, but was Capote a great writer?

G.P.: I think he was a great stylist. He worried over every sentence. Every sentence—almost—in Truman's work is crystal. I keep thinking of what Somerset Maugham said about his work, that he put himself, Maugham did, at the top of the second tier. And that's where I would put Truman, I guess, because he never really dealt, at least in his fiction, with great themes. You would have to put, of his contemporaries, Styron up there, and Saul Bellow, for sure, and Updike, and James Jones in particular who dealt with huge things—the war, modern dilemmas—whereas Truman's work was rather frothy. *Breakfast at Tiffany's,* for example, and *The Grass Harp.* And if you had to rank nonfiction writers—which would annoy Truman, because almost all writers prefer to be ranked according to their fiction rather than their nonfiction—I think you'd have to put him right up there with the very best of them all. *In Cold Blood,* which was the only really great piece of work he did, was about this murder case in western Kansas: The Clutters, a family of four, wiped out by shotgun blasts by these two fellas Dick Hickocks and Perry Smith, who had heard that this farmer had $10,000 in a safe. And when they got out of the kansas State Penitentiary, they went to this farmhouse and in a curious sort of rage killed this entire family because there wasn't any $10,000 nor a safe, and they then took off on this wild ride through the Southwest—all of which is brilliantly described in *In Cold Blood.* Truman went out there, actually, to Kansas on behest of *The New Yorker* to write not as much about the murders but how the murders affected this town, because when he went out there, they hadn't caught the murderers. They were only caught because Perry Smith, one of them, had a shoe that had the outline of a rooster in it, and that outline was in the cellar where they took Mr. Clutter and his son and killed them. They picked them up in Las Vegas and brought them back, and they were eventually hanged. The other interesting thing about *In Cold Blood* is that Truman had an enormous empathy for Perry Smith. Smith was a small man, about five foot one. He came from a dysfunctional family very much as Truman Capote had and wanted very much to be an artist. He had a very sensitive, a very poetic turn of mind. But something had gone wrong, to put it mildly, and here he was

on the gallows. Truman went out to see the execution. It had to be at the end of his book, and he was hugely affected by losing this man whom he really had become enormously attached to through a lot of correspondence. Indeed, one of the contributors to my book says they actually had a physical relationship in the prison. Very unlikely, but that's what this guy, Harold Nye, says, and it is actually corroborated by two prison officials. It's very unlikely, and it's refuted by another man, Charles Mackadee, who was a prison official. That's one of the troubles of oral biography, but one of its delights. A biographer would point out how absurd it is and probably leave out Harold Nye, but here, doing these voices, you have to sort of let the chips fall where they may.

w.o.: Questions you've always wanted to ask George Plimpton, literary lion. What's going on with Bill Clinton? A lot of your fans here in the Golden Apple are wrestling with this.

G.P.: I think we all wrestle with it. It's a very sad moment. My own feeling, which I must say is a very hopeful one, is I admire him enormously. I did a story on him. I traveled in *Air Force One* with him and went to the Olympics in Atlanta with him and sat next to him, and he said a rather interesting thing about the Olympics. I asked him: if he were an Olympic athlete, which of the disciplines would he pick, and he said the decathlon because you have to learn ten things instead of one—which I think is a good answer for someone like a president who has to deal with so many issues, including this one, to which he refers as being in a little box. My father was ambassador to the United Nations with Adlai Stevenson during the Cuban missile crisis, and I remember asking him how on earth can people like the president of the United States think of anything else? And Father said that people like that are able to compartmentalize their minds so that they can concentrate on something like Iraq and not be very much bothered by it.

w.o.: Has Bill Clinton been a good president?

G.P.: Oh, I think he's been a marvelous president. My hope is that there is a lot more fantasy going on in that young woman's head. And that's one of the reasons why, at this particular moment, they're having a lot of trouble with her, because maybe the story that she has to tell is not all that informed.

w.o.: I understand that you have a new movie out in which you play a crazy psychiatrist.

G.P.: It's a movie called *Good Will Hunting,* Matt Damon's movie. It's very good. They called me up one day and asked me if I would go up to Toronto and act in this movie. I had never heard of Matt Damon, I'm ashamed to say. I'm occasionally asked to be in films because I think the producers think I'm going to sit down and write copy that will then be used in the promotion and so forth, and I never do. I've been in over twenty-five films, starting with *Lawrence of Arabia* a long time ago.

w.o.: What do you want on the stone? There are so many parts to your life.

G.P.: I don't really know. I think "He sought an interesting life," perhaps.

w.o.: Did you find it?

G.P.: I had a marvelous time. I'm unbelievably lucky. I've had lucky moments, and I'll describe one to you. *Sports Illustrated* allowed me to go out and play with the Detroit Lions. The big moment came when we were being led into this classroom, and there were these playbooks sitting on a table there. The coach, George Wilson, when I got there said, "No, no, no. You can't go in there." I said, "Coach, don't you see what it is I want to do?" And he thought for what seemed to me an interminable amount of time—it was probably only about four or five seconds—and he finally handed me a book. And that was a very dangerous thing for him to do because he was letting a reporter into the intimate secret society, and I could have written a very different book, but the fact that he gave me that book was an incredible moment in my life because it made me a member of the team.

w.o.: You honor us with your presence, George. Do you still go to "21"?

G.P.: Yeah, sure, when someone invites me. I ride my bicycle there. I think it embarrasses the people at "21" because I harness it to the iron gate outside. I think they would rather I put it to a post a bit farther away than the *entrance* to "21."

w.o.: How old are you now?

G.P.: I'm seventy. I take these pills. They make me younger by the day.

<div align="right">January, 1998</div>

Interview with
Ernest D. Davis

An architect by trade, the Honorable Ernie Davis is achieving a national reputation for his work as mayor of the beleaguered city of Mount Vernon, New York. With his English suits, bow ties, and dreadlocks, the man is a compelling and vivid figure on the political scene these days.

W. O'SHAUGHNESSY: I have discovered tonight's guest late in life, I have to tell you. For twelve years he was on the high council that sits in White Plains, the County Board of Legislators. He is now lord mayor of a major Westchester city, Mount Vernon: Ernie Davis, the politician and public servant, not the football player.

Everybody is singing the praises of your beloved Mount Vernon. *The New York Times* just wrote you up.

E. DAVIS: Mount Vernon is one of Westchester's greatest cities. In colonial times it was part of the vast, sprawling Town of Eastchester. But in recent years we haven't planned properly. We know that we are too uniquely located next to New York City not to be flourishing now. So that means getting back to basics. We're going to pay attention to things that impact people's lives. We are going to make sure our infrastructure is correct and that our town is the best it can be. We are going to be invited to the party of progress. It's going to be safe, clean. And the next thing is involving the citizens in our resurgence. As you know, our tax burden is high, so we have to be creative. We have to involve the citizens in helping us refurbish the city until we can do major reconstruction deals. We're going to refurbish our stadium. We are in negotiations with Multiplex Cinemas. We already have a roller skating arena. We have CVS coming right up the street.

W.O.: Mount Vernon is landlocked. You've got no coast. You're cheek by jowl with Yonkers, where true love conquers, and New

Rochelle and Eastchester. How many people live in your care and keeping?

E.D.: More than seventy thousand people in just 4.2 square miles.

W.O.: Most of those are, shall we say, minorities.

E.D.: I would say. It's estimated about 55 percent would be categorized as nonwhite.

W.O.: Does it bother you when people like Bill O'Shaughnessy say they're minorities?

E.D.: I don't use the word *minority* because we have to be careful about words. When people categorize themselves as minorities, it means they will always be *less than*. That's what *minority* means. And we're saying people can't be less than. It's a wrong term to use for people. Race to me is a fictitious notion. It's not biologically supported. Life began in Africa. Everybody understands that, and if that's the case, *all* of us are African—even *you*, as light as you are, Bill. People forget the earth is millions and millions of years old and that we get the way we are because of the geographic places that we land in. You'll find that lighter-skinned peoples' features changed as they went north and had to acclimate to the weather. And that's why your skin is light and why your nose is narrow and your hair is straight. The reason I object to the term *minority* is because a people that has been subjugated should not be further subjugated by calling themselves minority.

W.O.: Is it all right to say, then, that there are 55 percent black citizens?

E.D.: You can say that. People say it all the time, people who are nonwhite.

I'm an architect—I keep saying that, and the reason is architects look at things differently than regular politicians. When I look at things that are not quite the way I want them to be, I go to work and plan for it to be better. I don't lament that it's bad. It's the way we architects work. For instance, many of the projects we're proposing have to be created because, just as you said, we're landlocked. We are 99 percent built up, but we still have needs. We have no movies in all of Mount Vernon. We don't have a lot of recreation.

W.O.: You also have another problem: the railroad cuts right through the middle of town.

E.D.: It's not a problem, it's an opportunity—my biggest opportunity.

And again, I'm looking at it as an architect. I have nineteen acres of land over that railroad cut that I can use for industry and business. Look at New York City's Park Avenue. It's the same concept. It's built over railroad tracks. Mount Vernon won't look like Park Avenue, but it can follow the same concept: taking the air rights and making it developable space.

w.o.: There used to be a lot of very flamboyant mayors, your predecessors. There was one guy who used to travel around with flags on his bumpers, Joe Vaccarella, and then there were Augie Petrillo, Ed Warren, Tom Delaney. I loved these guys, but you're a little more laid back.

E.D.: Yeah, because I came into this office reluctantly. I said I'd never do it. As you get older, life starts to mean different things to you. I have a city that was once the shining star of Westchester. Everybody I talked to—and most of those were white people—have fond memories of Mount Vernon. When I was up at Manhattanville at the tennis tournament I was talking to this man who said, "Mount Vernon really was *the* place to be." And he started chronicling all the things that he used to visit when he came down, and he said, "Everybody came to Mount Vernon." And then it went into a tailspin. The reason is that we didn't *plan* properly. You can have individual flamboyance in the chief executive, and that's fine if that's your nature. But I think now is the time to pull up our sleeves and start working and try to send a different message to our populace—that, number one, we have a "can do" spirit. One lady wrote and said I must have put my brains in my back pocket.

w.o.: That wasn't the exact phrase she used.

E.D.: It was a little more "graphic." She said I want to be a hero. And I was put off at first, and then I thought, "She may be right." Because it's time for people to *want* to be heroes. It's time for people to want to use the time they have in this life to mean something to other people. If we can do what I want to do with a railroad track, with a partnership with business, with making sure our young people carry on the values that we have—that's the stuff heroes are made of. And it's a lot of sacrifice, but I'm prepared to do it because I know my life has to be more than just walking through, taking up space, and taking up time. I'm trying

to prove we can do what I said we are going to do. I want to revive the town.

We are the eighth or ninth most densely populated city in the country. Some people would look at that as a negative. But remember how much talent comes out of the city! That comes because of a certain dynamic tension. Look at the talented people that come out of Mount Vernon. You have Heavy D of the rap group, Sean "Puffy" Combs, *six* NBA stars, Denzel Washington.

Ossie Davis's mother, Laura Davis, lives in Mount Vernon. She worked on my campaign. She's about ninety-nine and is one of the most fascinating people I have ever met. I was campaigning in this little church—White Rock—and I looked back and saw Mrs. Davis. She had just left the White House. She got up and she said, "You must vote for this man. He is the only person who can do what is necessary for this city." She started campaigning for me right at the church. Her son, I must tell you, is one of my great heroes. He's not only a great talent, he's a great citizen.

Mount Vernon is a very special place. I have never seen anybody talk about any city the way people talk about Mount Vernon. I have grabbed hold of that passion, and if we are able to shed some of the negatives and refocus that energy in the direction we need to go, we'll be a town people will emulate.

The population keeps shifting from ethnic to ethnic. We have ninety-six different nationalities in Mount Vernon. Everybody wants to live in Mount Vernon. And diverse people bring a lot of things to the table. They bring different cultures, and because of that we are very rich.

All the older folks can see is what's wrong. They haven't stopped to think how great Mount Vernon is until they leave, and then they come back. I was interviewed by a young architecture student the day before yesterday. She went to Mount Vernon High School and is at Syracuse University now. She is doing her Master's thesis about Mount Vernon. She always loved Mount Vernon, but she didn't appreciate it until she left, and she is going to come back when she finishes school and practice and be part of the structure. Mount Vernon has only 13 percent of its property devoted to industry and business. It started out as a city of "happy homes," and the residential part cannot survive unless it has more input from the industrial and business community.

w.o.: The city somehow prevailed on you to be the mayor. Everyone is rooting for you everywhere you go. But there is a lot of political stuff in Mount Vernon. Do they nibble you to death? Do you ever get fed up with it?

E.D.: If you have a passion and a mission, you start to overlook the back-biting and start to believe. I believe the best politics is doing the people's work. And I think if you're deft enough to let the citizens know what you're doing and involve yourself, people will look past all the negative stuff. In fact, I had a pretty tough race. It wasn't just a walk-on. We had about seven people running for mayor. All of them thought they could bring something to the table. I, of course, knew I was the best one there. And I'm happy to say we won.

w.o.: Did you reach out to those other six, the vanquished?

E.D.: My nature is to reach out to people. We know that all of us have ambitions, but sometimes we have to make our own ambitions work collectively for the good of the whole. What we want to do is set the stage for better leadership in Mount Vernon, and when all this is over, we hope the citizens will be ready for a person who can offer more than just lip service.

I hear politicians say a city should be run like a business. They don't quite know what they are talking about. There are some business practices we should use, but politics is service of the people, and you have to do the people's work. You have to balance that with what the people can afford to pay for. For instance, an article recently said we had a surplus. We don't have a surplus. It would make me look good if we did, but you can't have a surplus if you need trucks and sweepers and police cars.

What we are doing is creating an infrastructure, building on a firm foundation. If we partner with business, bring more jobs, bring more people into the situation, we'll have a good city and a safe city. That's what it's all about, this matter of urban governance.

March, 1999

Interview with
Michael Carney

Maestro Michael Carney is my favorite bandleader. He looks as if he just stepped out of the pages of an F. Scott Fitzgerald novel. His impeccable musical taste reminds us of the genius of the great American popular song.

W. O'SHAUGHNESSY: We're going to talk about society tunes and cheek-to-cheek music, the kind Fred Astaire and Ginger Rogers did, the kind that makes you think of Cary Grant. There are orchestra leaders perhaps better known than our guest: Lester Lanin, Meyer Davis, Peter Duchin, Bob Hardwick, and so on. We had Ben Cutler up at the Westchester Country Club years ago, and there's Lou Anderson. But the preeminent society bandleader, in every telling and by every account, all across this country, and indeed in Europe, is Michael Carney, here with us tonight.

Michael, we're glad you could leave the bandstand long enough to visit with us. You grew up in Westchester.

M. CARNEY: I grew up in Irvington, New York, on the Hudson. My father was a dentist.

W.O.: Did you think you'd one day be standing in front of a band at the Waldorf and all the grand ballrooms?

M.C.: As a matter of fact, I did not. I started playing music at the age of six or seven, practicing the piano. And I started a band when I was fourteen in Irvington, and we played around. We picked a real original name for the group: the Michael Carney Orchestra.

W.O.: But today would it have been a rock band?

M.C.: Yes, I would have had the influence of rock right from day one, and probably by the time I was eleven or twelve or thirteen I would be playing whatever the rock tunes of the day would be. In those days—we're talking 1951 to 1955—we were playing "Because of You" by Tony Bennett and "You Belong to Me" by Jo Stafford. It goes, "Fly the pyramids along the Nile. . . ." That

music has never really gone away. Now we play music from the twenties to the nineties. There are some new things similar in style to the music of the twenties through the sixties. Obviously, the crux of what we select are Broadway show tunes, movie themes, and offbeat songs. I can rattle off ten titles you've never heard of in your life—even you, Bill O'Shaughnessy.

w.o.: Is it pejorative when somebody says, "Mike Carney, the *society* bandleader"?

m.c.: There is no doubt most of my clients are upper middle class or higher. We do play all over the country and Europe. Society music is a particular kind of music having nothing to do with who dances to it. I don't use that term myself because I think we all do it differently. I've got about four major competitors who play what I think is society music, and they do it very well. And I do something that is different. It's much more along a swing vein than a society vein.

w.o.: Didn't you use to call it *dancing jazz?*

m.c.: I made up the term *dancing jazz* when I made an album about eleven years ago. I called it *Dancing Jazz* because no one else had come up with that and it sounded pretty good to me. We do different tempos, different instruments. We play a totally different repertoire.

w.o.: What are some of the songs people request when they are moving around the dance floor?

m.c.: Here are about five or six in a row: "Guys and Dolls": that's an old song from 1950, but when the show revived, all of a sudden people wanted to hear it. Another is "I've Got Your Number," a great song by Cy Coleman. We've got one called "My Own Best Friend" from a show in the seventies. And "Old Friend," which is probably the best Steven Sondheim song you'll ever hear, from a show called *Merrily We Roll Along*. We still do "One" from *A Chorus Line,* a huge hit from the seventies. We do "Riding High," one of the best Cole Porter songs. And "Shine on Your Shoes," a marvelous Fred Astaire song. We do about three or four other Astaire songs like "Puttin' on the Ritz" and "Steppin' Out with My Baby," which Tony Bennett recorded about three or four years ago and used as the title of his hot album called *Steppin' Out.* We do "Too Close For Comfort" from *Mr. Wonderful.* And a great song

called "You Fascinate Me So," which has more notes per second than you've ever heard.

W.O.: What do all these songs have that recommend them to you?

M.C.: There is one prime idea in my mind: I want to make sure people enjoy dancing. I try to select songs and the correct tempo they should be played in and then hope people love dancing to them. Certain songs lend themselves to different tempos. The songs I just rattled off to you were mostly in a medium-fast tempo. I could rattle off ten other songs that would be in a medium-slow tempo.

W.O.: Let me ask you something. Do you ever have an evening when it's not coming together?

M.C.: Yes. We don't like those a lot, but I do have those evenings.

W.O.: If people aren't dancing, what's your killer song to get them up?

M.C.: As a matter of fact, I'll let you guess what you think is the number one most requested song.

W.O.: "I Can't Get Started"?

M.C.: No. Not even close.

W.O.: "Night and Day"?

M.C.: "Night and Day" is in the top ten. "I Can't Get Started" is not.

W.O.: "Feelings"?

M.C.: Fortunately, nobody asks for "Feelings" anymore!

W.O.: That's an awful song.

M.C.: And I'm going to give you a quick reason why "Feelings" is such an awful song, even though it was probably the hottest song of the seventies. But it's half a scale. Can you imagine, if you were a publisher, and I asked you to listen to this song because it's going to be the biggest song for the next ten years: would you kick me out of the office immediately? The best version of "Feelings" I ever saw was on *The Gong Show*. They had five acts come on and do "Feelings," each worse than the act before, and finally, the last one was not even close. The place was in stitches.

W.O.: Let's say I'm a big spender and I come up and I'm paying you $30,000 for the evening, and I ask for "Feelings." I tell you my wife likes "Feelings." Please play it, Mr. Carney.

M.C.: Yes, I would play "Feelings," and I would try to do it as quickly as possible—hopefully in about forty seconds or less, so the rest of the crowd wouldn't realize that's all I know! Hopefully, your

wife would be very happy she heard "Feelings," and we'd be able to get back on to what I think people want to hear. The number one request we've had for fifteen years is "New York, New York." That song is one of the five best songs ever written. The saddest thing about "New York, New York" is that it has been played to death and everybody is sick of it. It's like seeing the best movie you're ever going to see. You really only want to see it ten times in your whole life, whereas "New York, New York" you've heard ten thousand times. But inherently, the music portion is just great, a terrific construction. It's got rhythm, a kind of medium tempo. Frank Sinatra's recording is one of the five best cuts of all time. It's a great arrangement by Don Costa.

W.O.: Rock groups have groupies. You've got *your* groupies: all the debs, their mothers, and even their grandmothers.

M.C.: You're full of baloney, Bill, but thanks for saying that. I do *not* have groupies!

W.O.: I see those ladies looking at you up on the bandstand.

M.C.: I hope they keep looking that way.

W.O.: What is the most romantic song you know?

M.C.: I'll tell you one that never occurred to me until about a year ago when a few brides started asking for it for the first dance. And it's going to surprise you because it's been around forever. The song is "The Way You Look Tonight." Sinatra recorded that fifteen or twenty years ago. Others are "Nice and Easy," "Summer Wind," and "I've Got the World on a String." For some reason now, all of a sudden, these young people, kids in their twenties and thirties, are finding these songs and requesting them.

W.O.: You've played the White House. . . .

M.C.: I had the great pleasure of performing at the White House twice during the Bush Administration. And we played three times for President and Mrs. Reagan, including his seventy-fifth birthday party in the East Room of the White House.

W.O.: Who's got better rhythm, Bush or Reagan?

M.C.: To tell you the truth, George Bush. I was told before I even got to the White House, "Don't even look for George Bush to dance because he doesn't like to dance." Not true. The Reagans did enjoy dancing, too.

W.O.: You play some rock songs. What's that one I like so much?

M.C.: "Leroy Brown." That song has become so overplayed that 90

percent of the world hates to hear "Leroy Brown." You're obviously in that other 10 percent. We've been playing that since about 1974 when it came out.

w.o.: What else don't you like to play?

m.c.: I'll tell you one other: "Alleycat Song."

w.o.: Is that where they follow each other around?

m.c.: It's sort of a line dance, and it's just not a very good song. About twenty or twenty-five years ago that was a hot song. I've got a bunch of other ballads I can't stand. One of which would be "September in the Rain." I just hate that song, the musical construction. When people talk about great songs, they're usually talking about the lyrics. They're usually *not* referring to the music. There are some exceptions. One song a lot of people think is one of the prettiest songs ever written is "All the Things You Are" by Vincent Youmans. It's a pretty song with a very interesting melody and chord changes. It's very appealing to the ear, but there are a lot of songs with great lyrics. For example, there is a song called "All of a Sudden My Heart Sings." It happens to be a song that is the *scale*. It's simply the scale with some very good lyrics. But pretty boring. The lyrics are important to me, but not nearly as important as the music. And when I'm playing for dancing, both are very important. You've got to find the right tempo. You don't want to play it too fast or too slow. You have to find that groove that is just right for people.

w.o.: There are showoff singers who emote and perform, and there are showoff bands that like to perform. I've watched you up there in all the grand ballrooms. You like people to have a good time, Mike.

m.c.: That's very important. I look out from the bandstand, hoping that a large majority of the people are enjoying dancing to what I'm playing. If they're *not* enjoying it, I have to change what I'm doing. I've got to change the tempo and the emphasis. After dinner, for example, is the appropriate time to do rock music. I don't think it should be during dinner. It's just too loud and disruptive for people who are trying to sit and enjoy their meal and talk to one another. In the latter part of the evening we try to do a comfortable mix of rock and good swing music that people can really enjoy.

w.o.: Is your music dying off? Here in Westchester, your old home

heath, every Saturday night at the Larchmont Yacht Club they used to have dancing. Also at the Westchester Country Club with Ben Cutler.

M.C.: I don't think the kind of music we play is dying out anywhere. I've been in 130 cities in 42 states, and I've played in about 10 cities in Europe, Canada, and the Bahamas. People seem to enjoy what we do.

W.O.: You play a lot of places like Palm Beach. What's the most obscure town you ever played?

M.C.: I just played—believe it or not—a town I never thought I'd play in my entire life: Culver, Indiana. I played at the Culver Military Academy. I think it was their one hundredth anniversary, and they had about 1,200 people—alumni, parents, and students—as diversified a group as you can imagine. It was in this enormous fieldhouse. They loved our swing music in Culver. I have to admit: the last hour and a half we played nothing but rock because all the adults had gone home, and the kids had a ball rocking. Frankly, I love to play where no one has seen me before. I just did a wedding in downtown New York about three weeks ago and I didn't recognize one person in the room, including the clients, whom I talked to on the phone. They had heard about me and said, "Let's do it." So I played this party, and it's fun to see people who have no idea who the heck I am, just enjoying our music. What can be nicer?

W.O.: In some weddings they have a "master of ceremonies."

M.C.: The "master of ceremonies" concept at weddings is as controversial a thing as there can be. At the weddings *we* play, I'd say 98 percent want no announcements at all. If there is an announcement, it will be, "Ladies and gentlemen, please be seated for dinner." They do not want me announcing, "For the first time, Mr. and Mrs. Mel Morabito!" I'm instructed *never* to say that stuff.

W.O.: Do most of the people you play for still wear black tie?

M.C.: Most of the things we do are black tie, probably 80 percent. A lot of weddings that start at five or six in the afternoon are not black tie. With weddings, there is no fashionable time, because most of them are on Saturday.

W.O.: Have you ever had to settle any arguments?

M.C.: No. I explain to people that at these weddings there are going to be decisions that have to be made. My favorite wedding is

really a free-form in which people really have a good time right from beginning to end and with less ceremony, fewer restrictions.

w.o.: A question I've never asked you: are you related to Art Carney?

m.c.: Art Carney is my father's brother. He grew up in Westchester, in Mount Vernon. He is still alive up in Westbrook, Connecticut. I see him every year or two. Art just had a birthday about five days ago, and I think he's seventy-six or seventy-seven. But he's in good shape.

w.o.: One quick, final question: You're at the bandstand. You see a girl—a beautiful and enchanting girl alone, or she's with a goofy guy. I hear you fall in love a lot.

m.c.: You didn't *hear* that. You just made that up this very moment, O'Shaughnessy!

w.o.: What *song* would you play to get her attention?

m.c.: I think you've stumped me. I probably would play "Old Friend" because that's one of my favorite songs. Or I might play "You Fascinate Me So."

1994

Interview with Hoagy Carmichael, Jr.

Hoagy Carmichael's father was one of our greatest composers. His son and heir, a successful television producer, speaks lovingly of the famous man whose name he bears.

W. O'SHAUGHNESSY: I try to make a living at 93.5 on the FM dial, my day job, playing the music of the great American composers and songwriters. WRTN is about the last oasis for good taste in popular song, and what we do has been enriched over the years by the genius of Cole Porter and Richard Rodgers and Lorenz Hart and Johnny Mercer. Tonight a famous son of a famous father, a resident of Westchester, with a career in his own right, as a television producer of *Mr. Rogers*. We're also going to talk about his famous—nay, legendary—father, Hoagy Carmichael. How does it feel to be the son of one of the icons of American music?

H. CARMICHAEL: That's the most asked question, and I have a very honest and straightforward answer. I really don't know anything else *but* being the son of my father, so I don't know what the alternatives are. We lived in a very odd part of the world, where Humphrey Bogart was our neighbor. Bing Crosby lived across the street. Lana Turner lived just up the block, and Judy Garland was next to Bogart. So we all went to school together at a place called Chadwick, where "Mommy Dearest" happened. All these people on radio or television happened to have children, so we were all part of that mix of young kids growing up that could pick up a paper and see articles about our parents. It was an area called Holmby Hills, a nice little spot.

W.O.: Your father wrote some classic songs called "Skylark," "Georgia on My Mind," "Stardust," "The Nearness of You," . . .

H.C.: Also "Up a Lazy River," "Lazy Bones," "Buttermilk Sky," "Heart and Soul," and "Memphis in June." Actually, his name was not

Hoagy, it was Hoagland, named after a railroad executive that my grandmother saw from a distance and thought, "Wow, he's an imposing man. I'm going to name my son Hoagland after John Hoagland." My father grew up in Bloomington, Indiana. When dad was at college, a young woman said, "I'm going to call you Hoagy." And it stuck.

w.o.: Did he write all these magnificent songs for the theater?

h.c.: Hardly ever for the theater. He just wrote—and this is the truth—because they were "there" for him. He always said, "All these tunes are just laying on the keys. All you have to do is just go find them." My dad had stuff on the ends of his fingers that some other composers have had too . . .

w.o.: It's called genius.

h.c.: His fingers went in some of the right places, and you can't buy that or make that or teach that or divine that. It just is there. I remember a time when Paramount was trying to get Betty Grable to stay at Paramount after she did *The Greatest Show on Earth*. Dad and Johnny Mercer were hired, and they had six weeks to write twelve songs. That's hard. They came back with twelve songs, one of which was "My Resistance Is Low." It's a great song. Also, "Cool, Cool, Cool of the Evening," which won an Academy Award. And then some fun songs including "He's Dead but He Won't Lay Down."

w.o.: You say your father had this genius in his fingers, but did you ever see him struggle and tear things up and say, "This doesn't work"? Did it really come that easy?

h.c.: No, but only for the sense of perfection. Many times we would stop the car, and the melodies were pouring out of him. That's the truth.

w.o.: How old are you now?

h.c.: Sixty. My father would have been one hundred this year. His centennial will be November 22—actually, the day Kennedy was shot. It's an interesting year. It's the anniversary of Noel Coward, Ernest Hemingway, Duke Ellington, and, of course, Dad. Next year is Satchmo [Louis Armstrong]. It was sort of a bumper crop for creative people.

w.o.: When you were running around Beverly Hills, what did you think of your father, what he did for a living?

h.c.: I don't think it was any different from the son of a plumber,

and I really mean that. I don't think I thought of it as being any more attractive or any different from another job. Yeah, we got big packets of fan mail, and we lived in a bigger house and that sort of thing; but kids don't think of that. I was interested in playing tetherball and seeing how far I could go on my bicycle. You tend to live as a child who finds those moments with his father, a creative person who is always on the go. My father had music at the end of his corridor, and we were all in these little doors, like these little rooms, and he would come in and share his life with us. But he was so driven by music . . .

w.o.: Would he break out in song?

h.c.: Sure, he would. But when he went to reveal a little something to you, or when he would go to a party at someone else's house for dinner, my father, like an alcoholic, would find, not the bottle, but the piano, and he knew if he could get to the piano and start playing, he would have that party in his hands. He could hold that evening. That's the mark of an entertainer, unfortunately or fortunately. He would find that piano, and he would start singing and playing and people would start adoring it and admiring it.

w.o.: He liked that.

h.c.: Entertainers like that. They love it. Bob Hope would do it today if he could.

w.o.: Hoagy Bix Carmichael, that's you. Where did you get the "Bix"?

h.c.: The cornet player, Bix Beiderbecke, was my father's friend. They had a sort of love affair in the twenties over music and this stuff called jazz that was beginning to permeate this country. Bix started when he was seventeen. By twenty-two, he was the greatest cornet player alive except for Satch. Bix is the guy who said to Dad, "If you want to go to law school, that's okay. But I'm going to Chicago next week, and I'd love to bring you and your songs. Come on, let's play." Bix died when he was twenty-eight in 1931 of consumption—really pneumonia. He's the one who really made my dad understand that the stuff at the end of Dad's fingers was important.

w.o.: You mentioned Johnny Mercer and your father. They have done a lot of albums, and they sing. Few songwriters can sing their own stuff.

H.C.: That's true. Johnny was not a great singer. Neither was Dad. Neither was Fred Astaire. But they could put songs across.

W.O.: Didn't Cole Porter say, "I'd rather have Fred Astaire sing my stuff than anybody?"

H.C.: And why not? Because he could make you understand the lyric. You could feel the song as it came out of Fred's voice.

W.O.: Who was your dad's favorite singer?

H.C.: I don't know if I've ever been asked that question or thought about that. I really don't know.

W.O.: Did you ever recall him seeing someone taking a Hoagy Carmichael song and murdering it?

H.C.: I saw it this weekend! As bad as I've ever seen it. It hurt me because the man who produced it is well known. It was at the 92nd Street Y. He was the guardian of my father's music that night, and he bowed to political pressure and the music suffered. And the music should never suffer. That's really all we've got. That's all Dad's got. That's part of what I do with my life, is make damn sure this music continues, that people know it's alive and get a chance to listen to it and enjoy the melodies.

W.O.: What are you going to do for your father's hundredth birthday?

H.C.: We have a lot of events going on in Europe, and the Hollywood Bowl is doing a nice thing. We're going to try to bring Dad's music to a younger audience. We've signed a group called Big Bad Voodoo Daddy, the swing band. They do swing music à la forties and fifties today.

W.O.: Like Lester Lanin, Emory Davis, Michael Carney?

H.C.: Lester Lanin should live so long!

W.O.: The Big Bad Voodoo Daddy. Are they going to play the American Yacht Club any time soon?

H.C.: No, no, no. These people want to play Dad's music because they understand what the music is, so we're going to do a television special around them and some other people this fall.

W.O.: When you were growing up, what did you want to be?

H.C.: I wanted to be a baseball player, of course. The Los Angeles Angels had some great players. Gene Mauch was on that team, believe it or not. A guy named Steve Belko. Do you remember him?

W.O.: Was he a first baseman?

H.C.: Good for you. He played for the Cubs for a cup of coffee. He had sixty-two home runs one year and beat Tony Lazari's record. He was a great AAA player. I knew the owners of the Yankees, so I used to come in when I was in New York. I didn't have the talent to make it. I played the drums for a long time, and I don't think I really had the talent for that either. Dad thought I was a better player than I was.

W.O.: One of my sons and heirs, David Tucker O'Shaughnessy, is in the television business. He's at Miramax, and when he heard you were coming on today he said, "Oh my God, forget his old man. *He's* a famous guy!" You produced *Mr. Rogers*.

H.C.: I did for a couple of years. I worked at WGBH in Boston. Going back a while to the late fifties when I was just a teenager, I hooked up with Burt Lancaster and Jimmy Hill and Harold Hecht. I ended up working at Universal and then Columbia Pictures and worked on some of their great pictures: *Elmer Gantry* and *Sweet Smell of Success* and *Separate Tables*. I worked with the director and the assistant director, carrying coffee or learning how to change lenses and all that sort of stuff. They gave me an opportunity to see the picture business from the inside.

W.O.: What was Mr. Rogers like?

H.C.: He's a great human being. As Johnny Carson said, "He's one of the best communicators this country has ever produced."

W.O.: You live like a country squire up in northern Westchester in North Salem. We lost one of your neighbors, Martin Stone, recently, who was in the "Stone Age" of television—pun intended. He had *Howdy Doody* and *Author Meets Critic*. Has television changed?

H.C.: Yes. Public access was brought in by the FCC in the seventies for what I thought were all the right reasons—to improve what we would see on television. This was after news and before the eight o'clock slot on television. What has public access turned into? It's turned into a lot of junk TV. The great children's shows are very few and far between now.

W.O.: What's it's like up in those rarefied precincts where you live?

H.C.: Listen to you, O'Shaughnessy. It's quieter, and it takes longer to get there. I got home last night around a quarter after twelve, but it's really pretty.

W.O.: If you could pick some musical greats today? Some singers?

H.C.: Billy Joel is an interesting case because he is a piano man, really, and he is a writer/singer that plays different stuff but he's also a melody-seeking guy. He's looking for a different way to put a song over. His approaches sometimes get a little screechy for me, but Billy is a consummate user of notes. And that's really what Dad was.

W.O.: Would you put Billy Joel's "I Love You Just the Way You Are" up there with Hoagy Carmichael's songs? Or "Piano Man"?

H.C.: Yes. You see, you *feel* that stuff.

W.O.: Do you think those songs will last like your father's songs?

H.C.: I think Billy's got a couple of songs that will last. I'm not sure I'd put my finger on exactly *the* song. The number one song in Europe is Paul McCartney and John Lennon's "Yesterday." "Stardust" is number two. In this country "Stardust" is number one. There have been more than 1,400 recordings of "Stardust." But there are some newer songs that have the legs that some of the older great songs have.

W.O.: Forget whose son you are. What are some songs you really like?

H.C.: I'm a jazz guy. I grew up wanting to be a jazz musician and playing along to jazz. I like melody and the way these tunes are fashioned, put together, more so than just plain songs.

W.O.: Did your father write the words or melodies?

H.C.: He wrote some lyrics, mostly the music. A lot of the songs that Dad has only taken the musical credit for, he beat up those lyricists and got the lyric he wanted. I've seen the sheets.

W.O.: "The Nearness of You" may be my favorite Hoagy Carmichael song—or my favorite song, period.

H.C.: It's the song we played at my wedding. I love that song too.

W.O.: Michael Carney, the society bandleader, tells me that the first song they're requesting now at weddings is "The Way You Look Tonight."

H.C.: I believe that.

W.O.: How does "The Nearness of You" go?

H.C.: "It's not the pale moon that excites me, that thrills and delights me, oh no, it's just the nearness of you." It's a wonderful song, and it's a jazz melody that Dad heard back in the twenties.

W.O.: Most of Hoagy Carmichael's songs, except for the bluesy New Orleans ones, are romantic songs, crooner's songs.

H.C.: A lot of them were romantic. Cole Porter grew up in Indiana

also. He moved to New York and spent his entire life writing about anything *but* Indiana, which is fine. He was a different kind of guy. Dad grew up in Indiana and spent his entire life writing *about* Indiana. Moons and moon country and buttermilk sky and rocking chairs and porches and little old ladies and stardust.

w.o.: Do you ever go out there now? Is there a Hoagy Carmichael homestead?

H.C.: There's no homestead, but we have a wonderful room at Indiana University, where all of Dad's archives are. It's a fabulous, big room, like his living room. His piano is there and photographs and all his sheet music, all his records, and all his notes.

w.o.: You're proud of your father, aren't you?

H.C.: I am, and I'm proud of the fact that what he did was very unusual. He had no musical training at all—none, zero. He was a bad actor, but he was in fourteen films. Howard Hawks told me once that he gave my dad the job to write the music for *To Have and Have Not,* and when he gave him a part in the film, he told him he could play the music in the film if he could teach Lauren Bacall how to sing the music, and still he's chasing Hawks around the studio with line changes. He wanted to rewrite the script! Dad had his own radio shows and his own television shows, and he just did it all by the seat of his pants. And I'm proud of that.

w.o.: Do you think he's proud of you?

H.C.: If he's up there looking at me, he should be. I've tried.

w.o.: Do you think they have Hoagy Carmichael songs in heaven?

H.C.: They have a lot of those songwriters up there now, so I'm sure Dad's up there along with them. One of the last songs Dad wrote was called "Serenade to Gabriel," and it says that when he got up there, they were playing Bix's songs.

w.o.: Gabriel is not ready for you quite yet, Hoagy Carmichael, Jr., famous son of a famous father.

May, 1999

Interview with Robert Merrill

Although Robert Merrill is one of the greatest baritones of American opera, he is also the possessor of the highly unusual Yankee baseball uniform number 1 1/2, which was given to him by the late Billy Martin and Merrill's friend, George "The Boss" Steinbrenner. When this nice man comes back in off the road from his national singing tours, he performs generously on behalf of a multitude of local charities, and he has adopted our local radio station as his own.

W. O'SHAUGHNESSY: Our guest tonight won the Metropolitan Opera's Auditions of the Air back in 1945. He made his debut at the end of the Second World War. He had a million-seller, "The Whiffenpoof Song." And he was with Maestro Arturo Toscanini on those historic NBC radio broadcasts. He's really done more to popularize opera and great classical American music than almost anyone. He has sung at the White House for every president from Franklin Roosevelt to Ronald Reagan. I should add, proudly, he's also our Westchester neighbor, number 1 1/2 for our beloved New York Yankees. He's Robert Merrill.

Let's get right to it. What about the Yankees this year?

R. MERRILL: If we get to the World Series next year, it will be the sixth World Series that I sing the national anthem at.

W.O.: Marian Merrill let you out the door today without your World Series ring.

R.M.: Actually, I have two of them: 1977, when we won the World Series from the Dodgers—and I remember that great series—and 1978. I left them home today.

W.O.: I hear George Steinbrenner also gave you a *uniform*.

R.M.: One day at the Old Timer's Game Steinbrenner said, "Bob, get down there and put on a uniform. I want you to manage the Old Timers." You know the Old Timers: Mickey Mantle and Joe

DiMaggio. So I went into the locker room and couldn't find a uniform. The guy that runs it got me a pair of pants and Bobby Mercer's trousers. Billy Martin was in his office and said, "Bob, come on in." And he gave me this 1½ uniform. Steinbrenner had put a ½ on his number 1 for a gag, and there it was hanging in his office. So he gave it to me and that's what I wore, and I've never given it back. It's my *official* number! I'm the only 1½ in baseball! I think Steinbrenner is a great guy. People don't realize when he came in, the Yanks were in last place. Within a short time they won four pennants and two World Series. People forget that because he is volatile and he makes decisions sometimes a little too fast. But that's George, and I like him.

w.o.: Do you consult with him on players?

R.M.: Periodically, he asks me, and I give him my opinion. He never accepts it, but I give it to him anyway!

w.o.: You sing the national anthem at important Yankee games. It's not really a good song, is it? I don't mean to be disrespectful.

R.M.: It's a marvelous song, but it's very stirring and difficult to sing for an untrained voice. That's why, periodically, you'll hear crooners and country singers having problems with it.

w.o.: But haven't they tried to make it "America the Beautiful"?

R.M.: By the way, I do "America the Beautiful" at Yankee Stadium, and "God Bless America" too. But, of course, the national anthem is our anthem, and I love to hear it sung well.

w.o.: How do you feel when Roseanne Barr grabs her crotch while singing it?

R.M.: Well, that didn't bother me as much as the fact that she killed the song! It was sacrilegious. I heard it and I almost upchucked my dinner. The Associated Press called me, and I gave them my opinion, and it made all the papers and newscasts all over the country. You can't expect it to be done legitimately all the time, but for heaven's sake, don't distort it and make it a parody.

w.o.: I want to talk to you about our home heath. I see you walking around the Wykagyl neighborhood in the north end of New Rochelle. I see you in the bagel store. I see you at our friend George the Barber. I see you at Marvin the Chicken Man. And who's your eighty-eight-year-old friend, the press agent?

R.M.: Sy, a wonderful guy who walks with a cane, and I enjoy his company. I enjoy all the people in the coffeeshop. I'm there prac-

tically every day, and when I take my two-mile walk I wind up there. I really enjoy my neighbors. It's a wonderful town, a very friendly town.

w.o.: But do they leave you alone?

r.m.: Yes, they do. I sign autographs when they ask me. When they want to discuss opera, I do. I'm flattered when they come over to me and ask me those questions.

w.o.: You've lived in the same house with "Maid Marian" for forty years. How come you don't live in Beverly Hills or Greenwich?

r.m.: I did live in Beverly Hills when I was with Paramount Pictures, and I did not enjoy it. It's slightly phony. If you're not making movies, you're not invited to parties. It was not my style, and I decided to live in the East. I love this part of the country.

w.o.: Do you still go down to the Friars' Club?

r.m.: I go to the Friars' and have dinner or lunch with some of my old cronies: Henny Youngman, Alan King, Joey Adams, Pat Cooper, and the guys. We have a lot of fun. I love the club very much. I've been with them about thirty-five years, and I'm a "monk." It's a privilege.

w.o.: When you have a Friars' roast with the likes of Don Rickles, are they pretty terrible?

r.m.: It's man talk. It gets a little rough. I was roasted, and Milton Berle was the roastmaster. Can you imagine Georgie Jessell, Milton Berle, and those guys roasting me? It's wonderful, wonderful fun.

w.o.: Did you get a chance to get up and get even?

r.m.: Who wants to take them on? Not really. I thanked them very much. I got a wristwatch. I had very few words in that crowd.

w.o.: Is Don Rickles the fastest?

r.m.: Don Rickles is fast. I think Milton Berle really is the fastest. He has an incredible mind.

w.o.: How about the comedians today? We see you on all the talk shows: Jay Leno, Arsenio Hall, Johnny Carson, David Letterman. You've also been with Oprah, Phil Donahue, Joan Rivers. Who is the best interviewer?

r.m.: They each have their individual personalities. It's so difficult to say who is the best. I go back to Johnny, and even before Johnny to Jack Parr, who I think was fantastic. You never knew when you went on the air what was going to happen.

w.o.: Tell us about Frank Sinatra. I called you the other day, and Marian said you were on the phone with Frank. Was that *the* Frank?

r.m.: The Frank, yes. We've been friends for more than forty years. I won the Major Bowes Talent Show in 1938 as a kid, and he won the Major Bowes too, and we both traveled the Major Bowes Tour. He was with the Hoboken Four and I was on my own, and we became friends. But we didn't see each other for many years until he opened at the Paramount with the bobby-soxers screaming outside. You remember that fantastic appearance? I was three blocks away, making my debut at the Met at the same time. We've been friends ever since.

w.o.: Did you slip into the Paramount to see Sinatra?

r.m.: I was called the Bobby-Sox Idol of the Met because of *him!*

w.o.: Can Sinatra still sing?

r.m.: Sinatra can still sing, but he's a great showman and he *interprets* songs. He thinks of a lyric and the words more than he does his voice. He's marvelous. I spoke to him recently on his birthday— his seventy-seventh birthday, by the way—and I sang "Happy Birthday" to him on the phone.

w.o.: You sang to Sinatra?

r.m.: Yes, and I sang it loud.

w.o.: What did he say?

r.m.: "You blank-blank showoff. You and that big voice of yours. *Shut up!*" We kid each other all the time. We worked together vocally, by the way. When he had a few problems, he called me. He's got such a musical instinct, he knew exactly what he was doing wrong.

w.o.: Sinatra was doing something wrong?

r.m.: He was using his throat instead of his vocal cords. He was singing a lot, and he got in trouble.

w.o.: Are you a baritone?

r.m.: I *hope* so! Heaven forbid if I were a tenor! Do you know what somebody once said about tenors? Tenors have resonance where their brains should be. It was only a slight exaggeration!

w.o.: There's a little competition there, I guess, between tenors and baritones.

r.m.: Not really. There's competition between *tenors* and *tenors*. Tenors get all the romantic leads in opera. I don't know why, because

we're usually better looking than the tenors! So they got the girls in the opera. I was always the villain or the father!

W.O.: I thought you were the charming boy wonder back in 1945. How did you become the villain?

R.M.: That's how they wrote the operas, Verde and Puccini. The baritone voice was the villain or the father.

W.O.: When you go around the country, what do you sing for them in the concert halls of the hinterlands?

R.M.: There are music lovers everywhere. I do a combination of show tunes, opera—a variety of songs.

W.O.: You did a wonderful benefit concert, if you'll allow me, for John and Cathy Spicer, and I heard you blew the roof off.

R.M.: I enjoyed it very much, and I'm glad it worked and the hospital profited by our performance.

W.O.: You make big bucks on the road but you won't take any money around here. I hear you don't know the word *no*.

R.M.: I enjoy doing things for my part of the country. Anything I can do to help wonderful New Rochelle, where I live, I will do, like that hospital benefit. We have our problems like every other suburban area. But I love it.

W.O.: What about the music on the radio today?

R.M.: We have all kinds of music on radio today. You pick out what you want to hear. If you like country music, listen to it. It's wonderful. Rock and jazz . . . but you also have the classics.

W.O.: With most of the stuff you can't understand the *words*.

R.M.: Sometimes you're better off, because I've heard some of those words!

W.O.: What do you think of Howard Stern?

R.M.: I don't listen to him much, and when I do, I have a problem with him.

W.O.: When you're out there in front of a crowd, what one song brings the house down?

R.M.: Believe it or not, when I do "Old Man River," I usually get a standing ovation. For some reason people love that song. It's stirring. I also do the Barber of Seville aria or the Figaro aria and the Gershwin tunes. That always works for me.

W.O.: What song do you sing when you're walking around or standing in the shower?

R.M.: In the shower I try to sing *tenor* arias because nobody hears me.

I'm nude. I'm excited. I would have loved to have sung a tenor role for just one night. I don't sing in the kitchen. I refuse to compete with chopped liver and things like that.

W.O.: What about Dean Martin?

R.M.: Dean Martin was a wonderful guy. He was so embarrassed when we did a TV show because he wanted to imitate me. He thought I would drown him out, so he kept vocalizing all day long at the studio, and finally, when we started to shoot this scene, he came out and he started to sing and he was hoarse!

I've had idols. I wanted to be a baseball player when I was growing up in Brooklyn. I used to pitch semiprofessional ball. It was my ambition to be a baseball player. When I finally got to Yankee Stadium for the first time I was nine or ten years old and saw Babe Ruth and then a little later saw a guy named Joe DiMaggio. I idolized Joe, and he is a wonderful human being, a great guy, a very sensitive man. Shy, but I love Joe, and I even managed him once in an Old Timer's game.

W.O.: You "managed" him?

R.M.: I asked him to *bunt!*

W.O.: Do you miss Billy Martin?

R.M.: Yes, I do. I was stunned when he was killed in that accident. I sang at the Mass at St. Pat's.

W.O.: Was he a good manager?

R.M.: Excellent. One of the greatest field managers ever.

W.O.: He was driven by his demons, though, wasn't he?

R.M.: He was brought up in California in the slums. He had to fight his way through, and he remained a fighter. I knew him very well, and I knew the reasons why he would blow and flare up. It was his childhood background. I loved him. He was very kind to young people. He'd leave the stadium, and hundreds of kids would ask for his autograph, and he would stand for a half-hour signing. These things they don't know about Billy. He was a wonderful, compassionate human being.

W.O.: Did you ever go drinking of an evening with him?

R.M.: I went out evenings with him, but I could not drink as much. I had one chocolate soda and he—God bless him—didn't drink that much. It's a fallacy. He would have one or two drinks, and it would affect him. He was not an alcoholic. But he knew the haze of an evening.

w.o.: What about Luciano Pavarotti?

R.M.: One of the great tenors. I had the pleasure of singing with him at one of his first performances. He was the heaviest tenor I've ever sang with. As a matter of fact, he played my son in *La Travi-atta!* He was seventeen years old and weighed 300 pounds! I weighed 150 pounds! A glorious voice.

w.o.: Did you ever go eating with him?

R.M.: I dined with him a *few* times. He ate more for lunch than I weigh! He has problems now, and I'm praying that he takes off the weight because the doctors have asked him to. He's been canceling performances. I'm praying for him because he's too great a talent to lose.

w.o.: They asked Louis Armstrong once who some of the great girl singers were, and he said, "Besides Ella?" Who were some great lady opera singers?

R.M.: I sang with Lily Pons. Renata Tebaldi I also sang with. Ella Fitzgerald and I were managed by the same manager, Moe Gayle, bless his heart and rest his soul. He found her, and in the early days I would do a date and she would be on the date. I'm in love with her singing and her interpretations. She's a great, gifted artist and a great lady. We've been friends for more than fifty years.

w.o.: I would not think of putting Robert Merrill and Ella Fitzgerald together in a duet.

R.M.: Why not? Louis Armstrong and I played the Sands Hotel together for five years every summer in Las Vegas, and we did duets and parodies together. I loved Louis. He's a great musician, a wonderful guy, and a lot of fun. Those were memorable moments.

w.o.: What about Fred Astaire?

R.M.: I never danced with Fred Astaire. It's been one of the frustrations of my life.

w.o.: He's a *singer!*

R.M.: He's not really a singer. He sang the lyrics. He was a showman.

w.o.: I thought Cole Porter used to write songs for him.

R.M.: Why not?

w.o.: Did anyone ever write a song for you? "The Whiffenpoof Song"?

R.M.: That was not written for me. It was written for Yale University.

w.o.: I hear they are bringing your albums out again. CDs for a whole new generation.

R.M.: Yes. I made many, many, many albums—show tunes, operatic—and they're reissuing them now. I have twenty-five CDs out, and it's a marvelous feeling because there is a new audience listening to them. I'm very excited about it, and they sound good.

w.o.: I'll see you at the bagel store, Robert Merrill.

R.M.: I'll buy you a coffee, O'Shaughnessy. Any time.

January, 1993

Interview with M. Paul Redd

M. Paul Redd is a longtime political activist and publisher of Westchester's only black-owned newspaper.

w.o.: He is a very influential politician in our home heath and enjoys a national reputation. He's also a publisher, and that recommends him to me because it's not easy to keep an independent entity afloat in this day and age. Jack Gould of *The New York Times* said any independent voice is a national resource. He's the promoter and drumbeater, owner and protector of an independent voice in Westchester, the *Westchester County Press,* a feisty and independent weekly. How old are you now, M. Paul Redd?

P. REDD: Surprisingly enough, the paper and I are the same age. I turn sixty-five on August 11.

w.o.: Happy Birthday times two. How is the *Westchester County Press?* You bought it from . . .

P.R.: I bought it from the Reverend Alger Adams and Mrs. Adams in November of 1986. It can always do better, Bill. It's like a catch-22. You need advertisers to get it out to the people, and you need the people to subscribe and buy it in order to get advertisers. It's difficult to get big business to advertise in an African American newspaper. For one thing, businesspeople believe they can advertise in a white newspaper that covers all the neighborhoods, but the *County Press* reaches people they don't traditionally reach. They have people of color who come into their businesses, but they don't believe they have to advertise in black newspapers. For example, you can't find a black newspaper with a supermarket ad in it. Certainly people of color buy plenty of food in supermarkets.

w.o.: Don't people of color read the Gannett papers or *The New York Times?* Or the *Post?*

P.R.: Of course they do, but they also read *"their"* paper. People of color like to read their own paper, and they also want other businesses to put something back into their community. When they buy advertising space in a black newspaper, they believe they're getting something back.

W.O.: But most of the people you sell ads to are not of color.

P.R.: That's true.

W.O.: Why are we talking about these things?

P.R.: I say it's pure racism.

W.O.: Why do we have to *have* newspapers for people of color?

P.R.: Because the newspapers and the regular media do not print black news as it is. They highlight the brutality, the murders, the rapes, and all that. We want to highlight some of the *good* things that are done in the black community. There's a small percentage of people in most ethnic groups that get into trouble, but most of the time we see in the white newspaper *blacks* on the front page! Let me give you one example. They had a black guy on the cover of the *Daily News* who defrauded the state of $17,000. Inside the paper there was a guy who had defrauded a major corporation of $250,000—in the business section, no picture or anything. There are a lot of young people doing a lot of great things in this county, and we try to get that message out.

W.O.: I know you also as a politician, back in the days of Bill Luddy and Max Berking, local Democratic warlords of sainted memory.

P.R.: They taught me a lot. Bill Luddy was the county Democratic chairman when I began in politics. Today we don't have the same kind of Democrats. When I got started, politicians stood more on principle. I find that the party now is focused more on "What can I do to *win?*" The Democrats' main *theme* is to win no matter what, and I don't like it. If they think that their stand on an issue will get them in trouble, they won't say it. I think the party as a whole has switched places with the Republicans, and the Republicans have switched places with the Conservatives. I don't know where the Conservatives are.

W.O.: What kind of Democrat are you? A Scoop Jackson Democrat? A Bill Clinton Democrat? A Mario Cuomo Democrat?

P.R.: I'm a Democrat from the past. If I had to classify myself, I'd say I am more a Clinton Democrat.

W.O.: Do people get rich in politics?

P.R.: I don't think so. Most of the people get rich after they leave politics. People believe they're doing politicians a favor by electing them to office. But to be an elected official, regardless of the party to which one belongs, is tremendously hard on the family. Take County Legislator George Latimer. I happen to think George is a very good and effective legislator. George works at it twenty-four hours a day. I'm in his district, and I can come home at two in the morning after working on the newspaper and wake up at seven and find literature at my door from George. He lives and breathes politics. It's a special kind of person who wants to put himself or herself into a political position because politicians can never satisfy anyone. They have to take positions.

W.O.: But there *are* some good people. You are married to a formidable woman, Orial Redd, who has her own career. Does Orial ever say, "Paul, let's get out of politics."

P.R.: I think that she deserves a lot of credit. I come home after being beaten up, and she has to listen to me. She's never said, "Let's get out of it." On September 4 we will have been married thirty-nine years. She started me in the civil-rights movement.

W.O.: David Dinkins and Rudy Giuliani: who are you for in that one?

P.R.: I think it's a racist campaign. This is the way the media does black people: when they talk about Crown Heights and the bricks and bottles blacks were supposed to have thrown at the Jews, they didn't show the other side. That whole situation over there was an accident waiting to happen. Every Saturday the seniors take over the street in caravans with immunity. Nobody wants to talk about the black kid that was killed. Obviously nobody condones murdering anybody, but both things were unfortunate. Why tag Mayor Dinkins twenty-four months after the incident happened?

W.O.: What of Mayor Dinkins? That he is a man of civility, we know. That he is a decent man and has a nice wife, Joyce, we know. Is he a strong leader?

P.R.: Let me put it to you this way, Bill. I've known Dave Dinkins for thirty years. Out of the four blacks in New York City who were likely to run for mayor—Percy Sutton who did run, Basil Patterson, Charlie Rangel, and Dave Dinkins—Dave in my opinion is one of the most sincere guys. He is not a flamboyant individual. He doesn't come up with big words and all of that. Dave, for as long as I have known him, has been a good, solid guy. He has

never been a person who tried to bring a lot of publicity on himself. They pushed him into running.

w.o.: Do you think he helps himself on the tennis court by playing an "elite" sport?

p.r.: I met someone who said they didn't like him because they saw him in his tennis clothes, so I said to the person that you also see President George Bush fishing, but did you ever stop to think that Mayor Dinkins and President Bush would love to go fishing and play tennis without anybody around? Just to be able to relax? That's the kind of life they have: twenty-four-hour surveillance. You give up a lot when you lead a public life. I'm sure Dave would love to go play tennis with his friends without any cameras or reporters, just for a couple of hours. Lots of people play tennis. There are black tennis groups here in Westchester. We have middle-class blacks. This is what I'm trying to tell you. Everybody perceives blacks as being the poor group. They're not. In fact, there are more whites on welfare than blacks. But every time they show welfare in the media, they always show a black woman!

w.o.: You're going to mess up a few stereotypes.

p.r.: No, I'm not. If you look at the statistics you'll find that I'm right.

w.o.: What about Rudy Giuliani?

p.r.: I heard Rudy was ahead in the polls. What has he done?

w.o.: He locked up a lot of guys.

p.r.: You've been around a long time, Bill. You also know a lot of those people he charged. A lot of them were never convicted. He ruined a lot of people's lives.

w.o.: A tough prosecutor. Isn't that what we need for mayor?

p.r.: Not necessarily. You're now saying that a tough prosecutor is what the City of New York needs. That's *not* what the City of New York needs. The City of New York needs someone who understands the plight of the people. A lot of people don't realize that David Dinkins had less power than any mayor in the City of New York ever had. Ed Koch was the last strong mayor.

w.o.: That's the sheer force of personality.

p.r.: No, it isn't. When they changed the charter and expanded the City Council from thirty-five to fifty-one and then gave the budgetary powers to the City Council, Peter Vallone, who is the majority leader of the City Council and who comes from Queens, found

himself with more power than the mayor. He just doesn't get to cut the ribbons. But any time the mayor wants a program that costs money, he has to go to the City Council. Before, the mayor and the five borough presidents had the financial power.

w.o.: I've debated all day whether to ask you the squeegee question. Suburban women are terrified. They drive into New York to spend money. They go down the West Side Highway ramp and there's a guy there menacing them with a squeegee. Throw him a dollar and he'll leave you alone. David Dinkins formed a committee to study why they are there menacing people. Why can't he send somebody over there and help those people if they want to spend their money at Bergdorf's and Saks and then go home. Why isn't he smart enough to figure that out? Am I a racist because I object to those guys?

p.r.: No, because I do too! When they come to my car I tell them to get away. I totally agree with you. I think the police should be there to move those guys out of there.

Carl Rowan, the noted correspondent, said a white guy asked him what his people want. Carl said, "I'll tell you what, sir. You go back home and write down everything that you want for your wife and your kids. When you're finished, sign my name." In other words, people of color don't want any more or any less than white people want. We don't want our kids brutalized, killed, or murdered any more than anybody else. We want them to have a good education, good jobs, big houses, lots of money—which is the same thing everybody else wants.

w.o.: My mind drifts back to 1965. I had to make a speech at Glen Island Casino, and my knees were shaking. I said something about "you people." The vice-chairman of the party grabbed me and said, "I'm going to give you some advice, O'Shaughnessy. Don't ever use that phrase again." Do you remember that? You were that man.

p.r.: Yeah. I do think that we overreact to "you people." I saw this happen also in Yonkers at an NAACP meeting. I think the time has passed for us to react . . .

w.o.: Don't bail out of it. I'm paying you a compliment. You gave me the best advice I ever had.

p.r.: "You people" goes back to the Southern people who said "you

people" and meant it in a racist way. You can tell when a person says "you people" and means it in a derogatory way.

w.o.: What about Andy O'Rourke, who runs Westchester?

P.R.: I think Andy O'Rourke has been a good county executive. I like him.

w.o.: He's a Republican, and you're a Democrat.

P.R.: What's that got to do with it? I think he has done a good job. But I think he has people around him who are not so good, and I think they have caused him problems.

w.o.: What about Mario Cuomo, the governor, an old friend of yours?

P.R.: Mario and I reserve the right to fight on certain issues, but I think he's been a good governor.

w.o.: What if Al Sharpton runs against Cuomo? Are you going to be out of town for that one?

P.R.: I don't think he's going to run. I think he's going to run for United States Senate.

w.o.: Sharpton against Daniel Moynihan?

P.R.: Sharpton is a very interesting individual, and I think he gave himself a lot of credibility last year when he ran in the primary against Bob Abrams.

w.o.: He's trying to get respectable, isn't he?

P.R.: I think he did gain respect. Don't forget he came in third out of four in the primary.

w.o.: In the intimacy of this studio let me say that he's a "character," Mr. Chairman.

P.R.: Sharpton raises issues that other people are afraid of, and when you do that everybody wants to tag you with all kinds of names. There are a lot of people who think like Al Sharpton but do not have the guts to say what they think because of the repercussions. He merely says the things they would like to say. He probably says some things that *you* would like to say, Mr. O'Shaughnessy.

w.o.: What about Bill Clinton, president of your country and head of your party?

P.R.: I think Bill Clinton has done a very good job. People want to put him down. He shook the trees in the beginning because he knew he would have a hard time getting some of these things through, but he has started the big fight now. I think that we should give him an opportunity.

w.o.: Mario Cuomo would say, *"Per cento anni,"* which means, "For a hundred years." I don't know what the Italian is for another sixty-five, but I wish you another sixty-five years with the paper and another sixty-five years of being M. Paul Redd.

Summer, 1993

Interview with Monsignor Terry Attridge

Monsignor Terrence Attridge was a "central casting" handsome priest who was loved and admired by many in the New York area. When he died last year at the age of sixty-one, five bishops and 130 fellow priests led five thousand mourners who came to the little town of Dobbs Ferry to bid farewell to the charismatic cleric.

W. O'SHAUGHNESSY: I am a poor, stumbling, staggering, faltering Catholic. But I do call it my own "personal" holy Roman Church. We've talked about religion and life with Brother John Driscoll, of Iona College, and Monsignor Ed Connors, the great preacher from Immaculate Heart of Mary Church. Tonight, we have the pastor of Sacred Heart in Dobbs Ferry. He is a former associate superintendent of schools for the Roman Catholic Archdiocese of New York and a police chaplain: Father Terry Attridge. Father Attridge, no one believes this, not even Nancy Curry O'Shaughnessy, but you and I are the same *age*.

T. ATTRIDGE: That's what they tell me, Bill. I was listening to all the guests you had, and it's really great to bring me in here to try to boost your ratings.

W.O.: We're off and running, Father T.! I remember when you were a young parish priest. You still look the same. You'll be ninety years old and you'll look like that. Can I mention that you're fifty-four?

T.A.: You just gave away the great secret of the county. But, Bill, if you started to live my life, *you* might be able to look more respectable.

W.O.: I'm the worst. I'm a derelict. Do you know the type? You ever encounter the likes of me in confession?

T.A.: The ones we like to welcome back all the time. People have this great fear of the sacrament of reconciliation, but it's a sacrament of healing. I think we have a whole church full of people who have been alienated in one way or another. They come to Sacred

Heart because we hear no evil, see no evil, and speak no evil. So you are welcome, Bill.

w.o.: You call confession "reconciliation." Somebody called you a "three Hail Marys for a homicide" priest.

t.a.: I never give out Hail Marys. I get people to do something like trying to be good guys instead of bad guys.

w.o.: In grammar school they told me a priest would take a bullet before telling what goes on in confession. But did you not also tell someone once that women have told you that it's the worst day of their life when they have an abortion.

t.a.: That was a *counseling* situation. What do you say, for example, to an eighty-four-year-old woman who had an abortion when she was sixteen years old and was forgiven by the Church but has been unable to forgive herself? Molly Yard will get up and say there is no emotional effect. That's a crock, Bill. Molly Yard is the former NOW [National Organization for Women] lady. You can justify a thing, maybe when you're seventeen or twenty-two, but what do you do later on when you realize what is taking place? It not only affects the woman, it affects the father of this child. The Church is there to minister to that person as well, to help with the healing process.

w.o.: I can't believe that someone would want that appellation "pro-abortion." I think lots of people are against it, but they'll say, "How can you guys tell women what to do? The church, the hier-archy—they're all men."

t.a.: I agree with you, Bill. I think women should take the stand on abortion because this is one of the areas destroying women.

w.o.: You don't get the best assignments. You are now the pastor in Dobbs Ferry. There's also a little problem about abortion clinics in Dobbs Ferry, people throwing themselves in front of bulldozers and picketing. You're right in the middle of it.

t.a.: The problem is one of the major life issues in our society. Abortion denies the basic right to life to the unborn. But I don't agree that demonstrating in front of a clinic is going to solve the prob-lem. A person can get pregnant in a moment of passion, and no one condemns that person. Instead of saying, "Get rid of it," we need to be saying, "We can help you." The Church, and John Cardinal O'Connor especially, has set up a whole program for any woman who finds herself in this situation. We can take care of

an individual from prenatal through postnatal care. And we can relocate that individual if she feels self-conscious about going to her job. We can get a person a comparable job out on the West Coast or any other place. If a person is a student in a school, we can get that person relocated.

w.o.: Should a woman have control over her own body?

t.a.: Not when it violates the right of the life that is there. That child, that baby, has a right too.

w.o.: What about the Church today? It's under siege in a lot of ways.

t.a.: I think it's very exciting to be active in the Church. We have a program now called the Right of Christian Initiation for Adults and people who have been baptized but have not been actively involved. The value system that the gospels and the Scriptures offer is really something that is desperately needed in our society. The Church is willing to take a stand on a lot of the issues facing society and, hopefully, wake a lot of people up. The basic conflict in our society rests upon life issues. We have a society that is willing to tolerate the killing of babies before birth through abortion. We have people who will do anything to their bodies to get high rather than dealing with issues. We have a society that gets upset over violence but is not willing to do something about it. We have so many people in our society who are hungry just because they can't take the meager income they are getting from their wages and feed themselves after paying rents that are out of sight . . . We have to be able to look at these issues as issues of justice.

w.o.: You were head of the D.A.R.E. national drug program. You started it. Are drugs really behind a lot of our problems?

t.a.: Drugs are a *symptom* of the big problem in our society. As the basic subcommunity of society today, the family, declined, crime and the drug problem escalated. I don't think a lot of our society is willing to deal with the basic issue. But to focus on the symptom: a lot of people will say that there are no drugs in their community. We are *all* affected by the drug problem. Before I moved up to Dobbs Ferry, I was living in Manhattan, and I was robbed fifteen times in fourteen years! I managed to talk myself out of it four times.

w.o.: But you're the police chaplain. They've got to be *dumb* robbers!

t.a.: That was how I was able to talk my way out of it! It's really a problem when we deny we have a problem. The number one

health problem in our society is addiction. We say it's heart disease and cancer. But if we look for the source of those diseases, we find alcoholism and cigarettes. People say the drug problem is declining. That's not true. Being involved with law enforcement for twenty-five years and dealing with the people in enforcement, I can tell you the heroin problem today is higher than it was in the past. And the quality of the heroin coming into the country today is better.

w.o.: We are sitting here in pristine Westchester. You're talking about downtown New York.

T.A.: The problem is here too, but we don't always see the crime. In Westchester cities the crime is escalating, but not in the Larchmont-Scarsdale area. And when you talk to the young people there, you'll find out that pot is in the house, pills are certainly there, and abusive prescription drugs are in all the affluent areas.

w.o.: Are you fingering booze as a killer? As dangerous as heroin and cocaine?

T.A.: I think it's as destructive. More people die from alcohol than from heroin. And for many people, alcohol is a trail into cocaine. I don't think you'll find any alcoholic under forty years old today who is just simply an *alcoholic*. Most of the times it is alcohol *and* other drugs. We know that male children of alcoholics have four times the potential of becoming alcoholics, and female children three to four times. These statistics are not scaring people.

w.o.: Drugs and kids?

T.A.: Part of the problem is that we're in *denial,* so a lot of funding has been cut. In prevention, you have to build up a person's self-esteem and get them in touch with natural highs rather than chemicals. Everyone has to share the vision, not just the schools. It has to be families, churches, synagogues, healthcare agencies, service organizations, and law enforcement as well. If you share the dream, you can bring it to reality. But what happens today is that we're doing it piecemeal. A lot of studies have shown that the D.A.R.E. program in the schools is not that effective. Instead, we should be trying to build up coping skills, to teach kids how to deal with unrealistic expectations, decision-making, problem-solving, and instant gratification. You can teach that in a school environment, but what happens when the kids leave the school

and go out into the streets? Kids do better if they complete something in their lives. Most kids never complete anything.

w.o.: Are we being as tough as we should be or could be on drug dealers? What do your cop friends tell you?

t.a.: They agree enforcement is not the answer. It's education and prevention, because how many people can we put in jail? My friends are looking to redo the Rockefeller laws because they take a poor person coming into the country as a mule and put him away for fifteen to twenty-five years. The people behind the traffic are still out on the streets.

w.o.: Governor Pataki wants to deep-six those laws, and he should. I'm a great Nelson Rockefeller admirer, but they get a kid who is an addict and put him away for fifteen years.

t.a.: Monsignor Bill O'Brien, the founder of Daytop, a therapeutic community, has shown that it's less expensive to put a person in treatment—and much more effective—than to put him or her into jail. And even when Julio Martinez was head of DSAS, the Division of Substance Abuse Services, he got money for treatment, but the prison people didn't agree. You could really set up a therapeutic community in our prisons so that being in prison would be "good" time rather than a graduate school for crime.

w.o.: What do a mother and father do to keep a kid away from drug dealers?

t.a.: I think they have to be parents. One of the biggest problems with parents is that they want to be their kids' friends. If they think their kid is going to be their friend, they're in deep water. And if this is the only friend this kid has, then there's a problem there also. Parenting is probably the most difficult vocation a person could have. If both parents are out working, their kid can become a "latchkey" kid. Or if they go to their room and they don't have interaction with their parents, that's another problem. Single-parent situations are even tougher. It's very important that there be a *relationship*, that there be *boundaries*, that a youngster knows what is right and what is wrong, that he or she understands *consequences* and can see the ripple effect.

w.o.: You were a protégé of Terence Cardinal Cooke. The word is you were like a son to him.

t.a.: He never said that, and my father would get upset if he heard it! I found Cardinal Cooke a very easy person to deal with. He was

very sensitive to social issues, a social worker by trade. And he was very sensitive to the needs of people. I had been associate superintendent of schools, and he pulled me out of that because he had set up a study to look at the problem of alcohol and drug abuse among young people. He thought that was a higher priority. I got myself updated by going into a treatment facility to learn about the problem from the point of view of the people in treatment. And I decided there are a lot of good treatment facilities, but the area we really have to address is *education* and prevention, which people talk about as the demand side.

This was back in the mid-sixties. At that time the problems were heroin and alcohol. *All* of the young people I dealt with at that time are dead, some of them by "contracts," others because of overdoses and so on.

w.o.: Tell me about Cardinal Cooke. Was he a saint? They're trying to make him one.

t.a.: He was a unique person, a prayerful person. He would give you a project and he wouldn't tell you how to do it. He suffered an awful lot over the years, for about twenty years from cancer. A lot of people didn't know that. He was willing to confront a lot of issues. I know people are praying to him, people who have cancer. Is he a saint? I think a lot of people are saints. He had limitations like all of us. We look at saints and we think these people were perfect all the time. Take Saint Augustine: he was the playboy of the Western world, and he had such a great sense of humor that he named the child he had with his mistress Adeodatus, which means "a gift from God"! Augustine made it to sainthood. All of us have a chance. Even you have a chance, Bill, to become a saint one day. We are all *called* to be saints.

w.o.: Do you pray to Cardinal Cooke?

t.a.: No. I pray directly to *Jesus*. I don't get into a lot of saints.

w.o.: What do you think about his successor, John Cardinal O'Connor?

t.a.: I think Cardinal O'Connor is a person who is really an "adopted" New Yorker because he came out of Philadelphia and spent twenty-eight years in the Navy.

w.o.: You guys call him "The Admiral," don't you?

t.a.: And they call 1011 First Avenue, the headquarters of the Archdiocese, "The Flagship." Cardinal O'Connor has a lot of very posi-

tive qualities. Being an admiral, he knows about delegating. In the area of substance abuse prevention, I was like a long-distance runner. I really didn't get too much support from people. Some called me an alarmist. But Cardinal O'Connor would be always there to support me because he was the person in charge of substance abuse prevention for the Navy! We would have DARE dinners, and he would get up and say how important this program is.

O'Connor has had the experience of standing up in front of the cameras, and because he realizes New York is the big communications center for the world, he'll take a stand and he'll get abused because of it. For example, I don't think any diocese has done as much as the New York Archdiocese has in the area of AIDS care. Not only in treatment, but in support groups. And this man very quietly goes over to St. Clare's hospital himself and functions as a "basin-Jason." He changes bedpans! You can call St. Clare's and talk to the administration, and they'll tell you what he does.

w.o.: Cardinal O'Connor has a different style than Cooke did?

T.A.: You learn to work with the person you're accountable to in your work. I find him very supportive. When Cardinal O'Connor came to New York, he gathered the staff together, and he looked down at me and said, "OK, you junkie, you've got the most difficult job in the world . . . "

w.o.: He called you a "junkie"?

T.A.: Yeah, the "Junkie Priest." But he's one of the few people who really supported me in the ministry because he knew what I was up against. People are fixated on treatment. Treatment is important, but it's too late. We really need to work on education and prevention.

w.o.: You also know the Holy Father. What kind of man is he?

T.A.: I found him very interesting. We talked about the drug problem. Several years ago he was concerned about the number of young people who were stoned when they came to Rome.

He heard about Monsignor Bill O'Brien in New York and had his secretary call him. The phone rings, and the person on the phone says he's representing the pope. So Bill says, "Yeah, sure" and hangs up on him. He calls back and asks Bill to meet with the pope in Rome on Thursday. Bill goes over to Rome. He ends up being in a room with an Italian street priest named Father Peaky.

Bill doesn't speak any Italian, and Peaky doesn't speak too much English. So the pope was basically the translator! They set up El Centro in Rome, a residential drug-treatment program. And then Peaky asked for the pope's *residence,* Castel Gandolfo. And the Holy Father said, "What do you need?" The young priest said that he would like to take the broken, unused parts of the property and build them up again. So the pope said, "Sure. Whatever you need you can have." I saw that site. It was absolutely beautiful what they did. So Peaky pushed the pope a little further and said, "We also want to use your *pool.*" The pope said, "My *pool?* I just got it fixed. But when you want it, you can use it."

My contact with the Holy Father was when he first came to New York in '79. I produced the show in the Garden. He really cares about kids. I think he's a pastoral person. But some of the papal advisors cause more pain than the leader.

w.o.: I remember walking around the tombs of the popes in St. Peter's one day and seeing some Midwestern tourists come upon the tomb of Pope John XXIII. And the father said to his children, "That's the 'Good Pope.' " What will they say of this one?

T.A.: It's very hard to say because we're immediately experiencing the person, and history is really going to tell the story. I think a lot of people like John XXIII because he was willing to risk the Second Vatican Council to change things. And that wasn't an easy deal because the Curia just wanted it to be the same old stuff. But during the third session Francis Cardinal Spellman of New York brought in Father John Courtney Murray, a Jesuit. They had a major effect on the session, and we ended up with the *Pastoral Constitution on the Church in the Modern World.*

There are so many things I think were very positive in the Church from 1963 to 1965. A lot of people have forgotten that and want a return to the past, but they don't really understand what happened with the Second Vatican Council. The pope himself and Cardinal O'Connor have encouraged us to go back and read and implement the documents.

We all find change difficult. But I think that's where Jesus calls us. In the Sermon on the Mount, Jesus constantly calls us to go beyond what we're experiencing. We're not supposed to be status quo people. We're constantly called to go beyond where we're at. I think Vatican II offered that opportunity and still offers it.

W.O.: What about the contretemps with the Hibernians and the gay community over the St. Patrick's Day Parade?

T.A.: The parade itself is a religious thing. There have been gays and lesbians in that parade for years.

I think the Church takes a lot of heat for its stance on homosexuality. I personally have ministered to a lot of gay and lesbian people. No one condemns them, but their ground rules in the Church are exactly the same as for heterosexuals: no sexual activity outside of marriage. The Church doesn't accept homosexual behavior. But if someone is homosexual the Church welcomes them back. It doesn't ostracize them.

W.O.: Who do you think will be the next archbishop? You know all the players.

T.A.: It's very hard to predict that, Bill. I know *I'm* probably not a candidate. You hear so many rumors. They tell me it's the Holy Spirit that creates these appointments. The track record of the pope seems to be that he takes people from outside and brings them into the diocese. Some of the names mentioned have been Henry Mansell, who is a contemporary. Archbishop Edwin O'Brien, who is a classmate, is now the archbishop of the military. And Justin Rigali, archbishop in St. Louis. I was looking at a news article recently that said the next Archbishop of New York is going to be Latino. They mentioned Roberto Gonzalez, who is in Corpus Christi, Texas. Or they might select Eddie Egan, who is in Bridgeport. He's a brilliant administrator, a prodigious fundraiser, and a wonderful diplomat with a lot of friends in Rome.

W.O.: What about "Monsignor" Plunkett: Bill Plunkett, the Catholic layman. Who says you have to wear a collar?

T.A.: Plunkett would be very good. I know you and Mario Cuomo like the guy. So does Governor George Pataki. But unfortunately, Bill, the pope still makes the call!

W.O.: It's Lent now. A few days ago, on Ash Wednesday, you put ashes on the forehead of your parishioners.

T.A.: A lot of people just go to get "ashed," and the idea is to recognize our human mortality. But we're really people of life. We're people who experience resurrection. Lent is an opportunity for us to refocus, to think about how Jesus lived and died and about how we might give ourselves *totally* and *selflessly* and *unconditionally* to other people and to God, as he did. As the minister says

when the ashes are administered, to turn from sin and believe in the Good News.

W.O.: You've been a priest of the Holy Roman Church for thirty-four years. You preach in Dobbs Ferry. Nancy and I slipped in there the other day, but some usher put us right in the middle of the children's section, so I babysat thirty kids! One was sitting on my lap. The other was stepping on my foot. Another was rolling her toys. Do the kids drive you nuts when you're preaching?

T.A.: I really don't hear them. A couple of times we've had kids run up and take over my seat—which is OK because I wasn't using it at the time. If they want my job that bad they can have it. We had about 500 families registered in the parish when I first got there. Right now we have over 820 families. A lot of people who were alienated from the Church are coming back. A lot of them are young couples with kids. I have never believed in "cry rooms" for the babies. In one parish I was in we used to call it the "bawl-room!" The parents would play there, and it's more of a distraction for them than the kids. I know some people are uncomfortable with young kids, but they're part of the family, and my whole focus as a priest has always been *family* ministry.

W.O.: Do priests sometimes burn out and have nothing left for themselves?

T.A.: That's part of our problem. We have about 400 active priests in the Archdiocese right now and 413 parishes, not to mention the various institutions. When I served as vocation director we ended up doing a campaign called "The New York Priest: God *Knows* What He Does for a Living." People started to think about what priests do. Most people think you get up in the morning, say Mass, and go back to bed after you've had breakfast. And then you get up and have lunch, then go back to bed. I challenge anyone to follow me around and stay up with me. Most of the priests are very active, but we are getting older. And we have to watch for burnout. We have to take care of ourselves. We have to involve a lot of people.

W.O.: I know priests who can't even wear their collars on airplanes because they just can't get a minute to themselves. People see the collar and start doing their life story.

T.A.: That's me. I travel in jeans. When I was working downtown I was taking the bus back and forth. When people saw me waiting,

they were hoping I'd be getting on that bus with them—they *reserved* a seat for me! And if there is a need, you respond. But you also need some quiet time. Even Jesus went up to the mountain and out to the desert, or climbed into the boat to get away for a while.

W.O.: When you don't have your collar on, do good-looking ladies ever ask what you do for a living?

T.A.: Well, I think the collar attracts them. When I'm not dressed up, they don't say anything. When you're in the collar is when they make their moves.

W.O.: Do you ever get scared?

T.A.: Frustrated probably is a better word.

W.O.: I want to talk to you about your cancer. Can we talk about that?

T.A.: I have an illness that is identified as malignant melanoma, and when I was told that by my primary care physician, I said, "OK, fine." He asked what I meant by, "OK, fine." I said that I was going to do something about it. I happened to know the senior vice president of Sloan Kettering, and I called Dr. Tom Fahey and told him what the situation was. He set me up with the right doctors there, and I had the surgery on my back. But somewhere along the line some of the cancer cells ended up getting into the bloodstream, and now I have some tumors on the liver.

Too many people in our society are ready to call the funeral director when they hear the word *cancer.* I've counseled enough people before I had it myself, so I know that the whole question is do you choose to die or do you choose to live? I choose to live. I think it's positive attitude that gets you through by working with the healthcare that's available to you. And in this particular field they are discovering new things all the time. I had a very depressed person call me the other day. He said he hadn't gone out since he had been told that he had cancer. I said, "Do you want to die? We'll call the funeral director. But if you want to live, get out, get some fresh air, get back to work, and do everything." That's my attitude.

I went through the whole chemo thing. I turned into a zombie. When they saw the cancer hadn't spread anywhere—it's still in the liver—they wanted to shrink the tumors, and so we're doing some clinical trials, and right now I'm working with arsenic triox-

ide. It's never been done with a melanoma, and hopefully it's working. I have confidence in the doctor. Turn it over to the Lord and things will work out, is my game plan.

w.o.: What's a killer prayer, Father T? When you're alone at night, what do you say?

T.A.: I think prayer is simply opening up your heart to the Lord. A prayer that I find helps a lot of people get through a lot of stuff is basically a prayer that comes out of the twelve-step program, the Serenity Prayer: "God grant me the serenity to be able to accept the things I cannot change, to change the things I can, and the wisdom to know the difference." It gets a lot of people through the day, whether it's church stuff, parish stuff, or whatever it might be.

w.o.: Do you think God knows what you do for a living?

T.A.: I hope so . . .

1999

Interview with
Rabbi Amiel Wohl

Amiel Wohl is a leader in the Interfaith Movement. He is also widely known for his radio ministry, and he has done wonderful work in bringing Jews and Christians to mutual respect and understanding.

W. O'SHAUGHNESSY: Tonight, I'm going to present my rabbi. He is, in almost every telling, the most distinguished and influential rabbi in our home heath of Westchester: Rabbi Amiel Wohl.

A. WOHL: Thank you, Bill, for the wonderful welcome. To be on your show is a privilege and honor. I've watched it often, and I'm so pleased with the quality and the caliber of the guests.

W.O.: Your influence, dear Rabbi, is everywhere apparent. You have a true outreach ministry with those Temple Israel radio broadcasts. You are a leader in the interfaith movement among Christians and Jews. You succeeded the legendary Rabbi Jacob Shankman. The guys in the control room don't believe that I come by your synagogue once in a while

A.W.: You've attended services several times and spoken at our temple.

W.O.: How did you get involved with the Westchester Interfaith Service? Every Thanksgiving Day it's cold, gray, and drodsome, but I know I have to get to the service or you're going to be mad at me.

A.W.: I look for you up in the balcony somewhere or way off to the side, but you're always there. Most communities have a clergy association of some kind. Very few have the all-encompassing interreligious council we have. When I arrived in New Rochelle, the Council of Churches was phasing itself out, and we invited the Catholic parishes and Jewish synagogues to come into a new organization, the Interreligious Council, in which people can join together in meetings, assemblies, and worship services such as that beautiful Thanksgiving service.

w.o.: It just blows your mind to see a Baptist preacher, a rabbi, and a Christian Brother of Ireland together.

A.W.: It's a beautiful sight, and it's really the American promise. The biggest mistake would be for any of the faith groups or ethnic groups or racial groups to hold back and not to take the hands extended to them. Because America really means a new nationality, a new chance, a new opportunity for all peoples to be melded together.

w.o.: Another beloved and respected figure, Brother John Driscoll, president of Iona College, told me that everything is in chaos in this world. What of the Jewish faith?

A.W.: The Jewish faith has something going for it other faiths don't. It's been around a long time, but it's also a *people*. In other words, the Jewish faith is the Jewish people—it's an extension of their own identity and their own idealism—so even if Jewish people aren't attending regularly or aren't worshipping regularly, they still feel a sense of identity. So they belong to the synagogue, they support the temple, and they attend worship. In the Christian churches, a person who isn't worshiping or doesn't attend very often feels that they don't need to support or belong to a church.

w.o.: But when you get together in high council and have a lemon squeeze with your Roman Catholic and Protestant counterparts, do you find you have the same problems?

A.W.: We have the same problems in that we're trying to hold the young people and we're trying to fight secularism—which is such a withering thing that takes away the soul and the desire and sense of equity and sincerity and so much of life today. Communities where people are no longer faithful, where they don't attend church or synagogue, where they are not imbued with what the religions teach can become altogether materialistic and selfish. And the big problem of our time, I think, is narcissism: people who are so enchanted with themselves, their own needs and well-being, and their own desires and maybe, in some slight extension, they are into their own families, but certainly not political movements, religious causes, or other groups in society who need help and attention. Most of our problems in American life occur because everybody is waiting for government to come up with the solution, whether it's drugs or crime or violence. But the solution really depends on an alert, concerned, and interacting populace, because if everybody sits back and let's the so-called

"pros" do it, we can't save the day. It's really up to people to become engaged and involved.

w.o.: Explain for me, dear Rabbi, how it works in your religion. You are a liberal . . .

a.w.: I'm a Reform Jew. In Judaism there are several different streams, or movements. There are the Orthodox, who are really the traditional ones who just won't change anything, out of respect or deference to the past. They wear yarmulkes and are more identifiable. In the extreme version they would be the Chasidim, who are the most visible. And then you have the Reform, my own group: people who have said that inasmuch as America is an open country and inasmuch as we live in modern times, we have a responsibility to be involved with everybody else in society, and we have a right to evaluate a lot of the religious traditions in a modern light. And then you have Conservative, who are somewhere in the middle: modern in a certain sense, but with much more affection for tradition as such. And you have several other denominations within the Jewish group.

Our Reform group has been in the United States for about 150 years. It originated in Germany about 1820. In a sense, it was created by Napoleon, who, wherever he went, gave orders that the Jews were to be let out of their ghettos and emancipated and given full citizenship. Well, the minute they were given full citizenship, many of them wanted to really, fully participate, so they gave up a lot of their distinctive garb and their own courts of law. They had lived for centuries as communities with almost full autonomy within the larger culture. In the United States there was never any emancipation because the Jews came as equals and there was no unity of church and state. That's why Reform Judaism did so well in America and has become the largest group of Jewish people here.

w.o.: It seems as if somebody has always been freeing the Jewish people or persecuting or oppressing them. What's going on today? What of the nation of Israel?

a.w.: Well, the State of Israel has been a normalizing element for Jews because it has given Jews a *choice*. If they want to be a full Jewish national—if they don't want to be part of another nation—they can emigrate to Israel. That choice didn't exist before. Israel has become a place of refuge to which Jews can go

when they need a home. And many have left the former Soviet Union and Ethiopia to go to Israel. Previous to the creation of Israel, if the Jews were dispossessed or exiled or expelled from a country, as often happened during the Middle Ages, they had to find a country that would take them. So Israel has created a much more natural sense of Jewish identity for every Jew, even for American Jews.

w.o.: Do you agree with all of Israel's actions?

a.w.: I agree with most of Israel's actions, strategic and diplomatic. Israel is a very small state, geographically surrounded by enemies sworn to its destruction. Israel came into being after the terrible years of Nazism, giving Jews a chance to once again be reunited with their ancestral soil. I could always understand their extra sense of security, their need to protect themselves. And sometimes when Israel's policies seemed to be expansionary, I looked at the map again and saw that they were just trying to defend their borders. Other nations or peoples have not always understood. I think the present leadership is much more willing to risk and is more desirous of gaining the favor of the rest of the world. The amazing thing about the policies of the recent Israeli government is that the minute these modern policies were put into effect, dozens of nations reestablished relations with Israel. Trade boomed, and Israel is in one of the most dynamic periods of growth it has ever had.

w.o.: There are still some right-wing fringes over there.

a.w.: It's more than fringes. I would say that probably 40 percent of the country doesn't like what is happening and is very worried about Israel's losing control of these areas.

w.o.: You open your temple to all sorts of disreputable types and derelicts like Bill O'Shaughnessy. Would you let Arafat speak?

a.w.: I wouldn't be ready to let Arafat speak. Not yet. Although I see that Israel has to negotiate with him because he seems to be the most authentic representative of the Palestinians, I still see that he himself is an archterrorist. He is directly linked to all kinds of murders.

w.o.: But they're shaking hands.

a.w.: I see that, but then, I'm dealing in something else. Perhaps other Palestinian individuals or leaders . . .

w.o.: Why can't you forgive Arafat?

a.w.: I could forgive Arafat, but let's take a little longer. Let's hope

that they will control some of their people, because Israel is still suffering from continuing terrorist attacks. Arafat doesn't or can't control all the Palestinian factions.

w.o.: For thousands of years the Middle East has been in turmoil. Is it ever going to be peaceful?

a.w.: I think it is going to be peaceful, if they can get the momentum to build a real unification of purpose among the states economically. It's an era when you have the European trade group, the Far Eastern group, the North American group, so there must be a Middle Eastern cooperative. And Israel has the brains and it's got some of the capital to help develop these countries that need exactly the kind of ability and talent Israel has. I think many of the businessmen in Jordan, Egypt, and Saudi Arabia realize it, and they want peace.

w.o.: I have no easy questions for you. I have to go to the problem the Jewish people have with blacks, and blacks with Jews. Would you let Al Sharpton preach in your synagogue?

a.w.: I would let Sharpton come in, sure. I think a lot of what Sharpton does is for effect and political impact.

w.o.: How about Louis Farrakhan?

a.w.: I wouldn't let Farrakhan come in because I think Farrakhan is an out-and-out enemy of the Jewish people and is really an anti-Semite. Sharpton may, once in a while, seem to be negative to Jews, but I think in a sense he does really embody a certain sentiment that exists in his people.

w.o.: Are you really afraid of Farrakhan?

a.w.: I'm not afraid of Farrakhan, but I think that he could, unfortunately, lead many people astray because he is such a captivating speaker, and when he speaks, he draws thousands of people. One of the problems with talking to a person like that is that they aren't really eager to engage in a debate. They are just eager to state their position.

I don't think I perceive a problem concerning Jews and blacks. I see that African Americans have the characteristics of every other group in the United States. I don't see them as having any more hostility toward Jews than they have toward whites. Sometimes their hostility to whites is perceived as Jewish because maybe the whites they are talking about are Jews. I don't think that the majority of blacks have this kind of antagonism, but I think they have picked up some antagonism from the general culture. There

is always a little bit of anti-Jewish attitude in the air. But their own demagogues, such as a Farrakhan, and this black Separatist Movement don't help. I think most Jews have deep sympathy for the historic position of blacks in America and their need for further assistance and an equal playing field. Of course, as in any group, there are Jews who are bigoted against blacks or against others, just as there are those in other cultures who are bigoted against Jews. There are some who are against Jews and blacks. And there are some people who think—and I don't see it this way—that a lot of this animosity is being presented by certain other people as a distraction to let Jews and blacks appear to be in conflict so that these other people can do what they want.

I admire Brother Driscoll of Iona tremendously as a sincere, wonderful individual, and Governor Mario Cuomo is a tremendous person, but I think that the American people are just being a little bit misdirected by some of our other public speakers. I'm glad people are watching this program, but I think they are being affected by too much television, too much lack of participation in more valid experiences.

I have the privilege of trying to influence people who come into my temple. Any of us in public life have this opportunity to affect people in the community, and we can feel every day that we did some good.

w.o.: I see you up there presiding at Temple Israel, and it looks as if you have all the answers. Do you ever get confused?

A.W.: I don't have all the answers. I have to do a lot of thinking. I pray a lot. I ask God for help. I find that that Divine reliance, reliance on God, can do wonders. When I don't know the answer, I just ask God.

w.o.: What's the best prayer?

A.W.: I think that there is no one best prayer. I just appeal directly to God. I *rely* on God. I ask God to lift me up, to enter into my life. I put it on a very personal basis, and I use some of our traditional Jewish prayers from our liturgy. And then it's just as if God is my friend or my Father. I've always felt that there is a relationship, personally, between God and myself.

w.o.: Does God talk back to you?

A.W.: God doesn't talk in words. But I feel a sense of God's presence.

<div align="right">August, 1994</div>

Interview with
Monsignor Ed Connors

Monsignor Ed Connors was vicar of Westchester and superintendent of Roman Catholic schools in the New York Archdiocese for many years. He is a preacher of rare and uncommon ability.

W. O'SHAUGHNESSY: Tonight, a man well known to all of us in Westchester. He is a consultor to the cardinal archbishop of New York. He was superintendent of schools for the archdiocese, and he's held every top job including running the seminary at Dunwoodie in Yonkers. He is now best known as the influential pastor of Immaculate Heart of Mary Church in Scarsdale: Monsignor Edward Connors.

Among those who present themselves in his church every Sunday morning are some of the most influential residents of Westchester: David Hartmann; Lou Boccardi, CEO of the Associated Press; Tony Colavita; the Rooneys of Yonkers Raceway. You get a lot of influential types, and you also get some lowlifes like me over there. We're glad to have you with us, Monsignor.

E. CONNORS: We're glad to have you with us on Sunday too, Bill. All of those people come as simple people of faith. They don't come parading titles or bringing anything with them but their desire for the Lord and for friendship and unity with other people. We're happy to have them and all the people of various jobs that make the county and the world run.

W.O.: You don't suffer fools or compliments well, but I'm going to try my best. You don't refer to yourself as "Monsignor." Rather, you prefer to say, "This is Father Connors." You don't preach from the pulpit, you go out in the aisles and talk to people; and yet you've held all the high estates that the archdiocese can bestow. What do *you* see yourself as?

E.C.: I see myself as a parish priest who is there to help people, to be

there with them, to respond to their needs, whether it's a young parent who is struggling to bring up a child or an older person who is getting ready to meet their Maker. It's a person-to-person deal, and I just like dealing with people.

W.O.: You're a priest according to the Ancient Order of Melchizedek.

E.C.: Melchizedek, from the Old Testament, was one who didn't have a beginning or an end. He was without ancestors, and he comes across the stage of the Old Testament as the symbol of the Eternal, that business of mediating between God and humankind.

W.O.: But that gives you a lot of power. You can forgive sins. Is there any greater power?

E.C.: In Roman Catholic teaching, the sacrament of reconciliation, or penance, provides God's forgiveness to a person who is properly disposed, through the mediation of the priest and through assurance from the Church, that God loves that person and God wants only the best for that person. Many a soul at a crisis point of life has been given God's grace and aided through that sacrament and the ministry of the priest.

W.O.: Do you see people coming back to the Church?

E.C.: We do see them coming back—not in droves, but steadily. One of the things that any church has to do is to serve people—and especially the marginalized people, people on the fringes of society, people who are poor, who have personal problems or trouble with their children, people who are finding it difficult to cope in times of unemployment. It's not just about serving the rich and powerful. They can usually take care of themselves, and they know it—and they're willing to help others. We have to try to bring people together to help one another on this pilgrimage of life.

W.O.: Has the Roman Catholic Church done a good job in reaching out to the unpopular, to the despised?

E.C.: I think so. In our own area, for example, there has been no greater outreach to AIDS patients than that by the Catholic Church, despite the vilification suffered by a man like John Cardinal O'Connor.

W.O.: Does the cardinal archbishop really go down and do those bed-pans, or is that a press story?

E.C.: Naturally, he can't do it all the time, but he does it. And he does it to keep in touch with the poor and the marginalized. He has so

many who are hurting in so many different directions that naturally he can't be there every single day, but he does it with enough frequency and enough sacrifice for it to hurt. Of course, he has the advantage of only needing four hours of sleep a night.

w.o.: Tell us about the cardinal archbishop. You were a friend of his predecessor, Terence Cardinal Cooke. Different types?

E.C.: They were different men for different times in history. Cardinal Cooke came to office at a time when all institutions were being questioned, universities and government and the Church too. He was a man who could stand at the middle and unite people. He was not confrontational. He was more collegial. A lot of healing took place, and now a new man comes who sees another need: it's to call it the way it is and to tell the world what authentic Catholic Christian teaching is in this age so there will be no mistaking it. He has a tremendous ability to do that. Cardinal O'Connor is a most articulate man, and he calls it as he sees it. He's quicker and more impulsive than Cardinal Cooke, who was more laid back.

w.o.: You're a consultor. Do you ever presume to slow him down on something? Do you ever disagree with him?

E.C.: Oh, yes, but you do it before the decision is made, and once the decision is made, it's right, you know? He's very open to consultation, but he's a strong man and he has a brilliant mind and takes everything into consideration. He has a lot of advisors—that's the other part—that feed his decisions. As a matter of fact, people talk up to him more than they ever talked up to Cardinal Cooke. One man said to me, "Cardinal Cooke was like God. You would never question something he would say." But with this man, there's something about him that makes you want to tell him exactly how you think.

w.o.: You mean they talk up without fear of getting assigned to a parish in Poughkeepsie?

E.C.: Absolutely, that's the way it is now. This is no business for shrinking violets, so they talk up. And I mean priests and religious and laypeople at public meetings. Once in a while the cardinal gets on his hind legs as a result of it, but most times he's able to take it and build it into his decision-making process.

w.o.: So you're saying he's human.

E.C.: He's human.

W.O.: The coat of arms of Cardinal Archbishop O'Connor has a line on it—his "slogan," if you will—"There can be no Love without Justice!" What does that mean, and what does justice mean for the Church?

E.C.: Justice means giving a person what belongs to him or her. If a person is working for the Church, he or she should be given a living wage. It isn't enough to do considerably less than that and then have a Christmas party or give a little trinket around Easter time. People should be rewarded for their labor. The cardinal is taking the position that, as a basis for charity and love, the first obligation is to give people what their humanity calls out for: respect, recognition, justice, and then on top of that to show love for one another.

W.O.: So as the cardinal means justice, it's not like the criminal justice system or the vengeful giving someone his or her due. That word seems a little jarring next to *love*. It's been suggested that of all things, love is the most important. Is it?

E.C.: Yes, it is. But *justice* is the first step. It's the foundation on which love is built, a recognition of a person's human rights and human dignity. When a person is exploited in any way—young, old, male, female—and is not given justice, you can't say that love is present. When they're given what belongs to them, that still doesn't mean that you absolutely are going out of your way to love them, it just means that you are giving them what their humanity calls for.

W.O.: I hear they're trying to make Cardinal Cooke a saint now. Do you ever pray to Cardinal Cooke?

E.C.: I don't, but many do. My own feeling is that if God wants Cardinal Cooke recognized as a saint, there'll be some strong signs .

W.O.: You ran the seminary on the hill, St. Joseph's at Dunwoodie. There aren't many young men aspiring to the priesthood or women aspiring to be nuns. It's a big problem, isn't it?

E.C.: It is, but this has always been cyclical. Perhaps the Holy Spirit is trying to say to us that we don't need quite this many priests and that the laity can now come into the picture? We're getting men who are a little older than they had been in the past. They might be in their mid-thirties or their early forties, looking at a second career. There hasn't been enough in life for them in their primary career, whether they were lawyers or engineers. The average age

of ordination used to be about twenty-six; now it's thirty-one or thirty-two.

w.o.: You've been asked this question a thousand times. This will be 1,001. If you dispensed with that vow of celibacy, would you get a lot more?

e.c.: Probably. We're not a completely celibate clergy. For example, in recent years we have taken in a number of former Lutheran pastors and Episcopal priests and their families. They have been ordained and are functioning in the Roman Catholic Church, in Europe and in this country. We also have all the Eastern Rites that are in union with the Roman Catholic Church through the Holy Father. They have a married clergy.

w.o.: Well, advisor to cardinals, if the pope called you up and said, "Monsignor Connors, should I let them get married?" what would you tell him?

e.c.: He wouldn't call me.

w.o.: But you send little notes to editors and people from time to time. You have enormous influence, in a subtle way, here in New York State. What's your opinion? Should they do it or not?

e.c.: I think they should study it out a little bit more. We have a universal church. We have a very traditional church.

w.o.: What is God trying to tell the whole world? How do you know that it's God speaking to you?

e.c.: It's always a problem. When we say God is *trying*, of course, we're being anthropomorphic. We're talking in human terms rather than in terms of God's kingdom and God's reality. Because if God wants to make us listen, he can make us listen; but that's not the way God has created us, so he doesn't do it that way. Through the Scriptures, through the lives of other people, through the intelligence that he has given us, we have a tremendous amount of material with which to work. In addition, we believe that he does send his grace in a mysterious way, that his Holy Spirit, which means God himself, is present to us and speaks to us, if we will just take a little time to pray and to listen and to reflect.

w.o.: God sometimes speaks in whispers. Didn't you say that once?

e.c.: Yes. And the sincere desire to find his will may very well be rewarded by a clear notion of what it is. And in every case it will probably result in a person's being more humane, more helpful

to others on this journey through life, with more regard and respect for other people as brothers and sisters of a common Father, a common Creator.

w.o.: You mentioned prayers. Are you talking about Hail Marys and Our Fathers?

E.C.: I'm talking more about just silence and reflection on the Scriptures, seeing in what way God is speaking to us today in the events of our lives and in the words of revelation through the great prophets of the Old Testament and through his Son, Jesus, in the New Testament.

w.o.: Do you still read the Bible?

E.C.: Every day.

w.o.: Don't you know it by heart by now?

E.C.: No, you never know it by heart. It means something a little different every day that you read it.

w.o.: You don't think it's outdated?

E.C.: Never outdated. It's the Living Word, and it's as effective and powerful as a two-edged sword. It's for today, and if we could recognize it as such, it would be a much better world.

w.o.: This is the Easter Season. Why is that so important? I remember from grammar school they said, "If Christ be not risen, then is not all our preaching in vain?" Did that prove Jesus wasn't a con man?

E.C.: I think what you have here is proof in the sense of there being nothing to disrupt our faith in the awesome event. Our faith is simply that God has spoken through this man Jesus whom he sent, who shares the divinity and has shown all of us that all forms of death in human existence don't have the last word. Life has the last word. That's why Easter is important. There is no such thing as Easter without Good Friday. There is no such thing as resurrection without suffering and death. And that's the road we travel. Even nature itself repeats that cycle of death and resurrection with the seasons of the year. We're now seeing the season of resurrection.

w.o.: It seems the slogan of the Church is that you have to die before you can be born again, but then others would say that God didn't intend for you to be unhappy.

E.C.: That's correct. We believe that there was an original rebellion of humankind against God and that we are possessors of a human

nature that is tainted. How can human beings who were created to be happy and meant to be happy perpetrate such things as the wars of our time, the holocausts of our time, the genocides of our time. Did God allow all that? God leaves us free to follow him or not to follow him. He has not created us as he created plants and animal life. He has created us as free human beings and called us to follow him in that way. We have within us, all of us, possibilities for great good and possibilities for great evil. Through self-discipline, through dying to self, we can rise above the evil impulses of our nature and overcome them and live in the manner in which God, through the Bible, has indicated we should live.

w.o.: Allow me please to ask you about a contemporary issue that has so divided our republic. I've heard you talk about abortion. I've never seen you locked up in front of an abortion mill over in Dobbs Ferry. You are protesting in a different way . . .

e.c.: Yes, through education and whatever political action people want to do as a result of the education. We don't as a church indulge directly in political action. I believe firmly that you have developing human life from the moment of conception, and anything else, I believe, is unscientific. You have those who would justify taking that human life in its early stages on philosophical arguments. They say it's a fetus instead of a child. But I would call it a violent solution to a human problem, the human problem being an unwanted pregnancy. And the life of that child is not unwanted. There are thousands upon thousands of wonderful people who would be delighted to adopt and give a life to that child. We have five local pregnancy care centers and many other groups. Cardinal O'Connor has put the guarantee of the Church behind providing the means for any young woman who is impoverished and would be seeking an abortion, and the Church will provide all the funds necessary for the woman to have that child.

w.o.: Is it possible to be pro-choice *and* pro-life? To respect the right of a woman, to believe that the state can't legislate where it has no power, that is, in a woman's body? Is it possible to be both?

e.c.: I don't think it's possible to be both. Life is from the womb to the tomb. If it is a human life, then society should do everything possible to protect that life. I would also be against capital punish-

ment. And the bishops of our state and country are against capital punishment. It doesn't work, and it doesn't give the protection to human life that it is alleged to give.

w.o.: You disagree with Bishop Austin Vaughn and the anti-abortion protesters . . . ?

e.c.: I don't disagree with them. I think that they've enlivened the issue. I just choose other ways to go on this matter.

w.o.: One day I came in and heard you recite something by Joyce Kilmer. Do you remember that? You said he wasn't the greatest poet but . . .

e.c.: Joyce Kilmer was a young man of great faith, and he was killed in World War I in Flanders Field. He once wrote a little poem, which is apropos of the Easter season, about the house with nobody in it, about suffering. It concludes:

They say that life is a highway and its milestones are the years.
Once in a while there is a tollgate where you buy your way with tears.
It's a rough road and a steep road and it stretches broad and far
but at last it leads to a golden town where golden houses are.

It's the story of death and resurrection.

<div align="right">April, 1992</div>

Interview with Brother John Driscoll

Christian Brother John Driscoll, former president of Iona College, is a renowned educator and one of the most cerebral individuals I've ever encountered. His take on contemporary moral issues challenges all of us to go beyond our comfort levels and be better people.

W. O'SHAUGHNESSY: When I go into that great, good night, I won't go gently to what Malcolm Wilson called "another and, we are sure, a better world." The individual I would like to have explain our mortality is the most respected man in Westchester County and one of the great educators of America: Brother John Driscoll.

J. DRISCOLL: Bill, does that introduction mean we are going to go together, or are we going to go separately and meet?

W.O.: I have to go first, and you have to be still standing. So you can do my eulogy!

J.D.: I see. It's one of the most attractive offers I've had this evening.

W.O.: We both have been doing a lot of eulogies lately. What does that mean?

J.D.: George Burns, on the occasion of his ninety-something birthday, was asked about the advantage of being that old, and he said, "There's no more peer pressure!" Perhaps some of our friends have taken an early departure, but I'm going to stay for a while.

W.O.: You are in your twenty-second year as president of Iona College. It used to be a little country commuter college. You've got a $70 million entity going now, and how many students?

J.D.: There were about 7,600 in September.

W.O.: You started life as a teacher. First of all, what are you?

J.D.: I'm a member of a teaching group within the Roman Catholic Church called the Congregation of Christian Brothers. I joined in 1948. I'll be sixty on my next birthday. I started as a child president, and I've grown into the job!

w.o.: You bang words around as well as any Irishman I ever knew, but you started as a *math* guy.

J.D.: I have degrees in mathematics and in physics. And then I was able to do some subsidiary work in psychology and administration/business management—tools you pick up along the way to get the job done. I thought of myself very early on as a brother who would be teaching English. I like writing. I like reading. I love the power of the word, whether it's a written or spoken word. Several words strung together can create a reality that did not exist before those words existed. It's almost like what God did, using the language to create the universe. I think I'm going to find my way back to the spoken and written word, but for an agenda that is larger than the university, but not any smaller than what a university should be involved with. The university is where the world does its thinking.

w.o.: Someone was saying the other day they saw you strolling around the campus, talking with the kids. Do you miss hands-on stuff?

J.D.: At the beginning I used to miss the classroom environment because by nature I am a teacher. But I quickly learned you can convert any business meeting into a successful classroom event by preparing for it and by always making sure there is some outcome that you expect during that half-hour or forty-five minutes. So actually, the pedagogical techniques that get you through successful classroom work apply equally to business environments. How you keep people engaged, get your point across, review the material, and test out at the end of a session whether or not the audience really captured the thought you were trying to put before them are all important.

w.o.: I have the same problem with you that I have with Mario Cuomo. Is it possible that being a college president for you, as indeed, being governor for him, limits you two guys?

J.D.: There certainly is limitation. I think part of the limitation is the experience of working with people who know you so well they presume too much. They think they know what your attitude is, where your mind is. It's an unfortunate experience because even though I have been working with some of these men and women now for two decades, I keep having new experiences. I meet new people on the weekend. It forces me to refine my position. So on

Monday I am incrementally different from who I was on Friday. If people presume that they know me on Monday, they're making an error. In some ways, that does limit you. The familiarity certainly breeds presumption.

w.o.: What do you do on weekends that is so different?

j.d.: Who knows who you're going to meet while playing golf, having a conversation, meeting somebody at a dinner. It's adding a new flavor into the stew that is called me.

w.o.: I must tell you it is easier to get an appointment with governors and captains of industry than to get a spot on your busy schedule. You fly all over the country raising money for that college of yours.

j.d.: Actually, the next project is to take our library and to add on about 50 percent additional space. It will take about $9 million. If somebody out there in the audience is listening . . .

w.o.: They just built a spectacular new building called Driscoll Hall.

j.d.: Named after my *dad*. As he insists. He's eighty-seven years old.

w.o.: I'm not going to let you get away with that. That's named for you.

j.d.: Yes.

w.o.: One of your fellow brothers—you call yourselves monks—said, "Brother Driscoll is here to raise money."

j.d.: I'm sorry that people have equated university presidency with going around panhandling and shaking a tambourine. What a terrible reflection that even some of my friends and peers have reduced me to be a beggar, even a very good beggar. I do that because the university needs resources that it can't get any other way. You learn how to do it. You have to step out of your own limitations and go beyond your own feelings. But anybody who says that Jack Driscoll is in charge of fund-raising or that's what he's going to do next really has only the most trivial and superficial knowledge either of me or what being a president means.

w.o.: Somebody told me the other day that Brother Driscoll is bigger than the office of the president.

j.d.: Does that mean I have to lose ten pounds, O'Shaughnessy? I think we all outgrow the day-to-day parts of the portfolio because you see beyond the agenda in front of you. Your main job is not to do what comes in the mail and on the fax and e-mail and the phone. Your main job is to remind people of what the *vision* is.

Anything that stops you from reminding them about vision is, I think, a very serious limitation and a dangerous one. If the CEO doesn't hold up that vision statement, then the people are very insecure.

w.o.: Lynne Ames of *The New York Times* did a story about this program, and she said the last time you were my guest you looked right into the camera when I asked if you were *sure* about all this religion stuff and said, "I'm sure." Are you still sure?

j.d.: Yes, wholesomely, willingly, fully, and enthusiastically.

w.o.: But you also asked me, "Tell me one entity—one nation, one college, one radio station—that isn't in a state of chaos." Do you still believe that?

j.d.: It's not a particularly bright statement to say that the world is in real stress. It may not be in more stress than in the past, but in any case, we know about it now because the channels of communication are so immediate. There isn't much you can do about distress in the large. There is a lot you can do about distress that is personal, in which you have some immediate role. Stress is necessary. We wouldn't do anything if there weren't a certain amount of stress. It's when it becomes distress that it requires some act. Hopefully, you can take care of it on your own. If not, there are professionals all around—thanks be to God—that can help you find a new way to get the *dis* out of the stress.

But as I look at people, I see them, in many cases, overwhelmed by the speed at which the machine is going. They put governors on engines to prevent them from outpacing themselves and flying apart. We should put a governor on ourselves! In the Jewish and Christian tradition, the governor is called a Sabbath. It exists so that one day a week we rest and recollect ourselves.

w.o.: What about the time you said, "I think God threw it all up in the air and said, 'Now I'm going to let you jackasses put it back together' "? You sound like the Jesuit, Teilhard de Chardin, and that infernal Mario Cuomo!

j.d.: I sometimes feel that is not a bad image for what's going on with the rate of change we are experiencing. Several summers ago, one of the Midwestern universities sponsored a think tank, and the challenge was to put on a large sheet of paper all the significant events from Adam and Eve on that had an irreversible effect on human history. Now the question was, which year, approxi-

mately, divides all of that activity into two equal halves? And the answer was 1954. Which means that you and I who are almost forty years old have been called on to absorb as much change as all of those generations and centuries that have preceded us. We have experienced so much change, so much trauma, so much alienation that I think it's a miracle of God's grace that we have remained civil toward each other. And I now understand how some people fall out of civility. They are just not able to handle any more chaos, any more change, any more demands. There were epochs in the past when people experienced maybe one change during a lifetime. I think sometimes that it is getting so complicated that we're going to be called to start over.

w.o.: Are you calling for the end of the damn world, Brother?

j.d.: No, I'm calling for transformations in the small, that in the aggregate will bring peace and justice. Let me give you an example. I have gotten very involved in the dialogue between Catholics and Jews. And I see this as being a very particular responsibility of mine. For this reason: I cannot see the rest of the world finding its way to harmony, peace, justice, and unity unless Catholics and Jews do it first. I think we come out of the same traditions. We have the same basic code of ethics.

w.o.: Right here in this country, or over in the Middle East?

j.d.: Just right in my neighborhood. I've gone to the Middle East several times just to continue to fire up my own passion to stay involved. Because you can get discouraged pretty easily.

w.o.: What about the ancient tribal hatreds in the Middle East?

j.d.: Tremendous problems. You have to take them on in some local environment first and practice the problem-solving and the art of mutual respect, then move the circle a little wider.

w.o.: You've given your life to that notion of service.

j.d.: There's a vision involved in it, yes.

w.o.: Does that vision ever get blurry?

j.d.: It gets so blurry that you cry over it. And it gets blurry if you reach out and you don't find ready hands to grab on to. You have to sit down and figure out where you are going to get the courage and the good humor and the companionship to go ahead with this.

w.o.: I spied on you one morning in the chapel at Iona many years ago. Your fellow Christian Brothers were tuned into a Higher

Power. And you just sat there struggling and churning. Are you still churning?

J.D.: I think we all churn. Certainly, my agenda is larger than my energy. And I think part of the churning is every day deciding which part of the agenda you are going to address. That hour of the morning before the work starts is my time to organize my energy and determination and renew my faith that this is God's work and I've been asked to share in it. When I get out of that chapel in the morning, I'm ready for a cup of coffee and the first phone call.

W.O.: Do you say formal prayers?

J.D.: There are formal prayers we, as a Christian Brothers community on the Iona campus, all thirty-five of us, gather in the morning to pray. We gather in the evening also, seven days a week.

W.O.: You have a lot of power. A $70 million budget, seven thousand-plus students, and a couple of thousand employees. When you go back into that house with the other Christian Brothers, are you just one of the monks?

J.D.: I'm just a pretty face. When I go home, I have no responsibility that the others don't have.

W.O.: You have the collar. Thus I am permitted to ask you what God means with all of this pestilence and plague and Rwanda and hunger and hopelessness in the land?

J.D.: Isn't that an extraordinary question? And it is asked so often. Why do bad things happen to good people? Why do such terrible things happen to people who are oppressed and have no way of defending themselves. I don't know that I'm any brighter than Ossie Davis or Mario Cuomo or any of the other people you have on this platform with you. But this I know—God is not vengeful. We're not being punished because God is upset with us. But our faith tradition does say that if we walk away from the Covenant that has been offered us—and which Jewish and Christian people have accepted differently but, in some way, jointly—God has not left the scene, we have. At this time of year our Jewish friends have been reminding themselves about the need for repentance, for return to the conditions of the Covenant. Christians do the same thing at a different time of the year, at Lent. Walking away from the Covenant is a very risky thing to do.

W.O.: What do you mean by the Covenant?

J.D.: The agreement that was extended by Yaweh on Sinai to people who believe in one God: Muslims, Jews, Christians. We've had a lot of rabbis, saints, prophets, and teachers who have marked out the ethical way to behave. To love your neighbor, love yourself, so that you can love your neighbor as you love yourself; and to love God. If we walk away and engage in selfish behavior, there is a cost. And the cost is a local disturbance, even if it's in my own heart. But it can be a holocaust cost too.

W.O.: You're making me uneasy. I'm a poor, stumbling, staggering, faltering, weak Catholic.

J.D.: Welcome to the human race. We're all weak, and no one has it made. We're all in this joint human effort to watch out for one another the way we watch out for ourselves. There has to be a certain amount of self-love. If we love ourselves properly and take care of our needs properly, then we're better prepared to deal with the injustices that surround us and to take some active part—to the extent that we're graced to do it—in bringing peace and harmony into areas of injustice.

W.O.: Some day you're going to have to step down and relinquish your high office.

J.D.: I'm a teacher by training. I'm not part of the church's hierarchy. I'll never be Monsignor Driscoll or Bishop Driscoll or Pope Driscoll. I'm going to be Jack Driscoll, and I don't know where my next classroom after Iona is going to be, but my instincts are those of a teacher.

Winter is the time when the world rests and prepares for the next cycle of life and love. If we didn't have winter, we wouldn't know spring had come. I think it would be wholesome for me to step down as college president and pick up another set of tools, and it would also be wholesome for the college. I was saying to my dad the other day that anything that stands in the sun casts a shadow someplace, and no matter how much sunshine hits the terrain, something is in the shadow. One day somebody else is going to come in as president of Iona and will see the things in the shadows that I never noticed. I think it will give the school a new burst of life.

I'm not going to get a job that has only a secular dimension to it, although it might have a secular setting. It's got to have some kind of apostolic dimension to satisfy the religious vocation I

have. All the years I have spent being groomed by experiences, by people, by conversations—I want to reinvest this kind of education into another form of apostolic ministry.

w.o.: John Gardner said, "You've got to change your career every four years."

j.d.: It's always a question about when to move and why to move. Four years in a CEO job—certainly in education—you barely know what the issues are, and it's not enough to manage the environment you're presiding over. You're not really a president until you're out in front trying to help shape public policy and government decision-making about the work of education. Being a president who stays home and runs the local agenda is only being an administrator. It's not being an educational leader. So you have to stay a lot more than four years before you can get face recognition in front of the people who form public opinion. In the beginning, you have to establish the way in which you're going to be chief administrator of the campus, and you're pretty much pinned to that desk until you're relieved of the day-to-day management. It's at that point you begin becoming a person of influence in the public domain rather than just a person who presides over a local campus. Longevity gives you the opportunity to step away from the local domain and involve yourself in a larger agenda.

w.o.: Have you asked God what you ought to do?

j.d.: I did that this morning in preparing for this interview.

w.o.: God said, "Don't show up: O'Shaughnessy is crazy!" What does God tell you?

j.d.: It's an ongoing conversation. God no longer speaks in thunder. It's now in whispers. She's a little quiet these days. But I'm paying attention. I'm not in a rush. I love what I'm doing. Being president of Iona College is a great job. It is never the same on the second day as it was on the first day. I love going to work. Thanks be to God, I'm very healthy. But I do feel—for Iona and for me—that both of us are going to go through a growth spurt brought on by change.

w.o.: Iona is always trying to expand. Some of the neighbors don't like it.

j.d.: The college is a citizen. We have to negotiate with the other citizens who are our neighbors. We have to make our needs known

to them, and they have to tell us what they think about our position. We have to find out how we can be in a mutual relationship. It doesn't go easy. But it does go on.

w.o.: You don't suffer fools or compliments well, but I'm going to presume to tell you that if Iona weren't around, that whole central part of the seventh largest city in our state would go down the tubes. And yet you always have to fight for everything.

J.D.: Both those things are true. Iona College does stabilize a very large part of the city of New Rochelle. And it's always tough going. It's particularly tough if there isn't a whole lot of other excitement in the city. If you are one of the few forward moving parts of the environment, everyone is watching that one place. Once the city begins to experience more growth, development, and life, it's going to spread out its attention to the other parts of the city. That does not remove the responsibility from Iona of being a good neighbor to our good neighbors.

There's a great part in the book of Ezekiel the prophet when the Spirit of the Lord led Ezekiel into a valley filled with dry bones. And the Spirit said to Ezekiel, "Call sinews and muscles and flesh to surround these dry bones and watch the Spirit breathed into them again and watch them come back to life." New Rochelle is now getting new sinews, new muscles, new flesh, new spirit, new life. Iona College is a real part of that.

w.o.: What about Westchester?

J.D.: I think what people have to understand is that there will always be cycles of death and renewal. It's in the seasons. The leaves come on the trees in the spring, they blossom in the summer, they fall in the autumn, and they go into some kind of death in the winter. Then they come back again. I think these natural cycles affect our bodies, our institutional life, and our communities. I don't think it's fair to take the temperature once and give a prognosis that is too self-assured. I think what we have to do is keep looking at where the new green growth is, and it's all around us in Westchester. You have to reaffirm your belief, and strength and rebirth come out of that reaffirmation.

w.o.: How do you find time for Jack Driscoll?

J.D.: That's the toughest part, given my dispositions and my compulsions. My basic compulsion is to run to a need and try and service it. The shadow side to that compulsion is that I frequently forget

myself and my needs. My best friends are the ones that say to me, "Hey, Jack, you're not looking good. You seem to be a little bit out of control. Have you checked in with *yourself* recently?"

W.O.: People dare say that to you on the campus?

J.D.: There are a lot of people who love me. And a lot of people who love me enough to challenge me.

W.O.: Was it Saint Paul who said, "What does it matter if *he's* alright and *she's* alright, if *I* am not alright?"

J.D.: That sounds more like O'Shaughnessy than Saint Paul! But whoever said it, said it well.

W.O.: Are you optimistic about the future of the college you've built?

J.D.: I am very optimistic. I have been Iona's president long enough to understand the cycles of students as they come through. They are being buffeted by the same public pressure any human being is buffeted by, but they process the buffeting in a way I recognize. Right now I like the adults I meet at Iona. I like the way they are addressing their own future. They are not too self-assured, but they are certainly not diffident, and they are beginning to realize that their colleagues and competitors come from an international community. It isn't just the international community of Westchester. It's the fact they are going to be working with and against professionals in Tokyo and London, and the key will be who can process the information most accurately, most quickly.

W.O.: What's the best field to go into right now?

J.D.: It depends on what gifts God has given you. I would love to be a poet. I would love to be a playwright, but early on in life I was moved into mathematics and physics, so I use those tools for problem-solving. A poet and a playwright would use absolutely different tools and still get the job done in a wholesome way. I would say the best field comes out of your self-knowledge. A good counsel early on in life can help the student find where his or her talents really lie and then develop those.

W.O.: One day we were talking about the temptations of this life? You had a great line about things that are so temporary having such allure?

J.D.: Now you've gotten Saint Paul, Bill! The line is, "If what is so temporary has any glory, what must there be in that which will last forever?" That certainly speaks to a Christian mind. For me, the idea is that this world is filled with beauty, with joy, with the

opportunity for satisfaction and accomplishment. There's a pale suggestion of the kind of afterlife I have grown to have faith in. That vision doesn't appeal to everybody equally, but for me, it is a powerful motivator.

w.o.: Again I ask you, are you still sure about all of this?

j.d.: I'm *sure* of it. I think of it every morning. I'm certainly as sure of that as I am about any other part of my life. I'm sure that what I'm doing is important. I'm sure what I'm doing is effective. I'm sure what I'm doing is really what I was called to do. I'm very happy in this work, very fulfilled in it, very healthy in it. I believe the end of it is going to involve a life without limits, without time, without space, without constraints. Heaven, in the Christian tradition.

A life of *forever*. It's a very, very powerful word I spend time with very often. What does that word *forever* mean *now?* And what do you *believe now?* I believe that nothing of beauty is going to be lost. I think it's all going to be resurrected, and I'm going to be part of it.

w.o.: What was that marvelous line you once left us with on the radio? "Eye has not seen . . . "?

j.d.: That's the promise as it is recorded in the Christian scriptures, that we really aren't able to make even the faintest judgments of the power of the promise or fulfillment that is ahead of us. "Eye hasn't seen, ear hasn't heard, nor has it entered into the mind of a person to *conceive* of the rewards God has prepared for those who love him" . . . or love her.

w.o.: A lot of people love you, Brother.

j.d.: Thank you. I think I know that . . .

<div align="right">Fall, 1994</div>

Interview with
Dr. Richard Fraser

A clear-eyed, jut-jawed, handsome neurosurgeon, Dr. Richard Fraser has the most valuable pair of hands in the world. He also has some highly unorthodox views on the medical profession.

W. O'SHAUGHNESSY: The old Jesuits used to say you don't really mature until you deal with mortality. The man we are about to meet knows a lot about that. He is a a neurosurgeon, perhaps the finest in the nation: Dr. Richard Fraser of Rye, New York.

R. FRASER: I thank you for that excessively generous introduction.

W.O.: You don't like it when I call you the best? I'll tell you why I do that. They asked Louis Armstrong once who the best girl singer was, and he thought for a minute and said, "You mean, besides *Ella?*" I heard some doctors talking and they said, "Who is the best brain surgeon in the country?" And one of your colleagues said, "You mean besides Richard Fraser?" So you're fingered as the best there is.

R.F.: I appreciate being elevated to such a level.

W.O.: Let me see those hands. How much are those hands worth?

R.F.: My mother thinks a lot. They are not insured. It's an odd question that you asked. As I tell my patients and residents, you don't operate with your hands, you operate with your brain. It's judgment, not manual dexterity. You can teach almost anybody to do an operation, even a technically difficult one. What you can't always teach is when you should operate and perhaps even more important when you shouldn't operate. There are times when you should say, "Hey, you have something I can only make worse, or which I cannot make better; therefore surgery shouldn't be used here." If surgeons were not paid for what they do, the number of operations in this country in all surgical specialties would plummet.

w.o.: It's a mark of great trust to let someone go inside your head with a scalpel. Do you ever think about the power you have when you're in somebody's head?

r.f.: No, I never do, but I certainly recognize there is a huge transfer of trust. And I know a lot of people wonder if they're going to wake up again after the operation or are they going to be able to speak, move, be conscious. Just yesterday I was taking a brain tumor out of a young mother of four, and the tumor was right next to her speech area. The big risk was that she would be unable to speak and might perhaps be paralyzed on the right side. She said she was terrified, and I said to her that she had every reason to be. Here I'm going to open up her head. As I explain to people, I'm just a trained instrument who will try to do the best job possible. I strongly believe that a lot of what we do is luck if it turns out well. I like to say that God's guidance helps.

w.o.: A combination of luck and God. What are you saying, that God is smiling on *certain* people?

r.f.: I don't know if I can explain this. I certainly believe that we take individual responsibility for what we do, but there's a lot of guidance that comes in there, and I can't tell you where it comes from in neurosurgery. After one has practiced this craft for a certain time, a lot of nonverbal learning occurs that some people would call intuition and judgment. It doesn't come out of a textbook. You can't teach it to somebody. It's experience. Any pilot will tell you the same thing, as would anyone who has practiced a technical craft for years.

w.o.: Do you ever say, "God, this is a tough one" during an operation?

r.f.: I do that all beforehand.

w.o.: You've operated on a lot of famous people, like the Rockefellers. Can we mention any of the others in whose brain you've poked around?

r.f.: That's enough I think.

w.o.: How about Ralph Lauren of Polo?

r.f.: I did operate on Ralph Lauren. He, fortunately, had a benign brain tumor, and he's perfect.

w.o.: And the wife of John Hay Whitney, the former ambassador to England?

r.f.: Betsy Whitney. There's an interesting story there because Betsy

Whitney—and she must have been seventy when I operated on her—was just gorgeous. She was one of the four daughters of Harvey Cushing who founded brain surgery. And I remember taking her to the operating room and thinking I might go down in history as the person who knocked off Harvey Cushing's last surviving daughter! Fortunately, that did not happen, and she became a friend. I made many visits to their beautiful home out in Long Island. She just died last year, twenty *years* after I operated on her.

w.o.: You don't just do brains, you also do other stuff, like spinal surgery. You threw my father-in-law, B. F. Curry, the auto magnate, out of the office.

R.F.: I threw him into the hands of a physical therapist and said, "You don't need an operation." To the best of my knowledge physical therapy has worked out quite well. I think there are two forces at work. One is the old adage "Give someone a hammer and everything looks like a nail." Give someone surgical training, and instead of thinking what patient should I give this treatment, they think what operation should I give this patient. A doctor is supposed to be a little bit more discriminating. And the other and even less palatable force is the fact that doctors are greedy, and if they're paid to do surgery . . .

w.o.: You're chief of neurosurgery at New York Hospital. That last comment cannot endear you to some of your colleagues. You're saying they do unnecessary surgery.

R.F.: There are certain areas in neurosurgery that are terribly abused—and, of course, spine surgery, neck or back. The vast majority of spine operations that are done in this country, by my standards, are totally unnecessary. That's a pretty terrible statistic.

w.o.: Why do your colleagues do it?

R.F.: Money! Well, that's unfair. I was too quick to say that. Money is certainly a big motive. I think a lot of surgeons honestly think they can make a patient better by operating on their neck or spine, when most of those people, if they did an exercise program and a physical therapy program, would get completely better.

w.o.: Unlike broadcasters or clergy, doctors are greedy. They're human.

R.F.: They're human. But with this indemnification type of insurance that has existed in the past three, four decades, doctors have been able to name their own price for what they do. If their office costs

go up, they jack the price up, and that's why to some degree your healthcare costs in this country are 50 percent of the GDP. It's terrible. Of course, a lot of this is reversed now because the HMOs have come into the situation.

w.o.: We read in the press today that your whole profession is in chaos. First of all, on the national level, what about this health-care problem? Hillary Clinton is working on it. I would be astonished if you thought that was a good idea.

r.f.: I don't think it is a good idea. I don't know that Hillary Clinton has any special training to arrive at the appropriate decisions of what is proper for healthcare in the United States. I come from Canada, which has a long history of free medical care. Of course, there's no such thing as free anything, but it's taxation-provided healthcare, so no individual pays for any individual costs. I have a daughter who lives in British Columbia, Vancouver, who was recently desperately ill. She came through a major operation and lengthy hospitalization that cost me nothing, not one cent. I am grateful for that. I contrast that with my wife's operations. She's been a tennis player of great reputation since she was a child . . .

w.o.: Ann Fraser, the bionic tennis player.

r.f.: She recently had a wrist fusion because all these years on the court caused a dislocation of her wrist. The total bill I received for that you could buy a new car with. I didn't pay for that. My insurance did, but it was a huge, huge cost. To address your question: the central problem of all Americans is that healthcare costs in this country are absolutely through the roof.

w.o.: Who's making the money? Is it the doctors who are packing it in?

r.f.: There are some doctors who are excessively rewarded, no question about that. The total healthcare bill is roughly $900 billion this year; it will be $2 trillion by the year 2000. That's a totally uneconomic cost to the nation.

w.o.: Should the government try to fix it, Doctor?

r.f.: No question. But to try and fix it and go after doctors' salaries is going after the tail on the mouse because the total doctors' remuneration in this country represents less than 10 percent of that total bill. Are you going to go after 10 percent? That doesn't seem intelligent to me. Doctors represent less than 1 percent of the total population in the nation.

w.o.: Is it going to get better or worse, and will everybody have coverage one day?

r.f.: Yes, I think everybody will have coverage. Healthcare will get better because technology is improving. We're in the middle of a molecular-biological revolution, so diseases that aren't curable now are going to be curable in the next decade. Are you willing to pay for it? That is the question.

w.o.: How do you get doctors, the government, and the insurance companies together? Who takes the lead?

r.f.: I think we should have a national health-insurance scheme. Most doctors totally disagree with that. I think it's simply wrong for people not to get healthcare because they can't afford it.

w.o.: Is there any hope in your bosom that the whole healthcare field is going to sort out and get some balance and equilibrium to it.

r.f.: I think that is going to come for sure, but I think there are going to be some major battles on the horizon. Doctors are very resistant to change. The American Medical Association was a very reactionary group for many years. That's no longer the case. Doctors like to think of themselves as the last bastion of the individual entrepreneur who makes his own rules and runs his own business and is not told how to do it. But that costs too much. And there are too many different standards of care and too many people who don't get the care they should get. Doctors have lost that tradition of giving free care. Everyone used to do it. Now if you don't have a card that shows you're able to pay the cost, you can't get through the door. That's wrong. I think this is all going to be corrected, but at a cost to everybody. You may not be able to choose your doctor. Doctors are not going to make decisions about what they are going to do without other people questioning whether the decision is an appropriate one. That will eliminate a lot of unnecessary surgery.

w.o.: But would you not agree, sir, that a lot of doctors are like conglomerates. You have to work your way through twenty-three nurses to get to the doctor. They have "PC" after their names: professional corporations.

r.f.: It's true, and I hate it. There are many doctors who believe in revenue enhancement and in trying to make as much money as possible. I don't want to sound self-serving. I'm certainly one of

the better remunerated specialists, and we have three cars in the driveway and all that. But I'm pleased to be able to say that at least for myself about one third of what I do is for free. And some of my colleagues do about the same amount of free work. Typically, it is some kid who is sent over from Israel or Greece, whose parents have sucked up their last shekel to get them here, and they have no insurance. Typically, it is a brain tumor. I take it out for free, and I have an anesthesiologist who gives free anesthesia. You may have heard about that girl in Sarajevo, who had a terrible shrapnel injury from a firefight in which her mother was killed. We were organizing to bring her over here to New York to give her free medical care. Fortunately, she went to England and is being taken care of.

I used to have a fund that would provide hospital care. Now I don't anymore, and I have to admit that we sometimes have to use a bit of a scam to get people into the hospital. If New York Hospital's administration is listening to this, they have to know that we're not alone in this. Let me tell you what happens. Frequently people know they have a brain tumor or some horrible neurological disorder. They have their MRI scan or their CAT scan and they're in Colombia. They get on a plane and come here to New York. They come straight into our emergency room and say, "It's an emergency. I have a brain tumor." We have them scanned. Remember, if they get through the doors of our emergency rooms, we can't throw them out. It's state law. And it's an excellent law.

W.O.: So do they get *your* hands, just like the millionaires do?

R.F.: Sure. We give them free medical care, and they go off on their way. I have one, sad example of this working out badly. A woman came from another country from a very well known family—she was a diplomat's wife—with a massive brain tumor, which I took out. To my surprise, they had no health insurance. That's a phenomenon we're running into all over the place. In any event, after several days of doing quite well, she ended up getting an infection, which then went into her brain and eventually became untreatable. That was two years and one week ago. She has been in a private room in New York Hospital, comatose, for all that time. And the New York Hospital bill, which the hospital has eaten, is now well over $2 million.

w.o.: But you can't let her die.

r.f.: Can't let her die.

w.o.: You almost have an office in Armenia or some exotic place. What the hell are you doing poking around there?

r.f.: I don't have a drop of Armenian blood in my veins as far as I know, but within twelve hours of the earthquake in Armenia, in 1989, Dr. Edgar Housepian, a very prominent neurosurgeon at Columbia Presbyterian, asked me to go to Armenia and lead a medical relief team. And for reasons I really can't identify, I said yes. I have to say that was the most searing experience I have ever had. I have not lived through a world war, but I have seen pictures of what our bombs did to Berlin in 1945, and what I saw in Armenia was almost an exact replica of that. Modern buildings totally shattered. The dead were dead, and most of the dying were dead by the time we got there. There was very little we could do. We're going back again. But now it's for a different reason, and that's because Azerbaijan and the Armenians are having a little quarrel and there are a lot of people shot up. We're going to go and provide healthcare for them.

w.o.: Did you always want to be a surgeon?

r.f.: No, I didn't. As a matter of fact, I wanted to be a psychiatrist when I went to medical school. I would've made the worst psychiatrist I can imagine. First of all, I don't have the patience to listen to people's problems, and I think I'm too much of a disciplinarian to give in to those kinds of situations. Psychiatrist is a position—and I'm sure I'm going to be ridiculed by psychiatry immediately—that an intelligent Jesuit priest can do just as well or better in most situations.

w.o.: Jesuits are too smart. They'll get your head really crazy. So you decided not to work on the brain with talking but actually . . .

r.f.: Then I thought I should become a neurologist. I found, however, that neurology was simply making a diagnosis. A neurologist is someone who diagnoses brain diseases—stroke, multiple sclerosis, other brain disorders—but there's no therapy that comes out of it. And so just describing a disease, for me, wasn't that attractive. I decided to go into neurosurgery, and that was the luckiest decision I've ever made.

w.o.: Do you want your kids to grow up and become doctors?

r.f.: I would love it if one of my four daughters would grow up and

become a doctor. I think it's a wonderful profession, fascinating and very gratifying, but also very burdensome. I went into medicine for all the wrong reasons. My girlfriend at the time had a father who was a doctor, and I decided to emulate him. I've been a doctor since 1962.

w.o.: When someone is confronted with a brain operation, it sort of puts it all in perspective, doesn't it? What do you tell them? "I'll do the best I can"?

R.F.: I tell them I'm just a well-trained instrument. I cannot control all things. If they do well, they should thank God.

w.o.: Do you ever feel when you have somebody at your mercy that you're playing God? I don't know how to put it any other way.

R.F.: No. I'm carrying out a physical task . . .

w.o.: Because if you slip, they are gonzo.

R.F.: Last week I was doing a very difficult aneurysm, which is a weak spot in a blood vessel, in a woman. It was a terribly risky case in which one puts a clip on the aneurysm to cure it, and in this case the artery was so friable that putting the clip on it completely lacerated the artery. As soon as I saw that, I knew I had just killed this woman. And sure enough, she died. It was unavoidable and . . .

w.o.: You didn't kill her.

R.F.: . . . it happened. And, no I didn't murder her. But those are the burdens that we as neurosurgeons have to accept. We have to accept individual responsibility for what we do.

w.o.: Do you operate on your friends?

R.F.: Occasionally.

w.o.: Is that tough to do?

R.F.: Believe it or not, once you've made the decision to operate and you're actually in an operation, you've forgotten who this person is. It's a task that you must carry out. Personalities are totally gone. The truth of the matter is that most of one's patients become your friends. The difficult burden in neurosurgery for me, because mostly what I do is taking out brain tumors, is that half of those people have malignant brain tumors and they'll all be dead and I'll see the families' tears. That's very difficult to deal with. So I tell somebody in the family beforehand. You have to be candid without removing all hope. I don't tell you, "Look, Mr. O'Shaughnessy, your tumor is malignant, and you're going to be dead in a year to two, and much of your last few months you're

going to be paralyzed or have lost your conscious human traits."
I tell a patient generally, if their tumor is malignant, that we will
control it for a time. Most people don't ask how long they have
to live. I'm sure they know. It's extremely rare for a person to ask
me if I can cure their tumor. And if they do ask, then I say I don't
think so.

w.o.: How long do these operations last? How long are you standing
there?

R.F.: The longest brain operation I was ever involved in took about
twenty-four hours. That was when I was a resident. That opera-
tion today would take me about four hours. That was an unneces-
sarily long procedure performed by a very deliberate neurosur-
geon. All neurosurgery should be performed with deliberateness,
but this was excessive. For me the average brain tumor takes prob-
ably two to three hours, and we generally do two or three of those
in a day.

w.o.: Are you exhausted when you come home to Rye?

R.F.: No. I used to be when I started out in this business. If I had taken
a brain tumor out, I would have to put my feet up for the rest of
the day because I would be emotionally drained and tired beyond
belief. It's a matter of doing so many now I don't find it fatiguing
at all.

w.o.: When you are operating on somebody's brain, do you think
of their soul? Isn't that where your *thoughts* come from? Can you
almost see somebody think?

R.F.: Well, believe it or not we *can*, but it's not through my intuitive
understanding. I can put you into an MRI scan and ask you to
read a word, to think of a word but not read it, to think of a
thought and don't tell me what it is, and through something
called functional MRI we can see different areas of your brain
light up. So all that tells you is where this is going on in the brain.
It doesn't tell you how it's going on, but we now understand, for
instance, that language is ordinarily in the left hemisphere of the
brain. If somebody learns to speak a second language, on func-
tional MRI we can see a separate area light up if they are an adult.
If they are a child and they learn two languages simultaneously,
they only develop one language area. It's fascinating.

w.o.: I read in one of the national journals that you had some inter-

esting thoughts about the death of Abraham Lincoln, our greatest president. John Wilkes Booth didn't kill the guy?

R.F.: I was turned on to this subject by looking at Presidents William McKinley and James Garfield and their deaths. I was so appalled by the quality of the medical care that they were given. They were clearly killed by their physicians. Garfield lingered for three months after being shot in the back, and in his case fourteen doctors in the first twenty-four hours all shoved their unwashed hands into his back to explore the wound. That was in 1881, well after the Civil War, and it was well known this was a no-no. McKinley, who was shot in the belly in Buffalo in 1901, was given appalling medical care, and his death resulted in Teddy Roosevelt's becoming president of the United States.

The great Lincoln was shot with a Derringer .44-caliber revolver with a muzzle velocity less than that of an air gun. The barrel was only two inches long, and it's muzzle velocity was less than 900 feet per second, which is pretty slow. It's the muzzle velocity that kills you; that's what has the damaging power. Lincoln was taken across the street to a Mr. Peterson's house where they tried to give him something to *drink!* Here's a man who was unconscious; to give him brandy was dumb. Number two, they put probes into his brain and explored his wound with a finger. When I read this, I was just astounded. We developed a thesis—and I think this is supportable—that Lincoln's devastating wound was converted into a fatal one by his *physicians.* In fact, this would turn out to be of great benefit to the nation because there was no way Lincoln could've functioned as president with that wound.

W.O.: Could you have saved Lincoln if you had been in Washington that night?

R.F.: Probably. You never can say 100 percent for sure, but I think he had a salvageable injury.

W.O.: You are also a doctor in addition to being a surgeon, and at the risk of embarrassing you, I hear that at three o'clock in the morning families in Rye who can't get their own doctor call you and you go out in your hot little sports car. Don't you know you're supposed to have an unlisted number?

R.F.: I don't know that. But most of the time you're not going to be able to get through anyway because my daughters are always on the phone. Yes, believe it or not, I still make house calls when

they are necessary. My grandfather did it, and I'm happy to keep the tradition.

W.O.: But haven't doctors gotten away from resembling that hometown country doctor in the horse and buggy who made house calls? Somebody told me a woman, not of standing or high estate, had a problem with her son who wasn't moving, a five-year-old kid. You told her what to do over the phone, then you showed up at the door unannounced and wanted to look at the kid.

R.F.: That's true. I think doctors have gotten away from the type of physician my grandfather was. And unfortunately, in many ways, it's impossible to turn back the clock. My grandfather didn't even have X-rays. Today I have the gold standard of computerized imaging: an MRI scan. It allows me to perform surgery that couldn't be dreamed of even ten years ago. Medicine today—and certainly neurosurgery—is totally different from what it was twenty years ago, but I think that doctors, in the main, still go into medicine because they're interested in helping people and are interested in biology.

W.O.: I saw you jump in a pool one day for a swim, and you had your pager on your bathing suit. Do you go anywhere without it?

R.F.: I always have it. Unfortunately, it didn't work very well after I took it swimming.

W.O.: On Sundays and Saturdays you look as if you are just coming out of the operating room. These are supposed to be days of rest.

R.F.: I wish they were. One would think that the administration would reduce the amount of operating I'm doing because I'm chief of the service. In fact, the opposite occurs. I'm operating seven days a week very frequently now. I wish I did not have to, but that's what I signed on for.

W.O.: I hear other doctors talk about your legendary prowess, not only with using the scalpel and the knife but also with raising money. I hear a lot of wealthy people are happy to throw money at you for your hospital and your work. Is it hard asking people for money?

R.F.: Believe it or not, I have never actively solicited a cent from anybody. I've got a lot of New York's wealthiest people as patients. I would also say they have been among the most generous people I have run into. Typically, at Christmas time, checks will come in

unsolicited, which we use for research purposes at Cornell Medical School. I am very grateful.

w.o.: What do you think about your country, what we're doing now in Washington? Do you talk to your wife about this stuff?

R.F.: Yes, we do talk. Personally, my wife is a great admirer of William Clinton, and I have become one also, though I voted for George Bush, whom I happen to know and admire. Bill Clinton, without question, is one of the most intelligent, articulate people who have occupied the office. He, of course, has benefited mostly from the good economy. His personal behavior, as far as I'm concerned, just doesn't count. To have been maneuvered into a position in which he had to lie about it and commit perjury—that's another matter, unfortunately.

w.o.: You're a warden of the church.

R.F.: I'm on the vestry of the Episcopal church in Rye, Christ Church.

w.o.: So you don't think what he did was wrong?

R.F.: No question, it was wrong. For an intelligent man to behave that way is extraordinarily stupid too. Is it impeachable? I don't think so, but I'm not there to judge that. I'm sure our nation will survive this. I think this is a minor blip on the radar screen and will disappear shortly. If it disappears with his disappearance from that office, we'll survive that also.

w.o.: How about community hospitals? Is United going to survive? Is New Rochelle going to survive? St. Vincent's?

R.F.: I don't think any of these hospitals are going to survive unless they are aligned with a major medical center. United Hospital is in the process of joining New York Hospital. Westchester has a lot of hospitals in big trouble. United Hospital happens to be the one I know in our community, and I think that it is a terrific institution. Of course, a hospital is not the bricks, it's the people. All the doctors that I know at United Hospital, in every specialty, are of a very high caliber.

September, 1998

Interview with C. V. "Jim" Woolridge

The Honorable C. V. "Jim" Woolridge is one of the most popular and beloved figures in Bermuda. Eighty-five percent of the residents of that idyllic island nation wanted him to be prime minister, but Jim Woolridge put his tremendous reputation on the line to maintain Bermuda's allegiance to the Crown. As tourism minister, Woolridge has traveled the world as the Pied Piper of his homeland.

w. o'shaughnessy: He is one of the most attractive human beings I have ever met. When we had him as our guest on WVOX and WRTN, the lines were ablaze. He is the poet of the charms of the island nation of Bermuda: C. V. "Jim" Woolridge. We both have on our Bermuda shorts. I would expose my knees only for you, Minister.

c. v. woolridge: It was a very attractive gesture on your part, Bill. As a matter of fact, when I insisted that you come on the show wearing shorts and socks, some of your friends said you would never wear socks. Now that you've worn them and Nancy has given her sign of approval, I'm sure you will show up at the studio dressed in the proper Bermuda style.

w.o.: Nancy thinks you are perfectly suited to be the Bermuda minister of tourism and deputy prime minister. She also finds you one of the most charming of men.

c.v.w.: Your wife is very kind, and her brilliant judgment was confirmed when she chose you to be her leading man.

w.o.: We've had a marvelous cast of characters on this program, but you are one of our favorites.

c.v.w.: I always feel good when I come to Westchester because we have consistently had support from your people who have found Bermuda to be their favorite destination.

w.o.: Bermuda is beguiling, and so are you. You're also a Commander of the British Empire.

c.v.w.: Commander of the Most Excellent Order of the British Empire. Her Majesty, the Queen, gave me that during her Birthday Honors. Twice a year on the New Year's Honors and Queen's Birthday's Honors in June, people throughout the British Commonwealth who have given outstanding service to the community in sports, government, politics, or civil service are recommended and honored by Her Majesty. I was one of those awarded the CBE, Commander of the Most Excellent Order of the British Empire.

w.o.: Is that like a knighthood?

c.v.w.: Just one step away. I'm highly honored to be recognized for something I enjoy doing. I have enjoyed the last twenty-six years in Parliament, and I will say, without contradiction, they were the most formidable years of our country's history. And to have been a part of it. We've seen more positive upward mobility—socially, economically, and politically—during those years than any other part of our history. We have developed a beautiful country, one of the highest standards of living in the world, one of the highest per capita incomes, and it's all come through the hospitality industry, our tourism as well as our international corporate business. The infrastructure for tourism is what feeds our international business, together with our banking, our expertise in accountancy, as well as the tremendous law structure in place. Today Bermuda has about 7,500 international companies that support our tourism industry. The importance of tourism cannot be overemphasized because it is the lifeblood of our country. We don't have sufficient soil to support ourselves: in addition to the needs of the permanent population of 56,000 people, we're talking of a floating population of 600,000. That's the number of people we play host to during the course of the year.

w.o.: Everything you do has a certain style to it, Minister Jim Woolridge. You are perfect for Bermuda. Bermuda is like no other place.

c.v.w.: Bill, I think you are perfectly correct. It's probably the most beautiful place in the world. The poet said, "God made earth for man to love, and one spot to love overall." He had to be thinking about us. The island is absolutely beautiful. It's almost an accident, six hundred miles out in the middle of the Atlantic off Cape

Hatteras. We've been able to retain the natural beauty and not allow our island to become over-commercialized since we rely on tourism. I think this is a great tribute to the people of the island because we have not given in to the pressures for tremendous building programs and things of that nature. We try to preserve the amenities. Just last Friday in Parliament, our government approved the purchase of two stretches of land—one of twenty-four acres and another of fourteen acres—to join up near Tom Moore's Tavern. We spent $3.5 million to purchase that because we think it's insurance for the future.

w.o.: You've also still got the great beach.

c.v.w.: We do have some of the finest beaches in the world. We have beach weather right down to the end of November. As a matter of fact, people swim in Bermuda on New Year's and Christmas. What we're doing now to dispel the myth that it gets too cold in Bermuda is the "temperature guarantee": if the temperature fails to reach 68 degrees, they'll get a 10 percent discount on their room rate as well as 20 percent discount in the stores. We have no neon signs, no graffiti. But the thing people come back again and again for is the quality of life there, the warmth and friendliness of our people. You'll find people still have a respect for the rule of law and for one another. These are things we guard zealously. Our fastidiousness comes from the cradle up. In our schools we have campaigns to Keep Bermuda Beautiful. We have cleanups throughout the island. We teach our youngsters why it's necessary to be friendly and courteous and why the island should be kept clean for the benefit of our visitors.

w.o.: When you arrive in Bermuda, you are met by erudite and most unusual taxi drivers. I feel inferior. They're like Ph.D.s, all very British . . .

c.v.w.: We refer to our cabdrivers as "good-will ambassadors." They are some of the most knowledgeable people. They know every bit of foliage and the history of the island. The cabdrivers and waiters in the hotel spend more time with our valued guests than any other people. They must make folks feel completely at home the moment they put foot on the island. We have a high repeat factor of about 46 percent.

w.o.: A lot of ambassadors and other diplomats watch this program, so I don't want to alienate anybody or start an international inci-

dent, but Bermuda does not seem to have the problems of "locals" against tourists. Down in some Caribbean countries there is a lot of unrest.

C.V.W.: We recognize that tourism is the main source of revenue. It's responsible for 68 percent of our income. The international corporate business, our secondary industry, is an offshoot of tourism. On that beautiful little island of ours where we enjoy one of the highest standards of living in the world, the GDP was $1.6 billion: $600 million came from tourism, $400 million from international corporate business, and the rest from import duties and license fees. We have no income or sales tax. It's the most fascinating little place in the world, and we still are able to have a per capita income of about $23.5 thousand. So this answers your question as to why the Bermudian people are so pleasant to visitors. Because we recognize tourism is the only thing we have. I am a native son because my father's people came in 1703. We call ourselves "Bermuda onions." We started to grow actual Bermuda onions many years ago, and then some smart Bermudian decided to teach the Texans how to grow onions, and now the Texans grow them bigger and better than Bermudians. It put us out of business for onions, so we had to go into the tourism business.

W.O.: You're so successful at singing the charms of Bermuda, I hear the other island nations have a price on your head.

C.V.W.: We're friendly competitors. We give them all kinds of technical assistance.

W.O.: You are also like a senator in your nation.

C.V.W.: I'm an elected member of Parliament. I've had the privilege of topping the polls in every election. I've held three very important portfolios: I was minister of labor for about six and a half years, then deputy premier for about four and a half years, and I've been tourism minister for thirteen years.

W.O.: Who owns Bermuda, Minister?

C.V.W.: We are the only self-governing colony in the British Commonwealth. I wouldn't say Britain *owns* us. They have "jurisdiction" over us because the British first discovered the island in 1609 when Admiral Sir George Summers was on his way to Jamestown, Virginia. He was shipwrecked off the island. We got our charter in 1612. We're the oldest Parliament outside of Westminister. We have the oldest Anglican Church in the Western

Hemisphere in St. George, where the first Parliament met. We have a governor, Lord Whitington, appointed by the Queen, and he has three reserve powers: foreign affairs, defense, and internal security. Britain does not give us a penny. We pay for everything, including the governor's salary. We have forty members of Parliament elected by the people . . . We have the one main street and the little adjoining alleys with such peculiar names such as Old Maid's Lane, One Gun Alley, Silk Alley, Petticoat Lane, Shinburn Alley. Even though the buildings may be owned by individuals, they cannot touch any of the exteriors because it's under control of the National Historical Trust. Because if we lose our roots and destroy our antiquity, we've got nothing.

w.o.: Do you still dress up in those wigs?

c.v.w.: The Speaker of the House still wears a wig. The Clerk of the House wears a wig. Our judge and our attorneys still wear wigs. We have those British traditions. We drive on the left-hand side of the street. Our businesspeople wear short trousers, which is a part of our tradition.

w.o.: Minister Jim, they tell me you're pretty formidable during election time.

c.v.w.: I think I'm in touch with the people. I have seven churches in my area. I either try to join them for services, or I send flowers to the altar with my compliments.

w.o.: You've been accused of being the most popular man in the entire island nation, but I also know what you do on your days off. You're a cricket announcer. On the radio!

c.v.w.: I'm the leading cricket commentator on the island. They refer to me when I'm wearing my broadcast hat as the "Voice of Summer." Cricket is the most fascinating game in the world and possibly one of the finest character-building sports. A former governor of the island, Lord Montemare, one of the most popular governors we ever had, was invited to be the guest of honor and present the prizes at the conclusion of our Annual Cup Match. It's like your World Series. He said at the conclusion of that game that Bermuda is the only country in the world where they give a two-day public holiday to play a game of cricket. It's a social function and a fashion show. Everything takes place at the Cup Match. It's usually the last Thursday and Friday in July or the first Thursday and Friday in August.

The fact that I broadcast cricket helps me come into the homes of the sick and shut-ins. All those folks who helped to give us the wonderful, prosperous life we're enjoying. And by doing the cricket broadcasts I'm giving back a little of myself.

There's a wonderful story I'd like to tell you about this old man who was standing on the corner one day by a bank. He had a white cane and dark glasses, and I asked if I could help him. He said it was quite nice to meet me. But I told him he had me at a disadvantage since I hadn't had the pleasure. He said on behalf of Beacon House for the Blind he wanted to thank me for bringing sports into their lives. He said they laugh when I laugh and that I not only give a brilliant description of the match, but I tell them about the fashion and florals and even what the girls are wearing! He took my hand, and I thought he would never let go. Three days later this old man sang "Deep River," a bass solo at the Bermuda Cathedral on the occasion of Lord Montemare's final service in Bermuda. And two days later I read in the paper that he had gone to his reward. I felt I had put a little sunshine into the life of a man who had been committed to darkness but who could still enjoy the beauty of hearing. That's what life is all about.

w.o.: Don't you think it's a little beneath you to be a broadcaster and a government minister too?

c.v.w.: I don't ever want to be beneath the common person because I've never forgotten my roots. When I first became a minister back in 1970, one of the senior ministers said I should not be broadcasting these cricket games anymore, and I said these are my roots and I think I should be in touch with the people. But I spoke with Lord Montemare and asked if I was detracting from my portfolio as minister, and he said it would probably be a mistake to start a broadcast career, but given the fact that I was well established as the "Voice of Summer," it would be a mistake to stop. And besides, who would he listen to? This is the twenty-ninth year I've done cricket commentary.

The power of radio is unbelievable. You are able to translate your feelings and what you see through your eyes to those at home. That's what communities are built on. Communication and the wonderful power of radio and television is able to do that for us.

w.o.: What's your view of our politics, sir?

c.v.w.: You can't throw out all the people with experience. I think the politicians who find themselves caught in this kind of situation have not been paying attention to their constituents. I think America is the greatest country in the world and I love it dearly, but maybe so much attention is being paid to the international scene that folks have forgotten about home. You must come back to your constituents. That's why I find it important and necessary to go to the Women's Day service at the Methodist Church. That's why I find it important to assist the seniors when a young lady called me a week ago and said this old folks' home next to her needs a television set. Those people have helped give us a good life, and these are the folks who have the wealth of knowledge.

w.o.: We hate politicians right now in this country. We hate them all.

c.v.w.: I'm a politician, and I think I'm a nice guy. People are angry again because the politicians haven't paid attention. That's one of the reasons why I do the cricket broadcasts. I don't want to be above the people who put me in Parliament. Once you lose contact with the people who put you there, they are eventually going to say you are out of touch. America is no different from any other place. When things are not going well, everyone tries to find a scapegoat. It's the same in Bermuda. Our economy is doing well but not as well as it was three or four years ago. They're all looking to see what I'm doing wrong. I'm not doing a damn thing wrong. We're facing difficult times. The world pendulum swung up, up, up. Sooner or later it had to come down. The degree in which it comes down depends on the people. What we need to do is trim our lamps and cut our material according to the cloth. You cannot continue to spend when you are not having prosperity. Meanwhile, the general public is continuing to demand more services.

w.o.: Are you talking about Bermuda or here?

c.v.w.: Worldwide.

w.o.: So you're in the same boat?

c.v.w.: Yes. But you must be able to justify your actions. In Bermuda there is not a soul under thirty-five who knows what it is to be in need. They have lived in prosperity . . .

w.o.: You have no poor?

c.v.w.: I'm the poorest one there! That's why I wear short trousers!

w.o.: Recently, the United States went into Haiti. Does Bermuda approve?

c.v.w.: I believe the president had the support of a number of Caribbean islands in providing peacekeeping forces there. But it is most fortunate for the world that there was no conflict, nor any type of resistance. And I believe the former president, Mr. Jimmy Carter, and Mr. Colin Powell, as well as Senator Sam Nunn, deserve the thanks and appreciation of the entire world. You mentioned early on that I received a CBE from the Queen. I would be happy to give it to each one of those chaps because they've done a great service to humanity. They've gone in with a view to remove suffering, and this is important because each and every one of us is our brother's keeper. This is an obligation we have in this world, whether it's in Haiti, Bosnia, Rwanda, or the Sudan. That's what it's all about.

w.o.: A lot of people say, "He's another damn liberal."

c.v.w.: We're talking about the suffering of the people. I don't think America went in there because of Mr. Aristede. America went in there to relieve the suffering. We have to think of the positive in this world, Bill, and not how it's going to affect one individual. That's what life is about.

w.o.: What about President Bill Clinton?

c.v.w.: I think Mr. Clinton is doing a reasonably good job. He has an awful lot of problems on his hands. He has a domestic situation. He's dealing with Bosnia, Rwanda, Haiti. As a politician, I think there are times when we have to work for the good of the country. If we allow a country to degenerate because we support one faction or another, we're not being true to the cause of national purpose. Factionalism can be very destructive, Bill.

w.o.: What if you just don't agree with the leader of your country?

c.v.w.: You can agree to disagree, but you do have the democratic process in which this can be rectified. And it must not be thwarted.

w.o.: Do you feel as if what happens in the rest of the world doesn't concern you?

c.v.w.: We're small—only twenty-two and a quarter square miles—but I cannot be removed from what's happening in the world because we have forty-seven channels. And what takes place in Washington and in Bosnia is right on my screen. I see the suffer-

ing and inhumanity in Rwanda and Bosnia. I cannot be immune to it.

w.o.: Do you still have those thrilling motorbikes? I ride real motorcycles, but I'm going to tell you, coming back from supper, I have had some "interesting" rides in your lovely isle.

c.v.w.: Most visitors enjoy our mopeds, but they must adjust to being on the *left* side of the street. The majority of people have not been on a peddle bike since they were teenagers, so they have to readjust to being on a motor bike too. Once they overcome that we feel very safe.

w.o.: Where do you get your drinking water?

c.v.w.: We get all our water from the heavens. We have no lakes, no rivers, and no streams. And we have no contaminants. Nor do we have industry to contaminate our water supply. Like I said, God has smiled on us.

<div align="right">June, 1992, and October, 1994</div>

E. Virgil Conway

E. Virgil Conway made a pile of money as one of New York's preeminent bankers. He was chairman of Seaman's Bank for Savings and in recent years served as head of the Metropolitan Transportation Authority, the largest in the world. Virgil Conway is one of the nicest men to ever submit to the rigors of public service. He and his formidable wife, Elaine Wingate Conway, divide their time between Bronxville and Montauk. But this power couple always seems to find ways to do marvelous things in the public arena.

W. O'SHAUGHNESSY: Somebody said O'Shaughnessy has only legends on this program, or at least somebody who has done something nice for Westchester or his radio stations. You could be right about that. Tonight's guest is guilty in all these categories. He's been a commissioner of the New York State Banking System. But recently, in a weak moment, he agreed with our governor and his friend, George Pataki, to take on a very difficult assignment. So he presents himself tonight as chairman of one of the largest transportation systems in the world: E. Virgil Conway. How the hell did George Pataki talk you into this?

V. CONWAY: It occurred in a rather simple fashion. I had worked very hard to help him be elected governor. That campaign was successful. And then last April the governor asked me to be chairman of the Metropolitan Transportation Authority, and it was pretty hard to say no when you had urged him to be governor.

W.O.: You've taken a few shots from the press. Even from Jack Newfield. I told him you were one of the nicest men in public life.

V.C.: That's part of the job of the chairman of the MTA, especially in these times when we're facing fiscal restraints. When I assumed the chairmanship, the MTA was facing substantial operating deficits. This year $130 million, and next year close to $400 mil-

lion. This required solutions that were not without pain, and that pain had to be a shared pain, in my view, shared by the management, labor, and the users. When you have a plan, it's bound to make some people unhappy because they don't want to share the pain. The people that are for the plan don't come out and tell you they're perfectly content. They stay home. You tend to get the critics out to tell you why they do not like your plan to save and strengthen the transportation system.

w.o.: You don't mind sitting up there at the public hearings?

v.c.: Not at all. I think it's very helpful. We get suggestions, and we're also able to determine the pulse of the people. I say it generally attracts the naysayers. On the other hand, you can certainly measure to some degree how they really feel. I'm delighted we have this process. It's absolutely imperative prior to any move such as a fare increase. Everybody pays. That's one issue we should tackle right off the bat. Part of the criticism is coming from the city. People said it's unfair that the straphangers have to pay an extra quarter, a 20 percent increase, while commuters on Metro North and the Long Island Railroad, average a 9 percent increase. Those are the amounts needed to meet the deficit. It would not be fair to raise the railroad users on a much higher percentage and then just have the money left over. You base the fare increase on what you need to meet the deficit.

w.o.: You're talking like a banker now, aren't you?

v.c.: I think I'm talking like someone who wants to develop a credible plan.

w.o.: John Lindsay, the former mayor of New York, took you to task in print a couple of weeks ago. The New York politicians all want to save the subway.

v.c.: He didn't really take me to task. He took the allocation of the Triboro Bridge Authority's *surplus* and outlined a history of that and suggested that allocation should be changed. That's a matter for the New York State Legislature. For several years bills have been brought before the Legislature advocating that the surplus, which is allocated equally between the suburban railroads and the subways, be changed. Those bills haven't passed. In developing the plan, it would not have been credible for me to assume that the Legislature is going to change its mind. I have to present a plan that is responsible and credible, and you don't do that with

pie-in-the-sky dreaming that the Legislature is going to do something they have refused to do for years.

w.o.: You have a brilliant young man named Steven Reitano as your chief financial man. When you sat down with this plan, what were you after? Just a fair deal for everybody?

v.c.: A fair deal—spelled "f-a-i-r" not "f-a-r-e"—for everyone! Steve has been great. We were fortunate to entice him down from Westchester, where he was commissioner of finance. Now he's responsible for $5 billion.

w.o.: Did I hear you say you ride the train? You used to ride around in a limo when you were a bank chairman.

v.c.: I didn't ride around in a limo all the time. But now I do ride the train. I take Metro North in every day and walk over to my office at 52 Vanderbilt. If I have to go downtown—which I do on some other activities I'm connected with or on MTA business—I take the subway down.

w.o.: You can't move around the New York metro area much without using Conway's stuff.

v.c.: I wouldn't call it Conway's stuff. It really is guided by the State Authority, which was the creation of Governor Nelson Rockefeller. It's a fantastic concept because it brings together the "circulatory" system, or the arteries if you will, of the metropolitan region. This vital circulatory system has to exist for the economic growth and health of the region. Economic growth is a broad term. Our system is used by people to visit their doctors and friends. But it's also a great amenity for use by visitors.

w.o.: How many employees have you, Mr. Chairman?

v.c.: Close to 60,000.

w.o.: You mentioned Nelson Rockefeller, our Westchester neighbor. You've known all the governors. How do you rate them?

v.c.: I won't rank them because many of them were dear friends of mine. And yours. They were all great men. Nelson Rockefeller, whom I worked for in the New York State Banking Department, was a fantastic visionary, a builder. He has the State University system and the MTA as two of his monuments. He also rebuilt the city of Albany. No task was too large for him. His vision was absolutely staggering. He also was a joy to work for in that he gave you a task to do and he let you do it. There was very little interference.

w.o.: How about his successor, another friend of yours, Governor Malcolm Wilson.

v.c.: Governor Wilson also is a great man. I was with him yesterday when both you and I, Bill, were at the dedication of the Malcolm Wilson Park on the Tuckahoe border. In his ten years as lieutenant governor he was a tremendous support to Governor Rockefeller, and then as governor he carried on Nelson's policies.

w.o.: Do you think Malcolm Wilson has been given his due?

v.c.: He's venerated. Surely I think any honor you could give to Malcolm is not enough. I think we are recognizing that by naming the Tappan Zee Bridge and the park after him. Malcolm gave his entire professional life, as assemblyman, lieutenant governor, and governor to the people of this state. He was just a fantastic human being.

w.o.: After the two Republicans you mentioned, Rockefeller and Wilson, we had Democrats: Hugh Leo Carey and Mario Cuomo.

v.c.: They both were fine individuals. Governor Carey will always be remembered for the responsible leadership he gave during the New York City fiscal crisis. I worked on that fiscal crisis with the governor, trying to help make recommendations to change some of the city's management practices. Carey's leadership and vision in that matter were tremendous. Mario Cuomo is a visionary and a great moral leader of this state. I did not agree with all of his policies, but he certainly is a fine human being and a man of great accomplishment.

w.o.: You are a rock-ribbed Republican. Does it hurt you to say those things about Democrats?

v.c.: You have to be fair. Cuomo's policies were fiscally unwise. He never saw a tax or a state service he didn't like to expand. That doesn't take away from his stature as a human being and great moral leader.

w.o.: Did you ever think Pataki could beat the great Cuomo?

v.c.: I never had a doubt. The closest I came to doubting was about ten days before the election, but by the final weekend I was sure Pataki was going to win.

w.o.: Tell us about George Elmer Pataki.

v.c.: George is already, in the few short months he's been in office, proving to be a great governor. To be able to shepherd through the Legislature a budget, for the first time since 1941, and lower

than the previous budget. The tax reductions that he also got through, and the no-nonsense changes that were made in the criminal laws. These things give signals around the world—because I consider us the capital of the world—that New York is again going to be friendly for economic growth and friendly to the business community.

w.o.: So you really believe in what Senator Jack Javits used to call the genius of the free enterprise system. You create jobs and wealth, and it somehow trickles down.

v.c.: It doesn't trickle down. It *flows* down, because as you create economic growth, it's always a *triangular* motion. It's coming down from the top, so you create a few jobs with one business, and that business needs supplies from another business, so now there's another business created. The base is vastly wider than the top. It is an explosive flow . . .

w.o.: You're sure it works?

v.c.: I'm positive it works. You can see the explosive economic growth we had under President Ronald Reagan's policies. Bill, I've said to all these naysayers that we're in an age of Pericles. This is probably going to be one of the great ages of humankind, and it's just beginning. The absolute explosion of the Information Age and the electronics and business growth we're experiencing now is really a Golden Age. There's no question that we have problems, and that we must work hard to make sure that everybody is brought into the system. It means that when things are going the right way, you have to work to see that the entire system covers as many people as possible.

w.o.: I have to ask you if it bothers you that these companies are making all this money and laying off thousands?

v.c.: When you say "laying off," I say "improving productivity." That in the end will create more jobs, not fewer jobs, because they're taking some of the bloat out and also taking out layers of middle management that are no longer necessary. It used to be that middle management's job was to provide information up to the top. Now that can simply be done with electronics. By making something more productive, they're able to grow their business, and as they do it someone else is going to be able to grow their business because the first will be ordering goods and services, so there will be jobs available someplace else. This does cause dislo-

cation. But it's very important to the process. That's why corporate earnings are going up. Those corporate earnings will well serve our economy.

w.o.: Will you please give our best to your estimable Mrs. Elaine Wingate Conway? I call her Mrs. Commissioner.

v.c.: So do I!

w.o.: What is she doing now?

v.c.: Elaine is director of the Division for Women of New York State in the governor's cabinet. She is in charge of identifying the issues of concern to women and seeing that they are brought to the attention of the governor. She has organized volunteers all over the state, and we're very proud of her.

w.o.: You are a nice man in a tough job. Thank Elaine Conway for allowing us a few moments with the chairman.

<div align="right">September, 1995</div>

Interview with Al Pirro, Jr.

Al Pirro came off the streets of Mount Vernon, New York, accompanied by a rich admixture of charm, brains, and chutzpah. He made himself into one of New York State's most potent and well-connected fund-raisers. The flamboyant real-estate lawyer got tangled up with the Feds in 1999 and is presently paying his debt to society. Al Pirro's fall from grace was one of the truly sad stories we've had to cover in the last several years. This interview was broadcast before life turned sad and difficult for the highflier.

W. O'SHAUGHNESSY: He is a power lawyer in our home heath, a famous man married to a famous woman. He presents himself tonight for your perusal as the spokesman and representative of one Donald Trump: Albert Pirro, Esquire. You've come a long way from the streets of Mount Vernon.

A. PIRRO: It's been a long journey but a lot of fun too.

W.O.: Our director says he remembers ten years ago at the local country club when you used to drive up in your Ferrari.

A.P.: I remember him also. I had to pay him a little extra not to drive away with it.

W.O.: Do you still have your Ferrari?

A.P.: I do.

W.O.: You got mad at me once because I said on the radio that you and your Mrs., our esteemed district attorney, have *two* Mercedes cheek-by-jowl in your garage.

A.P.: You corrected me. One was a Ferrari.

W.O.: How is the Mrs.?

A.P.: She's doing great. She's working very hard. It's refreshing to observe someone who gets up in the morning and is so enthusiastic about going to work at all hours.

W.O.: The Mrs. being the chief law-enforcement officer of our county of one million, the Honorable Jeanine Farris Pirro, our district

attorney. You're the celebrity power couple of our county. Does it bother you when I say that?

A.P.: No, it doesn't bother me. I think that, frankly, it's difficult for both of us. Jeanine has a career that is entirely different from mine. Jeanine is truly, in every sense of the word, a public servant. She is really into the prosecution of crime and law enforcement in Westchester, and she believes in what she's doing. It's all she's done for twenty years. I, on the other hand, have chosen to go in the direction of enjoying our free-enterprise system to its fullest. My primary mission is to provide an education for my children and a comfortable place to live. Along those lines, we've both been reasonably successful, and it presents interesting conflicts from time to time.

W.O.: You're a power lawyer now. You came off the streets of Mount Vernon, but I saw you in New Rochelle, my home heath, when they had a groundbreaking some time ago for Home Depot. How do you get all these big clients?

A.P.: Ten years ago we were extremely assertive about going out and getting clients, and we were successful. As we were achieving our success in different projects, we were making sure other developers were hearing about us, and we were very lucky to be in the right places at the right time. In New Rochelle we did the Price Club transaction, now Costco, and we have been retained by Lou Cappelli's New Roc Associates, which is the new mall project. As you mentioned, we're working for Donald Trump and Home Depot.

W.O.: You're getting richer and richer.

A.P.: We're paying more and more taxes.

W.O.: How many lawyers work for you and your law firm?

A.P.: In our office we have twenty lawyers.

W.O.: How many lawyers work for Jeanine Farris Pirro, the DA?

A.P.: I think she's up around 125 or so. She clearly has a larger law firm!

W.O.: Where's the balance of power in a marriage like that?

A.P.: There is no balance. Jeanine has *all* the power in our marriage. The power to *indict* is the *maximum* power. Kidding around aside, it doesn't really work like that. If I may take the liberty of explaining what our marriage is like . . .

W.O.: When you come home out of your ivory tower and she comes home out of her glass bowl . . .

A.P.: First of all, we both work out. Jeanine will get up early in the morning and go to the gym. She lifts weights. I run in the morning. And then what happens is Jeanine will come home early enough to get the kids ready for school, get their breakfast, and get them off on a bus. There are security people who work for us because of the profile we both have, to make sure the kids get on the bus properly and that they disembark from the bus at school. Then the phone calls start and the faxes start coming in. Whether it be a story about a murder or a story about an abortion clinic in Westchester or Geraldo Rivera or someone else who wants to talk about O. J. Simpson or the First Amendment and the Oklahoma City case, Jeanine will be involved from minute one during the day. She is a terrific administrator, and she keeps her staff around her all the time.

I have a much less significant role than she has with our family. I'll get up in the morning and have my coffee and grunt and say, "Hi," and then we'll start to talk about the scheduling of the children through the week. For example, this afternoon Alex has a tee-ball practice at four o'clock. Jeanine can't go because she has something going on in her office, so I'm going. On the weekends Jeanine does very little other than spend time with the children. On Friday nights, instead of running around with other people at various events because we've been at them three to four nights a week, we'll take the children out for dinner. It's that simple. It's really not what people think.

W.O.: It's been in all the papers. You had the governor at your place a few weeks ago. My colleagues at Gannett said that because she's the DA, she can't have the governor for a visit. I disagree with my colleagues. I think your Mrs. has every right to have any damn person she wants in your house. How do you feel?

A.P.: This is a perfect conflict issue for us in our marriage. I'm not a public figure. Jeanine is. The Gannett newspapers have a job to do, and their job is to be constructively critical of us—and we accept it for what it is. We don't take it as being beat upon or anything like that. The media sometimes can help keep us all in balance and keep us looking into what we're doing and make sure

we take the straight road. So we understand that, but we disagree with them on this particular case.

As a lawyer, I have to promote my personal interests. One is my business, and the other is my particular political bent, which is Republican-Conservative. George Pataki is the governor of this state, and it's an honor to have him in my house. He was in my house when he was an assemblyman. He was in my house when he was a senator. He was in my house when we were watching basketball games together. And certainly he's going to be in my house—if he'd like to be—when he's governor.

w.o.: But does it help you or hurt you that your wife is the DA?

A.P.: It hurts. Jeanine's being the DA is not an asset to my business, and I have had to give up innumerable business opportunities strictly because of appearances. I might even tell you this, which we haven't discussed with anyone: I was called recently to represent certain associations to do a transaction in Westchester for Hunt's Point, the fish market, which was looking to acquire a new site in Westchester. We turned down the project simply because there was too much negative press about it.

w.o.: So if your wife hadn't been the DA, you would've attempted to take that?

A.P.: Well, I certainly would have looked at it more closely. Similarly, there were other projects in Westchester that people have come to us with, and because they are public/private ventures with the county, I passed simply because of the criticism I went through with other projects I've been involved in.

w.o.: Is it hard for you sitting here in the spotlight?

A.P.: No. I'm just waiting for you to nail me! I'm only kidding. Actually, this is not my style. I'm comfortable though with you, Bill.

w.o.: Does your friendship with the governor help you or hurt you?

A.P.: I think it's similar to Jeanine's situation in that you have to be concerned, not just for your own particular interests but also for the governor's. You have to be concerned that you do not in any manner, shape, or form embarrass him and his office. You can't lead people to believe that because you know the governor you'll have an advantage over anyone else. If we do help people raise monies for the Republican Party, we always ask them for one thing: don't discriminate against us because we help you. And

isn't that what politics has come down to? The more you help people, the less you can do.

W.O.: Joe Pisani, a former state senator and a great admirer of yours, has had his problems but has survived all of it and is now practicing law again. He points out that you're a high roller but you haven't forgotten. I saw you at that groundbreaking for Home Depot, and all of the townies were embracing you and you were kissing them, like the neighbor who made good. You can still walk those streets.

A.P.: You never know when you'll be back on them. As far as I'm concerned, what is there to forget? If I'm lucky enough or you're lucky enough to be successful, it seems to me that's something—I don't mean to be Pollyanna about it—God has blessed us with. The people we came from are the people that we are. Just enjoy what you have and don't forget what you're about. I can never be a white Anglo-Saxon Protestant. I am an Italian from the streets with a humble background, and that's it.

W.O.: It just fascinates me and so many people here in Westchester that the woman with whom you reside is so accomplished and has so many gifts, there are those out there who think that she can go beyond Westchester. Do you want her to do that?

A.P.: That's a difficult question. Let me try to answer it this way. First of all, I want her to do all she is capable of doing. I mean that from the bottom of my heart. And I also want her to do everything that she wants to do. However, with that comes certain qualifications. There is the issue of the children. Our children are six years old and nine years old. I would not be comfortable with Jeanine running for Congress. It seems to me that maybe somewhere down the line Jeanine should be thinking about Congress. She has a great deal of talent. When I speak to her about this subject, she unabashedly says she is delighted to be the district attorney. I remember when we were first married, she wanted to be the district attorney. She admired Carl Vergari. Today I say to her there may be things opening up in the future. The governor could run for national office. Senator Daniel Patrick Moynihan may decide eventually not to run. If Bob Dole wins, they may be looking for someone for attorney general of the United States. You never know what life will bring, especially to a woman like Jeanine who is so talented. But the fact of the matter is, to this point

anyway, she has expressed no interest other than in the district attorney's position, and I'm happy about that.

I want to tell you a cute anecdote about my son. My son, Alex, who is six years old, was sitting at the kitchen table having breakfast, and he said to Jeanine, "You're the district attorney, Mom." She said that she was. He said, "I want to be the district attorney when I grow up." She said, "That's great, Alex." And then he asked if *boys* can be the district attorney!

w.o.: That's a wonderful story. Tell me about Donald Trump and David's Island. It's been empty, rotting in the Sound for years. A guy named Gordon Marshall from Mamaroneck tried to develop it for years. The environmentalists killed it. Yet you and Trump want to develop it. First of all, have you met *Marla?*

A.P.: I have. She's a lovely lady. The interesting thing about Marla that people can't appreciate—besides the fact that she's obviously one of the most beautiful women you'll ever meet—is that she happens to be exceptional in terms of her personality and her warmth. She comes from just outside of Dalton, Georgia. Her mother looks about as young as Marla does. And she has a grandmother who is equally young looking. It's just a wonderful family and a beautiful baby, and the fact of the matter is that she's very *spiritual*. She is nothing like you read about in the tabloids. Donald happens to be a very lucky man. She's a great woman.

w.o.: Now Donald Trump and Al Pirro have designs on David's Island. You're working with Tim Idoni, the mayor of the city. How do you rate him?

A.P.: I think Tim Idoni is an exceptional person. It's essentially a Democratic council, and Tim is a very conservative individual. I am a Republican, but I have been able to go to that council and work with that mayor apolitically—irrelevant as to background, politics, or anything else. He is strictly business when it comes to the development of the city of New Rochelle. He truly believes economic development is the key to raising the socioeconomic level of the city.

w.o.: How about Al and Jeanine Pirro: would you move out to David's Island?

A.P.: Well, we're pretty satisfied where we are right now. But if Donald made us a good offer on a piece of property, I might build a home on the water.

w.o.: How's Andy O'Rourke doing?

A.P.: Andy is a great county executive. He is doing wonderfully well. I think eventually he's going to the bench and a judgeship somewhere down the line. He's much more of a statesman and much more of an intelligent attorney than people know.

w.o.: Whom are you backing for president?

A.P.: Dole.

w.o.: Has he got the legs?

A.P.: He's got the legs, and he's got a wife who has more energy than many other former senators and leaders in this country.

w.o.: You should know on that subject.

A.P.: Jeanine's a great woman too.

w.o.: Give our best to your lady, Albert J.

A.P.: Thanks, Bill, I will.

w.o.: Will you bring Trump someday?

A.P.: Anytime you want him, I'll bring him.

w.o.: How about Marla?

A.P.: If it's appropriate, we will.

<div align="right">May, 1995</div>

Interview with Barry Slotnick

The famed defense lawyer from Scarsdale has represented some good guys and some of less than stellar reputation. But he believes everyone is entitled to the presumption of innocence. When he's not performing in the courtroom, Barry Slotnick displays a keen interest in matters political. Cindy Adams is crazy about him. And so am I. He's active in the civic life of Westchester and a man of faith who, with his wife, Donna, takes a lead role in Jewish and environmental affairs.

W. O'SHAUGHNESSY: American Lawyer magazine has accused him of being the best criminal defense lawyer in the Republic. Ditto the New York State Bar Association. Some of the people he has represented include Bernie Getz, the subway gunman; former congressman Mario Biaggi; and John Gotti. I'm talking about Barry Slotnick, Esquire. *I'm* asking the questions now. You're on the witness stand. How does it feel?

B. SLOTNICK: I'd rather ask the questions.

W.O.: Is it true you went for twelve years in courtrooms all over this nation and didn't lose a trial?

B.S.: That's true. I tried about sixty cases over that time. I won every one and felt invincible. Then I finally lost one and went back to the drawing board and continued to win thereafter.

W.O.: How did you feel when you lost?

B.S.: I disappeared for about two weeks. It was very lonely.

W.O.: Who was the defendant?

B.S.: The defendant was a man accused of a crime dealing with white-collar economics.

W.O.: What did Donna Slotnick say?

B.S.: Donna Slotnick said, "It's going to happen. You can't win all the time." And I refuse to accept that. I just feel that you *can* win all the time. If you've got enough talent. If you've got enough

money, which is part of the system. If you've got enough temerity to go in and unleash everything that you can do regardless of what it means in a courtroom, regardless of what the judge may think or may not think, you can win. I don't believe there's a criminal case out there that can be lost.

w.o.: Here's the question for the hundredth time. Have you represented people you knew were guilty?

b.s.: I've represented people who I knew, without a doubt, were guilty because they told me they were. Does that affect me, which is the next question? Only in one way: I don't put them on the witness stand. But in terms of putting them on trial, that's not a problem to me.

w.o.: How can you free up somebody and let them walk around if they've done some terrible thing?

b.s.: This may sound a little strange, but I'm a *special* citizen of this republic. I am liberty's last champion, because if you or anybody else is accused of a crime, the accuser has to prove you guilty beyond a reasonable doubt, and that's an important circumstance. If you're guilty and you're convicted on lesser evidence because the lawyer feels you're guilty or the jury may have read something about it as they go out of the courtroom setting, that's a very dangerous situation. If somebody who is guilty can be convicted on lesser evidence, so can any journalist or any politician or any citizen of this country.

w.o.: It doesn't matter if you're guilty or not?

b.s.: Absolutely not. The prosecution has got to *prove* it. The accuser says, "I accuse." Now prove it beyond a reasonable doubt. And if he can't, that man or woman, no matter how venal or terrible, must walk out of that courtroom a free person.

w.o.: Is it true that prosecutors move only when they have the cards stacked?

b.s.: No, not really. Prosecutors sometimes move because of bad judgment or publicity or pressure put upon them by citizens groups or the media. And then, of course, they do move when they have the cards stacked. But there are a lot of factors that go into the judgment of the prosecution.

w.o.: You are well respected in your home heath of Westchester. You're a man of faith, and in politics you've shown a generous interest in the Republican Party. You and Donna have worked

long and hard to clean up Long Island Sound. I hear you've almost given up on that.

B.S.: We sold our boat. I just wasn't going to ride around in filth, and that's what the Sound is like.

W.O.: I thought it was getting better.

B.S.: Maybe that's what we've been reading in the newspapers, but peek out when you're on the waters of the Sound and you'll see the garbage. I understand there's a lot of bacterial waste going into the Sound too. I don't know where it's getting better; maybe in some cove someplace, but certainly overall it's not.

W.O.: Do you swim in the Sound?

B.S.: No.

W.O.: You'd never jump in?

B.S.: Not unless I lost my sanity.

W.O.: Do you ever see any bodies floating around there?

B.S.: No, I haven't. The Sound needs a massive federal program. It needs money. It needs people to come in and clean up around the shores.

W.O.: I thought you were a conservative Republican. Now you want to throw big federal bucks at it.

B.S.: I *am* a big conservative Republican, but I also realize that when it's a choice of a principle and who can do the job, I want the job done. The only people who can do that job is the federal government because the state sure as hell can't do it. Nita Lowey, our representative in Congress, talks about doing a good job in cleaning up the Sound. I don't think she's doing a good job. I don't see any improvement whatsoever.

W.O.: How are the Slotnicks of Scarsdale going to vote? Joe Dioguardi or Lowey?

B.S.: There's no question that this Slotnick is going to vote for Dio-Guardi. I can't speak for the other Slotnick. Because I know that I can sit back and talk to him and discuss the Sound and other issues and get a reaction. I know what he's going to do. With regard to Nita Lowey, I'll get a lot of yeses, but I don't see a lot of action.

W.O.: We had once great giants in our seat in Congress: Ogden Rogers Reid, Richard Ottinger. Do you think Dioguardi is in that league?

B.S.: No, I don't think he's in that league. He says things sometimes

that are not the smartest, but he's a constituent kind of person. If you call him, he'll do something.

W.O.: Why didn't you run?

B.S.: I almost did run. I got a call one day from a former congressman by the name of Mario Biaggi. Mario was at that point in Dallas when he was on "vacation." He called, screaming, saying, "What are you doing? Are you crazy? You can pick up the phone and have one hundred congressmen jump at your call. Do you want to be at the other end of that? If you want to get things done, stay where you are. Don't go to Washington." And I thought about it. He was right. He convinced me, and I stayed out of the race.

W.O.: What about Mario Biaggi? He is getting murdered in the press, including *The New York Times* and *The Journal News*. He's going to be running again against this guy Eliot Engel from the Bronx.

B.S.: Mario decided that's what he knows and that's what he wants to do. He was a great congressman. He was a constituent person. When I represented Mario, I didn't climb into a cab or meet an elevator operator or a doorman, in or out of his district, who didn't have a Mario Biaggi story about how he helped them or their family. Mario is made for the job.

W.O.: Did he take the money?

B.S.: I don't believe he took any money. As a matter of fact, in the case that I tried for him, he was acquitted of bribery. No, I didn't try the Wedtech case for him. I tried the first case in Brooklyn! But he was convicted of obstruction of justice because there was a tape that the jury interpreted in a bad way against him. And he did his time. I don't think that made him a terrible crook. That made him a pretty good congressman. Had he been returned to office, he'd be a super congressman again. Certainly he doesn't owe anybody anything, and he has one concern at this point of his life . . .

W.O.: His reputation?

B.S.: That's right. When people accuse him of falsifying a reaction for a lesser sentence, that's nonsense. There is—and I think I've heard some pretty smart people say it—real pain that pervades his life when he walks. He's not in the best of health because of his legs. He's on crutches now, but he knows issues. He's been in Congress for a long time. He'd be a credit going back there.

w.o.: I happen to agree with you. Whom do you admire in public life today?

B.S.: The president of the United States. President George Bush has tried very hard, and he's done some masterful things. He's getting a bum rap on the economy. In foreign affairs what he's done personally will take us out of a troubled world to what will be, ultimately, a world of peace. I like a fellow by the name of Al D'Amato. Alfonse is superb. He is a great senator. You talk about constituent service. If you call his office and tell him you live in Massachusetts, if it's a worthwhile effort he'll go out there and help you. He's smart, and he knows the issues. He doesn't always side with his party. He's probably the one senator who has voted against the president's programs more than any other in the United States.

w.o.: You're a deeply religious man, I am told. Jewish people are not so strong on Bush.

B.S.: They weren't because they felt he was putting tremendous pressure on Israel. The first thing that we get hit about is, what about Israel? What about Bush? What about his policies? I say, "He's the president of the people of the United States. He's not the president of the people of Israel." He's doing what he thinks is right for the United States. He's also going forward and playing politics toward a goal. He wants peace in the Middle East, so he's pressuring Israel. Politics is not always an open affair in which you can sit back and say, "This is what I'm going to do." Sometimes you have to play poker. George Bush is a great poker player, but ultimately he plays the right card.

w.o.: Did you ever take a client whom you didn't like personally, toward whom you had a visceral . . . ?

B.S.: No. The worst case I ever had was someone who walked in and retained me. A week later my investigator came in and told me this guy was a member of the Nazi Party. I called him in and told him he'd obviously made a mistake. I gave him his check back. He asked me why I gave the check back, and I told him he probably didn't know that I was Jewish. He said he did know that. When I told him that, subconsciously, I wouldn't be able to represent him, he said, "Mr. Slotnick, that's my business, and I just don't have that concern. Please, I know you're Jewish. I also know you know, now, who I am."

w.o.: You were representing a Nazi?

b.s.: Yes. Many, many years ago. He was an idealistic young lawyer. And I won for him, too. It was very distressing and distasteful for me.

w.o.: What did your friends say?

b.s.: My mother used to call me very angrily. My friends were not happy about it. I felt that I had at that point an obligation, as I said, as "Liberty's Last Champion." I absolutely detested him, but I felt he had been wrongly accused, and I couldn't allow that to happen in this country. That's an even greater danger than he poses.

w.o.: George Bush has been going around trashing lawyers. He says we're a litigious society suing the hell out of everybody. Is he right about that?

b.s.: I sat at a dinner, and when I heard him say that, one of my partners said, "How can you support him?" I said, "Because he is right." We *are* a litigious society. We do sue each other too much, and that's got to stop. It's all being battled out in the courtrooms. We spawned a lot of lawyers and they will be busy, and the fact of the matter is that we are putting people in bankruptcy. We are putting companies out of business as a result of being overlitigious. There has got to be an even-handedness about this.

w.o.: Do you do divorces?

b.s.: I take anything that will get me into a courtroom so I can deal with the issues in a courtroom and look mean and win for my client.

w.o.: But how do you feel about breaking up marriages?

b.s.: I don't feel good about breaking up marriages, but then again I don't break up marriages. At least, I don't know of any that I have. I'm sure my wife would have told me about it. When the people come to me, they are already broken up or gone. We talk about reconciliation, but that's usually quickly passed over. They're involved in the loot. That's why people go to matrimonial lawyers or they come to us, because they're interested in one thing: money.

w.o.: Did you ever go to a conference or a convention for matrimonial lawyers?

b.s.: I've been there as an outsider because I use matrimonial lawyers to prepare papers and documents. There is a second issue: hate

and revenge, which are all the same. Unfortunately, people put in that position do hate and want revenge, but it's the money that's really the major issue.

w.o.: But when you take on one of these cases, aren't you thus an instrument of that hate and that revenge?

B.S.: Absolutely, but lawyers are there for the purpose of protecting their clients. If a man or woman, former husband or former wife, thinks that they're entitled to something, we talk sense to them. We say this is right and this is wrong. No one is going to force me into continuing in a case in which I don't believe that what I am doing is correct and proper and I'm not protecting somebody. I'm not going to go out and restrain people for the sake of destroying them because someone is paying me to do that. I'm not a gun for hire. Lawyers can do terribly destructive things. Lawyers are more potent than hitmen with Uzis. Lawyers can tie you up. They can restrain you. They can embarrass you. They can sue you. They can do anything they want up through the court system, to a point. Sometimes people can't afford to reach that point of untangling themselves. I've been called a bomber, but there's a difference between being a bomber and being someone who deals with matters that should be sanctioned. I have never, ever instituted litigation or pursued an issue that I felt was inappropriate or improper.

w.o.: I'm stumped on you because your very name strikes fear into the hearts of those on the other side. But I know people who know you, and they say you are a gentle man and a good man and you worry about things like who's doing what in Long Island Sound. Is there one Barry Slotnick up here in Scarsdale tonight and another Barry Slotnick tomorrow morning in the office?

B.S.: I hope so. We all suffer from massive schizophrenia. Some of us have more than others. When I walk into a courtroom, there's a transformation. I dig in and I know that if I have to hurt somebody, I will, in the courtroom, for the benefit of my client. In my general life, in my community, with my family, I'm not looking to do battle. I don't want to hurt anybody. I'd like to improve things.

w.o.: Did you ever have to have police protection?

B.S.: On one occasion twenty years ago, when someone bombed my office because they didn't like some of my clientele, the police

"imposed" themselves on me. I asked the police to leave, but the circumstance made me feel I was doing my job well.

W.O.: Your son and heir aspires to follow in his daddy's footsteps.

B.S.: I'm not sure if he's going to follow in my footsteps. About two years ago my son Stewart called me and told me he's going to law school. And I said, "You know, Stewart, if you want to go to law school, go to law school." What he's going to do with it, I don't know. I have never encouraged him or discouraged him. I'm not in a family business. He knows that if he is going to do the law, he's got to do it well and do it right.

W.O.: You appear before judges all over the nation. Are there a lot of hacks on the bench?

B.S.: That's a relative term. There are some judges who are unbelievably competent, scrupulously careful. We can start with Sol Wachtler. The chief judge of the state of New York is pretty good. We've got a Court of Appeals that's dynamite. Those judges are appointed by Governor Mario Cuomo. We've also got appellate divisions all over the place with judges. I'm not going to name names because all that's going to do is get me in trouble.

W.O.: What about the Supreme Court?

B.S.: The people elect a president. He comes in with a political philosophy. He's going to appoint people he believes match his political philosophy. And that pendulum swings back and forth. What happens is that the court turns out decisions that last for a long time and have a bit of a taint of a political philosophy, but it works and it has always worked. It's what makes for a very free country.

W.O.: Who would *you* put on the Supreme Court?

B.S.: I guess Bill Clinton is going to put Mario Cuomo on the Supreme Court if he gets elected. The governor will be an interesting justice. There are a couple of issues I don't agree with him on. I'm not too sure I agree with him on the death penalty. I'm not too sure that I agree with him on the abortion issue, although I'm not too sure I know what his position is.

W.O.: You think the state should kill?

B.S.: No, I don't think the state should kill. I think there should be a penalty imposed in which death is an alternative under a lot of circumstances that are very protective. I don't think anybody

should kill. That's a bad term, Mr. O'Shaughnessy, and you know it.

w.o.: But you're for the death penalty.

b.s.: I believe that we should have a death penalty in this state, yes.

w.o.: And you don't overlook the fact that every industrialized society has given it up?

b.s.: We have a death penalty in some other states. It's important in this time when crime is so rampant that the population knows there is a penalty.

w.o.: What would some of your clients say if they knew you were for the death penalty?

b.s.: They do, and they're not pleased by it. Fortunately, we really don't have that as an issue because in this state there is no death penalty. Senator D'Amato passed a bill mandating a federal death penalty, and I haven't had any of those cases yet. And if I did I would fight like crazy to make sure my client didn't get the death penalty. There is a difference between defending against it and understanding the need for it. At this time, the people need it. We have too many locks and too many burglar alarms and too many guard dogs and too many people who are afraid to go out at night.

w.o.: What you want on your gravestone? "Liberty's Last Champion"? It has a pretty nice ring to it.

b.s.: I wouldn't mind that as an epitaph, but I would hope that there would be somebody else so I wouldn't be the "last" champion. And as long as there are lawyers that come out of law school, Liberty will have lots of champions.

Fall, 1994

Interview with
William Dennis Fugazy

William Dennis Fugazy is an authentic and beguiling New York character.
A friend to governors, mayors, judges, and cardinals, Bill Fugazy also pals
around with Lee Iacocca and George Steinbrenner. Despite a somewhat
checkered career as a businessman, the charming Fugazy remains a major
power-broker. He has his detractors. But I am among his many fans and
admirers.

W. O'SHAUGHNESSY.: Your committee, the National Ethnic Coalition of
Organizations, also known as NECO, sounds like a *candy*.

W. D. FUGAZY: Well, it's sweet, alright. And we do a lot of good things.

W.O.: What about race relations in New York City, a city the Fugazys
know so well?

W.D.F.: I think it's a very serious situation. As you know, Mayor David
Dinkins appointed me to study Crown Heights. I tried to do the
best I could, and we did a lot of good. I don't think people know
just how serious it really is. Young, underprivileged girls and boys
learn these ethnic hatreds, and these cause fights and disputes
that get to the families. That's where a lot of this crime comes
from. We've got to stop it. And the way to stop it is with programs
such as the Council for Unity, which lets them see that we're all
human beings. Whether you're black-skinned, Chinese, Italian,
or Irish, we've got to learn to live together.

W.O.: What is the big problem, Bill? Is it black against Jewish?

W.D.F.: That is so. And it is also black against Italian and Spanish. The
Dominican–Puerto Rican situation has gotten very serious. If you
talk to the Police Department, the experts on this, they will tell
you the crime that starts with young eight-, ten-, twelve-year-olds
is what builds up in the neighborhood. There shouldn't be these
problems because every one of these ethnic groups has youth pro-
grams, and in the youth centers, there are no problems.

w.o.: Haven't you always had these conflicts and tensions? Why do you bother trying to fix them?

w.d.f.: You just have to do it because the city, the state, and the country are going to go to pieces if we don't. We must learn to live together. We're taking the children out to Ellis Island, and we think that maybe they'll get the message out there, that this is what America is all about, that every group that came over here learned to live together. We have to learn that or we're not going to have peace.

w.o.: Trouble seems to follow you, or you follow trouble. What about the problem up in Briarcliff with the Irish community?

w.d.f.: That's a terrible situation. Some of the townspeople are picking on the Irish and coming out with statements that the Irish are going to urinate on the lawn and ruin the town. It's so ridiculous. The Tara Irish group is doing a commendable job of planning to run the old Briarcliff College as a cultural center. And prejudices like this are cruel and wrong. The courts, thank God, have been very strong in recognizing this as prejudice.

w.o.: Is it a not-in-my-backyard question?

w.d.f.: It's a total *bigot* program! There's no reason for it. The townies said the Irish were going to run soccer games there on Sundays with big crowds. They're really going to have children playing soccer there, and it will probably draw forty cars. Like a parent's day at school. This is strictly snobbery and ethnically motivated. The public officials have a little egg on their cheeks up there.

w.o.: You have an opinion about many of the current issues of the day. You know all the players. What about ABC-Disney's decision to dump Bob Grant?

w.d.f.: I believe in the First Amendment, but I certainly don't think you should use the First Amendment to create ethnic slurs. I've been very fond of Bob Grant at times, and I've been very mad at him at times. I was particularly mad at the attacks he made on Mario Cuomo, which were unjustified. He got mad at me because I defended Dinkins, who I think is a great American and a great mayor.

w.o.: How did you feel when Grant called him a "locker-room attendant"?

w.d.f.: That's bad. We just had this big battle against *The Village Voice* after they called Senator Joe Bruno a "wop" and a "guinea."

There's no place in our society for such insults. I love to listen to Bob Grant's program. But I think he was *wrong*. Should ABC have fired him? That's a tough punishment to take a man's livelihood away. Should he have been warned? I wish it could've been "corrected." I certainly don't agree with what he said. I think the death of cabinet member Ron Brown was a terrible loss for this country. He was a great man. I admired him.

w.o.: Is Bob Grant a bigot?

w.d.f.: I don't think he's a bigot. I think he gets on a cause sometimes and expresses himself with language that makes him *sound* like a bigot.

w.o.: What would you say to Mike Eisner?

w.d.f.: I know Mike. We gave him our Ellis Island Medal of Honor. I think it was too severe what they did to Bob Grant. If it had been me, I would've called Grant in and said, "We don't think this is right. Nobody is glad that anyone died in a plane crash. Nobody wants to see anyone die needlessly. I think you delivered the wrong message, and you should correct it." I think that would have been a good first step.

w.o.: You're a friend of Mario Cuomo. How do you feel when Grant calls him a "lowlife" or worse?

w.d.f.: I could never take that, and he knows how I feel. To call a man like Mario that is wrong, even if you don't like his politics. As an Italian, Bob Grant should've been proud of what Mario Cuomo has accomplished. I am, and I think most of the Italians in this country are.

w.o.: You're Mr. New York. How is Rudy Giuliani doing, and is he going to be reelected?

w.d.f.: Rudy is the greatest mayor—and I know my good friends David Dinkins and Ed Koch will get mad at me for saying this! Rudy has been the most effective mayor we've had. He's hard-nosed. He's doing the job. I think he comes across sometimes as too hard and too prosecutorial. But in the long run, people are going to realize that he is a great mayor who is facing the music. Nobody works as hard as this man.

April, 1996

Interview with Ossie Davis

Actor-playwright-activist Ossie Davis is one of my great heroes. Malcolm X used to sit in Ossie's living room and pour out his soul. I can understand why. Ossie Davis is a genuine, authentic American original who comes as close to sainthood as anyone in this book.

w. o'shaughnessy: Tonight's guest is one of the most extraordinary human beings I've ever met. He is a playwright of great renown. He is one of the greatest actors we've ever developed in this country and an author of a new book just out by Simon and Schuster. He is a movie and television star: you may have seen him in *Evening Shade* this very week. But he's more. He's our Westchester neighbor. Please welcome into your home our neighbor, Ossie Davis.

We think of *Purlie Victorious, Raisin in the Sun,* and your wonderful shows on PBS, and now you're on the network with Burt Reynolds. What kind of a guy is Burt Reynolds?

o. davis: He has that quality that makes him a neighbor and a friend no matter what the circumstances are. I've known him about twenty-five years. And I've respected him not only as a talent but also as a caring man. It's a joy and a blessing, really, to be able to work with him.

w.o.: Who are some of those you admire in the theater these days?

o.d.: In addition to Burt Reynolds, the others in our cast: Charles Durning, Elizabeth Ashley, Hal Holbrook, to mention the people I know intimately. But I saw something the other night with Katherine Hepburn, who is still able to sparkle, and I've always loved her as an actress.

w.o.: Do you know Katherine Hepburn?

o.d.: I've never met her, but the theater is a family. To belong to the

theater is to belong to Westchester. We're neighbors in a sense. I admire her greatly.

w.o.: Who are some of the great actors, present company excepted?

o.d.: One gentleman who may be underrated because we don't see him enough now is Sidney Poitier, who's still a dynamite performer. My Lord, you put me on the spot, forcing my brains to work. I won't have the answer to who are some of my favorites until I'm away from here, and then I'll say, "I should have told Bill this. I should have told him that."

w.o.: There's a new movie out. I hear it's wonderful. It's by your friend, Spike Lee, called *Malcolm X*. You gave the eulogy for Malcolm when he died. Do you remember what you said?

o.d.: I remember some of the things I said. I said he was our black shining prince and that now that he's dead, what we put in the ground is not a man but a seed and someday it will come back and we'll recognize it then, for he was and always will be to us a black shining prince. Ruby and I had known him intimately. Of all the civil-rights leadership that we met—and we met almost everybody—Malcolm happened to be the one we knew best. I had a tremendous respect, admiration, and love for him. On one occasion near the end he drove up to our house in New Rochelle. He came alone and drove around the house a couple of times so as to get to the house exactly at ten o'clock. He came in and sat down with his back to the wall, and you could see on his face the agony and sadness. He desperately loved Elijah Muhammad, the man who had become a father to him and had sort of spiritually engineered his reconstruction as a man. The break came with Elijah, and Malcolm never fully recovered from that. When he came to our living room, Ruby and I just listened to him talk, and he just seemed to address the question of what that man and that influence had meant in his life. He understood better than anyone else what was going on. He had no recriminations for the old man, even at that time.

w.o.: Do you think he knew he was going to be killed?

o.d.: Oh, yeah. He had said on many occasions, "I'm a dead man." I think he even told Mike Wallace that on television. And we who knew him from time to time would suggest, "Hey Malcolm, why don't you leave and go to some other place?" But he always had some plan, some project, something he wanted to achieve.

w.o.: Malcolm X wasn't perfect, though.

o.d.: By no means. But what there was about him more than any-thing else was a great capacity to grow and change. And with him, it was almost like becoming somebody else right in center stage. He would drop one persona and achieve another, not because he was slick or anything, but if in pursuit of truth he found that what he had been standing on the day before was false, he would aban-don it, and he would try and arrive at another position.

w.o.: Was there a lot of anger in Malcolm X?

o.d.: I never knew Malcolm to be truly angry. I was with him on many occasions when there were flashes of fire. He was one of the most witty, charming, and funny human beings I've ever met in my whole life.

w.o.: So you think Spike Lee did all right with the movie?

o.d.: Well, the truth of the matter is, I haven't seen the picture yet. Ruby saw it. As a matter of fact, I was the master of ceremonies for the world premiere, but immediately after that I had to leave the theater and get on a plane. I've been busy. Ruby said she's going to take me to see it as soon as I get back home, and I'm looking forward to it because she said it was quite exciting.

w.o.: You produced some memorable television about Dr. Martin Luther King, Jr. You played his father. What was Dr. King like?

o.d.: Dr. King was a sort of soft-shoe. He was very open and warm and down-home and smooth in the best sense of those words. He made himself right at home in your affections and in your under-standing, and he counted on you to love him and to give him your best.

w.o.: He's another one among us who wasn't perfect.

o.d.: Absolutely. By no means was he perfect. But I think Dr. King was one of the great Americans. A man we would add to the list with Thomas Jefferson and Abraham Lincoln and Franklin Roose-velt. I say this because Dr. King had time not only to live but to think and to write, to formulate plans and ideas, and he sort of left a rough blueprint for those of us who came along after to fol-low. Malcolm never had that chance. As a matter of fact, on the day Malcolm was killed, he was supposed to be unveiling what he had in mind, the way he saw the struggle going. Of course, he never got to reveal it. We love Malcolm because of his spirit and his individuality and his sparkle and inspirational quality, but

Martin gave us a plan and a philosophy and a reinvigoration of our religion. Martin was very deep and spiritual, and that's why I credit him with being one of the great Americans.

w.o.: Not too many people know this about you, but you still go out and preach almost every Sunday.

o.d.: I was hoping you wouldn't give that away. I've been accused of being a "bootleg preacher" for a very long time. There is a lot to be said, particularly to young people, and I want to say it. Ruby and I go to where young people are. Just this last Saturday we were in Lynchburg, Virginia, at Randolph Macon College for Women, and we performed and talked and carried on. And next week we'll be some other place. It's preaching and teaching, but we never tell them that's what we're doing. We just say we've got a few jokes, a few poems, a few little things we want to share with you. There are certain values too important not to be shared with the coming generation.

w.o.: Are those values in this new book, *Just Like Martin?*

o.d.: It's about a group of young people in Birmingham, although I don't name the city, in the year 1963, one of the most violent years in our history, and how they reacted to Martin Luther King, Jr. Our hero loves Martin so much that he wants to be just like him, including his nonviolence, and some of his friends test him. "You want to be nonviolent? Well, then. . . . " *Boom!* So it's about young people reacting to Martin and to his message, which was love, struggle, and, above all, nonviolence. How do you explain a concept like nonviolence, which a lot of us grownups have to grapple with, to young people in terms they can understand without making it namby-pamby and holier-than-thou? Making it, rather, an exciting adventure for their young souls? I tried to do it in the book. I hope I succeeded. The grandchildren have said it's a success, so I hope I live up to their expectations.

w.o.: An editor at Simon and Schuster told me this week that they've been trying to get you to do a novel for years. Why did you suddenly decide to do it?

o.d.: It started, Bill, when I was approached by a man who writes, stages, and produces plays for young people, about Thomas Jefferson, George Washington, Abraham Lincoln, and all. He called me and said, "Ossie, we want someone to do a book for young people on Frederick Douglass. Would you like to do it?" So I did the play,

and it was quite successful. And a publisher decided to publish it as a book. Then after that, it won prizes and is into a second printing. So they asked me to do another one. And I thought I'd like to do one on Langston Hughes, who, as you know, is one of my favorite people in all the world, my favorite poet. So I wrote it. Then it was suggested that maybe we should do a play that young people coming up could use to educate themselves about what it was like for young people in the sixties, about how they related to Dr. King. So I set out to write a play. But the canvas got too big. I couldn't present it all on stage, so I drifted into the novel form.

W.O.: I know you and Ruby Dee have opened your home in Westchester for all sorts of causes. Why don't you live up in Greenwich? You're raking it in. Why do you still hang out here?

O.D.: In the first place, New Rochelle is close to New York, and New York is important to us. It's where we got our theatrical training, and we didn't want to get too far from it. But I have been in New Rochelle since 1963, and it is home, and all my roots are there and my memories and my marriage, and my children grew up there. I can't imagine anything tearing me away from that. It would be like a tree that you pull up by the roots. I'm not a casual person. I'm not a drifting person. I have to find a place to sink roots. I think it's healthy. I think we all should do that, and I'm lucky enough to have understood it. And Ruby is the same way. Home as a refuge. Home as a nest. Home as a place of inspiration. Home as a place of ingathering. In a few days the Christmas holidays will be with us. All the children and seven grandchildren will come home. And my mother who is alive at ninety-four and lives in Mount Vernon will be brought over, and she will preside over the home spirit of Christmas for us.

W.O.: You know you cause a lot of whiplash, you and Ruby Dee. I know more people who have gone down Pinebrook Boulevard and said, "Was that Ossie Davis? Isn't that Ruby Dee out walking?" Do you still take your constitutionals?

O.D.: The doctor says it's necessary. I've grown to appreciate the importance of exercise. Ruby did long before I did. You don't have to bend your muscles unless you want to or run a thousand miles, but just that walk—talking to yourself, looking at the birds and the bees and the ducks and the swans, communicating with them and with nature. It's good physically. It's good spiritually. It's also

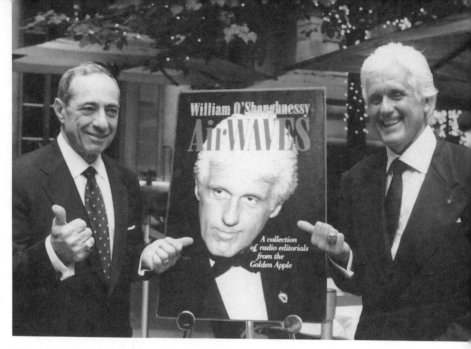

(Above): **All Thumbs.** Governor Mario Cuomo congratulates the author on the publication of his first book, *Airwaves*. (Below): **Icon.** The author and New York broadcasting icon Joe Franklin.

Famous Sons. Former HUD Secretary Andrew Cuomo and the late John F. Kennedy, Jr., take to the airwaves at Whitney Radio to advocate for housing for the homeless. As this volume goes to press, Andrew Cuomo is being talked about as a future governor of New York.

Icons of the Empire State. Senator Warren Anderson of Binghamton (left) and Governor Malcolm Wilson of Westchester. Anderson was majority leader of the New York State Senate, and Wilson was lieutenant governor all during the Rockefeller years.

Incumbent Governor. New York Governor George Pataki, Nancy Curry O'Shaughnessy, and the author. Pataki surprised everyone—including the author!—by defeating the articulate Mario Cuomo in 1994. Although the author did everything to derail Pataki's candidacy, the new governor extended the hand of friendship.

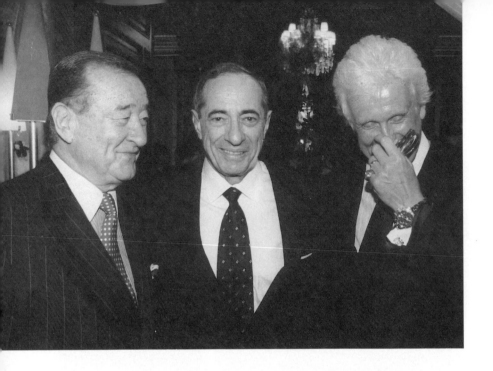

(Above): **Maestro.** Sirio Maccioni, America's greatest restaurateur, with two of Le Cirque 2000's patrons of an evening: Governor Mario Cuomo and the author. (Below): **Right This Way. . . .** (L–R) Mario Wainer, maître d' at Le Cirque 2000, the author, and Walter Weiss, long-time "21" Club maître d'.

Big Band Crooner. David Allyn has adopted our radio stations and visits often, bringing marvelous stories about his days on the road with Boyd Raeburn. *(Leonard Yakir Photography)*

(Below): **Rockefeller's Biographer.** The late Cary Reich, Nelson Rockefeller's biographer, receives an award from the author. *(Leonard Yakir Photography)*

(Above): **Broadcasting Awards.** Tim Russert, moderator of NBC's *Meet the Press*, presents an award for "Best Radio Commentary" to the author at the Sagamore, Lake George, New York. (Below): **Philanthropist.** The author with utility executive George Delaney, who led every charitable cause in Westchester during the seventies and eighties.

Holy Cow! Phil Reisman, the brilliant Gannett columnist, doing "research" for one of his witty essays on life in the Golden Apple. The author and Reisman are pals and friendly competitors.

(Above): **Off Mike.** The author doing his own "research" behind the scenes at the radio station. (Below): **Joe Candrea.** The author interviews the late Candrea, a daily "Open Line" caller who had an opinion about everything, but whose bark was worse than his bite. *(Leonard Yakir Photography)*

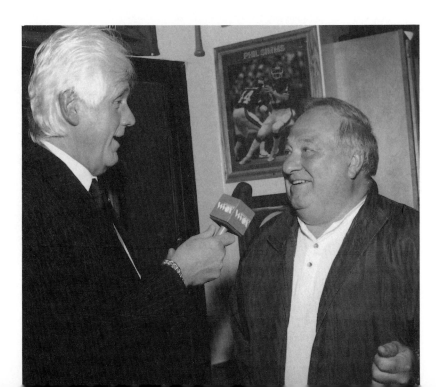

a sense of being home. I'm covering territory that my feet are familiar with, and every step I take says, "Man, this is New Rochelle, and you belong here."

w.o.: Just give us fifteen seconds on Bill Clinton. Is he going to make it?

o.d.: I think Bill Clinton is going to make it, but that depends upon the American people. I always, in a political sense, fall back on the true source of power in our Republic: the people. The country doesn't belong to the president or the Supreme Court or whomever we elect; it belongs ultimately to us. I truly believe that, and I think Bill Clinton will make it because I think he's open enough to be receptive to those waves of concern and love and care and anguish that will come to him from the people. If he goes to the White House and thinks that he has all the answers by himself, he won't make it. If, on the other hand, he's able to do what a lot of our great leaders have done—reach out to the people and say, "We're in this together. The problems are ours to share together. The promises are ours to share together. Let us do together what we cannot do separately"— and I pray that he does—then he will make it and the country will make it. If not, it's dire times ahead.

w.o.: Is it difficult being married to a famous actress yourself? Do you two compete?

o.d.: We compete, but not in a destructive way. We compete against an ideal of ourselves. The knowledge that you can do better. The knowledge that there is a temptation to loaf. The knowledge that there is a temptation to get by on your celebrity. She can spot it in me, and I can spot it in her, and we talk about it from time to time. I'm lazy and charming and I get away with a whole lot. But Ruby always says, "Ossie, you're skating."

In the dressing room and as we fly to and from engagements and as we're on the plane, we have our notebook and we're rehearsing. We're putting this piece here and that piece there, and we're remembering what happened the last time we got distracted or were talking too fast or too slow. In addition to that, Ruby is also a writer, and I am a writer, and I will generally give the manuscripts that I do over to her for her comments, and she will always give hers to me when she's finished. And we tell each other what we think about it, and then it's up to us to make the adjustments.

I'm from the South. I love language. I never say in one sentence

what I can say in five. Ruby is the other way around. So it would be difficult for us to work on the same project together because her way is to compress and mine is to expand. But once I have expanded, nobody in the world can help me get it back down to manageable proportions better than Ruby Dee. I've just written a play for Ruby, which we hope to put on this spring. I gave her the copy of it, and her first comments had to do with the number of pages. And I know that we're going to get that thing down from where it is—telephone-book proportions—to play-script size with her help.

w.o.: It's Christmastime, and not everybody is happy in the land. Does Langston Hughes have anything on . . . ?

o.d.: Oh, yes. Langston is appropriate for all occasions. Langston is a port to go shopping by, to walk a picket line by, to go to jail by, and Langston has written about those lonely people. And it is during the holiday that a lot of people are more lonely than ever before. This is a poem about loneliness and rejection: "Life Is Fine." I imagine this poem is about a young boy rejected by his love, and the poem goes,

> I went down to the river.
> I sat down on the bank.
> I thought about my baby and
> I jumped in and sank.
> I went down once and hollered.
> I went down twice and cried.
> And if it had not been so cold in that water
> I might of sunk and died.
> But it was cold in that water.
> Ooh it was cold.
> So I took the elevator sixteen floors above the ground.
> I thought about my baby.
> And thought that I would jump down.
> I looked down once and hollered.
> I looked down twice and cried.
> And if it had not been so high up there
> I might have jumped and died.
> But it was high up there.
> Woo-wee it was high!

So, you see, I'm still living
and I guess I will live on.
Now I might have died for love
but for living I was born.
And though you may hear me holler.
Though you may see me cry.
I'll be dog's feet, baby,
if you're going to see me die.
Life is fine.
Fine as wine.
Life is fine.

He chooses, at the end, life, no matter what, and that's the basic lesson. It's a good Christmas lesson, too. We must choose in the face of everything to reaffirm life: the story of birth in the manger, the symbolism, the sacredness of it. This is the season for us to refurbish our own inner nest and our own inner mangers, to start again, to be connected with that birth and to give it life, to give ourselves that one more golden chance.

December, 1992

Interview with Ruby Dee

When this great American actress takes her morning constitutional down Pinebrook Boulevard in our city, passers-by get whiplash: "Isn't that Ruby Dee?" It is. And she is.

W. O'SHAUGHNESSY: Tonight, another famous citizen of our home heath. She is possessed of a worldwide reputation in her craft. She's an actress of breathtaking range and a great writer as well: Ruby Dee.

Are you still out running in the morning?

R. DEE: I don't run anymore, but I do try to walk fast. I started maybe about twenty years ago, running. And then one icy morning I had an argument with Ossie—not a serious one—but I went out all "perturbed." It was a Saturday, and I broke my ankle, and since that time I've just been walking.

W.O.: Did you blame Ossie Davis, your husband?

R.D.: Yes! But also I blamed myself because I met Dick Gregory, who is a very well-known runner/walker, and he had told me not to run on *Saturday*. I don't know why he said that, but it stuck with me. It was a *Saturday* that I broke my ankle! It was a *Saturday* that a dog bit me! It was a *Saturday* that I tripped and fell another time!

W.O.: When you're walking along Pinebrook Boulevard, you're not on stage or before the camera. It's just you all alone. What do you think about?

R.D.: You know what I'm trying to do now? I'm trying to learn lines or I'm listening to a novel because I'm mad about books on tape. I've recorded quite a number of books myself. But if I'm trying to get ready to do a play or a film, it helps me to try to walk and do the lines at the same time. Walk and just talk to myself . . .

W.O.: You and Ossie have lived here and graced our neighborhood for so many years . . .

R.D.: We've lived in New Rochelle for thirty years, in Westchester for forty-three!

W.O.: You both are very accomplished in your field. You do television, you write books, you appear all over the country. Why did you pick New Rochelle? I can maybe see you in Greenwich.

R.D.: You know what, Bill? When I was living in a group in Harlem, and Ossie was in the Bronx in a house that was just about to fall down, we decided after we got married we were going to move to Long Island because everyone was moving to Long Island. And I never will forget an actor, a tall guy whose name is Stretch Ellis, said, "Why are you going to move to Long Island? Why don't you move to Mount Vernon?" So Ossie said, "Why don't we?" We hadn't any idea where to move. So we began to look in Mount Vernon. We found a little house on Cooley Place. It was owned by a German woman. In those days you could buy a house for $13,000.

W.O.: But you're making big bucks now. You can live damn near any place, even Bronxville or Bedford!

R.D.: We're very fortunate. We thank God there's nothing we think of that we need. Our main concern is having the resources to do the things we want to do beyond the jobs we do.

W.O.: This is a rare treat for me to have you all to myself. Ossie Davis is out of town. Where is he?

R.D.: He's in Memphis now, doing *Evening Shade*. He's also doing a part in a film called *The Quiet*. And he's done *Grumpy Old Men* with Jack Lemmon and Walter Matthau.

W.O.: What is the story on Burt Reynolds? Does Ossie like him?

R.D.: Oh, yes. They are very fond of each other. Maybe it's because they're from the same neck of the woods. They've worked together on a number of films. And it pains us . . .

W.O.: About the marriage with Lonnie Anderson falling apart?

R.D.: . . . because it was so unexpected. We like Lonnie so much and we like Burt and we like them together. And Quentin, the son. It was a surprise and a hurt. I remember when I got the news, I had an emotional reaction.

W.O.: Is it tough to keep a marriage together? You are two famous actors, two playwrights. You have your career. Ossie has his. But you've been together for a long time now.

R.D.: Oh, yes, I don't think there is anything easy about human rela-

tions worldwide, or in very small units like a family. I think love is a process. We learn to live together. The wedding is the fait accompli. But marriage is something that we continue to do every day. Of course, I think that if the things we do to make the marriage successful outnumber the times we divorce in the course of a day or a week or a month, then we're ahead of the game. But love is hard, I think.

w.o.: There are few men I admire more than your husband. He knows that and you know that. But I don't live with the guy. Do you two argue?

R.D.: Yes, we have arguments. I'm trying to teach him to argue better: don't change the subject when *I'm* winning!

w.o.: You mean you have to play fair even when you argue?

R.D.: Yes. And so I want him to be able to *fight* better!

w.o.: You are a *great* dramatic actress. I'll bet you can be a force to be reckoned with if you were angry or upset.

R.D.: Yes! Who of us is not a force to be reckoned with when we are angry? I've learned to be calm and tame that part of me. I grew up in the streets of Harlem. Early on, you see yourself in different perspectives. I learned to fight and beat up people and be tough and all that, but I try not to do that now. I try to control those impulses.

w.o.: There's a new book by Ruby Dee.

R.D.: Yes. Short stories and anecdotes. Ossie calls me a humorist, and indeed, I discovered that I guess I am. I like that book. I'm about to reissue it with some additions and perhaps do a one-woman show based on my one good nerve.

w.o.: You and Bobby DeNiro did a commercial for David Dinkins. What about the other guy, Rudy Giuliani?

R.D.: I guess I have not really investigated him. There's a gut reaction to the man, something about Giuliani I don't trust. I shouldn't say this because it's based on feeling, and that's not good enough. I should look at the man's record, but I'm committed to David Dinkins. I apologize for saying that, because when you say that you don't trust somebody, you should base it on some concrete proof. But as an actress I beg tolerance on that point because a great deal of things come to me just through the sensing of them, and when I've not obeyed my instincts, I've run into trouble.

w.o.: You and Ossie are always opening your home to all kinds of

politicians, but most of them are Democrats, I've noticed. Did you ever meet a Republican you liked?

R.D.: Oh, yes. As a matter of fact, I know Lionel Hampton. And you, Bill!

W.O.: Lionel Hampton is the only Republican you could think of?

R.D.: No. I know other people who are Republicans, but I really don't think there's much difference between Democrats and Republicans.

W.O.: Do you think Bill Clinton is all right?

R.D.: Yes, I do. I like his intelligence, his compassion, and I think he's trying to govern with wisdom. And he's married to a good woman.

W.O.: You like Hillary?

R.D.: Yes, I like her. First of all, a lot of people whom I know admire her. And I like her concern for people. The people in our world don't have many champions now, and I think she's a champion of people and people progress. I think our world is becoming so involved with mechanics and technologies that we're not paying attention to the human spirit. That's why we need a revolution.

W.O.: What do you mean "a revolution"? You'll make a lot of people nervous.

R.D.: A revolution in terms of our values. We need to care about ourselves and not what we can consume and not what we can get. We have to move away from "give me, give me" and "I got, I got." We have to look at the divinity of the human spirit. There is something absolutely astonishing that we're overlooking in our search for the irrelevancies.

W.O.: Your husband goes out on Sunday mornings and preaches in churches. Are you pretty religious? Do you believe in all that?

R.D.: I think everybody is religious. Where your thoughts and your mind are determines religion. What we dedicate ourselves to is a religion. I'm fascinated by the fact that we can't make ourselves. We can't make anything like us. We can't even make a chicken or a butterfly. Forget that cloning stuff. What a marvelous instrument we are. And how dare we overlook and expend this miracle! I think we should stop progressing and just coming up with new products. And get on with trying to even the equation. The human equation needs to be worked on in relation to the things around us. Where is the human being? Where is the human

spirit? We don't seem to care about that. My value system is all tied in with what I own and what I have and how I look. These things are not worthy of us. And the human spirit—I'm hoping that it's not beginning to wither from lack of use.

w.o.: Do you talk to God?

R.D.: I try to. Sometimes I'm too lazy. I'm talking to God right now— I'm talking to you. Each of us is a product with instructions, our piece of God programmed into us, and before you use the instrument you should read the instructions. And I think that's what life is all about, getting hold of those instructions.

w.o.: Malcolm X sat in your living room. You knew Martin Luther King, Jr., and Jackie Robinson. Are there any great heroes anymore? Anybody like those mythic figures?

R.D.: You mean who has not been killed off? They've managed to kill off our hopes. And it sends a message to the generations: don't try, don't rock the boat, or you will get shot. There are always great people around, and they will come forth, I believe. But more than anything now—as my husband says—it's not the man, it's the plan. It's not the map, it's the rap. So I believe that these hopes are going to become manifest in more of us, so it's going to be impossible to shoot one person and alter that human thrust toward righteousness. If one person is killed, twenty will take up that spirit.

w.o.: Do you ever get hopeless about the whole thing?

R.D.: As Lorraine Hansberry said once in an essay I read, "How dare you despairing ones think that only you have the truth." How dare I despair about human beings! Who am I to despair about this *wonder?*

August, 1993

Interview with Wellington Mara

Well Mara is a class act of the football world. The eighty-four-year-old patriarch of the New York Giants is one of the most beloved figures on the gridiron. And off. He is especially strong on pro-life issues and has raised millions for Catholic charities.

W. O'SHAUGHNESSY: We are so glad he is our Westchester neighbor. Since he last appeared on *Interview,* tonight's guest was inducted into the Football Hall of Fame. He is one of the most respected sportsmen in this country, a legend of the football world: Wellington Mara, co-owner of the New York Giants.

W. MARA: Bill, thank you very much. I'm afraid you're prone to exaggerate many things.

W.O.: What were your thoughts when you were inaugurated into the Football Hall of Fame in Ohio?

W.M.: Paramount was the thought that my brother Jack should've been there instead of me. Jack died a number of years ago, and he was the one who really inherited the Giants from our father, and he was the boss when he was alive. Many of the things that have made the National Football League what it is came from him. There was a time when the league was faced with a crisis: how to handle television. Instead of each team going out on its own, which would have been very profitable for the Giants, the Chicago Bears, and the Los Angeles Rams but would have been a disaster for teams like Green Bay, who didn't have a big television market. A vote was taken, primarily at the urging of my brother Jack, Dan Reeves of the Rams, and George Halas of the Bears, and the league agreed to *pool* all television receipts. Thus Green Bay, Buffalo, and Minneapolis get the same returns from television that the Giants, Bears, and Rams do. That was a revenue-sharing, selfless decision that was made for what turned out to be the great

benefit of the NFL. I think it was that decision that made the National Football League what it is, the standard and unattainable goal that all other leagues are striving for, because we have a sharing of our revenue that the other leagues can't possibly get together.

w.o.: You talk about your brother and your father, but you've been the one constant. You grew up with the Giants.

w.m.: My chief asset, as they say, is my longevity—and I'm very happy to accept it! I had some great footsteps to follow in.

w.o.: Are you going to see another championship?

w.m.: I don't know. I've seen two, and I'm happy with them. You're never satisfied, but I'm happy with what the team has accomplished.

w.o.: Who was the greatest Giant of all time?

w.m.: I think our greatest player was Mel Hine, who was our captain back in the 1930s and played many years. It's very difficult to compare players from different eras because our whole civilization is different, our training facilities are different, and players of the 1930s were much smaller—whereas a 250-pound player in the 1930s was the exception, now the standard is 300-plus for linemen—and I think inferior to players of today. But I think Mel Hine towered over the people in his era much the way Lawrence Taylor did over people in his. That's the only way I can compare them. How do they compare with the people against whom they played and with whom they played?

w.o.: Who's good now? Jason Sehorn caught my eye last year. Is he pretty good?

w.m.: Jason is an outstanding athlete who really has been virtually unsung. The fact that he didn't make the Pro Bowl last year was just a miscarriage of justice. He's a great, great athlete, and I think he'll be recognized as such this year.

w.o.: The football players idolize you. You stay in touch with them for years. You do a lot of things that you'll never tell anyone about. They're almost like your children.

w.m.: I like to stay in touch with them. I've been through a lot of different phases. When I started out, I was like the kid brother. Then I got to be a contemporary, almost like a father—and now I'm almost like a grandfather. I like to keep in touch, particularly with the ones who are my contemporaries.

W.O.: Speaking of your children, how many do you have now?

W.M.: We have eleven children. They're all grown, and ten of the eleven are married. We have thirty grandchildren, the oldest of whom is in the third year of high school, so we have a lot of excitement around our house on holidays.

W.O.: How about that spectacular blonde woman that I see you with?

W.M.: It must be Ann Mara. We've been married since 1954, and I've merely stood on the sidelines, applauding, while she raised the children.

W.O.: When you get together with thirty grandchildren, do you know them all by name? Do you remember which is which?

W.M.: Yes, I do. I'm not good on birthdays or classes in school, but I do know all the names and to whom they belong.

W.O.: How about your sons-in-law: do they show you the proper respect?

W.M.: Yes, they do, most of the time. Our son-in-law Doug Brown plays for the Detroit Red Wings, who have just won their second consecutive Stanley Cup. He and my daughter Maureen met when they were at Boston College and were married not long after and made hockey the secondary sport in our family, very close to football.

W.O.: I don't have to tell you that Nancy and I are crazy about one of your daughters and her husband, Susan Mara McDonnell and her husband, John, a Little League Baseball coach who looks like an actor, but he's the smartest darn baseball manager, they tell me . . .

W.M.: Well, he has a very good assistant who works on the first base line named O'Shaughnessy.

W.O.: And he is the father of Timmy McDonnell and also the twins.

W.M.: John McDonnell is the son of John McDonnell. John and Peter McDonnell were twins, and they were a class behind me all through school, and I was really rooting for that match of his John and my Susan to come about when they first started meeting at Giants Stadium. We were very happy when they married. As you know, they have twins, and the boy is John Peter McDonnell, named after his grandfather and his great uncle. The girl is Mary Catherine, a beauty like her mother and grandmother.

W.O.: The cardinal archbishop of New York, John Cardinal O'Connor, calls you one of the most generous men he's ever met. You

have a big charity luncheon once a year to raise money. What do you do with all that dough?

w.m.: We give it to Chris Godfrey, president of Life Athletes, an organization I'm very interested in. We have a breakfast at Yonkers Raceway each year for the benefit of Life Athletes, which the cardinal is always kind enough to attend. The theme was to raise $100,000 so the Knights of Columbus will match it. We made it, and they are matching it. So Chris Godfrey and Life Athletes will be able to do their good work on a very much expanded scale.

w.o.: You mean you just got on the phone and called one hundred guys and said, "I need a thousand dollars and you get scrambled eggs?"

w.m.: Well, not exactly. But we had a nice crowd: 103 people.

w.o.: Wasn't Chris Godfrey one of your guys?

w.m.: Yes. Chris played for us. He was one of the bulwarks of our 1986 Super Bowl champions. He was a guard. Prior to that he went to the University of Michigan, and he played on three Rose Bowl teams at Michigan. After leaving pro football, he went to law school at the University of Notre Dame. He's a member of the Indiana Bar, and he lives in South Bend, conducting the business affairs of Life Athletes there.

We think no one in any walk of life has the credibility—not just with young people, but also with corporate America—equal to what athletes have. When an athlete speaks, everyone snaps to attention and hears what they say. Although some athletes say they are not a role model, they are role models whether they realize it or not—some, unfortunately, not for the good.

Chris Godfrey has been very active in going around the country, running leadership camps. He recruits local athletes from college, high school, and professional ranks, and they work with these kids in developing skills in various sports. Chris lectures to them, and his theme is—this is where I live—*virtue, abstinence,* and *respect for life,* particularly for the unborn and for the aged. His message: If you fail, you don't quit, you just try harder the next time. Do what is right, what you think is right, even though it might be hard. If the person on the street or even the parents say that to the kid, the kids don't listen the way they do when professional athletes or the accomplished amateur athletes give it to them. We think Chris is doing great work.

We live in an awful age, a time when humankind displays an incredible arrogance and seeks to appropriate for ourselves the right to choose between life and death. Who will *live*, for how *long*. Who will *die*, and how soon. Who will be *born*, and who will *not* be born. We even have the arrogance to breed and harvest human organs and offer them for sale as "replacement parts"! This is really the *challenge* of our age, and the *shame* of it. It's a challenge that must be met, and a shame that must be expiated, not by ballots or bullets but by raising up and engendering a whole new generation that will seize, cherish, and practice the Code of Life that the Life Athletes organization presents: abstinence, virtue, respect for life.

Make no mistake about it: this is war, the war for *moral integrity*. We're grateful to Archbishop Edward Egan for providing us with a beachhead in this war—and ultimately to break out from it and spread the gospel of Christ, and the gospel of Life Athletes far and wide in our beloved country.

w.o.: Your faith is pretty important to you, isn't it?

w.m.: Yes, it is. I've never known a time when it wasn't. I've had eleven years of school with the Jesuits. They helped a lot.

w.o.: The Jesuits will get your head crazy.

w.m.: I think the essence of faith is that where you don't *know* for sure, you do believe for sure. That's the message I would give: if you're uncertain, trust in your faith and believe, and someday you'll get the answers.

w.o.: In your own profession, football, there are few families like the Maras and the Rooneys. The MBAs are coming in and running a lot of things. How about football?

w.m.: Football is no exception. Even before my time, it was strictly the families, and some towns such as Green Bay, that ran the teams. With the advent of television, the big money started coming in, and with the big money came the big-money people. I don't regret that. I don't demean people just because they have big money, but I don't think you can blink at the fact that things are changing. The striking thing to me was the recent sale of the Los Angeles Dodgers by the O'Malley family. They were the one stronghold that really held out. I speak specifically of professional football. I believe that the time is not too far off when the only way the Maras or the Rooneys will retain control of their teams

and compete on equal terms with the Murdochs and the Allens is through some type of IPO, initial public offering. For instance, there might be two classes of stock, ownership and voting; and hopefully, the Maras can retain at least 51 percent of the voting and a good portion of the ownership.

w.o.: You have a partner who watches this station, former Postmaster General Preston R. Tisch. Is he a pretty good partner?

w.m.: He certainly is, and he's been a great addition to our corporation. He came in and modernized our business practices. When he and I first sat down and talked about the possibility of his buying half of our team, he said, "I've been very lucky in life. My children are all taken care of. I have no interest in passing this along to them, but I would like to have ten years of fun out of professional football." I told him, not really in jest, that he'd have to spend thirty years in order to have ten years of fun!

w.o.: Does Bob Tisch have pretty good seats?

w.m.: He has the best seats: right next to mine!

w.o.: I observed you at a charity dinner. You and Mrs. Mara go to so many. The room lights up when you both walk in. You were bidding on some Yankee tickets, and someone asked why you don't trade *one* Giants ticket for one hundred Yankee tickets. How hard is it to get Giants tickets now?

w.m.: It depends on *who* you know . . . !

w.o.: Someone told me you have thirty thousand people ahead of you no matter *who* you know!

w.m.: It's very difficult. We're in a happy position of having a huge waiting list.

w.o.: How huge?

w.m.: I really don't know, but it's much more than we can handle. We get a small percentage of tickets turned back each year. Some people move away, and some people, unfortunately, die, and some even get disenchanted with our team. We do the best we can. We try to allocate them to the people who have been on the list the longest, and no more than two tickets per person. We've also built some more seats into Giants Stadium this year.

w.o.: If you fill every seat, how many people do you have?

w.m.: I think it's about 77,000.

w.o.: Is it tough for you to turn them down? Do people ask you for tickets?

w.m.: They ask to whom they should write to get tickets. I have a certain number of tickets in my name, and that number has gone down drastically in the last few years. I have very few left now.

w.o.: Nancy and I also saw you of an evening in the company of Leon Hess of the *Jets!* Do you hang out together?

w.m.: I don't know that we hang out together, but we are very friendly. I regard him as one of my best friends—except for once or twice a year. I often ask him to come in and give a pep talk to my team because he is very effective when he gives them to his team.

w.o.: Which is the great rivalry now? The dreaded Dallas Cowboys? I'd love to see the Giants beat *them.*

w.m.: It changes from year to year. A lot depends on where we are in the standings. I don't know that there's any one particular team now. Going back to the 1950s, it was the Cleveland Browns. Before that it was the Washington Redskins. The team we'd like to beat most is the team we're playing Sunday, whoever that might be.

w.o.: I've also seen you with Art Modell, owner of the Cleveland Browns [now the Baltimore Ravens].

w.m.: We're very good friends.

w.o.: Can you all just bounce back? Let's assume you beat him. You'll have supper after . . . ?

w.m.: When we're playing somebody like the Modells or the Hesses or the Rooneys, I go out of my way to say hello before the game, and I then stay as far away as possible until the time comes when the wounds heal, whether they be my wounds or their wounds. It usually takes about a day.

w.o.: Jimmy Cannon, the late, great sportswriter, used to write of the Maras, the Rooneys, and the great families. Who are the great sportswriters of today? Who does Wellington Mara read?

w.m.: Jerry Eisenberg of the *Newark Star-Ledger* is my favorite. He is a great writer. He was with the *New York Herald Tribune* for a while, years ago. He has a great gift of the language and a feel for humanity. I laughingly call him my speechwriter because, on two separate occasions, I've taken columns of his and used them in talks I've made, notably at the memorial for Pete Rozelle a year ago.

w.o.: What about Pete Rozelle? Do you miss him?

w.m.: Yes, we do. Paul Tagliabue is a *very* worthy successor. Pete

Rozelle just was the right man at the right time for the National Football League. He was a great public-relations man, a builder, and a great parliamentarian. When he had something he wanted to get done, he knew when to twist arms and when to massage people. He was a great leader. Now we have a lawyer as our commissioner, and it's good that we do because we're involved in many lawsuits one way or the other.

w.o.: But Tagliabue is not quite as flashy as Rozelle.

w.m.: He doesn't have the flair for public relations that Pete had. No one does. But I think, once again, we have the right man in the right place.

w.o.: There's a scandal about Tagliabue. He went to school with Bill Plunkett, the great Westchester and New York power-broker and Catholic layman.

w.m.: I know that. Paul Tagliabue also played basketball at Georgetown, and he had the Georgetown rebounding record until a young man named Patrick Ewing came along and broke it. Paul's other roommate at law school was Lamar Alexander, who ran for president.

w.o.: When do you go to training camp?

w.m.: Our first day at camp is July 24. I love training camp. It's similar to what spring training is in baseball. It's a time when nothing has been proven to be wrong yet. Every player is going to have his best year, and everybody is going to always be in great shape. It's a time when dreams are built, and teams are built also.

w.o.: Do you go out on the field every day with them?

w.m.: As much as I can. I try to get my exercise by walking around the field.

w.o.: Who's that teenage kid that looks just like you, about fifteen years old? He's been tagging around after you the last couple of years.

w.m.: That might be Timothy McDonnell, my grandson.

w.o.: Is he going to training camp again this year?

w.m.: He'll be there.

w.o.: He loves football, and he adores his grandfather . . .

w.m.: He's a wonderful young man, and we're happy to have him around. Maybe he's following in the good footsteps.

w.o.: Do you ever pick a play or send one in?

w.m.: I've been around too long for that because I know, many times,

when you suggest something, it goes wrong. I believe in the chain of command. I'm an old Navy man, and I believe in loyalty up and loyalty down. And if I have some suggestions about the team, I go to our general manager. It used to be George Young; now it's Ernie Accorsi. And I say, "This is what I think." That way I get it off my chest. And if the general manager thinks it's worth passing on to the head coach, he does so. If he doesn't, that's fine too. I just feel as though it's important that the coach know that his chain of command is through a general manager, and his is to ownership.

w.o.: You are one of Westchester's most respected and beloved citizens—forgetting, for the moment, your reputation in the world of sport. We're glad you're our neighbor.

w.m.: I'm happy to be *your* neighbor, Bill.

w.o.: Will you give our best to the spectacular Mrs. Mara?

w.m.: Yes, I will.

w.o.: Forget your son-in-law, the Little League coach. I can handle him!

Summer, 1998

Interview with Allie Sherman

Coach Sherman ran the New York Giants during some of their greatest years.

W. O'SHAUGHNESSY: Tonight we're going to talk about the glory days of the New York Giants with a New York sportsman. He was a great football coach. He's a pioneer in cable television, a sports producer. And he ran OTB in New York. He's also an advisor to Time Warner and our friend Dick Parsons and a consultant to and confidant of Charles Dolan of Cablevision: Coach Allie Sherman.

A. SHERMAN: Bill, I should have had you on my team a long time ago. You can negotiate a heck of a contract, O'Shaughnessy.

w.o.: We still see you around New York, coach.

A.S.: It's the place I live, the place I love that has all of the history that makes me feel good. I lived most of my married life right in Westchester. Bill O'Shaughnessy, when you were on the radio and out on the streets, you made me feel like I was in the right place all the time.

w.o.: Do you miss being along the sidelines at Giants Stadium?

A.S.: You have to call it a business. When you're in it it's showtime. Everybody is getting ready to go out there at one o'clock to do war, and there's nothing like it.

w.o.: If you stop ten New Yorkers on the street right now and ask them who the head coach of the Giants is, six of them would say Allie Sherman. How long were you the coach?

A.S.: I was head coach of the Giants from '61 to '68. Way before that I was a backup quarterback with the Eagles. I didn't play much. Steve Owen was the coach of the Giants then and he brought me over to New York. He asked Greasy Neal, my coach, who was the best guy to teach the T-formation to a young quarterback by the name of Charley Connerly, who had just returned from the wars;

he was drafted by the Giants in '48. Charley had played one year but didn't know the T-formation. The Giants were the last team to go to the T-formation, which had become very popular because the Chicago Bears were wiping up the whole league. Clark Shaughnessy was doing it with the college teams. People in football are so "creative" they imitate whoever wins something. So they told me, "Teach Charley what he has to know. He's a great passer but he has the wrong formation."

w.o.: Tell me about Charley Connerly from the halcyon years.

A.S.: He was great, Bill, not only a great performer but a great individual. He went to the war, then was drafted by the Giants; and when he came out, he was a rookie at a much older age than the rest of them. I'll never forget the day I introduced myself to Charley at training camp. Remember, Charley is from Ole Mississippi, very easygoing, and he doesn't speak all that much. If you have six words with Charles during the day you have a heck of a dialogue. His teammates worshipped him though because he was a man of action. I'll never forget when I walked in—my first coaching job—I said, "Charley, how are you? I'm Allie Sherman. You and I have a big thing to do. Don't worry. It's going to be hard but . . ." He said, "Okay." He was reading; he loved to read Westerns, those little pocketbooks. In addition to that, I found out he had an attention span of about twelve minutes. After that he was gone on you. Every now and then I had to go a little more than twelve. I said, "Now, Charles, you've got to listen to me. When we flood those backs . . ." He said, "Now, Coachie, you've got to respect your elders. Take it easy."

w.o.: Charley Connerly had such grace. Did he ever get sacked?

A.S.: In 1950, when we tied the Browns for the championship and played a playoff game against them, which they did win by a few points, Charley took a beating. And then we got Frank Gifford: he was our 1950 or 1951 number-one draft pick. Kyle Rote was the other one.

w.o.: And there was another great quarterback, Y. A. Tittle . . .

A.S.: He came many years later when I rejoined the Giants.

w.o.: Who was a better quarterback, Tittle or Connerly?

A.S.: They each had their talents. I'm not trying to evade the question. A quarterback is as good as his talents, but how he works

with his ball club is important. Each of them had a different kind of team.

w.o.: You're a former quarterback. Who's the greatest quarterback you ever saw on the playing field?

a.s.: There's a man who helped pro football a great deal. His name was Sammy Baugh, a great passer and a man who played for the Redskins. He was the only mortal I ever saw who quick-kicked. After that you move into the era of quarterbacks really throwing the ball for distance. John Unitas played for Baltimore. He had it all. His techniques made him so efficient on the football field. He had great understanding of what he wanted to do with that ball. I think he might have been a production of a Frankenstein doctor. He was as cool as could be. The next great quarterback—and he won't stand up in the records—was Joe Montana of the 49ers. Joe didn't throw the ball like Sammy Baugh with that thing spinning in tight revolutions, but he had great technique masking the ball when handing off and running the football club. He also had ice water in his veins, and a great level of concentration.

w.o.: We remember Frank Gifford and Kyle Rote. In New York, in the sixties, Toots Shor called them his "kids." Did you ever enjoy the haze of an evening at Toots Shor's?

a.s.: I spent many evenings there. Joanie Sherman, my wife, would ask why we wouldn't go to Toots' place more often. I told her the boys went there, and they needed to be able to relax. Like it was a "guy" thing. But we used to go for late supper. And I would often see you there.

w.o.: Gifford and Rote were dazzling young men when they came to New York.

a.s.: Gifford was from Southern California, and Rote was from SMU. Toots Shor took these guys under his arm. He loved them almost as much as he loved Joe DiMaggio. He was a saloon-keeper. But Toots loved to spend time with them. "Let's go over to the apartment, gang." He listened to their tales of getting used to New York City. He was a great guy to tell them about the people in New York.

Of course, Gifford and Rote had a lot of people coming at them. They were tremendous football players, and they were very conscientious. They had an urgency to be the best. And they practiced like that.

Kyle Rote would have been—this is one time when I'll say it—one of the greats of all time in running. When we drafted him out of SMU as our number-one pick, he was a running back with great talent. He could pass the ball. He could catch it better than anybody. We were running a drill in Jonesboro, Arkansas, during one of the greatest heat waves the United States ever had. Kyle Rote hit a little rut in the turf, and his knee went out on him. He had to work over a year to get back into shape, and he became a great pass receiver.

Frank Gifford was a tremendous all-around back, just like Kyle. He stayed healthy by playing in the backfield. He was a tremendous runner. He didn't have the speed of some of the great runners, but he had a great cutting ability. He understood how to beat a man, and he could create pressure because he went out there on those passes just like Kyle Rote.

w.o.: The years have gone by. Gifford is married to Kathy Lee. Kyle has faded from the scene, although occasionally he is seen around Winged Foot, playing golf. Do you keep in touch with your boys?

a.s.: I see Frank at charities like the Special Olympics and United Way events. And Kyle comes into town for the Special Olympics and goes upstate to Albany for the Giants' training camp with the youngsters. Every now and then we see each other socially.

w.o.: Some guy who does not like football called the NFL the "National Felons League." Has it changed? Is there a different cut of guy playing ball today?

a.s.: It's changed. Physically, it certainly has. The linemen are 280 and 300 pounds, and they can move in ten or twelve areas like a tap dancer. The pro football player trains now nine months of the year. In the off-season they have mini camps: three- or four-day camps for the various positions. I don't know how that happened. You've got these big linemen who are very agile. On a coaching staff now you have a strength coach, an agility coach, a stretching coach, coaches that run the defensive line. . . . The training is better, and that's the biggest difference in pro ball.

These are also men who are much greater income earners. They draw attention from people, and they move in different circles. But they want to be careful about just how they "move" around and who they hang out with.

w.o.: What about the owners? We had the legendary Wellington

Mara on our show, the last of the great NFL owners, and the other night I saw Ann Mara around town with Mrs. Hess.

A.S.: The owners of these teams now have different styles too, Bill. In the days of the Maras, football was their main business. They were football people, and they grew with their club and with the league. As the league expanded there were different obligations and commitments a man had to make to get to be an owner. In yesteryear they didn't have to spend too much capital to acquire a ball club. Wellington Mara and Art Rooney of Pittsburgh and George Hallas of the Bears were people who didn't always know where pro football was going, but they stayed with it and built it, and they still look upon the teams as *their* ball clubs.

W.O.: What about Bill Parcells?

A.S.: He is an outstanding coach. People recognize that. What makes an outstanding coach is the ability to understand. To understand the technical teaching, the conceptual "feel" of the game, but also to understand how to teach the players, to put them into position, and to use them on game day. Take Vinny Testaverde, who was a guy with great talent but always felt he had to throw the ball fifty-five yards, just because he could. He never understood the game, how to move and when to get rid of the ball and just throw it away. Parcells got Vinny to understand what the game is about, and he became a great quarterback for them.

W.O.: Did you ever get sacked?

A.S.: Sure. I didn't play that much, but I got sacked, Bill. I got sacked one time when all the punt returners got hurt and Greasy Neal put me in. I received this punt, and just then four big Detroit Lions arrived!

W.O.: Soccer can't get off the ground. I think it's a graceful sport, but suburban fathers think it's a manly thing to knock people down. Has football lost its grace?

A.S.: I think it's still there. The offensive and defensive lines can't be graceful. You've got big people who are beating each other to create space. But you do have a number of receivers who will go down as great receivers in due time. You've now got people who are six feet three running pass patterns with swiftness and speed and great hands.

There were so many great ones: Y. A. Tittle, Joe Schmidt, a great linebacker for the Lions, Del Schoffner, a brilliant receiver, Jim

Lee Howell, Ken Kavanaugh, Tom Landry, who was a defensive coordinator before he took over the Cowboys, Otto Graham, Harry Gilmer, and Norm van Brocklin. I was the offensive coach replacing the legendary Vince Lombardi. But most of all I remember Joanie Sherman, who gave me the strength all the while I put her through the agonies of coaching. And my kids Laurie and Robin and Randy. I've been so fortunate.

W.O.: You're an icon of New York, Coach.

A.S.: When you say it, it means something.

<div align="right">2000</div>

Interview with John Sterling

The play-by-play announcer for the New York Yankees, Sterling is the Mel Allen of this day and age. His magnificent, resonant voice elevates and exalts the exploits of my beloved Bronx Bombers. He is the best sports announcer in the nation today, and no one on television or radio even comes close.

W. O'SHAUGHNESSY: I didn't pay any attention to baseball, the national pastime, for about twenty years. I would ask Robert Merrill about his Yankees, and he would try to tell me. But I would say, "There's really no one to root for and get excited about." And then one day I tuned the radio to WABC. I heard this *magnificent* voice. I always said I would go to the great beyond without ever hearing another Mel Allen. No one can be as good. But then I heard the richness and majesty of the voice that will be with us for the next twenty-seven minutes: the Voice of the New York Yankees . . . John Sterling.

J. STERLING: Bill, thank you, and please be as extravagant as you want!

W.O.: Just talk . . . or read the phone book, Sterling.

J.S.: That's what was said by one of our idols, William B. Williams, who used to say that he could have Frank Sinatra sing the Manhattan telephone directory!

W.O.: Before you became the Voice of the Yankees, you were on WMCA and WQEW. You should've been a disc jockey.

J.S.: You know all of this, so I'm not telling you, I'm telling the audience. I have known Bill O'Shaughnessy's name for so many years because he was a lucky stiff as a young kid: he was connected to the radio station of our dreams, WNEW AM 1130. I listened to everyone when I began. When you begin as a kid at a radio station, you do everything, and I was a disc jockey, but I wanted to

do more. If I could today spin records in addition to what I'm doing, I would want to do it like the great broadcasters of WNEW.

w.o.: Sometimes when you're on the Yankee broadcasts you'll break into song.

j.s.: Well, sure. I'll sing a little bit of a song . . .

w.o.: It's a little disconcerting to your partner, Michael Kaye.

j.s.: Because I don't sing very well. It serves as the basis for jokes back and forth or for his putting me down, which I love.

w.o.: You were in New York, and then you went on the road with the Atlanta Braves.

j.s.: It's a mercurial business. I did WMCA in the seventies, and the Nets and Islanders basketball and hockey, and Morgan State football out of Baltimore, and I went with the Nets fulltime for a while, and I wound up in Atlanta with Ted Turner doing the Braves and Hawks. And before the Hawks' season began in September of '88, a guy called from ABC and asked if I were interested in doing the Yankees. I asked why, and he said the new general manager didn't like the Yankee broadcasts, and he listens to you on the Braves and listened to you when you were at WMCA. So I had someone contact him, and I got the Yankee job without an audition—which is amazing. George Steinbrenner had to OK it, and *he* had heard me in the seventies. I began March 1, 1989, at spring training, and I came with a two-year deal and an option. Someone wrote that I would be like every other Yankee announcer, two years and out. This is going to be my twelfth year.

w.o.: You've worked with two characters, Ted Turner and George Steinbrenner. Who is the bigger character?

j.s.: They're very different. Ted was a little bit involved when I got there, but a guy you know very well was his right-hand man, Bob Wussler, who had left CBS to head up TBS. Ted had just put CNN on the air and was about to put CNN Headline News on the air, and he was so busy he didn't have much input. You'd almost never see Turner.

w.o.: Have they ever picked up the phone and told you not to criticize the team?

j.s.: Not *ever*. First of all, *George* criticizes the team, so he doesn't mind that. In fact, when I got to the Yankees, they were awful. No one remembers it now, because it's forgotten with this tremendous run we're having now, but in '89, '90, and '91 they were ter-

rible. One day I went on the air, and I was doing some kind of free-thought "editorial," saying to please not blame the general manager and the manager, blame the *players* who can't play. And George saw me in Milwaukee at a rain delay. I was walking around this old stadium, and Steinbrenner was sitting with Bud Selig and said, "Hey, John, I was in the car and I heard what you said. You're absolutely *right.*" Now he wasn't employing me. But Steinbrenner said, "I think you're great. You keep on doing what you're doing, and I'll never let you go. If ABC ever proposes someone else, I'll say no."

w.o.: A lot of our Yankees live right here in Westchester, in the Golden Apple. Mariano Rivera lives in New Rochelle. Joe Torre lives down the road a piece in Harrison; Paul O'Neill lives in Rye Brook . . .

j.s.: And Scott Brosius. Wade Boggs and Jimmy Key lived here. There was a time, Bill, when no one wanted to come to New York. If you live in Westchester there's no bridge. You can get to Yankee Stadium in twenty minutes, and yet you can live where you have small animals running around and it's very picturesque and beautiful, as you know because you are a Westchester guy. If you don't want to see the city—the great city—you never see it. But if you want to see it and go to the museums and the restaurants and the theater, it's there. Now there is a whole storm of Yankee players who live here as opposed to where I live in Bergen County.

w.o.: You and your Jennifer. I hear you're a father.

j.s.: Yes, we have a two-year-old, Abigail. Friends of mine called last night when I was out doing my own radio show and said that they wanted to see us and asked how Abigail was. Jennifer said, "She's two years old, and she's driving us crazy!"

w.o.: Are you a good father?

j.s.: Very. I'm very patient. I love her to pieces. When she's running around doing things, instead of yelling, I just say, "Abigail, don't touch that." She touches it anyway. She wants to touch it. She wants you to come after her. Yeah, I think I'm a very good daddy.

w.o.: Do you do the bottles and the burping?

j.s.: I do the diapers and the feeding and all that stuff.

w.o.: Questions you've always wanted to ask John Sterling. Who is your favorite Yankee?

j.s.: David Cone. I don't mean my favorite as a player, I mean my

favorite as a person. I think we're very good friends because we have a lot in common. David Cone was born in Kansas City and is now the quintessential Manhattanite. He has a home right near here too, in Greenwich. He also has a place in Manhattan and loves the city. He wanted to be a reporter, and he understands what the media need. He is very low-key. He is a guy who understands that it's *his* pitching. No one else contributes to his rise or downfall. When I go into the clubhouse—which is usually to find Torre to do the manager's show—David is there, and I can talk to him on the day he pitches. I can talk to him up to game time.

w.o.: Did he have a colorful life before the Yankees?

j.s.: He certainly did. You ought to interview him. He's very intelligent, liberal, and involved with the Players' Association. He loves the theater and the arts. You would find that you have a lot in common with him too.

w.o.: Are they going to bring him back next year?

j.s.: I hope so.

w.o.: From your lips . . .

j.s.: If they don't, they're making a big mistake. He has a lot of pitching in him, and he wants a two-year deal. They want one year and an option, but David did a great job for the Yankees, and he pitched his best after the perfect game, in the post-season. They ought to bring him back.

Joe Torre is probably the *closest* to me, because we've been friends even before Atlanta days. I had a very close buddy who was just an average player for them a few years ago, Dion James, who was a sweetheart. They're all a bunch of nice guys, but I'd say I have the most in common with David Cone.

w.o.: You travel with them. You know them, and you've interviewed them hundreds of times. Is Derek Jeter as nice a kid as he seems?

j.s.: Yeah. He has a forty-year-old head on a twenty-year-old body from the get-go. He is a natural leader like a Magic Johnson or a Larry Bird. He has so many attributes. And he's tough. Now people are thinking he was raised tough. No. He was raised *middle-class*. His parents are black and white. They're both professionals. His father is a psychologist. He had a very loving and nurturing home. So you ask how can this middle-class kid be this tough? And he *is* as tough as nails. When he came up, they were throwing hard inside and they couldn't knock him off the plate. As a

rookie, he was the first one out of the dugout if a guy hit a home-run or scored. He will be captain of the Yankees in due time.

w.o.: Will he be in the Hall-of-Fame?

j.s.: Absolutely.

w.o.: Guaranteed?

j.s.: Barring an injury.

w.o.: Superstar?

j.s.: Well, first of all, Bill, he's a shortstop who hit .350 with power. And he's won the World Championship three times in four years. Jeter only wants to win. We have a tendency to fault the modern athlete: they're spoiled, they're pampered, et cetera. Derek Jeter's such a good player that it rubs off. And the Yankees have a very unusual collection, which we probably won't see again for a long time. Derek would say they check their egos at the door: they only have one aim, and that aim is to win. You can see it in their at-bats. They never think they are out of a game. And so someone works a pitcher and gets a walk. Maybe someone gets a base hit. So the baton is passed, and that's how they score their runs. Anyway, Derek is one of the three truly great stars on the team. I'd say Bernie Williams is a great star. And Mariano Rivera.

w.o.: What's this talk about getting rid of Bernie Williams to get Junior Griffey?

j.s.: It's just tabloid talk picked up by the talk shows. Seattle doesn't want to get Bernie Williams because he makes $12 million now, and when you're traded in the middle of a long-term contract, you can opt out after a year or renegotiate your contract, so they'd be in the same position with Bernie Williams as they are with Griffey.

w.o.: Why do New Yorkers hate Griffey, or why does Griffey hate New York?

j.s.: Well, Griffey says—and he may be so spoiled and pampered himself; he's such a great star—that when he was a kid and his dad was playing here in the eighties, he was shooed out of the clubhouse, and he still carries that resentment. Imagine carrying that resentment when you're going to make $15 to 20 million a year and you probably have more talent than any other player. He does every single thing well, like Willie Mays. He hits for power, makes every catch, has a great arm, and can run the bases. Every time he comes to New York, Griffey says he will never play here.

Now his agent and probably his dad got to him and told him to drive up the price. So he sort of had an epiphany. I don't think they'll get him. But as Steinbrenner said in true George Steinbrenerese, "If you're not interested in Ken Griffey, you're nuts. And you know what? I'm not nuts."

One thing about George—and there are many great things about George that aren't written—he understands *business* principles. He understands you have to spend money to make money. Do you know the Yankees are in the last year of this tremendous MSG television contract, from which they get approximately $50 million a year? Well, the more the Yanks win, the more popular they get. If the Yanks continue to win, then George can say, "Who wants the Yanks, and how much?" So the price is going to go up. He understands you have to put a great product on the field, and he has.

w.o.: Nancy and I like Paul O'Neill a lot. He's very intense.

j.s.: Just intense on the field, as he should be: Throwing the helmet and throwing the bat. But he is such a low-key guy off the field. And he's such a nice guy. He just lost his dad and played through that and the World Series. His sister Molly O'Neill is the food editor of *The New York Times,* a terrific writer. He has a wife and three kids whom he adores. And he won't talk about himself. There's another guy who doesn't have an ego. He only cares about winning. That's what this team is all about.

w.o.: What about Tino Martinez?

j.s.: Well, Tino is not wound as tightly as Paul O'Neill is. Few people are. Tito's a very intelligent and lovely human being. Very family oriented. He lives over where I live in Bergen County and in Tampa during the off-season. He's another person you'd be very pleased to have at a dinner party. The Yankees are very fortunate they have people of good character in their clubhouse.

w.o.: Your descriptions of them just bring poetry and music into the thing. I'm like thousands of people who turn off the television sound and tune to you and Michael Kaye. Sometimes it's a little tricky, and I forget which is on. Do a lot of people do that?

j.s.: Well, we certainly hear it a lot, and every time we hear it it's wonderful. It's a very nice compliment.

w.o.: I idolized Mel Allen . . .

j.s.: Me too.

w.o.: I ask the young men in our radio station, "Who are your role models?" They all say you.

j.s.: That's wonderful.

w.o.: I say to them that they might not have a voice like yours, and they say that you have a wonderful richness to your descriptions. Who was *your* hero?

j.s.: I didn't have one, so I just say Mel Allen because it is a good answer to the question. Later on I became very, very friendly with Mel Allen. In the late seventies we had the Yankee rights at WMCA, so I did pre- and post-game. George built the team up, and they won the pennants in '76, '77, and '78 and the World Series in '77 and '78. I did shows with Mel Allen, and we did a show he referred to a million times: the night Reggie hit the three home runs, we did the show from George's office! We had everyone on, including Cary Grant! One guy would be on, and then I would go into George's office where all these celebrities were and get a guest, and we had this long post-game. Mel was always terribly bothered that no one even saved the tape.

w.o.: What did Mel Allen say for the home run?

j.s.: "Going, going, *gone!*" And then he used it as a commercial, which he would be killed for today. He would say, "White Owl Wallop" and "Ballantine Blast!" One great story from those days. When we were allowed to do a live spot—and you're not allowed anymore—at the end of the game, in summertime, we'd show a big, heavy, sweaty man in Yankee Stadium with a little cooler. And he would say, "After the game we like to pull out Ballantine beer." He would then pour a beer and throw it down in one fell swoop. That probably sold more beer than anything ever. It was one of the greatest spots you'd ever see in your life. And Mel Allen loved it!

w.o.: Your signature is "Yankees Win!" How do you do it?

j.s.: I started in Atlanta doing, "It is high. It is far. It is *gone!*" when I realized it was a homerun. But the Yankees didn't win much when I first got here, so when they'd win and it was dramatic, I'd say, "Yankees win! Yankees win!"

w.o.: You don't say it quite like that.

j.s.: Not at all. And then when they started winning *more,* I thought it didn't have rhythm, so I started saying, "Yankees win! The-uh-uh Yankees win!" Gee, it's taken off. I'll tell you a kick. Michael

and I are riding in one of the classic Caddys in the ticker-tape parade down the Canyon of Heroes, sitting in the back . . .

w.o.: Is that exciting?

j.s.: Oh, three years now, are you kidding? To have millions of people shouting out *love* to you! And so everyone is doing our homerun calls as we're riding up the Canyon of Heroes. Sometimes the caravan would stop. The cops along the way, holding the people back, would turn around and look at me and yell, "Yankees win! The-uh-uh Yankees *win!*" It's nice when you do something and it comes back at you.

w.o.: Is that a World Series ring with all the diamonds?

j.s.: That's a '96 . . .

w.o.: Is it heavy?

j.s.: It's heavy . . . and also it's "heavy." It *weighs* heavy, and *emotionally* it is heavy.

w.o.: Do the players wear their rings?

j.s.: A lot of times, and a lot of times no. We also have one, the '98 ring, in a safe-deposit box. I wear this one. As great as it looks, I don't think it's worth a lot of money. Let's put it this way: I've bought my wife rings that have cost a whole lot more. You can't replace it, and you want to give it to your kids. I never thought *I'd* get a ring. And this year we'll have the third ring. Isn't that something? How lucky is that?

w.o.: When do you go south?

j.s.: March 1. Usually, we'll do a game just after that. And do you know, we get phone calls that say, "Do you guys know you have the best job in the world?" And of course we *do.* It's certainly even a better job when they win like this.

w.o.: Ten seconds on Andy Pettitte.

j.s.: Very low-key. Very hard worker. He probably tries too hard. He's won a lot of big games for the Yanks. Everyone can't make $10 million a year even for George, and the more you win, the more the players' salaries go up. Andy Pettitte is making an awful lot of money, and he is arbitration eligible, and it's very tough to win arbitration when your team keeps winning. So if he is up around $7 or 8 million, he has to pitch very well to remain.

w.o.: Who is the most underappreciated guy on the Yankees?

j.s.: Because of his value, it would be Rivera. He's the best at what he

does. I think if he pitches the way he has for the next two or three years he will be the best of all time.

w.o.: Will anybody figure out how to hit Pedro Martinez?

j.s.: He's pretty unhittable. He throws all his pitches the same way and has great action on all of them, so they're tough to tell apart.

w.o.: Are these Yankees as good as Allie Reynolds, Vic Raschi, Joe DiMaggio, and Yogi Berra?

j.s.: I can't possibly compare. But one thing: when these teams win, they have to go through two *playoff* rounds. Those teams went right to the World Series. So they only had to win one round. Now they have to win three. It's a little tougher.

w.o.: I've asked you about your Yankees. You're also a great student of broadcasting and radio and singers and great American songs. Who is your favorite singer?

j.s.: I can name thirty singers. Frank Sinatra would have to be number one.

w.o.: They asked Louis Armstrong who was the greatest girl singer, and he said, "You mean, besides Ella?"

j.s.: I feel that way about Ella too.

January, 2000

Interview with Tim Rooney

This son of the legendary Art Rooney has valiantly tried to keep Yonkers Raceway up and running despite stiff competition from OTB and little help from the powers-that-be in Albany. In addition to the raceway, the Rooney family owns the Pittsburgh Steelers and dog tracks in Florida. Tim and his wife, June, also maintain a stable of Irish racehorses. Art Rooney was immortalized by the late Jimmy Cannon in a memorable column entitled, "The Plumed Fedora." The Rooneys, along with the Maras and the Modells, are the last of the great football families.

W. O'SHAUGHNESSY: If you like the racetrack, and football, you're going to like this program. And if you like Westchester, you're going to know this man, the scion of one of the great families of sports: Tim Rooney, Sr. First of all, how are the Pittsburgh Steelers going to do this year?

T. ROONEY: After winning four Super Bowls and being in the playoffs so many times, you get yourself in a position that if you don't go to the Super Bowl and you don't win, you feel that you had a disappointing season. We'll have a good team.

W.O.: Your family owns the Pittsburgh Steelers and Yonkers Raceway.

T.R.: And we have a dog track in Palm Beach across from the airport. So we have three things going right now.

W.O.: And you own a lot of horses: the "Rooney" stable.

T.R.: Shamrock Farms. My wife thinks I have too many horses.

W.O.: You are the son and heir of the legendary Art Rooney of the Pittsburgh Steelers. Jimmy Cannon used to write about him.

T.R.: He was a good friend of my father's.

W.O.: Your father was a legend.

T.R.: He is that.

W.O.: Is it all right if I tell you I root for the Giants?

T.R.: I root for the Giants too! I'm named after Well Mara's father,

and my daughter is married to his son, so I've been rooting for the Giants for a long time. Particularly because they're not in the same conference as the Steelers.

w.o.: What would you do if the Giants played the Steelers?

t.r.: I'd wish that we won a very close game.

w.o.: Tell us about Wellington Mara.

t.r.: Wellington Mara is one of the finest people you'll find anywhere, not only in Westchester but surely in the world, and he's been one of the real leaders of the National Football League. I was just thinking the other day, if it hadn't been for his father, there wouldn't be a National Football League today because one of the things that makes the NFL so great is the sharing of the television revenues. And I remember, when they were going around to get the first national contract, Bert Bell, who was commissioner at that time, asked my father to go see Mr. Tim Mara and ask him if the Giants would be willing to divide the money equally with the rest of the league. Don't forget the New York market was just a little bit bigger than Pittsburgh's. But he said he would. Dividing that kind of money up equally is what makes the National Football League so successful and so popular. Basically, it gives everybody a chance to win a championship.

w.o.: The Rooneys and the Maras are a dwindling breed. There is a lot of big money in football now. What of the great old families?

t.r.: The great old families: the Maras, the Hallases, the Bidwells, and the Rooneys. We go back to 1933. The Giants go back to 1925. The Cardinals—excuse me, they're not the Cardinals, they're Arizona—but they go back to the late twenties or the early thirties. And the Bears go all the way back to the real first teams in the National Football League.

w.o.: In addition to the Steelers, your family has sustained Yonkers Raceway all these years.

t.r.: We've been waiting for something to happen that will save us. Our business has dwindled. When we first bought Yonkers Raceway in the early seventies, our average attendance was 20,000 people. In 150 days of racing, 3 million people went to Yonkers for the races. Today, twenty-six years later, racing year-round, our total attendance would be around 300,000 people at the most. There's no way we can sustain ourselves as in the past. What has happened? With Off-Track Betting, with the Native American

casinos up at Foxwoods, and with Atlantic City, the Meadow-lands, the Lottery, the racing industry has gone from having a monopoly on legalized gambling to competing with many different new "products." There is no way racing can survive unless we are given the same products they have. If we were allowed slot machines—last year I hoped it would pass—it would put us in a more competitive position. The days of Yonkers Raceway, I'm sad to say, are numbered. We're in the final stages of a deal right now.

w.o.: You paid a lot of taxes in Yonkers, "where true love conquers." You have a lot of employees.

t.r.: We're down to about five hundred employees. When you think of the governor flying down from Albany to open a new super-market to employ a couple of hundred people! Then there are a lot of people who aren't working for us directly, like the horse-men and grooms. But a new endeavor at Yonkers would probably hire a lot more people than we're employing now.

w.o.: Didn't somebody want to put a Native American operation at the track?

t.r.: We've had a few tribes looking at it.

w.o.: How are you going to feel if you have to have the last race at Yonkers?

t.r.: It will be a very sad day. Next September will be our one hundredth anniversary. There's maybe two or three tracks that are older in the United States. I just hate to see anything historical have its demise, but from a practical standpoint you have to face reality. With the numbers that we're down to in attendance, you'd have a tough time keeping a good restaurant operating. The food at Yonkers is as good as anywhere. We have a great chef who used to be at the old Laurent in New York City. But getting people to come to the racetrack just to eat food and not watch the races is a great chore.

But in Yonkers you can really get down on the apron and the rail and hear the horses going by. It maybe isn't a thundering herd, but you surely can hear the noise from the hoofs on the ground.

The horses at our track are standardbreds, an old breed that used to be the carriage horse for the Rockefellers and Vanderbilts and the rich people of America. Coming back from church, they wanted to see who had the fastest horse! They all started buying

faster horses and better bred horses. From that you had the evolution of harness racing at fairs. They even used to race up Fifth Avenue! We have a great portrait at Yonkers Raceway, taken along the Hudson River Drive, showing people racing their trotters along the Hudson River. It's evolved into more of a bred and trained and driven horse than it was in the old days with the amateurs doing it.

W.O.: The Rooneys are the blue bloods of sport.

T.R.: In those days, when the Rockefellers were riding their horses up Fifth Avenue, the Rooneys were looking for an un-rotten potato somewhere! We were in Ireland until the late 1800s. Rockefeller was from a little different neighborhood than the Rooneys.

W.O.: But the Rooneys are one of the great, well-founded families.

T.R.: Today, we sure are. But that's seventy-five to eighty-five years after some of our ancestors entered this country.

W.O.: How fast do your horses go?

T.R.: When we first got into this business, if a horse could go a mile in two minutes it was flying. Today, horses are running a mile in 1:49. Not at Yonkers, because it's a half-mile track, but they'd go 1:51 there or 1:52.

W.O.: Take us back through the years, Tim Rooney. Who were some of the vivid figures you remember?

T.R.: My mind drifts back to Wellington Mara with my father and Sonny Werblin, the founder of the Jets. Well Mara and my father are members of the Football Hall of Fame. I don't know if Sonny is, but he should be. I also remember my father in Dublin for the Irish Derby. At Yonkers I recall Senator John "Chippie" Flynn, who probably did more than anyone to keep the raceway going in the seventies and eighties. And Mike LaChance driving Western Dreamer to the Triple Crown of Pacing. And, of course, the legendary Stanley Dancer, one of the really great, historic figures of harness racing—a great driver and superb trainer.

One of the memorable nights occurred at the centennial for the city at Yonkers Raceway. Governor Malcolm Wilson was there, and so was the mayor of Yonkers at the time, Al DelBello. I well remember the time Brother Jack Driscoll of Iona College had a supper for the Dalai Lama. My wife, June Marracini Rooney, and I really enjoyed that. I can still see my father, Art Rooney, receiving the first Super Bowl trophy from Pete Rozelle, who was a resi-

dent of Harrison. I don't wear my Super Bowl rings. They were made for hands bigger than mine. I have four of them somewhere in a box. There were a lot of great nights with John Cardinal O'Connor and Francis Cardinal Spellman. Also John Sharkey, president of MCI, and Lou Holtz, the head coach of Notre Dame.

w.o.: Wonderful stuff. I had a hard time getting those memories out of you. You are a modest man, Tim Rooney.

t.r.: I guess I am. I try to have modesty.

w.o.: I see a lot of you with archbishops, cardinals, and ordinary priests. There was also a marvelous story about your father of sainted memory called "The Plumed Fedora." Jimmy Cannon said your dad saw this priest at the airport who looked downtrodden and dejected. He said a hurricane had blown the roof off his church. And your dad asked how much and wrote out a check. Is that a true story?

t.r.: Probably. But he wouldn't write a check. My father would probably pull it right out of his pocket in those days and give it to him. He didn't write checks.

w.o.: Does your faith mean a lot to you? What kind of Catholic are you?

t.r.: I try to be a practicing Catholic and follow the rules of the Church. It isn't always easy to do, but if you have discipline and you get into the habit of doing things as a young person, it's easier to do. It's like running. If you run enough miles, you can run them more easily. If you live how you're supposed to, maybe it's easier too.

w.o.: What do you talk to Cardinal O'Connor about when you're at those charitable dinners?

t.r.: I wait for him to lead off the conversation. He is an interesting man to talk to, with wide interests. Unknown to most people, the cardinal archbishop was a pretty good golfer in his day.

w.o.: You and Mrs. Rooney also knew Terence Cardinal Cooke.

t.r.: He was a wonderful person. A saintly man. Not that the present cardinal isn't, but Cardinal Cooke was something else. A very special person.

w.o.: What about your father, Art Rooney?

t.r.: He also had deep faith. It may have been surprising to some, somebody as religious as Art Rooney involved with betting on horses.

w.o.: But did he pray? Help us beat the Giants or the Bears?

t.r.: We *always* do that! Sometimes you'd let it play out on its own. But if it got down to "rug cutting" time and it didn't look as if you were going to make it, you would resort to your prayers.

w.o.: You've been active with politics in this state. Do you ever feel the politicians haven't done anything to help you or your track?

t.r.: I could say that lately, but if it hadn't been for the politicians from the time we bought the track, we would never have lasted as long as we did. We've had tremendous help from "Chippie" Flynn, who was our senator; from Senator Nick Spano; from our local delegation in Albany. Both Republicans and Democrats have kept us going for years. For the twenty-six years we've owned the track, we've seen our average attendance go down from 20,000 people to 800 people. We went from paying the State of New York $35 million a year in taxes to $6 million a year in taxes. That's a huge drop, and we wouldn't have been able to survive without the help of our political leaders.

w.o.: Are there going to be racetracks in the new millennium?

t.r.: There are, but not as many racetracks as there are today. You will find that it's going to be a "smorgasbord," a supermarket of products. If you go to Yonkers Raceway, you won't be going just to bet on the horses racing there. With simulcasting, you'll be able to bet on five different racetracks. And at the racetracks that survive, you'll be able to play slot machines and card games and craps. Whether you like gambling or you don't, whether you think it's evil or not . . .

w.o.: Do you think it's evil?

t.r.: I think anything taken to excess is evil, and I think people gambling too much with money they don't have is certainly evil. Somebody who has taken their rent money to blow it on horses is surely wrong. And I hate to say it, but it's insane to buy a Lottery ticket instead of a quart of milk. And there's a lot of that going on. There's more money bet on those lotteries than there is at any racetrack. If I had a conscience I might think about doing away with those.

The one thing I've always thought about New York is that the sins are being committed. But they are being committed at Foxwoods or in Atlantic City too, and that revenue doesn't come back to New York State.

w.o.: Can you bet on the ponies?

t.r.: I can if I want to. I don't bet on them.

w.o.: Could you place a bet at Yonkers?

t.r.: Legally, I can. The only times I've ever done it were just to save my sanity or to escape the boredom of being there all the time and watching thousands and thousands of races go by. And sometimes I'd give $10 to my son-in-law and we'd try to handicap horses, but that's few and far between.

w.o.: Can you bet on the Steelers?

t.r.: Absolutely not. In fact, I can race one of my own horses at Yonkers Raceway in a stake race, but I would not be allowed to race one of my own horses at Yonkers Raceway in a regular overnight race. That would be against the law.

w.o.: You really have fine horses.

t.r.: I have some good horses, and I have some really terrible horses too.

w.o.: What is the most you ever paid for a horse?

t.r.: Gee, not that much. Everything is relative. I think $175,000. And I sold that horse for $500,000, by the way.

w.o.: What did June Rooney say?

t.r.: I hope she isn't watching this program because I don't know if she knows about my exuberance or that little transaction.

w.o.: What happened with the horse?

t.r.: He had a lot of little problems that were enough to make him not worth much money.

w.o.: Did you ever fall in love with a horse? Do you ever just look at the face and say, "That is a . . ."

t.r.: Only when they were good. I fell out of love quickly when they were bad.

There are some horses that are kinder than others. There are horses that are friendlier than others. They're like dogs. Some horses try to kick you, and some horses snuggle up to you. But the nicest horses are the ones that are winning a lot of races.

w.o.: Do you ever go out when the foals are born?

t.r.: I do.

w.o.: Isn't that wonderful?

t.r.: That's really enjoyable. One of the most interesting things to do in racing is to breed a mare and then pick out which stallion the mare is going to be bred to and raise the foal to be a good foal and

a good racehorse. You really get enjoyment from breeding some-
thing special.

W.O.: Mr. Rooney, you and your family are special, and you're greatly
respected in our home heath and all across this country. Is there
any way to keep that damn track going?

T.R.: Well, if the Legislature wants to pass slots before we are sold,
we'd sure love to stay a racetrack.

W.O.: Thank you, Tim Rooney. You are your father's son. I'm capable
of no higher compliment.

<div align="right">September, 1998</div>

Interview with Guido Cribari

As Westchester's premier sportswriter in the seventies and eighties, Guido Cribari covered all the sports legends. And in the process he himself became one. Even today Cribari moves with great style down the fairways of Westchester's many golf courses. He looks like a movie star. Westchester's most beloved sportsman is in his eighties, and he damn well shoots his age. This icon of the golf world is still very much in the game he has distinguished for so long.

W. O'SHAUGHNESSY: Tonight, we're going to talk with Guido Cribari about all the great sports legends of Westchester and this nation. Now in your seventy-seventh year, you were the executive sports editor of the Gannett Suburban Newspapers for forty-eight years. What do you think of your old colleagues at the paper?

G. CRIBARI: I still read the paper every day. I've been reading it for exactly fifty years, going back to the time when Bill Fanning was president and Hugh W. Robertson was executive editor and editorial vice president. They are probably the two greatest newspaper people I have encountered in my lifetime.

W.O.: You used to play a lot of golf with some of their successors, Chip Weil and Tom Dolan.

G.C.: Chip Weil is running papers in Arizona, but Tom Dolan I don't know too much about. I played golf with all of them going back to Gene Sarazen and Walter Hagen's day.

W.O.: Why aren't you on the golf course on this nice summer day?

G.C.: I would be were it not for Bill O'Shaughnessy. And in an hour or so I hope to pick up a couple of bucks by sitting at a word processor. It's pretty tough to live on retirement pay, Bill.

W.O.: You're an icon of Westchester. I always see you coming to and from Winged Foot. How many days a week do you play golf?

G.C.: If I had my druthers, I would play seven days a week. But I try to play one, just to keep my finger in the pie.

W.O.: What's your handicap?

G.C.: Bad left *knee;* the left *elbow* isn't so hot; I'm losing sight in my left *eye.* But other than that I'm a legit 13 or 14 handicap. Which means I have to hit somewhere between 81 and 88 to keep my wallet in my pocket!

W.O.: What's the best golf course in Westchester?

G.C.: Very difficult question. If you mean as a test of golf, you would have to say Quaker Ridge or Winged Foot. If you mean for personal enjoyment, I'd like to play Blind Brook every day because it's only 5,800 yards long, flat, and just delightful. It's right next door to PepsiCo and at one time was probably the most exclusive men's golf club in the world. The ladies had something to say about that some years ago, and I think they are allowed to play a little golf there now as well.

W.O.: But you don't tee-off with the ladies . . .

G.C.: No. There are *no ladies* allowed on the grounds when I play at Blind Brook!

W.O.: Times have changed!

G.C.: You bet they've changed, for the *better,* I might add!

W.O.: We barely got through the Westchester Classic without labor problems there. Remember when it first started?

G.C.: I sure do. That's forty-three years ago, when Bill Jennings decided he was going to put on a tournament to raise money for United Hospital in Port Chester. They had a little one-day pro-am at Apawamis in Rye. The tournament featured Willie Turnesa, the U.S. amateur champion; Ray Billows, who was runner-up to Turnesa; Claude Harmon, who was the pro at Winged Foot and Masters' champion; and the fourth was Herman Barron, who was the pro at the Fenway Club in White Plains and probably the greatest Jewish golf professional the world has ever known. I'm sorry to see that he has been forgotten.

W.O.: Who was the best Westchester pro in your fifty years of covering golf?

G.C.: All I can tell you is that the nicest people I ever met in my entire life have been golfers by far, and the most charitable as well. You can name no other sport that has made the contribution to our civic welfare that golf has made. Just think about it. That little

Apawamis pro-am went on for thirteen years, and then it developed into the Thunderbird Tournament at Westchester Country Club. Vin Draddy had a lot to do with getting Westchester Country Club. We had five Thunderbird Tournaments, and then it became the famous Westchester Classic. Bill Jennings and Fred Corcoran are the people who orchestrated that entire enterprise that now has raised over $21 million for Westchester hospitals. Think about that!

It's almost impossible to total up the monies golf has raised for charities in Westchester. You've got the Heart Fund, the Cancer Fund, Guiding Eyes for the Blind—millions and millions of dollars—and the Westchester Caddy Scholarship Fund, which has helped over 1,500 kids in college and raised close to $4 million!

w.o.: Fred Corcoran, Mister Golf?

g.c.: He sure was that. He started the Women's PGA. He started the Golf Hall of Fame. He helped start the International Golf Association, which puts on World Cup matches. He started the Golf Writers Association of America.

w.o.: You mentioned another legend, Vincent DePaul Draddy, the Izod man, with the alligator shirts. Remember him?

g.c.: It just so happens that I'm wearing his suit today.

w.o.: What about that hat?

g.c.: That's an Izod piece, too!

w.o.: What about Draddy? He was a man's man.

g.c.: They all were celebrities in those days. They were *born* to make headlines. I'm convinced that Fred Corcoran and Vin Draddy were. Bill Jennings was, although he was a little different. He was one of the most introverted people I ever met in my life. He literally disappeared into the background. But he was an incredible person. To think what he did with that damn little one-day pro-am, turning it into $21 million!

w.o.: That marvelous Harvey woman, your wife of so many years, slipped me a few pictures from your archives. Who is that on the left?

g.c.: We were playing at a tournament in White Plains. The foursome was Perry Como, Willy Turnesa, Louise Suggs, and myself. The announcer on the first tee was Harry Wismer, one of the great sportscasters in America's history. I kid you not, he introduced me, Willy Turnesa, and Perry Como, and then he introduced Lou-

ise Suggs and said, "How did she get in there with that mafia gang?" Perry Como went bananas. Fifteen holes later he was still threatening to go back and kill that man on the first tee. He said he'd never come back to Westchester to play. And I don't believe he's ever been back to play since that day.

W.O.: What a story! Let's go again to the Guido Cribari archives. Here's President Gerald Ford . . .

G.C.: That was the year I was president of the Golf Writers Association. Ford was our featured speaker that year.

W.O.: These are all from your den. On the left . . .

G.C.: . . . the incomparable Freddy Corcoran. Corcoran managed Stan Musial, Ted Williams, Patty Berg, Tony Lima, and Ken Venturi. As a result of my friendship with Freddy Corcoran I was able to get close to and write about some of the most important people in the game.

W.O.: Who's that old guy in the middle?

G.C.: The old guy in the middle just happens to be probably the greatest all-around baseball player ever, Ty Cobb, who shortly thereafter killed himself by blowing his brains out.

W.O.: Let's go again to the archives. On the left?

G.C.: Slammin' Sammy Snead. There is no one like him. Still, at eighty years of age, he has the most fluid golf swing.

W.O.: And who's the white-haired gentleman?

G.C.: What a sportsman he was: Art Rooney, who started and owned the Pittsburgh Steelers and Yonkers Raceway. He had four great sons.

W.O.: Is that Tim Rooney's old man?

G.C.: Yes. The four famous Rooney sons run Yonkers Raceway, the Palm Beach Kennel Club, and the Pittsburgh Steelers.

W.O.: There's Bill Jennings . . .

G.C.: William Mitchell Jennings. I have to say that he probably was the finest amateur sportsman I ever encountered.

W.O.: Did he own the New York Rangers?

G.C.: No, he was president of the Rangers and president of Madison Square Garden. A great lawyer.

W.O.: What's this picture?

G.C.: A part of that "mafia" we were speaking of earlier: Cribari and Frank Sinatra.

W.O.: Who's the lady?

G.C.: Dinah Shore, who had also made a large contribution to golf in this country with the tournaments she has put on, and she has raised considerable amounts of money. She's one of the great benefactors of the LPGA (Ladies' Professional Golf Association).

W.O.: She's also a great singer.

G.C.: Yeah, she can carry a tune. And she and Frank sang together, as youngsters, at your old stomping grounds: WNEW. Her name in those days was Fanny Shore.

W.O.: From the Guido Cribari archives . . .

G.C.: There's one of my favorite people of all time: much-maligned George Steinbrenner. Maligned primarily by Murray Chass of *The New York Times*.

W.O.: Somebody told me you and Boss Steinbrenner are very close.

G.C.: We are. He's one of the most misunderstood fellows I have ever known. Other than Bill Jennings and a couple of others, he's probably done more good than anybody. But he's taken a pretty good pounding from the New York media, unlike a few others who really deserve it. Let's put it this way: if George Steinbrenner were president of the New York Mets today, they would be running him out of town, wouldn't they?

W.O.: Somebody told me that you would never say anything bad about Steinbrenner.

G.C.: I couldn't. Because any time I ever wrote to him or called for help—some kid in the hospital wanted an autographed baseball or something—never once did he turn me down in the twenty-two years I have known him.

W.O.: The guy on the left is one of the sweetest men ever: Kyle Rote.

G.C.: One of the all-time greats of professional football, and unfortunately for Kyle, he never really capitalized on the success he had. It's sad because, you're right, he's one of the sweetest people that ever lived.

W.O.: Here are some more.

G.C.: There's the greatest golfer of all time, Jack Nicklaus. A pure, pure, pure human being.

W.O.: Who was better, Arnold Palmer or Nicklaus?

G.C.: I think you would have to go with Nicklaus. Let's face it, he's the only one who has won twenty majors. Nobody else has come close.

w.o.: Let me go to some other sports. Who was the greatest baseball player ever? You mentioned Ty Cobb.

G.C.: Well, I never saw Cobb play. I have to go by the records and what I've heard about him. The most exciting in my time were Ted Williams and Joe DiMaggio.

w.o.: If you had to pick one . . .

G.C.: I think I would take Ted Williams because he was the greatest hitter, the last one to hit .400. Nobody else has come close.

w.o.: What about the mystique of Joe DiMaggio? I hear he is a reclusive guy.

G.C.: Introverted is the word. Another one of those background people, like Bill Jennings, who prefer to stand back and have the limelight on other people. But they achieved greatness from that position. I can't comprehend how DiMaggio could get together with Marilyn Monroe . . .

w.o.: She wasn't good enough for him?

G.C.: No, it's just not the kind of person that you would expect Joe DiMaggio to be with. He was so reserved, so quiet, then to pick the sex queen of the universe. It just doesn't fit.

w.o.: Does it bother you when we see some of these sports stars signing autographs for money?

G.C.: It's absolutely sickening. They all do it, and it's a sad commentary on the times we live in. I wonder where we are headed. To think that there are guys making $25 and $30 and $40 million playing baseball is ludicrous. And then not making a real effort to go for a line drive or catch a ball for fear of hitting the stands. You have to think of Pete Reiser, an outfielder for the Brooklyn Dodgers, who would delight in whacking his brains against the centerfield stands just to make a catch. And what was he making in those days? Probably $6,500 a year. I think Ralph Branca, the year he won twenty-one games as a twenty-one-year-old, was making $9,100, if that.

w.o.: Where does it stop?

G.C.: They will suddenly awaken one morning and find that the whole bottom has fallen out of baseball. It just can't continue to go the way it is. The game can't afford it.

w.o.: What happened to the Mets this year?

G.C.: I asked you earlier before the program if you would please

refrain from asking me that question. I'd rather talk about the Yankees and Steinbrenner!

w.o.: But Nelson Doubleday is a good guy . . .

G.C.: A great guy. The collapse of the Mets has got to be one of the great mysteries of all time. The talent is all there—or maybe they are short a frontline pitcher or two—but position by position, there is no way that team should be where it is.

w.o.: What about this poor guy who lost twenty-five games in a row.

G.C.: That's sad. I've watched this guy; he's got a lot of talent. I think they're convinced he has that talent and that he is going to be a good pitcher.

w.o.: We've talked about the legends of old. Are there any legends in the making today, anybody with great mythic qualities in any sport?

G.C.: I'm bothered by the money influence in the game. The sports page reads more like the financial section. I'm wondering whether it isn't time we took the managers and agents and put them off the sports page, put them somewhere else in the newspaper, along with the financial situations of some of these players. I don't enjoy agents making squawks to newspapermen and then reading it in the columns.

w.o.: What sportswriters do you read today?

G.C.: I read the local and the national scene. I read the *White Plains Reporter Dispatch,* now *The Journal News,* because I worked in that office for a number of years—forty-five, to be exact. I read *The New York Times. The New York Post* has a sportswriter who I think should get some Pulitzer consideration, Phil Mushnick. He really works at it. He's had a campaign now for years, criticizing some of the sneaker manufacturers, really laying into them about the Price of some of these sneakers because kids are going out stealing and injuring people to get those sneakers and jackets and the rest that cost $125 and $185.

w.o.: Have you seen the sneakers that light up?

G.C.: They do *everything!* They even play the game for you, according to the manufacturers. Read Phil Mushnick in *The New York Post* and you'll agree with me.

w.o.: How can you tell a kid he can't have a pair of sneakers, those Air Jordans with the lights?

G.C.: I read a piece the other day: I don't know where the sneakers

were manufactured originally, Korea or someplace else, and then they moved to where the labor was much cheaper. The best pair of sneakers made overseas costs $6 to make. And they're selling them in America for $185. Something is radically wrong somewhere.

w.o.: We were talking about sportswriters you have known. We lost a great one here recently: Tom Whalen.

G.C.: Tommy Whalen was one of the precious people I have known in my lifetime. He worked with me for forty years. He was fired a couple of times, and I insisted they bring him back. They threw the mold away after Tommy Whalen arrived on the scene. This man was loyalty personified, and his death really hurt. I was very close to Tom. Let's get back to the old ones: Red Smith.

w.o.: In the last column he ever wrote he said, "I think I have squandered my talent on those that are less than great. Not to worry, someday there will be another Joe DiMaggio." Was Red Smith the greatest of all in your tribe?

G.C.: Pretty close. Bill Corum was up there, and Stanley Woodward, sports editor from the old *Herald Tribune*. The greatest sports staff I ever encountered was at the *New York Herald Tribune*. We lost a great newspaper when the *New York Herald Tribune* went down. And let's not forget Dan Parker of Bronxville and Jimmy Powers of Tarrytown with *The News* and the *New York Daily Mirror*. And Joe Williams of the old *New York Telegram*. The greatest golf writer I ever read was a chap by the name of Lester Rice for the old *Journal American*.

w.o.: Jimmy Cannon, my favorite, called sports "the toys of a nation." Do you think you've squandered your life on toys?

G.C.: Wouldn't Jimmy Cannon be surprised to learn that today those toys are worth millions and millions and millions and millions.

w.o.: Somebody told me to ask you about Sally Francis.

G.C.: Sally Francis was a woman who lived in Mamaroneck who gave me the thrill of my lifetime. When we started the Caddy Scholarship Fund, we had the dean at NYU and the dean at Fordham pick the caddies who were going to receive scholarships, and they whittled it down from sixty to thirteen. All we could afford was six scholarships, and we had to turn the other seven down. I wrote a column the next day saying how sad it was that we had to turn these seven kids down. No sooner was that paper out than

this woman called and told me how disgraceful it was. I told her we had no money. She asked me to find out how much we needed, so I called Willie Turnesa, and it turned out we needed $13,000 a year to send those other seven to school. So I called the woman, and she told me to sit tight and the check would be delivered to my office. And she gave $13,500 every year until her death two years ago!

W.O.: Sally Francis was a hell of a dame! We have two minutes left. You came in here without any socks on. Where did you learn that trick?

G.C.: Before you? First one I ever saw go without socks from May to September was Tommy Goodwin, who reminds me of you. He was the original Errol Flynn. He was also probably the greatest amateur golfer, sailor, and swimmer this county ever had. And one of the great sportsmen of all time. I walked ten holes with him in a money match one time. He was playing against three very wealthy men, and he had twenty-nine for the first nine holes at Westchester Country Club and made a hole-in-one on the tenth hole, giving him thirty for ten holes!

W.O.: Please give my best to Dorothy Ethel Harvey Cribari. We love you, Guido Cribari. You are a certifiable Westchester legend and our greatest living sportsman.

G.C.: It's been a hell of a game. I've had a few good rounds, Bill.

<div align="right">June, 1993</div>

Interview with
Sirio Maccioni

The ringmaster of Le Cirque 2000 is America's greatest restaurateur. Sirio, his wife, Egidiana Palmieri, and their handsome sons Mario, Marco, and Mauro are among the most generous and respected New Yorkers. This gifted Italian impresario is recognized for his genius on every continent. Maestro Sirio is the Winston Churchill of the restaurant world. Or maybe the Frank Sinatra of his tribe. Either description fits.

W. O'SHAUGHNESSY: Our guest is the ringmaster of Le Cirque, on which *The New York Times* and *Forbes* and Bob Lape have bestowed four stars—making it a twelve-star restaurant! He is a great statesman of his tribe. Lape, in *Crain's New York*, called him the greatest restaurateur in the world: Maestro Sirio Maccioni.

S. MACCIONI: Greatest restaurateur? No, no. Do you know what a restaurateur is? He is only a presumptuous waiter! I sell soup. If he doesn't remember that, he is finished. Being a restaurateur is hard work and that's all.

W.O.: Sirio, a lot of French chefs are upset that an Italian—a Tuscan—has achieved such fame . . .

S.M.: I hope not. Some of my best friends are great French chefs, and they all come to see me every time they are in New York. Perhaps there really is something different that only in New York we do. Our kitchen is really a serious matter. After so many years of working in difficult conditions, I was very happy that I could offer my chef the best. Ours is the best kitchen in New York.

W.O.: You came to this country from your native Tuscany as a busboy.

S.M.: I was less than nothing. I went to France, Switzerland, Germany to school. In those days, in the fifties, everybody from Europe wanted to go to England because English was the language everybody wanted. It was easy for a European to go to Germany, Swit-

zerland, and France, but it was very difficult to go to England because the Germans, the French, the Italians, the Spanish all wanted to go to London, in our business especially. There was a certain time they had to wait.

I was working on a ship as an interpreter in the fifties. The cruises were very sophisticated. We used to go all through the Caribbean. And one day I mailed an application to stay here to do a summer course at Hunter College, and I stayed and started to work. Money was always very scarce. I didn't have any. And so I started to work on weekends downtown in a restaurant called Oscar Delmonico. They were Tuscan. I got a green card through them. The head of immigration in 1950 was a gentleman named *William O'Shaughnessy!* This man used to come to the restaurant all the time. Then I found out that I was doing something wrong, because one day the immigration authorities came in and asked to see if we had anyone working without permits. I was the manager. When they left, I realized *I* was the only one without a permit! So I went right away to see Mr. O'Shaughnessy and start the procedure. In the fifties Wall Street was the financial center of New York, so you had people from all over the country, and I was really the only one who could speak French, Italian, German, and English. Within six months I got the visa.

w.o.: I'm glad that other O'Shaughnessy did the right thing in those days. You now have a villa in Montecatini, and you've become the Winston Churchill of your profession. You're off to Paris next week to receive yet another honor. You lectured at the Culinary Institute last week. Mario Cuomo called me up and asked why Le Cirque is a French restaurant when you and your sons are from Tuscany. And your beautiful Edgidiana. Why don't you just come clean and make it a damn *Tuscan* restaurant?

s.m.: I'll tell you exactly. I am Italian. But I am not a political person. I like to tell the truth. In my own town, Montecatini, there are five restaurants that have a French name. There has always been this history in Italy and France. You go to Paris and you'll find Italian restaurants, which are not Italian, only with an Italian name. You have to understand that twenty years ago when I came to this country, there were no great Italian restaurants in New York. They were not "in"—like it was not "in" to be an Italian in Paris in 1951. The Colony, which everybody thought was one of

the greatest restaurants in the forties, was Italian. The name of my place is French. The reason I call it Le Cirque is because I like the name. First of all I wanted to give it a name which took away the presumption. Le Cirque in French means if last night you went out with a group of people and you had a good time, last night was a *circus*. So the mural in the restaurant has monkeys and everything.

In the kitchen I have thirty people. I have four or five Italians. I also have French cooks. I have a lot of Americans. I think I have encouraged many young Americans to go to Europe, starting with some of my best friends like David Bouley downtown, who started at Le Cirque. The chef at "21," Michael LaMonaco, is a creation of Le Cirque. So I think I have done something in this field. I don't call Le Cirque Italian or French or American. Le Cirque is *my* philosophy of what a restaurant should be all about.

w.o.: I was recently in Italy. You are one of the most famous sons of that country.

s.m.: I'm glad of that because everybody has to be what they are. You never talk bad about your country, your mother, your family; you try to solve the problem. Even to very high, important people in Italy. In Italy it has been a disgrace what has occurred. It's the power of Italian small enterprise that makes Italy what it is, the fifth power. Most of the political groups are really a disgrace. Communism can be good, but it is bad when applied in the wrong way, and Communism has been applied the wrong way in Eastern Europe, so why do we have to try it in Italy? Italians are not communists. Thank God they are not *with* anybody. They are *against* everybody! They're even against *themselves!*

w.o.: One of your customers right across the courtyard is the cardinal archbishop of New York. You're right behind St. Patrick's Cathedral.

s.m.: John Cardinal O'Connor is our landlord and a very, very nice person.

w.o.: Does he come over to pick up the rent or borrow a cup of sugar?

s.m.: We send the rent, but he came in and blessed the restaurant. He is very, very important with the whole family, including Mario's daughter, Olivia. She is the center of attention. I hope she doesn't take too much advantage. Olivia is almost three. And if my son

ever gives me a hard time, I tell him I'm going to take Olivia and disappear and live happily ever after!

w.o.: You recently fed not just the cardinal archbishop but his boss, the pope.

s.m.: There were sixteen cardinals at the table in the residence of the pope's ambassador to the United Nations on 72nd Street.

w.o.: Is the pope a good eater?

s.m.: The pope is a very good eater. He finished his plate.

The day was Friday, and Archbishop Renato Martino, who is a great, intelligent man, asked me, "Sirio, what can I do to entertain the Holy Father? Can you give me a hand and feed him well?" I said, "We do everything, Excellency!" So we did. We went and we cooked, with security from the United States, Italy, and the Vatican looking at everything and tasting everything. The Holy Father ate risotto with porcini mushrooms and fish. My chef and pastry chef were there. And they did a replica of St. Peter's Basilica in white chocolate. I was very honored.

The archbishop asked the Holy Father if it wouldn't be very nice to have a great restaurant up in heaven, and the pope looked at him, me, and Cardinal O'Connor and said, "Are we really *sure* that we go *up* there?" It was amazing because he spoke to me in Italian. I spoke to him in English. He spoke to the pastry chef in French. He spoke to my head chef in Thai. He didn't have anything written.

He asked me, "Are you a good Christian, Sirio? Or just another Italian who only becomes religious when they get sick?" In Italy we think because we have the pope there are a lot of local calls we need to make!

w.o.: If you're not a pope or an archbishop, how do you get into Le Cirque? You have a word that you use: "correct." Do you have to look "correct"?

s.m.: Yes. It's important. The people who come to Le Cirque from New York and those who are visiting New York like to show that they are correctly dressed. I don't see any reason why in July when the temperature outside is 95 degrees somebody should come into Le Cirque, which has air conditioning, in a shirt that looks like it came from the shower. It's not reasonable if you want to go to Le Cirque in the evening to come in with a windbreaker

without a jacket. New Yorkers are elegant people. New Yorkers should teach the world everything.

w.o.: Do you have to wear a tie?

s.m.: If possible for dinner, yes, I would prefer it. A journalist tried to be cute the other day. First of all we said, "You're here with a nice sweater, fine. We're not going to ask you to leave, but next time wear a tie." And he wrote completely the reverse of what we told him. But that is how it is sometimes with journalists. They have to make some kind of story out of everything. But the press has been very good to us.

w.o.: Four stars in *The New York Times*. Four stars in *Forbes*.

s.m.: Also *Esquire* and *Wine Spectator*. *New York* magazine asked me why I have been chosen as one of the thirty most important men. I don't know the reason. I just sell soup.

w.o.: Is it hard to get a table?

s.m.: No, it's not hard to get a table. Of course, if you call a restaurant and say you want my table in the corner at eight o'clock, sometimes you're in trouble. But if you say, "I would like to come to your restaurant. What time can I come to the bar and get a drink?" at Le Cirque you'll get a table.

w.o.: I've noticed that when some people walk in, you say, "Over there for them." You just nod. What do you look for?

s.m.: I look to recognize a face that I know. You need regular people in a restaurant. We have a percentage, about 50 percent, of people who come all the time—two, three, four times a week.

w.o.: Tell me about Donald Trump, one of your regulars.

s.m.: For me, he is a very nice person. I call him. If he's not there, in one minute he'll call me back and say, "Yes, Sirio, what can I do for you?"

w.o.: What happens when Donald Trump walks in and his ex-wife, Ivana, comes in at the same time?

s.m.: I think at this point they have good relations. Of course, you don't sit them next to each other. But they're all very intelligent, and nothing happens. I don't want to know what is the problem between other people. I'm talking about what people are doing with me.

When someone comes into the restaurant two or three times a week, you have to be able to recognize them and know that they like certain tables. Some people like to sit on the bar side, so you

hold a table because you know they are coming. It's important to understand what people want and not to be intrusive with the people who come to your restaurants.

A restaurant is like everything else. You go to buy a tie, a suit, or a car, you have to look at the color and you have to try. A famous writer in our field a couple of weeks ago gave us a big compliment, besides giving us a good rating. She said, "Le Cirque is like a Ferrari; you have to know how to drive it." I never did anything in order to say I was better than others. We did it because it was something we had to do. We are working people. We work and the thing happens.

Because we have a very big menu, we're not pretentious. We have a prix fixe lunch for $29 and no extra. *Everything* is included. I want to take away this nonsense that Le Cirque is very expensive. It's not so.

W.O.: Someone said, "Sirio feeds not only their stomachs, but their egos."

S.M.: That's everything. Why do people buy a suit from Versace when you could buy something that costs 60 percent less? It's a question of ego. In life everyone should start equal. But then I don't believe in egalitarian any more, I believe in elite. Because everybody should go up. I have three sons, and I tell them if one of you gets up at eight o'clock, one at ten, and one at twelve, the one that gets up at eight o'clock in the morning has more right than the one who sleeps until twelve o'clock. It's a simple philosophy. You have to respect the people. But tell them that everyone should try to do their best, and *help them* to do their best.

In a restaurant, it is the same. When people come in and they look around, they don't look at what they can enjoy, they look for what they can criticize. And it's very easy to criticize everything. You cannot have a restaurant like ours, which is a show every night, and be less than positive. I don't expect to be perfect in everything or for everybody, but we try as much as possible. Life in the big city is so hectic, people come to us to have fun and to know that they are not being taken advantage of.

W.O.: I was sitting with you of an evening, and your maitre d', Mario Wainer, and Benito Sevarin, your general manager, came up to you and said, "Sirio, Julia Roberts would like a table for Saturday night." And you thought, for a good long time, and said, "OK."

Any restaurateur in the country would love to have Julia Roberts walk in at any hour!

s.m.: First of all, we always call back to make sure it really was Julia. Many times people will use the big names. But if it's not Julia Roberts, even then don't be offensive because they tried to come to your restaurant. They are not trying to steal anything from you. As long as they come with shoes and a tie and jacket and the money to pay the bill. Now that's being very American and very reasonable.

w.o.: The "ladies who lunch" all repair to your tables. What do they talk about?

s.m.: It's not only the ladies. The ladies will not come if there is not a gentleman there. The ladies are all very intelligent, more intelligent than gentlemen. They have a certain feeling. You cannot fool them.There are a lot of business ladies: power ladies. They really don't come there just to talk. I would say that today 80 percent of the people that you see in a restaurant for lunch are there for business. Dinner is different. Dinner can be out with the family and friends, entertaining.

What do they talk about? Another good rule for a restaurateur is not to listen too much to what people talk about. Just look at them and make sure they are happy with their lunch or with their dinner. That's more important. I would like my sons to hear this: the most important thing you have to realize is that you are there to make sure the people at our tables have what they want. Look at the people. Don't be pretentious. And say, "Can I do anything for you?" This is the magic word. Not to take anything for granted. You have to think that tomorrow you can do just a little bit better. And take a complaint. But a complaint, if you take the time, can become positive. If you just forget about it and think the person didn't know what they were talking about, then it becomes a negative thing and you never catch up again.

Yes, it's a show. When I go to work, I'm a completely different person than when I'm out of an evening, but I like what I'm doing.

w.o.: I saw that you kissed the Queen of Spain's hand the other day. What did you say to her?

s.m.: "Your Majesty." I have to say that Juan Carlos is a gentleman. We used to call him a playboy, but he is the one who really saved

Spain. They love him in his country. You need some flamboyance, and you need to be represented by someone intelligent as long as they don't take advantage. To be a king or a queen goes with having people kiss your hand, like the pope.

w.o.: You have something named after you: pasta primavera. *The New York Times* said you invented it on a hunting trip. Is that a true story?

s.m.: Yes. It was in 1974, on Memorial Day. We were invited by the Canadian government to go to an island in Nova Scotia Bay, near Halifax: *The New York Times'* Craig Claiborne, Pierre Frenay, a couple of restaurateurs from Europe, and I was from New York. They have the most fantastic wild boar and fish, lobster and pigeon, so they wanted to publicize that. After three days of eating lobster, pigeon, and wild boar, people started asking for some pasta. I was in somebody else's house, a beautiful villa. The owner was Italian, and his wife was a Melville—a famous family. So I went to the fridge downstairs with my wife, and we found pasta. We also found some vegetables, frozen, but very good. Peas and asparagus and everything. Somebody asked for fettuccine alfredo. In those days, in the seventies, that was still fashionable, fettuccine with butter and cream and cheese. And the others were saying they wanted something with vegetables. I wanted to do two different types of pasta, and at the last moment I saw it was very confusing, so I mixed everything together. And it was the first time for an Italian to do pasta with cream because we really don't use cream. But I put in cream, cheese, and butter, which is the classical way to do fettuccini alfredo, but then I added vegetables: asparagus tips with peas, zucchini, and mushrooms. And being it was spring and there were vegetables, they asked, "What is this? What kind of pasta is this?" And I said "primavera," but I didn't even think to classify it. Then a few people, including Mr. Claiborne, asked for the recipe of the pasta I did in Canada. He wrote it up on October 2, 1974, and the rest is history.

w.o.: Do people still ask for it at Le Cirque?

s.m.: We never did put it on the menu. But we have people who still come in and ask for primavera.

w.o.: What about food trends, Maestro Sirio? We have Thai food, Mexican food, Japanese food, and Chinese food now.

s.m.: In Western food—French, European, American, Italian—I like

to say there are only *two* types of food: good food and bad food. China and Japan improved the presentation of vegetables. Before that vegetables were all overcooked. I still believe in the basics. A good rack of lamb or a sole should be good in New York, Paris, Rome, and Berlin. The regional food is a different story. Italians have an advantage in regional food because every home is something different. If you ask me what is the best food, what is the greatest restaurant? The ones that use a chef with a French mentality. A great chef should be able to do great Italian food. In Italy we are too intelligent. I'm not saying this as a joke. In the kitchen you have either genius or mediocrity, and it's very difficult to work with both of them. So we had to go to Italian ladies for cooks, and they're fantastic. As a matter of fact, in the fall I will have four or five ladies from restaurants in Italy and southern France prepare the best food. These are regional cooks. They come in only to do one dish for lunch. But that dish has to be perfection. You cannot take a restaurant from Italy or France and bring it to New York. You need time to adjust yourself.

w.o.: You said once to a reporter that sometimes people can't eat caviar or foie gras all the time. Sometimes you need "vulgar" food.

s.m.: I don't mean vulgar, I mean *paesan* food. We have on our menu pigs feet, tripe and boiled beets, Italian bolito, lamb chops cooked with potato, roast chicken. I do that because people are used to it. These are the things we grew up with, and everybody, including me, is not easy to please in a restaurant.

w.o.: What about the new rules? The IRS say businesspeople can deduct only 50 percent of their meals.

s.m.: I was here at the time of the three-martini lunch, and even then people used to go out for lunch. I'll give an example that maybe someone in the tax department can explain to me. You can take a first-class trip on the Concorde to Paris, or vice versa, and subtract everything for business; it's as much as four or five thousand dollars a trip. It's completely deductible. But you go out to a restaurant and have lunch and only 50 percent of over $100 is deductible. Maybe you can call this discrimination against restaurants—I'm saying that laughing—but this is true. Eighty to 90 percent of the ladies and gentlemen who come to Le Cirque for lunch are there for business. Especially the young executives. They are there for business, and that's all.

w.o.: Someone said magic happens when Frank Sinatra walks out on a stage, when Mario Cuomo gets up in front of a crowd, when Joe DiMaggio goes to bat. There's something magic about you walking through a dining room . . .

s.m.: My sons can walk better. They have to start to *believe* a little bit more when they're walking. But it's good not to be pretentious.

w.o.: Sirio . . . a couple of things I've been meaning to ask you. Why is Gianni Agnelli, the chairman of Fiat, known as "L'Avocato," the Advocate.

s.m.: Very simple: because the name "God" was already taken.

w.o.: What was that you once counseled a gentleman about flirting with the ladies?

s.m.: I may have told him it's all right to *look* at beautiful women, but at the last moment you should send your driver!

w.o.: And what's that line? "If you wake up in the morning . . ."?

s.m.: The Italians have a saying: "If you wake up in the morning and nothing aches, you're dead!"

May, 1998

Interview with Adam Tihany

Designer-restaurateur Adam Tihany is a certifiable genius. He has designed the interiors of hundreds (read: most) of America's most exciting dining venues. Tihany has also created all kinds of dazzling things, including his world-famous martini glass, graceful furniture, and soaring hotel lobbies all around the globe from his design atelier in Manhattan. But he and his brilliant wife, Marnie, come home to Westchester each night to gather their energy and recharge their creative juices.

W. O'SHAUGHNESSY: Tonight, another of our neighbors who is the best in the world at what he does: preeminent restaurant architect and designer Adam Tihany. You've designed most of the great restaurants in New York. You have a gorgeous, extravagantly beautiful new book. We know you're a legend in your field. Any restaurant you've done seems to become an instant classic. How the hell did you come to specialize in restaurants and food?

A. TIHANY: The truth is that all good things in life seem to come by default. I was born in Transylvania and grew up in Jerusalem. I went to design/architecture school in Milan, and that's where my formation and background come from. When I came here in 1974, my dream was to design *everything!* I thought I was a European designer. With a pencil and paper I could design anything. I started looking for a job, and people would ask me, "What do you do?" and I told them I was a designer. I was asked, "What do you design?" and I said, "Whatever there is to design, I design." I was the factotum. I was the Italian maven who knew everything. After about two years of not being able to eat, I realized that I had to call myself something and specialize in something. Maybe you don't know this, but I designed Xenon many years ago. The big disco right after Studio 54.

I had an American client who decided to open a restaurant, and

he said to me: "Would you want to design a restaurant?" I said, "Sure, why not? I'm a designer. I have my pencil." I started working on this project, and what I discovered during the process was that a restaurant has architecture, space planning, furniture design, accessory design, lighting design. Suddenly I was designing everything I wanted to do in one particular space. I decided from then on to be a restaurant designer.

Strangely, the name of the place was La Cupola on 32nd Street. It was the first grand café in New York and really the "birth" of the profession of restaurant design. Before that there were no restaurant designers per se. Tables and chairs and a bar and some flowers. That was it. Nobody called it a profession.

w.o.: In the introduction to your book, Paul Goldberger of *The New York Times* says you are a genius. When you were a youngster in Transylvania . . .

A.T.: Transylvania is the Hungarian-speaking part of Romania.

w.o.: . . . did you always noodle around and draw things?

A.T.: No. I actually wanted to be a biologist when I finished my military service in Israel. In Israel we go into the Army at the age of eighteen. In the Six Days War I was with the Air Force. I was in the War of '73 as well, in the infantry in the Golan Heights.

w.o.: Were you ever shot at?

A.T.: Quite often, actually, and for quite some time. But I was very skinny and very fast, so they had to find me. After I finished my military service, I had one really big goal, which was to get out of there! I wanted to study biology. The only place I could go, an Israeli student who did not speak Italian and didn't have any money to pay tuition, was Milano. And the two subjects that you could study at the time as a foreign student were veterinary medicine and architecture. And this is a true story. I looked up architecture in the dictionary, and it looked like something I could make a living out of, so I decided to go and study architecture. As I said, it was really by default, because I didn't want to become a veterinarian.

w.o.: As you look at things—cups, saucers, chairs, restaurants—do things offend your eye?

A.T.: It's the contrary. Things excite me. I found out at a very early age that I had a good connection between the eye and the hand. I could draw what I saw and change the perspective, and I could

change the proportions and manipulate space, and things became more friendly, more beautiful, more sexy, more usable. I think it all comes from the fact that I really love people and I really love the hospitality business. I like the relationships. I like to see people comfortable. I like people to look beautiful in the restaurant. You can create a wonderful, compelling, exciting environment where everybody is ready for something to happen. That takes talent. It's something you develop because as you get to know people better and as you immerse yourself in the world of the culinary experience and in what foods and restaurants represent as cultural phenomena, you get real excited about it. You love it, and once you love something, you have to do it right.

w.o.: In addition to designing restaurants—the mighty Le Cirque 2000 and some others—you couldn't resist being a restaurateur yourself.

a.t.: My place is called Remi. About fifteen years ago, while I was designing the DDL Food Show—if you remember, Dino DeLaurentis opened those huge food stores—I met a young Venetian chef named Francesco Antanucci. He used to be the chicken man on the rotisserie at the DDL Food Show. I continued working with Dino and designed other restaurants like Alo Alo and the Bistro in Trump Tower, and Francesco kept popping up in these places. We became real good friends. He used to cook in my house. We used to hang out, and one day he said to me, "I would really like to open my own restaurant." And I said, "Yes!" He asked if I could help him find some money and design it. The word *partners* never came up. So I started to look for a place where the investment wasn't too big. Remi is currently on 53rd Street between Sixth and Seventh Avenues, but the original Remi was on 79th Street between First and Second. We found this derelict bar, and it was a small investment—something like $250,000. He had $50,000. I had $50,000. We found a third guy who put in the rest, and we opened Remi in 1987. We've been partners since. It's a very strange thing because I never wanted to be in the restaurant business.

w.o.: Do you go there of an evening? Do you seat people?

a.t.: I used to for three years when it opened. I used to be the front man because Francesco was just starting in business and was quite

shy. He didn't want to leave the kitchen, and I had somewhat of a reputation of a front-floor guy.

W.O.: Do you "dress" the room? I mean, do you have to look a certain way to get a good table in one of the Tihany restaurants?

A.T.: You should know that! You frequent some of them. Seriously, I don't think so. You just have to have the right *attitude*. You get a good table with a little bit of luck, and by showing up at six or at ten you can always get a good table in any restaurant in New York City. If you are a decent customer, a regular customer, every restaurant extends the courtesy to you and will give you favorable treatment. It's true in every business. There are a lot of people complaining, "I don't get treated well when I come here. The maitre d' stops me and puts me in Siberia." I usually ask them how often they go to this restaurant, and they tell me it's their first or second time. I say, "Maybe they have a lot of faithful customers who come all the time." And that's true in a clothing store. It's true in any kind of retail environment. If you are a regular customer, they treat you differently.

W.O.: Do you ever encounter obnoxious people?

A.T.: Of course. You encounter obnoxious people everywhere. A lot of people get irritated if you don't recognize them immediately, but I think recognition comes from frequenting a certain place often! You get to know the people. You talk and begin to develop a relationship. You can't expect a good maitre d' in a great location in a good restaurant to remember every customer. It's an absolute fantasy. If someone says, "I walked in there once and they remembered me," it's one out of a million. You must have done something to be remembered by.

W.O.: *Tihany Design* is the name of your new book. Amazon.com gave it five stars. I was going to say it's a coffee-table book, but you can't put it down. It is almost as if you're taking a tour of these restaurants. When you design for a famous chef like Charlie Palmer or a famous restaurateur like Sirio Maccioni, do you lose any arguments or do you always win?

A.T.: We don't have arguments. You can confirm that with my absolutely spectacular, wonderful, and adoring wife, Marnie.

W.O.: Does she ever look over your shoulder when you're designing and say, "I don't like this."

A.T.: She looks over my shoulder always in more of a protective way.

She's my soulmate and bodyguard and the best thing that ever happened to me.

I also did Circo in Las Vegas, the Maccioni kids' restaurant. It's the second restaurant I designed for the boys. They're the sons of Sirio Maccioni, who also owns Osteria del Circo restaurant on Manhattan's West 55th Street. It was my privilege to do the father's mothership, Le Cirque 2000, in the Villard House across from where the cardinal lives. Actually, the cardinal used to live where the restaurant is.

w.o.: Was this your most controversial assignment.

a.t.: Yes.

w.o.: The old Le Cirque was kind of a drawing-room, sedate, laid-back, Park Avenue venue, and in the new place you were unable to violate the stately ceilings and the floors. So what did you do?

a.t.: I have to explain to you a little bit about my design philosophy. I am no different from a portrait artist. I design portraits of my clients—not in paint, not on canvas, but in space. You should stop me if I'm wrong, but Le Cirque 2000 is the exact portrait of Sirio Maccioni. He has that exterior Renaissance veneer of a very traditional man, but inside he's an absolutely fantastic ringleader. He is joyous. He is playful. He is funny. He loves a little bit of what he calls "casino": he doesn't like things that work perfectly. When the opportunity came to move Le Cirque, we went to see the Villard House together. I told Sirio that we had very few choices here. One was to take the space and clean it, restore it beautifully and respectfully, put in period furniture, create a museum or, at best, a very hush-hush church. It would not be a restaurant. It would not be sexy. It would be magnificent and everybody would say, "You did an 'appropriate' job." Or we could go the other way and deal with it the way a good Italian would deal with his monuments: we fix it up perfectly, clean it up, and then park a Ferrari in the middle and see what happens.

w.o.: I see the look in your eye. You made a hell of a circus out of it.

a.t.: The interiors of the building are landmarked, which is quite unusual in New York City. That worked in our favor because everything you see in there is removable. There's nothing attached to anything.

W.O.: You mean Sirio can up and leave town in the middle of the night.

A.T.: Not only Sirio. You can fold this whole décor and take it out.

W.O.: The papers went nuts. All the "ladies who lunch" thought you had lost your mind.

A.T.: But here is the point, in terms of the real conception of a circus. The circus comes to town, builds a tent in the middle of the square, does the show, folds the tent down, goes away, and nothing has changed. I'll tell you why the ladies who lunch got crazy. They did not know Sirio. They didn't expect him to be so flamboyant. And when they saw the real man, they said, "Wait a second."

Anyway, at the same time we did Le Cirque I also did the new Jean Georges, completely 180 degrees the opposite. Jean-Georges Vongerichten is another four-star chef who is very well known, and we went back to the concept of portraying an artist.

I've also designed a restaurant called 160 Blue in Chicago, which is owned by an equally famous owner who is not necessarily a chef. He's a very famous retired basketball player. I can't tell you who.

W.O.: Michael Jordan.

A.T.: I can't mention his name. I didn't say that.

W.O.: Can Michael Jordan fit under the ceiling of his own joint?

A.T.: Yes. The place is tall, dark, and handsome, like the owner.

W.O.: You also did the Adam Tihany martini glass. Doesn't that ball go around in the middle?

A.T.: No, you can just lift the glass without touching the base. It comes out.

W.O.: How much does that little item go for?

A.T.: The last I looked, it was $550. It was the most expensive martini glass on the market.

W.O.: And you need *two* of them.

A.T.: The day that the paper said the most expensive martini glass is hitting the market, it was sold out!

W.O.: It's always sold out. You can't get them.

A.T.: I'm also working on the lobby of the King David Hotel in Jerusalem, one of the great landmarks of the Middle East. It's a hotel where every head of state and every celebrity stays, and every-

body just flocks to see it. It was an honor and a totally scary prospect to redesign the King David Hotel in the city that I grew up in—and where my mother actually lives with all her friends, so they're going to go and see it and criticize me.

w.o.: What does your mother say about this?

a.t.: She thinks I did a good job. She really doesn't praise me to my face. She's a very wonderful Jewish lady, but you don't get compliments. Only with the back of the hand.

w.o.: Does she know how successful you are in America?

a.t.: She does. She actually comes quite often and helps us in the office. When I work, I sit in front of my drafting board and draw with a pencil on paper. I still haven't mastered the use of the computer. I have a real old-fashioned design atelier, where we're not unlike a custom tailor. We take your measurements and sew every button by hand, and then take your measurements again. We also do quite a bit of furniture and product design under the Tihany Design label for a variety of manufacturers. We just introduced a line for McGuire. We have designed furniture for Pace, for Bill Battaglia. We've even done a chair named for Mrs. Tihany: the Marnie Chair. She loves it.

w.o.: Can I ask you something? Sirio has some chairs at Le Cirque in the foyer, from which you need a derrick to help you stand up when it's time to go. Did you ever sit in those chairs?

a.t.: I'm a bit younger than you, so maybe I can get out of them by myself! I'm fifty-two, O'Shaughnessy.

w.o.: Then you have another good twenty years. What are you going to do?

a.t.: We are currently renovating the Mandarin Oriental in Hong Kong, which is one of the greatest hotels in the world. It's getting to the point where my ultimate fantasy is to have a Tihany Design project in every major town in the world. I'm going to have a very, very busy next twenty years to just accomplish half of that.

w.o.: Do you go out to eat here in Westchester County?

a.t.: Hardly.

w.o.: Do you ever take a day off?

a.t.: Yes, I do. I cook for my kids. We're up in the house every weekend, and we're cooking virtually all the time.

w.o.: What do you like to cook?

a.t.: I'm good at pretty much every variety of Italian food. Inciden-

tally, the book I did before this was *Venetian Taste,* about Italian-Venetian cooking with Francesco, my partner.

w.o.: We'll see you soon at Remi. You're a delightful guy, and not without a little talent. I'm glad you were fleet of foot up there on the Golan Heights.

February, 2000

Interview with Erik Blauberg

Chef Blauberg, with encouragement from the British billionaire James Sher-
wood and his Orient-Express Company, has reinvigorated the legendary
"21" Club in recent years. Who ever said the rich and powerful don't like
to eat well?

W. O'SHAUGHNESSY: Tonight the hottest chef in New York and thus the
country. He is the new executive chef of the legendary "21" Club
in Manhattan, and we've taken him out of his kitchen to bring
him into your hearth and home: Erik Blauberg.

E. BLAUBERG: Bill, it's very kind of you.

W.O.: I've heard about you for years. You made a great name for your-
self at a restaurant called Colors and American Renaissance. Then
you did hotels in the South . . .

E.B.: And the Caribbean. I've traveled all through Europe, and I've
trained in Japan. I've been with Paul Bocuse in Switzerland too.

W.O.: There were hundreds of applicants for the job at "21." Why do
you think Bryan McGuire, the majordomo, picked you to zoom
up the food?

E.B.: I'm not really sure. I was down in Florida working with Michael
Eisner on a new project, and I got a call asking if I were interested
in "21,"and here I am.

W.O.: "21" was just taken over by James Sherwood, who owns a few
interesting venues, including the Orient-Express luxury trains
and hotels all over the world, such as Dottore Natale Rusconi's
fabled Hotel Cipriani in Venice. "21" is another of Mr. Sher-
wood's trophy properties. And to his credit he's kept it the way
it's always been for so many years. Were you a little intimidated
by the lineage of "21"?

E.B.: I've been to so many places, I'm very adaptable to a business
that is running at a good pace and doing well. If there's one thing

I have learned, it is don't go into a place and try to change it. Test your customers out first. You see me walking through the dining room. I talk to my customers and see what their feelings are, what they like. I tell my customers that if there is anything not on the menu they would like, give me a day in advance, and if it's in season, I'll bring it in.

w.o.: What do those moguls and potentates eat?

e.b.: For lunch we still have the traditions: chicken hash, the "21" burger, the Senegalese cold curry soup. Also the organic chicken . . .

w.o.: I hear you took a few shots for fooling around with the famed "21" burger.

e.b.: Yes. When I originally came here, I stood over by the dishwashing machine and watched the food come back to see what people were eating and what they weren't eating. That's a good barometer. I saw the french fries and the coleslaw coming back. So I said, "Let me fiddle around with this burger." I did a different version of it with pickled vegetables and potatoes sautéed in duck fat to give them flavor, with a scent of rosemary, fresh thyme, and some shallots. It went over for a little while, then people started to ask for the french fries. So now you have a choice of french fries or sautéed or mashed potatoes. I've gone ahead and seasoned up the "21" burger a little bit because it had only salt and pepper on it. So I put on some fresh herbs, and that went over very well. You can still have your choice, but it's funny to see even old clientele ordering the sautéed potatoes now.

w.o.: At "21" what do the "ladies who lunch" eat? Don't they have filet of sole and chopped-up salad?

e.b.: They have more of the lighter foods such as salads. We have a pepper tuna that is served with a seaweed salad and an avocado and shrimp roll. When President Bill Clinton was in town for Chelsea's birthday, that's what he ordered.

w.o.: Somebody told me President Clinton was eating off of the guy's plate next door.

e.b.: You're right, Bill. He was greatly taken with Senator Ted Kennedy's chicken hash. And the First Lady had the Dover sole.

w.o.: Did you go out and meet the president?

e.b.: Yes, I did. I cooked their meals and served them personally.

w.o.: He's not known as an eater of grand food. But he liked it?

E.B.: The plates were clean.

W.O.: "21" is a legendary *place,* but what kind of food do you serve these days?

E.B.: I went through some of the older menus at "21" going back to the thirties and looked at our current menus. There are some surviving items such as the chicken hash, the burger, Dover sole, and those will always remain. It's part of the legacy of "21." On the other side of the coin, I like to cook a lot of light foods. In the old days "21" was very French. I noticed a lot of butter sauces and heavy cream. That's what they were eating back in that era. With the older customers French is still in. But the newer customers seem to be eating healthy.

W.O.: Are the jockeys still out in front at "21"?

E.B.: They are standing guard over our speakeasy wine cellar from the Prohibition.

W.O.: I hear you can rent that out. Wonderful, classy Bruce Snyder who is truly the keeper of the faith at "21" told me it's only about $400 a person! Do people order dessert?

E.B.: They starve themselves until dessert. Dessert is still in.

W.O.: Are Jerry Berns and Pete Kriendler, the founders, still around.

E.B.: Yes, they're legends. They're in there just about every day for lunch.

W.O.: Do people still dress up when they come to "21."

E.B.: That they do.

W.O.: But you're letting them in there without ties?

E.B.: For lunch only.

W.O.: Someone told me there are only a few restaurants where you can go and have *fun.* What does that mean?

E.B.: It means it's your restaurant. It's not the chef's restaurant. It's not the owner's restaurant. It's the customer's restaurant.

W.O.: Is it easy to get in there? They used to be a little snobby.

E.B.: Things have changed now since Orient-Express has taken it over. It's taken a new image and a friendly atmosphere.

W.O.: Do you still have the "toys" hanging down from the ceiling in the barroom?

E.B.: The toys are still hanging from the barroom ceiling. Including your book, which is on permanent display right over the bar!

W.O.: What do you do when you walk into a new restaurant? Are you apprehensive?

E.B.: I don't like to use my name. I just call and make a reservation, and usually when I arrive people will recognize me and I'll be seated.

W.O.: In your kingdom—the kitchen at the legendary "21"—how many people help you?

E.B.: A total of 178 colleagues, because we have ten banquet rooms upstairs. Right now there are two kitchens, and there will be a third one added for the wine cellar.

W.O.: How many people do you feed in a day?

E.B.: I would say around one thousand.

W.O.: You can't cook every single meal.

E.B.: I do cook. I am behind the line, and I delegate to make sure everybody is getting a quality product.

W.O.: Is it hard to find good, young chefs in this day and age?

E.B.: Yes, it is, Bill. What I look for is a good attitude more than a lot of experience. If I have a person with a good attitude who is willing to learn, that person tends to send a lot of positive energy throughout the work environment, and they become great chefs.

W.O.: But when you're presiding over the stove, is it not kind of a frantic place?

E.B.: I don't allow any yelling or screaming back there whatsoever.

W.O.: I hear you run a tough kitchen.

E.B.: I wouldn't say that. We all get along great. In the front of the house *and* in the back of the house we work very well together, and it's very important that we have that rapport.

W.O.: When you're at your leisure and cook for your friends, what do you cook?

E.B.: Simple food, pastas and chicken. When I go out to dinner, I order simple foods as well. I like to be very creative in my kitchen and do cutting-edge American cuisine along with great traditions at "21." It's hard to get invited to anyone's house because they're so intimidated, so I'm very grateful to have a plain-cooked, simple meal.

W.O.: Do people ask for your recipes?

E.B.: All the time.

W.O.: What are the hot new foods?

E.B.: I think a lot of Asian influences are coming into play. But American food is what is happening right now. And people like ingredi-

ents found in the United States. I order my fish directly from Maine, and my prime meats come from the Midwest.

w.o.: Can you look at a steak before you cook it and know if it will be good?

e.b.: At "21" we go through a lot of meat. I use prime twenty-one-day dry aged beef. It's not so much in the marbling. When you slice off a huge piece of strip, you can actually rub your finger across the steak—the flesh of the meat itself—and if it seems coarse, 99 percent of the time it's going to be tough when you cook it. If it's smooth because the fibers have broken down in the aging process, it's going to be very tender and melt in your mouth.

w.o.: What are the hot new vegetables?

e.b.: Rice, peas, corn. English peas are in season, and we do an English pea soup with parmesan crisps.

w.o.: What's a good fish to order? People just seem to stick with filet of sole and snapper.

e.b.: I've been getting some Hawaiian red snapper, and I do a tartare with papaya and mango with an Asian dressing.

w.o.: Do a lot of people like raw fish?

e.b.: A few years back it was really hot, but a few people got sick from it, and people started to get leery. But it's definitely coming back. You try to work with the Japanese on the tuna. I have a contact that actually gets on the boats before Customs releases the fish, and he picks his fish out first so it's the best quality. You can tell by the color of the fish and the firmness. That still doesn't give you a guarantee as far as parasites. So I definitely look them over too.

w.o.: How do you cook and keep all 170 people in focus?

e.b.: Everybody has a job to do, and it takes coordination and organization, and before each service we have meetings with the back-of-the-house staff as well as the front-of-the-house staff, and we go over what the routine is going to be for each service. We also have a few people who "float" for an emergency.

w.o.: I recently observed one of the lions of Wall Street yelling at the waiter. Do they ever come in and say, "I've got a tough one at table four?"

e.b.: If they do, I like to go out to them and ask what the problem is. Maybe he didn't like the table.

w.o.: There's a marvelous man who's been there for fifty years named Walter Weiss, with a craggy face, and another named Oreste Carnevale, who came from the Four Seasons. Also wonderful Harry Lavin at the door. Then there is the restaurant manager. Bruce Snyder, whom Nancy and I have loved for years, is *Mr.* "21." They're always prowling around the dining room. Sometimes I see them go through your kitchen and down the stairs. Where are they going?

e.b.: To the the famous "21" Prohibition Speakeasy Wine Cellar. It is protected and hidden by a two-and-a-half-ton concrete wall. The way it was originally back in the twenties.

w.o.: And they still have the private stock wine, for Richard Nixon and Shirley Temple?

e.b.: All those wines are still there. When President Clinton was in for Chelsea's birthday, he put away a bottle of Cristal for her for the year 2001 when she becomes twenty-one. Some very famous people have wines down there. And your sons Matthew and David have many bottles, placed there when they were born by their grandfather Walter Thayer.

w.o.: We're grateful to Bryan McGuire and Dean Andrews for allowing you to leave your kitchen. "21" is booming these days thanks to you and this new team Mr. Sherwood has in there. So from all of us who love the damn place, thank you for restoring a glorious New York icon.

2000

Interview with Julian Niccolini and Alex Von Bidder

They couldn't be more different, say the wealthy patrons of the Four Seasons restaurant. But the unique chemistry between the dazzling Niccolini and the solid, taciturn Von Bidder has enabled them to take their Manhattan landmark restaurant to new culinary heights. When they return home after presiding over their pricey tables with grace, wit, and style, Alex and Julian do cookouts in their Westchester backyards just like everyone else.

w.o.: I always think about food. Nancy says the biggest thing of my life is what I'm going to have for *dinner*. When I really want to think seriously about food I think of our two guests. They are among the most accomplished restaurateurs in America: the owners and managing partners of the legendary Four Seasons restaurant, Julian Niccolini and Alex Von Bidder. You just celebrated a big birthday.

A. VON BIDDER: We celebrated the fortieth anniversary of the *restaurant*. We're a bit older, my partner, Julian, and I.

w.o.: We're not talking about the Four Seasons Hotel on 57th Street. We're talking about the legendary Four Seasons *restaurant*, on Park Avenue in the Seagram's Building.

A.V.B.: The Four Seasons Hotel is a beautiful place, a great place to sleep, but if you really want to *eat*, it's 52nd Street: the Four Seasons restaurant.

w.o.: Tim and Nina Zagat said that not only is the Four Seasons famous, it is America's *favorite* restaurant.

J. NICCOLINI: The restaurant itself has been there since 1959. There are a lot of other restaurants in this wonderful country, and they're actually *designed* to be great restaurants, but the Four Seasons was endowed with such incredible space, fantastic service, and continuity over the years. Zagat is absolutely right. It is a great restau-

rant, but we have to be there every day. We cannot be absentee owners. We have to love what we're doing.

w.o.: When the food critics come in—Ruth Reichl, John Mariani, Bob Lape, William Grimes, Steve Cuozzo, and Zagat—do you spot them? Do they wear wigs or disguises?

J.N.: At the very beginning, when Ruth Reichl came in to the restaurant, we didn't even know what she looked like. She's definitely the most powerful woman in American food today, and she has great taste. I don't find anything she and I would disagree about.

w.o.: What other great restaurants are there in New York these days? Restaurants come and go every day. Their shelf life is about six months.

A.V.B.: If you look at the Zagat guide over the last fifteen years, you'll find the top ten or fifteen restaurants are pretty steady. Le Cirque is there. Daniel is there. Aureole, Union Square Café, Gotham Bar and Grill, La Caravelle. The really serious restaurants have staying power.

w.o.: The three "power" restaurants these days are clearly Sirio Maccioni's legendary Le Cirque 2000, the "21" Club, and your Four Seasons.

J.N.: I would say that's essentially true.

w.o.: But you just can't dial up and say, "Two for seven o'clock."

J.N.: We are very lucky because basically we have *two* restaurants: the Grill Room, which is famous for our power lunch, and the Pool Room for people who really want to enjoy themselves and take time off from their business schedule to be in a wonderful location and enjoy their food amid the serenity and great service. We have a lot of tables and a lot of space. This is not a small restaurant. And we rarely say no to anyone who calls, even at the last moment, because we are in the hospitality business more than the restaurant business. We constantly have to be the so-called "yes" people, and personally, I enjoy that. Everyday—sometimes it's 12:00, sometimes it's 12:30—I get a phone call, and if I have a table I'll be more than happy to accommodate them. Believe me, that gentleman or that lady is going to keep coming back and back and back if you are cordial and extend yourself for them.

w.o.: How do you get in if you don't *know* someone?

J.N.: I don't think that's a problem at all. Our job is to make people feel as comfortable as they would walking into our own homes.

We are not there to discourage anyone from walking into the Four Seasons. We want to make everyone a customer. We want everyone to love us and be more welcoming to everyone.

w.o.: One of your former partners, one of the founders, Tom Margittai, once said he's not in the *food* business, he's in the *real estate* business. He rents you that table for two hours so you can enjoy your companions and your food.

a.v.b.: That's true. Ruth Reichl described it once by saying we give "oceans of space in the middle of Manhattan." It's a luxury.

w.o.: Your restaurant is also a historical landmark. No one can touch it. You can't put a Modell's in there. There's a piece in your book about an Irish broadcaster from Westchester who testified on your behalf before the Landmarks Commission. I didn't know what I was talking about, but it's now a landmark.

a.v.b.: It's the only interior landmark in Manhattan that is a restaurant.

j.n.: As a landmark, it is not a restaurant that you can just do whatever you like with. The only addition Phillip Johnson was able to make in 1981 was a partition of shattered glass, and it is spectacular.

w.o.: The Pool Room is your most romantic room. Does anyone ever try to dive into the pool or walk on water after a few drinks?

a.v.b.: Yes. There's a famous story that Sophia Loren was the first one! It was in the early sixties. I was too young to see that, but two years ago we actually filmed an episode in which Lauren Hutton pushed Raquel Welsh into the reflecting pool!

w.o.: What would you do if one of your customers jumped in the pool?

a.v.b. First we would laugh, and then we would get the towels!

j.n.: They *try, many* times. We "discourage" them.

w.o.: What's the best table in the Grill Room, where the moguls are?

a.v.b.: The ones against the wall are frequently requested. They're really quite unobtainable because the same people have been sitting there for close to twenty years.

w.o.: Who are some of the people in your care and keeping at lunch?

a.v.b.: Of course, the Bronfmans are with us all the time.

w.o.: The Bronfmans are your landlords. They just have to come downstairs.

a.v.b.: The Four Seasons is like the Seagram's cafeteria. And there is

Henry Kissinger, Michael Korda of Simon and Schuster, Sandy Weill of Citigroup, Steve Florio, Barry Diller, Jack Rudin and Lou Rudin—the biggest landlords in the city of New York, and the nicest too—Fred Wilpon of the Mets, Nelson Doubleday, and, not often enough, Nancy Curry O'Shaughnessy. We are also very privileged to have the presence of Brooke Astor. She's a wonderful lady. She comes for lunch two or three times a week, and she is the most elegant woman I know.

w.o.: This is not being a gentleman, but isn't she about ninety-three?

a.v.b.: I don't know her exact age, but she is often next to Phillip Johnson, who built our building, the dean of American architecture, and they are both in their mid-nineties. I think it's wonderful that they still have the stamina, interest, and enthusiasm to go out for lunch and dinner. We also frequently see Tom Wolfe, one of my favorite writers. He's a man for all seasons. He always wears the white suit, and he is very distinguished. I remember doing book parties for him twenty years ago. He's a good friend, and the best tailored man—and, of course, a fantastic writer.

w.o.: Does he ever spill on his suit at the Four Seasons?

a.v.b.: Not that I know of. Of course, the key is to order something that goes with the tie so you won't notice.

w.o.: I've seen Mario Cuomo in there, James Brady, the writer, all the publishing and magazine crowd. What do you do if a Ron Perelman, the rich guy from Revlon, walks in at the same time with young Bronfman?

a.v.b.: We treat them as friends. That's why we have two partners. Julian will say hello to one, and I'll say hello to the other.

w.o.: Who gets the better table?

a.v.b.: It's not about the better table. They are used to *their* table.

w.o.: How many times do you have to go to the Four Season before you get your own table?

a.v.b.: About ten years, everyday!

w.o.: Who better to ask? You have people at your tables who control billions of dollars and large corporations. As you eavesdrop, do you notice if they're happy?

j.n.: I hope they're happy for their own sake. I don't believe it's necessarily true that people with a lot of money are very happy people. I think a lot of people have a lot of problems, but when they come to the Four Seasons, they leave those problems behind.

They come there to enjoy themselves. We really do try not to listen to their conversations.

W.O.: It's the only restaurant I've ever discovered where *nobody* can hear what you're talking about.

A.V.B.: Isn't that wonderful? A restaurant where you can't be overheard.

W.O.: Is that why they come for the power lunch?

J.N.: They come to the Four Seasons for the so-called power lunch because they like to have a good laugh, and I make them laugh. From Pete Peterson to Henry Kissinger to Bill Blass to Ralph Lauren. You have to make people laugh because their days are filled with meetings and arguments. They want to be seated at their regular table and eat the same type of food they eat all the time.

W.O.: What do those guys eat?

J.N.: When I first started working there I basically told everyone exactly what to eat. Every one of them. I used to take orders for the entire restaurant, about twenty-one tables. One day I went over to Phillip Johnson, the famous architect who designed the Four Seasons, and Tom Margittai, who used to be the owner, said to me, "This is going to be the most difficult person you ever met in your life." So I introduced myself. He asked what the special of the day was, and I told him it was such and such. He had something else. The next day he came back again and asked what the special was. I said, "From today on you're going to listen to me if you like to eat the right way, the right food." And so he did. From that moment on everybody ate the special the chef was making at the time.

W.O.: You make them all eat the same thing?

J.N.: I did, for quite some time.

W.O.: I hear Mario Cuomo was in there the other day. He's a tough guy. You don't tell him what to eat.

J.N.: That's right, you don't tell Mario Cuomo what to eat! But sometimes I tell Henry Kissinger.

W.O.: What do these moguls order for lunch? Do they still do the "three-martini" lunch?

A.V.B.: The "three-martini" lunch is really a myth. It really happened long before we were born. Mainly newscasters and people in the television business went downstairs and had a few before they

went on the air, but I don't think that flies anymore. Our moguls drink lots of water and occasionally a glass of wine. When they drink wine, they drink excellent wine. But it's mostly water at lunchtime.

w.o.: They're not embarrassed to say, "I'll have a glass of water"?

a.v.b.: Absolutely not. It's mostly Pellegrino and Evian and the new Fiji water.

w.o.: Designer bottled water. You get a lot of money for that, don't you?

a.v.b.: I hope so.

j.n.: The so-called three-martini lunch was just an issue in the media. They were trying to embarrass the restaurant people. We're talking about 1970. Even after 1979 and the eighties, people never had three-martini lunches at all. They always drank wine, because if you drink three *martinis*, you're going to be dead! You're not going to be able to go back to work and conduct your business. It was just an issue to make people not go to great restaurants. I really believe the tide has totally changed.

w.o.: What do they order for their main course?

a.v.b.: It's 60 percent fish. Broiled fish, vegetables, maybe some chicken salad. It's very, very simple at lunchtime. So we try to make simple, fresh ingredients look and taste wonderful.

w.o.: What's the most popular thing to order at the Four Seasons for dinner?

a.v.b.: Our duck is world famous. It's a roast duck that's very crisp and absolutely delicious. Right now, we're serving it with Bing cherries, and it's out of this world. I know you like it with the peppercorns.

w.o.: They talk about the architecture, the heritage, the lineage. You know what I like about the Four Seasons? You not only get good food, you have *fun*. There are restaurants for very serious eating: "foodies" love them. They just go nuts over the food, but nobody is having any fun.

a.v.b.: It's sad. Eating is about being with friends and having a good time. Of course, the food and the wine are important. But it is important for us to have a lot of fun doing it because that way you will come back.

w.o.: Do you still have that dessert when you have a birthday: the big cotton candy?

A.V.B.: Sure. It's part of the Four Seasons fun. When a serious restaurant gives you a cotton candy as dessert on your birthday, we get a lot of smiles.

W.O.: Do you two get along?

J.N.: Absolutely. We've been working together for over twenty years. It's not like we just started yesterday. It's a great partnership.

W.O.: Julian is very dashing, colorful—a great impresario in the dining room. You're the more serious, sober, well-buttoned-up guy, Alex.

A.V.B.: It's a long-standing marriage of twenty-three years. We fight every day, and we love each other every day.

W.O.: Are you closer than you are with your wives?

A.V.B.: Well, we see each other much more. We have no choice but to spend a lot of time with each other. Sometimes with the wives it's not that way.

W.O.: Tell me about Julian.

A.V.B.: Julian Niccolini is a handsome guy. The ladies love him. He is of Roman descent. He is an emperor in his own mind, and he is a lot of fun. People love to come to the restaurant just to see him.

W.O.: Julian, how did you start at the Four Seasons?

J.N.: I've always loved food and wine, so one day I decided to go to the Four Seasons for dinner. I had such an incredible dinner that the next day I called up the owners of the Four Seasons, Tom Margittai and Paul Kovi. And I said to them that I had such a wonderful dinner and was so totally impressed that I'd love to be a part of this restaurant, so if you ever have a job for me, please let me know. About six months later, in 1977, they did have a job for me: Grill Room manager. That was the beginning of the Four Seasons' fabled "power lunch." From that moment on the restaurant taught me so much, and I am really incredibly proud to be a part of it for so many years.

W.O.: Twenty years ago you succumbed to the charms of the Four Seasons, and now you're the owners.

J.N.: We love being the owners of the Four Seasons. We're very lucky to be a part of such an incredible institution. Alex Von Bidder is not only a great partner, he's a great leader as well. Our major partner, of course, is Edgar Bronfman, Jr., a major shareholder of Seagram's and MCA as well.

W.O.: Are you always in a good mood like this, Julian? They say

you're the best dining-room man in the world. Except maybe for Maestro Sirio!

J.N.: You have to be in a good mood. Basically, I love my job. I always wanted this. I remember when I was twelve years old and my father would take me out to restaurants in Italy where I come from. Every time I went to a restaurant or a store to buy food or to buy wine, I always wanted to be in the restaurant business.

I'm from the northern part of Tuscany, and I grew up there until I was sixteen years old. Then I went to Rome for school and came to this country when I was eighteen, and I happened to come here on Columbus Day, believe it or not! I didn't realize it until I arrived and everyone was celebrating and I said to myself, "What the hell are they celebrating? I must be a lucky man." I thought the occasion was my arrival on these shores.

W.O.: Is it hard to be nice to some people in your restaurant?

J.N.: It's not really difficult to be nice to people. I believe it is much harder *not* to be nice. It takes much more muscle in your body to be nasty to people. Maybe it's inside me. Every day when I get up in the morning, sometimes even in the evening, I dream about food and wine and I dream about people. In the morning I'm always in a great mood. I don't want to run to the Four Seasons, but I love to be there and constantly discovering new dishes, new wines.

W.O.: Alex, you and John Mariani, who does restaurant reviews on WRTN with Lynn DiMenna every Friday night, have just done a book.

A.V.B.: John and I were working on it for three years. It's the history of the Four Seasons restaurant. The idea was to capture everything that went into the making of this incredible restaurant. It was important for me to talk to Phillip Johnson and Joe Baum and Paul Kovi to get their ideas and thoughts about where they were in the mid-fifties and early sixties and how this all came about. It was just in time, as Paul Kovi died last year, and we lost Joe too. Joe Baum is a legendary restaurateur. He has to his credit not only the Four Seasons but also the Rainbow Room and Windows on the World. He was a great showman and knew what customers were looking for. Those monumental places he built are still going today. John and I interviewed all these people. We talked to the staff and asked our customers to share their favorite fun

stories from the Four Seasons. It all ended up as a very interesting and loving description of our dream restaurant. You're even in the book, Mr. O'Shaughnessy.

w.o.: The Four Seasons is in the Seagram's building. Are the Bronfmans good people?

j.n.: The entire Bronfman family—Edgar, Matthew, and Edgar, Sr.—are incredible human beings. They love the Four Seasons. It was their idea to build it in 1959. They put up one of the best buildings in New York City. It is still called the Seagram's Building and is one of the most spectacular buildings in New York.

w.o.: What about the dress code? Do gentlemen wear ties?

j.n.: It's very rare that people come to the Four Seasons without a tie.

w.o.: Do you ever see ladies who are a little bit "over-exposed"?

j.n.: I see them everyday. It's a lot of fun, Bill. It's very exciting!

w.o.: Where do you put them, in a corner?

j.n.: You put them right next to the pool so everyone can enjoy the view! Actually, I'm kidding; you put them in the corner, yes.

w.o.: You used to have a sign at the Four Seasons: No denim, no jeans.

a.v.b.: We say, "Jackets are required" and "No jeans, *please.*" But really, we like people to dress nicely when they come to us. We don't like people who come in sandals and shorts. Europeans do that. And some Hollywood moguls. We tell them that we're sorry but we cannot accommodate them in that attire.

w.o.: I was in Los Angeles recently. Even in the finest restaurant, Wolfgang Puck's Spago, I was the only one with a tie. They were looking at me like I was from outer space . . . or New York! But Frank Bowling makes you spiff up in his wonderful dining room at the Bel Air Hotel.

a.v.b.: It's sad. There will always be places for special occasions that people like to dress up for. The more the new dress codes sweep across the country or around the world, the more there will be places where you go and dress up just for a change. In the summertime we are a bit more relaxed. You don't have to wear coat and tie in the summertime.

w.o.: Do you ever see young couples as impressionable as young Julian Niccolini was that day so long ago?

j.n.: Absolutely. We see young couples all the time walking into the

restaurant. We see people celebrating birthdays or something special. If they come in one time they will come back again.

One day I was at the front desk and a wonderful old couple walked up to the restaurant. The gentleman came over to me and started laughing. I said, "We really don't have a table for two but let's see what I can do." So the lady approached and said, "I have a letter here in my pocket that I've been carrying for more than thirty years." I said, "What is it?" She said to me, "We were here thirty years ago on our first wedding anniversary." Then she pulled out this letter written by the manager of the Four Seasons at that time. Apparently, they did not have a good experience that evening. The next day the manager wrote them a letter saying, "Please come back any time you wish as our guest." So thirty years later they came over to the Four Seasons and produced this letter, and they couldn't believe I would say to them, "Absolutely." They were the happiest couple you could ever imagine. I sat them in the Pool Room and sent over a bottle of champagne. They even shared the champagne with the next table. It was marvelous!

A.V.B.: That story reminds me that one of our best nights was JFK's last birthday party. That was just before Marilyn Monroe sang "Happy Birthday, Mr. President" at Madison Square Garden. I still have the menu hanging in my office. And, incidentally, the president ordered a roast beef sandwich and a beer. So I think he was a regular guy.

W.O.: Do you ever encounter really obnoxious people of an evening?

A.V.B.: Very, very seldom. Jerry Berns of "21" used to say, "We're not just serving tea." What he meant was that we do serve alcohol, and some people, when they have a little too much to drink, might get angry or nasty. We know how to handle that.

W.O.: Even the big shots?

A.V.B.: Even the big shots. Very rarely, though. Maybe one a year.

W.O.: I asked you about obnoxious patrons. What if you encounter an obnoxious *waiter*?

A.V.B.: It doesn't happen at the Four Seasons because that person would be gone instantly. We are about fun and a good time.

W.O.: But if you go into a restaurant other than the Four Seasons and the waiter is not having a good day, what do you do?

A.V.B.: Well, if I have to stay there for whatever reason and I have an

obnoxious waiter, I try to turn him around. I can turn him around with humor or ask him what's going wrong—treat him like a human being. A lot of people forget that serving food or being a waiter in a restaurant is very high stress. It's very hard physical work. The important thing is to make a connection and say, "How are you doing today?"

W.O.: When you go into a restaurant, how much do you tip?

A.V.B.: I tip 20 percent. I believe that's very generous.

W.O.: Who gets that 20 percent?

A.V.B.: The captain and the waiter on our level.

W.O.: How about the busboy?

A.V.B.: Basically, the service staff shares. In some restaurants 5 percent goes to the captain and 15 percent goes to the waiter, and out of the waiter's share they pay 15 percent to the busboy.

W.O.: What about the maitre d'? Do you have to fade the maitre d' on the way in?

A.V.B.: I believe that's the worst thing you can do in a serious restaurant. A maitre d' who takes money in advance of performing any kind of service is really dishonest or is selling himself. We do not permit that. We think there's nothing wrong if you tip a maitre d'. You should tip a maitre d' for something special when he looks out for you. But always do it *after* the fact, never before. Before is like a bribe to me.

W.O.: Can you go and have lunch at the bar?

A.V.B.: Absolutely. To celebrate the fortieth anniversary we give you a three-course lunch at the bar for $19.59. 1959 was the year we opened.

W.O.: You said you try to be nice to one and all no matter their standing or station, Julian.

J.N.: I really believe the most important thing when you walk into a restaurant is that you have a very warm welcome. If you don't get that there's definitely something wrong with that restaurant.

W.O.: What is a great white wine to order, if you want to show the captain that you know a thing or two? You have a wine cellar like nothing I've ever seen.

J.N.: It basically depends on your mood. If you like California wine, we have some great chardonnay from Chateau Montelena, which is superb. It's a white wine made 100 percent with chardonnay grapes, and it's only available for sale in restaurants. If you like

red and you want to go with some American wine, you can have some pinot noir from Domaine Drouhin from Oregon, one of the finest red wines in America.

w.o.: What's your "house" wine at the Four Seasons?

j.n.: We have a lot of house wines: Sterling Sauvignon Blanc, chardonnays from Tesera from California, a chardonnay from Louis Latour from France, a merlot from Sterling. We have Perrier Jouet, our favorite champagne by the glass.

w.o.: What's the most expensive bottle of wine you've ever sold?

j.n.: Very likely Chateau Mouton-Rothschild at about $2,500 a bottle, and it was great because I drank half of it! I really take great pleasure in selecting wine for our customers, and every chance I get I have a glass with them. Last night, for instance, we had a great dinner for Marvin Shanken of *Cigar Aficionado,* and everybody was there from Wayne Gretzky to Linda Evangelista and Tom Selleck. They were all drinking Chateau Mouton 1975.

w.o.: Who's your favorite customer?

j.n.: I have so many favorites: Bill Blass, Ralph Lauren, Mario Cuomo, Linda Wachner, James Brady, John Fairchild, Edgar Bronfman, Jr., Jack Rudin, Bill O'Shaughnessy's wife!

w.o.: When you get out of the Four Seasons, what do you have at home? Do you eat ordinary things like hamburgers?

j.n.: Only in my backyard!

August, 1999

Interview with Frederic Fekkai

He looks like a movie star. And most of his clients are. Frederic Fekkai presides over the hottest beauty salon in Manhattan. He flies his own helicopter and recently sold a big chunk of his Manhattan-based enterprises to Chanel. But the handsome, charismatic Fekkai is still very much in control of everything he surveys.

W. O'SHAUGHNESSY: Tonight on *Interview* we have the preeminent hair stylist in the world. His clients include Demi Moore, Bruce Willis, Kelly Klein, Paula Zahn, Jane Pauley, Ron Perelman, that rich guy who smokes cigars and is worth about $4 billion! I almost forgot Barbra Streisand, Timothy Hutton, and Kim Basinger. Please welcome Frederic Fekkai. Maestro, I'm having a bad hair day.

F. FEKKAI: No, you're not, Bill. You have the greatest hair of all . . . fabulous!

W.O.: I wish I looked like you.

F.F.: Oh, come on. My hair is always a mess. You have a natural head of hair.

W.O.: I run a great risk by allowing you to come into Westchester, where you have so many fans and admirers, because Nancy Curry O'Shaughnessy would dump me in an instant if you did more than air kiss. Do you really kiss-kiss with the ladies?

F.F.: No, but I do love to charm them. I love to seduce them my way. I love to make sure the woman feels great in her chair, feels like we give her lots of attention. They deserve it. A woman wants to feel great. I really love to play with my clients and make them feel good. There is no tension. It's not a sexual thing. I'm there to help them find a look and create a style for themselves.

W.O.: Let me see those hands. How how much do you get for a little snip?

F.F.: It's $275 a haircut, but as I said once on CNN, when someone

asked me how I can charge that much, when you really know what you do, it's beyond cutting hair or doing a blow dry. It's about finding the right style, helping people create a look for themselves. A lot of people today have no idea how to do that. When someone knows how to create a style, they're worth the price.

w.o.: *W* magazine, which all the fancy, swell ladies read, called what you do "sex with scissors."

f.f.: The fact that I'm quite good looking and young, dynamic, and playful makes people feel I'm some kind of sex symbol in my industry. I just enjoy the pleasure of working, that's all.

w.o.: Someone told me you don't cut the ladies sitting in the chair; rather, you make them stand.

f.f.: It's true. I really want to observe the attitude and also the proportions: the hair to the body, the shoulder, the neck. I want to see those things to really make sure everything makes sense and there is a flow, a volume, and a shape that correspond to a body. So I stand them up and look at the profile and at the back. A haircut is not only on the front.

w.o.: Maestro, at the risk of sounding too interested in the commerce of your profession, I hear it only takes six minutes sometimes.

f.f.: I'm booked every fifteen minutes. First of all, I do a consultation. I want to make sure we all agree on what I'm going to do. I can do what I do in fifteen minutes. Cutting hair is not the most difficult thing for me. What is important is to figure out what I'm going to do. Once you know how to walk you don't think about it, you just walk. I'm cutting hair like I walk. It's a natural thing for me.

w.o.: I saw you showing off your son and heir, Alexander. How old is he now?

f.f.: Alexander is eight months old. He's such a fun, happy baby. He comes to visit, and the ladies go nuts when they see a baby. That helps. When I'm in trouble, I come with the baby. He likes to come and see Papa work.

w.o.: Does your wife ever get jealous of all these beautiful women?

f.f.: A little. It's part of the deal.

w.o.: When Barbra Streisand comes in, do you ever argue with her? She wants it one way and you say, "No, no, no."

F.F.: I learned not to argue with everybody—especially not Barbra Streisand! I love Barbra Streisand. I know what she wants. We have great communication. She has a trademark. Her look is her "look." There is no point in arguing. Her hair looks so great the way it is, so it's fine.

W.O.: There's one more that I have to mention carefully in my household: Hillary Clinton.

F.F.: Yes, I was very proud and flattered when I was asked to do her hair a year ago—her first haircut, if I may say. I took her from the bob to the shoulder look. But I haven't been very successful with the press because she had her hair done in Washington afterward.

W.O.: The guy at the L.A. airport, when they closed the airport. That wasn't you.

F.F.: That really got a lot of attention. And I don't think it was a good thing for Hillary to have the most expensive hairdresser in the city.

W.O.: Did the Secret Service make you nervous when you were snipping away?

F.F.: Not really. It was a great experience. I had a wonderful welcoming when I was at the presidential suite at the Waldorf-Astoria.

W.O.: Which is tougher to cut, women or men?

F.F.: There's no one tougher than the other. Again, at my level it's not about cutting hair. My clients understand what I want to achieve, and they often, especially men, are very special. They say, "What are you going to do? What is going to be different?" And then they come back and say, "Wow! I've never had so many compliments. Can I come back? Please, cut my hair." Sometimes it takes a little longer with men because when it's short you need to get a little more technical snip out of it.

W.O.: Are men more vain than women? Of course, I wouldn't know about that.

F.F.: We are surprised, but men are very vain. They are very self-conscious about how they appear. They don't want to look phony.

W.O.: Who are some classically beautiful women?

F.F.: I was astonished by Sharon Stone when I was working with her. Obviously, Claudia Schiffer or Cindy Crawford or Linda Evangelista or Stephanie Seymour or anybody like that. And they're all very nice people, too. Claudia Schiffer is a very, very business-oriented lady. So is Cindy Crawford. Christie Turlington is more

obsessed with charity walks. Right now, she's doing a lot of charity walks and enjoying her life. She's a little more quiet. When I talk to Sharon Stone, she's very interested in the next property, or the next movie. She's very into the Hollywood scene.

w.o.: What makes a woman beautiful?

f.f.: To me a woman is beautiful when she acts like she is beautiful, when she feels beautiful, when she is comfortable with herself, when she understands her style, when she really is happy. It's not a woman who is artificially over made-up or overdressed. A beautiful woman knows that beauty is so simple.

w.o.: I read somewhere that you don't like long fingernails. I'm with you.

f.f.: It is true. I want everyone to look beautiful the natural way. I like women with natural nails, not too short and not too long. I like clear nail polish, or a red that goes with a dress. The lipsticks—I don't like them too frosted, too pinky or too purple. I don't like make-up to show. I say to all my ladies that I don't want to see the make-up, I want to see their beauty. Just simple and beautiful. I think that's always been the best.

w.o.: What kind of shampoo is good?

f.f.: It's very important to have a mild shampoo or a shampoo that is pH-balanced, something natural with not too much detergent—essentially, very gentle to the hair. Always alternate between two shampoos. There is no such thing as one great shampoo. There are a lot of great shampoos out there. But also a lot of bad shampoos.

w.o.: What about mousse and gel and hair spray?

f.f.: I'm against everything with too much alcohol. It's the same thing as the make-up. I don't want to see the product on your hair. I want a product that helps to texture your hair, to style your hair, to shape your hair but doesn't show in your hair. It's the most unpleasant thing to see hair with sticky or greasy gel. I want something natural.

w.o.: I am surprised to see men sitting cheek-by-jowl in your salon with women. Does Ron Perelman smoke a cigar when you cut his hair?

f.f.: Not at all. Ron is a very busy man, so he gets in the chair and gets on the phone and gets his haircut. Actually, it's the only fif-

teen minutes of his life when he's relaxed. He loves to be surrounded by all these beautiful women. And I don't blame him.

W.O.: You ride a motorcycle. Does your wife allow you to do that still?

F.F.: She told me she doesn't want to change my lifestyle but that I should pay attention to all the risk I'm taking by riding my motorcycle.

W.O.: I hear you have a helicopter also.

F.F.: I lease one. Flying is one of my hobbies. When I'm up there I don't have to think about anything else but the helicopter.

W.O.: On Friday afternoons you race out of your salon and run to your chopper and fly out to your place at the beach.

F.F.: Yes. I enjoy that. It takes about thirty-six minutes, Manhattan to Southhampton. I've been doing this for four years. I love it. It was either that or become a race car driver.

W.O.: Is a lot of what you do theater and showbiz?

F.F.: It's a package. A good haircutter must know what to say and talk about to make people feel comfortable. I love to go to charity and social events. I'm a personable guy. I love the nice New York crowd, so I'm out there socializing and jet-setting, you might say.

W.O.: Aren't there a lot of phonies in those circles?

F.F.: Certainly. But you just do your own thing. You don't change your personality. You always go with the people who are nice and live a nice lifestyle and share the same goals and the same values. That's who you hook up with.

W.O.: Do you ever get someone whom you just don't like?

F.F.: Oh, yes! You'll always find some people who give you an argument and trouble, but you ignore it.

W.O.: How do you find the very rich? Are they nice or not so nice?

F.F.: I'm very surprised. I think that the very rich are very nice. The people who are between social climates are the ones who are too pushy and too harsh. They are uncomfortable with themselves. But the people who are very happy with themselves—it doesn't matter if you're very rich or not— are always the nicest.

W.O.: I hear it takes three months to get in your care and keeping.

F.F.: A new client would have to wait about three months to get in, but I always have my calendar open for my very good clients. I don't want to disappoint them. If they're very beautiful, I may even give them *your* appointment, Bill!

1995

Interview with Kenneth Cole

Here's a guy who really deserves his remarkable success. This talented, young designer-entrepreneur is proof that sometimes nice guys do finish first. Kenneth, who is married to the dazzling Maria Cuomo, has raised millions for charities, including the HELP organization, chaired by his activist wife (and founded by his brother-in-law, the former Housing and Urban Development chief, Andrew Cuomo). The Coles are the antithesis of all the vapid, selfish dot.com millionaires who, having made it big, continue to take *and put nothing back.*

W. O'SHAUGHNESSY: Tonight, a friend of mine. He is a world-famous designer of many things: shoes, handbags, and pocketbooks. He's got his name on damn near everything in the stores these days. Somebody just put up $22 million to back his action on Wall Street. He's also the first son-in-law of New York State. I'm talking about Kenneth Cole. I have to be very careful with you.

K. COLE: You certainly do.

W.O.: Because of Maria Cuomo Cole, your formidable wife.

K.C.: I would not want to be in your shoes at this moment, Bill.

W.O.: Already it starts! That's right, my Kenneth Cole shoes. You have a secret name you call your father-in-law and your mother-in-law.

K.C.: I must explain. I married Maria seven years ago, and in the courting period I had the wonderful pleasure of meeting her parents. And as the relationship evolved, it appeared that we were going to get married, and how one addresses one another during those circumstances changes. So, given the grandeur, prestige, and magnitude of Mario Cuomo, how does one address him as "Mario?" You can't. It's just inappropriate. You buy pizza or you buy stock from "Mario." You don't speak to Mario Cuomo by that name. Obviously, "Governor" is not quite appropriate either.

w.o.: How about "Your Excellency"? That has a nice ring to it.

k.c.: That was considered and overruled! So we came up with Fil. For Father-in-Law. A little code name. It worked well. His wife became Mil. His sons became Bil Jr. and Bil. Sr., and I've got two Sils. It just seemed to work. So now I'm his "Sil" and he's my "Fil."

w.o.: You're also the father of three of his granddaughters.

k.c.: Which gives me an incredible amount of leverage.

w.o.: Has he ever taken you aside and said, "You have beautiful daughters now, but I'd like a grandson?"

k.c.: He's been very accepting of his three beautiful granddaughters.

w.o.: We're so pleased you and Maria now reside among us with your fair young daughters. Is it tough being a famous son-in-law of a famous father-in-law?

k.c.: I'm not a famous son-in-law. I am who I am. I do what I do. It's not difficult because I don't try to do anything but what I do, and I don't try to be anything but who I am. I'm just incredibly in awe when I get the privilege to be with the Cuomo family. I'm so overwhelmed by the intensity and the focus of every one of them as individuals—how the world seems to take on so much more of a meaning, and the family just exists within it. It really helped me put into perspective who I am and what I do, and you learn real quickly not to take yourself too seriously because there is so much of importance out there.

This weekend we made our annual pilgrimage up to Albany. It's amazing that this governor has no Kennebunkport and there is no Camp David. There was once a governor's retreat, which he sold, as he did all the governor's limousines and some of the governor's planes. He rides in an old Caprice. He works every day. In the seven years since I've know this man, he hasn't taken a day off. He hasn't taken a week off or a vacation! He'll spend a few hours every day dealing with state business. He gives new meaning to "public servant." He's an amazingly committed, intense, hard-working individual.

w.o.: The governor said recently that he could lose this race.

k.c.: Certainly he is realistic. I think he also went on to say that if you don't believe you can lose, you will, which is the way it is in politics. Here's a man who is committed to principles. He's stuck by them over the years, and times have changed. It's very easy when you go through tough times to blame the man who is sit-

ting in the top seat. It's a difficult time for incumbents. But the reality is that New Yorkers don't realize what they have in their head-of-state. I speak to people all the time and they say, "Times have changed. The man's got to go. Our taxes are too high." What are our taxes? "I don't know." People don't know how much they're paying in state taxes. The truth is that twelve years ago, when he came into office, state taxes at the top level were 14 percent; today they're 7.8 percent. And we're getting more government for less money. People often don't even ask the question. They don't know that $50 billion was spent by Governor Cuomo on infrastructure, roads and bridges. They don't know that we're spending over $9 billion on education, which is twice what we were spending earlier. This is unprecedented compared with other states. Personal income taxes were twenty-fourth among all the states, and we were fourteenth per capita.

w.o.: Is this what you talk about on the weekends with your wife and in-laws?

k.c.: A lot of people crack on New York State because they have a perception that is rarely reflective of reality. People don't truly understand, as the governor often says, that New York State is bigger than most nations around the world. It has a larger gross national product. Mario Cuomo has done a remarkable job running this state, this "business."

w.o.: Nancy often says, "You either get Mario Cuomo or you don't."

k.c.: People see the check they write to Uncle Sam each year and they say, "I'm paying too much in taxes, so my politicians have to go." They don't really want to take the time to study exactly where the problems are, and they don't ask the obvious question, which is, "What am I getting for what I'm paying?" Or "If I were to go next door, what would I get there and what would I pay for what I'm getting?" The fact is here you're paying less and you're getting more.

People don't understand the brilliance of the man and the commitment of the individual. As a businessperson, I know if I work hard what the rewards are going to be. The more I put in, the more I'm going to get back. That isn't the case with our leaders. You've got not just the man but the organization and the people that work with him who work harder and are more committed than any businesspeople I know.

w.o.: When people whack around your wife's father, do you have to peel her off the wall? Does she take it hard?

k.c.: People just don't appreciate her father, and I think Maria has the ability, knowing him better than anybody, to be objective because she knows his strengths and she knows his weaknesses. She knows the injustice that is so often served upon not just this leader but all our leaders.

w.o.: You're also the brother-in-law of Andrew Cuomo, a cabinet officer in Washington, and Christopher Cuomo, who's got wall-to-wall shoulders and hangs around with Billy Baldwin. Do you compete with those guys?

k.c.: I try not to. I learned that a long time ago. But you should know too that these guys also believe that it's more important what you stand for than what you stand in. Now how do you compete with that?

w.o.: There you go again! Another pun! Another ad for Kenneth Cole shoes.

k.c.: Seriously, I just really adore and have wonderful respect for each of Maria's siblings, as well as her parents.

w.o.: You've raised millions for AIDS and AIDS research, and in order to get you to accept an award, they had to pull a scam and make you think you were going to a party for someone else.

k.c.: I haven't really raised millions. I've tried to create a little bit more awareness. Here this disease is devastating our schools and communities. It is something we can't cure, but we can absolutely contain. We know how it's transmitted: by a deliberate conscious act by two individuals through intravenous drug use or unsafe sex. But we can't seem to get that message out. I have made an effort and used certain resources available to me to try to get that message out.

w.o.: When you raise money for AIDS and you go out publicly, do people say, "He's one of those New York designers. He must be that way"?

k.c.: If everyone who has an advertising budget ran out and said what was on their mind, it could create chaos. So there is an inherent responsibility that one assumes. But also, today government is able to do less. The needs of society are greater, and I think business has to step forward and play that role. As individu-

als and as businesspeople we have to serve the community that serves us.

w.o.: So it's not a gay disease?

k.c.: Absolutely not.

w.o.: It's not the vengeance of an avenging God?

k.c.: This is a disease that's devastating every structure that exists— our Medicaid, our hospitals, our businesses, our inner cities. There is no way of monetarily or emotionally articulating the impact that AIDS is going to have. It's going to affect everybody, not just ourselves but our children's generation, which will never know life the way we knew it.

w.o.: Do you like being a public company now—Kenneth Cole Productions?

k.c.: I don't like being a public company.

I'll tell you an interesting story. A few years ago I said to my daughter, who is three years old, when she was laying in bed, "Emily, you are so beautiful and so wonderful. I love everything about you. I don't want you to grow up. So I spoke to your mother and we're not going to feed you anymore." She said, "Well, if you don't do that, Daddy, I'm going to die." And it made me think.

We had a sales meeting a week later, and the message was just that life doesn't afford us any options. Either we grow or we die. The fact is today in business you have to grow. You have to keep pace with the changing times or else you'll cease to exist, and so we felt a need to go to the public markets to raise that little bit of extra money to afford us that luxury to grow. Being public and being a little bit more in the public eye is not enviable. It's not a position I wanted to be in, but it's a small price to pay for the luxuries and opportunities it will afford our business.

w.o.: Do you like the sometimes phony world of fashion design?

k.c.: I love the industry. I love the business. But it's business to me, and it's a wonderful challenge. What I love about the business is that it changes every day. You're never content. You are rebuilding your business every three or four months. It's dynamic and invigorating and challenging every day. And the business affords me the opportunity to do all this other work.

w.o.: Nancy is going to kill me for picking on you, but your shoes are way out there. Where do you get those ideas?

k.c.: I don't think they are. They give people the opportunity to form

their own individuality, their own personality. It gives them the opportunity to reflect on themselves as a person. I create what people want.

w.o.: They're not for white-haired gentlemen like me.

k.c.: I think they are, Bill. I give you more credit then you give yourself.

I have stores in New York, Los Angeles, and San Francisco, and we're going to be opening up about forty more stores in the next three years. And we have licenses throughout Europe and Asia. We have a store in Amsterdam, a city with an incredible amount of energy. The shoes are made in Europe and South America and Asia. The world has all come together in the last few years. It truly is a world market, and you can't exist in a vacuum.

Government doesn't exist anymore in a vacuum. This state went through two difficult recessions under Mario Cuomo, but the fact is the world went through those same two recessions. We saw Europe's economy decline. Unemployment in Japan is the highest it's ever been in postwar history. I feel a need to do a certain percentage of my business in Europe and Asia for it to truly have the balance I feel it should have.

w.o.: What are the big important things in your life right now? You want to get that father-in-law reelected.

k.c.: To me it would be an injustice to the whole community if he weren't. The man certainly has worked for it and deserves it, and the community needs it. Personally, there is business that, unfortunately, I need to do to keep everything else working. There's that triangle to keep in balance: the family, the community, and the business—to make them all work for one another.

w.o.: We see your name in the gossip columns from time to time, but I don't get the idea that you run on that fast track.

k.c.: I go home every night. It's very hard because I have to travel, and the business itself, when I'm here, is very demanding of my time. But when I have time, it's my family's. There's nothing more important to me than being at home with my little girls and my wife.

People have no idea how intricate and complicated making a shoe is—you can spend weeks on it—and you take the shoe and put it on a shelf, and it stays there and it doesn't need anything. It requires nothing of the person that created it. Then you spend

a little bit of time and you make a baby, and it's needy every second that it's there. You put it on a shelf and it doesn't stay. And it has an opinion. So I'm putting my parenthood into perspective everyday and loving it and enjoying it and giving it whatever time I have.

W.O.: Thank you very much for joining us.

K.C.: Thank you very much, Bill. And please, for the benefit of all our viewers, stay off motorcycles. Keep your two feet on the ground.

W.O.: Give our best to Mil and Fil and your daughters and your Maria. One other thing. You could've lived anyplace. Why'd you pick Westchester?

K.C.: Westchester, to me, offers the best of everything. You have just a little bit of country, a lot of suburbia, and access to New York, the greatest city in the world. You've got nine ways to get there, whereas you go to Long Island, you have two and it's a little bit more congested. Forget about Jersey. I wouldn't live anywhere else.

1994

3

Radio
Editorials

An Endorsement for President, 1992

When we were burrowing through Whitney Radio's voluminous archives to prepare the manuscript for Airwaves, *we unearthed several thousand editorials and commentaries on a wide variety of topics. (Many of them I wanted to take back or renounce outright!) However, we somehow missed this one—which reflects our "unease" with Bill Clinton early on—though it was widely circulated throughout the country and noted by several of my New York radio colleagues, including Bob Grant, who read it on the air almost in its entirety. All to no avail.*

Now, years later, I can only observe that President Clinton has enriched our purses at the expense of our spirits. I think we had the guy dead to rights from the beginning.

> *gravitas:* n. a certain reserved dignity; propriety and good taste in behavior and speech, as of a leader or official
>
> *unctuous:* adj. characterized by a smug, smooth pretense of spiritual feeling, fervor, or earnestness, as in seeking to persuade; too suave or oily in speech or manner

This is an endorsement for president of the United States of America with which our two Eastern Establishment broadcasting stations now attempt to "save" the Republic from Governor Bill "Slick Willy" Clinton. By this fine, selfless act of sheer patriotism, I hereby and forever alienate Nancy Q. Keefe, star feature columnist of the powerful Gannett Suburban Newspapers, and her editor Lawrence "Excellence in Journalism" Beaupre. This will also bring symptoms of cardiac arrest to several other admirers of these splendid radio stations, such as Pete Hamill, Lars-Erik Nelson, Mary McGrory, Jimmy Breslin, Michael Kramer, Jeffrey V. Bernbach, Justice Samuel George Fredman, Nita Lowey, the Honorable John Marino, Dennis Mehiel, Ken Auletta, Messrs. Arthur Ochs Sulzberger, Senior and Junior, and one Joseph Spinelli, survivor of seven

FBI shootouts. Our courage will not go unnoticed by Frederic Dicker, state editor of *The New York Post,* or Marc Humbert of the mighty Associated Press. There is, however, absolutely no telling what his boss Louis Boccardi will have to say when this reaches the world headquarters of the AP in Rockefeller Center.

We are *for George Bush.*

You can, all of you, just forget the 16 percent lead now possessed by William Jefferson Clinton. I am used to these odds. In 1982 Mario M. Cuomo was down 38 percent to Koch the mayor. Cuomo's bright, fine mind and his magnificent tongue had nothing to do with that episode. And, incidentally, it is yet another myth that Andrew Mark Cuomo was somehow responsible for his father's come-from-behind victory. This is nonsense. It was only *my* editorials, which have more circulation by *mail* than by *air,* that saved my beloved New York State from Koch. I will now proceed to save an entire nation.

I begin by reminding you that the same pollsters, pundits, and prognosticators, some of whom I have chosen to identify above, are the same highly placed and intelligent individuals who insisted you install Michael and Kitty Dukakis in the White House four years ago, and the very same folks who have forgotten those 22 percent interest rates, those helicopters crashing in the desert. Not to mention the oil problem and our making nice with the rocket scientist who ran the corner gas station as well as his genius brother-in-law who dispensed extra gasoline cans at the True-Value hardware store to enable us to hoard three gallons of super unleaded premium petrol while Jimmy Carter, Bert Lance, and Hamilton Jordan ran the country in such splendid fashion.

All of which means that it is one thing to be very important in Plains, Georgia, or Little Rock, Arkansas. It is quite another to be stellar in Washington, D.C., where one might be called at any moment to order a nuclear strike or be required to conduct a civilized conversation with François Mitterand, Helmut Kohl, or Boris Yeltsin.

The President

There is a word flying around the Westchester and Fairfield Counties' cocktail parties. You hear it on the North Shore too. The word is *gravitas.* It means substance and weight, and it is one more reason I am for George Bush. Bush is a man of substance, depth, breeding,

and intelligence, with a keen understanding of geopolitical matters. And, yes, he is a gentleman who has shown great patience and grandness of spirit during this bleak, mean campaign in which the president has been subjected to much worse than the routine pummeling our nation feels compelled to heap on its sovereign every four years. President Bush has endured a torrent of derision and ridicule unheard of even in a society not renowned for civil discourse.

Let's set the record straight. George Bush should not be blamed for the instability in the international fiscal and monetary circles. It is worldwide, and that global tide that lifts all boats also lowers all boats as it recedes. In the face of this recession, the president has had the courage to reject any radical "instant fix" by holding to the sensible notion that "no *one thing* got us into this, and no *one thing* is going to get us out." Bravo, Mr. President!

The Japanese and the Germans work harder, smarter, and longer. And the Mexicans and Chinese work cheaper. But the United States, in President Bush, has a world-class strategist who understands global realities and is determined to get us back on a competitive footing. It can't be done with Governor Clinton's slogans or glibness or with Ross Perot's populist "kick ass" rhetoric and entertaining bon mots.

Ross Perot

As for Perot, we can't do better than Michael Kramer in *Time* magazine, who exquisitely dubbed him "a paranoid hoisted by his own self-regard." He does, however, roll a good show, and the "Joe Six-Pack" crowd is having a whopping good time watching this breathtaking intrusion of ego and money into presidential politics. OK, Ross, we know who you are now . . . we heard you, Ross, now pipe down . . . Ross, please! Actually, in a funny way, I could almost take the mischievous, jug-eared, diminutive, cock-of-the-walk Texan over the eager striver from Arkansas. Both of them aspire to the highest office in the land without having acquired the depth of knowledge or the breadth of experience possessed, in great abundance, by President Bush.

Slick Willy

Mike McAlary of the *Post* got it about right when he called Bill Clinton "a disingenuous bore." Or is the word *unctuous?* In the first debate, Slick Willy stood in the hot television lights and imagined

he was Jack Kennedy: "A new vision . . . a new tomorrow . . . a new beginning . . . a new era . . . let's get this country moving again. . . . " Ad nauseum. The right forefinger, bolstered by the thumb, went out and chopped the air, and I recalled the words of the Pulitzer Prize journalist from Arkansas, Paul Greenberg, who has covered Clinton for decades: "At the core, at the center, there is nothing."

Notice there is one word his advocates and surrogates never use to describe him. The word is *inspiring*. "Dazzlingly competent," "youthful," even "dynamic," but never "inspiring." And so he crisscrosses the nation, reciting clichés and slogans in parrotlike fashion. "Unctuous" is a good epithet for this man who would bring down a president. And "slickness"—which may be consistent with political adroitness, but it doesn't inspire. Sadly, but ultimately, Bill Clinton comes across as something smaller than what we want in our leader.

It's about music, the music that's made when your heart comes together with your intellect. Bill Clinton is energetic and resilient, but he does not inspire confidence. He makes no music. And as frantically as our colleagues in the national press wave their batons, there is no sweetness to the sound of Bill Clinton. He is dancing to the sound of a kazoo. It is harsh and shrill and self-centered. The Democratic Party, which once offered such towering figures as FDR, Lyndon Johnson, Adlai Stevenson, Harry Truman, and Jack Kennedy, had just one chance to make us forget Carter, Mondale, McGovern, and Dukakis. Only the governor of New York could have brought worth, substance, stature, dignity, meaning, passion, and eloquence to the Democratic cause. Instead, the Democratic Party of the United States has again put up two "suits" with eager, red ties and upwardly mobile wives.

The Hillary Factor

Since we cannot have a sheer, pure, natural force known as Matilda Raffa Cuomo in the White House, I will gladly continue Barbara Pierce Bush as First Lady. Barbara Bush has served this country with a marvelous and becoming serenity, gracious bearing, and gallant dignity. She is much to be preferred to Hillary Clinton, who runs together in the minds of many observers with Anita Hill, Geraldine Ferraro, Linda Ellerbee, and Suzi Oppenheimer, better known in these parts as "Senator Suzi." You either buy their act and believe

the stuff they're selling, or you don't. We don't. They have only ambition in common. We simply can't detect any of the grace Nancy Q. Keefe and other pundits find in them. And Hillary Clinton, standing off to the side of a podium, nodding mock-serious approval, while Slick Willy spouts pure "wisdom" into a microphone, just doesn't ring true. But she sure is eager. And like her husband, she is ambitious.

I have always been suspicious of that marvelous phrase uttered by so many well-intentioned parents, "Even then I knew . . . "—as in "my son Billy (or Albert) would be president" or "my daughter Hillary (or Tipper) would be First Lady." It has to do with destiny, I guess. And with sons in eager, red ties and suits that make them look like regional managers of K-Mart. And with daughters who discuss grand ideas with Barbara Walters or on *Good Morning America*. Dear Marshall McLuhan, what is happening to this country? And to all of us? I mean, I *like* Larry King! He's a *friend!*

The Jewish Problem
Since I had to be dissuaded (by local rabbis) from flying the Israeli flag over these radio stations during the Six Day War, I guess I'm entitled to respectfully suggest that a Connecticut Yankee WASP, George Herbert Walker Bush, and James Baker, with the cowboy boots, have done more to ensure the safety and integrity of Israel than any two others on the face of the earth. Israel got the loan guarantees—and a lot more—thanks to two damn shrewd poker players who had to get the Arab representatives to the table in the first place in order to begin the long, arduous journey toward peace. The president gets appropriately high marks as the warrior-leader of Desert Storm. But it is as a peacemaker and global statesman that George Bush truly deserves to be remembered.

And so, after some more meaningless debates and television journalism and Rush Limbaugh and *Larry King Live* and symbols and slogans and rhetoric and posturing, the nation gets to elect a president. We've got a pretty good fellow in there right now. Maybe even a great one. WVOX and WRTN endorse President George Bush for president.

P.S. If you're still not persuaded, try to imagine a Democratic president in Washington alongside our wonderful Democratic Congress. OK, I'll stop. I don't mean to get anyone crazy.

November, 1992

George W. Bush for President, 2000

For eight years Bill Clinton and Al Gore have led a nation that has become rich and powerful but stands for nothing. And now William Jefferson Clinton, he of majestic name only, is hoping you will pass his battered baton to Albert Gore, Jr.

And the Democratic Party of our parents' time—from the days of Franklin D. Roosevelt, Al Smith, Adlai Stevenson, Jack and Bobby Kennedy, and Hubert Humphrey, to the magnificent brilliance and soaring passion of Mario Cuomo—that party has now become an amorphous, pragmatic, cynical, hollow shell of its former self, adorned only with a centrist label that resembles the mantra of every spoiled and selfish dot-com millionaire: "Gettin' it done! . . . Doin' whatever it takes! . . . Make it happen!"

And we feel lousy about ourselves and our country.

Albert Gore is the quintessential product and embodiment of these times. He has embellished and reinvented himself so often he has become a Doctor Spock–like chameleon who climbs up on every stage, no matter the venue, to present himself with meaningless, empty slogans and always with the chant, "Ah . . . *want* . . . to *fight* . . . for *you* (whoever happens to be in the audience on any given day)!" He has no grace, no rhythm, no music. He is a man who *wants to get elected*. And he attempts to divide with his demagogic calls to class warfare.

The vice president was raised in privilege—almost, it seems, born and bred to grow up and one day assume his "rightful place" as president of the United States. George W. Bush is a man with *another* sort of "mission." The Texas governor has, with patience and even, occasionally, with considerable bravery, forced us to think about loftier things, those timeless virtues that have been ignored and almost forgotten in the go-go Clinton-Gore years.

The editorial writers of the day, our colleagues in the press, labor

valiantly to have us stick to the *issues,* and concentrate *only* on where the candidates stand. But the issues evolve and change. And the so-called "issues" of this mean election season will recede and disappear as our nation confronts new challenges not yet seen or imagined—from within and without. It has always been thus in the roiling history of our Republic. So no matter what the pundits and talking heads tell us, we are left, then, with only the matter of *character*. And *values*. And the "vision" thing both candidates are trying to develop.

The difference is that George W. Bush brings a remarkable *conviction* to his pronouncements. There is a *center* to the fellow, a core. He *stands* for something.

After a shaky start, Governor Bush has grown in wisdom on the campaign trail. We see it every day. And as we watch his hopeful, positive demeanor (marred *only* by his bewildering enthusiasm for the damned death penalty!), we are reminded that George W. Bush is the son of one of the most decent and classy men ever to serve as president. (He also has a pretty formidable mother, who is one of the most respected women in America!) For many of us, that he is his father's son (and his mother's too) would be reason enough to recommend him. But George W. Bush brings more than good bloodlines to this race. He approaches us with a *realness* that can't be imagined by Vice President Gore or manufactured by his handlers.

We're for George W. Bush. For we would rather have a president whose actions are informed by the counsel of Dick Cheney, Colin Powell, John McCain, and Condoleeza Rice than by James Carville, Paul Begala, Harold Ickes, or Susan Estrich. (Secretary Cheney, especially, has been a *spectacular* pick as a running mate, while Senator Leiberman has been preachy, all-knowing, holier-than-thou—and not a little bit "pragmatic" himself.)

Long-time listeners to these stations, who have indulged and suffered our enthusiasms for so many years, will recall our telling you, on countless occasions, that Nelson Aldrich Rockefeller and Mario M. Cuomo would have made splendid presidents. They never made it. But we hope George W. Bush does. He's got Cuomo's conviction and passion and Rockefeller's dynamism. And he's a *gentleman* who will restore, almost instantly, dignity and stature to the presidency.

In this, perhaps the closest presidential election of our lifetime, we commend to your favorable judgment the Republican candidate: George W. Bush of Texas. We endorse Governor Bush because he takes us beyond the "issues" to a higher place.

November, 2000

Westchester's Highflier: Guilty As Sin!

Albert J. Pirro, Jr., who came up from the streets of Mount Vernon, New York, sat at the defendant's table in a stark courtroom on the sixth floor of the Federal Courthouse in White Plains. His wife, Jeanine Pirro, the comely and attractive district attorney of Westchester, sat in the front row of the spectators' gallery. Al and Jeanine Pirro braced themselves as a lawyer for the people of the United States of America told Judge Barrington D. Parker, Jr., and the jury here assembled that Mr. Pirro committed a "massive fraud" that enabled him to "live like a Rockefeller" and "spend like a Donald Trump."

The tough, no-nonsense government lawyer tore into Mr. Pirro with a long litany of offenses, which were part and parcel of an extravagant lifestyle. For five and a half hours the charges rained down on Albert Pirro, count after count, more than sixty in all. He was even slammed for being generous to his mother-in-law!

Albert J. Pirro, as my colleagues in the press never tire of reminding us, is a highflier with a flashy lifestyle, flamboyant personality, and craving for material things such as cigars, cars, and his children's three pot-bellied pigs that graze on the lawn of his ornate mansion on Flagler Drive in Harrison.

He is also something of a swashbuckler who now goes home to a high-profile wife and two beautiful children whom he adores and indulges in the overdone Italianate mansion with a Bentley parked cheek-by-jowl with a Mercedes, and a Ferrari in the garage. Pirro has high-level contacts in Albany and Westchester and Donald Trump and Louis Capelli for clients. But he has never really lost his enthusiasm for the "townie" residents of his old neighborhood.

Al Pirro has recently acknowledged some emotional and mental problems as a result of living in the fast lane. But you should know that the feisty power-lawyer has also been observed on his knees

alone with his God at Resurrection Church in Rye during the last trying months. (It seems you can't even *pray* alone these days!) In matters more temporal Pirro is given to sloppy accounting and paying his taxes late. And despite shelling out thousands of dollars to an army of public-relations hacks, Albert Pirro now stands revealed, thanks to my colleagues in the press, as quite the highest flier in the entire history of the Golden Apple, a man over the top with pigs on his lawn.

He's guilty, I tell you, of very bad taste. And of poor judgment. I mean, can you just imagine his tony Harrison neighbors' reaction to those *pigs?* In wonderful, pristine *Westchester?* The papers are right on! The man is guilty as *sin!*

But Albert Pirro, Jr., also happens to be one of the most generous souls in our home heath and the kind of guy I think you could call on for help at three o'clock in the morning. So I am among those who hope he gets a little mercy and maybe some understanding from that jury.

The highflier has already been brought down to earth.

I don't know if it's "class warfare," as some of Pirro's friends would have it. I only know the government of the United States of America did a very good job on the flamboyant fellow from Mount Vernon.

May, 2000

Al Pirro was found guilty on most counts. He spent most of 2001 as a "guest" of the government at a minimum-security federal facility in Florida. It is expected that, having paid his "debt" to society, he will, upon his release, once again be an active and familiar presence in New York State.

Sixty: Neal Travis Makes It!

A lot of money changed hands at Elaine Kaufman's legendary saloon this week when Richard Neal Travis showed up to celebrate his sixtieth birthday.

Travis is the star feature columnist of *The New York Post,* which is the very first newspaper I read every morning. He is a Runyonesque figure of great charm who confounded damn near everyone by just walking though the door on the glorious sixtieth anniversary of his natal day.

This remarkable feat was accomplished even though Travis conducts much journalistic research in pubs, taverns, and venues of questionable lineage, such as Langan's, which is owned by a Desi O'Brien and is a three-and-a-half–minute walk from the desk provided for Travis's use by Rupert Murdoch, and Ken Chandler, and Col Allen. *The Post* columnist has also known the haze of an evening at such disreputable dives as "21," Le Cirque, the Four Seasons, and Della Femina's. But Langan's and Elaine's are his favorite haunts.

Despite his rigorous lifestyle and demanding schedule, Travis is lean, with clear, bright eyes. And women, my wife included, find him "quite attractive" and "a darling man." He drives a BMW and usually wears a blue blazer, velvet slippers with no socks, and tight jeans and is usually to be found in the company of one Steven Dunleavy, another journalist of stellar reputation and considerable renown.

Travis's occupation must be listed as "gossip columnist." He is one of the "founding fathers" of the genre, having started Page Six even before he got his very own column next door to Page Six. He has also written ten books. His profession, which once boasted such writers as Walter Winchell, Dorothy Kilgallen, Ed Sullivan, and Jack O'Brian, now includes Cindy Adams, James Barron, James Brady,

Richard Johnson, the Transom in the *New York Observer,* and Liz Smith. Even in this company Travis is a star. And he is unique.

All gossip columnists wield enormous power, especially in New York, but none more than Travis, whose daily column is practically an "assignment desk" for network camera crews, editors of other newspapers, and even radio reporters who must play catch-up ball with the wily, shrewd journalist of keen intelligence from New Zealand.

Nancy Curry O'Shaughnessy had it about right when she arrived at the birthday party and greeted Tolly Travis, Neal's spectacular Australian wife. "A lot of other writers could fill a room like this," said my Nancy, "but a lot of those people would probably be motivated by a rich admixture of fear and self-preservation. We're all here because we *love* Neal!"

Tolly Travis, a woman of great style, calls him "Nealy." And she rounded up all those glitterati last night by suggesting that "instead of a dull sit-down dinner party, we'll just have a *drinking* party, darling!" This grand idea certainly resonated with her husband and Mr. Dunleavy. And I do not think Sidney Zion much cared that he might miss a seven-course dinner, either.

It is clear that all those who came to fete Neal Travis were impelled by their great affection and respect for this extraordinary and eminently likable journalist. And what a turnout: Al D'Amato (with yet another blonde), Donald Trump with Melanie (and their bodyguard), Andrew Stein, William Bratton, Zion the writer, and *Times* titan Abe Rosenthal, now slumming at the *Daily News,* Ian Rae, who runs FOX News, Dominick Dunne, Sir Howard Stringer, who runs a little company called SONY, and the aforementioned Dunleavy, who was cursing a temporary ailment known as sobriety (at least last evening).

And there, roving around the barroom, was Ambassador (and Madison Avenue legend) Carl Spielvogel and his Barbarlee Diamondstein Spielvogel. And, of course, as always, there was Elaine, perched on her stool near the bar, watching the man who has made her a legend among contemporary saloonkeepers. Finally, the singer Leslie Gore, a Travis neighbor out in the Hamptons, blew the roof off the place with a marvelous, rocking rendition of "It's My Party . . . and I'll Cry If I Want To!"

But all the movers and shakers there assembled weren't crying in

their cocktails. They all seemed to know at Elaine's last night that when you're peddling a story to try to hurt someone in this town or destroy a political career, there are a lot of takers. But if you want to build up somebody or espouse a good and worthy cause, the first call goes to Travis, who has a peculiar reputation in his craft as the only gossip columnist who has never *hurt* anybody. At least that's the view of Mario Cuomo.

It was a glorious night, for a darling man. Damn, he *made* it!

Good for Travis. *Great* for all those who love him.

<div align="right">April 7, 2000</div>

Jimmy Breslin: A New York Writer

Jimmy Breslin is a New York writer. That is, a New York writer as opposed to a Cleveland or Buffalo writer. And he is certainly not a Bronxville or Bridgehampton writer, either.

Breslin writes passionately and brilliantly of the churning, roiling streets of New York City, which he would have you believe is the only place that matters.

Everyone is familiar with the marvelous cast of characters who appear regularly in his columns: Fat Thomas, Marvin the Torch, and Klein the Lawyer.

Breslin would also have you believe that he himself is quite a character. But the truth is that he is a very sensitive fellow who provides for six children who lost their mother last year, the one he called the former Rosemary Datolico.

When Breslin lost Rosemary, he went to the streets and to his typewriter. I always preferred his columns about famous political figures like Tip O'Neil, the Kennedys, and Winston Churchill ("the last great statue of the English language"). But in recent years Jimmy wrote of men with names like Jesús and Ramón and Angel and with last names like Robles and Miranda and Rodriguez.

His is the only column that lives and breathes in New York newspapers—and now he has written another book, a novel called *Forsaking All Others.*

I steer clear of novels that reside in the fiction section of my local bookstore. Give me a biography or something that *really happened* by someone who lived it is my plea whenever booksellers try to sell me on a work of fiction.

But as he is of my tribe, I buy everything by Breslin, and this new novel, *Forsaking All Others,* is marvelous.

The hype on the jacket notes calls it "deeply felt . . . powerful,

moving, angry and often funny." It is all of these things, and it is also sweet and real. There is a gentleness about the story.

It is a love story, which is what the man should write because quite apart from his image as a hard-drinking, colorful Irishman, Jimmy Breslin, in truth, is a thoughtful, loving man who visits people who are sick and hurting and who worries about the children of his friends who are going through a divorce. Like the book, the man who wrote it has a real sweetness. And it will not serve him well to broadcast this—but at least one candidate for governor of New York, the failed baseball player with too many vowels in his name, swears that Breslin is not such a great drinker. I know it's a low blow on him to tell you this, but I hope you will go to your bookstore and buy his book anyway. Even if you're not a fiction reader, this is one you don't want to miss.

<div align="right">July 19, 1982</div>

Breslin has written many books since then. My favorite is his 1996 memoir, I Want to Thank My Brain for Remembering Me, *which was written following a brain operation. His newest is* I Don't Want to Go to Jail.

Monsignor Silverstreak

M onsignor Anthony Wallace, the pastor of Blessed Sacrament Church, is leaving New Rochelle, and he is going to be missed in this town. The influence of this ramrod-straight clergyman with the Irish lilt in his voice extends far beyond the holy walls of Blessed Sacrament.

Monsignor Wallace did all the things men of his calling are supposed to do. He baptized his people when they came into this world. He married them. He forgave them their sins. He preached the gospel. He comforted the sick and buried the dead. It goes with the territory.

But Monsignor "Silverstreak," as they called him in the seminary, did more. He treated those who were called "nonbelievers" by the old Irish with the same love and concern he had for his own. Monsignor Wallace reached out to Protestants and Jews and everyone else in this town. And he was a leader with Rabbi Amiel Wohl and Reverend Donald Roberts, the Presbyterian, of what they call the ecumenical movement—which means, I guess, that God loves all people, that we are *all* God's children.

Monsignor Wallace served for years as a Navy chaplain, and his determined, efficient, straight-ahead pronouncements often made him seem less real or compassionate than he really was. He loved to dress up in his dress blue uniform. But this priest did some of his best work in reaching out and touching people, and for that New Rochelle should salute him.

"BS," as it is known on the streets, one of the oldest parishes in Westchester, has had a lot of legendary, dynamic, creative pastors. Monsignor Wallace, the one they call Silverstreak, was in that great Blessed Sacrament tradition.

June 17, 1981

Latimer for County Legislator

S ervice on the County Board ain't glamorous. It's about the nitty-gritty and nuts and bolts of how we live. But George Latimer, chairman of the County Board, elevates the mundane with his service and stewardship.

Latimer is Westchester's most impressive citizen-politician of this decade. By his devotion, integrity, and sense of commitment, he gives politics a good name. He makes the County Board work. He makes the pieces fit. And the engine runs on time. Everyone in this county can be grateful he has been persuaded to run for reelection. And although he has only token opposition, we just want to take a minute to tell you of our tremendous regard for this able and gifted public servant.

He presides over a disparate group of legislators, some of whom bring rough elbows and their own agendas to the county seat. But Latimer, a great diplomat, keeps everything moving forward.

Frankly, it's a privilege to be able to get on the radio and say nice things about George Latimer. He is the very best, as a legislator and as chairman.

October 26, 1999

Ribicoff vs. Javits: Good vs. Great

Back in the fifties, the good people of Connecticut so loved and admired their governor that it was not uncommon to have a picture or likeness of Abraham Ribicoff on the kitchen wall, sometimes next to a picture of Jesus Christ or an image of Fulton Sheen, the archbishop.

We were reminded of this after learning of yesterday's attack by Connecticut's Senator Ribicoff against our Senator Jacob K. Javits.

Senator Ribicoff broke a traditional rule against personal attacks on a fellow senator to accuse Senator Javits of "hypocrisy" and a "lack of guts." We're not going to get into the complex and difficult issue that brought about the unfortunate confrontation, and we'll leave it to others to discuss the delicate compromise arranged by Senator Javits on the matter of school desegregation. Senator Ribicoff may have felt that the compromise was not acceptable. And that's his privilege. But how dare he rise to attack Senator Javits before that forum of senators who are not Javits's equal in stature or in courage.

The senior senator from New York needs no defense from us. He can handle himself as well as any man who ever stood in that Senate. But observers say he was so stunned by yesterday's attack that he sat quietly and just let the charges float around the historic Senate gallery.

However, we promise you that long after this intemperate outburst and attack on him is forgotten, the courage, dedication, and example of the U.S. Senator from New York will still be admired and remembered. Time and again, Senator Javits has led brave, unpopular causes, and he did not deserve this astonishing rebuke from Mr. Ribicoff.

No one stood up for Charles Goodell after he was abandoned. No one except Jacob Javits, who knew well that Goodell was doomed.

And yet Javits walked the streets of Westchester last fall, laying his prestige on the line in an attempt to save the upstater in that bizarre three-way Senate race. And Javits knew it was not exactly a popular cause, as was later proven by Goodell's blazing 17 percent of the vote in Westchester.

But Javits fought. And he has never hesitated to remind people in suburban areas like Westchester that with their advantages come special obligations to the poor and to their neighbors in the dying city. He took on the powerful broadcasting industry and embittered many of our more powerful colleagues. He has been the patron and champion of every progressive reform of the last twenty-five years. And he stands today as one of the finest and most eloquent senators in the history of our nation.

Senator Ribicoff ran on a slogan of "a good man doing a good job." And he is undoubtedly that. But Senator Javits is a *great* man, doing a great job.

He did the nation and Senator Ribicoff a favor by walking away from a personal encounter in the Senate he serves so well. He emerges a bigger man. And when the chips are down and when the call is for guts, we'll take Javits as our advocate and champion any day.

April 22, 1971

Rambling *without* Gambling

This editorial was named the Best Radio Commentary of 2000 by the New York State Broadcasters Association.

I s there a place on radio for older listeners?
George Plimpton once called radio "a nifty, little device . . . a marvelous companion which follows us damn near everywhere." E. B. White observed long ago that "a radio was more than a box or kitchen appliance." Radio is still the medium closest to the people because it is free and "over the air."

Former New York Governor Mario Cuomo (who still does an intelligent, highly literate weekly show on upstate public-radio stations) likes to remind broadcasters that the instruments of communication that reside in their care and keeping have the potential to resemble more than a jukebox. With his customary eloquence, Cuomo advises us that a radio station can be a platform or forum and can make a community "stronger, better, even sweeter, than it is."

Radio is like the biblical Lazarus. Television couldn't kill it. Cable and the internet couldn't do it in. Maybe the only thing that can conquer radio is radio itself. And its listeners.

These thoughts occurred to me when *Newsday's* Peter Goodman delivered the sad news earlier this week that John R. Gambling was leaving WOR. Gambling's departure marks the end of the longest-running family franchise on New York radio. For seventy-five years, through war, turmoil, social change, and prosperity, a Gambling has presided over WOR's morning show. "Rambling with Gambling" was the oldest early-morning radio program in the nation.

John R. Gambling did not have the edginess and occasional vulgarity of Howard Stern or the rich admixture of social commentary and bombast Don Imus brings to his many fans. And Gambling the

Younger's benign, low-key (dare I say, pleasant?) performances never included the dazzling production values and quickness of Scott Shannon. Gambling was a morning man the way the listeners of our parents' time imagined them to be: agreeable, comforting, reassuring, reasonable, nonthreatening, optimistic, hopeful. And he was a mighty good, reliable companion. These were qualities and attributes handed down to him by his father, John A. Gambling, and grandfather, John B. Gambling. It was breeding and good bloodlines that enabled him to produce "family entertainment" that was a welcome and reliable presence in homes all over the metropolitan area.

No matter the terrors, disappointments, and loneliness of the previous night, there, for seven decades, was the comforting, soothing voice of a Gambling to reassure us, get us centered, and help us greet a new day by dawn's early light. It seemed that it was ever thus around here. They were an enduring and endearing fixture of great value and warmth.

"I liked the Gamblings because they were clean, friendly, and nice," said Grace Sensbach, a Westchester woman who collects antiques (no pun intended!) and was very upset by recent developments at 710 on the AM dial. She was too much of a lady to point out that John Gambling also lacked a "trash mouth," which appellation has been affixed to some of Gambling's contemporary competitors.

So John R. Gambling's departure is an unwelcome sign of the times. In the world of radio, it is not unlike the disappearance of the family farm. Today, the sad truth is that stations are worth more "in play" among speculators than they are while operated as radio stations. Most frequencies in the New York area have now fallen to speculators and absentee owners. "Asset managers" have replaced the old-time, independent broadcasters who once considered theirs a profession instead of an industry. The quaint notion that a radio station operates as a public trust is now a hollow echo from the halcyon days of broadcasting.

Truth to tell, it would be nice to blame Gambling's demise on one of the aggressive, new, business-school M.B.A. gunslingers who now populate the ranks of our tribe as a result of Consolidation. But the scion of a great broadcasting family controls WOR. The Buckleys are an altogether benevolent bunch compared to some of the conglom-

erateurs now preying on the electronic media in every community. Rick Buckley and Bob Bruno, his affable, veteran general manager, are both enormously respected for their generosity and stewardship. But in this day and age, even a nice family like the Buckleys has to make "prudent" business decisions based on shifting demographics dictated by Madison Avenue marketers who crave only the hip, the young, and the impressionable.

It has happened before—and all too often. I get a flash of déja vu as my thoughts drift back to the once glorious WNEW with the incomparable William B. Williams and programs like "The Make-Believe Ballroom" and "The Milkman's Matinee." The much lamented DJs and greatly missed air personalities of the sixties, seventies, and eighties merely had to entertain. Now, radio performers are called on to titillate, distract, and shock us. And they must never, ever, under any circumstances, cause us to *think* about anything of redeeming social value or about the great issues of the day.

Although one has to acknowledge that the problems and pressures facing society are quite different in this high-tech, electronic, speeded-up era, I wonder if there is any room left on the airwaves for performers who are only as "clean, friendly, and nice" as John Gambling. Ultimately, only the discretion of the audience will determine whether there is any room for taste, class, or grace notes on the airwaves. WOR didn't let young Gambling go. We did.

P.S. There may be some hopeful signs that civility is not completely lost to the popular culture. Just this week I encountered seventy-four-year-old Tony Bennett in Manhattan telling one and all that his recent concert at the vast Radio City Music Hall was sold out with not even standing room. And then Michael Carney (Art Carney's nephew), leader of the hottest society-swing band in the country, called to report that the song most requested for the first dance at weddings is now Jerome Kern's lovely classic "The Way You Look Tonight."

But this doesn't lessen the sadness that accompanies John Gambling's dismissal.

December, 2000

For Governor George Pataki

Anyone with a brain, and everyone who *cares* about this richly endowed state, is voting for Governor George Pataki. And so are we.

All the editorial writers have told you how strong he is on the issues. But this endorsement is personal for me and mine. Maybe a little too personal. But as you have indulged my enthusiasms and ravings for damn near thirty years as I've told you about Nelson Rockefeller, Malcolm Wilson, and Mario Cuomo, I think I now must tell you why, by my own reckoning, George Pataki is so deserving of reelection.

Almost four years ago, come Tuesday next, a woman of my acquaintance was in White Plains Hospital trying to save a baby that we hoped would look like her, with a laughing face. It was Election Day, 1994. A friend of ours was also scrambling on that bad November day. For his political life. I had done everything I could on the radio to rough up his opponent. And so at mid-afternoon on Election Day, and against the wishes of a Doctor James Howard, my wife, the former Nancy Curry, slipped out through the hospital lobby and raced down Route 22 to vote for Mario M. Cuomo for governor of New York and against our Westchester neighbor George E. Pataki. After performing this act of citizenship, she returned to the White Plains Hospital to face what will always be remembered as a bad day for us. It was also a very bad day for Mario Cuomo.

But now it is 1998, and this autumn we are required to evaluate the stewardship of the man who vanquished Mario Cuomo. In a word: George Pataki has been spectacular. The son and heir of Louis Pataki, a mailman from Peekskill, has turned out to be a superb governor. Sure, the cyclical gods have smiled on this attractive, gangly neighbor of ours, and New York *is* enjoying golden times and the benefits of a runaway market and a robust national economy. But

that view greatly underestimates the remarkable accomplishments and quality of the extraordinary fellow who now commutes between Garrison and the state capital in Albany.

Governor Pataki has restored vigor and optimism to our Empire State with solid, prudent, steady policies. To accomplish all this, he has assembled a dedicated cadre of gifted public servants, the likes of which even his mentor Nelson Rockefeller would admire.

Some of the more stellar performers attracted to government service by George Pataki include

- Brad Race, his chief of staff, a towering figure respected by everyone for his fairness and strength.
- Lou Thomson, who heads all the corporations and authorities.
- E. Virgil Conway of Bronxville, the selfless, nice man who tamed the vast MTA bureaucracy, made the trains run on time, and restored Grand Central Station to its former glory. Conway is one of the most decent men in public life.
- Tom Egan, the low-key Harrison stockbroker who pulled the SUNY college system out of a tailspin.

Although he still has some "take-no-prisoners," us-against-them zealots in his high councils, Governor Pataki has, for the great part, staffed his administration with good, solid, nonpartisan, professional managers.

And always, for the great issues, the governor wisely relies on the prudent counsel and judgment of William Plunkett, Esquire, who, although reluctant to admit it, has become the conscience and gray eminence of this highly successful administration.

There is one other. Libby Pataki, New York's First Lady, is a gracious, stylish woman, and she and the governor make an attractive, valuable, and irresistible combination. While some may underestimate the governor, few make that mistake about Libby Pataki. She is a marvelous resource for our state and a great role model. The Pataki's Hudson Valley neighbors, the Friars at Graymoor, can tell you about the strength and quality of Mrs. Pataki—and what a great mother she is in addition to fulfilling her ceremonial and public duties.

As for the governor himself: "He's the *smartest* guy I've ever seen in public service," says William Plunkett. "The governor is pos-

sessed of a great intellect. He's just smarter than the average 'smartest' guy, a keen *student,* and a quick study on damn near any subject."

Add to all this: George Pataki doesn't hold a grudge. He's a very generous fellow who has been unfailingly gracious and considerate of his eloquent, gifted predecessor. Indeed, in the very first days of his administration, George Pataki went out of his way to embrace many, like us, who were not with him during the race for governor.

Four years really does make quite a difference. Mario Cuomo has left Albany for New York City, where, from his perch at the Willkie, Farr & Gallagher law firm, he ventures forth once more to confront, with wisdom and grace, the difficult issues of the day. He is now a respected national figure who has become perhaps our greatest political thinker and moral analyst. A sought-after speaker all over the globe, Mario Cuomo has gotten over the events of four years ago. And so have we.

This time the Curry woman and I would go through bullets to cast our ballots for George Pataki, Republican, for governor.

<div align="right">October 29, 1998</div>

The "Necessary" Senator: D'Amato or Schumer?

There is no glory, no music, no poetry, no majesty in the New York Senate race. Just two damn tough, aggressive, bar-the-door politicians. Of the two, we much prefer the Republican Al D'Amato. We are for Senator D'Amato because:

- He knows the Senate and how to maneuver around those Southern senators who hate New York. With his seniority and shrewdness, Senator D'Amato can do more for New Yorkers as an influential member of the powerful Finance, Banking, and Housing and Urban Affairs committees.
- He is often demeaned as the "pothole" senator. But that obscures the very real fact that Senator D'Amato also possesses a keen intellect, which accompanies and complements his vaunted dynamism. He is as *bright* as he is *tough*.
- Senator D'Amato provides good "balance" to the incomparable Daniel Patrick Moynihan, our towering gift to the Republic. Only the enlightened and diverse Empire State could field two such disparate types. Moynihan honors and elevates us. D'Amato *works* for us, *advocates* for us, *fights* for us. He does the "necessary" stuff.
- Chuck Schumer has been a good congressman with many of the same vivid, relentless qualities D'Amato displays in the Senate. Schumer is *almost* as good as our magnificent Nita Lowey. But he is *not* as good as D'Amato.

It all comes down to *this:* If your family should ever need an advocate in Washington to cut through the bureaucracy or to champion their cause, there is *no question* you would want Senator D'Amato on the case.

Finally, we're for Senator D'Amato because the statute of limita-

tions has run out on what he did to Jacob Javits and Mario Cuomo. Like we said: D'Amato is a tough guy. But he's ours. He is, to put it a nice way, the "necessary" senator. We should keep him.

Incidentally, if you're still *undecided* in this close race, don't take our word for it. Ask the "neutral" Swiss government and their "discrete" well-tailored bankers. They'll tell you all about D'Amato, who taught them the meaning of "cajones" when he went after them and their ill-gotten gains.

P.S. You're right. I've never before used "cajones" in an editorial. But sometimes you gotta do what you gotta do to get the point across.

Just like Senator D'Amato. We're for him all the way!

<div align="right">October 20, 1998</div>

Hillary Rodham Clinton

That old Jesuit admonition to "love your neighbor" was really put to the test when the Clintons descended on Westchester. I'm trying. I'm trying. But still we couldn't resist having a little fun with Saint Hillary and all the "Evita," cult-like nonsense that surrounds her.

I hate to say "I told you so" (actually, I do love it!). But we predicted "Senator" Hillary would cause panic among her fellow senators should she ever succeed in her quest for the seat held with great distinction by Daniel Patrick Moynihan. And now, six months later, my colleagues in the press are filing stories that the mighty solons, pooh-bahs, and panjandrums of the Senate are not at all happy. Ted Kennedy, Trent Lott, Orin Hatch, John Kerry, Bob Toricelli, Chris Dodd, and other senators of long tenure find they can't get their precious headlines anymore. Ditto Chuck Schumer, her colleague from New York, who, all of a sudden, found there actually is someone between him and the nearest camera! Her very presence is viewed by the good old boys as a threat to the tradition of "collegiality."

During the campaign, we told Mrs. Clinton that she and her husband have taken enough from the body politic of this nation. We announced that our New York Senate seat was *not* available as a stepping-stone or way station on the agenda of her breathtaking ambitions. Nor was it to be used as a device to continue the Clinton legacy.

Whitney Radio also decided to discontinue coverage of any staged events in which Mrs. Clinton held herself at arms length from the press because we would not allow our radio stations to serve as "props" for Hillary's Evita-like campaign, which had all the trappings of a coronation. And we chastised our colleagues in the press for resembling a bunch of damn ducks crossing the road, one

after the other, yelling, "Quack, quack, quack," hoping for a morsel from the First Lady and the outriders and retainers of her considerable entourage with flying squads of Secret Service agents.

We invited her to appear on our radio stations to participate in an actual live, unscripted dialogue with our perceptive listeners. She actually accepted the invitation. However, "scheduling conflicts" prevented her from following through on her promise. Thus her only radio interview during the entire campaign was a disastrous confrontation with a Buffalo disc jockey who damn near lost his job for engaging her in some spirited discourse. She never took a spontaneous question after that. All of her other events were staged, screened, rehearsed, and scripted. And everywhere she went, all across the Empire State, there, day after day, stood Candidate Clinton with a comfortable forty-foot safety zone (which her press advisories designated a "forty-foot drop") between her and the press.

Despite all this, our own stations had some sport with Madame Hillary, "reporting" on "unconfirmed miracles" attributed to her in several "far-flung" upstate villages near the Canadian border and broadcasting as "urgent bulletins" the latest pronouncements issued forth from her "balcony" in Chappaqua. All this to the swelling accompaniment of the majestic theme song from Evita, "Don't Cry For Me—Arkansas!"

But all kidding aside, we did take issue with her resurrection of the archaic honorary "First Lady" appellation that was traditionally declined and gracefully rejected by her distinguished predecessors of the modern era, Barbara Pierce Bush, Nancy Reagan, Pat Nixon, Rosalynn Carter, and Lady Bird Johnson. These marvelous women were sure of their positions. They had great self-confidence and saw no need to elevate themselves. Indeed, George Bush called his wife "Bar," and Ronald Reagan referred to his as "Nancy."

I still maintain that Mrs. Clinton's recent political maneuverings are all about ambition and about our craving for celebrity. It's about theater. And holding on to power. There is no *realness* to Mrs. Clinton, and I regret that the voters of New York gave her the honor of sitting in the same chair that over the years was occupied, with great distinction, by Jacob K. Javits, Herbert Lehman, Robert F. Kennedy, Kenneth Keating, and the great Moynihan himself. She has her admirers, who are even now talking of Hillary as a future president. But as you can tell, I am not among them.

2000

4

Of an Evening

Book Party

*Although I've spoken on countless occasions at testimonial and civic din-
ners all over this country, and these usually entail a lengthy and effusive
recitation of encomiums and the presentation of an award to some deserv-
ing soul, I find it somewhat awkward and difficult to be the recipient. That's
what happened to me at Le Cirque 2000 when Fordham University Press
and my wife, Nancy, launched my previous book,* Airwaves, *with a spec-
tacular book party. My dilemma was further compounded by the fact that I
had to follow Mario Cuomo to the microphone. You can read the governor's
gracious remarks elsewhere in this volume. This is what I had to say on that
delightful evening:*

Thank you, ladies and gentlemen. Thank you, Governor. I will
not intrude for very long. How many times have you heard me
say this, Nancy? But please know that when I am very old—and I'm
already sixty-one (I don't know how much older I can get!)—I will
remember this night and I will remember that all of you were here.
Nancy, thank you for this spectacular party. In the introduction to
the book you will read just how special Nancy is. Great thanks to
Maestro Sirio Maccioni, America's greatest restaurateur—and I say
this in front of the owners of The Four Seasons, the hierarchy of
"21," and the proprietors of Della Femina.

I am an Irish time salesman, and I would go into these upscale
venues, these high-class saloons of an evening, to sell a little adver-
tising, and I would see these marvelous people that I've written
about. I wish Toots Shor could be here because he said, "You'll *never*
amount to anything, O'Shaughnessy!" But I conducted my research
and knew the haze of an evening in marvelous places all over this
town and in Westchester as well.

Someone asked how long it took to write the book, and I said I
knocked it off in just thirty-five short years! It was very easy for me

because I am just a gifted writer. But I do think everyone should write a book every thirty years, so I would invite you all back here when I'm ninety-two for my *next* book!

As I thank you, I want to thank Fordham University Press. It's a distinguished institution, a great Jesuit publishing house with a tremendous reputation in academic and literary circles. The elders are here tonight, and I'm very grateful to them. I went to a Jesuit high school, and once again they are exhibiting some inexplicable confidence in the product of my meager brain! I'd like to present the director of Fordham University Press, Saverio Procario, my old friend from the Rockefeller years. Also the managing editor of Fordham University Press. He writes *prayer* books and books about popes. And we often were toe-to-toe, nose-to-nose as he said, "That *sentence* goes nowhere! That *paragraph* means nothing!" I said, "I sort of like it." He said, "I edited a *pope*! It's out!" He's a tyrant. And a great editor! Just look at that kind face: Anthony Chiffolo! And the members of the Fordham University Press Board of Directors: Martin Fogelman, Robert Himmelberg, and John Macisco. And the incomporable Loomis Mayer, production manager. I think it's a handsome book, thanks to Willem Hart, a certifiable genius of a designer. The inside you can blame on me but the feel and quality of it is because of Loomis. And wonderful Margaret Noonan and Jackie Philpotts. Also my incomparable Cindy Hall Gallagher and brilliant young Matthew Deutsch.

There are wonderful characters and rich figures in the book: Nelson Aldrich Rockefeller, Governor Mario Cuomo's illustrious predecessor, and Malcolm Wilson, our New Rochelle neighbor, and all the marvelous "townies," the people with *roots.*

There are a lot of book editors and colleagues from the press in the room, and it's now to them to decide if my ravings have any merit. There are also some real, authentic, legitimate writers here: Phil Reisman, Peter Maas, and Ken Auletta. I'm immensely grateful to them and to my friend at the *New York Observer,* Terry Golway. I'm not in their league, but I've seen some things and felt some things, and I've gone home and put them down on paper. Then I put those feelings on the radio. And now the Jesuits have put them in a book. We have a book for everyone tonight—in plain brown paper so you don't have to be embarrassed to carry it down Madison

Avenue. Mr. Robert Blau Lederer of the fancy leather store even has it in his windows on the corner!

Most of all I should thank Mario Cuomo. There is no one I have ever encountered over the last thirty-five years who has inspired me more. I would not have done this book without his urging. He is a *real* writer of great gifts and soaring brilliance. If you read my book you will know again how great and how unique Mario Cuomo is to so many. You honor me, sir. I'm so grateful to you, Governor, and to all of you.

July, 1999

For B. F. Curry, Jr.

"When I Am Eighty: A Wish List": Remarks of William O'Shaughnessy a/k/a/ "His Favorite Son-in-Law," on the Occasion of His Eightieth Birthday, June 20, 2000, at Le Cirque 2000, New York City

Bernard Curry is the patriarch of one the most respected automobile companies in the nation. And he presides over an extraordinary Westchester family. When he turned eighty last year The New York Times *did a marvelous piece on this towering man (he's 6' 6") and his achievements. He's also my father-in-law. But don't hold that against BFC, Jr.*

As this evening is about B. F. Curry, Jr., our incomparable Papa, please allow me only a very brief presentation on this eightieth anniversary of his natal day.

We usually celebrate family occasions, holidays, and birthdays in the great Curry manor house in Scarsdale where you preside, Sir, and where we have been so many times before. But this evening is really very special, as Nancy has observed. We have chosen—thanks to Maestro Sirio Maccioni and his Egidiana—America's most spectacular restaurant (where you are known and loved by every waiter, captain, and busboy!). And so I beg your indulgence and the forbearance of those here assembled who have come from all over the country to celebrate your *first* eighty years.

Frankly, I have been wondering, Papa, what it might be like when *I* achieve your age (should Nancy permit such a thing!). And I realize that due to a campaign of some *mis*information, of which you appear to be the author, there seems to exist this evening a bit of *confusion* as to whether we are asked to celebrate your seventieth or your eightieth. Generous as always, I will deal with the more *inflated* number.

Thus when *I* am eighty, Sir, this is what I wish for *myself:* I hope I

can ski Old Baldy Mountain in your beloved Sun Valley with a U.S. Olympic Team Gold Pass around my neck, in a ski jacket with big, wide shoulders, just like you. And *I* want to still be qualified to fly *jet* planes.

I will also require a great extended family, filled with large, rich, vivid, loving characters who disagree on practically everything. But all of whom have a deep and abiding love only for *me*.

That's what all of us want, Papa, if we should all somehow get to be eighty. And as I think about those dinners at your great house in Scarsdale, I hope I will also have maintained the family domicile as a haven for almost sixty years. And kept it always welcoming and available for all my children in every season of their lives.

I've thought a lot about this. And I hope I have your charm (forgive me; there is no other word I can use), your sense of humor, your charisma. And your absolutely inimitable voice, which never fails to prompt the now famous and familiar response: "*Yes*, Papa!"

Anyway, when I get to your age on this planet I hope Bill Clinton and Al Gore will wonder why they can't quite beguile me with all their "rhetoric" and their, uh, you know, "stuff!" And I hope as many will seek my approval and value my judgment as do yours, on so many subjects, personal as well as temporal. I hope my children will keep coming back for *my* counsel and support and encouragement.

But one thing I must insist on. And I even pray for this. I petition Heaven itself that I will have better *sons-in-law* than you have been dealt! I also say this on behalf of that stellar cast of characters: John Trimper of Palm Beach, George Bernacchia III, and Francis Xavier Young, Esquire! In this alone, I hope for better luck than has been visited on you!

Also on my wish list, Papa: I hope I can shoot skeet and trap and hit a golf ball, low and straight and sweet, as you do in the summer, with Bill Butterfield, the Sun Valley pro, watching. I'd like to have friends like Michel and Helga and Goody, Dean, the Mitchells, and all the "characters" at Michel's Christiania. And I hope Claude gives *me* the best table at The Lodge Dining Room. We will absolutely require table 34 at Le Cirque and the "Mr. Curry Cut" when they carve the roast beef at Winged Foot on Saturday nights or at Duffy

Widmer's Pioneer Saloon most any night! And I hope someone will maybe look forward to being at *my* table as much as Nancy and I enjoy our "encounters" with you on Saturday nights. And they *are* encounters! And we *love* them.

I hope captains and maitre d's and waiters and busboys and parking-lot attendants will take the same delight in seeing *me* as they do when *you* come into view.

As we come into mortar range of eighty ourselves, we've got to hope our children love *us* as much as Nancy Curry loves you. And ditto Barbara, Bernie, Diane, Robin, Leigh, and Cynthia. Each in their own way. And each in their "own heart," as Nancy would say.

We are aware of your reputation and the respect in which you are held by all those who know you in New York State, and the absolutely extraordinary national reputation of the great automobile company, handed down to you from your beloved father, which you have nurtured and sustained for five decades. Many of your colleagues and long-time associates are also here tonight to salute you, Sir. There are, I understand, a lot of "colorful," swashbuckling types in the car business (unlike radio, where we are all so shy, modest, and retiring!). The presence of your peers and business associates confirms your unique standing in the automotive world—for honesty, decency, fairness, and integrity.

Before I yield, Papa, I'd like, on *my* eightieth, to still preside over a company that is respected all across the country. This is also the eightieth year of CurryCorp, and I hope they can say, as we do about you, that I upheld and sustained a proud tradition, kept it going and independent and strong. (I also hope I will have enough money left to afford those $9 haircuts on Central Avenue! *And* the tip!)

Finally, I aspire to be as prompt, as current, as *on time,* as solid, as vibrant, as interested, and as interesting as you are. Come to think of it, Papa, I'd like some of these things *right now,* in my sixties! The old Jesuits used to say that *finite* is the strongest word in any language. (It was either an old Jesuit or Mario Cuomo!) In Latin it's *esse,* "to be." And as we're all so glad to acknowledge tonight, Papa: you *are. You are.* May you continue to terrorize and confound your cardiologist, Dr. Herschel Ozick, for another eighty!

And just one more: I hope good-looking girls will want to hang around with *me* when I am eighty.

Happy Birthday, Sir.

We really—*all of us*—love you!

<div align="right">June, 2000</div>

An Inaugural Ball for Mayor Ernest Daniel Davis

One of the happiest nights I can remember occurred when the people of Mount Vernon feted their newly reelected mayor, Ernie Davis. It was quite a glorious celebration for a city that hasn't had many victories in recent years.

M r. Mayor; Congressman Engel; Consul General and your counselors from the People's Republic of China; Mayor of Port-au-Prince, the capital of Haiti; Chairman Alpert; Chairman Lafayette; Mayor Idoni; Mayor Delfino; Lawrence Dwyer, head of the Westchester County Association; Economic Chief Bill Mulrow, former managing partner of Rothschild; M. Paul Redd; and my colleagues in the press . . .

This is a remarkable evening. Almost a thousand people here at the VIP Country Club to honor one absolutely unique individual. And so allow me to welcome you to the Second Inaugural Ball for Mayor Ernest Daniel Davis. That has a nice ring to it!

You have left your hearth and home on this chilly, windy night to pay tribute to an extraordinary public man and a great Westchester city. We are grateful not only for the generosity of your purse, but also for the gift of your presence.

I won't intrude for very long on your evening. But I do want to tell you and my colleagues in the press why we're here in such numbers and with such enthusiasm and affection. First of all, we're here to celebrate the decisive, unmistakable, and clear victory of Mayor Davis in the Democratic primary. And we're here as well to acknowledge his incredible landslide win in the general election that left no doubt that Ernie Davis is not only very special but that he is also the mayor of *all* the people!

Mount Vernon has been very good to Bill O'Shaughnessy and very generous to WVOX and WRTN. And so I come in gratitude for

what you have done for me and mine. But mostly I come because I share your admiration for quite the most attractive and one of the most able public servants in New York State today.

And it seems it was ever thus. Joe Jackson and Ed Pitt, his old classmates at North Carolina A & T, told me this evening what His Honor was like as a youngster in college: "studious, serious, and *always* with a slide rule in his pocket!" He was a little "quiet." But he *always* "got the job done."

Mount Vernon has had some other vivid mayors over the years. During my time I've been privileged to observe several. I mentioned some of them in the first volume, *Airwaves*. And tonight I recall Augie Petrillo, Tom Sharpe, and that absolutely irresistible individual Joe Vaccarella, Westchester's Fiorello LaGuardia! Mayor Joe was right out of the mind of Damon Runyon himself! And just last week we bade farewell to another giant of the times: Judge Irving Kendall, who I think was also acting mayor for a time.

Each of these chief executives had a compelling style. But Mount Vernon became a city unto itself, a community looking only at itself and ignoring the rest of the world. And then four years ago you found Ernie Davis. Before His Honor, few of your leaders looked outward, beyond the city limits of this landlocked, misunderstood city. Good men with limited vision, they were content to preside over municipal matters, the day-to-day minutiae of governance, separate and detached from the rest of the county and New York State.

And then, as I said, we found Ernie Davis with his open, generous, enlightened, welcoming style. His intelligence, his strength, and his quiet dignity, ladies and gentlemen, speak volumes. And the way he conducts himself screams to those *beyond* Mount Vernon: "You can't forget my city! You can't ignore Mount Vernon. You can't overlook our potential! You can't demean our people! They are just as worthy and just as important as those up-county, in Bedford or Chappaqua, in Rye or Scarsdale! You must deal with us!" That's the message of Ernie Davis. That's the song he sings.

"Don't move us aside! Don't put us down! Listen to us in White Plains, the county government. In the corridors of political power in Albany. And in Washington. We need *you*. And you need *us*!" That's the message of Mayor Davis. That's why you brought him back with overwhelming affirmation!

And, Your Honor, you do all this without shouting, without dem-
agoguery, without harshness or stridency. You advocate with reason
and clarity and with a remarkable and relentless hopefulness, which
has brought Mount Vernon to the beginnings of a great renewal,
where once your city teetered on the brink of neglect and urban
chaos. And so we are here to honor you and to thank you, Ernie
Davis.

Ladies and gentlemen, his Mount Vernon neighbors, and those
who value and treasure good government, his admirers from all
over Westchester and New York State: the mayor in whom we are so
well pleased, the friend who renews our spirits as he renews our city:
Ernest Daniel Davis, the Mayor of Mount Vernon.

<div align="right">January 29, 2000</div>

For Justice Daniel Angiolillo

When New York State Supreme Court Judge Dan Angiolillo ran for office, his supporters and campaign advisors ran ads depicting him as a "tough-as-nails" and "take-no-prisoners" judge. The thoughtful soft-spoken jurist is anything but. And a "lock-'em-up-and throw-away-the-key" guy he ain't.

Welcome to the Westchester Hills Club.

As I told the Republican Leadership Council at the Crowne Plaza yesterday morning, I first entered the hallowed precincts of this historic club when I used to come and sit at table with Edwin Gilbert Michaelian of sainted memory.

Ed Michaelian, as you know, was the Father of Modern Westchester. He built White Plains—the inner city—and, with Bill Butcher, helped establish the I-287 corridor with all those corporate headquarters.

(He was also, I should tell you, a great patron of WVOX and WRTN.)

But I remember Ed Michaelian's telling me one day that his greatest accomplishment was that as a Republican leader he was able to persuade men and women of ability, probity, intelligence, and compassion to turn away from the siren song of a lucrative law practice and serve, instead, in the Halls of Justice as judges, magistrates, and justices.

I will tell you why I also think this is so important. We are instructed by another towering figure of those days, our beloved and esteemed former Governor Malcolm Wilson. The greatest orator Fordham ever graduated loved to remind us, in almost every speech, in every forum in which he would present himself with such eloquence, of that magnificent inscription on the façade of the Federal Courthouse at Foley Square in Manhattan: "The True

Administration of Justice Is the Firmest Pillar of Good Government." It means that any government of people can survive a less-than-enlightened executive branch. It can also survive shortfalls in its legislative branch. But a government will not prevail if you have a less-than-enlightened judiciary.

Which brings us to the man you honor by your presence tonight: Mr. Justice Daniel Angiolillo. What makes Dan so damn special, so worthy of our encouragement, and so eminently qualified to serve on the New York State Supreme Court?

Unlike most of you, I never went to law school—or even one day of college! But I think as we answer that question we have also to confront a larger question! What has made our experiment in democracy so special, so resilient. What has made it endure?

God gave us an abundance of water, agriculture, a mostly hospitable climate—a location in which to build an infant republic. But it's not just these things that have made our nation the toughest and strongest, or Westchester so desirable.

It's not the *place,* not the *people.* It is not even—and this may be blasphemous—a greater Power.

The *rule of law* is responsible for all that we are. It forms us and defines us. Everything we are proceeds from it. It has protected and sustained us for two hundred years.

The law is the miracle of what we are. The law that formed Daniel Angiolillo, the law that we entrust him to interpret and define. The law he taught in college and practiced as a lawyer.

The law he now interprets as a judge, however, does not apply to every single case or circumstance or even, perhaps, to every day and age. So he is required to take this wonderful instrument, the Constitution, and to apply it to each case, to fit it to reality.

To work well, Dan knows, the law has to have the restraint that comes with firmness and strength. And it also needs to move and bend and be compassionate, to deal with each new circumstance.

What qualities, then, should we have a right to expect in the men and women we raise up among us to interpret and define the rule of law? They must have:

- Experience
- Intelligence

- Integrity
- Wisdom
- Compassion

Where do you find people with such qualities? Where might a governor who appoints them, or those who can elect them, find such people? Not in every lawyer (to be sure!).

To whom, then, do you entrust the power to restructure families? To take a business or affect a purse?

In Judge Angiolillo we have it all, a judge with a compassionate and loving touch, with a gentle heart to interpret the law, but with the firmness and power to apply it.

He is so good that Chief Administrative Judge Jonathan Lipman and Presiding Judge Frank Nicolai (a Democrat) designated him to preside over New York State's very first Domestic Violence Felony Misdemeanor Court.

They wanted a man of wisdom, compassion, intelligence, and patience.

They wanted a Dan Angiolillo to deal with the broken families, the hurting children—all the heartbreak and passion, chaos and confusion that descend on that special court!

Finally, we should also remember and be glad that he is a law professor who created and developed revolutionary courses on the rights of crime victims for Manhattanville and on judicial procedure for Iona.

He is one of Westchester's finest sons, a child of the neighborhood in whom we are all so pleased.

Mr. Justice . . .

White Plains, New York
September 30, 1999

General Alfred M. Gray, Commandant, U.S. Marine Corps

The gutsy former Commandant of the U.S. Marine Corps was a vivid, dynamic leader who is remembered with considerable awe and great affection as the living embodiment of the great Marine tradition. I was summoned to introduce the general one afternoon at the Hotel Hershey in Pennsylvania.

As our keynote speaker for this historic conference, the radio and television broadcasters of Pennsylvania and New York are very proud to welcome not only a charismatic military leader and great motivator, but a great American as well. However, the appellation of which he is most proud is that he is a *Marine*.

As Commandant of the U.S. Marine Corps, he is the leader and spokesman for 198,000 Marines, ready to go anywhere on the face of the earth in defense of all those fragile beliefs we share as Americans. He is responsible for three active Marine divisions, three air wings, one reserve wing, and three combat-service-support groups. There is a U.S. Marine on duty, right now, on every continent, in every time zone, across every sea. The general oversees and administers 12 percent of this nation's total military budget (for which, he likes to point out, the Marines deliver *20 percent* of our defense capability!).

It was in that context that I first saw him in action on C-SPAN, when the chiefs of all the armed forces were called to testify before a congressional committee. He will forgive me if I tell you the other chiefs resembled rather austere British warlords: cautious, politic, saying very little and always very carefully. And then it came time for the Marine commander. I recall—even watching on television— the air seemed to come alive in that committee room and fairly crackled with excitement as our speaker leaned into the micro-

phone, looking those senators straight in the eye and telling them what they wanted to hear. Or rather, what they *didn't* want to hear!

Jack and Bobby Kennedy used to say: "One man can make a *difference;* every man should *try*." And in our own calling, our own profession, Roy Howard, Julian Goodman, Ward Quaal, and others have proposed the bold notion that you can't have a great newspaper, or a great radio or television station, unless you have *one* man or woman, one individual of vision and conviction who has *something to say.*

And since that first day of July, 1987, when he became Commandant of the Marines, our speaker has, by every telling and in every account, reinvigorated his beloved Corps and breathed new life into the finest fighting force in the world.

Everybody knows the Marine's legendary motto: "Semper Fidelis." They have another battle cry: "First to Fight." And the Commandant, who has been heard to observe that "nothing very important ever happens inside the Capital Beltway," has been on the road day and night, reminding every Marine everywhere of their proud traditions and brilliant heritage by insisting the Corps get back to basics.

"We are *warriors*," said the Commandant on *60 Minutes,* "the First to Fight." And when I heard you say that, General, we recalled a remark by the gifted governor of my own State. "Don't let us forget *who* we are and *where* we've come from" is the familiar and stirring plea of one Mario Cuomo, who, as you know, General Gray, is a great admirer of yours and who called to make sure we extend the Governor's own personal regards. I'm really not at all surprised these two extraordinary individuals have this mutual admiration society, ladies and gentlemen. Because as I see it, you're in the same business—the governor and the general—the business of motivating and inspiring people and institutions. By example. By dedication. And by getting us back to basics and reminding us *where we've come from.*

Finally, there is talk in the land about our speaker, the kind of talk once heard about Dwight David Eisenhower, who retired to this gentle and beckoning state, just a piece down the road in Gettysburg, in fact. It should be quickly pointed out that *this* general is not at all "cooperating" with all the speculation. Hell, I understand you won't even sit for the Commandant's official portrait! And further,

that you've advised the painter you'll only submit if you can wear your *combat fatigues*, which no Commandant has *ever* done!

At any rate, while one might wish for some of his dynamism and considerable talent in the body politic, I doubt if any amount of flattery or any enticements would persuade him to abandon his beloved Marines who take such pride in his leadership. As we do.

So, my colleagues from the great Keynote State and from our own Empire State, we're pleased to present a candid and remarkable American, the Commandant of the U.S. Marine Corps: General Alfred M. Gray.

<div style="text-align: right;">

Pennsylvania and New York Broadcasters Conference
Hershey, Pennsylvania
October 3, 1988

</div>

New Rochelle Police Foundation Dinner Honoring John Spicer

John Spicer is a highly-regarded healthcare executive who took the small, struggling New Rochelle hospital and made it into the Sound Shore Medical Center of Westchester, a major regional provider in the New York area. I was privileged to present an award from the Police Foundation last year.

I think I know how we all feel about the New Rochelle Police Department. In my remarks last year, which are printed in tonight's program, I wondered what parent or child or grandparent has not had occasion to be grateful at one time or another (or, in my case, on countless occasions!) for the work, forbearance, understanding, diligence, patience, and professionalism of the men and women of the New Rochelle Police Department.

I would suggest the same question could properly be applied to the work of those who labor at our magnificent Sound Shore Hospital and Medical Center. It also occurred to me a long time ago that John Spicer is absolutely the essential man of our city. For if we didn't have his medical center—that special and valuable entity over which he presides—we'd have to invent something just to hold the core of our city together.

The work Mr. Spicer does, as the Bible instructs us, is the highest and most worthy endeavor to which we can aspire: to care for our neighbors, to love them, to nurture them, to comfort them in their afflictions. And with God's help (and the collaboration of superb doctors and nurses), to cure them. To provide a place for them to come into this world as infants full of hope and divine potential, and to leave it, when our work is done, with dignity.

These are all the things a great hospital does. And tonight's honoree—the one I'm privileged to present to you—took that marvelous entity in our midst from a parochial, limited facility (with all due respect to his predecessors) and elevated it and put it in the big

leagues. He made it a major, regional medical center and healthcare facility.

He did this with hard work, conviction, determination, and not a little bit of genius, as well as the finesse and charm he possesses in such great abundance. And yet with all the spectacular growth we have witnessed during the Spicer years, he has never forgotten that he presides—ultimately, essentially, and vitally—over our local community hospital, close to our neighbors, close to all of us and those we love.

No entity means more to our community, not even our two great colleges. And if you'll allow me, no institution is more aware of, or more sensitive to, the community in which we live than Sound Shore Medical Center.

Our honoree brings to his portfolio and his tremendous responsibilities a wonderfully agreeable and winning personality. And he also brings to all of us, and shares with all of us, a spectacularly gifted wife whose energy, dynamism, and wonderful spirit inform everything he does for our hospital and everything he does for our community. My Nancy thinks Kathy Spicer is sensational. And I absolutely agree!

Now although John, I know, would have us share our honor tonight and our accolades with his 1,700 employees—his colleagues, co-workers, and disciples in the Lord's work that he performs—the Foundation has chosen to honor *you*, Sir, for your leadership in our community, and for your stewardship of our great medical center, because the work you do has great value, meaning, importance, and relevance to all of us.

So, ladies and gentleman, on behalf of the Police Foundation, our directors, President Charles McCabe, Commissioner Patrick Carroll, and every single police officer of our city, I'm pleased to present your New Rochelle Police Foundation Award for the year 2000 to New Rochelle's *essential* John Spicer!

November 9, 2000

Clinton in New Rochelle

As they were preparing to leave the White House, Bill and Hillary Clinton immediately zeroed in on Westchester and went house-hunting in our home heath. They eventually settled (most people think not for long) up-county in Chappaqua. But not before they checked out the local housing stock in New Rochelle. I had just left ten o'clock Mass one Sunday morning when I heard that the commander-in-chief and Hillary were sniffing around our neighborhood. Somehow I found myself inside the house when the Clintons knocked on the door.

First of all, everything you've heard about Bill Clinton is true. In fact, everything you've heard about Hillary is true. They both know how to work a crowd.

The president came into our city yesterday with his very best "aw' shucks," down-home demeanor. And when he addresses you—male or female—the nation's commander-in-chief fixes you with a laser-like look, like he *really* means it. Clinton drills a hole with his eyes right at the bridge of your nose and waits till you blink. And Hillary (I really have a hard time with that "First Lady" nonsense) also has that laser-beam "you're the only person in the world right now" focus down pat.

I was treated to all this because of an elite section of the New Rochelle Police Department. It's called the Critical Incident Unit, and they are very good at making sure there are no "critical incidents." Like yesterday, when they were dispatched to 222 Lincroft Road.

The house is an aging, faded Lorelei owned by some lovely Albanian people who make their money from real estate and a travel agency in the Bronx.

The house described in today's papers as "Tudor with a touch of Mediterranean" is at the end of Lincroft near Beechmont and backs

up almost to Pinebrook Boulevard. There's a pond with a footbridge in front and the obligatory swimming pool in the backyard. It is exactly five long blocks from the nearest McDonalds.

The bathrooms, kitchen, and fixtures need a little updating. But you couldn't tell that to wonderful, old Frances Eisner, the doyenne of local realtors who had scoped the Lincroft Road site for the Clintons.

I was standing in the living room as Mrs. Eisner went from room to room turning on the lights. Although it was midday, it appears the Albanians (they are really from Montenegro) are just as frugal as the rest of us. And just then, up the driveway came William Jefferson Clinton, Hillary Rodham Clinton, and Chelsea. The Albanian owners were especially taken with Patrick Carroll, our town's central-casting police commissioner, who as a high-ranking NYPD official handled a lot of presidential visits in the big city. I was sticking very close to Pat Carroll and found myself practically "showing" the house to the president.

Out on the street, one of the commissioner's troopers set the tone by advising my colleagues from the national press, "Look, I'm going to ask you not to *lunge* at the car. Let's treat this just like an *ordinary couple* house-hunting in Westchester on a Sunday morning." And then, with a wink, the New Rochelle officer added: "The fact he's the most powerful man on earth right now should not deter you from civility."

After about twenty minutes, as Hillary and Chelsea marched from room to room, out the kitchen door comes William Jefferson Clinton to stand there almost alone with us in the driveway. As the president made small talk, one of the Albanian women burst through the door with a tray of coffee. "President, president, where are you? I've been looking for you with coffee!"

Sheepishly, the president said: "Well, I just came out for a little air. There are some people here," gesturing to Commissioner Carroll and his wife, Kathleen. He then looked out at the small garage and inquired of the owners: "Uh, is there a room up there over the garage?" "No," said the owner of the property, "there's no room up there over the garage, Mr. President."

The president, still waiting for his wife and clutching a book about Montenegro, the owner's homeland, said, "I just talked to your president"—which pleased the owner of the house.

And then emerged Mrs. Clinton. In the spirit of the moment, I'm afraid I *may* have said, "You know, I haven't been as nice to you as I might have been."

She said, without missing a beat, "I know, Mr. O'Shaughnessy. You certainly haven't been very nice!"

On a roll, I then invited her to come on your hometown radio station in the very near future.

"I will," said Mrs. Clinton, "and I'll take calls from your listeners."

So our shy, modest, retiring listeners may want to start thinking up a few really good questions for the woman who wants to replace Daniel Patrick Moynihan in the Senate of the United States. But first she needs a house and a place to hang her hat (and maybe her husband!).

Incidentally, WVOX News has learned that this was not the First Lady's *first* visit to 222 Lincroft. She's been there before, and in fact, she spent *three hours* during a previous visit, accompanied by her *mother*. So she obviously had said, "Mom likes it, Bill. I want you to see it." It appears she may have developed a real attachment to the old 1920s pale pink Tudor on Lincroft. Hillary was doing a lot more than kicking tires.

And as the Clintons left, Frances Eisner, the realtor, was still telling one and all who would listen what a great First Lady we have. And what a great house, just minutes away from Wykagyl Country Club. In fact, the president could be at McDonalds in about two minutes. But if only it had a room upstairs over the garage for Bill Clinton . . .

On the way out the driveway, Bill leaped out of the presidential Suburban and waded into a gathering of neighbors who treated the Clintons' visit with great civility. Most said they'd be pleased to have Bill and Hillary in our home heath.

As the Clintons took their leave, I'm still repeating something I heard from the lips of Father John O'Brien of St. Pius X Church earlier in the morning, the admonition to "love your neighbor."

Say what you will about him, Bill Clinton, on this lazy Sunday in our city, was really not unlike any other husband being dragged around by a wife to look at homes.

Having said that, I had a strange feeling about all of this, and the cynic in me began to wonder, as the president drove off down the

road, if there might be more to this story than meets the eye. It is well known that the owner of the house is a behind-the-scenes power-broker of considerable standing in the growing Albanian community in the Bronx and Westchester. When the Clintons looked at several other homes in the county, they kept their distance from the neighboring townsfolk. So was this faded, old, pink Lorelei of a house, which stood exposed to the road with absolutely no security, ever really in the running as a domicile for the president? Or did the president and Hillary go through the whole exercise of touring the house and schmoozing with the neighbors just to flatter the powerful Albanian owners in hopes of securing yet another voting block for Madame Hillary's senatorial campaign? Naaaah . . . Bill Clinton would never think of such a thing. But I wonder who tipped off CNN and ABC.

<div align="right">August, 1999</div>

The Ursuline Sisters

A lot of successful, high-rolling Westchester residents have forgotten their roots. And I'm afraid the Irish and Italians are among the worst of those eager to pull up the ladder after them. The unfortunate recipients of their hostility these days seems to be those immigrants—many of them illegal— from Mexico and South America. But these strugglers have some powerful friends too. Like the Ursuline nuns.

The Ursuline Sisters are always stirring up trouble, and I'm glad to be here to stir up a little myself.

What a worthy, relevant religious community! When they are not stimulating our intellect on the college campuses, which they run with such distinction, the Ursulines are constantly, it seems, nagging at our consciences and challenging our souls.

Wonderful Monsignor Ed Connors has allowed them to use his name and fame to raise money for yet another of their nefarious schemes. Three years ago the Ursulines created the Adult Learning Center in a storefront in downtown New Rochelle. In the heart of our community, this unique resource helps hundreds of new and old immigrants master the English language, that threshold, that first thing that makes their pursuit of the American dream a reality.

At the Adult Learning Center the Ursuline Sisters tutor Hispanics—mostly Mexican immigrants—some legal and some not. They educate them. They give them hope. They teach them skills and how to find a job in this day and age to enable them to support their growing families. They level the playing field for them as other priests and nuns before them encouraged our own forebears: the Irish, the Italians, the Germans, and the Poles.

Mind you, this is an endeavor that does not exactly endear them to many of our well-founded, affluent Westchester neighbors, who don't seem to mind at all having the Mexicans remain uneducated

so they can continue to clean our houses, mow our lawns, and clear our tables and sweep up our crumbs at restaurants.

And so we are here tonight to salute what the Ursulines expect will only be a temporary "two-year project." Forget "two-year project." I predict it will be a *forever* project. Because the Ursulines *never* walk away from any need. They never abandon any endeavor well begun.

New immigrants will continue to come to renew America and strengthen our communities. And these remarkable women will be there to help them seize new opportunities, to get them through the door.

There will always be Ursulines to help them. And us.

<div align="right">March, 2000</div>

Independence Day Observance

The National Shrine of the Bill of Rights, St. Paul's Church, The Eastchester Village Green Mount Vernon, New York

St. Paul's Church is a National Historic Landmark. It is also the birthplace of Freedom of the Press, and every Fourth of July thousands come to the Eastchester Village Green to hear the bands play and listen to patriotic speeches by soapbox orators. I was honored to climb up on that soapbox one Independence Day long ago. I hope my remarks on that July afternoon painted a character portrait of the American people.

Ladies and gentlemen: I shall not intrude for very long on your holiday. I come in gratitude and friendship for all the City of Mount Vernon has done for WVOX. And I come to be with you because while others have forgotten what day it is, you have not. You come here as patriots, and I am proud to share this day with you.

We come to this Independence Day observance without shame. We come with confidence that our American nation will prevail because of each of you. You, ladies and gentlemen, members of the Westchester community and citizens in 1974 of the American nation, have not forgotten your country today.

To many this July Fourth is but the first of a five-day holiday. "The Glorious Fourth," the headline writers will call it as our neighbors pursue all sorts of fun and games, so many of them in flight from the responsibilities of citizenship. And though so few have remembered, it is right and proper that we should come here today to the Eastchester Village Green, to historic St. Paul's Church, to renew, restore, and rededicate ourselves to the great and towering principles that were identified and established in this special place.

It is the peculiar glory of this spot that it witnessed that dawn of civil liberty in America. We do not honor this so-called Shrine of the Bill of Rights. This lovely old church is but a monument; thus it is perishable and will not last forever.

But the *idea* and the *principle* of Freedom of Thought, which was affirmed here and went forth from this spot and spread throughout America and England, is worthy of our tribute.

On this glorious summer day in the 198th year of our American nation, that idea, that glorious principle, is still not secure. It is still under attack and in need of your patronage and protection.

A big Westchester developer suggested to me at a dinner only a month ago: "Maybe we've gone *too far* with civil liberties." And some years ago, we recall sadly, it was demanded that Eldridge Cleaver not be allowed to speak on the campus of a great Westchester college. I'm proud that our radio station identified with those who insisted the militant be heard. "We can never be sure," said John Stuart Mill, "that the opinion we are endeavoring to stifle is a false opinion, and if we were sure, stifling it would be an evil still."

And I haven't gone "public" with this, ladies and gentlemen, but I can tell you in the intimacy of this quaint village green, that during this week just past an outstanding national organization that should know better has been trying to drive a radio program off the airwaves simply because it does not agree with the views espoused on the program or with the views of the principal backer of the program.

For me it is a simple issue: if you believe as we do that a radio station achieves its highest calling when it resembles a platform or a community soapbox for the expression of many different viewpoints, then as fiduciaries and trustees of the public airwaves, do we not have a clear obligation to let diverse and, at times, even outrageous viewpoints share that platform? WVOX shares that soapbox with the entire community. And that's why I'm so proud to be associated with a station over which many different voices are heard in the land.

I'm also proud that the Westchester-Rockland newspapers are encouraging more dissent, more feedback, and greater participation by their readership.

It was not easy for the itinerant printer John Peter Zenger two hundred years ago. And it is not easy for his heirs today. Thus I hope you will object and disagree with all your might when a newspaper or broadcaster says or publishes something you disagree with. But remembering the lessons enshrined in this place, I hope you will

insist on his or her *right* to say it. Indeed, his or her responsibility and obligation to say it.

By the same token, if a publisher or broadcaster will not allow you access or is doing a poor job, "censor" him or her by changing channels or by not buying that newspaper. That's as it was intended by our founders who tried to eliminate real censorship from our vocabulary forever.

Finally, I would not do justice to the occasion, ladies and gentlemen, if I did not say a few words about our country and what it means to be a citizen in the 198th year of our splendid Republic. These are difficult and confusing times for America. But it was ever thus. And even a casual reading of our exciting history will convince you that it has never been lacking in drama and turbulence. But America—I promise you—will be equal to the challenge of the present and to the challenge of the future as well.

It has been written that a nation is its people. America is not the Statue of Liberty or the Lincoln Memorial. It is not this great historical site, St. Paul's Church. It is not even our Stars and Stripes. These are symbols. America's richest asset is its people. America is the courage and sensitivity and determination and devotion in the hearts of ordinary men and women just like each of us. We cannot leave the preservation of our democracy to our president or to our governor or to our legislators. The responsibility is ours as members and citizens of the American Nation.

We salute a great nation today. And as we do, there are certain timeless virtues that must guide us: love of our neighbors, reliance on our benevolent and generous Creator, and awareness of the responsibilities of citizenship.

I'm reminded of a marvelous statement by the late Adlai Stevenson that is quite appropriate to this occasion: "We need a patriotism that puts country ahead of self." And that is easy enough to prescribe. But we also need "a patriotism which is not short, frenzied outbursts of emotion, but the tranquil and steady dedication of a lifetime. These are words, which are easy to utter, but it is a mighty assignment. For it is often easier to fight for principles than to live up to them."

When we say we love our country, we mean not only that we love the Westchester hills, the Hudson River glistening in the sun, the wide and rising Long Island Sound, the great mountains and the

sea. We mean that we love an inner light in which freedom lives and in which a person can draw the breath of self-respect.

"Be Counted Again" is the current and recurring theme of the American Legion, which summoned us here to the Eastchester Village Green. By your presence here this morning, you have truly been "counted again."

Now go to your homes, ladies and gentlemen, secure in the knowledge that you at least remembered what it is we celebrate on this fourth day in July. You remembered why the bands play and why the flags fly. The principles and ideas of freedom and liberty and independence are alive in your hearts. Let them mean something in our everyday lives. And let our neighbors learn from your example.

<div align="right">July 4, 1974</div>

The Lincoln Hall Autumn Dinner and Presentation of The Abraham Lincoln Spirit Award

L adies and Gentlemen, welcome to the Country Club of Westchester for the presentation of Lincoln Hall's prestigious Abraham Lincoln Spirit Award.

You've left your hearth and home on this fall evening at the start of the Christmas season for a noble purpose. And I won't intrude for very long on your evening, especially since, as Malcolm Wilson, of sainted memory, would recognize and observe, I am, as tonight's program indicates, the only one that stands between you and your dinner. That is a position from which I plan to extricate myself promptly and expeditiously, if not deftly. But I do want to thank you for the generosity of your purse and the gift of your presence.

We are here because no one in our home heath can resist a summons from our invincible dinner chairman, Bob McCooey, and his wonderful Mary. It is also the towering reputation and tremendous example of your president, Jim Nugent, that compels our presence.

It occurred to the Great McCooey and President Nugent some time last year that it might be quite a brilliant idea to have a little supper for a few hundred of their closest friends to celebrate and salute the splendid work and to herald the unique mission of Lincoln Hall. So they did just that. They rounded up a few hundred McCooeys, Joyces, Egans, Maras, and Plunketts—all the usual suspects. And they damn near filled the place by persuading a generous Lew Lehrman to accept the first Lincoln Award. But knowing McCooey, he also made Mr. Lehrman spend almost an entire day touring the campus to observe, firsthand, the marvelous work being done at Lincoln Hall. And knowing Lehrman and McCooey, I'm sure Bob got Mr. Lehrman to drop off quite a nice check before he'd let him out of the place! That was last year.

In the process, they raised over $50,000 for the Scholarship Fund, which provides grants for deserving young men when they leave

the care and keeping of Lincoln Hall: an altogether nice piece of change for one night's work. But not at all unusual for Bob McCooey.

So this is a McCooey crowd tonight. They told him you can't have another dinner in December. That's all Bob needed. And so we are here again. And we come in admiration of Bob and with gratitude for his friendship.

The unique mission of Lincoln Hall also inspires our presence. Lincoln Hall, named for our greatest president, was founded 135 years ago and has compiled a remarkable record through all the years. But few among us knew anything about Lincoln Hall.

Family Court judges knew about Lincoln Hall. Youth counselors knew of its work. So did social workers. And Terence Cardinal Cooke and Francis Cardinal Spellman knew about it. And so did our beloved John Cardinal O'Connor. And if you'll notice, the chairman of the board is now one Edward M. Egan, the archbishop of New York, in whom we are all so well pleased. The Church has known about Lincoln Hall because of its national reputation as a haven and place of restoration and renewal for young boys, twelve to seventeen years old, who are given a chance to reshape and rebuild their lives.

President Lincoln, in his first inaugural address, called for a "new birth of freedom." That's what Lincoln Hall has meant to tens of thousands of youngsters. And today Lincoln Hall focuses not on the punitive measures that are currently so popular but on rehabilitative strategies that really work and cause lasting change.

Most of Lincoln Hall's boys come from turbulent neighborhoods teeming with drugs, poverty, and illiteracy. They are from streets filled with prostitution, degradation, and little hope. Most of them, as the incomparable Mario Cuomo once so stunningly observed, knew the sound of gunfire before they ever heard the sound of an orchestra.

So your presence here and your generosity directly benefits the 225 boys who are at this moment putting their lives back together up on that spectacular campus in Lincolndale.

And on behalf of those young men, I thank you.

I also join you in saluting Joseph Joyce, the chief general counsel of PepsiCo, for his tremendous work over the years.

Permit me also a word of admiration for Lincoln Hall's brilliant

and dedicated executive director, John Michael Chiaravalloti. The staff loves him, and the boys admire, respect, and trust him. Thank you for letting us participate in your work. We want to hear more from the unique institution named for our greatest president.

Here now, ladies and gentlemen, to present the Abraham Lincoln Spirit Award is Mr. Douglas Wyatt.

> Westchester Country Club, Harrison, New York
> November 30, 2000

National Conference of Christians and Jews Presentation to George Delaney

I think I've squandered half my life covering (or emceeing) civic dinners and charitable events. But George Delaney, a utility company executive, was king of the Rubber Chicken Circuit. He was present for every good cause and was a respected Westchester leader. Night after night this handsome, grey-haired Irishman presided at charity dinners, presenting awards, encomiums, and tributes to all sorts of do-gooders in his broad, nasal, utterly sincere New Yawk accent. This was my tribute to Delaney.

F ather White; Brother Gregory; Margaret Gilmore; my bright and wise friend Brother John Driscoll, president of Iona; County Executive Andy O'Rourke; my neighbor Tony Colavita, Mr. Republican; Charley Matero, the great leader of the Operating Engineers, a man with a national reputation who was always such a great friend of our late and greatly missed neighbor Nelson Rockefeller; ladies and gentlemen:

What an extraordinary gathering of neighbors. Seven hundred and fifty of us. And what a compelling and significant tapestry of Westchester and all that it is. There are, in this great ballroom tonight, the Valentis, Bergers, Petrillos, and Fredmans. I see, cheek by jowl, at the same table, the Martinellis, Bermans, Hooleys, Colavitas, Ungaros, and Cuddys. There is a Meyer and a Dioguardi, the Cribaris, Gilberts, DiMarzos, and Driscolls. I guess that's the way it should always be. At least if the NCCJ has its way, and if our own better instincts could prevail every day of the year.

I am here as a surrogate for all of you, the preeminent and the well-founded of Westchester. And you have come here tonight to honor George Delaney with the highest award that the National Conference can bestow.

I come also bearing the gratitude and friendship of all those thousands of men, women, and children who have been the beneficia-

ries of George Delaney's compassion, caring, and love. The ones who couldn't afford to be here and sit at these fine tables and eat and drink as generously as we have. I am here for them too.

George Delaney is, as we know, our regional co-chair with Marty Berger and Judge Ruth Washington. But his influence is felt far beyond our home heath, as George is also a trustee of our national board. We also realize that he sits in the high councils of the powerful Westchester County Association and is not exactly unknown in the corridors of power in Albany and Washington.

Delaney is a man of many parts, and there is a big, broad range to his life. George's exquisite and finely tuned sensitivity has led to positions of leadership in many other worthy organizations that help people. Real people. His neighbors. Our neighbors. He is chairman of that splendid entity known as the Private Industry Council, which employs and trains thousands, with a bias for the poor. And Lloyd Jones, that great, good man who runs it, is here tonight.

George is a director of the Westchester Coalition, which assists the underprivileged, those with low incomes. It is such a valuable vehicle for bringing the races together.

He is, by trade and by calling, the chief operating officer of the Edison Company's vast Westchester region. And as such, he supervises two thousand employees who provide the power for our industries and our homes. In this calling he's the careful shepherd of a $100 million annual operating budget, for a growing, robust division that has sales revenue of $700 million annually.

So all of these things describe for us his standing and positions of responsibility and high estate in our county. But George Delaney is more. He is the first person to whom any of us repair for support for any good cause. And we're attracted to him not alone for the generosity of his company's purse. When we go to his door, when we repair to his counsel, he always gives us not only a respectful hearing but his own marvelous enthusiasm as well. And as we bombard him with our ideas and schemes, we're secure in the knowledge that we'll get his help—if our ideas have any merit at all, certainly if they have any potential for helping people.

And once he is committed to a cause, his participation is constant and consistent. He gives freely, unstintingly, and without condition. That's the way he is. There are a lot of takers in our country—those who take and put nothing back, those whose charity and par-

ticipation come with strings and are calculated to make the giver look good in the press. We know a lot of them.

And then there is George Delaney, who comes without strings, with only a good heart and a real love and concern for people.

And finally and ultimately, his greatest achievements, by his own words, are his four beloved sons—one of whom is here tonight, representing his brothers, to witness the esteem we have for their father. I'd like you to greet John Delaney. He is fifteen, and his father is well pleased with him.

Now, as it is time to present your award, George, on behalf of the National Conference of Christians and Jews, with the permission of our dinner chairman Charley Matero, I would like to yield the privilege to your son. John Delaney, as you are your father's son, will you please come up here.

<div align="right">June, 1984</div>

A Birthday Celebration for Andy Spano, Westchester County Executive

When the Westchester County Executive first ran for office, I backed the Other Guy—a tall, central-casting, multimillionaire, Republican, Wall Street banker from Rye who spent $3 million (most of it from his own pocket) to try to beat Andy Spano, who had only himself and a very devoted wife. He also has an exquisite feel for politics at the local level. I've come to really admire Andy for his goodness and lack of pretension.

Welcome, ladies and gentlemen.

I've discovered I'm the only one who stands between you and our honoree—a predicament from which I intend to extricate myself expeditiously, if not deftly. So I won't intrude for very long on your evening. But I *do* want to thank you for the generosity of your *purse* and the gift of your *presence*.

You can actually blame my participation on that absolutely indispensable and remarkable woman Brenda Resnick Spano, who with her usual instinct for high drama, has selected an Irish, Rockefeller–Malcolm Wilson Republican who endorsed the *wrong guy* three years ago! Brenda, you are nothing if not tolerant, generous, and altogether forgiving.

You can absolutely be sure I won't repeat my folly this fall. Mario Cuomo said, "I *assume* you've seen the light, Brother Bill!" Forget the governor's importunings. And ignore even the none-too-subtle "hints" I received tonight from his son and heir, Andrew, concerning the county executive! Nancy Curry O'Shaughnessy will make damn sure I do the right thing because she likes Andy Spano too! And she's crazy about Brenda.

You, ladies and gentlemen, need no such encouragement. You've been Andy's friends for a long time and in every season of his life.

I've been given just a very few minutes to introduce the feature of the evening, the only speaker and the reason we are here. And if

you look around the room and measure the people who came, you get some idea as to who Andy Spano is. How *special* he is. How *valuable* he is. And how absolutely *unique* he is in this day and age.

This is an extraordinary gathering. A thousand people from every station and walk of life! (All this with the Yankees in town and Andy Pettitte on the mound for the first night game of the season!) As I look out across this room, the thought occurs that Bill Luddy and Max Berking, Democrat icons of sainted memory, could have only imagined this spectacular turnout. I've squandered half my life in this particular venue, and I can tell you that for years in this county, only the Republicans could have filled this vast ballroom!

We're here not only to mark the anniversary of Andy Spano's natal day. And not even because we were summoned by Brenda. We've come tonight for one evening in the springtime of the year to salute a public official in whose exemplary service we are all so well pleased, a man's whose agreeable persona and footsteps are welcome in every neighborhood of our great county.

Being involved in today's politics is not easy, especially when you're an executive trying to run a big, sprawling, complex entity like Westchester. To govern and manage requires all kinds of special skills, some almost exquisite. But the best of those in the public arena have more than skill. The best have something that's not exquisite. The best are possessed of all those plain things that aren't as ordinary as they ought to be: civility, collegiality, a real abiding, genuine interest in people, common sense, decency, fairness, niceness, and an ability to listen. The best are people of patience and judgment and realness who know how to handle all the tough issues, all the colorful egos, how to maneuver among all the competing factions among our villages, cities, and towns, from Mount Vernon to Peekskill, and from Bedford to Bronxville.

Actually the great Cuomo had the best line of all about Andy: "How the hell can you beat a combination of *Harry Truman* and *Francis of Assisi!*" Don't even try to mess with that one, baby!

This is a celebration tonight, not a political rally. And you already know Andy's accomplishments. They're part of the public record. We've read of them in the newspapers, seen them on TV, and heard about them on the radio. These include his work on the environment, such as the thousands of acres of open space preserved for our grandchildren, and the things he's done to protect the very water

we drink. He also laid the groundwork for a state-of-the-art children's hospital, unmatched anywhere in the country, soon to be a reality in our own backyard. He's confronted the terrible societal issues of the day with wisdom and firmness in programs like the Westchester Gun Safety Act, a Tobacco Reduction campaign, zero tolerance for domestic violence.

And with Bill Mulrow, for whom I also have tremendous regard, he's been aggressive and creative—even relentless—on economic development.

Andy even created a special Bureau for senior citizens (to help aging white-haired Republican broadcasters!).

And finally, he's cut taxes, three years in a row! His shy, modest, retiring chief of staff Larry Schwartz just wanted me to "mention" that in passing, mind you. In case my Republican friends are listening! Republicans love to hear you cut taxes!

It's all in the record. And as a result, in just three short years he's become a statewide and national leader in county governance.

But all of his accomplishments, as I've suggested tonight, proceed ultimately and essentially from those timeless virtues Andy possesses in great abundance: the ones in such short supply today.

So please welcome the nice man who does the people's business in Westchester in such a unique, effective, and really quite wonderful fashion: County Executive Andy Spano! Happy birthday, Sir.

<div style="text-align: right">

Rye Town Hilton
April 4, 2001

</div>

5

The Tables
Are Turned

Interviewing the Interviewer

Kevin McCabe, News Anchor on Cablevision

O nce giants walked our land. They strode the boundaries as patriots, journalists, and rebels. They put into words the feelings and concerns of those yearning to be citizens of this new nation. New Rochelle's Tom Paine, whose cottage is still there on North Avenue, helped incite the American Revolution with his famous pamphlet "Common Sense." Paine's incendiary ravings were not the words of those who traffic in the innuendo and mud we see today. The journalists of Paine's day were not trying to be famous (that could get them hanged), but they were delivering information and rendering opinions concerning the times in which they lived. And they confronted the issues affecting their neighbors.

This country has always had those who would step up to the plate when the opposing pitcher had a full count on the home team. And in the Queen City of the Sound there still exists a squire who calls the alarm today when individual rights are threatened. William O'Shaughnessy is the inheritor of our founders' brave example and proudly wears the mantle of those agitators of long ago. His voice rings true and clear on the airwaves instead of in the pamphlets of that bygone era. O'Shaughnessy is a homerun hitter. When others shy away from the pitch, he swings for the bleachers. He calls many of the great elected officials of our time his friends. Yet he doesn't pander to them, or to anyone else. O'Shaughnessy is an exquisite crafter of words, a painter of pictures, and a molder of opinions. He uses the details to tell the big story.

The rebel in him surfaces when others lie still. He does not wet his finger and hold it aloft in the wind. When a certain politician moved to our state to seek office, he refused to cover her "listening tour" until she agreed to "talk" to the press.

When the wife of the former vice president made a hell of a ruckus about labeling records to indicate their "suggestive" or pruri-

ent content, O'Shaughnessy roared his opposition like a lion. He reminded the nation that songwriters, poets, and minstrels, no matter how scraggly or long their hair or ripped their t-shirts, deserve the same respect that was given to Cole Porter, Rodgers and Hart, and Johnny Mercer. In fact, when O'Shaughnessy is not dealing with the great issues of the day, he makes a living out of playing the great American popular songs, many of which were a little "suspect" in their day.

Bill O'Shaughnessy rides to the sound of gunfire. The ripples he has caused in the small but enormously influential pond that is Westchester have ricocheted out across our nation. He does not give lip service to the First Amendment. He lives it and has, for years, been the point man for the broadcasters of America against government incursion into programming on the airwaves. He is the one who suits up when the likes of Howard Stern are under siege from our own tribe.

I think the day O'Shaughnessy was born God said to his guardian angel, "Make sure he stirs things up down there. Give him a free rein and let him throw lightning bolts across the sky. Let his words fall like a soft rain on the Irish meadows, and glow like a rainbow when the storm has passed."

I once asked O'Shaughnessy during one of our television talks what should be written about him when his voice is finally silent. He told me this: "He struggled. He made a lot of mistakes. He loved his family. He probably didn't take advantage of all the opportunities God put in his path. He would have done a lot of things differently. But he tried to love."

In this volume's essays and in our interviews, he uses his eloquence to enlighten, inform, amuse, agitate, and make us believe. He wears the mantle of "townie" with pride. He knows who he is, and from where he came.

When you talk of the great landmarks and various attributes of this extraordinary suburban county, include him among the schools and universities, the arts and Fortune 500 companies, the governments and the people, the hills of northern Westchester and the cities of the southern tier, the blue lakes, the beauty of Long Island Sound, and the majesty of the Hudson River.

The following section features highlights from Cablevision's year-

end specials during which I coaxed the great O'Shaughnessy over to the other side of the microphone. See if you don't agree that a giant still walks our land here in New York's "Golden Apple."

Kevin McCabe is a veteran news anchor for Cablevision in the New York area.

Westchester Newsline: Kevin McCabe Interviews William O'Shaughnessy

December, 1986

K. MCCABE: I'm Kevin McCabe, and this is *Westchester Newsline*. When I was studying history and we got to the Revolution, this old Roman Catholic priest started complaining about what he called "the agitators," people who might be looked on a few hundred years later as Founding Fathers. Perhaps we've taken a lot of their humanity out of them and just made them into saints. But they weren't that way, and this priest used to get very mad that journalists like John Adams and Tom Paine would write pamphlets but also get involved in what was going on in matters political. They didn't just record events, they helped make them. And thus became personalities themselves. Well, I think if Bill O'Shaughnessy had been around two hundred years ago, he probably would have fit in with a lot of those people. He's a journalist, but he also becomes involved in everything. If he has a trademark, I guess you can call him a man who is eloquent, not only with words but also with deeds.

When you came in here, you had that old granny sweater on, and I thought, O'Shaughnessy is starting to look old here.

W. O'SHAUGHNESSY: I don't suffer the winter well . . .

K.M.: I see you're wearing *socks,* though! You must *really* be cold. "The quintessential preppie," as *New York* magazine called you, with socks on!

W.O.: Never mind those publicity notices. It gets cold, and I go to socks.

K.M.: Let's start with journalism. We're going to have to discuss the biggest story going on right now: the troubles Ronald Reagan is having with the presidency and Iran Contra–gate, undoubtedly his biggest crisis so far. Is Reagan's presidency really in as much trouble as people are saying it is?

W.O.: I've been thinking about this all day. You and I spent some time today with Senator Al D'Amato, and I asked him directly if it's as bad as Daniel Patrick Moynihan says: does the president really have only forty-eight hours? And he said no. As an American—forget journalist—I'm uncomfortable with the situation. I hate to see our president at peril. We've got to look like jackasses abroad. Yet one side of me whispers it's the genius of this country that we have an aggressive press snarling at the heels of these covert activities.

K.M.: In *Time* magazine today, Reagan says his mouth was filled with bile because of the great "irresponsibility" of the press—phrases I don't think we've ever heard Ronald Reagan use.

W.O.: A few minutes ago Bruce Morton on CBS lifted a clip from Richard Nixon saying almost the same thing. Press-bashing is an easy instinct to give in to.

K.M.: Is there too much of a Watergate mentality, especially in the Washington press corps? Not that I'm here to defend the Republicans or the president, but is there a tendency for the press to go overboard?

W.O.: You and I are of the same tribe. We make a living at journalism, and we know the mantra of our craft, the marvelous reminder of a government without newspapers and so on. You've got to have a robust, dynamic, aggressive press. You've got to open the activities of the high officials and elders of this country to scrutiny. But you've also got to be able to wheel and deal. The practical side of me, anyway, says Reagan is going to be our president for two more years, with all his faults and with all the glitches. Whatever the hell happened here, let's get it behind us. I want to cover some other story.

K.M.: I know you've supported the president in the past. But isn't there something owed above the man to the system, to the office of the presidency itself?

W.O.: I'm a Rockefeller Republican. To me, Ronald Reagan was not a very beloved figure for about fifteen years of my life. He may be a great actor, but I think he's a good, decent man. I get into a lot of big arguments with my liberal Republican friends about this, the few of us still around. I want him to succeed. I want our country to look stellar to people overseas.

K.M.: What do you think about journalism here in Westchester?

You've been covering it probably as long as anyone. O'Shaughnessy has been everywhere for three decades. He was in the taverns. He was in the schools. He was on the streets. He was in the city halls—with a microphone.

You've had your share of headlines and interviews on national television and your picture in the paper often enough, and you probably could've left Westchester many times in your career, but you have stayed here. You said to me about a year ago that Westchester was a small pond but we sure have a lot fun covering the swimmers. I dare say some of the ripples *you've* caused in this small pond have ricocheted out across Westchester and across the country. It's not unusual to pick up *Broadcasting Magazine* and see you standing at a bar in Washington because you refused to go to the French Embassy for a reception after they refused to let our planes refuel and your "boycott" was picked up by the wires around the country. Why did you stay in Westchester?

w.o.: Westchester has been very good and very generous. Where else could you cover a neighbor as vivid and as zestful as Nelson Rockefeller as we did for so many years? Or Malcolm Wilson, a great, classical orator. Or Tony Colavita, the State Republican chair, who is a neighbor down the road. This is a dynamic place to work. I always kid about the bagel store in Wykagyl. Sometimes I pretend to drop a dime and wait to see how many people push me over to get next in line. The first place I head when I come back from the country is the bagel store because there is a bounce to it all. The *Wall Street Journal* accused our little 500-watt radio station of being the quintessential community radio station in the country. If I were in Cleveland or Kansas City or Denver, I wouldn't have the impact I can have right here.

k.m.: Tell me about Tony Colavita.

w.o.: Tony Colavita is sui generis. He has struggled valiantly to restore the Republican Party. After Nelson Rockefeller departed, the cash went with him, and Colavita has resisted the temptation to sell the nomination. Lew Lehrman bought it for $15 million. Ron Lauder almost bought it for $3 million. Now Mr. Colavita hasn't given nominations to the dilettantes with mama or papa's fat purses at their beck and call. He's gotten the Republican Party back to the grassroots.

k.m.: The man who lost to Governor Mario Cuomo is Andrew

O'Rourke, our county executive, who is also a very good friend of yours.

w.o.: We endorsed Andy O'Rourke for Westchester county executive. I think he did a very good job getting us back on track. I was not a great fan of his predecessor. I was greatly in the minority, but I thought Al DelBello did some astonishing things like hiring that group of Mormons who wouldn't let the poor people have their picnics at Playland, and he had these guys from Harvard Business School walking around with clipboards. Andy O'Rourke opened up Playland to the people again. I think he's a bright man and a good man. I urged him not to enter this race. But he quoted Marshall Ney and said, "I have to ride to the sound of gunfire." In other words: go where the action is. I said, "Listen, Andy, in four years you won't have a Mario Cuomo to run against. But then again you may have one of those dilettantes with the big 15 million bucks, so I don't know what you ought to do."

K.M.: Even though she passed through here for only a short time, Bella Abzug was such an interesting personality . . .

w.o.: Before the campaign began, when she was just taking her soundings, she came in and right away saw a picture of Tip O'Neill and Garrett Fitzgerald, the prime minister of Ireland, on my wall, and she allowed that I must be okay. Although looking at a picture of me in my pinstripe suit, she said, "Who is this *Republican?*" To her great credit, she did not take my advice. She ran, and I must tell you I like Bella Abzug a lot better than I thought I was going to like her.

K.M.: Do you think Mario Cuomo is going to run for president?

w.o.: Kevin, I think Al D'Amato said it as well as anyone today. He said, "It's wide open. Anyone can win this thing." Cuomo is such an extraordinary and bright character who struggles and churns. I said to him once that he may very well end up in the tower of London like his hero and idol, Thomas More. There was a big pause at the other end of the line. I think that Cuomo's contribution might be in the spiritual realm or as a teacher because I think he's operating on a level that is far above that of every other contemporary politician.

K.M.: You've said that before.

w.o.: Cuomo's genius is that he "stays." Over in the fourth ward, Rocco Bellantoni, Jr., told me the old men of his father's time

used to have a great tribute: they would put their hand out palm down and say, "He stays!" I think the governor is not a finger-in-the-wind guy. I think he believes deeply on the death penalty—the thing that first attracted me. And Nelson Rockefeller's former secretary, now in her eighties, an indomitable old dame named Ann Whitman, called me up and said, "O'Shaughnessy, that friend of yours from down in Queens: what's his name? He's so damn brave." Incidentally, before she worked for Rockefeller, she worked for a guy named Dwight Eisenhower. The office of the president in the old days used to be Ann Whitman and four assistant secretaries. Now it's 973 guys, and you see how well they're doing. I said, "Ann, what side are you on?" She said, "Never you mind. Just tell Cuomo he's so damn brave." I'm almost suggesting Cuomo might be too good to prevail. Can he relate to people? I've seen him on a flatbed truck in the garment center in New York with elderly women hanging out the window on Seventh Avenue, and I've seen Jack Kennedy and Bobby in that precise spot, and he's as good as any of them. But what recommends him to me is that he struggles with it all.

K.M.: I've been in rooms with four to five hundred people, and when Bill O'Shaughnessy walks into a room, everyone turns around, and they all know who you are . . .

W.O.: I want to mark this date. It's the first time you've ever embarrassed me.

K.M.: But that's your style. And you know that. You work at it. What do you think about Bill O'Shaughnessy, and why are you that way?

W.O.: When you have 500 watts, as WVOX does, you go with what you've got. I'm the rainmaker. I'm the editorial director. I pick the music. I scream at the office boy to pick up the papers on the lawn. I try to get a better price for washing the windows. And I go out and meet people. You can either walk into a dinner anonymously and hide in the corner, or you can walk right in there and say, "I'm here to cover it, and I want to know what the hell you have to say."

K.M.: There's no doubt about where you stand on things.

W.O.: I have my say. A lot of broadcasters choose to see themselves as entertainers or performers. I see myself as a fiduciary, as a trustee. If you agree with me that a radio station, a cable station,

or a newspaper serves best if it's a mirror and a forum for the expression of many different viewpoints, then you try to use your genius to get people to participate in their franchise. So I just mouth off about something to provoke that vox populi. Our call letters are fabulous! I was never a great scholar. But I learned about that voice of the people from the Jesuits. So many radio stations don't *fit* their call letters. I think our community radio station does.

K.M.: When I first took over this show, I was looking for a Catholic priest to come on because I had some theological question I wanted to ask. And you gave me the names of some priests to call. And then you told me if I can't get any of them, *you* have a Roman collar and you'll fill in. I knew you would have done it.

W.O.: I'm easy. Three Hail Marys for a homicide!

K.M.: The pope has been talking about the right to dissent in the Roman Catholic Church. He wants to pull everyone into line. Modern Catholics in the United States are looked upon as the yuppies who want to liberalize the Church, but also it's coming from the developing countries where priests are involved with socialist causes and human-rights movements. Do you see that the Catholic Church is going to have to move away from that strict dogma of whatever the pope says goes?

W.O.: I have an opinion on damn near everything, but I don't feel comfortable criticizing this Church. It really is made up of human beings. I can tell you that not enough attention is focused by any of us on the parish priest. Like Stuart Sandberg who bedevils the Establishment from his pulpit at IHM, a high-class church in Scarsdale, driving them crazy with his antiwar sermons. And he's always trying to drag me down to soup kitchens in the South Bronx. Or Father Terry Attridge, the head of drug- and substance-abuse prevention programs for the archdiocese. He also the PBA (Police Benevolent Association) chaplain. Don't think that priests don't struggle just as we do.

K.M.: Even you, the great agitator: you see no room for dissent here?

W.O.: I think Christ was a radical. Priests have to talk in the vernacular of the day and use whatever gifts God has given them to preach that message of good news and salvation. I wouldn't for a minute attempt to tell the Catholic Church how it ought to do that in every single instance or circumstance, but there are won-

derful, creative, loving, relentlessly giving priests and nuns who don't play politics with the hierarchy and have no title or estate. They are not monsignors or bishops or archbishops or cardinals or princes of the church, but right now they're over in that hospital praying with the sick.

K.M.: I'm going to give you a journalistic assignment here. "Bill O'Shaughnessy died today." Give me a quick obit on him.

W.O.: He struggled. He made a lot of mistakes. He loved his family. He probably didn't take advantage of all the opportunities God put in his path. He would have done a lot of things differently, but he tried to love.

December, 1988

K.M.: The electors from all around the nation are getting together to elect the president of the United States today, and George Herbert Walker Bush will be inaugurated in January. What can we look forward to in a Bush administration? He's an old preppie like you are, Bill.

W.O.: It is no secret that I would have preferred a failed baseball player with too many vowels in his name, Mario Cuomo. I still think the governor will yet somehow, in the history of the Republic, slide in from third base and score the winning run. But we have to hope and pray that George Bush will be a great president.

K.M.: What's going to be the legacy of eight years of Ronald Reagan?

W.O.: As a Rockefeller Republican for many years, I didn't like Ronald Reagan and those West Coast arch-conservatives. But let me tell you something. You and I make our living with words, and I am too old to be greatly impressed by a turn of phrase. But the night before the election, Ronald Reagan got on television and looked in the camera and said, "Tomorrow when the mountains greet the dawn, could I ask you one more time to win one for the Gipper?" That got even me.

K.M.: Will an Eastern liberal like Michael Dukakis ever be able to become president, or is your brand of Eastern liberalism dead on the national scene?

W.O.: I'm not a good guy to preach to the Democratic Party because I am a Republican. Dukakis didn't lose because he is a "Northeast liberal" but because he was greatly lacking in gifts. At first I said I can't dislike this guy solely because he's not Mario Cuomo, who

is *so* gifted and has so much good stuff in him. Nor was it enough to say Dukakis has no music in him. I found the guy to be probably the weakest candidate in the last twenty-five years ever to be presented by a major political party for the highest office we can bestow. He's a guy who could be a great speaker of the New York Assembly.

K.M.: Are we going to see more negative campaigning like the Willie Horton commercials in the future? Is that what America wants?

W.O.: Governor Cuomo has spoken often at meetings of the national broadcasters and journalists associations about these thirty-second sound bytes. He was one of the first major national figures to inveigh against this dangerous trend. I have confidence in the people of this country to separate the truth from that propaganda. Cuomo talks in elegant paragraphs, not in thirty-second sound bytes. Your question lingers, but I think the people will go beyond slogans and glibness.

K.M.: Doesn't four years of George Bush as president take Mario Cuomo out of the running?

W.O.: There is a prophecy abroad in the land that when Bush gets in the whole damn economy now held together with scotch tape and bailing wire will go into a tailspin, and that then the governor will be summoned. I think that's a cynical and calculating scenario, and as an American I don't want to have any part of it. I can tell you that I talked to the governor, and he was very gracious. He said this guy is our president, and boy, we've got to support him.

K.M.: Will Mario Cuomo play in Peoria? Is his style acceptable to the rest of the nation: the Western conservatives you mentioned earlier, the sunbelt folks, people down south looking at a guy with too many vowels in his name coming from that liberal eastern state of New York?

W.O.: That's a very good question, and an essential question people all over the country are asking. The stuff he's pushing from his heart sets him quite apart. A lot of people think the glibness of his tongue is what recommends him. But I think it's his example. Here's a guy who said, "I am an elected governor of New York and I can't do both jobs. I can't go around in a cattle show to present myself and also be governor, so I will stay at my task, I will keep at my post, and I will run the race you gave me." I think he's

operating on a level far above that of any contemporary politician. Now, your question suggests there is prejudice out there because there are too many vowels in his name, but you'd be surprised that upstate New York is not unlike Georgia or Utah or Iowa. And I find some people, lifelong Republicans, who see there is something very special going on with this fellow.

K.M.: Let's talk about Westchester, and the unfortunate death of Judge Dick Daronco this year. Your editorial was, I think, you at your best and most eloquent. You were talking about the old New Rochelle—meeting people in taverns and what they were doing—and I loved every phrase of it. Are those days gone?

W.O.: Dick Daronco was a child of the neighborhood, and he was a bright star indeed. I remember prevailing on him to delay a plane ride so he could meet Senator Al D'Amato, who recommended him to the president for that federal judgeship. I made speeches for him back in the sixties. He was like an Italian Jack Kennedy in those days, coming off the streets of Pelham. His death is a tragedy of unbelievable proportion. It's a great loss for the judiciary and for Westchester.

Are there any Ed Michaelians now? Are there any Bill Butchers? Nelson Rockefellers? Fred Powers? I'd have to tell you no. But there are some bright lights, some people of good heart who want to do good things. There is young Andrew Mark Cuomo, for all his reputation as a tough political manager of his father's fortunes. I have seen Andrew fighting with people who were screaming, "Don't build housing in *my* backyard!" I think Andrew is doing a very good job. Another emerging star is Nancy Q. Keefe, the editorial director of the Gannett Suburban newspapers. I disagree with her only about 50 percent of the time.

K.M.: You were on the air with Andrew Cuomo and Nancy Q. Keefe. Someone called and said, "We can't have Westhelp. O'Shaughnessy, you, Keefe, and Cuomo are an *unholy alliance* in Westchester." What do you think when someone says something like that to you?

W.O.: We have "families of the night" in this county, which includes Bronxville, Bedford, Rye, and Larchmont—all these pristine, wonderful bedroom towns. There are four thousand people with no place to go. And these aren't just minorities. These are children and mothers, and this county is spending $50 million a year

on them. The Gannett papers should win a Pulitzer for what they've done. You and Ira Birnbaum and your Cablevision colleagues could not have given it more time on Channel 3, so you're part of the "unholy alliance," if indeed it is unholy and if it is indeed an alliance.

K.M.: The governor's office called me just before we went on the air, and they told me the groundbreaking ceremony for Westhelp. in Mount Vernon tomorrow has been canceled. Will Westhelp work?

w.o.: I think that Andrew Cuomo is of good heart. I don't know how he finances this stuff. He seems to just get people together. I watched Andrew when a big developer in this county, who is probably watching right now, said, "Andrew, forget it. Don't build this housing for the homeless." And Andrew, with unfailing courtesy, asked where we should put the homeless people, and this guy looked him right in the eye and said, "Get those people in trailers or put them in boats on Long Island Sound or on the Hudson. Or we have plenty of parkland. I realize it will be tough putting them in tents during the wintertime." Incredible, but true. Andrew listened to this NIMBY nonsense with great patience. Do you know how many big homes there are here with only one person living in them? Seven-bedroom estates in Rye and Greenwich?

K.M.: There has been talk of some communities "seceding" from other communities over this very issue. I'd love to have a revolution in Westchester. What a story that would be!

w.o.: As his father, the governor, has accurately suggested, people are motivated by fear. Yonkers, for instance, is a town to which people don't move as a steppingstone to somewhere else. They don't aspire to Bedford or Chappaqua or Darien. They move there, and that's where they want to put down their roots and live their lives in peace and contentment. So they're worried about any change in the dynamics of their neighborhood. There's no greater problem before us.

K.M.: On another subject, was the report in the Gannett newspapers true? Did you really wash Nasty Ronny's underwear?

w.o.: Kevin, you're making me work pretty hard. Nasty Ronny was a rock group, since disbanded, and my son Matthew has this heavy metal show on the radio on Saturday nights. He came to me and

asked if the high-class people who listen to society music—Fred Astaire and Mabel Mercer—go to bed early, and I said yes. So at midnight we start wailing. All these groups from all over the country come by his show now. One day a big Greyhound cruiser pulled up. The band had been on the road for weeks. After we fed them, I went down to the laundry room and found Nasty Ronny's laundry, so I just helped out a little bit. We had to use a lot of Tide. And bleach.

K.M.: What do you say to critics of heavy metal music? People who want that stuff off the air because they think it perverts children's minds?

W.O.: I say the same thing I said to Tipper Gore and Susan Baker, Jim Baker's wife, down in Dallas last year. The songwriters and poets and minstrels of today, no matter how scraggly or long-haired, with their ripped tee-shirts, deserve the same respect and protection we gave to the writers of those songs we think are great, like Johnny Burke or Jimmy Van Heusen or Johnny Mercer or Cole Porter. Indeed, Cole Porter and Noel Coward and all the great artists that we so admire—and that I've made a living out of playing—were censored in their day. They were called risqué. Heavy metal is an expression of anger. I suppose if I were a teenager in this day and age I would be angry, but I'd rather have them take that anger out by listening to some noise or tribal rhythm on the radio than by doing violence against a human being.

K.M.: Why did you put former state senator Joe Pisani on the air?

W.O.: Joe Pisani is another child of the streets. He grew up in New Rochelle. He has made some mistakes. I couldn't find a rock to throw at him, so we gave him a radio show. He has a great feel for the people, and they like him.

K.M.: You've hired some of the best reporters in Westchester County over the years. What do you tell them when they come on board? What do you tell them that they owe this community as a journalist?

W.O.: Local radio, even in this electronic, speeded-up day and age, is still the medium closest to the people, so a young reporter or disc jockey or broadcaster or announcer ought to see him- or herself as a fiduciary who uses his or her genius to make it easy for people to get on the radio. And that's the sticking point because a lot of

young people who aspire to our calling just want to be entertainers or performers.

K.M.: How would you describe WVOX?

W.O.: The *Daily News* called WVOX a "glorious hodge-podge . . . much of which even O'Shaughnessy can't get excited about." You've got a lot of colorful types here, and so does WVOX.

K.M.: What makes O'Shaughnessy run?

W.O.: I like what I'm doing. For instance, I like it that our little radio station encouraged Nita Lowey in that congressional race. I must tell you, I never thought she could win.

K.M.: Your editorial endorsed her back in the Democratic primary. What can we expect from her in Congress?

W.O.: I think Nita Lowey brings enthusiasm and a broad and generous heart. She's a great lady, and she's accessible to one and all. I think there's good stuff in this dame.

K.M.: Is New York City tired of Ed Koch?

W.O.: New York City is almost ungovernable. Who would want that job? I had a drink with John Lindsay the other night. Jack Newfield, our colleague at the *Daily News,* did a "Jimmy Cannon" column and said, "Somebody tell John Lindsay he did the best job he could do." Koch is inexhaustible, indefatigable; he is an honest man, and he is a lot brighter than people give him credit for. How do you attract young men and women of quality to your side? Who would want to be taxi commissioner of New York City? Who would want to be the parking meter violations bureau chief of New York?

K.M.: What were the biggest news stories we covered in 1988?

W.O.: Unquestionably, the election of George Herbert Walker Bush and the whole Russian thing. Mikhail Gorbachev is very important to the history of this planet. I pray for him every night.

K.M.: Looking ahead to 1989, what do you see as the big issues?

W.O.: Here in Westchester: the homeless situation; this whole suburban thing about melding the new people who have come in with the townies. Westchester is changing.

K.M.: Are we still the bedroom community? You used the word *townies,* and I know you say that with great pride.

W.O.: I think Bedford, Chappaqua, and Rye are bedroom communities. But the genius of Westchester and its strength and its heart and soul are in *southern* Westchester: New Rochelle and Mount

Vernon. The tragedy is that most people are commuters. Judge Alvin Ruskin, the former mayor of New Rochelle, used to tell me they come home exhausted at night, they pay their taxes, and you don't hear from them unless you want to build a high-rise on Quaker Ridge Road or on Wilmot Road in Scarsdale!

K.M.: What do you think of this idea of putting luxury condominiums on David's Island? You *sold* David's Island one time, didn't you?

W.O.: As a matter of fact, I did. As you know, Alvin Ruskin, the mayor of the day, wouldn't call the Edison Company, and Charles Luce, the chairman, wouldn't call the mayor. So we had dinner at Toots Shor in New York and a few drinks at a place called "21." The next morning in the mayor's office they did the biggest land deal in the history of the county: $10 million. And then the word got out that the Edison Company might want to do some nuclear power business over there, and all *hell* broke lose! After a little negotiation they sold it back for one dollar. Years later, when Charles Luce asked me to meet his daughter, he told her I was a very important man to know, especially in real estate if you ever want to lose money!

What will happen out on David's Island now should not harm the environment. I think we should encourage some development there.

1990

K.M.: Brother Bill, it's good to see you again. This has become a yearly tradition here in Westchester County, your coming in and wrapping up the entire year—news, entertainment, everything— putting it in perspective for us as only you can.

W.O.: I don't know if I have any answers this year. These are uncertain times.

K.M.: Let's talk about a friend of yours who passed away this year: Bill Paley, one of the giants of this industry. I can't think of anyone who has had more influence on the public through the medium of television—not only entertainment but news. What is his legacy going to be? And what kind of guy was Bill Paley?

W.O.: Mr. Paley was really sui generis. I don't think there will ever be anyone like him again, especially in these economic times when most of the great entertainment companies are run by bookkeep-

ers and accountants and guys with business-school degrees. Paley was the quintessential showman. Paley was a marvelous, zestful man with great presence. There's a new book out by Sally Bedell Smith called *In All His Glory: The Life of William Paley.* Nancy and I went down to the service they had for him on Fifth Avenue, and all the elders of our tribe were there: Tom Murphy, Dan Rather, Walter Cronkite.

K.M.: William O'Shaughnessy is also quoted a few times in the book. What about the Japanese coming in and taking over all of the entertainment companies now? They've bought out the Hollywood studios. What effect is that going to have on this country, and are we losing control?

W.O.: I think the Japanese are mostly passive investors. You've got to be a free trade guy. I don't think this new money from abroad will impact negatively on the creative processes. What I'm more concerned about is when guys with little vision can capture a major network. As the publisher Roy Howard used to say, you can't have a great newspaper unless you have one man or woman who has something to say. It's true of a cable station or a radio station or a major network.

K.M.: Ed Murrow said television can be a great instrument of learning or it can be just lights and wires and a box.

W.O.: E. B. White said the same thing: "A radio can be more than just a kitchen appliance." But I don't think you believe that television is just lights and wires and a box. I don't think Ira Birnbaum, who runs this cable system, or Chuck Dolan at Cablevison, believes it. I would urgently suggest that we don't believe it at WVOX or WRTN, and I'm sure there are good, dedicated men and women working for the networks who don't believe it. Ted Turner, for all his swagger and bravado, does some very good things with cable television. And Bob Rosencrans. There are still the good guys, around but their influence is not as strong as it was in the old days when Paley and Frank Stanton and Fred Friendly and Cronkite and Murrow were abroad in the land.

K.M.: What role should we be playing on the local level?

W.O.: Your strength and your genius is that you are very local. That's always been the salvation of the media. The media has vast potential, yet unrealized. If we can wean ourselves from sitcoms and go back to the good, probing stuff.

K.M.: Let's go hopscotching the world for headlines. What are we doing in the Persian Gulf?

W.O.: I am the least knowledgeable on that subject. It's easy to say that Saddam Hussein has to be shut down. But it's easy to say that if you don't have a son among the 300,000 men and women over there right now in the sands of Kuwait. Israel has been very restrained. The sovereignty of Israel is paramount to the interests of this country. But there are also some Arab problems that have to be addressed. The Palestinian problem involves millions of people. How we get beyond the rhetoric and the suspicion and the hatred, I don't know.

K.M.: What is happening to the Bush presidency right now? Since he's gotten involved in this adventure over there, we see him slipping every day in the polls. He's at his lowest rating right now.

W.O.: I don't think the polls mean anything. You and I indulge ourselves in polls, and we rush to broadcast the latest findings. I think George Bush is a decent, good man. He feels betrayed, legitimately so, by Saddam Hussein's move. There is a feeling abroad in the land that maybe no one has the answers on the national scene right now.

K.M.: In past years we've seen people running for president years before the next election comes around. But there is nobody on the scene now who can be said to be actually running for president. What does this mean for 1992?

W.O.: You and I have seen the same stories about the people up in New Hampshire. They want some of us to come up there and spend some money in the motels. They want any candidate whose pulse is strong enough to tread their streets. And they're also waiting out in Iowa. But how can you go up to New Hampshire and present yourself as a presidential candidate when we have this situation in the Persian Gulf? You've got to support the commander-in-chief—which is not to say that the elected representatives ought not to bring their thinking to bear on this subject. George Bush is being strong and tough. I suspect the only things Saddam understands are strength and determination.

K.M.: What happened to the Republican Party in New York State this year?

W.O.: The same thing that is happening to the Republican Party nationally. It used to be the party of anti-communism and low

taxes. Now it stands for nothing. I've had many talks with the chairman about the future. For sixteen years now we've been saying we miss Nelson Rockefeller. We've been looking around for someone who brings not only a bankroll but also a marvelous dynamism and zest and energy to the political process. Will the Republican Party become the party of Ronald Reagan and Newt Gingrich? Or of the more liberal guys?

K.M.: What message were the voters sending Governor Mario Cuomo this year? He came in at 53 percent of the vote, which for anyone else would be a comfortable margin.

W.O.: When John Patrick Barrett, the Republican Party chair, took a poll early this summer, he put a ficticious name in there: Joe McCormick. Joe McCormick got 20 percent of the vote! So that means that going in, 20 percent of the people are going to be *against* the governor. Mario Cuomo, for a third-term governor, did tremendously well, better than Tom Dewey and Franklin Roosevelt in similar situations. He won by over a million votes. He's very proud that he was able to cut over $1 billion out of that budget. That's not easy for a guy who feels as deeply as Mario Cuomo because he'll sit there with those bookkeepers and accountants and the elders of the Assembly and see *names* and *faces* behind those numbers. He can see hurting people. This is not a good time to be governor. It's not a great time to be president of the United States either.

K.M.: What's going to happen when our county executive, Andy O'Rourke, becomes a federal judge, Bill? There's going to be a scramble for power in this county.

W.O.: For once I'm encouraged that there are a lot of attractive candidates lining up for this post. George Pataki has a lot to recommend him. He seems to be the anointed choice of our friend, Tony Colavita. There's Dick Brodsky. He's been taking O'Rourke's pulse now for a couple of years. There are also a lot of dark horses. Steve Tenore would make a brilliant county executive. Sometimes I worry that men and women of ability won't subject themselves to the political process, but in this particular situation I am encouraged. We've disagreed with O'Rourke often, but he will be a tough act to follow because he really is like the *Atlanta Constitution* newspaper: its fame grows as you get *farther away*. He's proba-

bly one of the best county executives in the country. I'm not sure our colleagues in the press realize it.

K.M.: We're going to take a look now at what I think was the biggest event our county has ever seen.

W.O.: That woman on the screen is Nancy Curry O'Shaughnessy. Sometimes God in his wisdom takes angels and puts them among us. She's watching Judge Ruskin pronounce the words at our wedding. I'm the guy shaking next to her.

K.M.: How lucky can you be to find someone like Nancy?

W.O.: Extremely.

K.M.: Where is this county going, Bill?

W.O.: Before we deal with the county, I think we must confront a much larger picture. Far more at issue is where is New York City going? We don't acknowledge our *proximity* to New York City. We don't acknowledge the dynamic, as commerce and industry and cultural life flow back and forth. New York City has big problems. But we've got our own problems in the southern-tier cities, such as the homeless and the poor that O'Rourke and Andrew Cuomo have tried to do something about. And if New York City goes down, we're going down.

K.M.: What about this newspaper strike at *The Daily News*? Is there a hero here? Is there a villain?

W.O.: That is nothing but a tragedy. I can remember John Hay Whitney shutting down the *Herald Tribune*. The death of a newspaper is a bad story. It's a story I don't like to cover. An employer has a right, if people go out and leave their jobs, to keep that institution operating. But how do you do that without destroying the whole collective-bargaining process? There's unquestionably been featherbedding. And some of those *Daily News* drivers make $100,000 for a couple of hours of work. It's a terrible situation.

K.M.: What is your old friend Jimmy Breslin doing?

W.O.: Breslin is keeping his mouth shut these days. He should just write. He is a marvelous writer, our best.

K.M.: Another columnist, Pat Buchanan, is championing a new kind of conservatism: "America First." He says we shouldn't be policing the world. Is that philosophy taking root?

W.O.: You will always have the Pat Buchanans abroad in the land. He has a constituency. I don't agree with him, but he's very articulate.

K.M.: Governor Cuomo likes to be an underdog. Are we going to see him finally run for president in 1992?

W.O.: I take his public pronouncements at face value: to wit, "I have made no plans and I don't plan to make any plans." I have gently suggested to him that there may be forces beyond him. I think Cuomo has gone beyond even being governor, and he doesn't know it. He's the only one who can lift this country up. We have to do something about the disenchantment and the sense of hopelessness of the minorities in the inner cities. I know of no one else who can speak to their sense of frustration and hopelessness.

K.M.: Will his act play in Peoria?

W.O.: The only thing ultimately that recommends Mario Cuomo is the idea of Family. It sounds square—feeling one another's pain, sharing one another's burdens—but that's what democracy and a nation ought to be all about. Nobody is talking that way today.

K.M.: Is Nancy Q. Keefe right when she says he is going to have to lose his soul if he runs for the presidency?

W.O.: Nancy knows Mario Cuomo at the deepest level. We love the guy, and we don't want to see him out posturing and pandering for votes or selling himself like soap out in the cornfields of Iowa. But Mario Cuomo will never do any of that. He may lose, but you'll never see him sell his soul.

K.M.: I remember Jimmy Carter talking about a malaise years ago. Is that where we are now, or are you hopeful as we enter into this new decade of the nineties?

W.O.: *Newsweek* just had a cover story about young people returning to the churches and getting back to basics and that sense of family. And I think that every once and a while we need to remind ourselves, as Cuomo himself says, where we came from and who we are.

1992

W.O.: What am I doing here? I'm supposed to be over there, on the other side of the microphone.

K.M.: I've talked to other reporters and broadcast people, and whenever you turn the microphones on them, they get nervous and ask what you're going to ask them and what they're going to talk about. It's a different feeling . . .

w.o.: I don't like it over here, Kevin. Why don't we switch places? I like to ask the questions. It's easier. And *you* give the answers. You do that so well.

k.m.: You started your TV show at TCI Cable this year. What has been the reaction?

w.o.: It's a little tougher than radio. Over at WVOX and WRTN you just drag them in, and you can have blue jeans and be a little puffy from the haze of an evening the night before, but here you have to show up looking pretty bright and like you know something.

k.m.: This is the ninth show we've done ending the year here in Westchester. You're looking better, and I'm looking older.

w.o.: No, Kevin, you look terrific. They tape this *before noon*. It's a good time to do two Irishmen—before lunch!

k.m.: What happened to President George Bush?

w.o.: His one problem was he could not explain things. He did not run a good campaign. He just couldn't believe the country would turn him out. *I* couldn't believe they'd do it. I just have yet to tune into Bill Clinton and Hillary Clinton. It was a peculiar election for me to cover because I would've loved to have seen Mario Cuomo in the race. I think he's the one guy who can lift this country out of its restlessness and sense of hopelessness.

k.m.: Cuomo has said, when asked about future presidential campaigns, "'Dem days are over now." Do you feel like you've been left at the altar one too many times? You were a supporter of Nelson Rockefeller, who came so close, and then Mario Cuomo.

w.o.: When it was clear that Nelson Rockefeller wasn't going to be president, Malcolm Wilson, our Westchester neighbor and the fiftieth governor of New York, said, "Although we did not prevail, we know we were right to try." I'm only one of hundreds of millions of people, and so are you. We just happen to have a wonderful bully pulpit here on Channel 3 and on WVOX and WRTN, where we can give our opinions a little more easily than the man in the street. I'm proud of the people we've backed.

k.m.: What about Ross Perot? This was a crazy election year and he made it crazier. Look at the votes he got.

w.o.: Perot ultimately hurt the president. He's a very colorful, aggressive, beguiling guy, but for president of the United States . . . ?

K.M.: You mentioned that we're sometimes called "political pundits."

W.O.: We've been called a few other names.

K.M.: We certainly have, but this is a family show, so we can't mention those. What should our role be? Should Pat Buchanan be running for president? Should John McLaughlin, of *The McLaughlin Group,* be showing people shouting at each other on Sunday mornings.

W.O.: Well, the Lou Boccardis and the Larry Beaupres of Gannett could give you a much more intelligent and scholarly answer. I think our only goal is to illuminate and sometimes to explain. We offer snapshots, we offer words, but when we try to explain, that's when we get into a problem.

K.M.: Let's get into Westchester. Andy O'Rourke is making noises about running for another term.

W.O.: I like Andy O'Rourke. He's intelligent. He's attractive. He's certainly a cut above the usual man or woman you see as county executive across this nation. But he's a hard guy to reach out and grab hold of.

K.M.: Your beloved home city, the Queen City on the Sound, New Rochelle, has taken some hard shots in recent years. You are probably the biggest booster of New Rochelle. The Chamber of Commerce named you "Man of the Year" last year. You have your "Good News Days," where people call in and just say good things about New Rochelle. Why do you do that?

W.O.: Credit for the "Good News Day" should properly go to Judy Fremont, our very gifted and intelligent general manager. New Rochelle has been endowed by our Creator with nine miles of natural shoreline. It's a perfect place. It's got very attractive people. It's a great mosaic, a melting pot. But it's in trouble. One problem we've had is that developers, people who come in with money, don't know who to deal with. Who's the *one* guy? In White Plains it was the late Edwin Gilbert Michaelian, mayor and later county executive. In Eastchester, Tony Colavita, "Mr. Westchester." I'm not pinning this all on the city manager form of government, but developers like to deal with a mayor. They see the city manager as a functionary. But now we have a good mayor in Tim Idoni. He's young. He's got ideas. I'm also very taken by the city manager. He's very honest and he admits that neither he, nor the

mayor, have the contacts to bring in big, multimillion-dollar development. So he's now going out knocking on doors. A lot of men and women who live in New Rochelle have big jobs in New York City and enormous power, and they don't do a damn thing for the town. We're going to try and flush some of them out.

K.M.: A couple of years ago you got into a national debate with Tipper Gore, wife of the vice president-elect. It was about freedom to say what you want in music. She wanted to put stickers on albums to indicate if they had lyrics alluding to suicide and to drug use, and you stuck up for the First Amendment. You took a lot of heat on that. The issue has surfaced again over songs by rappers about offing the cops. Do you still hold the same beliefs?

W.O.: The heavy metal stuff seems simple now. It's amazing to me how many of our colleagues are ready to throw that First Amendment over the side for a little government intrusion into what we do. I don't listen to Howard Stern, but I have made a career out of defending him. I served as a director of the National Association of Broadcasters for almost a decade, and I had to head off motions from the floor of our national trade association to denounce and censure Howard Stern. It seems to me that the ultimate protection is that marvelous little dial. If somebody doesn't like what Stern is doing, they can zap him. I don't like the examples we have to use now. I don't like the lyrics, but I'm not sure I want the government poking around in this thing. The government has no place in your newsroom. The government has no place in this studio. This is a hard sell, but imagine some rapper as the Cole Porter of today. They're not as graceful or as eloquent, and they have no sweetness, as Cuomo would say, but I think they deserve the same protections that we've given to creative people in this country for so many generations.

K.M.: We've seen a rise in hatred. Racial incidents in Crown Heights after the Rodney King verdict, young people out on the streets of New Rochelle, throwing rocks. What can we do to bring our people together?

W.O.: We have to have a really serious discussion in this country about whether we are or aren't our "brother's keeper." You can pass all the civil rights legislation you want. You can make all the quotas. But the problem is that hatred is a hard thing to reach out and grab hold of. We see it in Germany, Spain, France too. It goes

beyond borders. It goes beyond economics. It goes beyond slogans. There will always be the haters in any community. But there will also be those who love. It's been said in this very studio and at this very microphone that if New York City goes down, we go down. Some people think they can inure themselves from Crown Heights riots or from the people throwing bricks through the wealthy suburban woman's Mercedes and grabbing her pocketbook at the Willis Avenue Bridge. But we can't. That simmering hatred and hopelessness are here. All of a sudden the pristine suburbs are in peril. So now we'd better talk about these things. We better stop this NIMBY crap, if you'll forgive me. And the tensions are being exacerbated, to use Al D'Amato's word, by politicians who are using the issues to their own ends.

K.M.: Where does our backyard end? Does it end in New Rochelle? Does it end in New York City? Does it end in Bosnia-Herzegovina? Does it end in Somalia? Should we be the world's police force?

W.O.: A lot of people I respect will tell you, with conviction, that we ought to take care of our own first. I think our responsibility ends in the farthest corner of the global village. I think it's right and proper that we're in Somalia. We're really doing the Lord's work in delivering food. I don't think we can turn away. In Kuwait, we were saving our oil and saving the Kuwaitis. Whether it becomes a quagmire, I don't know. But I think we've got to try.

K.M.: I'm always happy to get an envelope from WVOX and WRTN because I know inside is an "editorial of the air" from William O'Shaughnessy. I've heard them on the air and they don't lose any of their impact when you're reading them in print. You probably reach more people sending out your editorials than over the air. You send them to the movers and shakers around New York State and around the country. What inspires you?

W.O.: I'm not a writer. I'd rather give a pint of blood than sit down and try to string two words together. I should do more of them, but I'm lazy.

K.M.: Mario Cuomo says when you do write and you're on your mark, you are the best there is.

W.O.: It's a good thing Cuomo is up in Albany because he's better on the radio and television than any of us.

K.M.: Are you an optimist, Bill?

W.O.: You have to be an optimist. You can't look at Christmas and

the calendars and the clocks and the seasons without being an optimist.

K.M.: I hear so many comments about Bill O'Shaughnessy, probably more comments than about any figure in Westchester County. How would you like to be remembered?

W.O.: Are you talking about the tombstone?

K.M.: Yes.

W.O.: I always ask that question in interviews, Kevin. "He struggled and he churned. He kept those two little radio stations going. He's got some good friends like Kevin McCabe, and he's got a great wife." That's all there is.

K.M.: I think the day O'Shaughnessy was born God said to His guardian angel, "Make sure he stirs things up down there." We're all better for it in Westchester, and the nation, indeed, is a better place for it too.

PressTime with Carll Tucker

Carll Tucker is a noted country-squire publisher and a former editor of Saturday Review. *He also dabbles in cable television and invited me to come on his program.*

C. TUCKER: Welcome to *PressTime*. My guest today is a local legend, perhaps more noted for his mellifluous radio voice than his luxuriant dashing white mane. Mario Cuomo calls him "The Squire of Westchester." Hundreds of New Yorkers, from the late Nelson Rockefeller to John Cardinal O'Connor to almost every political heavyweight you can name have called him "Friend"! William O'Shaughnessy is president and editorial director of WVOX and hosts his own cable television show, *Interview with William O'Shaughnessy*. His newly released collection of editorials, *Airwaves*, chronicles his long and colorful career in radio, politics, and Westchester's community life.

W. O'SHAUGHNESSY: You and I are related, Carll. My mother was a Tucker. Not the country squire *Bedford* Tuckers. But I grew up in Mount Kisco. And I used to caddy at the country club for your mother and father.

C.T.: Then you must have gotten a lot of balls because they shagged a lot.

W.O.: They were good tippers, but I got more from them than tips, because they were lovely people. I must tell you I'm a great fan of yours. I subscribe to the *Patent Trader*. I love your "Looseleaves" column. It's gorgeous stuff. Before you can write it, you have to *think* it—and you're a great thinker.

C.T.: Take us back to the beginning. How did Bill O'Shaughnessy get into the radio business and become such a colorful and well-known public figure?

W.O.: I started right here in your home heath of Mount Kisco. I was

the first advertising salesman for Martin Stone at WVIP Radio, which went airborne on October 27, 1957. I used to do the storm closings from "Mobile Unit #6" until I scared the hell out of them one day and said there was a school bus slipping and sliding. They got a thousand phone calls. And then I went down to WNEW. There are pieces in *Airwaves,* my previous book, about William B. Williams, who did the *Make Believe Ballroom.* He walked with Dr. Martin Luther King, Jr.,at Selma. John Van Buren Sullivan ran WNEW, which was accused by *Variety* of being "the best sound coming out of America." This was some twenty-five years ago. Then I came back to the *Herald Tribune* Network. WVIP was part of it, and WVOX was the southern Westchester branch of it. I acquired the remnants of the *Tribune* Network from Ambassador John Hay Whitney and Walter Nelson Thayer.

C.T.: Is there any local radio left? There used to be independents like you. Now it seems to be nothing but conglomerates: faceless businesspeople.

W.O.: I have the privilege of representing all of the radio stations in New York State and New Jersey in Washington as their federal representative, so I have to be somewhat discreet . . .

C.T.: I like uncareful guests, Bill.

W.O.: If pressed, I have to admit most stations have fallen to absentee owners and speculators. I think a radio station, if run right, can do more than convey information about products or services. You can be a reflection of the community. Most broadcasters come to work to preside over a jukebox. They just push the buttons. And everything is canned these days. You buy a program and you pull it off a satellite and sit back. WVOX is south of I-287, where the people are, where the energy is. Its turf is not the rarified air of northern Westchester. WVOX is a townie, local-yokel, rock 'em-sock 'em radio station. We also have an FM station. A lot of people from up here seem to like it at 93.5, Return Radio. We call it "Music for the folks who live on the hill": the "Country Club Sound."

C.T.: You were very close to Nelson Rockefeller *and* Mario Cuomo. How did you get involved with politics?

W.O.: I think politics is kith and kin to communications and journalism. How could you not be taken with Nelson Aldrich Rockefeller? He was Westchester's most dazzling son for years: vice presi-

dent, governor for three terms. Rockefeller was everywhere apparent in this county for years. We were sort of his self-styled hometown radio station. We'd meet him as governor at the county airport, and he'd shake off the national press and come right for our microphone. And he'd call up and ask me to go to Cleveland on the spur of the moment. So we'd ride to Cleveland with my tape recorder. One day we went down to Mobile, Alabama. He charmed Cornelia Wallace, George Wallace's wife. He was down there looking for votes. He wanted to be president of the United States.

c.t.: What kind of guy was Nelson Rockefeller?

w.o.: I think he was zestful and quite fabulous, to use his own favorite word. With all his money, he could have been a glorious bum. He was a rich man's son and a richer man's grandson. But Nelson was of good heart and good intentions. He stood bravely against the reactionaries and the yahoos of my Republican Party. He'd light up a room when he walked into it with that "Hello . . . "

c.t.: . . . "How ya' doin', fellas?"

w.o.: You've *got* it! But he could never give the great speech. At the convention he just couldn't do those Kennedy-esque phrases. Yet I remember one day at the Miami convention in 1968 he went up with Walter Cronkite in the skybooth, and Cronkite said, "Our guest is Nelson Aldrich Rockefeller, the governor of New York." Nelson said, "Just a minute, Mr. Cronkite. I'd like to tell you how much I admire *you* and the way you conduct yourself, sir!" He bagged him right there on national television! That was Nelson. I remember so many things about him. We were sitting in the drodsome, rundown, slightly thread-bare Sheraton in Cleveland one night, and the right-to-life pickets were chanting below. When we walked into the presidential suite and took off our jackets, they provided a bottle of Dubonet, a quart of milk, and a thousand Oreo cookies grandly wrapped in cellophane. I could have used a Canadian Club or something, but Nelson was like a kid eating Oreo cookies.

c.t.: Rockefeller goes out. You're friendly with Malcolm Wilson and then Mario Cuomo. You're a Republican, and the head of Republicans for Cuomo, in fact.

w.o.: We won three times, Carll.

After Nelson died, you could've floated Albany down the Hud-

son and I wouldn't have cared. Hugh Carey was a great governor. He kept us away from the death penalty, which demeans us, but I didn't really focus that much on Hughie. When Mario Cuomo walked into the radio station one day, I kept him waiting in the lobby. I thought he was the district attorney of Queens! I had read what Ken Auletta, Peter Maas, Pete Hamill, and Jimmy Breslin had written in *The Village Voice* about this Italian from Queens who spoke in elegant paragraphs. When I met him, I knew right away there was something very special about him.

C.T.: You must have taken some heat from your Republican friends.

W.O.: I'm at a certain age, sixty-one, when everything reminds me of something. Andy Albanese ran this glorious pizza restaurant. The food was always horrible, but Andy was there—a great personality, later chair of the Westchester County Board of Legislators. So I went in there one day and picked up a pizza and a check for $1,000 for Governor Cuomo's campaign. All hell broke loose. I once lost the McDonald's account because the owner of a lot of McDonald's locations said he wouldn't advertise with me because it would help Mario Cuomo.

C.T.: The consistency between being pro-Cuomo and pro-Rockefeller—how did you straighten that out?

W.O.: They were both progressives who did unpopular things and were both of good heart. With Mario Cuomo, you either get him or you don't. You can explain Bill Clinton to me until midnight and I won't get him. Same with Cuomo. Only I hear *his* music. I think he's a great moral thinker. During my time on this planet I have not seen anyone with his intelligence and goodness, a guy who tries very hard every day to do the Lord's work.

C.T.: What do you two talk about?

W.O.: I imagine the same things you talk to Governor George Pataki about: our sons and daughters and our souls and our books and writing. He has a lot of guys to talk with about issues and policies. He makes me think. Some guys would throw their mother-in-law over the side for the presidency. He wouldn't. He's always trying to pull himself back. The question has been asked ten thousand times: why didn't he run?

C.T.: Why didn't he run?

W.O.: I never saw the precise *moment*. And you won't believe you're hearing this from my lips, but I thought George Bush would've

beaten Mario Cuomo. Bill Clinton is here, there, all over. But Cuomo is right in one place.

c.t.: A fixed target. Fixed targets are easier to hit.

Who were some other major figures who influenced you?

w.o.: I learned a lot at the old WNEW, and William B. Williams was a lovely man and so nice to me, a young Irishman from Mount Kisco. We don't have anybody like Billy on the radio today. I used to have lunch with him at the Stage Delicatessen and hang around with him at Toots Shor's place. He taught me a lot. He taught me how to drink.

c.t.: Taught an Irishman how to drink?

w.o.: Don't fool with me, Carll Tucker, WASP that you are! And Sirio Maccioni of Le Cirque. I used to sit with him late at night and just write down his wonderful thoughts. The editors of Fordham were very tough with me. My editor, Anthony Chiffolo: we were toe-to-toe and he said, "I edited a *pope*." [He has edited books about Pope John XXIII and Pope John Paul II.]

c.t.: You've lived your whole life in Westchester. If somebody came from a different planet and asked you to tell them about this place where you live and what it's been like over the past fifty years, what would you tell them?

w.o.: It's a place for the "townies": people who have roots in the community. It's not a pejorative term for me. It's a mark of great respect. A lot of people take and put nothing back. It used to be if you wanted to be a lawyer you had to join a party, either the Republican or the Democratic. You had to participate. But now you don't. The Rotary Clubs used to have 150 people. Now they have thirty guys getting away from their wives. There were so many vivid, marvelous figures, it seems, back in the sixties and the seventies. I see a lot of yuppies running around this country, but I don't see them building up their communities. They weren't born and bred to it. It's like a shortstop who never learned how to go to his left. Some of these people have made a lot of money. They know how to play the numbers on Wall Street. But they don't know what their responsibilities are. Cuomo has a wonderful Jewish phrase: "*Tikun olam*, repair the universe"—build up the community. And then the Christians stole it whole from the Jews: "Love your neighbor as you love yourself."

c.t.: So community spirit is not as strong as it was twenty or thirty years ago.

w.o.: Some people just use Westchester as a bedroom.

c.t.: And with easier communication, it's a bedroom not only for New York but for the whole world. You can take your limo to the airport and get on your private jet and go anywhere. You don't have that sense of affiliation with the guys at the pizza parlor. Is it a better county or a worse county than thirty years ago?

w.o.: We've done some good things, but we still have homeless people coming every night to shelters all over this county. We've got to learn that what happens in Mount Vernon and Yonkers is ultimately going to impact Bedford and Pound Ridge and North Salem.

c.t.: The great surprise for people that live in the northern part of the county is that the southern part of the county actually exists. You've accomplished a tremendous amount, this Irish boy from Mount Kisco. If all your dreams came true for the next ten years, what would you hope to get done?

w.o.: I just want to keep our radio stations independent.

c.t.: You're a dinosaur.

w.o.: When somebody asked me how long it took to write my first book, I said it was easy, I knocked it off in just thirty years! I think you should write a book every thirty years, so I'll be ninety-two for the second volume!

June, 1997

Afterwords

Future Stars

Michael Powell
The new chairman of the FCC is not the only member of his family called to the service of our country by President George W. Bush. Like his father, our new secretary of state, Michael is thoughtful and intelligent. We predict a great future for the public servant who believes in what Jacob Javits once called "the genius of the free enterprise system."

John Eggerton
The gifted editorial writer for *Broadcasting and Cable* magazine is a keen observer of the Washington scene. He'll make sure Michael Powell does the right thing. Especially on First Amendment matters.

Mario, Mauro, and Marco Maccioni
The three attractive Maccioni sons have their father's dazzle and their mother's resourcefulness. They'll make their mark in the hospitality business.

Amy Paulin
Just elected to the New York State Assembly from Scarsdale, Amy Paulin has finally embarked on the political career that has been predicted for her by her many admirers for years.

James Generoso
I have the privilege of serving on the board of the Fund for Modern Courts. There is no better-run or more compassionate courtroom than New Rochelle's hall of justice, thanks to the dedication and hard work of the clerk of the court, Jim Generoso.

John Verni

John Verni is one of those rare individuals who submits to the rigors of public life. He's run our local Habitat for Humanity, and when he's not devoting his energies to all sorts of community and state issues, Verni is a lawyer in Malcolm Wilson's old law firm in White Plains. The Republicans have big plans for this gifted and graceful young man.

Ralph A. Martinelli

This scion of the Martinelli publishing empire (his father, Angelo, was mayor of Yonkers and his uncle, Ralph R. Martinelli, is the fiery publisher of eight weekly newspapers) has just done a major make-over on *Spotlight* magazine.

Mark Racicot

Although President George W. Bush didn't appoint Governor Mark Racicot as attorney general, this thoughtful, focused westerner, who riveted the public with his intelligence during the Florida chad fiasco, is destined for stardom in the political arena.

Robert Giuffra, Jr.

This former law clerk to Chief Justice William Rhenquist grew up in Bronxville and carries himself like a young prince in judicial circles. Robert Giuffra has recently advocated for substantial pay raises for federal judges. Don't be surprised if a future president nominates him to the Supreme Court.

James Maisano

This citizen-activist, who became a Westchester County legislator, is a down-home politician who plays the Marine anthem at the beginning of his weekly visit with his constituents on our local radio station. Maisano has tremendous energy and a wide following.

Glaring Omissions

I've tried to say something nice about so many characters in this book, and it's been a privilege to celebrate their genius. I do, however, acknowledge a few glaring omissions. But I don't take full responsibility for them, and thus I can only hope that someday the following remarkable individuals will somehow surprise me with a splendid gesture that will convince me I've been wrong about them all along. It won't be the first time I've overlooked real quality.

Dick Armey
Jon Ballin
John Patrick Barrett
Glenn Bernbaum
David Boies
Barbara Boxer
Mario Bruni
Hillary Rodham Clinton
William Jefferson Clinton
Catherine Crier
Tom DeLay
Alfred Benedict DelBello
Tom Doherty
John Dugan
Dick Ferguson
Clare Palermo Flower
Dale Gatz
Adam Handler
Arnold Heaps
Henry at Shun Lee West
David Hochberg

Dewey Isdale
Jeff at "21"
James Jeffords
Dorothy Ann Kelly
Jim Killoran
Ira Kleinman
Bill Lacy
Patrick Leahy
Cheryl Lewi
Sam Litzinger
Vince McMahon
Gus Nathan
Suzi Oppenheimer
Corey Platzner
William Powers
John Roberts
Mauro Romita
Polly Rothstein
Mike Sakala
Sam Scatterday
Chuck Schumer

Donna Shalala
Al Sharpton
Chuck Sherman
Liz Smith
Martha Stewart
Zane Tankel
Geoff Thompson

Ann Tucker
Guy Valella
The Valenti Boys
Harold Vogt
John Zanzarella
Joe Zwilling

And anyone who uses the word *input* (or worse, *inputs*) or those marvelous contemporary business-speak phrases like "Whatever it takes!" "Gettin' it done!" and "Make it happen!"

I Should Have Said More . . .

As I review this collection, it occurs to me that I might have included something about several other rich and vivid souls I've encountered over the years. The following remarkable individuals really deserve their own essay.

Jim Lowe is the last of the great old WNEW disc jockeys. The voices of William B. Williams, Klavan and Finch, Jack Lazare, Ted Brown, Al Collins, Lonny Starr, and Pete Meyers are long silent. But Lowe is still making beautiful music on his own coast-to-coast mini-network. *The Jim Lowe Show* originates from Bob Batscha's Museum of Television and Radio in Manhattan. This classy composer and entertainer lives year-round in East Hampton. He is a dear man who will still tell you he hails from "Springfield, Missouri, the 'Paris' of the Ozarks!" And he calls his friends "You old spotted dog, you."

Charles Kafferman and **James O'Shea** are proprietors of the famed West Street Grill in Litchfield, Connecticut. They are quite the preeminent restaurateurs in the Nutmeg State. O'Shea, with his restless, relentless brilliance, and Kafferman, with his endearing, beguiling persona, are wonderful hosts. Their marvelous little bistro in the Litchfield hills is home to writers, actors, and artists. And you'll even see Ed Koch there of an evening.

Sir Richard Rodney Bennett, the scholarly award-winning English composer of "The Theme from *Murder on the Orient Express*" has a "side" career as a cabaret performer. Whether accompanying other singers on the piano or whispering his own achingly beautiful song "I Never Went Away From You" into the Café Carlyle's microphone, Richard is class personified.

Murray Grand *looks* like Ed Koch. The composer of "Guess Who I Saw Today?" "I'm Too Old to Die Young," and countless Broadway favorites now lives in Florida. But he still plays selections from his tasteful and witty repertoire on weekends in the Fort Lauderdale

area. I have fond memories of many nights listening to Murray Grand perform at piano bars all over Manhattan before he went south to play and sing.

Don West was Frank Stanton's executive assistant at CBS during the network's glory days. And for the last several decades Don has been a powerful and respected Washington presence as editor of *Broadcasting and Cable* magazine. He is possessed of a great intellect and a deep and abiding belief that the founders of this country would have extended First Amendment protections to the electronic media.

Bobby Short is the quintessential New Yorker. From his perch behind the grand piano at the Café Carlyle, this darling of café society brings us back to a more glamorous and civilized era with his tasteful renditions of Cole Porter's classy songs. Bobby Short is one of New York's great treasures, and I hope he goes on forever.

Jimmy Cannon was the greatest sportswriter of all time. Period. I know some sing the praises of Red Smith, Grantland Rice, and others, but Cannon, who spawned a whole generation of strong, muscular writers like Jimmy Breslin and Pete Hamill, was the mother lode. Cannon has been gone for several decades, but *The New York Post* continues to mine his passionate gems from their archives, and I'm so glad they print them every Sunday.

Libby Pataki is a great first lady of New York. She is a gracious and beautiful woman who is totally devoted to her husband and her family.

Diane Straus Tucker and **Carll Tucker** are one of Westchester's most attractive couples, and once again, I think it's in the genes. Diane's mother was the late Ellen Sulzberger Straus, the spectacular New York woman who founded "Call For Action," and her father is Ambassador R. Peter Straus, who ran radio station WMCA and headed Voice of America. Carll was editor of *Saturday Review* and, until very recently, presided over his family's publishing ventures. His father and mother were country squire publishers of considerable note. Diane is now publisher of Arthur Carter's *Fairfield County Times* monthly, and Carll continues his exquisite writing via his weekly "Looseleaves" column in *The Patent Trader* newspaper. He is also working on a novel.

Gordon Hastings and **Ed McLaughlin** had distinguished broadcasting careers. McLaughlin was president of the ABC Radio Net-

work, Paul Harvey's mentor, and the discoverer of Rush Limbaugh! And Hastings was a radio station group owner and president of a national rep firm. But they're doing some of their best work these days, running the Broadcasters Foundation of America. These two statesmen of our profession took over a fading organization known as Broadcast Pioneers and in its place created a first-class and well-endowed foundation that has raised a million dollars for those forgotten behind-the-scenes men and women of our tribe who may have fallen on hard times. I am privileged to serve on the board of this national charity, which has some really high-powered individuals. But McLaughlin and Hastings deserve all the credit for the remarkable growth of this worthy endeavor.

Daryl Sherman is a saloon singer of considerable talent. But don't get me wrong: the *venue* where she sings and plays is the Waldorf-Astoria. And the *piano* at which she presides each evening was Cole Porter's. This classy cabaret artist knows all the great songs, and unlike so many others in her field, Daryl really is an *entertainer* and not just a *performer.*

Edward "Ned" Gerrity is another Westchester treasure. In days gone by he helped the legendary Harold Geneen run ITT, the first American international conglomerate. (Even President Lyndon Johnson used to call public affairs chief Gerrity to "check up" on the CIA.) Gerrity is a delightfully witty man who divides his time between Palm Beach and Westchester. And he still dispatches his irreverent missives to editorial directors and journalists.

Bruce Snyder is the Keeper of the Flame at the invincible "21" Club. This attractive and stylish fellow is the ranking expert on "21's" history and lineage. He is the quintessential New York gentleman and as much of an institution these days as is the great saloon over which he presides most nights of the week.

New York Supreme Court Justice **Samuel George Fredman** is a Westchester legend who has been successful in many different fields during a long and colorful career. Once the preeminent matrimonial lawyer in these parts (I used to call him a nice man in a murky profession!), Sam Fredman was appointed to the New York Supreme Court by Governor Mario Cuomo and served with great distinction. He remains a towering figure in judicial and legal circles and in Jewish affairs.

Jack Valenti, the chairman and CEO of the Motion Picture Asso-

ciation, who served as Lyndon Johnson's chief of staff in the White House, is now one of the most powerful lobbyists in Washington. What recommends him to me is his passionate advocacy of the First Amendment. Earlier this year Valenti jogged the consciences of my fellow broadcasters with a soaring speech in Las Vegas. He spoke eloquently of "those forty-five simple words bound together in spare, unadorned prose which are indispensable to the nation's security. Of all the clauses in the Constitution, the First Amendment is the one that guarantees everything else in the Constitution, the greatest document ever struck off by the hand and brain of man. I have but one objective—to fortify the right of artists to create what they choose without fear of government intervention of any kind, at any level, for any reason. I stand with all other Americans who believe it is their solemn duty to preserve, protect, and defend those forty-five simple words and to lay claim to future generations that the First Amendment is the rostrum from which springs the ornaments and essentials of this free and loving land." Powerful stuff, indeed. Why must we broadcasters always leave it to others to speak for us?

Louis Freeh was director of the FBI during a turbulent time in America. The former federal judge who was once a Westchester resident actually started as a field agent for the Bureau. His partners were Joe Spinelli, who later became Inspector General of New York State, and John Pritchard, who ran the New York City Transit Police and the Mount Vernon Police Department. All three crime-fighters are tremendously respected in law-enforcement circles. When he retired from the FBI, Freeh said he wanted to better provide for his growing family. But as Judge Louis Freeh is one of the most extraordinary and decent individuals ever called to the service of our country, the hope here is that this great American will one day return to public life. We'd back him for *anything* to which he might aspire.

Henry Berman is now the preeminent matrimonial lawyer in Westchester. Once a protégé of the legendary New York State Supreme Court Judge Samuel George Fredman, he is widely respected for his judgment, patience, and discretion. There are a lot of contentious "bombers" in the field. But Henry Berman is just as happy when his clients reconcile their marital issues and live happily ever after. He is a nice man in a murky profession.

Emily and **Eugene Grant** are greatly heralded for their philanthropy and civic leadership in Westchester. In any community

there are those who take and put nothing back. But occasionally there appears in the midst of all our secular selfishness an enlightened couple like the Grants. Their quiet, consistent generosity is the stuff of legend in New York State.

Dick Crabtree is a big, tall, handsome guy who, with his wife, Mimi, and son, John, took over an old, faded historic Westchester inn—the Kittle House in Chappaqua—and made it one of the best B&Bs on the East Coast with a four-star restaurant. Crabtree's place sits cheek-by-jowl next to the world headquarters of Reader's Digest and up the road a piece from Hillary and Bill Clinton's abode. In fact, President Clinton took his first meal after leaving office at the Kittle House. A brigadier in the National Guard, General Crabtree, now semiretired to South Carolina, still flies his own plane up and down the eastern seaboard. Dick Crabtree is one of the most generous of souls, in any calling.

We can be grateful that women like **Mary Jane Reddington** and **Ruby Saunders** will submit to the rigors of an election just for the "privilege" of serving on a school board. At a time when it is very difficult to persuade men and women of quality to serve on local school boards, these extraordinary Westchester educators have committed themselves to a difficult arena. Their great intelligence will serve us well as our national debate sharpens over the question of providing vouchers while maintaining a strong public educational system.

Frank Bowling is a gifted and graceful hotelier who once ran the mighty Carlyle in New York City. But for more than a decade, Bowling has presided over the lovely Hotel Bel-Air out on the West Coast. This serene oasis of charm and luxe on Stone Canyon Road is in the tony Bel-Air section of Los Angeles, which is home to movie moguls and President Ronald Reagan. You feel like an expresident when you cross over the entrance footbridge guarded by the Bel-Air's famous white swans, to be met by impeccable Maestro Bowling, who likes to escort every guest to their suite, all the while blowing air kisses to his "swans" (the West Coast version of the "ladies who lunch," which usually includes Nancy Reagan). The Bel-Air is a perfect setting for the genius of Frank Bowling, who moves like Bobby Short or Fred Astaire. He presides over America's greatest hotel.

Any recitation of the great masters of hospitality—those who pro-

vide temporary haven and shelter from a busy, speeded-up, high-tech world spinning out of control—has to include **Dottore Natale Rusconi**, in whose care and keeping resides the Hotel Cipriani in Venice. Other standouts in this field are **Paul Thompson** of Lyford Cay in the Bahamas, **Marcel Levy** of the Eden in Rome, **Maria Razumich** of the New York Palace and **Richard Cotter** of the St. Regis in New York City, **Elizabeth Blau,** a rising star at the Bellaggio in Las Vegas, **Adriana** and **Bob Mnuchin** of the Mayflower Inn in Washington Depot, Connecticut, and **Francis Longueve** of the Hôtel de Paris in Monaco.

In Paris itself these days some love the Hôtel de Crillon. Others savor the reputation and grandeur of the majestic Ritz Paris. And the lovely Plaza Athénée has many admirers. But in this glorious city Nancy and I have found no more perfect haven than **Pierre Ferchaud**'s incomparable Hôtel Le Bristol. Director General Ferchaud is truly one of the great statesmen of his profession, and Le Bristol is a serene reflection of his exquisite taste and generosity of spirit.

Having acknowledged these other stars of the hotel and hospitality business, if we had to pick just *one* absolutely perfect venue, it would have to be **Natale Rusconi**'s Hotel Cipriani. This unique perch on the island of Guidecca across the Grand Canal from bustling and beguiling Venice is almost like a state of mind. Lovingly restored and maintained by London billionaire James Sherwood and Dottore Franco Delle Piane, who runs Mr. Sherwood's Orient-Express collection of hotels in Europe, the Cipriani has been identified with Rusconi almost forever. Today, the Hotel Cipriani is the loveliest Lorelei in the Venetian lagoon. And one of the great hotels of the world. A lot of its stately and irresistible charm proceeds from the proud, cultured aristocrat who runs it with such style and grace.

Susannah McCorkle, a cabaret singer possessed of exquisite taste, left us just as I was putting the final touches to this book. All the New York papers carried the sad news when she took her own life that dark, desperate night in May. A linguist and translator who spoke five languages, Susannah developed a considerable following all over the world for her sophisticated, smoky interpretations of classic American popular songs. Included in her stylish repertoire were thousands of achingly beautiful love songs from the likes of Cole Porter and Antonio Carlos Jobim. When she walked out into a spotlight, Susannah brought with her a fragile vulnerability, which

had a mesmerizing effect on the habitués of the posh venues in which she displayed her classy songs. Thanks for the memories, Susannah. And all the songs. As I observed in *The New York Times,* it was a privilege to amplify her sweet voice. The melody lingers on in her seventeen almost flawless CDs.

President George W. Bush has taken more than a few shots for his lack of scholarship and erudition—many of them mean-spirited—from my colleagues in the press. However, I was struck by this beautiful passage in the president's inaugural address: "John Page, a signer of the Declaration of Independence, in a letter to Thomas Jefferson, observed, 'The race is not to the swift, nor the battle to the strong. Do you not think an angel rides in the whirlwind . . . and directs this storm?' " And later in his address, with his father and mother looking on, President Bush assured our nation, "An angel still rides in this whirlwind and directs this storm." The former president and Barbara Bush weren't the only proud Americans that January day. I think their son George W. is well begun. I like the guy very much. And practically every one I know is rooting for him.

And so, once again I write "Finis" to another volume. That's Jesuit book talk for "30."

Thank you for listening to me on the radio.

And in this book.

I hope you might consider this volume worthy of a place in your personal library.

That would please me . . .

Index

A note about the typeface

The typefaces chosen for William O'Shaughnessy's *It All Comes Back to Me Now* are Stone Serif and Stone Sans. Designed by American type designer Sumner Stone (b. 1945), it was issued in 1987 through Adobe and in 1989 through ITC. Designer Willem Hart feels it suits this book because, like the book, it is American and contemporary. In spite of its digital character, it has a healthy respect for tradition. Its large x-height and foreshortened characters give the Roman a somewhat Edwardian tone, according to type expert Robert Bringhurst. This characteristic well suits the Squire of Westchester County. The sans serif, while closely matched to the roman, is different enough to provide a pleasing contrast in shape and weight.

This book was composed by Coghill Composition Company, of Richmond, Virginia, and printed and bound by Edwards Brothers, Inc., of Ann Arbor, Michigan, and Lillington, North Carolina.